A HISTORY OF
ART IN
AFRICA

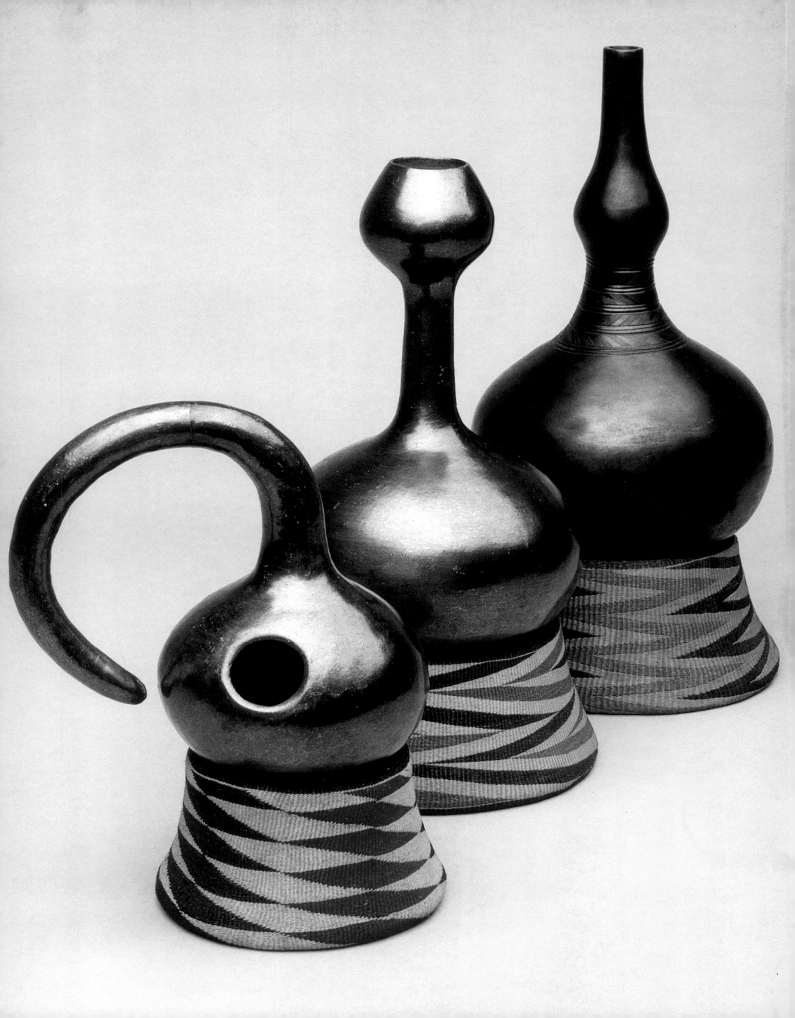

A HISTORY OF

ART IN

AFRICA

MONICA BLACKMUN VISONÀ

ROBIN POYNOR

HERBERT M. COLE

MICHAEL D. HARRIS

Introduction by Suzanne Preston Blier

Preface by Rowland Abiodun

HARRY N. ABRAMS, INC., PUBLISHERS

Acknowledgments

This book is the result of more than two decades of work by hundreds of people (including those noted in the Annotated Bibliography). We have been assisted by art historians, anthropologists, archaeologists, photographers, photographic researchers, editors, and designers. The initial discussions on the need for this book were held by members of the Textbook Committee of the Arts Council of the African Studies Association (ACASA). These led to discussions with Eve Sinaiko of Abrams, whose vision and commitment were eventually to bring the book to publication. Sinaiko helped shape the first few chapters, then relinquished development to the consummately professional Mark Getlein, who is responsible for making a whole cloth of many strands. After the initial gathering of text and images by Abrams' New York staff, the entire project was moved to London and placed in the capable hands of Kara Hattersley-Smith of Calmann and King. Hattersley-Smith and her colleagues (especially photographic researcher Julia Ruxton) have graciously and effectively managed to coordinate the efforts of contributors on three continents. The book has finally become a reality through the unstinting work of Julia Moore, our editor at Abrams for the duration.

A generous grant from the National Endowment for the Humanities allowed Robin Poynor and Monica Blackmun Visonà to visit photographic archives in London, Cambridge, Oxford, Paris, and Tervuren and to take leaves of absence from teaching in order to write the first drafts. We thank those who offered us advice and hospitality in Europe, especially the staffs of the Photothèque of the Musée de l'Homme, the Musée National des Arts Africains et Oceaniens, the Institut du Monde Arabe and Hoa-Qui in Paris, the Royal Anthropological Society and the Royal Geographical Society in London, and the Afrika Museum in Tervuren. While we do not have space to thank all the scholars, photographers, and photographic researchers who have assisted the four principal authors since that trip, we are especially grateful to the staff at the Fowler Museum of the University of California Museum and Christraud Geary at the Elisophon Archives of the National Museum of African Art. The four of us would also like to thank our fellow faculty and administrators at Metropolitan State College of Denver, University of Florida, University of California at Santa Barbara, and University of North Carolina at Chapel Hill for allowing us release time from our teaching and administrative duties so that we could produce this book. Our students have suffered through early versions of chapters, yet they have sustained us with their enthusiasm. Most of all, the authors wish to acknowledge the wisdom and generosity of the men and women in Nigeria, Ghana, Côte d'Ivoire, Mali, Kenya, Malawi, and the Republic of Benin who over the years have molded our lives as scholars and as people. We could not have written this book without the support of our spouses (Paolo, Donna, Shelley, Janine, Rudi, and Lea); and we dedicate it to our children: Mark, Marian, Chris, Sarah, Thomas, Peter, Luke, Shani Naima, Dara Ayana, Jocelyn, Adebayo, Aina, and Oluwole.

For Harry N. Abrams, Inc.
 Project director: Julia Moore
 Development editors: Eve Sinaiko and Mark Getlein
 Design concept and jacket: Darilyn Lowe Carnes
For Calmann & King, Ltd.
 Editor: Kara Hattersley Smith
 Designer: Karen Stafford
 Maps: Eugene Fleury
 Picture research: Julia Ruxton

This book was produced by Calmann & King, Ltd., London

Library of Congress Cataloging-in-Publication Data
A history of art in Africa / Monica Blackmun Visonà ... [et al.] ; preface by Rowland Abiodun ; introduction by Suzanne Preston Blier.
 p. cm.
 Includes bibliographical references and index.
 ISBN 0-8109-3448-5 -- ISBN 0-13-442187-6 (PH pb)
 1. Art, African. I. Visonà, Monica Blackmun, 1953-

N7380 .H54 2000
709'.6--dc21 00-22796

Printed and bound in Italy

Frontispiece: Gourd-shaped vessels on basketry stands, Ganda. 20th century. Terracotta, graphite, glaze, fiber; height of tallest vessel 13³/₈" (34 cm). The British Museum, London

Harry N. Abrams, Inc.
100 Fifth Avenue
New York, N.Y. 10011
www.abramsbooks.com

CONTENTS

II. Western Africa 166

III. *Central Africa* 328

IV. Eastern and Southern Africa 438

V. The Diaspora 498

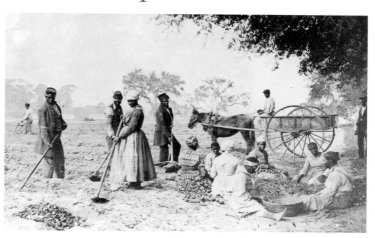

PREFACE

SINCE ITS INCEPTION *LAST* CENTURY, the field of African art studies has been vexed by the problem of cross-cultural translation. How can one, for example, meaningfully present to a Western audience two radically different Yoruba works? The *ako* is a seated, life-like, life-sized, human-garbed burial effigy carved in wood which is painted to enhance its mimetic qualities—a social and psychological reconstruction of the dead (fig. i). The *aale* is a hanging, seemingly abstract sculptural construct made from a bit of red rag, a slipper, a metallic soup spoon, and some sticks—a deterrent impregnated with *ase*, the catalytic life-force, to stop thieves and ward off unauthorized

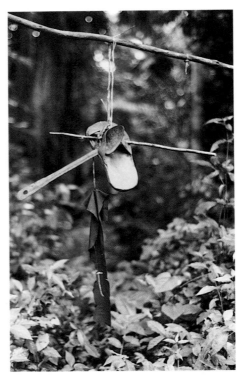

ii. AALE (AN ABSTRACT POWER-IMPREGNATED SCULPTURAL CONSTRUCT). PHOTOGRAPH 1982

i. AKO EFFIGY FOR MADAM ALADE, IPELE-OWO, NIGERIA. PAINTED WOOD. PHOTOGRAPH 1972

persons from one's property (fig. ii). Both of them could have been created around the same period, possibly even by the same artist. Quite often, our inadequate preparation to grapple with seeming incongruities of this kind has led to many misconceptions, bizarre conclusions, and at other times, brilliantly presented but untenable theories on African art. This simple comparison reveals how, in considering African art, conventional Western art-historical assumptions of stylistic progression and individual artistic identity are called into question. To make any substantial progress in dealing with the problems of cross-cultural translation as it pertains to the study and presentation of African art, we must consider both perspectives: the indigenous as well as the Western.

While it may have been useful to utilize only Western theoretical paradigms in the study of African art history and aesthetics in the early twentieth century, it has now become imperative to search carefully within the African cultures in which the art forms originate and to use internally derived conceptual frameworks in any critical discourse on African art. There are, however, difficulties in translating this theoretical position into practice. The study of African art, having begun within the discipline of anthropology, inherited some pertinent and vexing questions. Among these is the false assumption that Western scholars can fully understand and interpret the cultures of other peoples only by using their Western cultural notions, values, and standards—a claim that cannot be divorced from a long-standing Western, imperialistic involvement in Africa. In the traditional discipline of art history, the importance of African art has hardly advanced beyond that of catalyst and sanction for the revolutionary goals of European artists such as Pablo Picasso at the beginning of the twentieth century. Thus, Roy Sieber, a leading scholar in African art, has noted that an insufficient understanding of African art has caused it "to fall prey to the taste of the twentieth century."

In a bold and innovative manner, the authors of this textbook have taken a major step toward the goal of fashioning a new "lens"—one which appreciates the methodology of the finest traditions in Western art history but which also recognizes the need to critically examine, modify, and expand. This will enable scholars to deal with the special challenges presented by the visual art traditions of

predominantly non-writing, pre-colonial peoples of Africa. To illustrate my point, let us consider the question of anonymity in African art, a problem exacerbated by the fact that traditional African artists do not sign their works in the way artists in many contemporary Western societies do. Western audiences have become accustomed to appreciating and enjoying African works of art without knowing the names of their creators. Why should there be an interest in the issue of artists' identities now? Have we not read works by many scholars and even some "African art experts" premised on the notion that supposedly rigid African traditions are oblivious or even hostile to notions of individuality itself? The situation is complicated further when we consider how some art dealers and collectors view the issue of anonymity. A collector has been quoted as saying, "I am completely enchanted by the artist's anonymity. Not knowing the artist is something that gives me enormous pleasure. Once you hear who made it, it ceases to be primitive art."

To continue with the example of the Yoruba of West Africa, research confirms that Yoruba people not only know the value of the authorship of works of art, but that they, in fact, celebrate it through the literary genre known as *oriki* (citation poetry). There are, of course, other appropriate traditional contexts and occasions in which an artist's name may be heard and used. They include child-naming, installation and burial ceremonies, blessing and healing rituals, and important family gatherings. The myth of anonymity was constructed and reinforced by many early Western researchers who believed that,

although the artifacts and the traditional thought systems (their *raison d'être*) belong to Africans, the interpretation of such works and the theorization of African art would always be a Western prerogative. Many scholars today (including the authors of this volume) are, however, more cautious about not repeating that same old error; i.e., believing that if the definitions of art or artistic procedures in other cultures do not take the forms with which we in the West are familiar, they must be lacking.

In considering the question of anonymity, it is important to note some reasons that the Yoruba may not publicly or openly associate specific art forms with the names of their authors. Often, names given at birth are closely linked to and identified with the essence of one's personality and destiny called *ori inu* (inner spiritual head), which in Yoruba religious belief, determines a person's success or failure in this world and directs his or her actions. In Yoruba society, the act of calling out a person's given names generally functions to differentiate individuals. In their religious system, naming also is believed to have the ability to arouse or summon a person's spiritual essence and cause him or her to act according to the meaning of those given names or in some other way desired by the caller. This is the basis of the Yoruba saying, *oruko a maa ro'ni*: "one's name controls one's actions." For example, a name like Maboogunje is actually a plea, the full sentence being "*Ma(se) ba oogun je*," the translation of which is "Do not render medication ineffective."

Yoruba naming ceremonies and practices are among the most elaborate and sophisticated known anywhere. In

addition to serving as identification, a name also incorporates elements of family history, beliefs, and the physical environment. With every naming, there begins a corresponding *oriki* (citation poetry), which grows with an individual's accomplishments. Thus, leaders, warriors, diviners, and other important personages, including artists, are easily identified by their *oriki*, which chronicles intricate oral portraits of all that is notable in their character and history. To illustrate, let me cite a part of the *oriki* of Olowe, one of the greatest traditional Yoruba sculptors of the twentieth century:

Olowe, oko mi kare o
 Olowe, my excellent husband
Aseri Agbaliju
 Outstanding in war.
Elemoso
 Elemoso (Emissary of the king),
Ajuru Agada
 One with a mighty sword
O sun on tegbetegbe
 Handsome among his friends.

Elegbe bi oni sa
 Outstanding among his peers.
O p'uroko bi oni p'ugba
 One who carves the hard wood of the *iroko* tree as though it were as soft as a calabash.
O m'eo roko daun se ...
 One who achieves fame with the proceeds of his carving ...
Ma a sin Olowe
 I shall always adore you, Olowe.
Olowe ke e p'uroko
 Olowe, who carves *iroko* wood.

Olowe ke e sona
 The master carver.
O lo ule Ogoga
 He went to the palace of Ogoga

Odun merin lo se libe
 And spent four years there.
O sono un
 He was carving there.
Ku o ba ti de'le Ogoga
 If you visit the Ogoga's palace,

Ku o ba ti d'Owo
 And the one at Owo,
Use oko mi e e libe
 The work of my husband is there.
Ku o ba ti de'kare
 If you go to Ikare,
Use oko mi i libe
 The work of my husband is there.
Ku o ba ti d'Igede
 Pay a visit to Igede,

Use oko mi e e libe
 You will find my husband's work
there.
Ku o ba ti de Ukiti
 The same thing at Ukiti.
Use oko mi i libe
 His work is there.
Ku o li Olowe l'Ogbagi
 Mention Olowe's name at Ogbagi,
L'Use
 In Use too.

Use oko mi i libe
 My husband's work can be found
Ule Deji
 In Deji's palace.
Oko mi suse libe l'Akure
 My husband worked at Akure.
Olowe suse l'Ogotun
 My husband worked at Ogotun.
Ikinniun
 There was a carved lion

Kon gbelo silu Oyibo
 That was taken to England.
Owo e o lo mu se.
 With his hands he made it.

The *oriki* of Olowe was collected by
John Pemberton III in 1988 from
Oluju-ifun, one of Olowe's surviving
wives, and has been found to be
instrumental in reconstructing his life
and work (fig. iii).

Clearly, neither Yoruba culture nor
the Yoruba system of storing and
retrieving important information
about their artists is impoverished.
We do know, however, that artists
may become vulnerable targets of
unknown malevolent forces because
of their profession and special posi-
tion in the traditional community. For
this reason, until relatively recent
times, artists rarely revealed their full
given names to strangers. It is, there-
fore, not surprising that many
outstanding Yoruba artists whose
works have been collected and studied
by researchers have been identified in
scholarly literature only by their
nicknames or bynames such as, for
example, Olowe Ise (meaning Olowe
from the town of Ise); Ologan Uselu
(Ologan from Uselu quarters in
Owo); and Baba Roti (father of
Rotimi). (The status of such personal
information is as confidential as
modern-day codes such as Personal
Identification Numbers for banking
purposes or government-issued social
security numbers.) Early researchers
were clearly ill equipped in their
training to grapple with the problems
of naming traditions different from
those with which they were familiar.
This initial lack of understanding may
have led them to assume that the
authorship of art works was unimpor-
tant among the Yoruba. Moreover, the
biases of these early researchers must
have prevented them from carrying
out any diligent probing for artists'
full given names. It is ironic that such

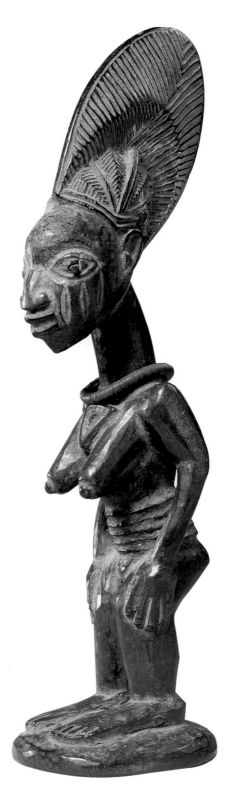

iii. Ibeji (twin figure). Olowe of Ise.
Before 1938. Wood, beads, iron,
pigment; height 13‐3⁄16" (33.5 cm). The
Collection of Mareidi Singer,
Munich

information was so highly valued by art historians in relation to Western art.

Most Yoruba people would, in fact, be surprised about the sensitivity I am attributing to them about the identity or name of a person. When a person's *oriki* is recited, it is assumed that anyone who listens carefully and understands it will know enough about the subject's identity, name, lineage, occupation, achievements, and other qualities so that stating the person's given name becomes superfluous. Hence a Yoruba saying (from the collection of Oyekan Owomoyela):

A n ki
 We recite someone's *oriki*
A n sa a
 We intone his attributes
O ni oun o mo eni to ku
 But one person says he does not know who has died
O ngbo "iku meru
 He hears, "Death has taken a renowned man.
Opaga,

A titled man,
Abisuutabiododo
 Whose yams spread like petals
Alabaoka,
 Who possesses a barn of corn
Arokofeyeje"
 Whose fields are a bounty for birds"

After this description, which clearly identifies a certain individual, there is a question:

O ni "Agbe lo ku ni tabi onaja?"
 This (foolish) person still asks, "Is the dead man a farmer or a trader?"

African societies recognize the contribution of individual artists, but they frame their praises in their own distinctive terms. Thus, according to Gene Blocker, a philosopher of art and aesthetics, the problem of anonymity in African art "has more to do with a tradition of individuality than with the 'fact of individuality.'"

The contributors to this book have critically reflected upon cultural and art historical assumptions and biases similar to the one just described. They have sought to locate meanings within the thoughts and practices of Africans themselves. This assembled volume on the art of the continent of Africa is also measurably more comprehensive than previous works of its kind. It includes, notably, Africa north of the Sahara and the African diaspora, both of which embody some of the most important developments spatially and temporally in the history of African art. These areas have likewise either been either underrepresented or simply ignored by a majority of textbooks on African art. In their detail and sympathetic insight, these chapters are a testament not only to the massive amount of research that the contributors have conducted over the years but equally importantly, to an open-eyed alertness to individual human achievements. This publication, therefore, represents a milestone in the study and future perception of African art.

AFRICA, ART,
AND HISTORY:
AN INTRODUCTION

iv. MASK FOR SANDE/BONDO,
MENDE OR SHERBORO, SIERRA
LEONE. LATE 19TH–EARLY 20TH
CENTURY. WOOD AND SILVER;
HEIGHT 16″ (40.5 CM).
BROOKLYN MUSEUM, NEW
YORK

AFRICA, A CONTINENT OF STRIKING cultural richness and ecological diversity, is distinguished by the visual power and creativity of its arts. This book examines the full corpus of these arts. It includes ancient art from Egypt and northern Africa as well as rock art from southern Africa and archaeological artifacts from western Africa (fig. v). It surveys architecture and arts of daily life, in addition to contemporary works by African artists and artists of African descent. The book's overarching focus is on Africa's many diverse peoples and regions, the artistic developments of each region, the broader cross-cultural traits that link them, and the different local and regional responses to historical concerns. This can be seen, for example, in the blending of Islam and Christianity into existing social and aesthetic structures, the creation of art in the context first of the slave trade and then colonial rule, and the rich, creative impact of recent post-nationalist and international art movements. Accordingly, this volume presents the arts of many different "Africas:" not only those of distinct regions, historical periods, and religious beliefs (varied local forms as well as Islamic and Christian) but also arts representing a diversity of social and political situations (dynastic and plebeian, urban and rural, nomadic and settled, outwardly focused and inwardly defined).

AFRICAN ART—GENERAL COMMENTS

At the risk of promoting an inaccurate sense of Africa as a place of unified or monolithic artistic practice, the question of what, if anything, is

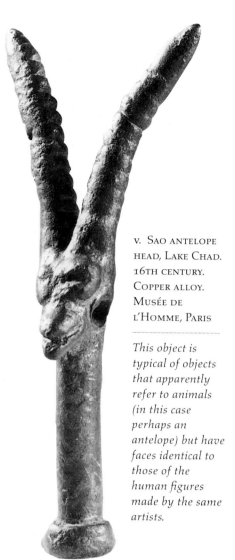

v. Sao antelope head, Lake Chad. 16th century. Copper alloy. Musée de l'Homme, Paris

This object is typical of objects that apparently refer to animals (in this case perhaps an antelope) but have faces identical to those of the human figures made by the same artists.

vi. Anei Kyr, the Reth (divine king) of the Shilluk, standing in front of his palace, Fashoda, Sudan. 1947

The palace is built upon the holy mound known as Aturwic. The Reth retires here for three days following his coronation.

Africa offers evidence of a larger continent-wide concern with artistic innovation and creativity. This can be seen not only in the variety of forms within a relatively small area (a single culture, a city or town, an individual artist) but also through history. The great differences between early (archaeological) works from the Yoruba city of Ile-Ife and twentieth-century art made at the same site are but one example (see chapter 8). Innovation has been widely promoted by local art patrons and cultural institutions, as in the imperative that kings coming to the throne must create a new palace and capital for themselves (fig. vi) along with a range of new art forms or textile designs that will distinguish their reigns. This interest in innovation can be seen in masquerades such as Flali, invented by an artist working with a performer in a Guro community in Côte d'Ivoire during the 1970s (fig. vii), and in the *mbari* houses built by the Igbo in the Owerri Igbo region of the Lower Niger River

vii. Flali mask in performance, Bangofla, northern Guro region, Côte d'Ivoire. 1983

distinctively "African" about African art is an intriguing and interesting one to address as a preface to the survey that follows. The answers to this question are subtly different with regard to specific areas of the continent and periods of its history. Among the formal features which stand out across the broad sweep of Africa are the following (not in order of priority):

Innovation of form. The impressive diversity of art traditions across

viii. CEMENT *MBARI* HOUSE, OWERRI REGION, NIGERIA. IGBO. 1982

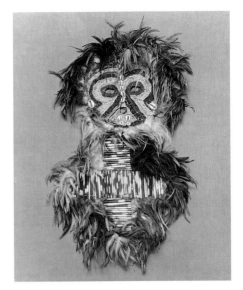

x. ELANDA MASK. BEMBE. LEATHER, CLOTH, PEARLS, AND COWRIE SHELLS. INDIANA UNIVERSITY ART MUSEUM, BLOOMINGTON

(fig. viii, see also chapter 9). African artists have long looked outside their own communities for sources of inspiration, not only in other cultural areas of Africa but also in Europe, Asia, and, recently, America.

Visual abstraction. There is a preference in much of Africa for varied forms of visual abstraction or conventionalization: that is to say, art works which in bold and subtle ways lie outside more naturalistic renderings of form. It was indeed these features of near-abstraction and visual boldness that in part led European artists at the beginning of the twentieth century to turn to African art in rethinking form more generally. The importance placed on abstraction in African art is evidenced across media—sculpture, architectural facade paintings, textile design, and other forms. In some cases, this non-realistic stylization is fairly subtle, as in the portraits of the Yoruba king of Ile-Ife mentioned above; only careful observers will note the ways in which the artists have smoothed and simplified the facial features. In other

works, such as a mysterious stone sculpture left in Central Sahara by an ancient Berber group, only minimal suggestions of brow and forehead tie the forms to the human head (fig. ix).

ix. STONE SCULPTURE, CENTRAL SAHARA. BERBER. MUSÉE DE L'HOMME, PARIS

Complementing the importance of abstraction is an emphasis on visual boldness. Many African masks, such as one used in the Elanda masquerade of the Bembe in eastern Zaire, are particularly forceful in their visual impact (fig. x) while many others are inventive departures from any animal or human form. Such dazzling images, however, are not confined to performed art works; a Christian manuscript painting from Ethiopia displays large staring eyes, juxtaposed patterning, and the color palette of Ethiopia (fig. xi). While illustrating similar biblical scenes to those in Christian European manuscript painting, Ethiopian compositions from the same period are strikingly unusual.

Parallel asymmetries. African artists often reveal a fundamental concern with a visual combination of balanced composition and vital asymmetries, This gives even a relatively

static form, such as the equestrian figure atop an iron staff of a Bamana association (see fig. 4-11), a sense of vitality and movement. Parallel asymmetries are also evidenced in profile and back views of the same figure and in the push/pull of negative and positive spaces. The overall painting of the symmetrical features of the body is frequently distinguished by asymmetry, as in the lines and shapes painted on the human body by the men of a Nuba group in southern Sudan (see fig. 13-48). Similarly, bold asymmetries characterize African architectural design (fig. xii) and facade paintings (see fig. 5-44), particularly when one looks at these works alongside the rigidly symmetrical architectural traditions of other parts of the world. In African sculpture and textiles, as in architecture, broken or undulating lines are generally preferred to rigidly straight lines. Varied pattern elements and intentional breaks or shifts in a pattern are also emphasized over exact replication (fig. xiii).

xi. Saint Luke from a painted manuscript of the Four Gospels, Ethiopia. The British Library, London

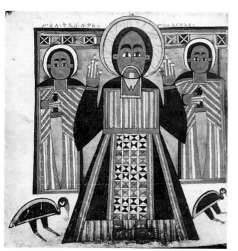

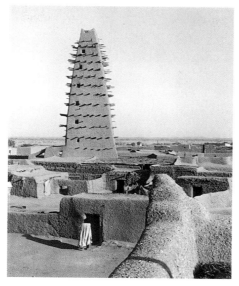

xii. minaret of the Great Mosque at Agadez, Nigeria. Built for Tuareg and Songhai patrons. Adobe

The gently uneven slopes of the minaret resemble those attached to the mosques of Sahara oases further south, particularly those of Mzab (see fig. 1-24).

Sculptural primacy. Most art in Africa is carved, molded or constructed into three-dimensional forms, even though important traditions of two-dimensional painted, engraved, or raised designs also exist. In many cases, even two-dimensional art forms are

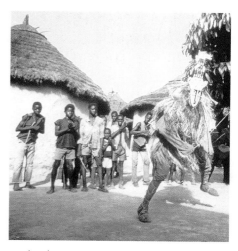

xiv. Age-grade masquerade danced for the inauguration of a health clinic, Malinke, Guinea

meant to be seen and admired primarily three-dimensionally, as when wall paintings (such as those mentioned above) wrap around building surfaces in ways that enhance their sculptural effects. Flat textiles become three-dimensional when used as tents or enclosures; they become four-dimensional (spanning time as well as height, breadth, and depth) when they move through space on the human body, as in the astounding variety of performed masquerades (fig. xiv).

xiii. dance skirt. Kuba, Bushoong. 20th century (?). Raffia with appliqué. Kasmin Collection

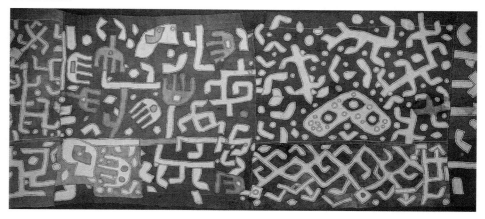

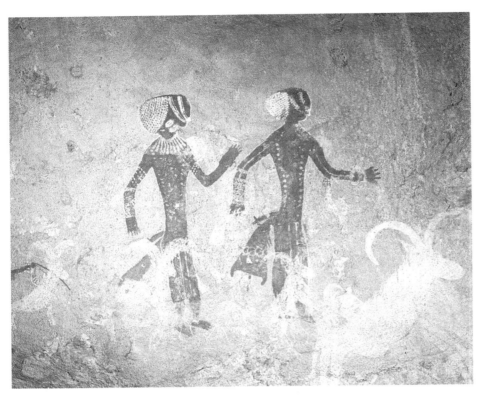

xv. Figures ornamented with elaborate paint and beadwork. rock painting, Tassili n'Ajjer region, Algeria. Archaic style, 8000–6000 bc. Pigment on stone

Earthen and stone architecture also have a sculptural tradition (see fig. xii) that distinguishes African Islamic and Christian examples from those of other areas.

Performance. Many of the visual art forms surveyed in this volume were first seen in performance contexts. Indeed, it may well be that for African peoples, performance, which always implies music and dance, is the primary art form. Elaborate personal decoration, for example, nearly always involves public display and very often invokes gesture, dance, and other stylized forms of behavior: in short, performance. Many groups of people both perform *with* art (such as sculptures, masks, and dance wands) and, in their collectivities, often *become* art. Statuary that resides in a shrine for most of its "life" may be ceremonially carried to the site in a "festival of images." The ultimate performance genre is the festival—with events invoking visual, audial, and kinetic forms of great variety and richness. These events are all orchestrated toward a large communal or state purpose, be it a proper funereal "send-off" for a prominent person, an initiation of youths, or a New Year's or First Fruits ceremony. Masquerades—in both prevalence and astonishing variety— are among the most complex and prominent of African arts.

Humanism/Anthropomorphism. Home to the first humans, Africa is remarkable for the emphasis its patrons and artists have historically placed on the adornment, and often transformation, of the human body. This use of the human skin as canvas can be seen in images painted in rock shelters of the Sahara more than seven thousand years ago, which seem to depict humans in elaborate paint and beadwork (fig. xv). The We of the Côte d'Ivoire consider a painted face to be the spiritual as well as the conceptual and physical equivalent of a mask (fig. xvi). African art also focuses on representations of the human body, human spirit, and human society, and most sculptural traditions in Africa incorporate human beings as their primary subjects. Even portrayals of animals in masquerades and other arts often include human-derived elements, such as jewelry or elaborate coiffures. Virtually all art and architecture on the continent (with the exceptions of Ancient Egypt) has been conceived on a human scale. Anthropomorphism also features prominently in African architecture, with the naming of particular construction elements to represent parts of the human anatomy, or the decoration of building facades to suggest textile patterns or body scarification.

Ensemble/Assemblage. An isolated statue or other African work is rare and exceptional. Varied works are usually assembled together, as in a shrine or multicharacter masquerade. And many individual works are themselves composite, having been made from diverse meaningful materials. Power figures from Mali to Benin and Nigeria and on to the Congo make this point with particular force, as the purposes of these images *derive* from their varied materials, just as their visual character is dependent upon them. Thus the ensemble—the collection of works or the assembling of composite materials

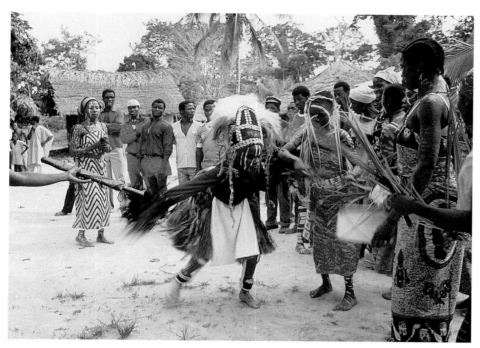

xvi. OUDHUÉ, OR TITLED FEMALE DANCER, PERFORMING AT A WOMEN'S FESTIVAL, OULAITABLI VILLAGE, BÔ REGION, WESTERN CÔTE D'IVOIRE

in a single work—is a vital trait of visual arts all over Africa. The idea is driven home by the elaborate assemblages of personal decorations featured for ceremonies nearly everywhere—scarification or tattoo, coiffure, jewelry, cloth, and sometimes body or face painting—and by the combination of varied arts, including music and dance, in festivals. It follows, then, that these art works and ensembles—in part because they omprisemany materials and forms—will have many meanings.

Multiplicity of meaning. Like a telephone line that carries multiple messages simultaneously, African art is characterized by its multiplicity of meanings and intellectual complexity. As in the varied rhythms and competing melodies of jazz, these differential meanings exist concurrently and harmoniously within the same work, giving it an even larger (broader) sense of symbolic and intellectual grounding

than it otherwise might have. In contrast to the Western Christian art traditions of symbolism (iconography) where a form would carry a single meaning (so that observers would associate a rose with the Madonna, for example), in African art a single form is often intended to mean different things to different members of society, depending on age, level of knowledge, and level of initiation. A Dogon *kanaga* mask form (see fig. 5-19) signifies at once a variety of beings, such as a bird, a crocodile, or a primordial being. Another example of this multiplicity of meanings is that of an Asante goldweight depicting a bird scratching its back with its beak or looking backwards. "Pick it up if it falls behind" is one common translation. This can refer to the "wisdom of hindsight"—how one can learn from one's mistakes—or it can indicate more literally that one needs to clean up things left behind,

such as an incomplete task or a mess. Thus there are many possible meanings for an apparently simple image depending on the circumstances of its occurrence or use, as well as each viewer's experience, knowledge of proverbs, and wisdom. This multi-referential quality in African art makes research into art symbolism both challenging and rewarding; artists and users frequently offer different interpretations to the meanings of a single given form.

CHANGING PERCEPTIONS OF AFRICAN ART

Africa was known to the ancient world for the power, wealth, and artistic magnificence of Egypt's monarchies and was a place of thriving art production during much of Europe's "dark ages." Great inland art centers, such as Zimbabwe and Ile-Ife, were flourishing at this time and have left behind striking evidence of the aesthetic and cultural complexity of powerful indigenous political systems. Africa has also been host to larger artistic encounters. Early on, Nubia, and later Ethiopia, became important global sites of Christianity, with local rulers commissioning handsome works of painting, sculpture, and architecture, cojoining the new liturgical concerns with indigenous African aesthetic vibrancy. Africa also played a crucial role in the development and expansion of Islam. Timbuktu (in present-day Mali) became the home to one of the world's most important universities, its large library specializing in law. The kings of Mali, who controlled much of the world's gold trade at this time, were wealthy beyond compare.

In addition to the gold-ornamented horse trappings and other decorative arts, made in Mali, court builders created magnificent multistoried architectural projects using local earth. During this period (eleventh to fifteenth centuries), east coast cities such as Zanzibar were said to be among the most handsome in the world, both for their inhabitants' elegant fashions of dress and for their unique traditions of decorative coral architecture. Asian merchants sought out these rich east African ports and interior markets, leaving behind large quantities of export ceramics and other materials that have been important for the dating of sites.

In the sixteenth through eighteenth centuries, Africa continued to be known as a place of powerful kings and lavish courts. In this era of broad-based sea exploration, many European travelers to Africa compared the continent's court architecture and thriving cities favorably with the best of Europe. They also brought home ivories, textiles, and other art works that eventually found their way into the collections of the most distinguished art patrons and artists of Europe, such as the Medici family and Albrecht Dürer. Even during the horrors of the slave trade, which resulted in inconceivable personal suffering, massive political instability in much of Africa, and the transportation of a significant proportion of Africa's own essential labor force to the Americas to provide for the West's industrialization drive—outside observers continued to hold highly favorable views of Africa and its arts.

These generally positive images of Africa changed dramatically in the late nineteenth and early twentieth

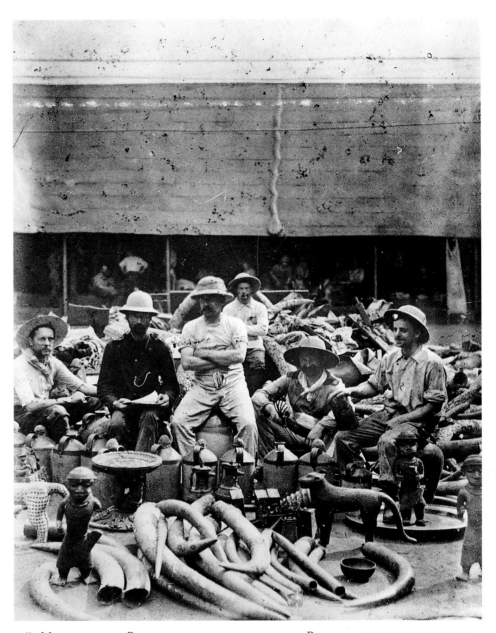

xvii. MEMBERS OF THE BRITISH PUNITIVE EXPEDITION IN THE BENIN PALACE WITH THE TREASURY OF ROYAL IVORY, BRASS, AND OTHER ARTS WHICH WERE REMOVED TO LONDON. 1897

centuries. Western desire for greater control over Africa's trade partners, religious beliefs, and political engagements led to an era of widespread colonial expansion. Consistent with the aims of nineteenth-century colonialism, Africa was then frequently described in published accounts as a place of barbaric cultural practices and

heinous rulers. If art was mentioned at all, it tended to be in negative terms. Charles Darwin's theories of biological evolution also had a negative impact and were used to support popular parallel theories of social evolution that falsely maintained that African societies (as well as those of other "minority" peoples such as American

Indians, Indonesians, Irish, and peasants more generally) represented a lower level of humanity, indeed an earlier prototype within the human evolutionary sequence.

Arts and other contributions of these societies were similarly disparaged as lacking in rational foundation, true innovation, and sustained cultural accomplishment. For example, when the great archaeological finds at Ile-Ife (in present-day Nigeria) were discovered at the beginning of the twentieth century, it was wrongly assumed that a group of lost Europeans was responsible for these technically and aesthetically sophisticated sculptures.

With the growth of colonial interests in Africa, writing about the social fabric of its arts also changed. Africa was described primarily as a place of separate (and fixed) "tribal" entities which lacked sophisticated political and economic institutions as well as broad-based authority. This was also the period when many major European collections of African art were started. Wealthy state treasuries of kingdoms such as Benin, Asante, and Dahomey (and their accumulated arts) were taken to Europe as war booty following the defeat of their rulers by European forces (fig. xvii) and formed the basis for the rich collections of newly founded ethnographic museums. In the literature of the time, the broad regional influences of these kingdoms were often played down in favor of narrow ethnic identities. Regional dialects of larger language groups in turn became erroneously identified as distinct fixed languages, each supposedly unique to a separate "tribe" and artistic "style." "Tribalism" became the predominant framework within which the continent's art

production was discussed, and to some extent this model of the distinctive ethnic group ("tribe") survives today. The great dynastic arts of Egypt (fig. xviii) were an exception that proved the rule, for by that time Egypt had largely been removed from consideration as an African civilization and was instead positioned culturally with the Near East. The Christian arts of Nubia and Ethiopia were rarely, if ever, discussed alongside other African works. Earlier maps highlighting Africa's impressive royal capitals, inland cities, and material resources were largely replaced with new maps showing small-scale rigidly fixed cultural boundaries (each "unique" to one "tribe" and one art "style") which were again falsely presumed to have existed for much of history. What was mistakenly called a distinct "tribal

style" in the early twentieth century was often the result of the iconographic requirements of a particular image type. Today, we also know that a number of art works were created in one place (and culture) yet used in another. Many "Mangbetu" works were made by Azande artists; a significant number of "Bamun" artists were from other grasslands cultures; some of the most important "Dahomey" artists were of Yoruba or Mahi origin; and many Bushoong/Kuba and Asante art genres also have foreign origins.

The longstanding and problematic label of "tribal art" has had a negative impact on the field African art and meant that until recently little academic interest was shown in the

xviii. MIRROR WITH FEMALE FIGURE AS A HANDLE. EGYPT. DYNASTY 18, C. 1479–1352 BC. BRONZE, HEIGHT 9½" (24.6 CM). BROOKLYN MUSEUM, NEW YORK. CHARLES EDWIN WILBOUR FUND

The varied uses of this African object revolve around its ability to reflect the image of the beholder during life and its presence in the tomb after death. The shape resembles the ankh, *the Egyptian symbol for spiritual life. Egyptians portrayed human spirits with wings, and the female figure that forms this mirror's handle is posed so that her outstretched arms connect with the object on her head to give an impression of wings. These references to life and to beauty were enhanced by the reflective surface of the sunlike disk, an image of the life-giving sun. Unclothed young women such as this were depicted on many works destined for the bedroom and the tomb, for they were meant to evoke the sexuality leading to both child-bearing and to rebirth of the soul in the afterlife. The heavy wig may link this figure to the wigged Hathor, a primordial goddess associated with the sun and with female sexuality.*

historical dimensions of these arts or the names of individual artists. This in part explains why far fewer dates and artist attributions are available to us than is the case in other comparable art surveys.

Other problematic views by colonial authorities influenced the early classification of African art within the larger context of world art history. In keeping with now long-disproven social evolutionary theories, early social scientists identified African art as a form of "primitive art," indicating that African art works, regardless of age, were necessarily primeval. Textbooks of the early twentieth century presented all African arts as conceptually similar to prehistoric works or to the arts of children. Even early modern artists, such as Picasso, assumed that African art was based upon intuitive, "primal" impulses. They did not realize that African art is as intellectual and intentional as Western own nor did they appreciate the degree to which African artists were grappling with the art historical traditions of their culture as well as with new, imported ideas and art forms.

Partly as a result of African art's "primitive" label—and even though today most art historians acknowledge its importance to the development of European modernism—too few African artists are credited for their understanding of the unique intellectual and formal possibilities of abstraction or for utilizing the vital aesthetic power of collage and assemblage, both of which were so central to the development of Western Cubism. Thus, whereas many twentieth-century art works in Western museums bear the label "abstract art," the comparable (and much earlier) abstract works made by African artists generally are not so labeled. It is assumed, wrongly, that Western abstract works alone are intellectualized and intentional, while abstract works by African artists are intuitive and/or the result of errors in trying to copy from nature. Comparable misunderstandings have also been frustrating for contemporary African artists seeking to gain wider acceptance for their art because their use of abstraction and similar "modern" idioms is seen by some critics as derivative of the West. African artists who seek to address contemporary issues or subject matter in their works face similar problems.

AFRICAN ART AS ART

Despite European modernism's universally acknowledged debt to African art, some art historians still ask: "Is African art really 'art'?" If today we tend to see art as something of beauty or visual power, but as something devoid of function, we would need to acknowledge that European religious and political arts—to say nothing of modern architectural works guided by the value that "form should follow function"—would have to be purged from a strict "art for art's sake" canon. In Africa, as in Europe for most of its history, a number of words for "art" and "artist" exist, but they are not those used by contemporary critics; they address questions of skill, know-how, and inherent visual characteristics.

"Something made by hand" (alonuzo) is how the Fon of Benin designate art. The nearby Ewe of Togo use a similar term, adanu (meaning "accomplishment, skill, and value") to refer at once to art, handwriting techniques, and ornamentation. For the Bamana of Mali, the word for sculpture is translated as "things to look at." In linking "art" to "skill," African words for art are similar to those used in late medieval Germany, or in Renaissance Italy. The Latin root for "art," ars, has its source in the word artus (meaning to join or fit together). Both the Italian word arte and the German word for art, Kunst, were linked to the idea of practical activity, trade, and know-how (Kunst has its etymological source in the verb können, "to know"). African words for art not only help us to further pry open the definition of the word "art," but also to reposition African art within its broader historical conceptualization. Recent debates in art history have caused the breakdown of modern categories dividing "high" art from "low" art, and "fine arts" from "crafts." These discussions have encouraged researchers in African art to study objects of beauty such as ceramics, or ornamented gourds (fig. xix), even when these works are made by women, and even when they form part of daily life. Contemporary Western art forms, such as performance projects and installations, also have parallel African conceptualizations—the masquerade (versus the mask) and the altar complex (versus the shrine figure).

As with all art forms, the market, collection history, and museum display also have an impact on whether or not Western observers can understand African art as "art." When works of African art are exhibited on special mounts under bright spotlights and behind the antiseptic barriers of glass

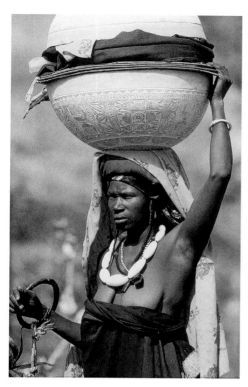

xix. Fulani woman carrying intricately carved calabash, Nigeria

vitrines in fine arts museums as "high art," or under fluorescent lights and in large display cases in natural history museums as "artifacts," they take on qualities more accurately attributed to the viewing than to the creating culture. Removed from their local contexts they look very different from how they were seen by local viewers. This is equally true for other arts too, of course, such as ancient Greek and Roman art, medieval art, and Renaissance Christian art, suggesting not that African art is "different" from these other arts (and must be displayed in different ways) but rather that museums need to be more creative in thinking about displaying all art forms.

In beautifully produced books such as this one, certain ways of isolating, lighting and photographing, and labeling objects also signal "art" to viewers, the camera lavishing a form of attention on the object that substitutes for the attention we would bestow in person. With works of African art, the tendency at one time was to photograph them using backgrounds, lighting sources, or angles that made them look mysterious or sometimes even sinister. This fortunately has changed. One of the noteworthy features of this book is the significant number of contextual photographs that help to remind us that, like other arts, African art works are (or were) a part of living cultures, and that the study of art history shares a close bond with anthropology—especially so in the case of Africa. How the anthropological study of art in Africa has differed from the art historical is not an easy question to answer. There has been excellent (and less good) research done on African art in both fields. Anthropology, a field within the social sciences, historically has focused on the broader contexts of visual experience; art history, a discipline within the humanities (which also includes literature, foreign languages, philosophy, music, and theater), has traditionally been interested in the history and symbolism of visual forms. Methodologies used for studying African art necessarily draw on the best features of both disciplines, as is done in the pages that follow.

Let us briefly examine one particularly beautiful, refined sculpture, a regal head once worn by a female leader in a masquerade (fig. iv). In this photograph, we are able to appreciate the aesthetic qualities of the carved image. While the artist and the owner of this work would also have been able to view it in such splendid isolation, everyone else in the region would have experienced it as fleeting part of an exciting performance, one feature in a ceremony such as that illustrated in figure 6-1. Both views of this type of sculpted mask are "true," even though only one may conform to the modern museum or gallery experience of art.

The importance of including the whole continent of Africa and the long history of its arts (including contemporary forms) within a survey such as this one is in part the result of the specific contexts in which Africa and its arts have been problematized in the past. By including Egypt, the authors of this book seek to bring back this art-rich civilization to the continent of Africa as one of its own. By incorporating African Islamic and Christian art traditions, the importance of Africa in the formulation and creative vibrancy of these religious arts is also emphasized. The inclusion of contemporary art from Africa makes the point that art in Africa is not dead, that African artists are continuing to make important contributions to both Africa and to global contemporary art movements. The addition of works by artists of the Diaspora, who were (or are) of African descent but who lived (or live) far from is shores, stresses the ongoing importance of Africa to world art.

I. From the Nile to the Niger

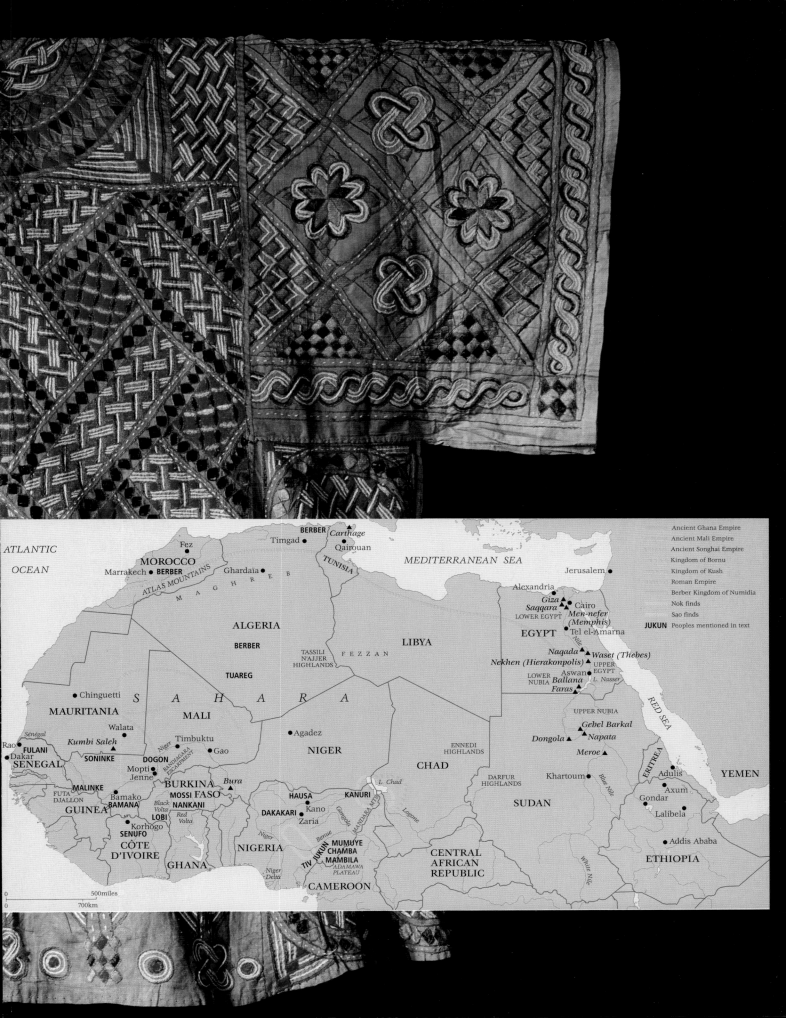

ATLANTIC
OCEAN

MEDITERRANEAN SEA

BERBER *Carthage*
Timgad ▲
Fez ● Qairouan
TUNISIA

MOROCCO
Marrakech ● **BERBER** Ghardaïa
ATLAS MOUNTAINS B
M A G H R E B

Jerusalem ●

Alexandria ●

Giza ▲▲ Cairo ●
Saqqara ▲ *Men-nefer*
LOWER EGYPT *(Memphis)*
EGYPT ● Tel el-Amarna

JUKUN

ALGERIA

LIBYA

TASSILI
N'AJJER
HIGHLANDS F E Z Z A N

Naqada ▲ ▲ *Waset (Thebes)*
Nekhen (Hierakonpolis) ▲ UPPER
EGYPT
LOWER Aswan ●
NUBIA *Ballana* *L. Nasser*
Faras ▲

BERBER

TUAREG

UPPER NUBIA

Gebel Barkal ▲
Dongola ▲ ▲ *Napata*

● Chinguetti S A H A R A

MAURITANIA **MALI**

● Agadez

ENNEDI
HIGHLANDS

Meroe ▲

Walata ●

RED SEA

Rao ● *Sénégal*
FULANI *Kumbi Saleh* ▲ Timbuktu ●
● Dakar **SONINKE** *Niger* ● Gao
SENEGAL **DOGON**
Mopti ● BANDIAGARA
ESCARPMENT
Jenne ●

NIGER

DARFUR
HIGHLANDS

CHAD

Khartoum ●

ERITREA

Adulis ●
Axum ●

YEMEN

MALINKE
FUTA
DJALLON Bamako ● *Bura* ▲
GUINEA **BAMANA** **MOSSI FASO**
BURKINA
*Black
Volta* **NANKANI**
LOBI
● Korhogo *Red
Volta*
SENUFO
**CÔTE
D'IVOIRE**

HAUSA
● Kano
DAKAKARI
Zaria ●

KANURI

L. Chad

SUDAN

Blue Nile

Gondar ●

Lalibela ●

● Addis Ababa

GHANA

Niger

NIGERIA

*Niger
Delta*

MUMUYE
JUKUN **CHAMBA**
TIV **MAMBILA**
ADAMAWA
PLATEAU

CAMEROON

Benue
Gongola

MANDARA MTS.

Logome

**CENTRAL
AFRICAN
REPUBLIC**

White Nile

ETHIOPIA

0 500miles
0 700km

Ancient Ghana Empire
Ancient Mali Empire
Ancient Songhai Empire
Kingdom of Bornu
Kingdom of Kush
Roman Empire
Berber Kingdom of Numidia
Nok finds
Sao finds
JUKUN Peoples mentioned in text

1

THE SAHARA AND THE MAGHREB

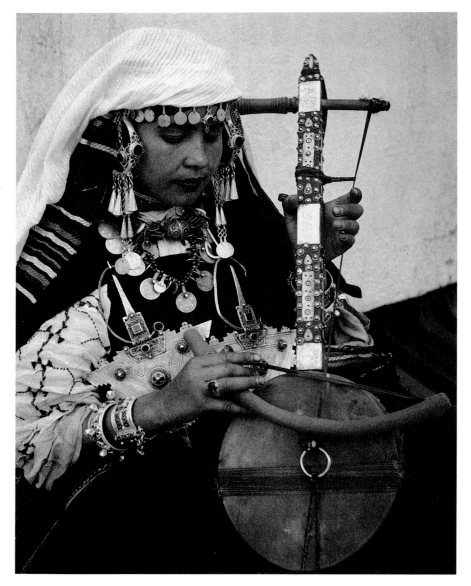

1-1. SHLEUH BERBER WOMAN, SOUS, MOROCCO. 1950S

This Berber woman is playing the one-stringed instrument used to accompany songs of love and war in many desert Berber groups. Tuareg women who compose these long ballads perform for large groups under the desert stars. At these concerts women of distant clans exchange news and young people form romantic attachments.

THE ARABIC NAME *AL-SAHRA* means simply "the desert," as though the Sahara were the definitive example of a dry, barren landscape. A vast expanse of stone and sand covering a landmass larger than the continental United States, the Sahara would seem to sever the coastal regions of northern Africa from the rest of the continent to the south. In fact, trade routes crossing the desert are older than the desert itself, and cultural exchange across the Sahara and in the oasis cities has played an important role in the history of African art.

Furthermore, the Sahara has not always been arid and forbidding. During a geological phase that began around 11,000 BC and lasted for some eight thousand years, the region was a well-watered savannah, a fertile land where diverse peoples invented new technologies and created new art forms. After around 3000 BC, as drought followed upon drought, Saharan populations would have migrated to more welcoming regions to the north, east, and south. The early arts of the Sahara thus most probably laid the foundation for artistic traditions in many areas of the African continent.

By about 1000 BC the desert as we know it had emerged. The cool mountains and coastal plains to the northwest, however, remained green and fertile. Divided today between the countries of Morocco, Algeria, and Tunisia, this region is known by its Arabic name, the Maghreb. The Maghreb has a long history of attracting foreign settlers, beginning with colonies founded by the Phoenicians and ancient Greeks during the first millennium BC and continuing through successive periods of conquest and rule by Romans, Vandals, Byzantines, and

Arabs. The Greeks referred to the indigenous peoples of the region (as they referred to all foreigners) as "barbarians," *barbaroi*. Their term is the origin for the word "Berber," the name still used to refer to these peoples. Inhabitants of the region since at least the second millennium BC, Berbers speak languages related to ancient Egyptian. Their arts, and the art of early Saharan peoples, are the principal focus of this chapter.

CENTRAL SAHARAN ROCK ART

Early arts discovered in North Africa include incised shells from Paleolithic sites in central Tunisia and intriguing semi-abstract stone sculptures from the central Sahara which may date to the first millennium BC. The oldest and most widespread Stone Age art form of the Sahara, however, is rock art. Symbols and images cut into rock have been found from the Canary Islands in the west to the Red Sea in the east, and from the Atlas mountains of northern Morocco to the Ennedi highlands of central Chad. The most fully documented sites are those of the central Sahara.

Large Wild Fauna Style

The Fezzan region of southwestern Libya is marked by rugged plateaus and outcrops of bare stone overlooking windswept plains of gravel and sand. Only a few brackish pools and two tiny oases provide water for nomads and their camels. Images of giraffes and an elephant incised by Paleolithic artists into the rock walls of a streambed, however, evoke a time when the region was filled with animals now extinct or found only south of the Sahara (fig. 1-2).

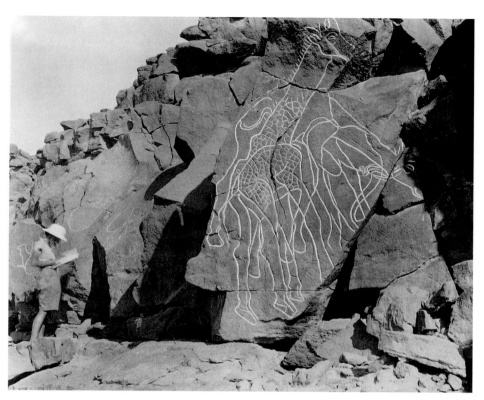

1-2. SUPERIMPOSED ELEPHANT AND TWO GIRAFFES, FEZZAN REGION, LIBYA. LARGE WILD FAUNA STYLE, AFTER 8000 BC (?). GROOVES IN STONE. PHOTOGRAPH 1932

This type of rock art is generally known as Large Wild Fauna style, after the impressive scale of the animals depicted. It has also been known as Bubalous Style, after *Bubalous articus*, an extinct species of wild cattle sometimes portrayed. The giraffes in the example here are almost life-size. Deep, smooth, and continuous, the outlines of the three beasts are so fluid that it is difficult to remember that they were laboriously ground into the rock with stone tools and abrasives. The portrayal is largely naturalistic and evidently observed from life (note the giraffe who bends down in a characteristic pose to drink). The size of the elephant's head is exaggerated, however, and all three animals bear the outsized, rounded feet typical of Large Wild Fauna images.

Hundreds of such images have been found in the central Sahara, especially in the Fezzan region. Scholars have often assumed that the images were somehow involved in "hunting magic," an attempt by Paleolithic peoples to control the animals they wished to kill. Yet this explanation is probably too simplistic. Large Wild Fauna images were more likely rooted in a conceptual system as sophisticated as the world view of the hunters who created the rock art of southern Africa (see chapter 14).

Some images clearly have a supernatural dimension (fig. 1-3). Here, a rhinoceros lies on its back, its broad feet waving in the air. Two human-like creatures, their legs in running position, their hands grasping unidentified objects, appear to the right

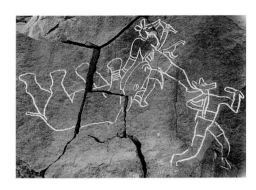

1-3. Jackal(?)-headed figures with rhinoceros, Fezzan region, Libya. Large Wild Fauna style, after 8000 BC (?). Grooves in stone.

of the animal. Instead of human heads, the figures have the heads of jackal-like animals. These energetic animal-headed human figures are not unique: depictions of canine- and feline-headed figures have also been found in the region.

The integration of animal heads and human bodies seems remarkably similar to the ways in which ancient Egyptian artists depicted their deities (see fig. 2-14). But until examples of Large Wild Fauna rock art can be securely dated, no firm conclusions can be drawn from such correspondences. Certainly the images were created after 10,000 BC, when humans reentered the newly green Sahara. The spread of new cultures across the region between 7000 and 5000 BC may mark the end of the style, for no references to the pottery, crops, or herds of these new cultures have been found in Large Wild Fauna works. On the other hand, the Large Wild Fauna culture may have lived alongside these new cultures until the desiccation of the desert was complete. For the time being, we can only state that animal-headed images from the Sahara preceded those of the Nile

Valley. Their presence in both areas suggests that ancient Saharans and ancient Egyptians shared some cultural features.

Archaic Style

Pigments permit images in the so-called Archaic, or Round Head, style to be much more securely dated. Carbon-14 testing in the Tadrart Acacus region south of Fezzan has yielded dates of 8000 to 6000 BC for works in the same style as this splendid horned female figure from the Tassili n'Ajjer highlands of southeastern Algeria (fig. 1-4). As in other Archaic works, shapes of

1-4. Horned female figure, rock painting, Tassili n'Ajjer region, Algeria. Archaic style, 8000–6000 BC. Pigment on stone

By the beginning of the third millennium bc, the Egyptians worshiped a cattle-headed goddess named Hathor, whom they called "the mistress of the western desert." This painting may honor a horned deity of the central Sahara, possibly one of Hathor's predecessors.

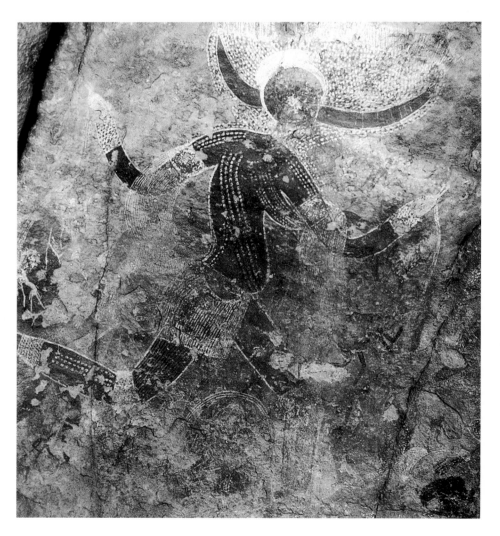

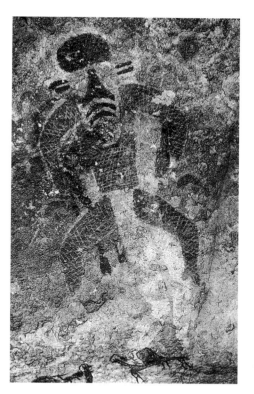

1-5. FIGURE WITH MASKLIKE HEAD, ROCK PAINTING, TASSILI N'AJJER REGION, ALGERIA. ARCHAIC STYLE, 8000–6000 BC. PIGMENT ON STONE

costume—here apparently knotted—and a wooden mask. Hands and feet, often carefully hidden in African masquerades, disappear here in the repeated curves of the figure's limbs. Whether this striking image depicts the masked human who temporarily made a superhuman being manifest, or whether it once evoked a spirit who would otherwise have been invisible, a spirit who was visualized in such a guise could easily have been manifested in a masquerade. We may thus be looking at some of the earliest evidence for one of the most important of all African art forms.

Pastoralist Style

Images in the Archaic style are sometimes found overlaid by paintings in the Pastoralist, or Cattle, style. Pastoralist works were created by herders and agriculturalists, who appeared in the central Sahara during the early fifth millennium BC.

The detailed naturalism of Pastoralist works is striking, and their depiction of everyday life unprecedented. In a typically large and complex scene, cattle are lovingly and individually catalogued (fig. 1-6). A man seems to tend his herd, while

1-6. SCENE WITH CATTLE AND FIGURES, ROCK PAINTING, TASSILI N'AJJER REGION, ALGERIA. PASTORALIST STYLE, 5000–2000 BC. PIGMENT ON STONE

The subtle reds, yellows, and browns in this painting show the wide range of ochers, or colored clays, used by the artist. White chalk and black charcoal may also have been used. Chemical analysis has revealed that the pigments were bound with milk. Thus the medium as well as the subject matter underscores the importance of cattle in the life of the Pastoralist people.

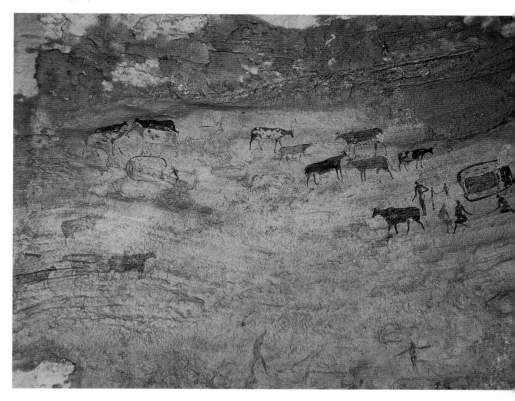

solid color are outlined in white or black. The round head is featureless. The fine lines streaming from the arms and hips may depict raffia garments, or they may allude to rain and moisture. Rows of dots highlight the legs, shoulders, and pointed breasts. Tiny dark figures surround the figure, emphasizing its majestic scale. Certainly, this rhythmic image is no mere dancing girl; she may instead represent or invoke a sacred horned being.

One of the most intriguing examples of Archaic art seems to depict a human figure whose outsize face is filled with exaggerated features (fig. 1-5). The image may well portray a masquerader, a dancer transformed into a deity or spirit through wearing a

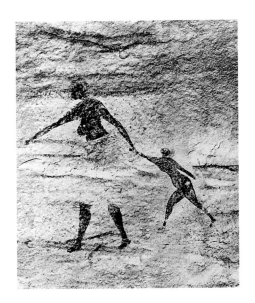

1-7. MOTHER AND CHILD, ROCK PAINTING, OZANÉARE, TASSILI N'AJJER REGION, ALGERIA. PASTORALIST STYLE, 5000–2000 BC. PIGMENT ON STONE

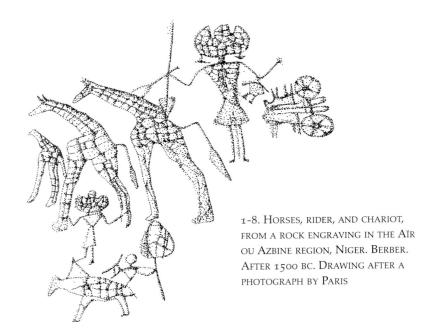

1-8. HORSES, RIDER, AND CHARIOT, FROM A ROCK ENGRAVING IN THE AÏR OU AZBINE REGION, NIGER. BERBER. AFTER 1500 BC. DRAWING AFTER A PHOTOGRAPH BY PARIS

women and children carry on a conversation. An oval shape may be a symbol transforming the images into a mythical realm, or it may simply depict an enclosure or a dwelling. In another detail from a painted rock face in Tassili, a mother strides forward with determination, pulling along a dawdling child whose whining protests are almost audible (fig. 1-7).

Most of the Pastoralist art of Tassili n'Ajjer and the surrounding highlands was produced during the middle of the fourth millennium BC. By the second millennium BC the Pastoralists seem to have left the Sahara, which had probably already become too dry to sustain their herds and crops. Scholars have speculated that their descendants now inhabit regions of the Upper Nile where cattle are the focus of present-day cultures. Yet elders of the cattle-raising Fulani people of West Africa have interpreted

some Pastoralist images as references to their own myths and religious initiations, and the influence of the Pastoralist people may have been widespread south of the Sahara.

Later Styles and Subjects

Even after the Sahara became dry and desolate, the practice of rock art continued. Horses and chariots are common later subjects (fig. 1-8). Simply drawn in a variety of stylistic conventions, the images mark locations along trans-Saharan trade routes used by semi-nomadic Berber peoples, who knew of the use of chariots in the Maghreb and Egypt, and who during the first millennium BC had increasing contacts with settled peoples of the western Sudan.

Some of the schematic, economical images of camels found throughout the Sahara share stylistic features with these horses and charioteers, and thus most probably represent a continuation of the same tradition. For example, the rod-shaped heads of the figures in one energetic painting

(fig. 1-9) can also be seen in depictions of horses and chariots. Although the image may have been painted almost two thousand years ago, the saddle and canteens resemble those still used by Tuareg Berber nomads today.

The drawing is a delightful arrangement of geometric shapes. The camel itself has been constructed of triangles and parabolas. The solid rectangular rider, probably male, is contrasted with the triangular forms of the figure in the enclosure, probably female. The two figures raise their arms in identical gestures, giving us the impression that they have been seized by some strong emotion. The square around the figure on the left seems equivalent to the home or symbolic space in the Pastoralist painting examined earlier (see fig. 1-6).

THE MAGHREB AND THE ANCIENT MEDITERRANEAN WORLD

As the Sahara dried out, the Maghreb emerged as a distinct region, an arc of land that remained fertile and green.

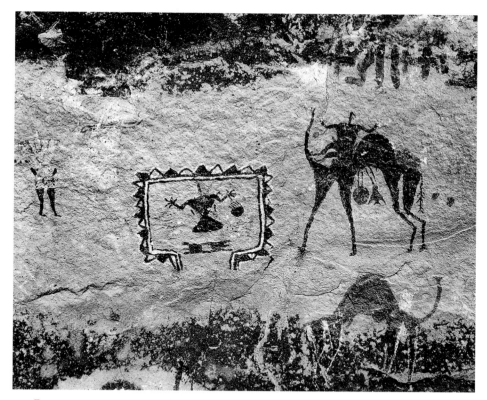

1-9. FIGURES WITH CAMEL, ROCK PAINTING, TASSILI N'AJJER REGION, ALGERIA. BERBER. AFTER 700 BC. PIGMENT ON STONE

lower register may be an image of male fertility associated with Baal, while the crescent moon and circular star or planet which form an eye-like image in the triangular projection at the top of the stone probably refer again to Tanit.

Hands, eyes, and fish still figure symbolically in Berber art. Similarities between Tanit's triangular symbol and the triangular figure in the Saharan rock painting examined earlier are especially intriguing (see fig. 1-9). Triangular shapes occur over and over again in Berber arts as images of female presence and power. We do not know whether one culture influenced the other, or whether the

1-10. STELE DEDICATED TO BAAL AND TANIT. PUNIC. 4TH CENTURY BC. STONE. MUSÉE NATIONAL DU BARDO, LE BARDO

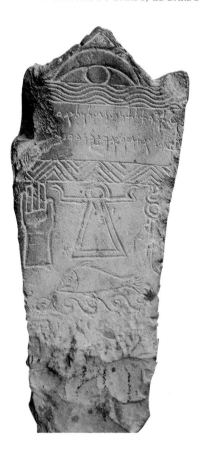

With the founding of the Phoenician colony of Carthage around 800 BC, the region and its peoples were drawn into a period of history marked by the growth of ever more expansive civilizations around the Mediterranean basin, a period which culminates with the unification of the entire Mediterranean surround under Roman rule.

Carthage

Carthage itself was one such civilization. A wealthy commercial city on the northern tip of present-day Tunisia, it soon founded colonies of its own and eventually came to control not only most of the Maghreb but also parts of Spain and the islands of Sardinia, Corsica, and Sicily. In general, the art of Carthage remained closely linked to the eastern Mediterranean world from which it had come. Distinctive stone votive slabs (steles), however, feature motifs also found in Berber arts over the centuries.

The votive slab here (fig. 1-10) comes from a *tophet*, or sacred area, outside Carthage. Dating from the fourth century BC, it honors two of the most important Carthaginian deities, the male god Baal and the female deity Tanit. The upper register is inscribed with a prayer in the Phoenician script. The middle register contains three symbols. At the left, a hand indicates worship or protection, or both. In the center, Tanit is represented by a triangle surmounted by a circle and two raised arm-like forms. To the right, Baal is represented as a horned circle upon an upright pole. The fish in the

similarities are a coincidence, a straightforward reference by both peoples to the pubic triangle. In any case, the Carthaginian triangle of Tanit must have resonated with local Berber groups.

Numidia and Mauritania

To the south of Carthage, a succession of Berber rulers consolidated a kingdom known as Numidia. Together with rulers from another important Berber kingdom known as Mauritania, Numidian rulers played an active role in the Punic Wars, the three great conflicts in which the upstart civilization of Rome, based in the Italian peninsula, challenged Carthage, then the dominant power of the western Mediterranean. Conspiring with both sides, Berber rulers were partially responsible for Rome's ultimate victory in 143 BC.

Monumental stone tombs of Mauritanian and Numidian rulers still stand from this period of powerful Berber polities. One of the most

1-11. Tomb, Tunisia. Numidian. 1st–2nd century BC. Height 115' (54.33 M)

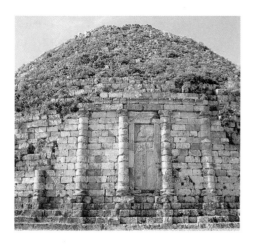

famous of these monuments marks the grave of a member of the ruling family of Numidia who died in the late third century BC (fig. 1-11). The huge conical structure, almost 116 feet in diameter, is supported on a shallow cylindrical base ornamented with engaged columns. The Numidian tomb resembles descriptions of the tomb of the fourth-century BC Greek king Mausolus, who ruled in Asia Minor. His tomb, which has given us the word "mausoleum," was famous throughout the ancient Mediterranean world, and it might well have seemed a suitable model for a powerful Numidian king. The interior of this tomb has chambers similar to those found in Egyptian and Nubian pyramids.

The Numidian tomb illustrates well the cross-cultural currents of the ancient Mediterranean world, but it also takes its place in an indigenous regional tradition of stone funerary architecture. Megalithic funerary structures of natural or dressed boulders were erected in the Maghreb as early as the third millennium BC. In the northern Sahara, chambered tombs of stone with earthen mortar are contemporary with later Berber, Carthaginian, and Roman monuments, while throughout the central Sahara are found numerous stone tumuli, mounds of uncut rocks piled into ovals or concentric circular patterns, which have not yet been dated.

Rome

Unlike earlier settlers, who had confined themselves to the immediate coastal areas, the Romans extended their control over most of the agricultural land north of the Sahara. Administrators, soldiers, and slaves

from as far north as Scotland and as far east as Iran were sent to Rome's African provinces, while Berbers were appointed to military and administrative positions throughout the empire. One of the most powerful Roman emperors, Septimius Severus (ruled AD 193–211), was of Berber origin.

Perhaps the most important legacy of Roman presence in Africa is the Roman city. A wonderfully preserved example is Thamugadis, or Timgad (figs. 1-12, 1-13). Built by order of the emperor Trajan in the early second century AD, Timgad was located along a major Roman road in the Aures Mountains of Algeria, in the heart of Numidian Berber territory, less than a day's journey from the Numidian tomb. Typical of the cities Romans built throughout the provinces of their empire, it was constructed on a square plan bisected by the *cardo* (the central north/south street) and the *decumanus* (the central east/west street). At their intersection was the forum, the central square of the city. A small temple, public toilets, and a public meeting hall called a basilica were all arranged around the forum. Near one end of the *decumanus* were spacious public baths, and at the

1-12. Plan of Timgad

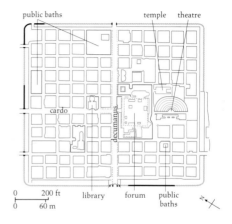

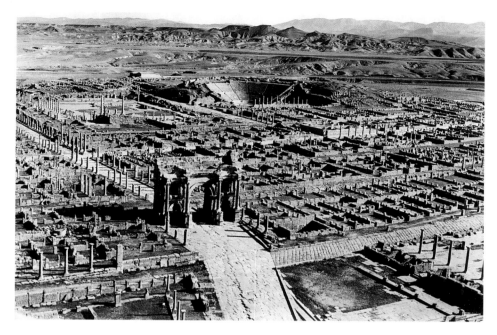

1-13. RUINS OF TIMGAD (THAMUGADIS), ALGERIA. ROMAN. EARLY 2ND CENTURY AD.
PHOTOGRAPH 1960

other was a huge triumphal arch, an imposing gateway to the city.

The public baths of Timgad have their equivalent in Maghreban towns today, for public bathhouses still function in North African Islamic culture as meeting places. Monumental arches in Roman cities such as Timgad were models for Islamic city gateways and mosque entrances. The most influential type of building in Timgad, however, was the basilica. Roman basilicas provided the basic plan for early Christian churches, and together with them served as sources for the prayerhalls of Islamic mosques.

THE COMING OF ISLAM

During the fifth century AD, Timgad was conquered by a Christianized Germanic people known as the Vandals, who entered and took control of Rome's African provinces. A century later, the region was reclaimed by the armies of the Byzantine empire, as the successor state to the eastern Roman empire was later known. Timgad was finally abandoned after the great cultural upheavals of the seventh century AD, when Arab armies, newly united under the banner of Islam, swept across North Africa.

The religious, social, and political order of Islam dates its beginnings to an event called the *hijra*, when the Prophet Muhammad emigrated from the city of Mecca to the city of Yathrib, later called Medina, some two hundred miles to the north on the Arabian peninsula. From Medina, where he quickly established leadership, Muhammad continued to preach *islam*, or "submission" to God's will. He also continued to have visions in which the Archangel Gabriel revealed to him God's word, revelations that were later written down and collected into the Qur'an, the holy book of Islam. The Prophet reached out through both diplomacy and warfare to bring the divided Arab clans of the peninsula into the single, all-embracing *umma*, or "community," of Muslims ("those who have submitted"). As the event that signaled the founding of the *umma*, the *hijra* marks the starting point for the Islamic calendar. It occurred in AD 622, or 1 AH in Islamic reckoning.

During the century following Muhammad's death in AD 632 (10 AH), the new order expanded dramatically as Arab armies conquered territories north to Persia, east to the Indian subcontinent, and west across northern Africa and up into Spain and France. The Byzantine army was quickly ousted from northern Africa. More significant resistance came from Berber groups led by such rulers as the Zenata Berber queen known to Arab historians as al-Kahina. Nevertheless, within a generation the Maghreb found itself part of a vast new Islamic world. North Africans, including Berbers, gradually converted to Islam, which over the ensuing centuries would also spread peacefully into western Africa and along the eastern Africa coast.

The Great Mosque at Qairouan

Taken from the Arabic *mesjid*, "the place where one prostrates oneself," a mosque is the Islamic house of prayer. The first mosques are said to have been modeled after the place where Muhammad had instructed his followers in Medina. A simple adobe structure, it consisted of shaded walkways surrounding a rectangular courtyard. As Islam expanded, its architects translated this early model into more permanent and monumental form.

One of the first stone mosques was built around AD 670 (48 AH) by the Arab general Uqba ben Nafi at his capital, Qairouan, near the northeastern coast of Tunisia. When that mosque was destroyed by rebellious Berbers, a new mosque was begun on its ruins. Completed in AD 836 (214 AH), the Great Mosque of Qairouan (fig. 1-14) is one of the oldest mosques still in use, and it has served as a prototype for later mosques throughout Islamic Africa.

The massive stone walls of the compound are strengthened by buttressing and embellished with arched gateways. The walls created an imposing stronghold for the local Arab leaders, who were the military as well as the religious rulers of the city. The prayerhall itself is preceded by a large open courtyard, *sahn*, surrounded by a covered, colonnaded walkway. In the center of the west wall of the courtyard (to the right in the photograph) rises a minaret, a tall platform for the crier, or *muezzin*, who calls the faithful to prayer. Minarets serve as a visual reminder that a town is under the protection of Islam. The minaret of the Great Mosque at Qairouan is a sturdy watchtower overlooking the city. It has an interior staircase, and is crowned

with two square rooms and a small dome. Elsewhere in the Islamic world, minarets developed into slender towers large enough for only a single *muezzin*, but the minarets of many African mosques have the imposing scale and sloping sides of the minaret at the Great Mosque at Qairouan.

At the opposite end of the courtyard is the prayerhall, a large rectangular room, its roof supported by sixteen arcades—rows of arches set on columns—running parallel to the wider central aisle. The columns were salvaged from earlier Roman and Byzantine buildings, and their capitals are carved in a variety of styles. The wall opposite the principal entrance is the *qibla* wall, the wall closest to and oriented toward Mecca, the direction in which Muslims bow to pray.

The *qibla* wall is marked by an empty niche called the *mihrab* (fig. 1-15), which may serve as a mystical reference to the presence of God. In the Great Mosque of Qairouan the *mihrab* is framed by an arch and two marble columns, and its curved stone surface is pierced through with floral patterns. Inset into parts of the *mihrab* and the surrounding wall are glazed ceramic tiles imported from Syria. Adjacent to the *mihrab* is a *minbar*, the pulpit from

which the *imam* (Arabic for "leader") leads the congregation in prayer. Elaborately carved of wood, it is the oldest known *minbar* still in existence.

The central aisle establishes an axis joining the main entrance of the prayerhall to the *mihrab*. On the exterior, the axis is made evident by two domes, one over the entrance and one before the *mihrab*. The section drawing in figure 1-16 taken along the central aisle, shows the two domes, the *mihrab*, and a supporting arcade. Like the Roman and Byzantine architects from whom they inherited the form, Islamic architects used the dome as a reference to the heavens and as a metaphor for the divine order of the universe. The fluted interiors of domes at Qairouan, with supporting ribs dividing the surface into concave sections, are a formal innovation.

The Qarawiyyan Mosque

During the eleventh century AD, nomadic Berbers from the southwestern Sahara, a region in present-day Mauritania, converted to a militant form of Islam. Led by charismatic generals, a group of these Berbers known as the Almoravids swept northward to conquer Islamic territories in Morocco, Algeria, and Spain. Within two generations the Almoravids ruled the lands from the Senegal River in western Africa to the Ebro River in northern Spain.

The Almoravids established their capital at Marrakech, in southern Morocco. The best-preserved example of Almoravid architecture, however, is the Qarawiyyan Mosque in the central Moroccan city of Fez. The mosque was named for a pious woman of Qairouan, who had established it as a

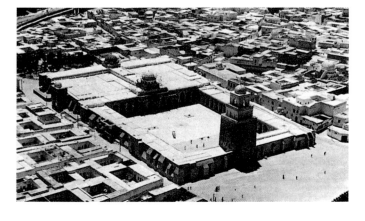

1-14. The Great Mosque, Qairouan, Tunisia. Aghlabid period, 9th century AD. Stone

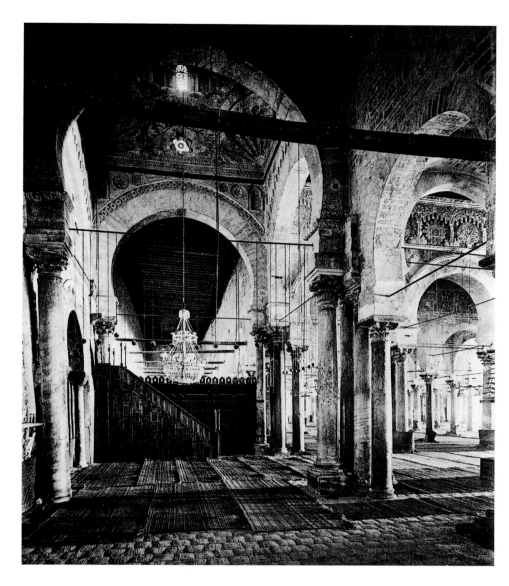

1-15. Interior of the Great Mosque at Qairouan. Aghlabid and Fatimid periods, 9th–11th centuries ad

1-16. Section taken along the center aisle of the prayerhall of the Great Mosque at Qairouan, showing *mihrab* at far right. drawing after H. Saladin

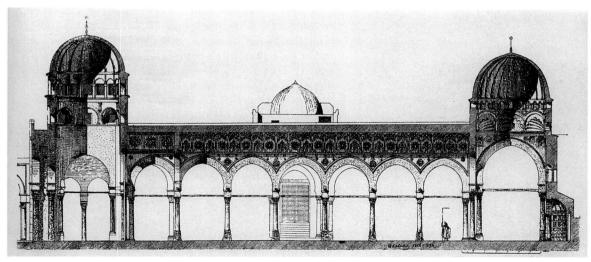

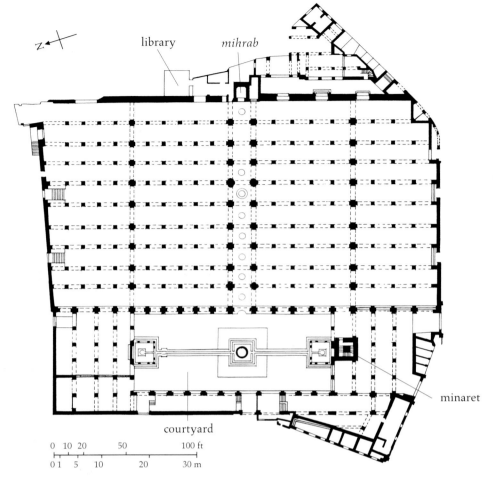

library *mihrab*

courtyard

```
0  10 20    50          100 ft
0 1  5   10      20       30 m
```

1-17. Plan of the Qarawiyyan Mosque, Fez, Morocco

hemispherical arches set on slender columns, Qarawiyyan's arcades are formed of horseshoe arches on massive square plinths (fig. 1-18). The austerity of these arcades, whose stonemasonry is covered by white plaster, seems linked to the spartan desert background of the Almoravids and the reformist nature of their religious doctrine.

Some of the most important features of the mosque, however, reflect a much different esthetic. For example, the dome above the *mihrab* is not a simple hemisphere, but a canopy of honeycomb-like projections of carved stucco. These crystalline structures, called *muqarnas*, appear elsewhere in Islamic architecture, but only in the Maghreb and Spain are they so exuberant. Some of their surfaces are ornamented with tracery in green and white, producing an effect similar to the embroidered panels that still ornament the tops of Mauritanian Berber tents. Even more delicate ornamentation can be found in the pavilions of

place of worship in the ninth century. A minaret was added a century later, and the originally modest prayerhall was expanded. But it was in AD 1135 (513 AH), under the Almoravids, that the Qarawiyyan Mosque was given most of its final form.

The plan of the prayerhall (fig. 1-17) resembles that of the Great Mosque at Qairouan: a rectangular hall filled with arcades, with a central aisle connecting the principal entrance off the courtyard with the *mihrab* on the *qibla* wall. The central aisle in the Qarawiyyan Mosque is set with a series of small domes, indicated by circles on the plan. The interior spaces of the two mosques, however, are quite different. In place of Qairouan's

1-18. Interior of the prayerhall of the Qarawiyyan Mosque, Fez, Morocco. Idrissid and Almoravid periods, 12th century AD. Whitewashed plaster over stone

1-19. FOUNTAIN IN THE COURTYARD OF THE QARAWIYYAN MOSQUE. 1613–24

artists employ a rich vocabulary of abstract, often symbolic motifs and patterns in architecture, ceramics, textiles, and body arts.

Architecture and Household Arts in the Northern Mountains

The architecture of northern Berber groups has intrigued foreign observers for thousands of years. Writing in the fifth century BC, the Greek historian Herodotus noted that a group of Berbers called Troglodytes lived in subterranean dwellings. Underground houses are still used in areas of Tunisia and Libya. Studies have shown that the interiors of these excavated spaces maintain a remarkably even temperature year-round.

Furniture in underground dwellings is carved from the surrounding stone and earth, then covered with whitewash, clay, or paint. Hearths, benches, and shelves of dried mud covered with plaster and paint are also found in Berber homes constructed above ground. In Kabylie homes, which are owned and decorated by women, rows of painted triangles surrounding square or rectangular niches in the interior walls are references to femininity. These triangular motifs sometimes bear a striking resemblance to the triangle-bordered enclosure depicted in the rock painting discussed earlier from Tassili n'Ajjer, a thousand miles to the south and perhaps many centuries older (see fig. 1-9). It is tempting to interpret the enclosure as also indicating a female realm, but we have no firm evidence for such links between Berber arts over distance and time.

Diamond-shaped motifs, or lozenges, occur in vertical and horizontal

the fountains in the courtyard, built in the seventeenth century (tenth century AH) during a later dynastic period (fig. 1-19).

Adjacent to the prayerhall is a library serving the needs of Qarawiyyan's college, *madrasa*, one of the world's oldest universities. Libraries and schools are joined to mosques throughout the Islamic world, and African mosques have served as centers of literacy and learning for centuries.

REGIONAL BERBER ARTS

Berber groups that inhabited the Maghreban plains have generally been absorbed into the international Arabicized culture that has developed throughout Islamic North Africa. Distinctive Berber languages, cultural practices, and art forms still thrive, however, in the more isolated communities of Tunisia and Algeria, and in Morocco south of the urban Mediterranean shoreline. Art forms created by and for Berber peoples during the twentieth century still bear influences of the many cultures that have flourished in the Maghreb and in the Saharan oases. Berbers have generally heeded the warnings in the Qur'an against idolatry by avoiding figural representation in their arts; masks and statuary are quite rare. Instead, Berber

bands in most Berber arts. This shape is seen as an eye of power and protection, capable of counteracting the gaze of evildoers or the "evil eye." Protection from the evil eye is also found in the five fingers, a concept expressed in the gesture of an outstretched hand and in the common expression "five in your eye." The importance of *khamsa*, the number five, is evident in the way diamond, zigzag, and triangular patterns are often grouped in fives. Protective images such as the eye, the hand, or the symbolism of five allude to spiritual defenses against misfortune and tap into a supernatural power known as *baraka*. Unleashed by certain substances, people, actions, and experiences, *baraka* is believed to bring prosperity and blessing to a family that properly conserves and controls this unseen force.

Pottery of the Kabilie and other Berber groups is also marked with rows of triangles. Although little research has been done on Berber ceramics, archaeologists suggest that vessels made by Berbers today appear to be identical to those used by their ancestors in the Maghreb over two thousand years ago. Both the overall shapes and the decoration with dark patterns over buff surfaces seem to have changed remarkably little over time.

The protective shapes found on the walls of this Kabylie house are also found in Berber textiles. A splendid wool rug or saddle blanket, woven by a Zemmour Berber woman from the hilly region between Fez and the northern Moroccan coast, displays multiple variations of these popular symbols (fig. 1-20). The horizontal bands feature at least eight different types of lozenges, some of which are

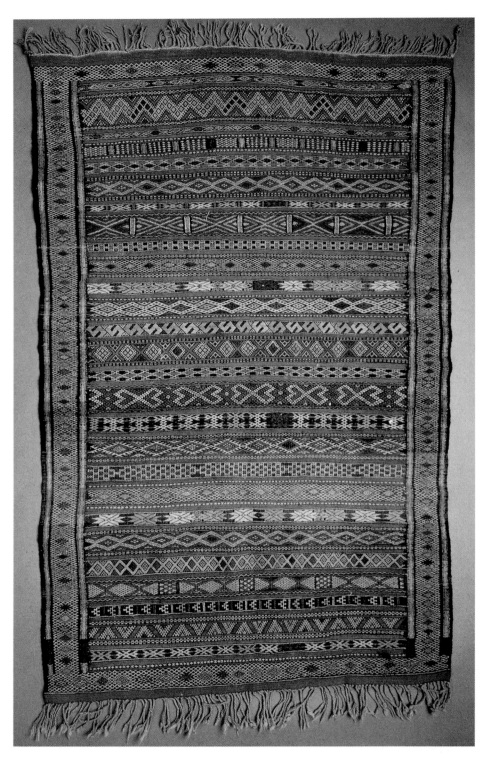

1-20. RUG OR SADDLE BLANKET. ZEMMOUR BERBER. 20TH CENTURY. WOOL, 5′2″ X 3′¼″ (1.57 X 1 M). THE BRITISH MUSEUM, LONDON

spiked with five projections on each side. Five tiny diamonds stacked vertically may be a motif known as the tree of life, and at least one of the zigzag forms may be a reference to a motif called fish tails, an ancient image of blessing and power. Textiles woven in the Maghreb have traveled over trans-Saharan trade routes for over five hundred years. As early as the sixteenth century, Portuguese vessels were carrying Berber weaving to both Europe and West Africa. Textiles in many regions of Africa south of the Sahara thus show the influence of Berber designs.

Perhaps the most visually compelling examples of Berber architecture are the fortress-like walled towns, *ksar* (singular *ksour*), of Morocco. Constructed of pounded adobe bricks, or stone plastered with clay, *ksar* are found in the river valleys of the southwestern slopes of the Atlas Mountains. One particularly imposing entrance gate to a *ksour* in southern Morocco is surmounted by triangular projections and flanked by towers (fig. 1-21). Its

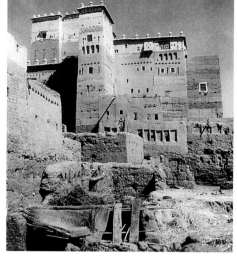

1-22. *KSOUR* AND *TIGHREMT*, SOUTHWEST OF ATLAS MOUNTAINS, MOROCCO. BERBER. AFTER 12TH CENTURY (?). STONE AND ADOBE. PHOTOGRAPH C. 1940

1-23. SECTION OF A *TIGHREMT*. DRAWING AFTER ADAM

subtly pointed horseshoe arch bears a resemblance to the arches inside the Qarawiyyan Mosque far to the north in Fez (see fig. 1-18). Above the arched opening is a paneled relief protected by

a shallow roof. Inside a *ksour*, closely packed three- to five-story dwellings line narrow streets, creating cool canyons sheltered from the harsh sunlight and fierce winds of the desert.

Fortified farmhouses known as *tigermatin* (singular *tighremt*) are often found near *ksar*, though isolated *tigermatin* are also known. A recent photograph shows a *tighremt* adjacent to a *ksour* in central Morocco (fig. 1-22). On the facade of the *tighremt* the bricks have been placed in layers to form relief patterns around the narrow openings. Sometimes fresh and crisp (as in this example), sometimes weathered and crumbling, these geometric decorations adorn the exteriors of both *ksar* and *tigermatin*.

A section drawing of a similar *tighremt* (fig. 1-23) reveals the

1-21. GATEWAY TO A *KSOUR*, SOUTH OF ATLAS MOUNTAINS, MOROCCO. BERBER. AFTER 12TH CENTURY (?). STONE AND ADOBE

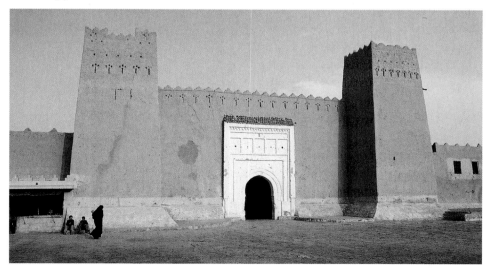

structure of this fortified farmhouse. Animals are stabled in the ground floor, where storerooms and granaries are located. A central courtyard opens to the sky, providing light and ventilation. Arched doorways open from the reception hall and living areas onto interior balconies overlooking the courtyard. The roof serves as a work area, and the towers as observation posts.

We do not know when or how these distinctive architectural forms developed. A fourth-century AD Roman mosaic from Carthage depicts a farmhouse whose fortress-like aspect, ground-floor granary, and corner towers suggest an early version of a *tighremt*. The names and locations of *ksar* can be found in Arabic geographies written in the twelfth century. But beyond these isolated clues nothing is known.

1-24. View of Gardaia, Mzab region, Algeria. Photograph 1980s

Architecture and Household Arts in the Sahara

Oasis cities of the Sahara have also developed distinctive architectural forms, all adapted to the task of sheltering dwellers from the extremes of the desert climate. In the northern Sahara, many oasis communities are administered by religious groups, Islamic congregations of Arab refugees and their Berber followers. They were joined in the past by Jews and Christians fleeing religious persecution. As important centers along the trans-Saharan trade routes, these northern oases have also attracted nomadic peoples as well as immigrants from the south. The architectural forms of these towns thus reflect influences from many African regions.

The cities of the Mzab oasis of north-central Algeria were founded by Ibadites, a group of Khajarite Muslims, in the eleventh century AD. The smooth and organic forms of their

mosques may be the result of sustained contact between the Mzab and the Inland Niger Delta empire of Mali after the thirteenth century AD. Gardaia, the largest community in the Mzab, is dominated by the tapering cone of its minaret and the curved walls of the mosque flowing over the hillside beside it (fig. 1-24).

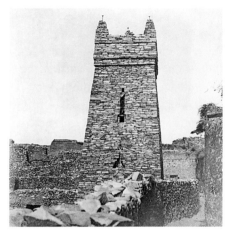

1-25. Minaret of the mosque at Chinguetti, Tagant region, Mauritania. Harratin builders (?) for Arab and Berber patrons. After 13th century (?). Stone

The oasis of Chinguetti may have been settled in Neolithic times, and was perhaps connected to trade routes serving copper and salt mines in the first millennium BC. The mosque and other stone buildings were probably constructed after the thirteenth century AD. Ostrich eggs set atop the four pinnacles of the minaret may share the symbolic meanings of fertility, purity, and adherence to Islam associated with eggs adorning mosques on the Niger River, which were also constructed by Manding architects. In the 1970s prolonged droughts left the region extremely arid, and today the city of Chinguetti has been virtually abandoned. This photograph, taken in the 1950s, shows the minaret after its most recent restoration.

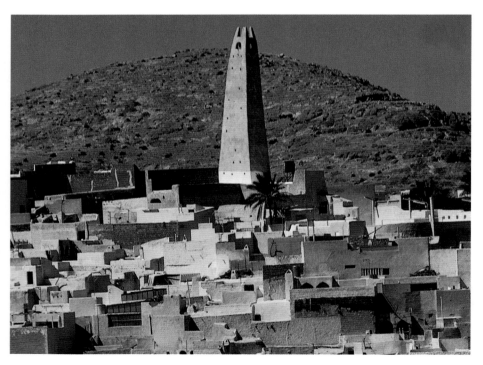

The Gardaia minaret echoes the square base, sloping sides, and general proportions of the minaret at the Great Mosque of Qairouan to the northeast (see fig. 1-14). But its soft contours and adobe plastering link it as well to the mosques of the Sudan across the desert to the south (see figs. xii and 4-8). The four horn-like projections at the top are similar to those found on the gates of the *ksour* illustrated above (see fig. 1-21).

A striking minaret flanks the main mosque of Chinguetti (pronounced "shinget"), an oasis over two thousand miles to the southwest in what is now central Mauritania (fig. 1-25). The stone minaret of Chinguetti shares the geometric outlines of the minaret at Qairouan, but has the four projections of the minaret at Gardaia. Like all the buildings in Chinguetti, the minaret and its mosque are made of narrow slabs of schist fractured from nearby outcrops of rock. The facades of important structures in the town are ornamented with layers of stones in different colors, with triangular openings above doorways, and with decorative courses of slanting rocks.

The history of the mosque at Chinguetti may be deduced from what we know of ethnic relationships in the southwestern Sahara. The dominant populations of Mauritania today are of Berber and Arabic origin, and speak an Arabic dialect known as Hassaniyya. They call themselves the Bidan, in contrast to their vassals, whom they call the Harratin. The Harratin appear to be the descendants of Manding populations such as the Soninke, who founded the ancient empire of Ghana (see chapter 5). Similarities between the stone buildings of Chinguetti and those found to the south at the ruined site of Kumbi Saleh, assumed to have

been the capital of ancient Ghana, suggest that stone architecture in Mauritania was developed by Harratin/Soninke builders. Stone architecture appears in the thirteenth- to fifteenth-century layers of Kumbi Saleh, and the stone buildings of Chinguetti also seem to date from this period.

The oasis city of Walata, in southeastern Mauritania, was also constructed by Harratin masons. The stone buildings of Walata are plastered with reddish clay, and their interior courtyards are ornamented with murals painted by Harratin women. Professional potters, the women are classified as artisans, *ma'allem*, by the Bidan patrons who own the houses. Each window and door of an aristocratic Bidan home in Walata is framed in white, and the whitewashed panels of the doorways leading to a wife's bedroom from the central courtyard are covered with designs.

A photograph taken in Walata shows designs in a courtyard which include most of the motifs recorded by

scholars (fig. 1-26). The white linear forms and dark bands closest to the openings are a motif called "chains," and seem to have the form of women's jewelry. The three dark cross-like forms in the surrounding white band were said to refer to people or community. The same symbol

1-26. COURTYARD WITH ENTRANCE TO A WOMAN'S ROOM, WALATA, MAURITANIA. HARRATIN ARTISTS FOR ARAB AND BERBER PATRONS. AFTER 14TH CENTURY (?). PIGMENT AND ADOBE OVER STONE, WOODEN *ASHENAD*

During the fourteenth century, the Arab traveler and writer Ibn Battuta passed through Walata on his way to Jenne and Timbuktu. He was impressed by the piety of the Muslims of Walata, but he was scandalized to find that both men and women had friends of the opposite sex who were not their spouses. He was particularly shocked to see the wife of one of his hosts talking to a male acquaintance while seated on a canopied bed in a courtyard such as this.

A

B

C

D

E

1-27. TUAREG BERBER TENT STRUCTURES. DRAWINGS AFTER LABELLE PROUSSIN, TAKEN FROM NICOLAS, FOUCAULD, LHOTE, AND CASAJUS.
A–C KEL AHAGGAR LEATHER TENTS
D KEL DENNEK LEATHER TENT
E KEL FERWAN MAT-COVERED TENT

occurs in the corners of the white band above. Between the crosses are a series of semi-circular linear forms with the wonderful and suggestive name "mother of thighs." A similar motif isolated in the center of the white band above is a variant of the woman with long hair motif, identifying the owner of the room as a mature married woman. On the same panel, two motifs flanking the door are elaborate versions of the Arabic letter *waw*, which has associations with male sexuality.

Beds can be seen in the courtyard, and a pair of wooden posts are set on either side of the doorway. Called *ashenad* in Hassaniyya Arabic, these are supports for calabashes, a type of gourd used as a container. In a Bidan tent, an *ashenad* is set up on the woman's side of the central partition, and the calabash it holds is filled with milk. The *ashenad* is thus an indicator that this space belongs to a woman, and it reinforces the visual messages of fertility and sexuality surrounding the door.

Although the buildings of the Saharan oases are of great beauty, the most important architectural form of the Sahara is the tent. A bewildering variety of tent forms exists, reflecting the multi-ethnic history of Saharan peoples. There are considerable differences from region to region, and from clan to clan. The drawing here illustrates some of the variations of the mat- or leather-covered tents of the nomadic Berbers known as the Tuareg (fig. 1-27). Speakers of a Berber language called Tamacheq, Tuareg aristocrats and their retainers travel through desert territories spanning thousands of miles in the central and southern Sahara. Droughts have

driven some Tuareg south of the Niger River into Burkina Faso.

A tent of the Kel Ayr Tuareg illustrates the interior furnishings of these structures (fig. 1-28). Made of straw mats upon an armature of bent acacia roots, it resembles tents of the Kel Ferwan (*e* in fig. 1-27). In the center is a bed, easy to disassemble and tie to a camel's back. Each leg and crosspiece is carved from a single piece of wood and ends in a flat ornamented disk. A man's shield and water container are suspended on the wall nearby. Elaborately appliquéd multicolored leather pouches and packs suspended from the walls are often used to hold the clothing and other personal articles of Tuareg men and women, though none are visible in this photograph. Their panels are dyed in vibrant contrasts of green, red, and yellow. The rectilinear geometric shapes created through painting and appliqué may be based upon the calligraphic forms of *tifinar*, the script used to write Tamacheq, just as the more curvilinear forms of the Hassaniyya speaking peoples are based upon Arabic calligraphy.

Most Tuareg leatherwork is fashioned by women known as Temaden. Wooden implements and metal objects, such as a man's saddle and sword, are made by their male relatives, the Inaden. Temaden and Inaden form an endogamous group of artisans within Tuareg culture. Such hereditary occupational groups are often found in African societies.

Personal Arts of the Shleuh and Tuareg

Well into the twentieth century, Berbers, Arabicized Berbers, Arabs, and Jews of the Maghreb wore distinctive

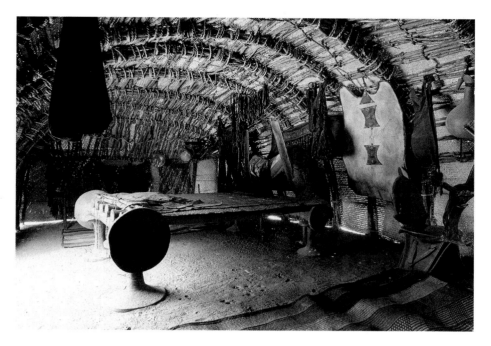

1-28. THE INTERIOR OF A 20TH-CENTURY KEL AYYR TENT. LEATHER, WOOD, AND OTHER MATERIALS

A Tuareg tent belongs to a woman, who both obtains the materials to build it and supervises its construction. The association between women and their tents is so strong that the same term, ehen, *refers to both a wife and a tent.*

styles of dress and jewelry, allowing knowledgeable observers to determine their ethnic identity, status, and even marital situation at a glance (see Aspects of African Culture: Personal Adornment, page 44). Today these references to identity are less clear, since social and economic hierarchies are more fluid.

The symbolic importance and aesthetic richness of Berber personal adornment can be seen in a photograph taken in the southern Moroccan coastal city of Sous during the 1950s (fig. 1-1). It shows an entertainer of the Shleuh people, who live in the southern Atlas Mountains. Her head is framed by distinctive jewelry and cloth, for Berber peoples believe that the head needs particular protection from the evil eye. The silver coins are believed to contain *baraka,* as is the pure white color of the headcloth. The deep reds, blues, greens, and yellows of her heavy enameled silver jewelry also increase the protective power of the ornaments.

The woman's huge ear pendants are too heavy to be hung from the ears themselves, and are supported instead by a hidden cord across the top of her head. An egg-shaped symbol of female fertility is suspended at her throat, and a four-pointed pendant lies upon her forehead. It may refer to the protective eye, a talisman in the shape of a jackal's paw, or an abbreviated hand.

The projections forming polyhedrons on one of the enameled silver bracelets may be related to the phallic extensions and pointed spikes on other Moroccan bracelets. Just as an eye form protects against the evil eye, a phallic projection evidently guards against unbridled male aggression, for women are said to have been able to fend off rapists with these heavy ornaments. Bracelets ending in similar geometric knobs are popular throughout the Sahara, and have been photographed as far east as Somalia.

The woman's dress is pinned together by enormous brooches modeled upon the much smaller fibulae once worn by wealthy Romans, while the techniques used to manufacture the enamel and silver may date back to the Vandalic and Byzantine eras. The triangular shapes attached to the pins are a characteristic Berber addition, and are probably related to the triangular pendants worn by the Tuareg.

Until recently, most types of jewelry in the Maghreb were made by Jewish silversmiths, or by endogamous groups of Jewish origin. Most Berber peoples seem to believe that the act of creating supernaturally charged, expensive metal objects is dangerous or polluting. In popular Berber thought, Solomon and other Jewish patriarchs were regarded as powerful magicians, and Solomon's heirs were thus believed

1-29. *Hanif* (cape). Berber, southern Atlas Mountains, Morocco. 20th century. Wool. The British Museum, London

to have the occult abilities necessary to manipulate *baraka* through silver-smithing. Large silver jewelry is increasingly rare in the Maghreb today, for most Jews left northern Africa after a series of persecutions in the middle of the twentieth century.

The woolen cloth worn by the entertainer was woven by women in her family. The Shleuh and their neighbors also weave beautiful cloaks called *hanif* or *aknif* for their husbands and sons (fig. 1-29). This warm woolen garment is a potent protection against the evil gaze, for the central red area is considered to be a gigantic, hypnotic eye. Geometric projections along the border of the eye, like the geometric projections around the storage areas of a Kabylie home, are often grouped by five, and are thus hand-like in their defensive qualities. Along the center of the red eye are additional protective designs which act as the weavers' signatures and give each *hanif* its individual identity.

Aspects of African Culture

Personal Adornment

Kaleidoscopic in its range and beauty, African dress embraces not only clothing and jewelry but also coiffure, scarification, and body painting. Like speech, dress is a primary civilizing phenomenon, a means of symbolic communication. Operating in a matrix of cultural codes and personal preferences, it conveys to informed onlookers a culturally constructed self or identity. Such an identity is rarely one-dimensional, and a person's various roles—family elder, diviner, government official—may each find expression in dress. Dress is thus transformative; its logical end point is the masquerade.

Campaigns of scars such as keloids (raised scars) or incised lines are a socializing process among many African peoples. Such patterning may be considered necessary not only for acceptance as a fully civilized being, but also for being considered pleasing to the eye, and to the hand as well, since many decorative scars have a tactile and erotic dimension. Against such permanent markings can be set other more or less transient embellishments. Applied in elegant complexes, some skin dyes may be intended to last for weeks; elsewhere body painting may transform the wearer only for the few hours of a ceremony. Hairstyles too may remain in place for several months. Social states that last for months or even years may in fact be marked by distinctive hairstyles, as when Maasai men during their warrior years wear long, intricately braided coiffures (see fig. 13-50). Many peoples wear substantial amounts of jewelry, sometimes constantly for many years, as visible signs of status and wealth.

Virtually all African peoples distinguish in their dress between daily life and exceptional occasions, when elements such as face paint or distinctive textiles are added to the ensemble to differentiate extraordinary from ordinary times. A person's dress ensemble also alters perceptibly with age or accession to a particular office. Changes in dress often identify age or status: marriageable girl, warrior, titled man, elder, woman past childbearing. Dress thus has a biographical quality. Usually beginning in childhood, too, dress is gender specific, as are social roles and occupations. At times, however, cross-gender

attire is sanctioned, as when Yoruba devotees of the god Shango wear brides' hairstyles to indicate their "marriage" to the deity (see chapter 8).

Dress codes depend as well on a culture's way of life. Nomadic pastoralist peoples, unable to carry with them much personal property, tend to wear their ensembles day and night and for long periods. They also tend to focus wealth in what is worn. The daily dress of pastoralist Fulani women, for example, includes heavy gold earrings and rich constellations of jewelry. Many settled farming peoples, in contrast, do not inform everyday dress with such artistry. Able to accumulate and store property, including garments and jewelry, they reserve their most splendid outfits for occasional use. Yet as the Fulani prove so well, pastoralists also amplify their already sumptuous attire for annual festivals of dancing and display (see fig. 3-38).

FULANI WOMAN IN A MARKET (SEE FIG. 3-34)

Motion and change are fundamental qualities of African dress. Kinetic elements such as feathers, raffia, and flowing cloth accentuate activity. Beads and mirrors flash and glitter; metal bracelets, anklets, and bells sound forth, announcing their owners. Skin painting, too, assumes the fundamental mobility of the body, especially in dance contexts. It may well be that dance, the primary African art form, is largely responsible for the prevalence of voluminous clothing and freely moving ornaments. The very opposite effect is also evoked in some instances, as when the *oba* of Benin is dressed so as to appear heavy and unshakable, aspects of his ritual persona that seem to express the sacred permanence of his office (see fig. 9-50).

The nomadic Tuareg have the most dramatic of Berber personal arts. Tuareg men wear dark blue robes and shimmering indigo veils, leaving only their eyes, hands, and feet exposed to view. Aristocratic warriors gird themselves with swords and amulets. Tuareg women also wear indigo scarves, although they leave their faces uncovered.

The elegance of Tuareg silverwork can be seen in the profuse ornaments of a wealthy Tuareg woman photographed in the Hoggar highlands of central Algeria (fig. 1-30). All were forged by the Inaden smiths who have a special relationship with her clan. Her large triangular amulets may be filled with sand taken from a tomb or other sacred site, a substance imbued with *baraka*. Or

1-30. TUAREG WOMAN OUTSIDE HER HOME, HOGGAR REGION, ALGERIA

1-31. *Women of Chtouka.* Chaibia Tallal. Acrylic mural, c. 9 x 16' (2.74 x 4.88 m). Photograph taken at artist's home 1978

began to paint as well. Their subject matter was based upon dreams and fantasy, or upon festivals and scenes of daily life. In Morocco these untrained artists have often shared exhibition spaces with academically trained artists, and the resulting interchange has greatly contributed to the vitality of Moroccan art. One of the most successful contemporary Moroccan artists is the painter Chaibia Tallal, a former housekeeper who was encouraged to paint by her foreign employers. Like most untrained artists, she paints in a very distinctive way and prefers figurative representation to abstraction. The faces and figures of her painting are barely discernible, for they are almost overwhelmed by vivid color (fig. 1-31).

and religious attitudes have discouraged women from enrollment.

During the same period, men and women with no formal art background

1-32. *Untitled* from The *White Series (Série Blanche)*. Jellel Gasteli. 1987–97. Gelatin silver print on fiber paper base, laminated on aluminum, 4'¼" x 4'¼" (1.3 x 1.3 m). Collection of the artist

they may contain a bit of paper or parchment inscribed with a verse from the Qur'an. The triangular shape of the amulets is given additional protective power by the fringe of five silver cones.

CONTEMPORARY ART OF NORTH AFRICA

When Morocco, Tunisia, and Algeria won their independence from Spain and France in the 1960s, national art institutes were established in each of these northern African states. Most of the artists who studied in these institutes were men, for social pressures

1-33. *Steel Talismans*. Rachid Koraïchi. 1994. Steel

Maghreban artists working for an international market have often looked to their cultural roots for inspiration. Tunisian photographer Jellel Gasteli (born 1958), for example, explores the whitewashed streets of the Berber towns of Hammamet and Jerba. His subtle images of walls, windows, and pillars emphasize abstract, formal qualities. This photograph of a saint's tomb is taken from a set of images entitled *White Series* (*Série Blanche*, fig. 1-32). Graves of holy men and women are visited by devout Muslims in the Maghreb because of their association with *baraka*, and Gastelli manages to capture some of the solemnity and purity of a sacred place.

As we have seen, the forms of the Arabic and Berber alphabets frequently serve as a source of decorative motifs in the arts of the Maghreb and the Sahara. The beauty, power, and mystery of writing underlies *Steel Talismans*, a series of metal tablets by Algerian sculptor Rachid Koraïchi (born 1947), who now lives in exile in Tunisia (fig. 1-33). The tablets evoke the writing boards used in Islamic schools throughout Africa. Wooden writing boards, which are usually inscribed, erased, and reused by students learning to write passages from the Qur'an, may be permanently painted and displayed as a type of diploma when a student completes his training (see fig. 3-31). Here, Koraïchi has covered the surfaces with calligraphic signs, but they are his personal marks rather than Arabic letters. Each tablet has become a point of departure, an object of individual empowerment and inspiration.

2
LANDS OF THE
NILE: EGYPT,
NUBIA, AND
ETHIOPIA

"I'VE KNOWN RIVERS ANCIENT AS the world and older than the flow of human blood in human veins," wrote American poet Langston Hughes in "The Negro Speaks of Rivers." One of the rivers the poet invokes is the Nile, the world's longest river, the nurturing force that sustained numerous African civilizations.

One of its tributaries, the White Nile, originates in the green hills of Uganda; a second, the Blue Nile, originates in the highlands of Ethiopia. In the vast region between these two rivers the ancestors of the human race may have first appeared. Flowing northward, the White Nile and the Blue Nile converge near Khartoum, in the center of Sudan. The Nile then describes a broad S-curve punctuated by a series of six unnavigable rapids known as cataracts. The region along this stretch of the Nile is known to historians as Nubia. After the northernmost, or first, cataract the Nile flows smoothly northward, finally fanning out into a marshy delta before emptying into the Mediterranean Sea. Before the river was dammed at Aswan during the twentieth century, the Nile gently flooded its banks for several months every year and then receded, leaving this stretch of the valley covered with a layer of fertile black silt. Ancient Egyptians called their country Kemet, the Black Land, after the color of this life-giving mud.

While the people of Kemet distinguished between Upper Egypt (the narrow southern floodplains), and Lower Egypt (the northern marshes of the Delta), the entire region shared a common culture. Their language belonged to the Afro-Asiatic family, and was thus related to Hebrew, Arabic, and the Amharic spoken in the

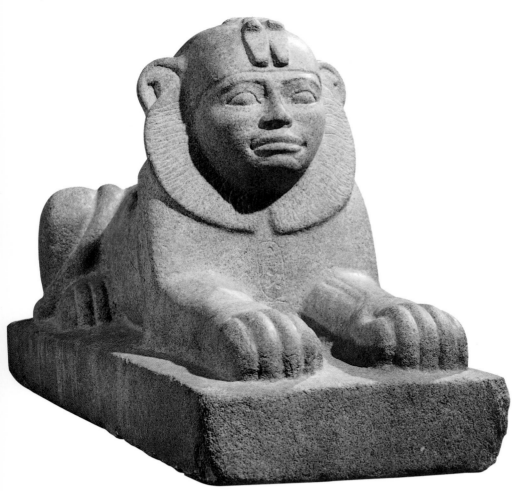

2-1. SPHINX OF TAHARQO. UPPER NUBIA (KUSH). EGYPTIAN DYNASTY 25, C. 690–664 BC. GRANITE, HEIGHT 15¾" (40 CM). THE BRITISH MUSEUM, LONDON

Art historians have noted that Kushite sculpture such as this portrait shares stylistic features with Middle Kingdom works from Kemet and revives the high standards of workmanship found in Old Kingdom figures. The Nubian kings were clearly interested in promoting the artistic as well as the spiritual values of the past.

Ethiopian highlands, as well as to forms of Berber and early Cushitic and Chadic languages.

In contrast to the people of Kemet and the peoples of central Ethiopia, most Nubians seem to have spoken languages of the Nilo-Saharan family. Distantly related Nilo-Saharan languages are still spoken today by nomads in the central Sahara, by farmers in southern Sudan and southern Ethiopia, and by cattle-raising pastoralists in Kenya and Tanzania. Unlike Kemet, which was bordered by particularly inhospitable desert, Nubia was linked to lands and peoples to the south, east, and west.

Although little is known of the history of the Ethiopian highlands prior to the first millennium BC, the region has been in contact with other regions of the Nile Valley for at least two thousand years. Trade routes joined Ethiopia's ports on the Red Sea to Egypt's desert coastline, while soldiers, pilgrims, and merchants traveled down the Blue Nile from the Ethiopian highlands to Nubia and Egypt.

The tombs of the ancient rulers of Kemet and Nubia provide our most extensive source of information about their cultures. While the tombs of Kemet have been looted for thousands of years, sometimes by the very workers who built them, an astonishing number of funerary objects have survived these thefts. Still more objects have been unearthed by archaeologists during the twentieth century. The monuments and artifacts illustrated here are thus but a tiny sample of the vast range of objects and monuments available for study today.

Since Kemet was affected by developments in Western Asia, and since the monuments and styles of this African civilization had a great impact upon the ancient cultures of Greece and Rome, to which Europe traces its own cultural roots, Egyptian art has most often been discussed in terms of its relationship to non-African cultures. Furthermore, the study of ancient Egyptian culture long relied on Greek names for rulers, cities, and objects—the word "Egypt" is itself of Greek origin. Even after the writing system of Kemet was deciphered during the nineteenth century, Greek terms largely remained in use. This chapter uses the words of Kemet whenever possible, often giving the better-known Greek equivalent in parentheses. Later art forms of Egypt, Nubia, and Ethiopia were strongly influenced by Greek, Roman, and Byzantine art, while developments in Islamic Egypt affected Islamic arts in the Mediterranean and in Western Asia. Yet despite these many crosscurrents, Egyptians, Nubians, and Ethiopians are all African peoples, nourished by the African past.

This brief survey focuses upon works from the Nile regions which share important features with other African art forms. Some of these similarities are rooted in the movements of peoples and ideas across the Sahara prior to the third millennium BC. Others are due to trade and pilgrimage routes joining the Nile Valley to the central Sudanic region over the past millennium. While in some cases these shared features may simply be coincidental, they nevertheless provide interesting points of comparison.

Many of the prevalent themes of Egyptian, Nubian, and Ethiopian art discussed here are not unique to the African continent. However, they have been eloquently and effectively expressed in the art of many African cultures, and reappear throughout this book. These include commemoration of ancestors and invocations of their protective power, alignment of the living with primordial beings through images of the creation of the world, rulers who personify divine justice, affirmations of sexuality as the source of life itself, and the layering of multiple images, symbols, and contexts within a single object.

EARLY NILE CULTURES

Between the eighth and fifth millennia BC, before the great savannahs of northern Africa became the desert sands of the Sahara, important cultural innovations spread from Nubia westward to the Atlantic Ocean. Populations began to domesticate cattle, cultivate grains, and fire ceramic vessels. "Wavy line" and "dotted wavy line" pottery dated to the eighth and seventh millennia BC testify to these changes. Found along the southern Nile and as far west as Mali, they represent one of the world's oldest ceramic traditions. By the fourth millennium BC, the Egyptian reaches of the Nile were increasingly influenced by these developments.

A female image in fired clay from the fourth-millennium Egyptian culture named for the site of Naqada displays the full curves and simplified features typical of objects from this period (fig. 2-2). Breasts are indicated by simple protrusions, as is the bird-like head. The arms curve upward as if in imitation of horns, recalling the gestures of horned female images from the central Sahara (see fig. 1-4). It is also tempting to link this figure to cattle imagery, because music and dance

2-2. FEMALE FIGURE WITH RAISED ARMS. EGYPTIAN. PRE-DYNASTIC PERIOD (NAQADA II CULTURE), C. 3650–3300 BC. TERRACOTTA, HEIGHT 11½" (29.3 CM). BROOKLYN MUSEUM, NEW YORK. MUSEUM COLLECTION FUND

2-3. FEMALE FIGURE. NUBIAN. C. 3000 BC. TERRACOTTA, HEIGHT 5½" (14 CM). BROOKLYN MUSEUM, NEW YORK. BEQUEST OF MRS CARL L. SELDON IN HONOR OF BERNARD BOTHMER

Systematic archaeological campaigns in the twentieth century have yielded an extraordinary amount of information about ancient Egypt and Nubia, and have produced important insights into ancient Ethiopia. Nubian objects similar to this fragment were unearthed as the result of an international effort to excavate sites flooded by the Aswan Dam. No comparable body of material exists for the rest of Africa, in part because no other regions have been so thoroughly examined by archaeologists searching for ancient civilizations. One scholar has estimated that for every ton of earth moved by archaeologists in the Nile Valley, a teaspoonful of dirt has been investigated by archaeologists elsewhere on the continent.

in Kemet were to be associated with Hathor, the bovine goddess of female sexuality. Yet we know very little of the function or meaning of this work. It may have been used during the lifetime of the deceased, or it may have been made especially as a funerary offering.

A similar figure from the Nubian culture referred to simply as A-Group was formed during the same period (fig. 2-3). Like the Naqada figure, the hips and legs of this female being also form a tapered base. Here, however, the wide hips are covered with circular lines radiating from the genital area. Intact Nubian female figures have phalliform heads, and these unbaked

clay figures may thus be an invocation of both male and female sexuality.

Other objects from A-Group burials include an array of ceramic vessels as thin as eggshells, their red and black surfaces burnished to a shine. These finely crafted pots and cups demonstrate the mastery that developed from regional pottery traditions that were already over two thousand years old.

Toward the end of the fourth millennium, around 3100 BC, a series of kings strove to unify the separate districts of Egypt into a single realm. A stone object known as the Palette of Narmer refers to these political developments (fig. 2-4). Unearthed in a deposit near a temple at Nekhen (Hierankonpolis), the Upper Egyptian capital of the First Dynasty, it is the most important work to come down to us from the years prior to the Early Dynastic period of Kemet (2920–2649 BC).

The object is called a palette because the indentation on one side may have held pigment. At the top of each side are early versions of a form of writing the people of Kemet called *medu netcher*, "the words of the gods." The symbols have become known in English as "hieroglyphs," from the Greek word for "holy carvings." Here the catfish, *nar*, and broad chisel, *mer*, combine to spell one of the first recorded names in human history, Narmer. Narmer is the largest figure depicted on the palette, and he towers over the less important human beings who surround him. This use of size to indicate relative status is known as hierarchical scale, or social proportion. Although hierarchical scale is by no means limited to African art, it is a particularly important feature of the

art of Kemet and occurs as well in much more recent depictions of kings in other African realms.

On one side of the palette, Narmer is depicted wearing the white crown of Upper Egypt (see fig. 2-4, right); on the other side he is shown wearing the red crown of Lower Egypt (see fig. 2-4, left). Both sides portray him victorious over his enemies as he raises a mace to smite a prisoner he grasps by the hair (right) and surveys a row of decapitated victims (left). Unlike the Pastoralist paintings of the Sahara created during roughly the same period (see figs. 1-6, 1-7), these images do not depict lifelike scenes of human interaction. Rather, they are coded visual proclamations of Narmer's kingly power.

By smiting his enemies and bringing order to chaos, Narmer upholds divine justice. Later kings of Kemet were to refer to this guiding

2-4. PALETTE OF NARMER. EGYPT. ARCHAIC, DYNASTY 1, C. 3000 BC. SLATE, HEIGHT 25" (63.5 CM). EGYPTIAN MUSEUM, CAIRO

The pictographs forming Narmer's name are suspended over a simple image of the mudbrick towers of the royal palace. The close association between kingship and the dwelling place of the king also occurs in the word "pharaoh." Evidently this Greek (and biblical) term for the kings of Kemet is based upon the ancient Egyptian words per-o, *which referred to the house of the king rather than merely to the ruler himself.*

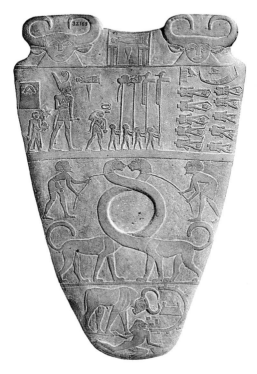
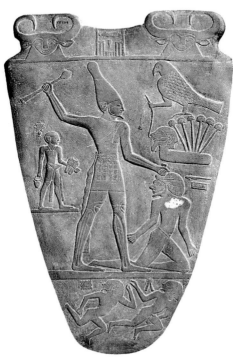

principle as *ma'at*. The king's victory is supported by divine beings who will reappear in the art of Kemet for the next three thousand years. His aggressive stance is mirrored by the actions of a bull, an emblem of virility and power later linked to the god Ptah, and a falcon, almost certainly representing the solar god Horus. Horus was closely identified with the kings of Kemet, and during this period the king was believed to make manifest the powers of the god. The bovine heads on the top registers are surely references to a celestial goddess who took the form of a cow or a horned woman.

The presence of so many potent deities suggests that Narmer may not have achieved the unification so boldly proclaimed here. Instead, this object may have functioned as a prayer, a petition to the gods asking that these events come to pass. Later art of Kemet is full of images serving as incantations, as visual spells to bring about a desired state of affairs.

The priestly role of the king, an important aspect of his reign, is also set forth in this work. The small figure behind Narmer holds the sandals of the king and a water container, evidently to wash and purify Narmer so that the king can walk clean and barefoot on holy ground in the presence of the gods. In later periods priests fulfilled their duties on behalf of (or as substitutes for) the sacred ruler.

Narmer and the other humans in this work are composed of disparate elements. Torsos, arms, hands, and eyes are turned toward the viewer and shown frontally, while legs and the rest of the head are seen in profile. Both feet are planted firmly on the ground, even though the knees are straight. Thus every part of the body is easy to read as part of the human form, just as *medu netcher* are easily identifiable images combined into legible words. Even at this early stage of Kemet, both written words and figurative art are conceived as visual equivalents of verbal statements. This specific combination of frontal and profile features to produce a figure, and the nature of images as elements in a visual language, were to be typical of Egyptian art for the next three thousand years.

Many other African art works, although created thousands of years later and by very different cultures, were also meant to convey a clear message to the viewer. Elsewhere on the continent, figurative images were not joined to a system of writing, and were not visual extensions of a prayer or incantation. Yet African sculptors in many regions emphasized features which depict a ruler's supernatural attributes, or metaphors connected to the reign, rather than his or her physical appearance. An appreciation of the symbolic nature of ancient Egyptian art thus heightens our ability to understand more recent African art as well.

KEMET

The history of Kemet after the Early Dynastic period is marked by three broad periods of unity and stability known to historians as Old Kingdom (c. 2649–2134 BC), Middle Kingdom (c. 2040–1640 BC), and New Kingdom (c. 1550–1070 BC). Each of these Kingdoms was succeeded by an Intermediate Period, a time of disunity. After the Third Intermediate Period comes a Late Period (712–332 BC). Marked by intermittent centuries of foreign domination, the Late Period ends with the conquest of Kemet by the Greeks.

Old Kingdom and Middle Kingdom

Perhaps the most influential monument of the Old Kingdom was the funerary complex constructed for the Dynasty 3 king Netjerikhet Djoser at Saqqara around 2620 BC (figs. 2-5, 2-6). A funerary district, Saqqara was located on the west bank of the Nile near the city of Men-nefer (Memphis in Greek), the capital of Kemet during this period.

An inscription in the tomb complex itself suggests that Djoser entrusted the architectural work to his advisor Imhotep; if so, Imhotep is the first artist in history whose name is known to us. Djoser's future grave was first marked with a large rectangular platform with sloping sides. The bench-like platform, known by the Arabic word *mastaba*, was placed over vertical shafts leading to underground chambers where the king would be buried. Previous kings had been buried under similar structures, but theirs were made of adobe, while Djoser's was stone. In a further innovation, five progressively smaller stone platforms were then stacked on top of the *mastaba* base, giving the finished monument a stepped pyramidal form some 195 feet tall.

The pyramid stood near the center of a walled compound. Next to it was a stone temple for the priests charged with the daily worship of the deceased king and the upkeep of his soul. Near this temple were two nonfunctional stone replicas of Djoser's Upper Egyptian and Lower Egyptian

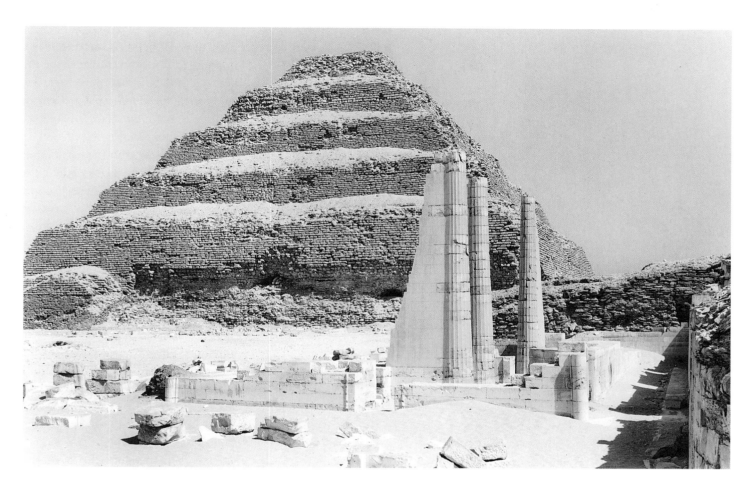

2-5. Djoser's funerary complex, Saqqara, Lower Egypt. Imhotep.
Dynasty 3, c. 2620 bc. Stone (partially reconstructed)

2-6. Plan of the funerary complex of Djoser. Drawing after J. P.
Lauer

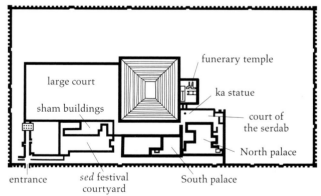

*The west bank of the Nile River, where the sun sinks into the horizon and
the dead enter the afterlife, was considered to be an especially suitable
site for tombs, just as the east bank (where the sun emerges) was the land
of living. The conception of spatial relationships as divisions between east
(the place of birth) and west (the place of rebirth) and between north
(Lower Egypt) and south (Upper Egypt) was clearly based upon the geog-
raphy of the Nile Valley. Yet similar emphases upon the cardinal direc-
tions appear in art and architecture elsewhere on the African continent,
and may be based upon ways of ordering the cosmos which are very old
indeed.*

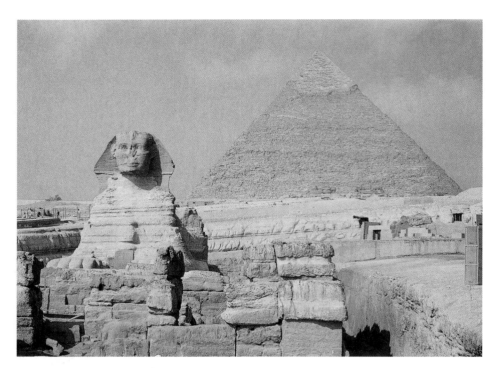

2-7. Sphinx and pyramid of Khafre, Giza, Lower Egypt. Dynasty 4, c. 2520–2494 bc. Stone, height of pyramid c. 69′ (21 m)

Yet the most intriguing innovation of Djoser's complex was undoubtedly the pyramidal shape of the royal tomb. It may have been seen as a version of the stepped podium which a living king mounted during his investiture ceremonies, or as a stairway leading from the earth (the place of mortals) to the sky (the home of the solar god). In any case, the pyramid of Netjerikhet Djoser was the first of a great series of pyramidal monuments.

The most famous Old Kingdom pyramids are the three enormous tombs constructed a dozen miles downstream from Saqqara at the west bank site of Giza (fig. 2-7). The oldest and largest of the three pyramids, not visible in this photograph, was built for Khufu (ruled c. 2551–2528 bc). It rises to a height of 481 feet from a perfectly square base oriented to the points of the compass. The smooth white limestone sheath once covering it has been stripped away over the centuries. Some of this limestone sheathing still clings to the apex of the pyramid of Khafre (ruled c. 2520–2494 bc), visible on the right of the photograph. The smooth, shining surfaces of all three pyramids must once have reflected the bright sunlight, and the people of Kemet seem to have seen these monuments as channeling or celebrating the sun's sacred, life-giving rays.

Each pyramid has a temple at its base, connected by a long causeway to a second temple on the Nile bank. Smaller pyramids and *mastaba* were built nearby for queens and other members of the royal courts. Near the causeway joining the pyramid of Khafre to the Nile, an outcrop of stone was carved to form an enormous lion with a human head. The form was

adobe-and-reed palaces. At one corner of the compound was a courtyard set up for a royal festival of dominion and rejuvenation known as *heb-sed*. During the *heb-sed* celebrated by Djoser during his lifetime, tents and reed pavilions served as temporary abodes for the deities. In this vast funerary complex, these temporary structures were reproduced in stone, as if to allow the king's spirit to celebrate his vitality forever before divine onlookers. The entrance to this courtyard was through a corridor ornamented with engaged columns carved to resemble bundles of reeds.

The funerary complex of Djoser had a significant impact upon later architecture. First of all, it inaugurated the use of stone as a suitable material for tombs, especially for the eternal resting place of kings and queens. The

task of quarrying stone on such a scale and of organizing the vast work force needed to build the complex may even have contributed to the development of the Egyptian state. In any case, the effort and expense involved in realizing such a huge project was only possible in a highly organized, centralized society with a large labor pool.

Other influential features were the roof supports and wall ornaments modeled after bundles of reeds or an aquatic plant such as papyrus and lotus. Freestanding columns in the later temples of Kemet continued to evoke these motifs. Supporting the broad roofs of enormous halls, closely spaced rows of such columns symbolized the marshes surrounding the primeval mound, the land that arose from the waters at the world's creation.

extended with stone blocks. This composite beast has become known as a sphinx, a word of Greek origin probably based upon the Egyptian term *shesep ankh* ("living image"). On this example, known simply as the Great Sphinx, the head wears a royal headcloth, and may be identified with Khafre himself. The leonine aspect refers to the power of the divine king, for lions had been emblems of kingship since Early Dynastic times. Similar associations between wild beasts and kingship are common throughout Africa.

Lions roaming the edges of the desert wilderness were also viewed as guardians of the rising and setting sun, and thus this composite creature seems also to have been associated with the horizons, themselves viewed as entrances to the underworld and afterlife. An image of a human figure or a solar disk between recumbent lions was one of the ways to indicate "horizon." In a metaphorical or mystical manner, a king was believed to approach the western horizon to enter into the underworld at sundown and death, and to reappear at the eastern horizon when he returned at dawn and resurrection. As a result of these complex relationships, by New Kingdom times the Great Sphinx was known as Horemakhet, meaning "Horus in the horizon," and was honored as a protective, divine image.

The third and smallest pyramid was constructed for the king Menkaure (ruled c. 2490–2472 BC). The walls of this pyramid's two funerary temples and the causeway that linked them were lined with fine-grained stone statues, among them an idealized image of Menkaure himself and Khamerernebty II, his Great

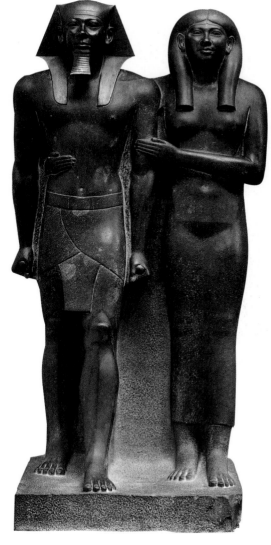

2-8. MENKAURE AND KHAMERERNEBTY, FROM THE FUNERARY COMPLEX OF MENKAURE, GIZA, LOWER EGYPT. C. 2490–2472 BC. SCHIST, HEIGHT 54½" (1.42 M). MUSEUM OF FINE ARTS, BOSTON

The height and facial features of Menkaure and his consort seem very much alike, and we know that they were half-siblings, both children of Khafre. Such royal incest set the king apart from normal mortals, and mirrored the incestuous marriages of gods. However, the union of royal brothers and sisters in Old Kingdom Kemet may have also served to repeat the creation of the world, when primordial twins Shu and Tefnut were the first beings to emerge and procreate. The people of Kemet valued duality in art and thought, and the king and queen form two halves of a single dyad.

Royal Wife, or principal consort (fig. 2-8). Khamerernebty shares the heavy wig and facial features of nearby sculpture depicting the bovine goddess Hathor. Since the principal queens of the Old Kingdom (both great royal wives and the mothers of kings) seem to have embodied the divinity of Hathor, this resemblance may have been deliberate. Khamerernebty's protective gesture is appropriate for a mother of a future king, who provides her husband with spiritual support.

The smooth and subtle surfaces of the statue suggest that the king and queen have young, firm bodies. Their slim waists and thick legs provide both solidity and grace, and their joined pose communicates strength and dignity. The artist or artists may have intended to cover the stone surface with a layer of painted plaster, a common practice in the Old Kingdom. If so, the pair would have been even more lifelike. However, their erect posture and their stances (arms at the side, fists clenched, one foot forward) are

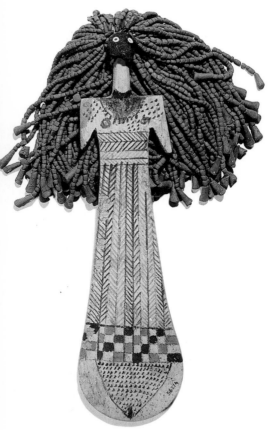

2-9. FEMALE FIGURE, FROM A
GRAVE AT WASET (THEBES).
EGYPT. DYNASTY 11,
2050–1991 BC. WOOD,
PIGMENT, CLAY; HEIGHT 9"
(23 CM). EGYPTIAN MUSEUM,
CAIRO

almost as conventionalized as those of
Narmer's palette, and their poses reap-
pear in the art of Kemet until the
beginning of the Christian era.

The Middle Kingdom is perhaps
best known for art found in the tombs
of the non-royal elite. While most
human and animal figures placed in
Middle Kingdom tombs were quite
naturalistic, some images were highly
abstracted, such as this flat, paddle-like
female form carved in wood and

painted with geometric patterns (fig. 2-
9). The head and arms are tiny, while
the mass of hair, the pubic triangle, and
the contours of the hip region are
greatly enlarged. The people of Kemet
considered abundant, well-groomed
hair to be erotic, and the emphasis on
genitalia suggests that the figure is
concerned with sexuality. The hair is
made of tiny beads formed from the
black mud of the Nile floods, and was
considered imbued with the mud's life-
giving fertility. The wood may be
sycamore or one of the other trees
sacred to goddesses of sexuality and
motherhood. Figures such as this have
been found in Middle Kingdom houses
as well as tombs. Evidently personal
possessions of the deceased, they were
assuredly not playthings, for they were
owned by men and women of all ages.

Female figures in many different
forms have been found in tombs of
both Kemet and Nubia through the
first millennium BC. The clay images of
the early Nile cultures discussed ear-
lier may well have been their
prototypes (see figs. 2-2, 2-3). Interest-
ing parallels to such female figures
may be found in doll-like wax objects
given to girls in central Sudan today.
In fact, in many African regions simi-
larly abbreviated female figures in
wood or wax are given to young people
when they are betrothed, or to women
who have had problems conceiving a
child. Although there is no clear link
between the Egyptian and Nubian
female figures and these other African
works, it seems safe to generalize that
all of these images may have had a role
in protecting the sexual and reproduc-
tive health of their owners. In Kemet,
this protective role would have made
them quite suitable as grave objects,
for by the time of the Middle Kingdom

the souls of the dead seem to have been
expected to draw upon sexual energy in
order to be born again in the afterlife,
just as sexual union is necessary for
birth into the world of the living.

New Kingdom

The New Kingdom was the era of
Kemet's greatest military and political
expansion. To the south, Egyptian con-
trol reached far into Nubia. To the
north, alliances were formed with peo-
ples of the Mediterranean and Western
Asia. As in the past, tombs were full of
artistic treasures, but now grave goods
were particularly lavish. Allusions to
sexuality and rebirth were still impor-
tant in New Kingdom tombs, but there
was a new emphasis upon the god of
death and rebirth, Osiris, his consort
and redeemer, Isis, and his son and
champion, another manifestation of
Horus.

Funerary chapels adjacent to the
sealed burial chamber served as set-
tings for annual memorial ceremonies.
Their walls were adorned with paint-
ings, or with painted images carved in
low relief, which often portrayed the
feasting, music, dancing, and drinking
desirable at a memorial festival. In
addition to inspiring the family who
gathered to commune with their ances-
tors, these murals encouraged
passersby to visit the chapel, where
they might leave a small gift for the
deceased.

A particularly beautiful New
Kingdom painting (fig. 2-10) was
removed from the walls of a chapel
that may have belonged to a man
named Nebamun, in the funerary dis-
trict west of Waset (Thebes). The scene
is both visually rich and conceptually
dense. On one level, the deceased man

is depicted young and alive, enjoying a pleasant family outing on the river. He stands in a reed boat, with his beautiful wife behind him and his young daughter between his feet. Both female figures are much smaller in scale than the man, one of whose hands is raised to throw a stick while the other grasps a clutch of waterfowl.

Yet the man's aggressive gesture recalls that of Narmer, and it proclaims the ability of the deceased, aided by the feral cat, to emerge victorious from the dangers of the transition from death to life. The marsh setting evokes the battle of Horus and his dangerous rival, the crocodile-like Seth, suggesting that the tomb owner's triumph over death replicates Horus's victory over his enemy. Isis, the goddess who prepared her husband Osiris for resurrection, also performed her magical acts of restoration in the marshes of the Nile. Finally, marshes were linked to the creation of the world in Egyptian thought as the place where life and order arose from chaos, just as rebirth and reordering will prevail over the chaos of death.

This fragment from the chapel walls also contains references to the creative power of human sexuality. The verb for "launching a throwing stick" was also the verb for "ejaculate," while the word "throwing stick," *qema*, also meant "to create" or "to beget." The action of the deceased is thus a visual pun. The elegant young wife, holding objects used in the worship of Hathor, is obviously dressed for a feast or ceremony, not a day in the country. The child is placed in a position to remind us that she is the fruit of the owner's loins. All these layers of meaning are echoed by the *medu netcher* written between husband and wife, which translate as "enjoying oneself, viewing the beautiful . . . at the place of the constant renewal of life."

The scene was probably painted during the reign of Amenhotep III, father of the extraordinary Dynasty 18 king who began his reign as Amenhotep IV but then changed his name to Akhenaten, "son of Aton." With this change the king proclaimed his devotion to the deity Aton (or Aten), whom he worshiped as a supreme being, and the corresponding suppression of the worship of Amun (also Amen or Amon), the solar deity of Waset. Akhenaten built a new capital, Akhetaton, whose ruins are now known as Tel el-Amarna. The period of his rule is thus called the Amarna Period (c. 1353–1333 BC).

Akhenaten has always been a highly controversial figure. He may have been a religious mystic, or he may have been a wily politician who sought to curb the wealth of the powerful priesthood of Amun and the other gods. He composed or commissioned evocative hymns to Aton as Lord of Creation, and his chief sculptor, Bak, wrote that he had been instructed by Akhenaten himself. Thus the king seems to have played an important role in developing a new artistic language to express his radical restructuring of Egyptian cosmology.

2-10. Fragment of a hunting scene, from the tomb of Nebamun, Waset (Thebes). Egypt. Dynasty 18, c. 1380 BC. Pigment on plaster, height 32" (82 cm). The British Museum, London

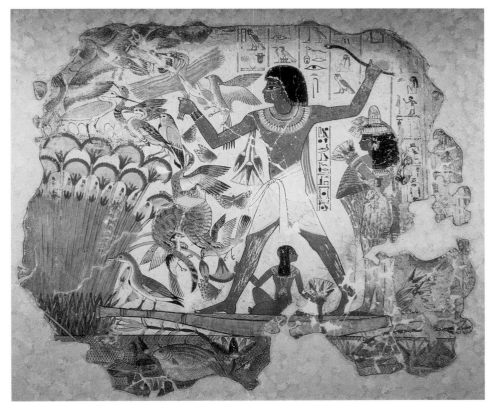

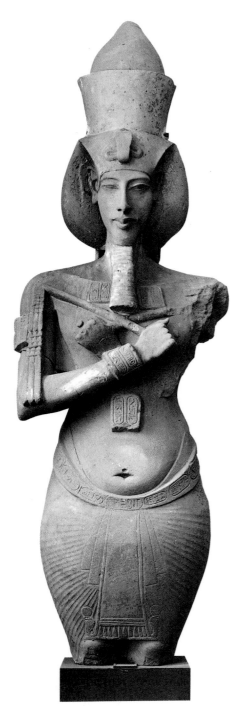

An excellent example of the earliest and boldest art commissioned by Akhenaten is a fragment of a colossal sandstone statue representing the king himself (fig. 2-11). Over three times life-size, it is one of several statues of Akhenaten discovered in the ruins of a temple to Aton near Waset. All had been thrown down and desecrated after Akhenaten's death. The headdress and the crossed crook and flail are familiar Egyptian symbols of kingship, but the proportions of the face and figure are completely novel.

Bak and the other artists working for Akhenaten were purposefully rejecting previous Egyptian conventions in favor of a different, equally artificial system of representation. The head is elongated, with sharp planar cheekbones, narrowed eyes, sensuous lips, enormous ears, and a prominent chin. The slim waist, broad hips, full pectorals, and distended abdomen evidently portray Akhenaten as a bisexual being, the embodiment of the creator and omnipresent god Aton. As the son of Aton, Akhenaten no longer worshiped separate male and female deities, but a single creator who was the source of both male and female sexuality. In the words of one of his hymns, Aton was "all alone and shining."

Figures and reliefs created later in the Amarna Period were somewhat more naturalistic. We would know little about art from the end of Akhenaten's reign, and from the reigns of his successors, if an archaeologist named Howard Carter had not discovered the tomb of Akhenaten's son-in-law, Tutankhamun, in 1922. Compared to the powerful New Kingdom kings who preceded and followed him, Tutankhamun (c. 1333–1323 bc) was a minor ruler indeed. Yet his tomb, unlike theirs, survived almost intact into the modern era. As we contemplate the fabulous treasures buried with this adolescent king, we must remember that most kings of Kemet were given far richer burials.

In one of the underground chambers of Tutankhamun's small tomb, Carter discovered a large rectangular sarcophagus. Inside it were three coffins, including one of solid gold. The mummified body of the young pharaoh still lay within, its head, chest, and arms encased in gold inlaid with semi-precious stones. After the garlands of long-dead flowers were removed, the expedition's photographer recorded the appearance of the body in its golden mask and golden gloves (fig. 2-12). Although only partially cleaned, the lustrous gold of the helmet mask still shines with the radiance of the life-giving sun. The precious metal affirmed the divinity of the king, for the flesh of the gods was gold and it never decayed. The cobra and the vulture, symbols of protective goddesses, are clearly visible on the brow of the mask.

Among the hundreds of art works accompanying the young king was a headrest carved of elephant ivory imported from the south (fig. 2-13). As in other African cultures, headrests supported the heads of sleepers in Kemet, taking the place of a pillow, and were treasured personal possessions. During the New Kingdom, headrests were also placed in tombs to protect the neck and fragile head of the deceased. This example is formed of a kneeling male figure holding the curved neck support. The figure's soft stomach reflects the lingering influence of the Amarna style.

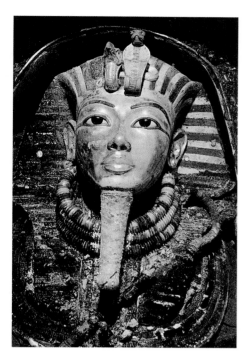

2-12. Funerary mask of Tutankhamun as discovered in his tomb. Photograph 1922

A small lion lies on each side of the oval base. The headrest is thus a reference to "horizon," for these are the lions of the desert who flank the hills framing the rising or setting sun. Here the hills are formed by the curve of the upper surface, and the head of the king would have taken the place of the sun. Falling asleep and rising from sleep were thus linked metaphorically to the journey of the sun as it sets yet rises again. Conceptually, this small ivory object is related to the Great Sphinx, the colossal leonine sculpture near the pyramid of Khafre (see fig. 2-7).

By Dynasty 19 (1307–1196 BC) increasingly elaborate mummification processes were used for royals and non-royals alike, and the ceremonies designed to bring the souls of the dead safely into the afterlife became more

codified. Funerary practices in Kemet during this period were similar to those of many other African peoples, in that deceased elders were elevated to ancestral status by the rites performed by their heirs.

Preparations for the afterlife were recorded and illustrated in long papyrus scrolls buried with the dead. Because the prayers, actions, and directives were present in the tomb as word and image, the people of Kemet believed that they were eternally and perfectly recited and re-enacted for the deceased. Such collections of funerary texts are known to Egyptologists as the Book of the Dead; in Kemet they were called Coming Forth by Day.

One of the most important rituals recorded in these collections is the Opening of the Mouth ceremony

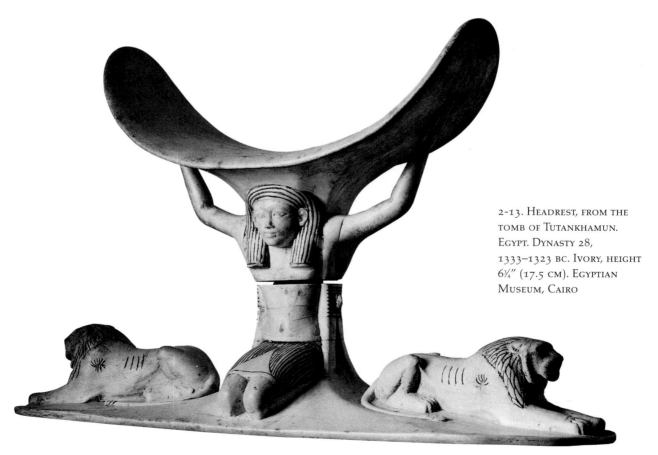

2-13. Headrest, from the tomb of Tutankhamun. Egypt. Dynasty 28, 1333–1323 BC. Ivory, height 6¾" (17.5 cm). Egyptian Museum, Cairo

2-14. Opening of the Mouth ceremony, from the Book of the Dead of Hunefer. Egypt. Dynasty 19, c. 1260 bc. Pigment on papyrus, height 15″ (38 cm). The British Museum, London

(fig. 2-14). These rites were performed both on a statue placed in a temple or funerary setting and, as illustrated here, on a mummy before it was sealed into a tomb. The carver's adz was applied to the inanimate figure's lips during the ceremony, as if the physical act of cutting out the mouth supernaturally allowed the statue or mummy to breath. The priests depicted in this papyrus carry the adz and other implements in addition to water vessels for purification. They are supervised by a temple official, or possibly by the heir himself, who wears a leopard skin and holds a smoking censer of incense. Both the leopard pelt and the incense would have been imported from the south, either from Nubia or through Nubian intermediaries.

To the far right is a tomb in the shape of a tapering pillar topped with a small pyramid. Now known as an obelisk, this form was called *tekhen* by the people of Kemet, who used it in several contexts. Enormous monolithic *tekhen* commonly flanked temple entryways. In front of the tomb is a stone slab covered with *medu netcher*.

The two women in attitudes of grief who touch the mummy may be impersonating the goddesses Isis and Nephtys, just as the deceased was believed to become the goddess's brother, Osiris. Behind the mummy stands the jackal-headed god of the dead, Anubis. It is possible that the role of Anubis may have been played by a masked attendant, although we cannot draw such a conclusion from the evidence of illustrations such as this one alone (just as we cannot be sure that the peoples of the Sahara used masks thousands of years ago on the basis of their art alone; see chapter 1). The papyrus probably places Anubis in the scene as a symbolic, invisible presence. Yet two masks of Anubis are known to exist in museum collections, and their rarity might be due to some type of ceremonial destruction. If masquerades did indeed play a role in the religion of Kemet, religious experiences in this ancient culture would have been more similar to those of the peoples of western and Central Africa, and less similar to those of the peoples of northern and northeastern Africa, than we have previously believed.

KUSH

The A-Group culture of Lower Nubia, discussed earlier (see fig. 2-3), flourished until roughly the beginning of the Old Kingdom in Kemet. Slightly later, around 2300 bc, a new cultural phase called C-Group emerged in northern Nubia, while near the third cataract a wealthy cultural center arose at Kerma.

Kerma and the C-Group culture were overwhelmed around 1500 bc, when Kemet at the beginning of its New Kingdom conquered Nubia as far south as the fourth cataract. With the waning of Egyptian power at the end of the New Kingdom, however, a new Nubian polity arose between the third and the sixth cataracts of the Nile, in the region where the river curves back toward the southwest before resuming

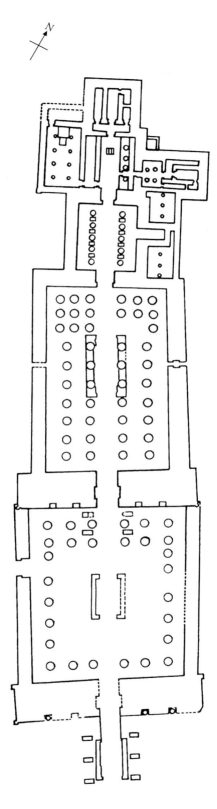

2-15. Plan of the temple of Amun at Gebel Barkal. Drawing by Pierre Hamon

its northward course. It is known as the kingdom of Kush.

The culture of Kush synthesized Nubian and Egyptian elements, reflecting both the centuries of Egyptian presence in Nubia and the heritage of Kerma. The kings of Kush built pyramidal tombs near their capital, Napata, and placed within them art works of gold, silver, and rock crystal. In the eighth century BC, Kushite kings responded to a period of divided rule in Kemet by marching northward and unifying it under their rule. Their reign forms Dynasty 25 of Egypt (770–657 BC), and ushers in the Late Period of Egyptian history.

As rulers of Egypt, the Kushites did not consider themselves to be alien overlords. In fact, they attributed their victories to the divine favor of the gods of Kemet, whose worship had been neglected during the upheavals following the end of the New Kingdom. The rulers of Kush particularly honored Amon or Amun, the solar deity of Waset, for they believed that his true home was a sacred mountain near Napata. New Kingdom kings of Kemet had built a temple to Amun in the shadow of this rocky peak, and the first kings of the Kushite Dynasty restored and expanded it. The site of the temple is known today by its Arabic name, Gebel Barkal, meaning "mountain of holiness."

Only the foundations of the temple of Amun at Gebel Barkal are visible today, but they have enabled archaeologists to reconstruct its plan and general appearance (fig. 2-15). There may have been an encircling wall of adobe or molded clay surrounding the entire structure, for in Kemet temples were identified in this way with the primal, muddy mound of creation. A monumental gateway, or *bekhenet*, marked the southern entrance to the structure. Usually known by the Greek word "pylon," a *bekhenet* took the form of two flat, sloping towers linked by a shorter, rectangular portal. Such gateways were a feature of temples in Kemet from at least the Middle Kingdom, and were usually adorned with protective images. In some New Kingdom temples the *bekhenet* faced east so that the open space above the portal and between the towers framed the rising sun. At Gebel Barkal, however, the *bekhenet* faces southeast, and the temple as a whole serves as a forecourt to the sacred mountain itself. Two grooves on each tower would have held wooden poles where banners or pennants were attached.

The stone walls of the open courtyard directly behind this first *bekhenet* were lined with columns in the shape of enormous aquatic plants. Colossal statues of Kushite kings stood in their midst. Beyond a second gateway, adorned with four more flagpoles, a longer and narrower courtyard was lower, darker, and filled with columns that also evoked the tall reeds of the primordial swamp. Only priests and rulers were allowed within the maze of small chambers behind the next gateway. There the image of Amun was kept in the innermost sanctuary, a room which represented the place of creation itself. At annual festivals, processions of priests carried the image from the dark heart of the temple, through the long courtyards, out to the bright sun at the first gateway.

A causeway leading to the entrance of the temple was flanked by stone sculptures, the emblematic animal of Amun. Figures of rams were also found before a temple at the site

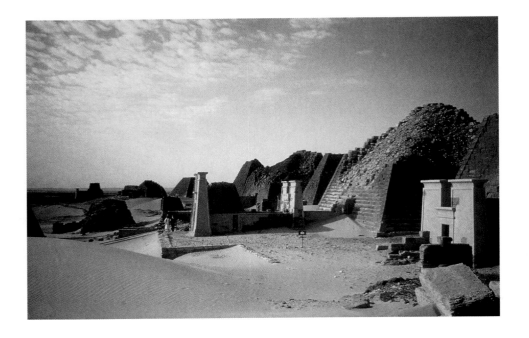

2-16. ROYAL PYRAMIDS, MEROE, UPPER NUBIA. C. 337 BC–AD 339. STONE

A nineteenth-century Italian adventurer searching for treasure dynamited many of the pyramids at Meroe, causing much of the damage evident in this photo. He took the burial goods of Queen Amanishakheto from the blasted rubble of her tomb.

of Kawa (modern Dongola), about a day's journey upstream from Kerma. Also from Kawa is a sculpture of a composite creature (fig. 2-1). It portrays a Kushite ruler of Kemet, Taharqo (ruled c. 690–664 BC), with the body, ears, and short mane of a lion. Although the headdress of double cobras was given only to Nubian kings, the combination of leonine and human features was well established in representations of the kings of Kemet, such as the Great Sphinx, Khafre's huge protective structure at Giza (see fig. 2-7).

After almost a century of Kushite rule, kings arose in Kemet to form new dynasties. Warriors from Western Asia invaded the Nile Valley on two separate occasions, but were driven back by Egyptian armies. Meanwhile, the Nubians moved their capital to Meroe, far to the south, a move that marks the shift from the Napatan to the Meroitic phase of Kush. By 337 BC, Nubian rulers were also buried at Meroe rather than Napata. Deep in the southern reaches of Upper Nubia, between the fourth and sixth cataracts, the kings and queens of Kush were to reign for seven more centuries.

The pyramids erected at Meroe for the kings and queens of Kush attest to the rich history of this enduring Nubian kingdom (fig. 2-16). Built between 337 BC and AD 339, they are much smaller than the Old Kingdom tombs constructed at Giza more than three thousand years earlier. In contrast to the pyramids of Kemet, each of the four faces of these pyramids is an isosceles triangle, and ridges along each side lead the eye upward. A mortuary temple with a *bekhenet* entrance attached to each tomb marked the last point of contact between the living and the dead.

From the pyramid of Queen Amanishakheto at Meroe comes a gold ornament made during the first century BC (fig. 2-17). Many of the images depicted on this precious object are familiar from the art of Kemet, including the ram's head of the solar deity

2-17. ORNAMENT FROM THE TOMB OF QUEEN AMANISHAKHETO. UPPER NUBIA (KUSH). MEROITIC PERIOD, 50–1 BC. GOLD WITH GLASS INLAY, HEIGHT 2 3/16" (5.5 CM). STAATLICHE SAMMLUNG ÄGYPTISCHER KUNST, MUNICH

Amun and the circular sun above it. Behind the solar disk is a portal, the central portal of a *bekhenet*, perhaps representing the entrance to a temple or tomb. The erect snakes at the top were associated in Kemet with an ancient protective goddess. Yet while images on this object were also common in the art of Kemet, their combination has no counterpart in the north. A fringe of cowrie shells (or gold replicas of cowries) originally hung along the lower edge of this piece of jewelry. In Kemet, cowrie shells were associated with female genitalia because of their shape, and were worn by women as amulets to safeguard their sexual and reproductive well-being. Nubians probably used these shells in the same context. It is interesting to note that cowries are still worn today by women and babies in northeastern Africa for protection and blessing. This gold object may have been a ring which covered the entire hand, or an ornament worn on the chest or on a belt. As recently as the mid-twentieth century, women from this region of Sudan wore golden disks on their foreheads. Perhaps the ornament here was the centerpiece of Queen Amanishakheto's headdress, a distant prototype of more recent Nubian jewelry.

Many temple forms were used by the Nubians during the Meroitic phase of Kush, including some evidently equipped with enclosures for elephants. An example of the simplest is the temple to the lion-like god Apedemak at Naqa (fig. 2-18). Commissioned by King Natakamani and Queen Amanitare during the early first century AD, this temple was a smaller and more compact version of the temple of Amun at Gebel Barkal (see fig. 2-15).

The facade of the *bekhenet*, shown here, is carved with monumental reliefs, which were originally highlighted with bright colors. On either side of the entrance, King Natakamani and Queen Amanitare are depicted smiting their enemies in poses almost identical to that of Narmer on his palette (see fig. 2-4). Instead of Narmer's single prisoner, however, these rulers hold great clusters of captives, and a lion rather than a bull refers to the divine power assisting them. While some three thousand years separate the Palette of Narmer from this temple, the meaning of the rulers' gestures may have remained fundamentally unchanged: the rulers are manifestations of divine justice, they act on behalf of the gods for their people, they create a secure world for the worship of the gods.

The artists of Meroe often portrayed their queens as large and heavy, as is the case with Queen Amanitare here. According to historical sources, the queen, *kandake*, of Meroe was a powerful figure politically. Since kingship in Meroe was matrilineal, rulers inherited their position from their maternal uncles. A *kandake* was either the partner of the king (as was the case for Amanitare) or a ruler in her own right who could have a male consort. The slender proportions used by artists for the royal women of Kemet, where few queens wielded such political power, may have seemed inappropriate in Nubia. Nubian conventions may better have suited a woman of strength and majesty, and probably reflect status rather than actual physical appearance.

2-18. *Bekhenet* (gateway) of the temple of Apedemak, Naqa, Upper Nubia. Merotic period, 1st century AD

The sloping gateways, or bekhenet, *of the temples of Kemet and Nubia marked the rising and setting of the sun, its birth and rebirth. These gateways are often known as pylons, after the Greek word for gate, and the sanctuaries are thus called pylon temples by some art historians.*

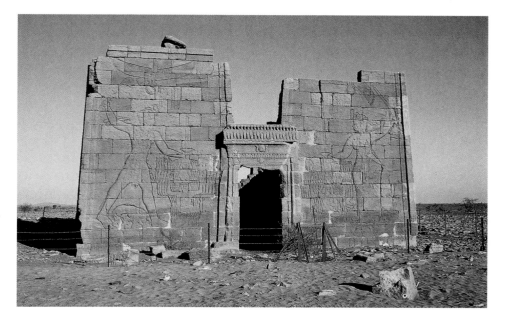

2-19. RESERVE HEAD OF A MAN. LOWER NUBIA (KUSH). MEROITIC PERIOD, 4TH CENTURY AD. SANDSTONE, HEIGHT 10½" (26.7 CM). SUDAN NATIONAL MUSEUM, KHARTOUM

An intriguing sculpture dating from the early fourth century AD, toward the end of the Kushite civilization, may be an example of what scholars call "reserve heads," after the theory that they functioned as replacements for the mummified body, as places for the soul should the body decay (fig. 2-19). Such heads are also known from Old Kingdom Kemet, some two thousand years earlier. This abstracted Meroitic sculpture is clearly not a detailed portrait of the deceased. In some ways it even appears to share the simplified styles of works from the earliest Nile

cultures of the fourth millennium BC (see figs. 2-2, 2-3). The lines across the forehead repeat the grooves marking the eyes and mouth. While these parallel lines across the brow may depict a headband, they may also represent scarification. Today Nuer warriors in southern Sudan incise their brows with identical furrows to celebrate their bravery and strength, their adult status, and their ethnic identity.

AXUM AND ITS TIME

While Meroe flourished in Upper Nubia, Kemet became increasingly tied to the political events of Western Asia and southern Europe. Conquered and ruled first by the Assyrians, then by the Persians, the country finally fell in 332 BC to the invading armies of the Macedonian king Alexander, one of whose generals founded the Ptolemaic Dynasty (304–30 BC) of Egypt. Egypt became a possession of the Roman empire in 30 BC when the Ptolemaic queen Cleopatra VII was defeated by the Roman general Octavian (later Augusts). After the Roman empire was split into eastern and western territories during the fourth century AD, Egypt was administered by the eastern Byzantine emperors, who reigned at Constantinople (present-day Istanbul).

The Greek, Romans, and Byzantines all engaged in trade along the Red Sea, in some cases even traveling by ship to distant India. It was the Red Sea trade, in part, which caused the state of Axum to flourish in the Ethiopian highlands, and it was Axum which emerged as the strongest of the three Nile civilizations at the beginning of the Christian era.

Egypt in the Sphere of Greece, Rome, and Byzantium

Egyptian art in the Ptolemaic Period included many conscious revivals of past styles, for the Ptolemies portrayed themselves as heirs to the glories of the New Kingdom. Religion for ordinary Egyptians, meanwhile, came to stress personal ties to specific deities, ties which could be strengthened through pilgrimage to the deity's holy city. There animals sacred to the deity were raised in the temple precinct. Ceremonially killed and mummified by priests, they were sold to pilgrims, who left them in the sanctuary as offerings.

Animal sacrifice was thus an important feature of Egyptian religion during the Ptolemaic Period. Wealthier worshipers often provided the holy animal with a splendid coffin in the shape of the animal itself. One particularly beautiful sarcophagus was built just prior to Ptolemaic rule for a sacred ibis of the god Thoth (fig. 2-20). Manifest as an ibis or a baboon, Thoth was

2-20. COFFIN FOR AN IBIS. EGYPT. LATE PERIOD, 332–30 BC. WOOD, GOLD, SILVER, ROCK CRYSTAL; 23³⁄₁₀ X 15" (58.8 X 38.2 CM). BROOKLYN MUSEUM, BROOKLYN, NEW YORK

believed to be present at the final judgment of the soul, and his blessing was needed for the afterlife. The ibis, like the hornbill in other African cultures, was viewed as an embodiment of divine wisdom. This precious object served as a reliquary, a container of Thoth's sacred power, as well as a gift linking deity and supplicant.

The ungainly appearance of the living bird has been transformed by the sculptor into an elegant, asymmetrical arrangement of forms. The simultaneous attention to detail (on the head and feet) and overall composition is particularly satisfying. The expensive and supernaturally potent materials of gold (associated with the sun and the flesh of the gods) and silver (associated with the moon, with the bones of gods, and with the foreign lands where it was mined) indicate that this ibis was offered by someone with unusual wealth, or by a person with a particularly pressing need for Thoth's divine favor.

The worship of ancient Egyptian gods and goddesses gradually faded during the first centuries of the Christian era. Christianity was formulated first in Western Asia from the teachings of a Jewish preacher and healer named Jesus, whose followers believe him to have been the Christ, or "anointed one," the Messiah spoken of in Hebrew scripture. In Christian belief, Jesus was both fully human and fully divine, both the Son of God and one with God. He is believed to have risen from the dead, and in this act to have triumphed on behalf of all humanity over mortality. Like other religions, including the worship of the Egyptian goddess Isis, Christianity spread through the network of travel and communication made possible by

2-21. COPTIC TAPESTRY BAND. EGYPT. AD 475–500. 57¾ x 10¼" (147 x 26 CM). MUSÉE DU LOUVRE, PARIS

the Roman empire, which at that time ringed the entire Mediterranean Sea. One of its most important early centers was in Egypt at Alexandria. Many Egyptians had already converted to Christianity by AD 325, the year the Roman empire legalized Christianity.

During the three centuries that followed, until Egypt's surrender to Islamic Arab armies in the early seventh century, Egyptians produced "Coptic art," the term "Copt" being derived from the Greek word for Egypt. However, "Coptic art" is also used to describe works created as late as the eleventh or twelfth centuries AD by Christian or non-Arabic Egyptians, or by artists working in a conservative, pre-Islamic style.

The Coptic textile shown here is typical of the complicated and colorful tapestry strips that ornamented the white linen garments of Egyptians during the centuries of Byzantine rule (fig. 2-21). It was woven during the late fifth century AD, when Christianity was the dominant religion of Egypt, yet the subject matter is tied to a pre-Christian past. The female nude in one frame and the male wearing an animal skin in the other may refer symbolically to Christian values, but it is more likely that they are simply dancing figures, celebrations of life based upon the poetry of the Greco-Roman world.

Palaces and Tombs of Axum

Beginning in the first century AD, a flourishing commerce joined the Horn of Africa (present-day Ethiopia, Djibouti, and Somalia) and the western shores of India. This trade in incense and other goods stimulated the development of interrelated cultures on both the eastern and western shores of the Red Sea. In southern Arabia and Eritrea, Ethio-Sabaen kingdoms shared similar Afro-Asiatic languages and scripts. By the beginning of the Christian era, an Ethio-Sabaen culture in the Ethiopian highlands had formed the kingdom of Axum. Axumite merchants, warriors, and diplomats traveled between the capital (the city of Axum, now in Ethiopia) and the coastal port of Adulis (now in Eritrea).

During the first two to three centuries AD, the kings of Axum built a series of spectacular stone palaces. Unfortunately, these palaces have since fallen into ruin, but by using the surviving foundations as ground plans, archaeologists have reconstructed the appearance of these lost works (fig. 2-22). Square in plan, the palaces of Axum were set upon stepped platforms. Judging from the construction techniques of stone churches built several centuries later in the same region, windows and doors were set into recessed panels in the layered stone and mortar walls. Wooden beams supporting the upper floors protruded slightly from the exterior walls, forming decorative bosses.

Valuable information about these lost palaces also comes from the enormous granite monoliths that marked royal Axumite burials (fig. 2-23). Erected between the third and fifth

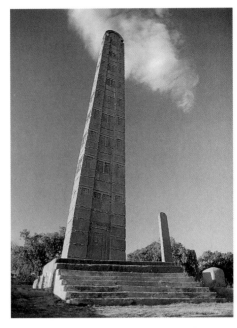

2-23. FUNERARY MONOLITHS, AXUM, ETHIOPIA. AXUMITE CULTURE, C. AD 350. STONE, HEIGHT OF LARGEST STANDING MONOLITH C. 69' (21 M)

centuries AD, the ten- to ninety-foot-tall monoliths are carved in relief to resemble skyscraper versions of the royal residences. Doors, inset windows, and protruding beam-ends are all faithfully copied in stone. Religious symbols such as lunar crescents or Christian crosses are sometimes carved at the summit. Beneath, the dead were buried in underground chambers.

Ballana

Around AD 330 the Axumite king Exana invaded Meroe, apparently bringing to an end the Kushite kingdom, which had flourished for a thousand years. Nubia eventually recovered some of its former prosperity, however, and a royal court was established at the city of Ballana,

2-22. RECONSTRUCTION DRAWING OF A PALACE AT AXUM. DRAWING AFTER KRENCKER

which flourished from about AD 350 to 700. Rich grave goods, including silver crowns for a king and queen, were found there by archaeologists in the 1960s.

While some of the Ballana works are quite similar to objects found at Meroe, others such as this large wooden chest show the influence of the late Roman and Byzantine world (fig. 2-24). Small insets of ivory are delicately etched with voluptuous figures in various states of undress. Some evidently portray Roman gods and goddesses, although Bes (the pot-bellied, large-headed deity) is from Kemet. Each ivory piece is framed in an architectural niche surrounded by organic and geometric ornaments, and the chest may be a miniature version of a many-storied palace. The lightly clad ladies and gentlemen of the Ballana chest may also be linked to the dancing figures of Coptic fabrics.

EARLY CHRISTIAN ARTS OF NUBIA AND ETHIOPIA

References to Ethiopia in Hebrew scripture attest to many centuries of relations between the peoples of Ethiopia and the Israelites. The Jewish faith itself was adopted by various communities in Ethiopia. During the fourth century AD, Judaism was joined in the Ethiopian highlands by Christianity. Exana, the Axumite king who crushed Meroe, established Christianity as the religion of Axum and was one of the first kings in history to strike coins with a cross. Three Christian kingdoms later arose in Nubia, all with close ties to the Byzantine world and to their Egyptian and Axumite neighbors. One, the kingdom of Makuria, grew out of the culture at Ballana. Its neighbor to the south was the kingdom of Nobatia or Nobotia, while still further south arose the kingdom of Alwa.

2-24. CHEST. LOWER NUBIA. BALLANA CULTURE. C. AD 375–400. WOOD WITH IVORY INLAY. ASWAN NUBIA MUSEUM

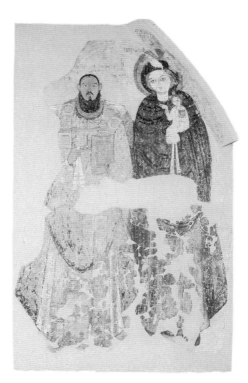

2-25. The Madonna and Child with Bishop Marianos, detail of a wall painting from the Great Cathedral at Faras. c. ad 1030. Pigment on plaster. Museum Narodwe, Warsaw

In a detail of an eleventh-century mural from the cathedral, Mary and the baby Jesus give their blessing to Marianos, a local bishop who was buried nearby (fig. 2-25).

The formal, frontal poses of the three figures, and the lack of interest in creating an illusion of depth, are typical of the style known as Byzantine. As in many other outlying regions once in the sphere of Byzantine influence, Nubian and Egyptian Coptic artists had continued using this style long after their rulers had severed ties with the Byzantine empire. The simple dark outlines of these Nubian figures, their enormous eyes, and the rhythmic parallel folds of their drapery, are particularly close in style to Coptic painting produced during the first three to four centuries of Islamic rule in Egypt. The pallid, greenish complexion of Mary and the rich brown tones of Marianos may reflect local conventions for showing gender or ethnicity.

Faras

The Christian faith of the Nubians found expression in churches built between the eighth and twelfth centuries AD. Archaeological work undertaken before the Aswan Dam flooded Lower Nubia revealed striking paintings on the walls of the cathedral at Faras. Faras was the administrative center of Makuria during this period, and portraits of the kingdom's religious and secular leaders adorned the church. Biblical scenes such as the birth of Mary, mother of Jesus, and the divine rescue of the three Israelite youths from the fiery furnace were also depicted.

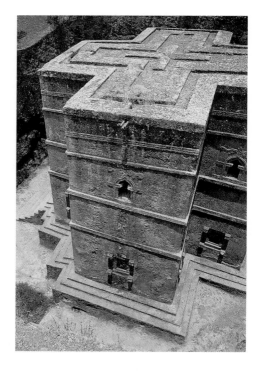

Lalibela

Although art historians have compared Nubian murals to Coptic paintings, the murals at Faras have rarely been compared with Ethiopian art of the same era. This is due in part to the limited number of Axumite paintings which have survived. Many seem to have been destroyed during the eleventh century, when Axum was invaded and conquered by the Zagwe (or Agwa), a people of the western highlands. Later monarchs considered the Zagwe kings to be usurpers, with no divine right to rule Ethiopia. However, the thirteenth-century Zagwe king Lalibela is still revered as a saint, in part because of his desire to create a new Jerusalem on Ethiopian soil. Jerusalem, the capital of Israel in the time of Jesus, is a holy city for Christians, as it is for Jews and Muslims. The site Lalibela chose to replicate this sacred place, in the highlands 8500 feet above sea level, now

2-26. Beta Giorghis (church of St. George), Lalibela, Ethiopia. 13th century ad. Cut rock

The excavated rock-cut churches of Lalibela may have been modeled upon small Axumite chapels nestled in caves, or even upon tombs cut into cliffs in the northern Arabian kingdom of Nabatea during Roman times. Yet the most fascinating parallels to this highly unusual architecture are found in central and southern India, where temples have been carved from the bedrock for over two thousand years. In spite of the ancient trade routes linking Ethiopia to India, we do not know whether these Buddhist and Hindu temples may have inspired Ethiopian Christian architects.

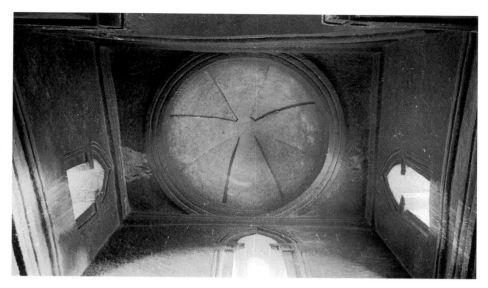

2-27. INTERIOR VIEW OF THE CENTRAL DOME OF BETA GIORGHIS

church. Processions wind their way downward and upward along narrow passages, tunnels, and stairways, while chanted prayers join worshipers above and below. This pattern of call and response is compared to the ways the praises of people on earth are repeated by the angels in heaven.

Some Lalibela churches have windows set in recessed panels like those carved on Axumite monoliths (see fig. 2-23), and are thus probably faithful replicas of Axumite palaces erected over a thousand years earlier. Beta Giorghis, however, has windows framed with organic linear designs similar to *harang*, the painted tendrils ornamenting the borders of later Ethiopian manuscripts (see fig. 2-28).

Inside, the ceiling of Beta Giorghis (fig. 2-27) imitates the hemispherical domes of Byzantine churches, known to Ethiopian priests who had made pilgrimages to the

bears his name. It is still a place of pilgrimage and retreat.

Stone carvers created at least eleven churches at Lalibela. Unlike earlier Axumite palaces and churches, they were not constructed of stone blocks and mortar reinforced with timber, but were carved from solid rock. Starting at ground level, the builders chipped away the rock from the roof down to the foundations, and tunneled into the mass of stone to hollow out the interior. The religious fervor that inspired this extraordinary work is legendary. According to one story, angels took up the tools of the sleeping workers every night to help them complete the churches in a miraculously short period of time. The sound of hammers striking stone is said to have resounded through the hills like the music of a great celebration.

Most of the rock-cut churches are square or rectangular in plan, but Beta Giorghis, the church dedicated to St. George, is in the shape of a modified cross (fig. 2-26). The carved lines on the roof of the church, partially visible

from the rim of the pit encircling the building, emphasize this central plan. Spectacular church ceremonies take advantage of the forty feet spanning the height of the surrounding earth and the depth of pathway around the

2-28. *GADL* (ACCOUNT OF THE LIVES OF SAINTS). ETHIOPIA. 14TH CENTURY. PIGMENT ON GOATSKIN OR SHEEPSKIN. CHURCH OF MARYAM SEYOU, LAKE ZEWAY

original Jerusalem. Its smooth surfaces manipulate the soft light entering from the underground windows, creating a mystical setting for priests entering the sanctuary. Other Lalibela churches reproduce in stone the timber ceilings of early Axumite buildings.

Early Solomonic Period

The Zagwe Dynasty was brought to an end in AD 1270 by the Amharic people of the central mountains. They were led by a king who claimed to be descended from the rulers of Axum, and who revived an old legend to establish himself as the heir of the biblical king David, who ruled Israel during the tenth century BC. According to this legend, King Solomon, the son of David, was visited by the Queen of Sheba. She bore a son named Menelik, who succeeded her as ruler of Ethiopia, and who had the wisdom and the divine favor of his father Solomon. The era of rule by Amharic kings is thus referred to as the Solomonic Period.

The early Solomonic monarchs of the thirteenth to sixteenth centuries were active patrons of the church and of liturgical arts, the art forms used in worship. The royal court of this period was itinerant, moving from town to town. While their parents traveled, royal princes were left in isolated monasteries to be brought up by priests. Their religious education led to royal involvement in theology, music, literature, and art. The fourteenth-century Solomonic king Dawit (David) may have commissioned this *gadl*, an account of the lives of saints (fig. 2-28). Like many Ethiopian manuscripts, it was written and lavishly illustrated in tempera paint on parchment, then bound in wood covered with leather

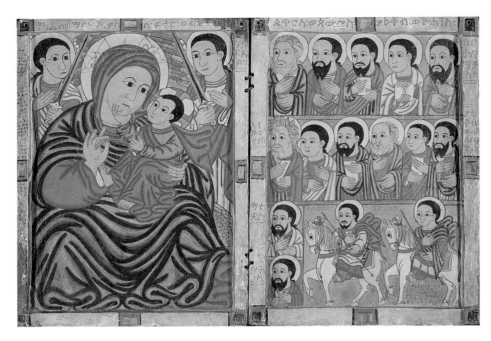

and stored in a box or chest of wood, leather, or quilted cloth.

The *gadl* is written in Ge'ez, an archaic language still used in Ethiopian churches today. Organic vegetation-like forms known as *harang* frame the text on the right page. The illustration on the left page depicts a church official named Abba Daniel and the Roman emperor Honorius. The two men are visualized almost as mirror images of each other. Each holds a staff topped by a cross. Their robes, indicated through broad areas of geometric patterns enclosed in black lines, cover all of their bodies with the exception of their heads, hands, and tiny triangular feet. While the flat, patterned surfaces and the boldly elongated heads and fingers of Daniel and Honorius are unique features of this particular *gadl*, high degrees of abstraction can also be found in some other early Solomonic manuscripts. In general this period of Ethiopian art is marked by a rich variety of highly diverse styles.

2-29. DIPTYCH ALTARPIECE. FERE SEYON. 1445–80. TEMPERA ON GESSO-COVERED WOOD, 17¼ X 24½" (44 X 62 CM). INSTITUTE OF ETHIOPIAN STUDIES, ADDIS ABABA

Fere Seyon was probably a debtera, a cleric who was not an ordained priest. For centuries the debtera have served the Ethiopian church as poets, cantors, dancers, musicians, sculptors, and painters.

During the fifteenth century, King Zara Yaeqob (Jacob) established new forms of worship for Mary, the mother of Jesus, encouraging his people to use images of Maryam (Mary) painted on wooden panels in their personal prayers and meditation. He invited foreign painters to work in Ethiopian monasteries, and imported devotional images from Jerusalem. The most influential artist of his court was the Ethiopian painter Fere Seyon, who

2-30. Bowl. Egypt. Mamluk period, c. 1300. Brass with silver inlay. Victoria and Albert Museum, London

Egypt. Mosques, schools, tombs, palaces, fountains, lavish private residences, and imposing city gates embellished Fustat, the first Islamic capital, and Cairo, al-Qahira in Arabic, the capital founded by the Fatimids.

The impact of Egyptian Islamic art can perhaps best be seen in the portable art forms which traveled far from their place of origin. Among these treasured objects are brass vessels. Made during the Mamluk period (AD 1250–1517), the shallow brass basin here is inlaid with silver and covered with bands of decoration (fig. 2-30). At the widest part of the bowl, Arabic letters are transformed into several series of vertical strokes. While many Mamluk brass basins displayed inscriptions—often quotations from the Qur'an or a short blessing—the calligraphy here is quite difficult to decipher, and may have served as a visual and verbal puzzle to amuse the owners. Beside the Arabic letters are circular shapes made of interlocking and radiating lines. These are part of the vast repertoire of Islamic designs drawn from geometry, calligraphy, and sacred divisions of space, which fascinated both Muslim and non-Muslim owners.

Metal basins were used for ritual washing before prayers and before entering mosques, and were proudly displayed in Muslim homes. In other cultures, these exotic and expensive objects took on other roles and meanings. In northern European churches, for example, imported Mamluk vessels sometimes served as baptismal fonts. Today Egyptian brass bowls and locally made replicas may still hold sacred substances in the shrines of southern Ghana (see chapter 7).

translated Zara Yaeqob's hymns and sacred poetry into visual form.

The portable diptych illustrated here is an elegant example of Fere Seyon's work (fig. 2-29). Painted in tempera on two pieces of wood, it can be closed for transport, then opened like a book and stood upright on a flat surface for use as an altar. The left panel shows Maryam with the infant Jesus in the crook of her left arm. As in many African depictions of motherhood, faces show little expression, but gestures are full of meaning; the child rests his foot upon his mother's arm, stroking her chin with one hand while grasping in the other the branch she is extending to him. Two angels fill the corners of the scene. On the right panel, three rows of saints turn to view the mother and child. Slight differences in their hair, beards, and hand gestures give variety to the assembly.

A comparison between the altar of Fere Seyon and the mural from Faras (see fig. 2-25) shows the Ethiopian artist's debt to Byzantine art. His work displays the rhythmic lines, stylized faces, and simplified shapes of the earlier Nubian painting of Mary. Yet Fere Seyon's work is smoother, more delicate, and more intimate, reflecting his patron's desire to interpret Maryam's role as a loving mother and an effective advocate for sinners, one who could petition her son on their behalf.

ISLAMIC ART OF EGYPT

Egypt was among the earliest of the Islamic conquests, surrendering to Arab armies around AD 639 (17 AH). Ruled initially as a province of the rapidly expanding Aghlabid empire, it came under the control of Fatimids, a North African dynasty, in AD 969 (357 AH). While Christian art forms continued to flourish in Nubia and Ethiopia under the Zagwe Dynasty and the early Solomonic rulers, a rich cosmopolitan Islamic culture developed in

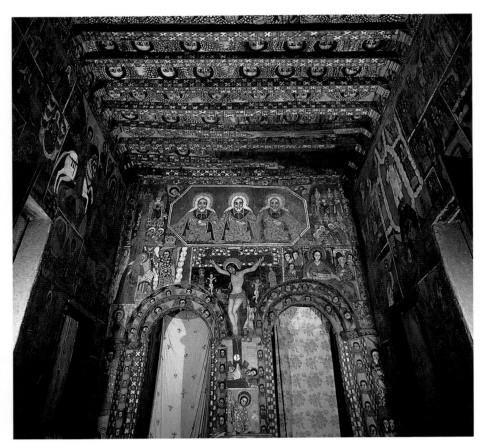

2-31. Interior of the church of Debre Berhan Selassie, Gondar, Ethiopia. 17th century. Pigment on plaster

LATER CHRISTIAN ART OF ETHIOPIA

In AD 1516 the Mamluk rulers of Egypt were defeated by the Ottomans, an imperial Islamic dynasty based in what is present-day Turkey. Nubia came under Ottoman control as well, and Christians in these regions of the Nile were pressured to convert to Islam. Further to the south, the Christian highlands of Ethiopia were overrun by Islamic forces led by Ahmad ibn Ibrahim. After twenty years, however, the Solomonic kings regained control of the highlands. While these Christian kings of the late Solomonic Period continued to move

their courts from place to place, they began to spend the entire rainy season at Gondar, in the northwest of their diminished kingdom, building there a series of palaces. Repeatedly sacked during the nineteenth century, the palaces are still imposing in their ruined and abandoned states.

The churches built by Solomonic kings during the seventeenth and eighteenth centuries have survived relatively intact. Debre Berhan Selassie ("Mount of the Light of the Trinity") was probably founded by King Iasu the Great toward the end of the seventeenth century. A small, thatched, rectangular church, it stands just outside Gondar. The wall paintings of its

interior display the full aesthetic impact of style known as Gondarene (fig. 2-31).

At the front of the church are the two arched and veiled entrances to the sanctuary, or "holy of holies," the area where sacred tablets are kept. Above and between the arches Jesus is depicted crucified upon a cross, the death he suffered as related in Christian scripture. The cross is shown issuing from the grave of Adam, the first man according to a biblical creation account, thus indicating Christ's role as the fulfillment of human history, the Savior whose death redeemed the human race from the sin committed by Adam. Over the crucifixion is a panel depicting the Holy Trinity, a central mystery of Christian doctrine in which God is understood simultaneously as one and three. Here, the Trinity is envisioned as three identical elders, each with a halo of gold and red light. In the segmented areas around them are depicted various saints and Mary, the mother of Jesus. The beams and ceiling are covered with the heads and wings of eighty angels interspersed with scintillating patterns.

The bright colors, lack of extraneous detail, and direct gaze of most of the figures are also found in the much earlier altar by Fere Seyon (see fig. 2-29). Yet the artists of Debre Berhan Selassie have added shaded areas to the faces of the Trinity and to the body of Christ to suggest rounded surfaces, and have emphasized the eyes of the angels and saints with bold dark lines. These characteristics emerged as a court style in Gondar during the mid-seventeenth century.

Although there is no longer a royal court in Ethiopia (the last king, Haile Selassie, was overthrown by his

2-32. Four *TABOT* (chests for sacred tablets), Tilafere Istifanos church, Tigray, Ethiopia. Wood. 17th–20th century; photograph 1960s

from a church for the photographer, are ornamented with triangular and linear patterns (fig. 2-32). The patterns were produced using a technique called chip carving, in which a series of chips, or tiny sections, of the surface of a piece of wood are removed, leaving raised ridges. Chip carving is also used in parts of West Africa and eastern Africa (see chapters 9 and 13).

During the festival of Timkat, the *tabot* are wrapped in cloth and carried from the holy of holies in a great procession (fig. 2-33). Umbrellas of costly brocade symbolize the dome of heaven and honor the sacred presence of these holy objects. Just as the Ark of the Covenant traveled through the wilderness with the people of Israel, the *tabot* spend the night in tents before being returned to the church the next day. The public appearance of the *tabot* also recalls the origin of Timkat itself, which commemorates the appearance of the Holy Spirit at Jesus's baptism. It is

military in 1974), historical paintings in the Gondarene style may still be made for foreigners and local clients today. Despite the invasions and civil warfare which destroyed much of Ethiopia's artistic heritage in the twentieth century, churches also continue to use carved and painted works of art during Christian worship.

The splendid paintings of Debre Berhan Selassie and the mysterious rock-cut churches of Lalibela still provide a suitable setting for *tabot*, the sacred tablets which are the central focus of worship in the Ethiopian Christian church. *Tabot* are considered replicas of the stone tablets of the Ten Commandments that the Bible relates were given to the Hebrew prophet Moses by God on Mount Sinai. They are enclosed in carved wooden coffers, or chests, just as the stone tablets of the Israelites were kept in a portable shrine known as the Ark of the

Covenant. These wooden containers, also called *tabot*, serve as altars and are stored in the holy of holies, where they can only be seen by priests. A particularly fine group of *tabot*, removed

2-33. Procession during the festival of Timkat, Axum, Ethiopia

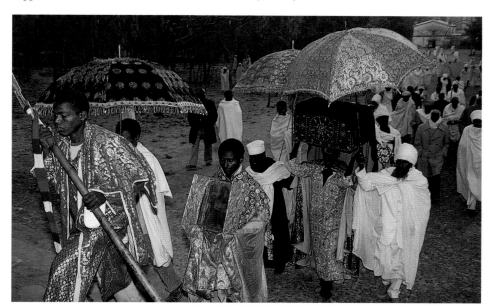

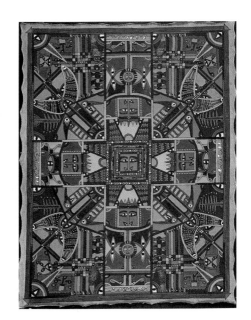

2-34. *Mystery*. Gera. 1988. Tempera on paper, 48 x 34⅝" (122 x 88 cm). Collection of Jacques Mercier

also strikingly reminiscent of the processions in which the priests of Kush and Kemet brought images of deities out of the dark recesses of their temples for annual festivals.

Ethiopian Christians believe that they should sing and dance before the *tabot* just as the Bible relates that King David once danced for joy before the Ark of the Covenant in ancient Israel. The processions are led by lay priests, or *debtera*, who are particularly accomplished singers, cantors, and dancers. The *debtera* may wear a finely worked crown of gold to invoke the majesty of David's kingship, and to bring divine blessing to the festival. The *debtera* and priests here carry processional crosses of brass and gold attached to which are long streamers of the cloths used to wrap them when they are stored. Some early iron, silver, and brass crosses have survived, but

the examples in this photograph are probably less than two hundred years old. The foliate forms on the cross to the left are typical of the late Gondarene style.

Prior to the 1970s, works in metal such as these crosses were often made by Ethiopian Jews known as the Falasha, who also were noted for weaving and pottery. *Debtera* themselves also made liturgical art, and the tradition of commissioning works of art from *debtera* has continued today. One of the *debtera* who has received considerable attention from foreign collectors is known simply as Gera (born 1941). Like many *debtera*, Gera works for private individuals as well as for the church. He specializes in talismans, sacred scrolls providing mystical protection for his clients. These are long strips of parchment or goatskin which can be laid over someone lying ill in bed, or hung in a bedroom. Ideally they are painted upon the skin of a goat that was sacrificed to God by the petitioner (the *debtera*'s client) to invoke blessing and forgiveness.

Based upon the Jewish mystical tradition known as the cabbala, these scrolls contain prayers written in Ge'ez and faces and figures representing both protective beings and monsters to be overcome. In function, the scrolls are quite similar to the ancient Egyptian collection of spells known as the Book of the Dead (see fig. 2-14), for the words and images they contain are believed by their presence alone to offer continual protection to the individual (living or dead) who owns and displays them.

Gera's recent work consists of original interpretations of these ancient protective paintings. He still uses the faces and intersecting geomet-

ric shapes painted on mystic scrolls, manuscripts, and pleated fans by *debtera* for centuries. In works such as *Mystery* (fig. 2-34), the motifs originally painted on long strips expand to fill a rectangular format, and patterns radiate to form stellar, circular designs similar to those on the Mamluk brass bowls (see fig. 2-30). The hues are rich and intense. Created largely for foreign collectors, paintings such as *Mystery* are no longer intended to bless and heal, but rather to intrigue and decorate.

LOWER NUBIA BEFORE THE ASWAN DAM

The Aswan High Dam, completed in 1971, blocked the free flow of the Nile to create Lake Nassar, a huge reservoir that supplies the present-day nation of Egypt with electricity and water for irrigation. The waters of Lake Nassar filled the Nile Valley between the first and second cataracts, the core of northern Nubia. Inhabitants were relocated, but nevertheless an old and deeply rooted culture was lost. Before these Nubian communities were submerged, their distinctive architecture was documented by photographers.

In the Kenuzi Nubian region of southern Egypt, domestic architecture was decorated by women, who painted the walls of interior courtyards with delicate polychrome patterns similar to those of their textiles and jewelry (fig. 2-35). In the Mahasi (or Feija) Nubian region of northern Sudan and southernmost Egypt, houses were decorated by itinerant male artists, who modeled and painted low reliefs on the exterior walls. Inside Mahasi homes the marriage hall, *diwani*, was also frequently painted (fig. 2-36). Reserved

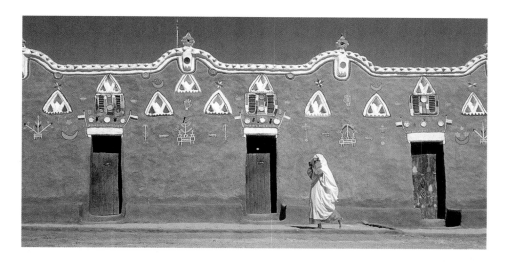

2-35. Painted houses, Nubia (southern Egypt). Photograph 1960s

2-36. *Diwani* (marriage hall), Nubia (northern Sudan). Photograph 1960s

for male guests of the groom during the long wedding festivities, a *diwani* could also serve as the temporary home of the newlyweds. Objects displayed in a *diwani* were chosen both for their beauty and for their associations with fertility and prosperity. The tightly woven palm fiber baskets hanging on the wall are trays used for feasts on saint's days or at weddings. Rolls of mats are tied under the ceiling, and wall paintings echo the geometric patterns of the basketry. The large marriage chest recalls the inlaid chest from the Ballana culture (see fig. 2-24), carved in the same region some 1500 years earlier.

2-37. *FUNERAL AND CRESCENT*. IBRAHIM EL SALAHI. 1963. OIL ON BOARD, 37" x 38" (84 × 52 CM). COLLECTION OF MRS. MARKISA MARKER

CONTEMPORARY ARTISTS OF SUDAN AND ETHIOPIA

While the contemporary arts of Egyptian villages have been documented by writers and photographers, artists working in the capital, Cairo, are relatively unknown outside of Egypt. Artists trained in Khartoum and Addis Ababa, on the other hand, have become important figures in the international art world in addition to enriching the culture of their local communities. This brief discussion of contemporary Sudanese and Ethiopian art introduces a few of the many artists whose work is shown internationally.

Ibrahim el Salahi (born 1930) was one of the first Sudanese artists to exhibit his paintings overseas. He studied art at an institute often known simply as the Khartoum School, which has changed names and affiliations several times since its foundation in 1947 and is now part of Sudan University of Science and Technology. Like many young students at the Khartoum School, he was influenced by Sudanese painters who with no formal training were creating landscapes and portraits for wealthy Sudanese patrons by the 1930s. After advanced art studies in London, el Salahi returned to Sudan, where he taught at the Khartoum School and met with other artists at the studio of Osman Waqialla. During the 1960s he also participated in workshops in Nigeria and in the United States.

In *Funeral and Crescent* (fig. 2-37) el Salahi remembers the death of his father, a Muslim cleric, and the affirmation of faith surrounding the burial. Heavy dark lines radiate from the mask-like faces and elongated bodies as the corpse is lifted upwards toward the lunar symbol of Islam. The colors are muted, purposefully echoing the hues of earth found in Sudan. The painting also expresses el Salahi's desire to create images through calligraphic strokes, merging the Islamic (or Arabic) heritage of sacred writing with the African heritage of figurative art.

Many Sudanese artists shared el Salahi's goal of combining Arabic calligraphy and "pan-African" styles and themes during the 1960s and 1970s. Other groups of artists from the Khartoum School formulated their own aesthetic programs. For example, Kamala Ibrahim Ishaq, one of the few women artists active in Khartoum, founded the Crystalist School in 1978. Another movement, known as the School of the One, was formed in 1986 to produce art closely attuned to the values of Islam.

El Salahi was imprisoned by the Sudanese government in 1975, and left the country after his release to live in

2-38. *GRAZING AT SHENDI*. AMIR NOUR. INSTALLATION AT THE NATIONAL MUSEUM OF AFRICAN ART, WASHINGTON, D.C., 1969. STEEL (202 PIECES), C. 9'11¼" X 13'5¾" (3.03 X 4.09 M). COLLECTION OF THE ARTIST

exile in Qatar and England. Political conditions in Sudan have driven many respected artists to emigrate. Sudanese artists now living in the United States include Mohammad Omer Khalil (born 1936), whose New York printshop has printed the work of American artists such as Romare Bearden and Louise Nevelson.

Sudanese sculptor Amir Nour (born 1939) is currently based in Chicago. Trained in Khartoum and London, Nour completed his studies at Yale University, and his work reflects American contemporary art movements such as Minimalism and process art. A sculptural group called *Grazing at Shendi* (fig. 2-38) is comprised of 220 stainless steel cylinders of various sizes, all curved into semi-circles. In this work, Nour invites the museum or gallery to participate in the artistic process by choosing how to place the forms in the display space. The arrangement photographed here was created by the staff of the National Museum of African Art in Washington, D.C. in 1995.

Despite the smooth finish of the industrial material used, this work makes references to the land near Shendi, the town on the Nile where Nour was born. In Nour's own words:

> As kids, we used to play outside and a man would come around collecting the goats and sheep, and he would take them out of town . . . When you see them from the distance, you don't see details . . . You just see dots on the space . . . I tried to put that

type of visual experience into metal to see how it worked.

But the shapes are not just grazing animals. Nour also describes crowds of worshipers praying outside at the end of Ramadan, the Islamic month of fasting and reflection: "They stand in straight lines. And then they prayed. And then they bent down . . . It's the same visual idea. It used to overwhelm me."

Other complex responses to local and international cultures may be seen in the work of Ethiopian artists. The first art institute in Ethiopia, the Addis Ababa Fine Arts School, was founded by Ale Felege Selam in 1957. Several Ethiopian artists who had studied and taught in Europe returned to Addis Ababa to teach at the school in the 1960s. One of these influential teachers was Gebre Kristos Desta (1932–1981).

Kristos Desta included abstracted yet recognizable figures in oil paintings such as *Crucifix* (fig. 2-39). He was criticized by some Ethiopians for using the styles and themes of European modernism to convey his own twentieth-century sensibility. Yet styles and themes of foreign art have been adapted to an Ethiopian context many times over the centuries, as, for example, in the fourteenth-century painter Fere Seyon's elegant reworking of Byzantine styles (see fig. 2-29).

Kristos Desta was forced to leave Ethiopia after the military takeover of 1974, and he died as a refugee in Oklahoma. Many of his former associates and students have also fled to

2-39. *CRUCIFIX*. GEBRE KRISTOS DESTA

the United States. Skunder Boghassian (born 1937), who once taught with Gebre Kristos Desta in Addis Ababa, has mentored generations of students at Howard University, in Washington, D.C. Elizabeth Atnafu, a former student of Gebre Kristos Desta, is an installation artist. Achameyeleh Debela (1947) uses computer-generated imagery to create art in cyberspace as well as photographic prints. The heritage of the Nile is thus not only accessible to Westerners through the vast array of archaeological work surviving in museums. It can also be seen in the varied and vibrant art made by Egyptian, Sudanese, and Ethiopian artists today.

3
THE CENTRAL
SUDAN

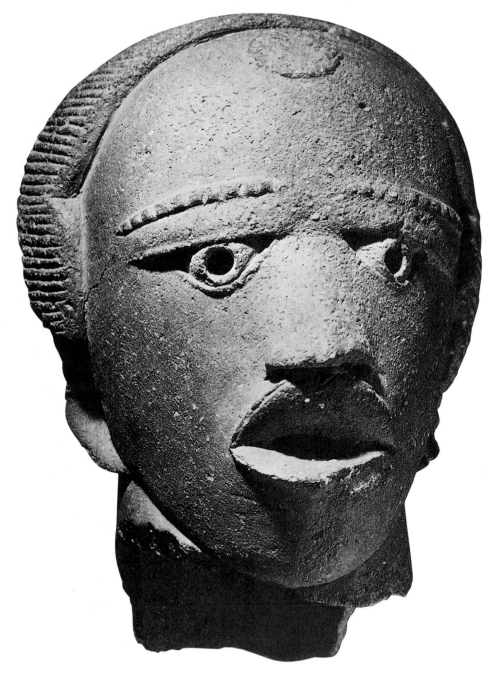

3-1. HEAD. NOK STYLE, C. 800 BC–AD 200. TERRACOTTA, HEIGHT 8⅓"
(22 CM). NATIONAL MUSEUM, LAGOS

SOUTH OF THE SAHARA AND north of the equatorial forest lies a transitional zone where the desert sands give way to fertile grassland. Arab travelers named this semi-arid region the *sahel*, meaning "port" or "shore"; here caravans rested after crossing the vast "sea" of the desert. It was also known as the Land of the Blacks, *bilad al-sudan*, where Africans rather than Arabs held political and religious authority. In English, the Arabic term "Sudan" has come to designate the entire band of savannah south of the Sahara, which stretches from the Atlantic Ocean in the west to the Great Rift Valley of eastern Africa.

The central portion of the Sudan extends roughly from the southward swing of the Niger River through the present-day nations of Niger and Nigeria in the west to the Ennendi and Darfur highlands in the east, which divide the nations of Chad and Sudan. These geographic markers do not reflect ethnic boundaries, however, and there are few cultural, artistic, or linguistic features that would clearly mark subdivisions within the Sudan.

A vast array of art forms have been created in the central Sudan by diverse populations with varied histories. Researchers have generally categorized these populations by language group, though cultural practices cut across linguistic boundaries as well. One such linguistic group comprises peoples who speak Nilo-Saharan languages and live in the lands east and south of Lake Chad, the large body of water at the heart of the central Sudan. While many are nomadic pastoralists, populations such as the Kanuri have built

fortified cities. Little is known of the art history of these Nilo-Saharan-speaking groups, who are mostly Muslim. Other central Sudanic peoples speak Chadic languages of the Afro-Asiatic family. Having migrated westward over the millennia, they now live in northern Nigeria and southern Niger. Of these Chadic-speaking groups, the Islamic Hausa have attracted the most attention from art historians, for their mosques, palaces, manuscripts, regalia, and embroidered clothing are spectacular examples of Islamic art. However, other Chadic-speakers are not Muslims. They live interspersed among the earlier inhabitants of this region (who speak either Adamawa or Niger-Benue languages of the Niger-Congo family) and share their art forms. These include body arts, metal and ceramic objects, statuary, and masks. Finally, a West Atlantic language of the Niger-Congo family is spoken by the Fulani people, who have entered the region over the last several centuries. Textiles and gourds made by Fulani artists may be purchased by their neighbors, just as the Fulani themselves patronize artists from other groups.

Despite this linguistic and artistic diversity, the peoples of the central Sudan do share some important features. Spiritual leaders wear distinctive dress and display sacred regalia. In the complex atmosphere of cross-cultural interactions that characterizes the region, personal adornment celebrates ethnicity as well as beauty and social rank. Objects used in daily life are given serious aesthetic attention, and architectural forms are among the most varied and most impressive in all of Africa.

ANCIENT ART IN FIRED CLAY

The ceramic arts of the central Sudan are rooted in regional practices which are thousands of years old. Recent excavations suggest that iron and copper have been smelted, forged, and cast in some areas for at least three thousand years. Metallurgy and ceramic technologies in the central Sudan appear to have been intertwined, for the oldest figurative sculpture in fired clay has been found in sites where iron was produced. Although there are still enormous gaps in our knowledge of the past, archaeologists have thus far identified three major types of ceramic images, known as Nok, Bura, and Sao.

Nok

During the first half of the twentieth century, Nigerians mining for tin uncovered fragments of fired clay figures. Hundreds of pieces were unearthed near a small town called Nok, which gave its name to these ceramic sculptures. Terracottas in Nok style have subsequently been discovered across an area of over one hundred square kilometers, suggesting that Nok figures were made or traded throughout the Plateau region north of the confluence of the Niger and Benue rivers.

A head found near the town of Jemaa is a fine example of these ceramic images (fig. 3-1). Like most Nok heads, it is hollow and was once attached to a full or partial figure. Its overall shape is a simplified geometric form; while this example is ovoid, other Nok heads are cylindrical, spherical, or even conical. Smooth round holes pierce the eyes, nostrils, and

mouth. The straight line of the upper eyelids joins the recessed space for the eyes to form a triangular shape, and the ears are placed in unusual positions at the side of the head.

We would expect such a work to have been formed by an additive technique, first built up and modeled from pliant clay, then fired to hardness. However, the crisp contours and the patterns of the hair, eyebrows, and lips suggest that the head was carved in a subtractive technique, perhaps from clay air-dried to a leather-hard stage. This unusual procedure suggests that the artist may have been trained as a woodcarver rather than as a potter.

Few complete Nok figures have been documented by archaeologists. One notable exception is a tiny image found along a river near the town of Bwari (fig. 3-2). Unlike most Nok works, it is solid rather than hollow. The opening between arm and head suggests that it may have been worn as a pendant. Although the surface of this seated or crouched figure is abraded, a broad collar, heavy bracelets and anklets, and distinctive chest ornaments are clearly discernible. Interestingly, the ornaments are almost identical to those depicted many centuries later on heads and figures from a civilization to the south, the Yoruba city of Ife (see fig. 8-12).

Carbon-14 and thermoluminescence dating suggest that the production of Nok images began about 800 BC and lasted until AD 600, a span of some 1400 years. Most, however, were made during a much shorter period of time, between 500 BC and the beginning of the Christian era. Unfortunately, most documented Nok sites had been disturbed by flooding and covered with sediment, their clay

images shifted from their original resting places. We thus know little about how or why they were first deposited. While recent clandestine digging has yielded spectacular terracotta objects stylistically akin to Nok pieces, these illicit operations are destroying the contextual information that archaeologists would have gathered.

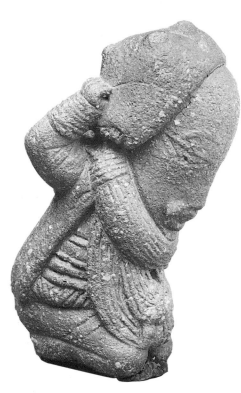

3-2. FIGURE. NOK STYLE, C. 800 BC–AD 200. TERRACOTTA, HEIGHT 4⅛″ (10.6 CM). NATIONAL MUSEUM, LAGOS

The proportions of this small Nok figure are quite different from those used by the Egyptians and Nubians discussed in chapter 2, for the head is large in scale compared with the rest of the body. Today many African peoples, particularly those who live in the forest regions of West Africa, emphasize the spiritual importance of the human head in this way.

Bura

The Bura region of Niger lies to the northwest of the Nok area, just west of the Niger River. Terracotta sculptures there were first discovered by a hunter, who noticed two figures protruding from a sandbank. His find launched an archaeological campaign by the University of Niamey, which located many more ceramic works in a large cemetery at a site known as Asinda-Sika. The burial ground was used between AD 200 and 1000; the earliest Bura ceramic figures and the last Nok works

3-3. DRAWING OF FRAGMENTS OF AN EQUESTRIAN FIGURE. BURA STYLE. C. AD 200–1000. TERRACOTTA. INSTITUT DE RECHERCHES DES SCIENCES HUMAINES, NIAMEY

could thus have been made during the same period of time.

Over six hundred ceramic vessels were found at Asinda-Sika. Each rested on its open mouth, as if placed upside-down, and most contained an iron arrowhead together with teeth and other portions of human skulls, suggesting that the vessels were spiritually empowered by the presence of ancestral

relics, trophy heads, or sacrificed captives. In the ground beneath each funerary vessel, a man or a woman was buried. Some hemispherical pots had been given facial features. Others were surmounted by a cylindrical neck and a flattened head, so that the body of the vessel evoked the body of a figure. Ovoid jars formed bases for heads or for half-figures, while tall cylindrical vessels served as pedestals for full figures, many of which depicted horsemen.

Unlike the Nok terracottas, which have been found at numerous sites but share a common style, the Bura terracottas come from a single site but display an astonishing stylistic variety. Since it has not yet been possible to date individual works and establish a chronology, we do not know whether differences in style and artistic quality reflect changes over time.

The bold geometric abstraction of one Bura style can be seen in the fragments of a horse and rider (fig. 3-3). The man's head is almost rectangular. Vertical lines mark the sides of his face and the concave curve of his forehead. The raised

3-4. Drawing of two figures. Bura style. c. AD 200–1000. Terracotta. Institut de Recherches des Sciences Humaines, Niamey

Pottery found in Bura habitation sites was made from the same type of clay as funerary terracottas and is similarly ornamented, suggesting that both types of ceramic works were made by potters. Since the production of household pottery in the central Sudan is usually the domain of women, the Bura terracottas were probably made by female artists.

oval eyes of both horse and human are punctured by slits, like the underside of a cowrie shell or a coffee bean. Long, tubular sections form the arms and torso of the proud rider and the head of the marvelous horse. Textured bands cross the rider's chest and depict the horse's bridle. The series of rings on the rider's forearm is an accurate depiction of a heavy iron bracelet found on a male skeleton buried at Asinda-Sika.

A second Bura style is seen in two half-figures, possibly a man and a woman, broken from a round vessel (fig. 3-4). Although their smooth limbs, cylindrical torsos, and long necks are ornamented with the patterned bands seen on the equestrian figure, their heads are spherical rather than rectangular. The round volumes of their faces are emphasized by circular ears, eyes, and mouths.

After the Bura sites were abandoned, several centuries were to pass before the Hausa and the Songhai established centralized states in this region. While written sources exist to chronicle the history of the area after the rulers of these states converted to Islam, archaeology has given us our only record of the pre-Islamic peoples who once lived along this stretch of the Niger.

Sao

A third terracotta tradition arose far to the east in the floodplains directly south of Lake Chad, a region divided today between northeastern Nigeria, northern Cameroon, and southwestern Chad. Here ceramic figures and other terracotta objects have been found in mounds. These low hills,

enlarged by the remains of human habitation, rise above the surrounding plains, which are flooded during the rainy season. Some are still surmounted by towns and villages, but many are no longer inhabited.

Especially large mounds along the Logone River support the walled cities of the Kotoko people, who are Muslims. French scholars who visited the Kotoko during the 1930s searched for insights into the people who built up the mounds, the pre-Islamic predecessors of the Kotoko. Older chronicles and contemporary inhabitants of the region refer to any pre-Islamic population (including a mythical race of giants) as *sao*, and thus objects unearthed in the mounds south of Lake Chad have been attributed to a generic Sao culture.

Researchers have explored over six hundred mounds in Chad and Cameroon. Unfortunately, the first excavators were trained as ethnologists rather than archaeologists, and they dug up objects without observing or recording the subtle clues that establish contexts and dates for buried materials. Since the 1960s, more scientific excavations have established historical sequences for mounds in Chad, Cameroon, and Nigeria, but relatively few metal or ceramic figures have been found at these new sites. A ceramic figure from Daima, in northern Nigeria, and a ceramic head from Messo, in southern Chad, have both been dated to the tenth century AD.

Like all of the Sao terracottas first unearthed by French ethnologists, the small ceramic head illustrated here was originally dated by guesswork to the fourteenth or fifteenth century (fig. 3-5). While the archaeological data from Daima and Messo suggest that it could

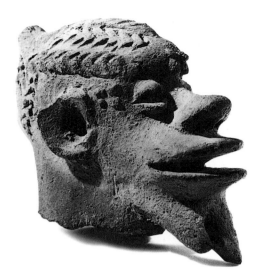

3-5. HEAD. SAO CULTURE. BEFORE C. AD 1600 (?). TERRACOTTA, HEIGHT 2½" (6.5 CM). MUSÉE DE L'HOMME, PARIS

have been fired as early as AD 900, we do not know when the production of these pieces ceased. We also know little about the function of the piece, which was found in Tago, an abandoned mound in southwestern Chad. It was part of a cluster of hundreds of ceramic fragments surrounding three figures or partial figures, also of terracotta. At least one of the three central figures had crossed bands depicted across its chest (perhaps representing a baldric), recalling those on some Bura sculpture. These three central images had been placed in the sherds of a funerary vessel, one of the large ovoid ceramic containers in which the inhabitants of the region once buried their dead.

Circular lumps of clay applied between the eyes and ears of this Sao head may represent keloids, raised scarification patterns. Both the shape of the eyes and the presence of these patterns are typical of Sao heads and figures, as is the fact that it is solid

rather than hollow. The protruding lips are found on heads of many Sao terracottas, even those assumed to be images of animals or other non-human beings. The attachment on the chin probably represents a beard, but may depict a lip ornament.

While ceramic figures are apparently no longer used in ceremonial contexts by the present occupants of the raised mounds south of Lake Chad, the Kotoko have identified some geometric clay objects found by excavators as offerings to supernatural forces. Today only Kotoko children form figures of people and animals, asking a sympathetic potter to fire their clay toys as she fires her pots.

LIVING ARTS OF SMALL COMMUNITIES

Vessels, figures, and other objects of fired clay are still very important in the lives of many rural peoples in the central Sudan. In these communities, ceramic arts can be studied in conjunction with architecture, body arts, and sculptural works in other media. Yet just as the archaeological record for the central Sudan is still incomplete, there are important gaps in our knowledge of its twentieth-century art forms. The accounts of the arts of various peoples discussed here are drawn from scholarly studies, but little has been written about the traditions of many of the other small art-producing groups in this region.

The Dakakari and the Nigerian Plateau

Numerous cultural groups now inhabit the Plateau region of Nigeria, the highlands north of the confluence of

the Niger and Benue rivers. In contrast to the stylistic unity of the Nok figures unearthed in this area, the art forms now found on the Plateau are quite varied. These include the arts of the Nupe people, who live on the southeastern corner of the Plateau and have had an important impact upon their neighbors both north and south of the Niger River. Their pottery, textiles, and mysterious masquerades (featuring a mobile cylinder of ghostly white cloth which ascends to an awesome height) have intrigued art historians.

Research has also focused on the memorial figures made by the Dakakari people. The Dakakari live northwest of the Plateau, several hundred kilometers down the Niger River from Asinda-Sika. They seem to have migrated into their present homeland from lands further north and west, which may explain why Bura figures from Asinda-Sika have their equivalent in the fired clay figures made by Dakakari female potters.

A Dakakari figure now in the British Museum once indicated the burial place of a man of distinction, such as a mayor, feast giver, high priest, hunter, blacksmith, military leader, champion wrestler, or productive farmer (fig. 3-6). Known as a "son of the grave," this rotund but dignified image was imbedded in the earth covering the stone burial mound of the man and his family, and was surrounded by household pottery. Covered with latex to give it a shiny water-resistant surface, it may have been further protected from the elements by a small thatched shelter.

The grooves covering the face and chest depict the scarification patterns worn by the Dakakari until quite recently, and the band across the chest probably refers to the baldric worn by military leaders. However, this memorial image is not a portrait of the deceased but an indication of his status; figures of women, equestrians, and large wild beasts may also be placed on a man's grave as a sign of honor. The open mouth is said to indicate a state of grief, and so the figure may be understood as a personification of mourning as well.

The Ga'anda and the Gongola River

While ceramic images of the Dakakari are made exclusively for tombs, clay images in cultures south and south-

3-6. FIGURE. DAKAKARI. 20TH CENTURY (?). TERRACOTTA, HEIGHT 16" (40.6 CM). FOWLER MUSEUM OF CULTURAL HISTORY, UNIVERSITY OF CALIFORNIA, LOS ANGELES

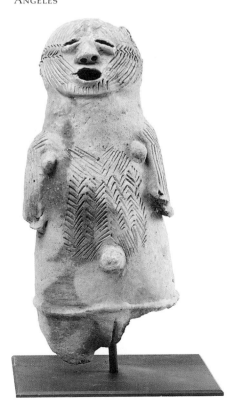

west of Lake Chad have a broad range of functions and meanings. This complexity of context is particularly striking among communities in the hills above the Gongola River, a tributary of the Benue River in northeastern Nigeria. Among these small populations, whose histories and languages reflect diverse origins, clay pots are used to address many spiritual needs.

The Ga'anda, a Chadic-speaking people of the Gongola River area, use fired clay vessels to give supernatural beings a tangible presence. The vessels allow the Ga'anda to have physical contact with (and a measure of control over) potent spiritual forces. A particularly important spirit guardian named Mbirhlengnda is hosted in meticulously ornamented containers of fired clay (fig. 3-7). Mbirhlengnda is honored by individual families and usually resides in a vessel, itself usually surrounded by other sacred containers for associated supernatural beings. Elders offer the vessel libations of guinea-corn beer during ceremonies connected with rainmaking and agricultural fertility. This particular example is enshrined in the cleft of a rock on a hill where Mbirhlengnda can oversee the community below, protecting it from the destructive powers caused by high winds.

The ceramic vessel is both a pot and an anthropomorphic being. The spherical shape which forms the "body" of the figure shares the profile of pots made by Ga'anda women for household use, but here the vessel's spout functions as the projecting mouth of the spirit's head. Tiny bent arms are attached to the smooth surface, and delicately textured ridges run vertically along the torso. Small round

Similar vessels made by the Cham (or Mwona) people, an unrelated group who live to the west of the Ga'anda, are used to ward off specific physical and spiritual ailments when the illness is transfered from a person to a pot. A particularly expressive container protects pregnant women and prevents them from vomiting (fig. 3-8).

Sacred ceramics from the Gongola River region share motifs and underlying meanings with other art forms, including objects of iron and brass, domestic pottery, ornamented gourds, basketry, architecture, and body arts. Perhaps the most dramatic art form in the region is the mobile, tactile art of scarification. For several generations, the elaborate scarification patterns of men and women living near the Gongola River have been hidden under clothing. However, women once left visible much of their sculpted skin. Among the Ga'anda, this form of body art, called *hleeta*, is created by making hundreds of tiny cuts in the skin, small wounds which heal to produce carefully spaced raised marks of identical size and shape. Lines of marks form single, double, or triple outlines for geometric shapes (fig. 3-9). Neither photographs nor drawings convey the subtle, textured effect of these patterns. The older women who perform *hleeta* are directed by a creative spirit named N'gamsa, and other supernatural beings may oversee the healing process.

Hleeta is done in several stages during a girl's lengthy betrothal to her first husband, beginning at age five or six. Every time she receives a new set of marks, her fiancé and his family must deliver gifts to her parents. There is thus a direct correlation between the sequence of *hleeta* patterns appearing on a girl's body and the number of bridewealth payments given to her family, and a girl may

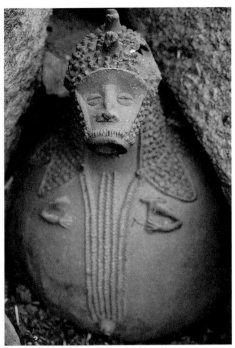

3-7. Terracotta figure of Mbirhlengnda enshrined in a rock cleft, Coxita village, northern Nigeria. Ga'anda. Photograph 1980

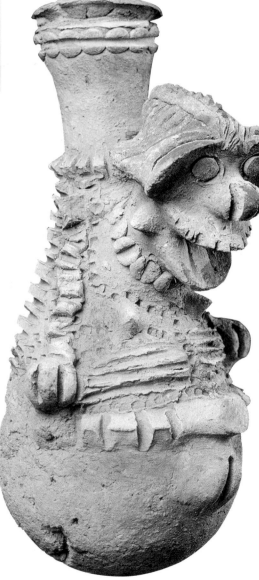

3-8. Vessel. Cham. Terracotta. Fowler Museum of Cultural History, University of California, Los Angeles

pellets fill an area which drapes over the head, neck, and shoulders and marks the line of the jaw. All these surface decorations have symbolic meaning. The bumps are probably an allusion to the skin diseases Mbirhlengnda may unleash to punish wrongdoers. However, the vertical ridges also refer to the Ga'anda practice of marking the skin of girls and young women with patterns of scars to celebrate their sexual maturity. These marks indicate that a girl has achieved responsible adulthood, and their depiction here suggests that spirit vessels are likewise thought to be human and civilized.

3-9. *HLEETA* (Ga'anda female scarification patterns). Drawing by Marla Berns after figure contours by T. J. H. Chappel

The importance of human skin in social relationships can be seen in the Ga'anda belief that Mbirhlengnda punishes anti-social behavior with skin diseases. Throughout the central Sudan, civilized behavior and community membership are linked to the willingness of men and women to alter the surfaces of their bodies with marks of beauty and status. Unfortunately, European languages have no words which adequately describe this type of sculpted skin; the terms "scar" and "cicatrization" do not have positive associations in Western culture.

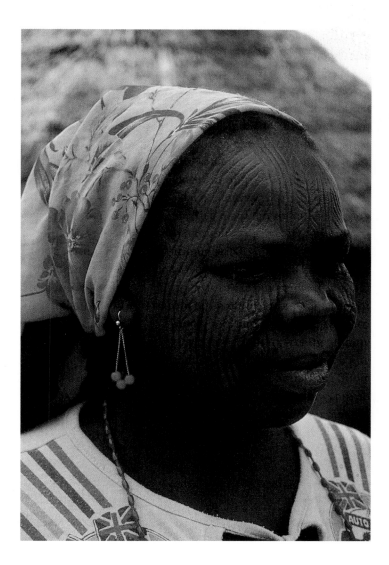

not consummate the marriage until she has received her final marks and the groom has fulfilled his obligations. New wives celebrate their completed *hleeta* at the annual harvest festival.

3-10. Facial markings on the face of the chief of Kamo's wife, Kamo village. 1982

The marks of men and women in many other Gongola River populations identify them as members of a specific community or cultural group. The slightly asymmetrical markings of a village chief's wife identify her as a member of a Tera community (fig. 3-10). The smooth grooves adorning these people were carved into their skin when they were babies.

Designs appearing on a woman's skin are also burned, impressed, or

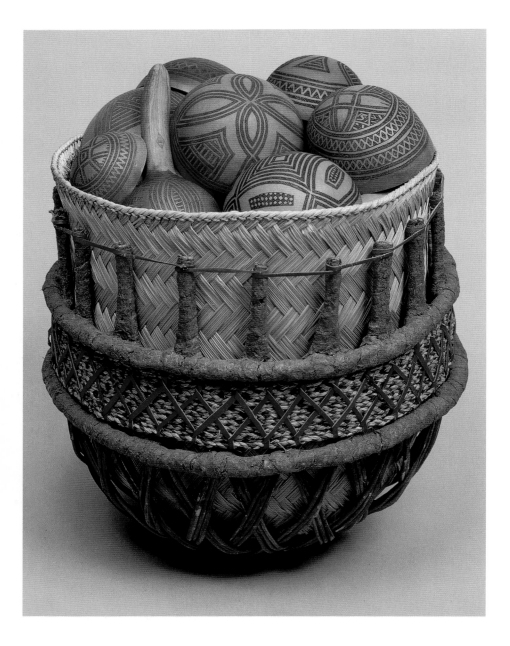

Among the Ga'anda, a basket filled with decorated gourds must be given by the groom's family to the bride. One of the calabashes arrayed in the Ga'anda bride's wedding basket illustrated here displays patterns similar to *kwardata*, the panels of double lozenges and vertical lines covering her upper thighs and the sides of her lower back (fig 3-11; compare fig. 3-9). Similar bands of lozenges encircle the large basket itself. The curved shapes in the centers of the calabashes recall the pointed ovals on the woman's abdomen. Broad lines pressed into the surface of the gourds (a technique known as "pressure engraving") are formed of numerous fine dark marks, just as the lines of *hleeta* are made of tiny points.

Ceramic vessels, gourds, and baskets all display the patterns of *hleeta*. Ceremonial weapons are also given these designs, as is the entranceway that a groom weaves for his wife's new home. Ga'anda art is thus based upon an integrated visual system, full of related and concerted references to the world of women, marriage, and sexuality, to socialization, and to the wealth of community life.

Musgum and the Logone River

The Ga'anda are not the only population to weave walls, roofs, and partitions to make structures analogous to baskets. Fiber-based architecture also appears in many other areas of the central Sudan. Still other communities build homes, furnaces, and granaries of modeled earth, buildings which are as carefully embellished as clay vessels.

Stunning architectural forms built from compressed, sun-dried mud

3-11. WEDDING BASKET WITH ENGRAVED CALABASHES. GA'ANDA. FIBERS AND GOURDS; HEIGHT OF BASKET 19½" (49.5 CM). FOWLER MUSEUM OF CULTURAL HISTORY, UNIVERSITY OF CALIFORNIA, LOS ANGELES

carved into the calabashes she owns. These gourds, whose outer rinds have been scraped, dried, and prepared for use as containers, are used by many peoples in Africa. However, they are the focus of especially elaborate aesthetic attention in the Gongola region. Beautifully ornamented gourds embellish a household and are adorned and displayed primarily by women.

3-12. Musgum adobe compound with large dwellings and joining wall, northern Cameroon. Photograph c. 1930s

In most communities of the central Sudan, families do not live in a single structure formed of many rooms but in a cluster of separate units encircled by a wall or fence. Each unit is a distinct building, often a single room, which is the property of an adult man or woman and may be abandoned when its owner dies. Women may share their housing unit with unmarried children and relatives. The individual buildings of a Musgum compound were of two basic types: large, domed dwellings divided into cooking and sleeping areas, and smaller, smoother granaries.

were once built by the Musgum and their neighbors, heterogeneous Chadic and Nilo-Saharan populations living east of the Mandara Mountains in southwestern Chad and northern Cameroon. During the early twentieth century, visitors to Musgum communities on the Logone River photographed and sketched the tall conical structures that rose above the low curved walls surrounding each household (fig. 3-12). The structures' raised patterns, which varied from household to household, served to channel rainwater and to provide toeholds for repair work, but were obviously chosen for their aesthetic impact as well. The walls were thin but strong. The interiors, rarely photographed by outside observers, were also finely sculpted, and almost all pieces of furniture were modeled out of clay (fig. 3-13). The Musgum still live in the Logone River valley, but today they build smaller, simpler homes.

The iron weapons of the peoples who live south of Lake Chad have also

impressed outside observers. The curved blades forged by blacksmiths in many of these groups are described as "throwing knives," for they can be hurtled sideways to slice through a target, or tossed into the air like a baton. Throwing knives vary in form, reflecting ethnic affiliation, individual workshops, intended use, and the social rank of the original owner (fig. 3-14). Musgum warriors and their neighbors once kept these graceful and dangerous blades in leather cases strapped to their backs. Although throwing knives are rare in the central Sudan today, men of high status may still carry a single weapon slung over their shoulder. However, some of these weapons were not meant to be thrown but to be carried as prestige items. Iron knives which are ceremonial or sacred objects may receive sacrificial offerings, or be said to cause lightning storms. Some have associations with female ancestors, or (as among the Ga'anda) are carried by female dancers.

Apart from sacred ceramic vessels, few figurative images have been

3-13. Interior of a Musgum dwelling showing sculpted shelving over doorway. Drawing after a photograph by McLeod

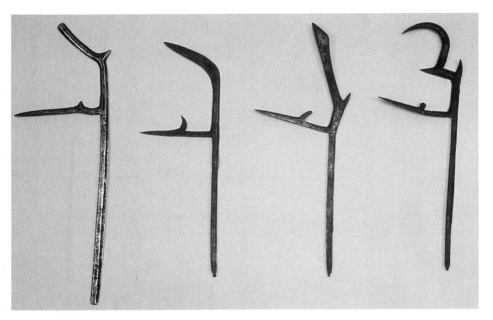

3-14. Throwing knives. Sara. Early 20th century. Iron, height of left-most knife 25⅕" (64 cm). The British Museum, London

anthropomorphic brass head is adorned with a crest, as are most figures and even some helmet masks in the region. From its mouth issues an iron blade. In fact, this bold object may be the Jukun/Abakwariga/Tiv counterpart to the ceremonial knives used further north.

The Chamba of the Nigeria/Cameroon Borderlands

Like the Jukun, some Chamba peoples have kings whose authority is mainly religious. These Chamba kings are assisted by royal women who serve as queens, and by members of their

recorded among the peoples of the Logone River, the Mandara Mountains, or the Gongola River. Farther south, along the Benue River, wooden figures and a variety of masquerades appear along with arts in metal and clay. As a corridor for migrations, the Benue River valley has facilitated the movement of peoples and art forms. Of the intersecting groups who live between the Benue River of Nigeria and the Adamawa Plateau of Cameroon, those known as the Jukun, the Chamba, the Mumuye, and the Mambila have been most fully studied. All four groups speak Niger-Congo languages, some of which are distantly related to the forms of Bantu spoken in the southern half of the African continent.

The Jukun of the Middle Benue River

The Jukun have a history of political authority in the middle Benue region,

and they share art forms with former allies and vassals on both sides of the Benue River. The divine kings of the Jukun are rainmakers charged with responsibility for agricultural and human fertility. Their brass regalia are similar to the staffs and swords of many neighboring groups and appear to be part of a corpus of sacred metallic arts found throughout this part of the central Sudan.

A ceremonial brass adz collected among the Tiv people illustrates the cross-cultural interactions characteristic of Jukun arts (fig. 3-15). This adz was probably made by the Abakwariga, nominally Islamic Hausa artists who work in the Jukun capital, Wukari, and who have produced regalia in copper alloys for Jukun kings. Yet the adz was carried in a Tiv healing dance led by Abakwariga women, who were possessed by spirits similar to those known as *bori* in other Hausa groups. The

3-15. Adz. Abakwariga artist for Jukun or Tiv patrons. Brass, height 17" (42 cm). Fowler Museum of Cultural History, University of California, Los Angeles. Arnold Rubin Collection

matriclans. Leaders of royal matriclans are sometimes responsible for the appearance of a masquerade, known by many names, that incorporates powers of the ancestral dead and of the wilderness.

The masquerade is danced with a wooden mask which covers the top of the dancer's head like a helmet (fig. 3-16). From the helmet a muzzle projects forward and horns project backward in a single horizontal plane. Generically this is known as a horizontal helmet mask, a type of zoomorphic mask that appears across western Africa. The hemispherical dome of this Chamba mask is related to death, for it is said to be like a skull, an ancestral relic taken from the grave of an elder. Other features are related to the wilderness: the open jaws are the jaws of the crocodile, the horns those of the forest buffalo. Painted red (the color of the blood of the hunt and of men), black (the color of night, witches, and women), or both red and black, the mask is linked to dangerous forces. The masquerader is hidden under a thick costume of plant fiber.

Royal matriclans claim descent from a forest buffalo who had been transformed into a beautiful woman, and in some way the Chamba queen is understood as her incarnation. In at least one Chamba region, the masquerade refers to this buffalo ancestor. For example, the king plays a crucial role in crop fertility, and the royal masquerader appears during planting ceremonies to assist its royal offspring in this important task. When the masquerader leaves the community to return to the river, it is understood to be returning to the site where the forest buffalo ancestor was seized by her husband.

Chamba boys learn the human identity of the masquerader when they are initiated. The legend of the royal matriclan's origin teaches them that a man animates the wild, death-masked creature just as a woman had been hidden under the skin of a forest buffalo. The boys also learn that the royal ancestor killed her husband when he shared his knowledge of her true identity, and that therefore they should never reveal the secret of the masquerade.

The masquerade appears at public funerals of elders and royals as well as during agricultural ceremonies. It thus presides at crucial times of transition in the life of the community. In fact, the masquerade dances when the world of the wilderness and the world of the dead merge with our own.

Other powerful objects are owned by Chamba clan organizations referred to as Jup or Voma, and are linked to their secret knowledge of remedies for illnesses and misfortunes. Among

3-16. Chamba helmet-mask in performance, northern Nigeria. 1965

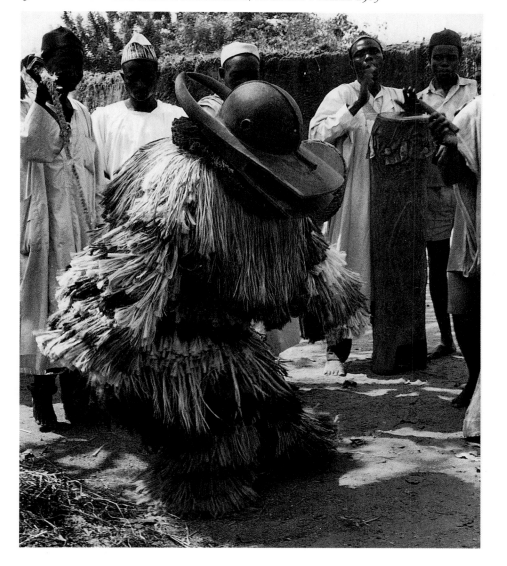

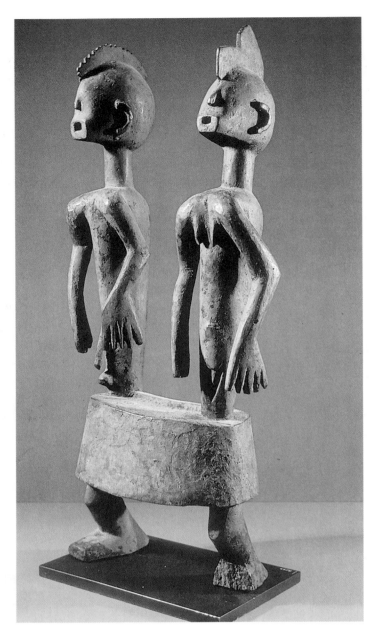

*Sagital crests, the central ridges
appearing on the heads of the
ceramic and wooden figures as
well as the masks of many peoples
of the central Sudan, often
represent specific hairstyles. Yet
these prominent extensions may
also be references to supernatural
authority.*

3-18. FIGURE. MUMUYE. WOOD,
HEIGHT 36¼″ (93.3 CM). THE
METROPOLITAN MUSEUM OF ART,
NEW YORK

these highly charged works may be
ceramics, brass figurines, musical
instruments, and wooden figures. All
are kept hidden in a bundle or under a
large pot. The unseen presence of this
sacred material transforms the pot or
bundle into an altar, a place of contact
between the natural and supernatural
worlds.

A wooden image of a joined cou-
ple may once have belonged to one of
the Chamba clan organizations which
use statues rubbed with ochre to battle
adultery and its corrosive effects on
the community (fig. 3-17). Although
no data accompanied the object when it
left Nigeria, its composition and style
suggest that it was carved by a

Chamba artist and that it strengthened the marriage relationship. Here a male and female form are joined as one being, just as a husband and wife should form a single unit.

The statue's combination of curved and flat planes effectively evoke human forms without actually transcribing them. Facial features are reduced to semi-circular ears, small bumps for noses, and small hollows for mouths. Sexual attributes are simplified but easily recognizable. Arms spring from the front of the body rather than the sides. Shoulders, elbows, and wrists mark the junctures of diagonal lines, and the arms and hands curve gently as if to encircle the cylindrical torsos. Such interplay between "zigzag" limbs and long narrow bodies appears in compelling variations in the religious sculpture of the Chamba and many of their neighbors. The sculpture's high degree of abstraction also suggests that the statue supported a moral principle. The figures are not portraits but rather symbols of male/female union. By avoiding any direct link with particular human beings, the artist encouraged members of the group to reflect upon ideas about relationships between men and women generally in Chamba society.

The Mumuye of the Upper Benue River

The Mumuye peoples, the northern neighbors of the Chamba, also display sculpture in a variety of contexts. Mumuye wooden images may be associated with elders, rainmakers, diviners, and other religious leaders. Like Chamba sculpture, Mumuye figures are highly abstracted, perhaps in part because they invoke forms of human and supernatural authority. A particularly powerful Mumuye statue is formed of long fluid shapes (fig. 3-18). Springing from an abbreviated base of legs and hips, the slender torso is framed by arms which curve downward, backward, then forward from the smooth arch of the shoulders and neck. The head is a double-crested abstract helmet with angular extensions, whose sharp front edge repeats the overhanging curve of the shoulders.

Mumuye wooden images are associated with elders, rainmakers, diviners, or other religious specialists and are often guided by a protective spirit known as Va. Many masquerades are known as *vabo*. *Vabo* masks may be carved for a newly trained age-grade which has demonstrated its prowess and is considered worthy of owning the masquerade and keeping its secrets. Identified with the forest buffalo, the masks have slit, cylindrical jaws, a central dividing ridge bisecting the rounded forehead, and upward-curving horns (fig. 3-19). Color defines and emphasizes features such as the circular eyes.

Vabo masquerades punish antisocial behavior and chase away criminals, and individual names given to each male *vabo* mask underscore their aggressive qualities. Yet there is

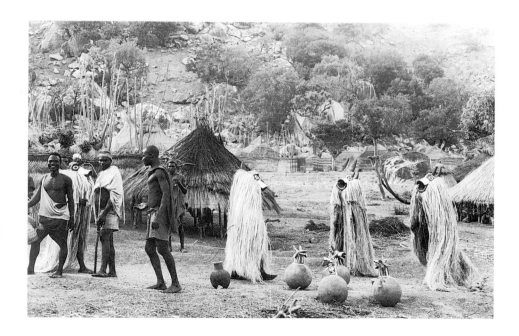

3-19. MUMUYE *VABO* MASQUERADERS AND CERAMIC VESSELS AT A FUNERARY CELEBRATION, NORTHERN NIGERIA. 1969

also an element of playful banter and male solidarity in some *vabo* performances. A "wife" or female counterpart to *vabo* may appear with the principal masquerader, acting out feminine roles in a humorous way. Sometimes these companions take the form of a carved pole set up in the center of the community as a hanger for the masquerader's long fiber dress. In other cases *vabo*'s female companion is danced, manifest as a sculpted head rising from a wooden support (fig. 3-20). The curved forms on either side of the head refer to Mumuye women's earlobes, formerly enlarged with wooden disks, just as the spiky protrusions in front may represent the brass nose ornaments they once wore.

3-20. *VABO* DANCE HEADDRESS, NORTHEASTERN NIGERIA. MUMUYE. 1965

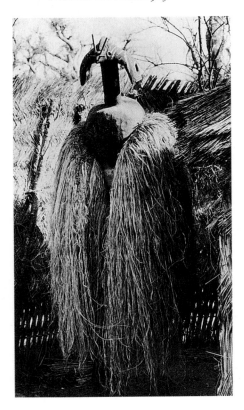

Vabo's most important manifestation may occur during men's funerals such as the one photographed in figure 3-19. During these ceremonies, *vabo* masqueraders and their attendants gather ceramic vessels from the homes of all the men who have died during the year. Each spherical pot, whose finial is a miniature version of the forest buffalo mask, has sheltered the soul of the deceased since his death. After carrying the pots to a sacred area, the dancers remove their masks and, as humans rather than spirits, smash the pottery to release the souls. Women organize similar ceremonies for deceased female elders.

Both Chamba and Mumuye masks bring dangerous animals from the wilderness into the community, and both appear at funerals. Further variations of the form and meaning of horizontal helmet masks in this region may be seen in the art of the Mambila people, who live southeast of the Chamba.

The Mambila of the Nigeria/Cameroon Borderlands

Mambila art centers upon an association called Suaga. Unlike the Jup or Voma of the Chamba, Suaga is not primarily concerned with the illness and psychic healing of an individual, but with justice and supernatural cleansing within the community. Training in Suaga allows elders to extract powerful oaths from disputants, who know that they will receive supernatural punishment if they break (or have broken) their promises. Suaga may also protect a homestead or a community by spiritually "burying it," and placing it out of harm's way.

Every year or two, Suaga masquerades are performed in sequence, starting from a central community. Groups of boys are initiated into Suaga as it arrives in their region. When the masqueraders appear, women and young children retire, for women dressed in rags and vegetation present their own version of the masquerade at a different time and place.

Male masqueraders wear knitted or knotted fiber costumes of solid black or colored patterns. Masks with wide mouths, protruding eyes, and upright ears were formerly worn, although they are quite rare today. The example illustrated here resembles Mumuye *vabo* masks in its colors and proportions, though the curved planes of its surfaces are more exaggerated (fig. 3-21). The round eyes marked by concentric circles seem to burst from their sockets, while the flared jaws open in a gaping grin.

The costumes, musical instruments, masks, and figures used in Suaga ceremonies may be stored in small granary-like buildings in the homesteads of their clan or family owners (fig. 3-22). The front wall of such a storehouse was once covered by a painted wooden board or surrounded by three-dimensional objects which protected and proclaimed the sacred power of the objects within. A painted wooden figure known as a *tadep* came from one of these storehouses (fig. 3-23). Just as the limbs of Chamba and Mumuye figures fold out from the base or front surface of the torso, the arms of this Mambila statue form semi-circles in front of the body. Spherical segmented shapes represent hips, knees, and feet. The separation of the eyes and facial plane into a nested series of concave circles is specifically

3-21. *SUAGA* MASQUERADER.
MAMBILA. BEFORE 1960

3-22. STOREHOUSE FOR *SUAGA*
SOCIETY PROPERTY, NORTHERN
CAMEROON. MAMBILA.
PHOTOGRAPH 1936

3-23. *TADEP* FIGURE. MAMBILA.
20TH CENTURY. WOOD AND
PIGMENT; HEIGHT 17⅛" (43.5 CM).
THE METROPOLITAN MUSEUM OF
ART, NEW YORK. FLETCHER FUND

Mambila, as are the compressed
(rather than elongated) proportions.

Today the Mambila carve few
masks or figures for Suaga. As in past
centuries, art objects are often adopted
or abandoned by communities in
response to shifting political and reli-
gious contexts. Mambila religious

practices have been particularly
affected by Christianity. The most
potent agent of change in the central
Sudan during the past four centuries,
however, has been Islam.

THE IMPERIAL ARTS OF THE KANURI AND HAUSA

Islam was adopted in the central Sudan
by three important groups, the Kanuri,
the Hausa, and the Fulani. Each of
these peoples, while strongly influ-
enced by their non-Islamic neighbors,
have in turn influenced the art and cul-
ture of broad areas of the region. The
Kanuri and Hausa, the first peoples in
the region to form centralized states,
were also the first populations to con-
vert to Islam, and their cultures thus
share many features.

The Kanuri originated in the vast
dry portion of the continent lying
between Lake Chad and the Nile River.
Like the ancient inhabitants of Meroe
(see chapter 2), the Kanuri speak a
Nilo-Saharan language, and their cul-
ture is centered on the institution of
divine kingship. Kanem, the first
recorded Kanuri kingdom, arose during
the last centuries of the first millen-
nium AD and was probably linked by
trade to the Christian kingdoms of
Upper Nubia. The king, *mai*, of Kanem
converted to Islam during the eleventh
century, when the kingdom was at the
height of its power.

By the thirteenth century Kanem
was torn by dynastic disputes, and a
clan broke away to form the kingdom
of Bornu in the more fertile lands
southwest of Lake Chad. During the
sixteenth century Bornu absorbed
Kanem and became the most powerful
political force between Lake Chad and
the Niger River. Although Bornu was

superseded by Hausa and Fulani states
during the eighteenth and nineteenth
centuries, it remained an important
kingdom until the beginning of the
colonial era. Today Bornu is an emirate
within the nation of Nigeria.

The Kanuri were a nomadic or
semi-nomadic people for much of their
early history, housing the *mai* and the
royal court of Kanem in tents or
portable structures of thatch. Bornu,
however, had a walled capital. Courtiers
dressed in fine textiles; during the early
nineteenth century a European traveler
noted that a ruler of Bornu distributed
over a thousand robes to loyal subjects.
One of the prestigious garments seen
by this visitor may have been this
vibrantly colored, densely ornamented
men's robe (fig. 3-24, see pages 24–5).
The back, shown here, is divided into
square or rectangular panels. The cen-
tral panel is criss-crossed by diagonal
bands, while the surrounding sections
alternate geometric shapes (particularly
circles and triangles) with floral motifs
or knots. While some of these designs
are quite similar to triangular- and
lozenge-shaped motifs on textiles from
North Africa, many are probably
derived from patterns found on glass,
pottery, or metalwork made in Islamic
Egypt (see fig. 2-30).

Kanuri warriors and dignitaries
once carried impressive weapons and
wore costly armor, including plumed
helmets and shirts made of chain mail.
Even today, mounted courtiers and
equestrian guards in Bornu and other
kingdoms of the central Sudan perform
spectacular maneuvers on horseback at
festivals. Young riders of the Djerma or
Zerma people, who are unrelated to the
Kanuri and live far to the west of
Bornu, nonetheless display helmets
similar to those photographed on

3-24. EMBROIDERED ROBE. KANURI. EARLY 19TH CENTURY. COTTON AND SILK; LENGTH 32″ (99 CM). MUSEUM FÜR VÖLKERKUNDE, STAATLICHE MUSEEN, BERLIN

Kanuri warriors almost a century ago (fig. 3-25). The thick, quilted cotton armor worn by the horses and their riders is said to have been invented in the Hausa city of Kano some six hundred years ago. The bold stamped patterns of the cloth here are much brighter than the original Hausa armor, however, which was probably plain white cotton.

Hausa Mosques and Civic Architecture

According to legend, six of the original Hausa cities were founded by the sons of a heroic stranger who had slain a mighty serpent and married a local queen. Since the Hausa are a Chadic-speaking people, historians believe that

3-25. DJERMA WARRIORS IN QUILTED CLOTH ARMOR, NIAMEY, NIGER. 1970

The Djerma are allied to a Hausa city-state in Niger. These young Djerma equestrians could be the descendants of the warriors who were buried centuries ago beneath terracotta horsemen in the Bura region of Niger

they were one of many groups to move south and west to settle in what is now southern Niger and north-western Nigeria, possibly over a thousand years ago. The legend may refer to these migrations.

By the sixteenth century, important Hausa city-states such as Kano, Katsina, and Zaria were fortified with thick adobe walls and administered large areas of neighboring territory.

During this period the king, *sarki*, of most Hausa cities was a Muslim. His official allegiance to Islam allowed the Hausa to conduct alliances with the Islamic states of Songhai, a multi-ethnic empire further up the Niger River, and Bornu. During the early nineteenth century, many Hausa lands were conquered by the Fulani leader and religious reformer Usman dan Fodio, and the recent histories of

the Hausa and the Fulani are thus intertwined.

The Friday Mosque of the old Hausa city of Zaria was designed during the first half of the nineteenth century by Mika'ilu, both a Great Artist, *babban gwani,* and a Hausa flag-bearer of Usman dan Fodio. Parts of the mosque were probably commissioned by Usman dan Fodio himself and by his son Mohammed Bello. Like all Hausa architects responsible for the design of important buildings, Mika'ilu was also a *malam,* a learned man who could read Arabic and interpret the Qur'an. Instructed in geometry, *malam* have the skills needed to plan a building complex, and as religious specialists they know the prayers and incantations required for such an enterprise. Having made at least one pilgrimage to Mecca, a *malam* such as Mika'ilu had also seen many mosques and architectural forms in the course of his travels, and could incorporate this knowledge into his work.

Square in plan, the prayerhall of the Friday Mosque of Zaria is capped with six domes (fig. 3-26). It was once set within a square courtyard. Entry to the courtyard was through one of four entrance chambers built into the enclosing wall. Each entrance chamber, *zaure,* had a dome, a doorway leading to the exterior, and a doorway leading to the interior courtyard. Inside the prayerhall, the domes are crossed by ribbed arches resting upon large piers

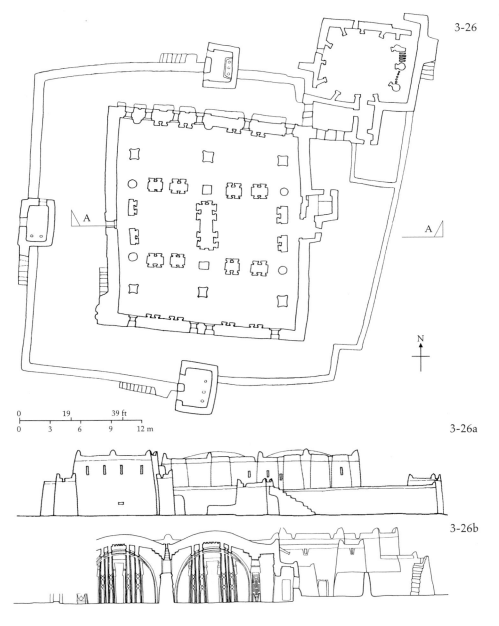

3-26

3-26a

3-26b

3-26 Plan of Friday Mosque, Zaria, Nigeria. Drawing by J.C. Moughtin
3-26a North elevation of Friday Mosque
3-26b Section of Friday Mosque taken along the A-A axis marked in fig. 3-26

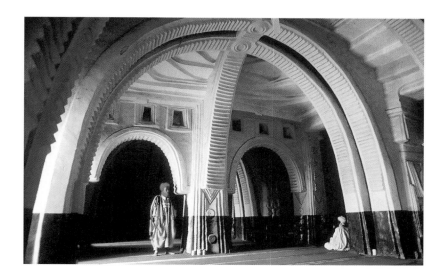

(fig. 3-27). The arches and piers are ornamented with ridges and other austere geometric designs. A Hausa *malam* has compared the white ribs of this mosque interior to the long white cloth wrapped around the head of a man who has made a pilgrimage to Mecca, and the photograph reveals their grace and beauty. Unfortunately, the Friday Mosque has since been partially dismantled, repainted, lit with fluorescent lights, and placed inside a larger cement structure, resulting in the loss of much of its original character.

The mosque is situated on one side of a plaza-like area called a *dendal*. Major streets leading from the gates of the city intersect at the *dendal*, which acts as both a parade ground and the focus of public ceremonies. On one of the other sides of the *dendal* is the palace ("house of the king," *gidan sarki*) of the *sarki* of Zaria. Like mosques, Hausa palaces and private residences are walled, and are entered through a *zaure*. Inside the palace walls, small buildings may be set aside as reception rooms, which are particularly ornate. One of the reception rooms of the *sarki* of the Hausa city of

Kano, built during the first half of the twentieth century, has a domed ceiling held in place by a network of arches (fig. 3-28). Patterns sculpted in relief are emphasized by contrasting areas of bright color. The paint may be given a light varnish containing bits of mica so that the entire surface sparkles. At the intersection of each ribbed arch is a shiny enamel plate, now much more common in Hausa ceilings than the brass plates placed there in the past.

The distinctive form of the Hausa ribbed dome seen here has intrigued art historians. Small pieces of wood laid side by side in regular patterns are plastered with clay on the underside to form a ceiling, and covered with water-proofed mud above to form a roof. The gentle curve of this mud-plastered surface is supported by arched ribs, which transfer the weight of the roof to walls or pillars. Each rib is made of lengths of palm wood embedded in mud, similar to the way ferroconcrete is made of steel embedded in cement.

This ribbed vaulting could be an imaginative adaptation of North African architecture; one of the oldest ribbed domes of the Mediterranean world is in the Great Mosque of Qairouan, a place of worship known to Hausa *malam* who travel to Tunisia for study and trade (see fig. 1-14). Yet the Great Mosque of Qairouan is built of stone blocks, not wood and clay, and its

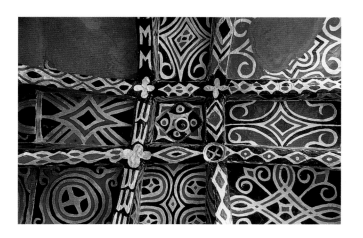

3-28. Ceiling of a reception room in the palace of the *sarki*, Kano, Nigeria. 20th century. Palm-rib vaulting, mud plaster, paint

domes are almost fully hemispherical rather than gently convex. It seems more likely that this distinctive technology comes from the architectural traditions of the Hausa themselves. Like the Kanuri, most Hausa commoners lived until very recently in houses woven from thatch. The techniques used to bundle wood and grasses into a framework for a dwelling of thatch are very similar to those used to construct the ribs of earth reinforced with wood.

Hausa adobe walls are also constructed using sophisticated techniques. Clay is mixed with organic material, dried, moistened, kneaded, then formed into irregular ovoid bricks. These are then laid in courses while still wet, and covered with a smooth layer of mud and waterproofing material. Patterns are then pressed into the damp surface.

The wall which usually receives the most aesthetic attention is the facade of the *zaure*. Within the *zaure* of a household, guests are received, art objects and other trade goods are produced, and lessons from the Qur'an are recited. During the early twentieth century, curved shapes in high relief surrounded the doorways of *zaure*. Horned projections on the roof above were similar to those found on the gateways of southern Moroccan towns (see figs. 1-21, 1-24), possibly because both Berber and Hausa peoples seek to fortify doorways with references to spiritual powers imbedded in these shapes.

By mid-century, *zaure* reliefs had become both more calligraphic and more representational. Abstract designs were often invocations or adaptations of Arabic letters or words. As in the Mauritanian city of Walata (see chapter 1), the use of sacred script

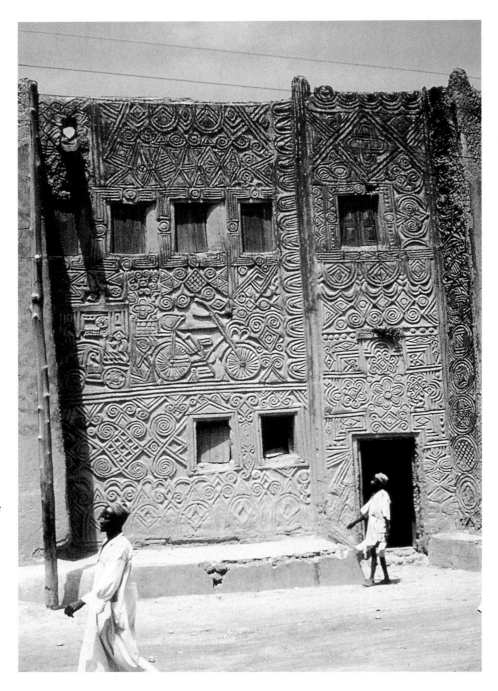

on portals evidently blesses and protects the owners as well as proclaiming their status and wealth. Other reliefs featured motifs evoking power and modernity such as swords, cars, rifles, or bicycles (fig. 3-29). More recently, the reliefs have been highlighted with bright pigments, and are dazzling

3-29. Facade of a *zaure*, Zaria, Nigeria. Hausa. Adobe. Photograph 1950s

announcements of the social role of the family that lives within the compound.

Art, Literacy, and Mystic Faith

Learned men in many Islamic African cultures are known as *malam*, a title akin to "master" or "teacher." In addition to designing buildings, *malam* use their knowledge of geometry, calligraphy, and numerology to produce visually and spiritually effective works of art. Most rely on income from embroidering clothing, hats, purses, and from making charms and other protective devices to supplement the alms they receive from students and benefactors.

A "great robe," *babba riga*, is usually embroidered by a *malam* with cotton or with *tsamiya*, the thread of wild silkworms. A particularly popular motif sewn onto the panel on the left side of such a garment is called "eight knives" because of the three long triangular forms at one side of the opening for the head of the wearer and the five long triangles in a row at the base of the opening. Such motifs were evidently protective devices, possibly similar to the horned and pointed motifs on Islamic arts from the Maghreb (see chapter 1).

These Hausa robes were both exported for sale to non-Muslims, and copied by neighboring peoples. The garment shown in figure 3-30, described as an *aobada*, was collected among the Yoruba people in the late 19th century. Unlike the Kanuri garment, where designs cover the surface, ornamentation here centers around the opening for the head (just as architectural ornamentation is richest on the facade of the *zaure*, where the household opens onto the street). On the right shoulder is a segmented square within a circle. Squares correspond to the four corners of the world and other Qur'anic images of God's creation and power. The divisions of this square, and its placement within a circle, are probably also references to "magic squares," which the Fulani call *hatumere*.

Drawn in ink by a *malam* on paper or cloth, magic squares are divided into compartments filled with letters or numbers. Since Arabic letters may be assigned a numerical value, letters may correspond to powerful holy numbers or sums of numbers, while a sequence of numbers may spell the name of God. Based in part upon ancient Jewish mysticism, this sacred numerology has been practiced for centuries throughout the Islamic world. Though it is rare to find a Hausa *malam* able to construct a true magic square, in which numbers actually correspond to letters and can be added or subtracted to produce holy numerals, most Islamic scribes in the central Sudan can construct convincing facsimiles, drawings of grids containing bits of script or simple geometric shapes. These are still viewed as effective, for the protective value of a magic square does not depend on the ability of its owner or even its maker to understand or interpret it. Magic squares are often enclosed within leather, cloth, or metal to form an amulet, a protective object whose power derives from the mystical wisdom hidden within. The square within the circle on the Hausa robe is thus the equivalent of an amulet, which alludes to sacred power but does not display it overtly.

Muslims believe that the Qur'an contains the words of God as recited by his prophet Muhammad. The text itself is thus held to be imbued with

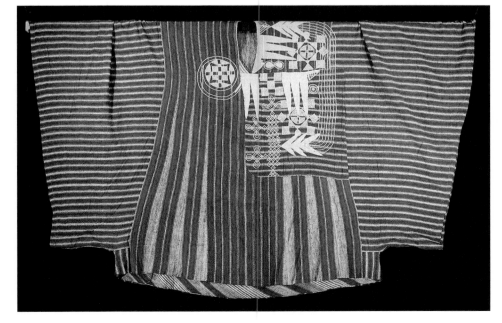

3-30 ROBE EMBROIDERED WITH "EIGHT KNIVES" MOTIF. HAUSA OR YORUBA. LATE 19TH CENTURY. COTTON AND *TSAMIYA* (WILD SILK), LENGTH 4'2" (1.26 M). MUSEUM FOR TEXTILES, TORONTO

God's power. Hausa respect for the sacred written word may be seen in their treatment of writing boards, *allo*. An *allo* is a flat piece of wood with a short handle. Students use it to practice writing verses from the Qur'an, washing the ink from the board after each verse is memorized. As in many parts of Islamic Africa, upon completion of his studies a student writes a passage from the Qur'an onto his writing board in permanent colors rather

3-31. *ALLO ZAYYANA* (WRITING BOARD WITH PERMANENT DECORATION). SALIH MUHAMMAD SANI NOHU. 20TH CENTURY. WOOD, PIGMENT, LEATHER; HEIGHT 23½" (60 CM). COLLECTION OF SALAH HASSAN

than washable ink. The permanently adorned writing board, *allo zayyana* in Hausa, serves as a sort of diploma and testifies to the owner's ability to recite the entire Qur'an. The *allo zayyana* illustrated here was painted by Salih Muhammad Sani Nohu, a *malam* of the Hausa city of Kano (fig. 3-31). The crescent-shaped handle is covered with fringed red leather.

The decoration at the base is a *zayyana*, a decorative panel that may ornament a writing board or divide sections of a manuscript. The *zayyana* is also an allusion to magic squares, for its geometric design contains both square and circular shapes. The *zayyana* thus refers to the graduate's mystic knowledge of amulets, prayers, and medicinal charms, while the passage from the Qur'an refers to his familiarity with the principles of the Islamic faith.

THE FULANI

As the Kanuri were forging the empire of Kanem on the Lake Chad floodplain at the end of the first millennium AD, another group of semi-nomadic pastoralists began to travel eastward from the arid savannah south of the Senegal River. These peoples are called the Fulani (after Fulbe, the West Atlantic language they speak) or the Peul (after *pullo*, their term for a Fulani man). However, they prefer to refer to themselves by the name of their lineage and their occupational group. A lineage is ranked by the Fulani according to whether its members herd cattle, weave cloth, compose songs, make objects of wood, leather, silver, or iron, or act as servants to other groups. The cattle herders, Wodaabe, consider their occupation superior to all others.

The original homeland of the Fulani may not be in Senegal. A Fulani scholar has claimed that some of the ancient Pastoralist art of the Sahara depicts scenes from the creation and migration legends of Fulani pastoralists (see fig. 1-6). In any case, by the end of the first millennium AD the Fulani had entered the lands of the Mande speakers north of the Niger River and found pasturage in the floodplains of the Inland Niger Delta. During the next few centuries they moved south to what is now Burkina Faso and began their westward migration toward the kingdom of Bornu. Isolated groups also brought herds of cattle southward along the Niger River to the highlands near its headwaters. This southern region, in the present-day nation of Guinea, is known as the Futa Djallon. Today there are Fulani groups from the Atlantic Ocean to the Nile River, and from the edges of the Sahara to the edges of the coastal rainforests, an area larger than the continental United States. Despite common features shared by all Fulani pastoralists, important regional variations in Fulani arts reflect separate histories.

The Futa Djallon

The Fulani who entered the Futa Djallon region gradually abandoned pastoralism and replaced their portable tents with permanent homes. At some point these "settled" Fulani adopted Islam. By the late eighteenth century they were the dominant ethnic group in the region, and during the nineteenth century they launched a military religious campaign against their non-Muslim neighbors.

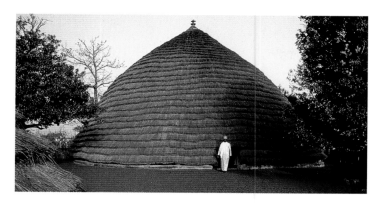

3-32. Great Mosque, Futa Djallon region, Guinea. Fulani builders working for El-Hadj Umar. c. 1883. Mud, thatch, wood

As visible symbols of their sacred and secular authority, the Fulani erected numerous mosques in the Futa Djallon. A mosque built during the late nineteenth century shows the scale of these impressive structures (fig. 3-32). The prayerhall is square, with mud walls, but it is completely covered by an enormous thatch roof, which rises from the ground to a height of some thirty feet, pierced only by tiny doors. The faithful must crouch or kneel to enter the mosque, thus preparing themselves for the humble act of prayer. The plan of the mosque recalls the square-within-a-circle motif on the Hausa gown above (see fig. 3-30), and signals the importance of magic squares in architecture as well as in two-dimensional arts.

During the first part of the twentieth century, Fulani women could be easily distinguished from women of other groups in the Futa Djallon by their distinctive hairstyles. A photograph taken during the 1950s shows the elegance of sculptural forms created from hair, silver, and other materials (fig. 3-33). The crests arched over the head of this young woman are constructed as if they were tent supports, and must have been particularly lovely in motion. The dramatic appearance of Fulani women was both a vivid reminder of the leisure and wealth of this elite group (who obviously did not have to carry loads on their heads like their hardworking neighbors), and a demonstration of their refined tastes.

The Inland Niger Delta

The cultivation of physical beauty is a characteristic of Fulani culture and wealthy pastoralists present themselves in gorgeous attire (fig. 3-34, see

3-33. Fulani woman, Futa Djallon region, Guinea. 1950s

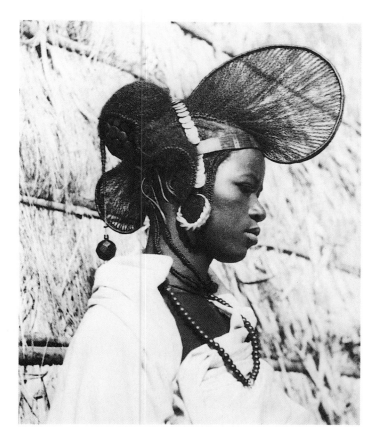

3-34. Fulani woman in a market, Mopti, Mali. 1970s

also page 45). This young Fulani woman was photographed as she sold milk in the town of Mopti in the Inland Niger Delta region of Mali. Her normal business attire featured huge flared earrings beaten from solid gold and etched with discreet symbols, which were both items of display and a family investment. The gold or gold-plated pendant on her chest was made by a Senegalese jeweler in the style of the Wolof or Toucouleur people, and her machine-embroidered robe is Hausa in inspiration if not manufacture. The small circular ornaments are made of gold wire (or finely twisted straw, which looks like gold) and were purchased in Mali, while the massive

amber (or imitation amber) beads in her hair may have been imported from the Red Sea. Each visual element has been gathered from complex international and inter-ethnic trade networks.

In a tent owned by another woman from a very prosperous family in the Inland Niger Delta, the marriage bed is shielded from view by a magnificent wool hanging known as an *arkilla* (fig. 3-35). Far wider than an ordinary blanket, it has four or five times the number of panels used in an average textile. The color red predominates, and each panel is richly ornamented with geometric motifs. Such large *arkilla* are rare today, for they are extremely costly to

3-35. FULANI TENT INTERIOR WITH *ARKILLA* (WEDDING BLANKET), BELONGING TO MRS CEYDO BA-KUYATE, N'GOUMA, MALI. PHOTOGRAPH 1982

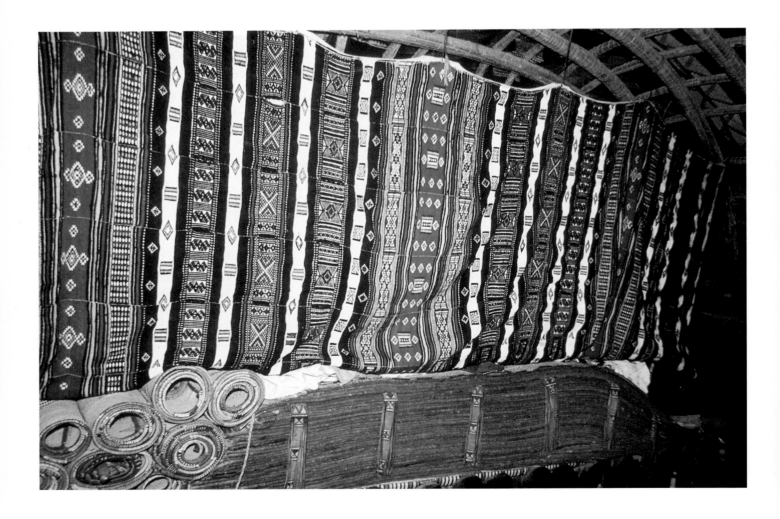

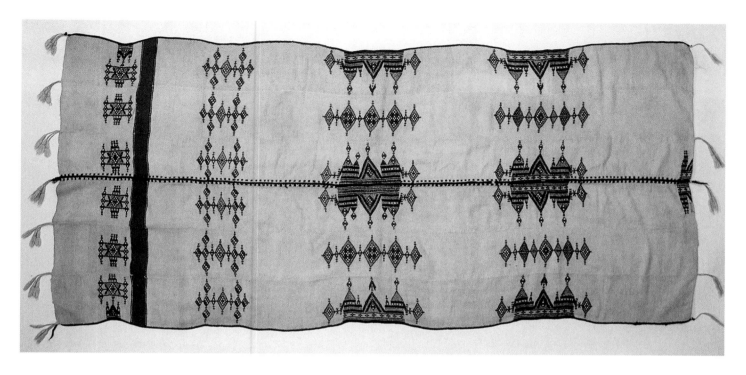

3-36. *KHASA* (BLANKET). FULANI. BEFORE 1928. WOOL. SMITHSONIAN INSTITUTION, WASHINGTON, D.C.

commission. Owned by Fulani women of the cattle-herding group (Wodaabe), *arkilla* are woven by men of a different Fulani occupational group, the weavers, Maabuube. Fulani weavers often live in settled communities where they may also cater to non-Fulani clients. In some regions, Fulani pastoralists also purchase large blankets from non-Fulani weavers such as the Djerma of Burkina Faso, who are able to work in a Fulani style.

A particularly fine example of a wool blanket, *khasa*, was purchased in 1928 in the Hausa city of Kano, in Nigeria, but may have been woven in northern Burkina Faso (fig. 3-36). Modern weavers have identified the designs as scenes from Fulani pastoral life and ancient myths. The six motifs

at the right are called either "water container" or "mother of the *khasa.*" Appearing at the lowest portion of each strip, they are the first design to be woven. The blood-red stripe above them is described as a woman's mouth, and the stacked lozenges that follow are said to be fruit tree-like forms linked to the forked sticks used by the Fulani to support calabashes full of milk. All of these motifs are related in some way to women and fertility.

References to the land crossed by two brothers in Fulani mythology appear in the large central designs, but some of these repeated lozenge and triangle shapes may refer to another story about a leper. The name of one of these motifs, which occur in sets of five, is "hand of the leper." These are surely Fulani variations on the Berber five-fingered hand, *khamsa*, used to ward off the evil eye (see chapter 1), and they may similarly serve as protective devices.

Southern Niger

The *khasa* illustrated above was brought to Kano along trade routes linking the Inland Niger Delta to the Fulani and Hausa emirates of northern Nigeria. Although an urban, settled Fulani elite now lives in this region, the lands to the north are still home to Wodaabe. These Fulani share some of the grasslands of Niger with the Tuareg (see chapter 1) and purchase silver jewelry and multicolored leatherwork from Tuareg blacksmiths. Cloth, brass, and decorated gourds are made for the Wodaabe by Hausa artists. In this dry region Fulani women do not build large mat-covered tents, but sleep in simple shelters of grass or woven materials. The shelter is placed within an area encircled by a brush enclosure and segmented by a rope to tether calves. Apart from the marriage bed, the only important furnishing of the woman's half of the enclosure is a type of table or rack

where calabashes, mats, and other belongings may be stacked.

During annual lineage meetings, *worso*, married women bring their racks to a public area to display their calabashes formally (fig. 3-37). To amass such an impressive collection, a woman must sell many gallons of milk and spend many hours adorning or arranging the gourds. The centerpiece of this array consists of one or two elaborately wrapped packages of cal- abashes, cloth, and mirrors. The larger bundle, *kakol*, is given by a woman to her daughter when the young woman leaves her mother's home with her newly weaned firstborn child to estab- lish a household with her husband. The smaller package, *ehel*, is a gift to the bride from her husband's mother. These presents acknowledge a woman's right to fill gourd containers with the milk of her husband's cows, and they are carried on poles so that they can be seen as the household travels or sets up camp.

3-37. FULANI (WODAABE) CALABASH DISPLAYS, SOUTHERN NIGER. 1980S

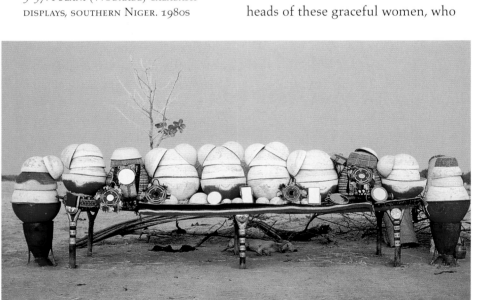

3-38. FULANI (WODAABE) WOMEN AT A *GEREWOL*, SOUTHERN NIGER. 1980S

3-37. FULANI (WODAABE) CALABASH DISPLAYS, SOUTHERN NIGER. 1980S

Calabashes are grown and pre- pared by farmers, and both Hausa men and Fulani women carve, burn, or press designs into their outer surface. In addition to valuing collections of cal- abashes as personal treasuries, pastoral Fulani women use calabashes for per- sonal adornment. Calabashes filled with milk are carried to market on the heads of these graceful women, who believe that well-arranged images on calabashes both attract clients and accentuate their own slender beauty.

Though less prosperous than their counterparts of the Inland Niger Delta, pastoralist Fulani women of central Niger also create personal mobile art forms, covering themselves with multicolored wire, embroidered cloth, beads, and brass (fig. 3-38). Numerous small areas of color com- plement the women's feathery facial tattoos. The two unmarried girls shown here are participating in a *gerewol*, a Fulani festival celebrating masculine beauty and charm. *Gerewol* is similar to other Fulani festivals that test the restraint and endurance of young men in that the dancers are not allowed to show signs of fatigue or discomfort. Women act as judges, selecting a champion from among the dancers. Unmarried women are also free to bestow their sexual favors upon a particularly attractive dancer, even though their averted gaze

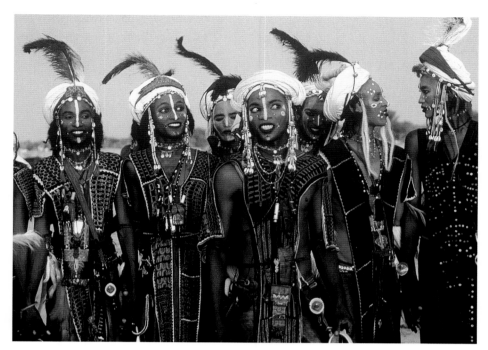

3-39. Fulani (Wodaabe) men at a *gerewol*, southern Niger. 1980s

reflects the reserve women are expected to exhibit in public.

Fulani men are encouraged to flaunt their best features at a *gerewol* (fig. 3-39). Dancers celebrate their beauty even as they proclaim their virility and strength. Clear eyes, white teeth, and well-formed noses are valued traits, and are thus accentuated by bright paint, big smiles, and wide-eyed glances. Friends and relatives assist each other in assembling ostrich feathers, weapons, hats, jewelry, and talismans for the hours of dancing and singing. Embroidered panels are contributed by sisters and girlfriends.

The *gerewol* reflects Fulani delight in male and female beauty and the culture's acknowledgment of sexual desire. This sensuality is directly linked to their desire for healthy and beautiful children, however, and is not solely oriented toward personal pleasure.

Northeastern Nigeria and the Adamawa

A generation after Usman dan Fodio founded the state of Sokoto, a Fulani warrior named Mobodo Adama brought Islamic armies to the lands north of the Benue River. The Adamawa Plateau of Nigeria and Cameroon, named for this leader, is still dominated by Islamic emirates. Settled Fulani live in the capitals of these Islamic states, and pastoralist Fulani drive their herds through the Adamawa and the upper Benue region. Both groups are known for their ornamented calabashes.

3-40. Motifs from a pyro-engraved calabash. Drawing after T. J. H. Chappel

A drawing based upon a calabash collected in the valley of the upper Benue River records the delicate lines burned onto the gourd's surface by a young Fulani woman (fig. 3-40). She described the central motif as a tortoise and the square designs as writing boards (the Hausa *allo*). Other motifs were named for the fine, feathery facial tattoos worn by Fulani women.

The artistically embellished calabashes in Fulani culture remind us of the importance of calabashes to peoples of the Gongola Valley discussed earlier in this chapter. Just as Fulani calabash displays at a *worso* proclaim a woman's status as mother, wife, and provider, the wedding basket of decorated gourds made by Ga'anda artists is linked to female identity (see fig. 3-11). Such parallels demonstrate how common artistic practices are shared by neighboring yet unrelated peoples in the central Sudan. The different styles and varied cultural references of their motifs also reflect the diversity of art in this region of Africa, whose history has yet to be fully studied.

4

MANDE
WORLDS AND
THE UPPER
NIGER

SWEEPING NORTHWARD AND inland from the eastern hills of Guinea, the Niger River floods the marshy Inland Niger Delta in central Mali before turning to flow southward through Niger. Along this curved stretch of the river, known as the Niger Bend, inhabitants of the savannah encounter peoples of the desert, and traders from the coasts of northern Africa meet merchants from the southern forests.

Urban life developed in the Inland Niger Delta as early as the first century BC, eventually giving rise to the multi-ethnic empires of Wagadu (Ghana), Mali (Manden), Takrur, and Songhai, which flourished variously between the ninth and late sixteenth centuries AD. The peoples who live in this region today stress their historical relationship to these empires. The Soninke often identify with Wagadu; groups such as the Malinke ("people of Mali") and the Mandingo or Maninka ("people of Manden") are named for their links to the empire of Mali, as are the closely related Mande languages themselves. Some Mande-speaking groups are identified by their homeland, others by their occupation or their relation to Islam. The farmers of southwestern Mali who long resisted Islam are thus known as "pagans," *bambara*, and call themselves Bamana. The Bamana are famous for their metalwork, their mud-dyed cloth, their masquerades, and their sculpture.

The influence of Mande-speaking cultures has extended far beyond the banks of the Niger. The Jula (Dyula), traders who speak a Mande language, established mercantile networks which still link the western Sudan to the Atlantic coastline. Over the centuries, the Jula converted to Islam, and some

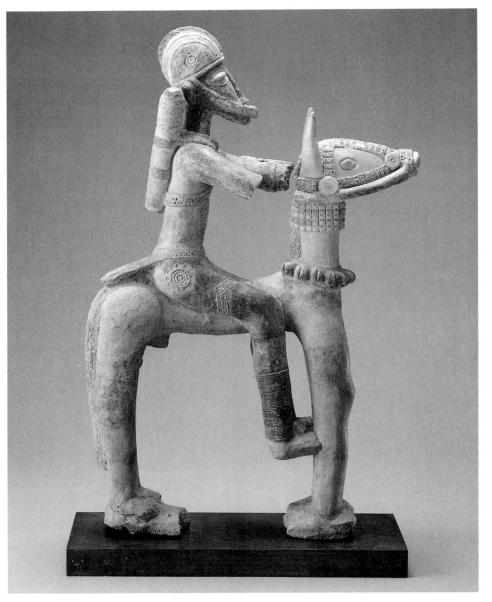

4-1. EQUESTRIAN FIGURE. ANCIENT MALI. 13TH–15TH CENTURY (?). TERRACOTTA, HEIGHT 27¾" (70.5 CM). NATIONAL MUSEUM OF AFRICAN ART, SMITHSONIAN INSTITUTION, WASHINGTON, D.C.

Jula groups formed independent Islamic states in Côte d'Ivoire and Ghana. Jula textiles, manuscripts, and amulets are still traded over vast distances. Peoples speaking Mande-related languages have also spread outward from the upper reaches of the Niger River to settle in Guinea, Mali, Senegal, Gambia, Guinea Bissau, and Côte d'Ivoire; their arts are discussed in chapter 6.

In Mande-speaking communities today, leaders take an active role in educating children and guiding youth. Art objects assist elders in their search for esoteric knowledge and encourage both young and old to pursue wisdom and justice, the foundations of the Mande worldview. As in the past, arts viewed as imbued with timeless power coexist with secular arts of entertainment, and artists create new art forms to address a changing society. Yet the diverse arts found along this section of the Niger River still instruct the viewer, imparting moral values and enforcing ethical behavior.

IN THE SPHERE OF ANCIENT EMPIRES

The floodplains of the Niger and Senegal rivers and their tributaries are dotted with raised mounds known as *toge* (sing. *togere*) to the Fulani herdsmen who live among them. Formed over the centuries by layers of sediment, *toge* are the remains of ancient towns. The oldest were occupied over two thousand years ago. While most have been abandoned over the last five hundred years, some are still inhabited, or are connected with modern communities.

Wagadu

One of the first mounds to be excavated was Kumbi Saleh, a large site located just north of the present-day border separating Mali and Mauritania. The site has been identified as Qunbi, the capital of the early state known as Ghana to Arab historians and called Wagadu by the Soninke, the Mande-speaking people who are descended from its inhabitants. Arabic documents chronicle the foundation of Qunbi by a hero who lived many generations before the birth of the Prophet Muhammad, and suggest that Wagadu flourished from the ninth through the eleventh centuries AD. Excavations of Qunbi/Kumbi Saleh support these dates, documenting occupation levels ranging from the sixth through the fifteenth centuries.

According to reports gathered by al Bakri, an eleventh-century Muslim scholar, Qunbi consisted of two towns. One, inhabited by Muslims, sheltered a dozen mosques. The other was the town of the king and his subjects. Surrounding the royal town were priests' dwellings and sacred groves housing prisons, royal graves, and what Muslim visitors described as "idols." The palace has not yet been located, and excavations thus far may have only probed the Islamic portion of the town.

The most important building yet unearthed is a mosque (fig. 4-2). The earliest level of the mosque at Kumbi Saleh dates to the tenth century AD, only four centuries after the *hijra*. It was thus one of the earliest mosques constructed south of the Sahara. Later versions of the mosque, constructed prior to the fourteenth century, seem to have been influenced by the Great Mosque at Qairouan in Tunisia (see

4-2. *QIBLA* WALL AND TWO AISLES OF A STONE MOSQUE, KUMBI SALEH, MAURITANIA. SONINKE BUILDERS. ANCIENT GHANA (WAGADU), 10TH–15TH CENTURY

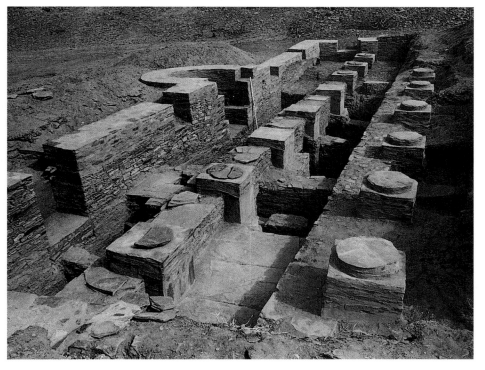

4-3. Female figure from Kumbi Saleh. 6th–7th century ad. Terracotta, height 4¼" (10.5 cm). Musée National, Nouakchott

refuse beneath the eleventh- and twelfth-century levels of a dwelling. One of these objects, a fragment of a small female figure in terracotta, has a slim waist with a large protruding navel and strikingly pronounced buttocks (fig. 4-3). The excavators believe that it may have been made as early as the sixth or seventh century AD, before the arrival of Islam.

Dwellings of Muslim merchants dating from the eleventh to the fifteenth centuries have also been found at Kumbi Saleh. Like the mosque, they were built of layers of flat stone fragments, sometimes ornamented with triangular niches. Their rectangular plans and the techniques used to stack the locally quarried, irregular stones

recall the architecture of Saharan cities such as Chinguetti, in Mauritania (see fig. 1-25). The similarities suggest that buildings throughout a vast area of the western Sahel were constructed by Soninke peoples, even when (as is the case with the Soninke-speaking Harratin of Mauritania) they were working for Arabic or Berber patrons.

Many *toge* in the Inland Niger Delta may well have served as burial mounds rather than habitation sites. One such mound near the town of Tondidaru, between the ancient cities of Jenne and Timbuktu, has been excavated and dated to the seventh century AD. Near this site are several clusters of monoliths. During the

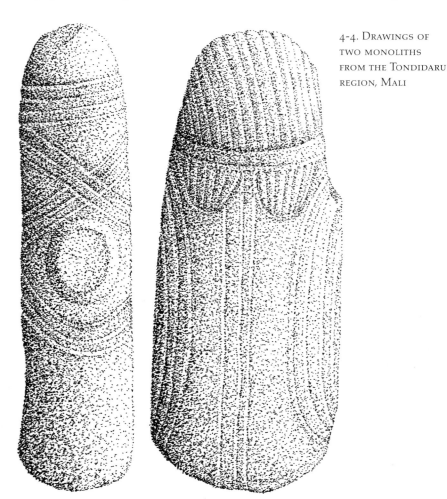

4-4. Drawings of two monoliths from the Tondidaru region, Mali

fig. 1-14), for in the prayerhall were rows of cylindrical columns, and the *qibla* wall was ornamented with painted stone plaques. Yet unlike Qairouan, where Roman and Byzantine ruins supplied builders with monolithic columns and capitals, Kumbi Saleh is located in a region where stone is found only in thin slabs. Builders created columns by stacking stone disks.

A pre- or non-Islamic presence in Kumbi Saleh was revealed by a few ceramic objects found in a layer of

1930s the largest cluster was set upright, and several of its stones were shipped to a museum (fig. 4-4). Even though this grouping is now disrupted and incomplete, an undisturbed group of monoliths has allowed archaeologists to determine that the stones are contemporary with the nearby funerary mounds. The monoliths were thus erected by a people who may have been in contact with Wagadu, which was being established less than two hundred miles to the west.

The monoliths may have served as sanctuaries, stone equivalents of the sacred groves used by many cultures in the region to shelter boys during their initiation into adulthood. This impression is strengthened by some of the linear designs carved into the stones, which make their phallic nature clear. Ranging from 80 to 160 centimeters in height, the stones are about as tall as initiation-age boys. One of the stones has a circular boss possibly representing a navel or face (see fig. 4-4, left).

Mali and the Inland Niger Delta

South of Wagadu, in the hills along the Upper Niger, the kingdom of Mali (or Manden) arose during the twelfth century AD. According to the epic songs of Mande bards, Mali was organized as an empire by Sundjata of the Keita clan of the Malinke people. The son of Sundjata, who succeeded him as king (*mansa*), was a Muslim. During the fourteenth century, a king of Mali named Musa became famous in the Islamic world for the wealth and generosity he displayed during his pilgrimage to Mecca. Musa was instrumental in establishing the cities of Timbuktu, Walata, and Gao as centers of Islamic learning, and he controlled the oases of the Saharan trade routes.

Excavations at Niani, believed to be the ancient capital of Mali, have thus far yielded few objects of any esthetic interest; the most fascinating archaeological finds come from other sites connected to this wealthy kingdom. One of the most important is near the present-day city of Jenne, a site usually referred to as Jenne-Jeno, or Old Jenne. Jenne-Jeno was inhabited by the beginning of the Christian era. During the height of the Mali empire, its population was apparently related to though culturally distinct from the Malinke.

Interest in ceramic figures from Jenne-Jeno has encouraged smugglers, and since the 1980s hundreds of terracottas have been illegally unearthed in Mali and sold to foreign art dealers. Although thermoluminescence testing cannot accurately date individual figures without accompanying data from the sites where they were deposited, test results are able to show that the ceramics as a group were probably produced from the thirteenth to the sixteenth centuries.

The majesty and composure of the terracotta equestrian figure illustrated here amply demonstrate the appeal of the Jenne style (fig. 4-1). The artist has arranged the tubular limbs and torsos of both man and horse so that positive forms outline negative spaces of great formal beauty. The distinctive eyes, ovoid head, and naturalistic proportions are typical of works in the Jenne style. Details, especially on the face, seem to have been scratched or carved into the surface rather than modeled, a technique also used in the much older Nok terracottas (see fig. 3-1). It is interesting to compare this sculpture with the figures of mounted warriors produced in the Bura region of Niger at least three centuries earlier (see fig. 3-3). The Bura figures were found in a funerary context. This figure, however, was excavated illicitly, and thus we cannot know how it was originally used.

Terracotta figures in other styles have also been taken from mounds in other areas of the Inland Niger Delta. Apparently they date from approximately the same time period as the Jenne-style works. A figure seized by Malian authorities at a clandestine dig near Buguni, in southernmost Mali, was seated in a cross-legged position with its hands on its knees, a pose similar to positions now used in the region for prayer or supplication. Ornaments (or snakes?) were coiled around the neck and arms. The elongation of the arms and torso distinguished it from figures in the Jenne style, as did the softer contours and the spherical (rather than ovoid) shape of the head.

Other ceramic figures dating from the thirteenth to sixteenth centuries are said to have been found in or atop memorial mounds at Bankoni, near the Malian capital of Bamako. These stone-covered earthen domes were evidently raised to honor an ancestor or group of ancestors. The five figures illustrated here share the style and possibly the function of documented terracottas from Bankoni (fig. 4-5). The proportions of the figures resemble those of works from the Buguni region, but their distinctive heads are more crisply defined. The long noses are unique to the Bankoni style, as is the notched rim encircling each male face.

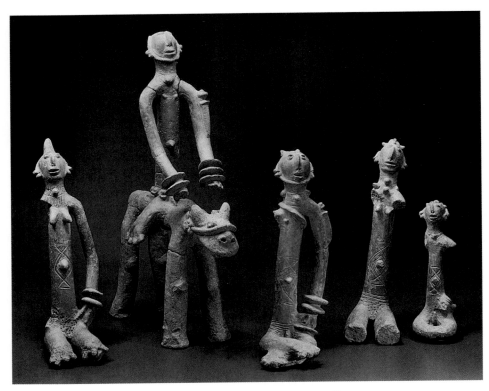

4-5. FIVE FIGURES. BANKONI, ANCIENT MALI. 13TH–15TH CENTURY. TERRACOTTA, HEIGHT OF EQUESTRIAN FIGURE 27½″ (70 CM), OTHER FIGURES MAXIMUM HEIGHT 18″ (46 CM). THE ART INSTITUTE OF CHICAGO, ADA TURNBULL HERTLE ENDOWMENT

The Architectural Legacy of Jenne

Terracottas from the Inland Niger Delta were created during particularly turbulent centuries for the Mali empire. During the fifteenth and sixteenth centuries the empire of Songhai arose along the Niger Bend and conquered lands formerly controlled by Mali. During the sixteenth century, Mali's cities on the Niger were raided by soldiers from Morocco.

Stately houses in the Muslim city of Jenne were built during the sixteenth and seventeenth centuries for community leaders variously descended from Arab scholars, Berber soldiers and their Spanish slaves, Songhai lords, Jula traders, Sorko and Somono fishermen, and local Bamana farmers. Linked to Moroccan models but infused with Mande architectural traditions, these homes were the prototypes for the distinctive and dramatic houses found in Jenne today.

Contemporary Jenne dwellings constructed in this seventeenth-century style are similar in many ways to tigermatin, the fortified households of central Morocco (figs. 4-6, 4-7i, 4-7ii; compare fig. 1-22). Both are built of adobe bricks plastered over with a layer of mud, though Moroccan bricks are rectangular while bricks made by Jenne masons are oval, much like the ovoid bricks used by Hausa builders (see chapter 3). Like tigermatin, Jenne houses are multistoried, with an interior courtyard, a formal reception room on an upper story, and a flat roof used as an additional work-ing space. Multiple floors and multiple rooms distinguish homes at Jenne from most other dwellings found south of the Sahara, which usually have only a ground floor and an attic or roof area, and which are formed of separate, single-roomed buildings.

Facades of Jenne houses resemble those of tigermatin, and in some ways also mirror the gateways of ksar, walled Moroccan towns (see fig. 1-21). Protected by an overhang, doors in Jenne are set into an arch or a rectangular frame. Earthen benches along the base of the wall invite passersby to sit and rest even as they protect the foundation from water damage. A central window covered with an iron or wooden grill marks the location of the formal reception area, hu gandi, on the upper floor. Some older window grills in Jenne are almost identical to those of central Morocco. Along the top of the facade are five cones, possibly invoking the protective five fingers or related numerical symbols of Berber and Arab art.

The interior rooms are divided into areas for men near the front of the house and areas for women at the back. The entrance room, sifa, is a semi-public space similar in function to the Hausa zaure (see chapter 3). Other rooms on the ground floor are set aside for storerooms and kitchens. The upper-floor reception room, hu gandi or har terey hu, belongs to the male head of the household and overlooks the street, while private spaces for women overlook the interior courtyard. A screened toilet is located on the roof, over an earthen shaft that reaches to ground level. The shaft can eventually be broken open at the base and the decomposed waste removed for use as fertilizer.

Most architectural terms in Jenne are Songhai, for the guild of Sorko masons is Songhai-speaking. The names reveal an interest in identifying architectural elements with the family. The doorway is the "mouth of the house," *me*, and the "archway of the mouth," *gum hu*, surrounds it. The two central engaged columns are the "feminine pillars," *sarafar wey*, possibly in opposition to the obviously phallic projections of the framing columns at the corners, *sarafar har*. The five central cones are the "sons of the pillars," *sarafar idye*.

sarafar idye

toron

sarafar woy

gum hu

sarafar har

4-6. Facade of an adobe house, Jenne, Mali. Songhai builders for Mande patrons. After 16th century

4-7i. Facade of an adobe house in Jenne. Drawing after P. Maas and G. Mommersteeg

4-7ii. Plans of the ground floor (a), second floor (b), and rooftop terrace (c) of an adobe house in Jenne. Drawing after P. Maas and G. Mommersteeg

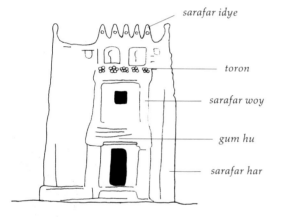

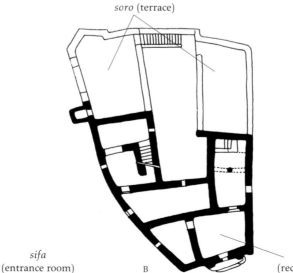

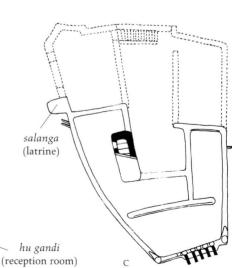

batuma (courtyard)

soro (terrace)

salanga
(latrine)

sifa
(entrance room)

hu gandi
(reception room)

A

B

C

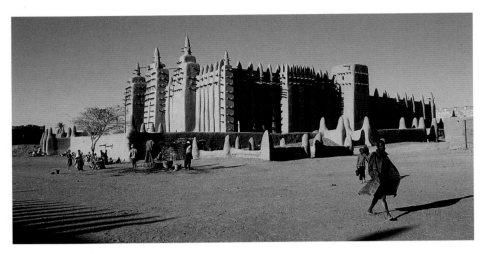

4-8. Great Mosque, Jenne, Mali. Founded 13th century, rebuilt 1907. Adobe

Mande influence is also strong in these Jenne homes, however. The term for the facade itself is *potige*, a local adaptation of Mande words used in greeting a respected person. The house can thus be seen as a self-presentation by its owner, evoking honor and status. The features of the *potige* seem related to the importance of doorways and facades as the intersection of public and private domains. They also reflect ancient religious practices in Mande-speaking communities, where sacrifices to the ancestors are often poured out on doorways. Projecting from the *potige* are five bundles of wood known as *toron* (sing. *toro*). While their functions may be both aesthetic (an accent repeating the five projections and four recesses above them) and practical (as supports for masons repairing the adobe), the word *toron* connects them to the Mande term for a sacred tree, and they may be conceptually linked to the forked branches placed next to altars by Mande-speaking peoples.

A more dramatic use of *toron* can be seen in the Great Mosque of Jenne, one of the most imposing adobe buildings in all of Africa (fig. 4-8). According to Arabic accounts, the first version of this mosque was constructed during the late thirteenth century (seventh century AH), when the king of Jenne converted to Islam. He erected the mosque on the site of his palace, so that the new building absorbed the religious and political power of the old social order.

Subsequent rebuildings of the mosque reflected the tastes of later Moroccan and Songhai overlords of Jenne. In 1909, French colonial authorities allowed the city, then under Fulani leadership, to reconstruct the mosque under the direction of Ismael Traore, head of the masons' guild. As was the case with earlier mosques, the varied ethnic patronage of the Great Mosque resulted in a building uniquely suited to this multicultural city.

The *qibla* wall forms a backdrop for the huge central marketplace which dominates the cultural and economic life of Jenne. The *mihrab* is located in the interior wall of its central tower. On the exterior, horizontal rows of *toron* balance the strong vertical lines of the square towers and engaged pillars, grouped in fives. Each pillar projects above the wall in a point, echoing the five "sons of the pillars" in the center of the *potige* of a Jenne house. The pinnacle of each square tower of the *qibla* wall is set with an ostrich egg. Eggs were similarly placed on the minaret of the mosque at Chinguetti (see fig. 1-25). In Jenne, both Mande and Muslim philosophers see these white, moon-like objects as linked to fertility and the cosmos.

The main entrances and windows to the prayerhall are set into the north wall (in shadow in the photograph here). The slightly lower wall beyond it encloses the open courtyard, a parallelogram whose size and shape mirrors that of the covered hall. Inside the

4-9. Interior of the Great Mosque at Jenne

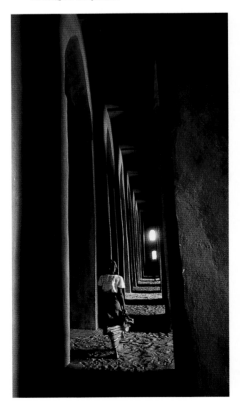

prayerhall, massive square adobe piers are joined by narrow pointed arches (fig. 4-9). Unadorned and unpainted, the interior is cool, dark, and austere.

Takrur and Jolof

In addition to founding Wagadu and Ghana, ancestors of Mande-speaking peoples had influential roles in the rise of other kingdoms and empires in the western Sudan. The Islamic empire of Takrur, Wagadu's western rival along the lower Senegal River, was firmly grounded in Fulani culture. However, an early dynasty may have been Mande-speaking. Thousands of burial mounds in western Senegal were built in or near the territory of Takrur, now the home of the unrelated Serer and Wolof peoples.

Some of these funerary mounds are covered or encircled with small stones. The best documented are those of Rao, whose cemeteries were in use during the eighth through fourteenth centuries. One contained the remains of a young person wearing 138 gold rings, a silver necklace, and a spectacular chest ornament of gold. The gold pectoral is usually dated to the thirteenth or fourteenth century. If this dating is correct, the burial can be associated with the Wolof state of Jolof, which succeeded the empire of Takrur. The pectoral's finely wrought surface with its hemispherical bosses resembles Wolof gold jewelry made during the last two centuries.

Links between past and present populations are difficult to make in southern Senegal and eastern Gambia, which were once part of the Mali empire. Some 817 tombs have been noted in this region, each encircled by polished volcanic monoliths (fig. 4-10).

While most monoliths are in the form of curved cubical or rectangular blocks, as here, some are partially bisected, giving them the appearance of two joined pieces. The grave circles were evidently erected over a very broad period of time from the beginning of the Christian era to the sixteenth century.

RECENT MANDE ARTS: NYAMAKALAW AND THEIR WORK

The tombs and cities of ancient empires have not yet provided us with documented examples of sculpture in metal or wood, and we have little information on the role of art and artists in past centuries. Today sculpture in iron or wood in Mande-speaking regions is created largely by male blacksmiths, who with female potters form an endogamous group of specialists known as *numuw* (masculine sing. *numu*; feminine sing.

numumuso). In part because of their ability to take minerals from the earth and transform them into useful or even dangerous objects, *numuw* are believed to be particularly adept at manipulating a type of esoteric force, a mysterious power known as *nyama*. Along with bards, leatherworkers, and

4-10. CIRCLE OF GRANITE MONOLITHS, WASSU, GAMBIA. 7TH–8TH CENTURY; PHOTOGRAPH 1970S

Monoliths mark or encircle graves in many African cultures. Stone slabs were placed before the tombs of the kings of Kemet before 3000 BC, and stones incised with images of cattle were placed on Nubian graves less than one thousand years later. Prior to the Christian era, monoliths were erected over graves in the Buar region of Central African Republic. Large upright stones marking graves have been documented across central Nigeria, while smaller gravestones are found in Burkina Faso, Sierra Leone, and Guinea.

other unusually talented groups of people, sculptors and other blacksmiths are categorized as *nyamakala*, sometimes translated as "handles of *nyama*." *Nyamakala* lineages are found in many Mande-speaking groups, especially the Malinke and Bamana.

Gwan and Jo

Blacksmiths are particularly proud of the staffs they forge from iron. These slender metal rods, created in secret and shaped with fire, are highly charged with *nyama*. They may serve as the insignia of leaders, or provide a spiritual charge for ancestral altars or graves. Staffs surmounted by figures are also placed near the sanctuaries of Bamana religious associations and are displayed during their initiations and funerals. These *bisa nege* ("rods of iron") or *kala nege* ("staffs of iron") receive libations of beer and other sacrificial drinks, and they warn visitors that potent forces are present.

In southern Bamana regions, organizations known as Gwan or Jo are dedicated to women who have had difficulty conceiving, delivering, and rearing healthy children. Each Gwan congregation assists women of the community who seek the support only sons and daughters can provide in Bamana society. The iron staff illustrated here, topped by an obviously male equestrian figure, was probably owned by one of these associations (fig. 4-11). The rider's erect pose and aggressive gestures allude to the heroism, occult power, and accomplishment of Gwan's leaders. His broad hands have been compared to the feet of a crocodile, a dangerous animal whose body parts are used by sorcerers as

4-11. STAFF WITH EQUESTRIAN FIGURE. BAMANA. 19TH–20TH CENTURY. IRON, HEIGHT 24²⁄₁₆" (61.2 CM). THE METROPOLITAN MUSEUM OF ART, NEW YORK. MICHAEL C. ROCKEFELLER MEMORIAL COLLECTION. BEQUEST OF NELSON A. ROCKEFELLER, 1979

well as by members of benevolent associations. Other staffs used by Gwan or Jo are topped by female equestrians, or by female figures in similarly assertive positions.

Blacksmiths also carve wooden statuary for Gwan and Jo. A regal seated female figure was probably the central image in a group of three or more statues once displayed during annual festivals (fig. 4-12). Known generically as *gwandusu*, the figure of a mother and child would have been given a personal name as well. It was accompanied by a male figure, *gwantigi*, and one or more female attendants. Through association, the compound name *gwandusu* links nouns such as soul, heart, character, passion, fire, courage (*dusu*) with adjectives such as hot, hard, and difficult (*gwan*). The *gwandusu* here wears an amulet-laden hunter's or sorcerer's cap, an item of clothing usually owned by powerful men. She is exceptional, a heroine and the mother or wife of a hero.

Gwandusu figures have been described as incarnations of Nyale or Musokoroni, deities who personify the female creative power which is believed to have appeared at the beginning of time. The statues' male consorts, *gwantigi*, have been identified as Ndomajiri, the personification of masculinity and the world's first blacksmith. Paired male and female statues may also be seen as heroic ancestors, founders of Jo or Gwan. Yet whatever specific names and relationships are given to individual sculptures, they all embody the association's goals. The tiny baby, so completely attached to the full abdomen of the *gwandusu* that it merges into its mother, is the deeply

4-12. *GWANDUSU* AND *GWANTIGI* (PAIR OF DISPLAY FIGURES). BAMANA. 13TH–15TH CENTURY. WOOD, HEIGHT OF LEFT FIGURE 4′8⅜″ (1.235 M), RIGHT FIGURE 2′11⅜″ (89.7 CM). THE METROPOLITAN MUSEUM OF ART, NEW YORK. THE MICHAEL ROCKEFELLER MEMORIAL COLLECTION AND GIFT OF THE KRONOS COLLECTIONS, RESPECTIVELY

The gwandusu (mother-and-child figure) of this pair probably came from the region where the Buguni and Bankoni terracottas (see fig. 4-5) have been unearthed, and it shares some of the stylistic qualities of the terracottas of ancient Mali. In fact, analysis has revealed that the wood from which it was carved is five or six centuries old. Since trees may have been standing for a hundred years or more before being used by carvers, the statue is likely to date from the sixteenth or seventeenth century AD. It thus bridges the time between the terracotta figures of the distant past and the wooden figures still being carved today.

desired result of the successful pregnancy that Gwan works to obtain for its members. The heavy breasts appear to be full of sustaining milk.

In some Jo associations, *numuw* youths are welcome to join all other young men of the community when an age-grade forms, usually about every seven years. The youths are taken to a sacred grove of trees, where they set up an initiation camp. There the leaders of Jo show the youths a variety of objects, perhaps including sculptural groups and iron staffs, which are symbols of important principles and sources of Jo's sacred authority. At the end of their initiation, young men celebrate their new maturity and knowledge by dancing for their community. They may then leave their hometown to visit neighboring and allied towns, and to meet future friends and potential wives. Each of these traveling groups of Jo initiates invents costumes, musical instruments, and theatrical skits to entertain their hosts. Young blacksmiths may also carry small wooden figures dressed in fine clothing and jewelry (fig. 4-13). Called "pretty little one of Jo," *jonyele*, these small statues remind both elders and eligible girls that the young men are seeking brides.

The polished and decorated surfaces of a *jonyele* do not detract from their strong, almost stark translation of the human form into geometric shapes and abruptly intersecting planes. Display sculpture for Jo and Gwan are today also carved in this style, which contrasts remarkably with the style of the older Bamana *gwandusu* and *gwantigi* figures discussed above. The *jonyele*'s circular hips, narrow cylindrical torso, and conical breasts echo the praises of an epic sung

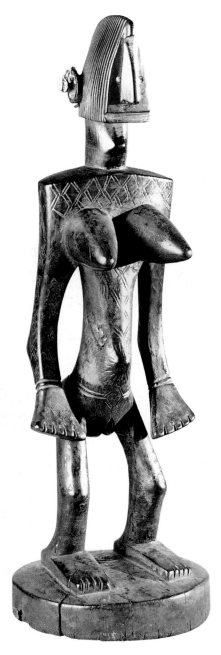

by renowned Malinke bard Seydou Camara:

> A well-formed girl is never disdained,
> Namu ...
> Her breasts completely fill her chest,
> Namu ...
> Her buttocks stood out firmly behind
> her ...
> Look at her slender, young bamboo-
> like waist ...

All of the *jonyele*'s features are clearly visible; when it was in use, the dramatically organized shapes could have been easily read as a female form, even in a crowd or at a distance.

Ntomo and Tyi Wara

In most Bamana communities, the roles played by Jo and Gwan are divided among other associations. Of the associations concerned with sacred power, *nyama*, the most widespread is Ntomo or Ndomo. Ntomo gathers pre-pubescent boys, separates them from their families, organizes them into age-grades, and conducts the training that culminates with their ritual circumcision.

As part of their training in Ntomo, boys wear masks alluding to principles of conduct they are being taught. Carved of wood, the masks may be covered with cowrie shells (a form of currency formerly used throughout the Sudan), blood-red seeds, or shining brass. A well-known example comes from Segu, in the western Bamana region (fig. 4-14). The oval face-mask is partitioned into

4-14. NTOMO MASK. BAMANA. WOOD, HEIGHT 25⁵⁄₁₆" (64.3 CM). MUSÉE DES ARTS D'AFRIQUE ET D'OCÉANIE, PARIS

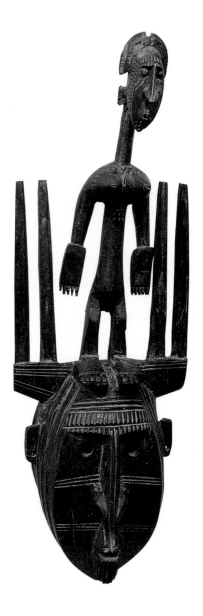

4-13. FIGURE, PERHAPS A *JONYELE* ("PRETTY LITTLE ONE OF JO"). BAMANA. WOOD, HEIGHT 24" (61 CM). THE NEW ORLEANS MUSEUM OF ART, BEQUEST OF VICTOR K. KIAM

Although the crested head of this female figure may refer to the rainbow-like arches of wood or fiber worn by new Jo initiates, we cannot be completely sure that it is a jonyele. It may instead be an image of a twin, a flanitokele. The Bamana consider twins to be living replicas of the first two human beings created, and a source of great blessing. When a twin dies in infancy, a wooden statue may be carved to represent the deceased child, and figures for deceased female twins are given the attributes of sexually mature young women. A female flanitokele *is thus indistinguishable from a* jonyele.

the curved plane of the forehead and nose and the flat surface below, which stretches from brow to chin. Above the face stands a female figure flanked by four vertical horns.

French researchers who studied Bamana religion during the middle of the twentieth century were fascinated by the complexity of the themes raised during Ntomo initiation. According to their reports, which may have been somewhat enhanced by the philosophical orientation of the researchers, boys in training re-enacted the creation of the world. The figures and the number of horns at the top of a Ntomo mask symbolized important principles; the four projections shown here referred to femininity, while three was a male number, and seven the number for the couple. The female figure was also described as a reference to sacred history, when the human race was separated into male and female beings, and a reminder to the boys of the training they had received concerning the opposite sex.

In many Mande-speaking communities, boys undergoing Ntomo or similar training live in temporary shelters. Along the Niger Bend, however, a newly formed boys' age-grade or youth association is housed in a more durable adobe dwelling known as a *saho*, built especially for them. The recessed geometric patterns of one such dormitory, evidently built for Somono initiates, may have been chosen for symbolic as well as aesthetic reasons (fig. 4-15). The members of the age-grade eventually marry and move to their own homes, and the *saho* is left to decay.

Prior to the middle of the twentieth century, the training conducted by Ntomo was completed when the age-

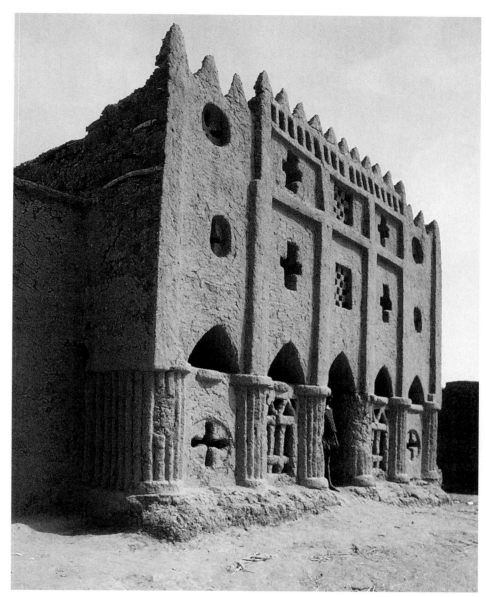

4-15. *SAHO* (YOUNG MEN'S HOUSE), MALI

grade entered Tyi Wara. Tyi Wara prepared them for their future roles as husbands and fathers by pairing them with younger girls who became their partners. It also focused upon the agricultural skills they needed to become successful farmers who could provide for their families and contribute to the community.

In Bamana belief, the primordial being Tyi Wara was the first farmer, a wild beast who taught mankind how to cultivate the fields. During annual ceremonies, two members of the age-grade were chosen to dance Tyi Wara and his female consort. A photograph from the early twentieth century shows a Tyi Wara masquerade in the

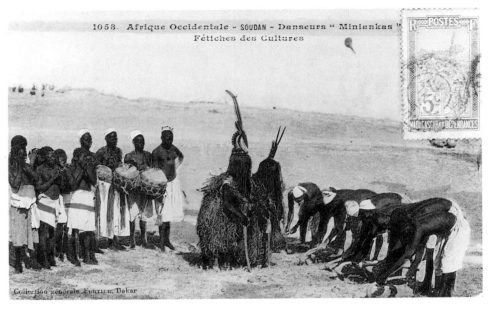

fields (fig. 4-16). Both masqueraders are bent over, for an excellent farmer hoes the ground continually, without straightening to take a rest. The costumes of darkened fiber, the cloth band tying the basketry caps to their heads, and the tall wooden headdresses attached to the caps are all clearly visible. Drummers provide the beat for the dance and for the youths of the age-grade as they till the soil. Their female partners exhort them to greater efforts and praise Tyi Wara.

The masqueraders shown here were probably from the Segu region of eastern Bamana lands, where the Tyi Wara headdress resembles the profile of a roan antelope. While stories about Tyi Wara link him with a serpent, and the word *wara* is often defined as "lion," the antelope is also an appropriate image, for it bends its neck just as the cultivators bend their backs, and its long horns are as straight and slender as growing millet stalks. The headdress of Tyi Wara's consort here depicts an antelope carrying a baby on its back, just as human mothers do. In other

4-16. TYI WARA MASQUERADERS, MALI. 1905–6

4-17. MAN HOLDING TWO HORIZONTAL-STYLE TYI WARA DANCE CRESTS, MALI. 1970

regions the two performers wear identical masks, and only the more dramatic, leaping dance of Tyi Wara distinguishes them.

Generically, such masks are known as crest masks or dance crests, for they sit on top of the dancer's head, itself usually hidden by a costume. North of the Niger River, Tyi Wara dance crests are carved in what observers have called the horizontal style, as opposed to the vertical style of Segu. As can be seen in a photograph of a man holding a pair of these sculptures, their horns sweep backwards rather than upwards (fig. 4-17). The snake-like horns clearly allude to stories about Tyi Wara, though the body and head are almost canine. Beads,

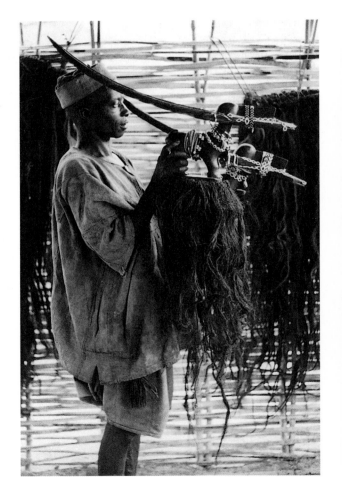

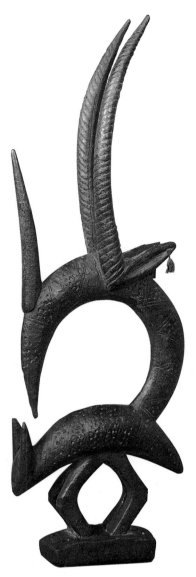

4-18. TYI WARA DANCE CREST. BAMANA. WOOD AND WICKER. MUSÉE DES ARTS D'AFRIQUE ET D'OCÉANIE, PARIS

leather, and metal attachments are added to embellish the masquerade; Bamana critics say that such ornamentation gives the dance crest *di*, "sweetness" or "tastiness."

Finally, an abstract style is used in the Buguni region where the southwestern Bamana live (fig. 4-18). It combines curved antelope horns, fragments of horns, anteater snouts (for rooting into the earth), and the canine animal of the horizontal style to create a multiple image. As in all Tyi Wara dance crests, a variety of textures marks each section of the sculpture, softening the austerity of the overall form.

There are large numbers of Tyi Wara dance crests in museums, and the vertical style of Segu has become one of the most recognizable and most reproduced of all African art forms. Yet these striking works are apparently rarely produced for Tyi Wara associations today. Now simply called "little antelope heads," *soguni kun*, they have instead been integrated into the performances of community age-grades and professional dance troupes, and have lost their religious power and their close identification with a primordial being.

Bogolanfini

Male circumcision corresponds in Mande thought to female excision, the surgical removal of the clitoris. Just as all boys who wish to become men must be willing to undergo seclusion, training, and circumcision, girls who wish to become women must undergo equivalent procedures conducted by a *numumusu* surgeon, usually a potter. In order to protect them from the *nyama* released during excision, the girls are wrapped in mud-dyed cloths called *bogolanfini* or simply *bogolan*. *Bogolan* are created by women, who paint mixtures of mud and vegetable materials onto locally woven cotton cloth in several different stages. The very complexity of the staining and washing processes may produce an object with the supernatural strength needed to guard the girls, just as the process of forging iron helps increase the *nyama* of a metal staff.

The geometric symbols that decorate the cloth illustrated here suggest that it is a *basiae*, one of the *bogolan* cloths used in Bamana excision (fig. 4-19). After a girl has worn a *basiae* during the ceremonies, she gives it to her sponsor, a female elder who is past menopause. When this old woman dies, she may be buried in the cloth in order to protect the mourners from the extraordinary amounts of *nyama* released at her death. These textiles therefore allow a community to acknowledge the power of women while deflecting its energy.

Mud-dyed cloth has always been an item of beauty as well as power; girls, female elders, and hunters appreciate the visual appeal of the art they wear as protection. Malian designers began to sew *bogolan* into fashionable clothing and accessories as early as the 1970s, and mud-dyed cloth can now be purchased in Europe and America as well as Africa. This international interest in *bogolan* inspired young male students at the Institut National des Arts in Bamako to study the technique with a woman renowned as a *bogolan* artist. In 1978 they founded a group named Bogolan Kasobane, which worked collectively on mud-dyed art works.

Ismail Diabate (born 1948), a graduate of the Institut National des Arts and a founder of Mali's Association Nationale des Artistes, has also explored the potential of this medium. His subtle and mysterious mud-dyed paintings reflect his experience with monotypes and mixed media (fig. 4-20). Transformed into more personal abstract shapes, the sacred signs of Bamana religious associations such as Komo and Kono, discussed below, are alluded to in his work.

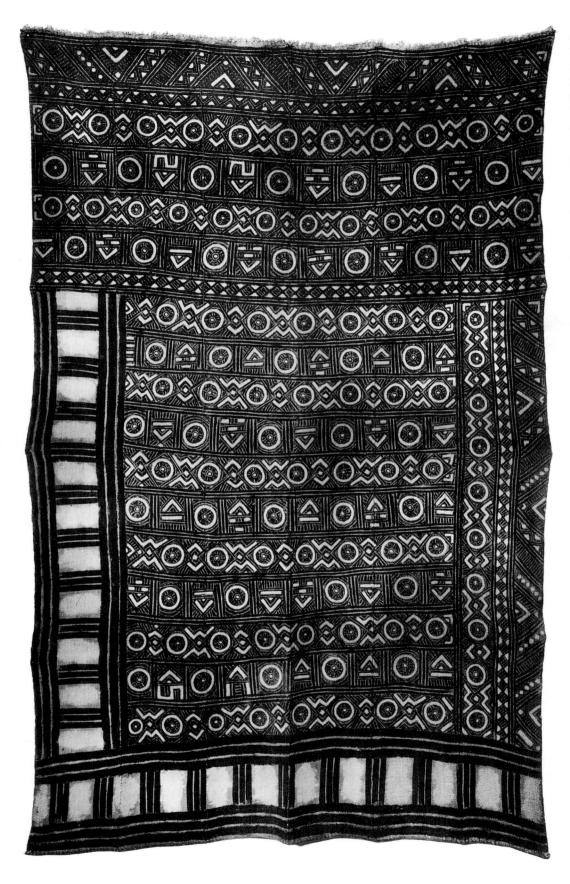

4-19. *BOGOLAN* (FEMALE INITIATION CLOTH). BAMANA. 20TH CENTURY. COTTON FABRIC, MUD DYE; 53½ X 32½" (136 X 83 CM). THE BRITISH MUSEUM, LONDON

While this bogolan *was probably used during a girl's initiation, other types of mud-dyed cloth are sewn into shirts for hunters, who need to be shielded from the* nyama *lurking in the wilderness and flowing from the blood of the animals they kill. The women who paint these geometric shapes on* bogolan *often give them individual names and meanings. Some signs may refer to the great Mande epics, to ideal behavior, or to the problems encountered by women.*

4-20. *Si Kolona* ("The Earth"). Ismail Diabate. 1992. Cotton fabric and mud dye. National Museum of Natural History, Smithsonian Institution, Washington, D.C.

4-21. *Komo kun* ("head of Komo"). Bamana. Wood, resin, feathers, quills, fibers, animal hair; length 27" (68.6 cm). Indiana University Art Museum, Bloomington

Komo and Kono

Great amounts of *nyama* are wielded by the blacksmiths who direct the social, political, religious, and judicial association known as Komo. Various accounts of its origin claim that Komo was spread through the Mali empire by a blacksmith who served Sundjata, or that a *musa*, king, purchased Komo

during his stay in Mecca. Despite these attempts to link it with the spread of Islam, Komo has often been persecuted by Islamic leaders. Its political roles brought it into conflict with colonial authorities as well. Yet in some areas this association has survived as a potent guarantee of public security, as a defense against witchcraft and anti-social behavior, and as an educational institution for men who seek to understand the secrets of the world around them.

Few photographs of Komo masquerades exist, for women and non-members are usually barred from Komo ceremonies. The dancers' costumes evidently consist of a series of rings into which feathers and other materials are set. The entire body is hidden. Upon the dancer's head is a headdress known as "head of Komo," *komo kun* (fig. 4-21). Sedu Traore, a Bamana *numu*, has said, "The *komo kun* is made to look like an animal. But it is not an animal; it is a secret." Indeed, although the domed central hemisphere, projecting jaws, and back-swept horns of a Komo headdress recall horizontal Tyi Wara crests, the *komo kun* is startlingly different from other Bamana art works. It is caked with a grayish dark substance, once wet and glistening, now dry and flaking. Horns of slain antelopes are lashed to the wooden substructure. Bundles of grasses and leaves, skulls, bones, and parts of animals may also be embedded in the thick surface.

Komo masters, *komotigiw*, cover a *komo kun* with mysterious materials to intimidate their audience and to refer to their secret knowledge of powerful substances. They further believe that the impression the headdress makes on the senses is but the

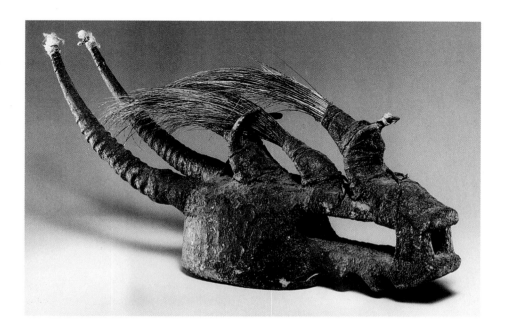

4-22. *BOLI* (ALTAR). BAMANA. BEFORE 1931. WOOD ENCRUSTED WITH SPIRITUALLY CHARGED MATERIALS, LENGTH 23½" (60 CM). MUSÉE DE L'HOMME, PARIS

outward manifestation of the *nyama* contained within it. By unleashing a properly prepared *komo kun*, a masquerader is empowered to perceive and destroy evil.

A *komo kun* can be described as a *boli* (plural *boliw*), an altar activated by mystical substances, but it is not necessarily the only potent object kept by the association. While *komo kun* go forth to perform before the men who have been introduced to their secrets, another *boli*, an amorphous three-dimensional object, stays in the association's small shrine. Like *komo kun*, these resident altars are also assembled from secret materials which may direct them toward a specific purpose.

The *boli* illustrated here seems to have been confiscated by colonial authorities from a shrine used by the men's association known as Kono (fig. 4-22). The size of a small child, its ambiguous form seems to evoke an animal. A hollow channel running from "mouth" to "anus" may have allowed libations may be poured

through it. The *boli* was activated, spiritually charged, when it received the libations, the blood sacrifices, and sometimes the spittle of the assembled members of the association. It was thus is a reservoir of their *nyama*.

Kono, like Komo, was once an important anti-witchcraft society among the Bamana, though it is now in decline. Evidently the leaders of Kono were bards and leatherworkers rather than blacksmiths, but their shrines, altars, and masquerades were very similar to those of Komo. The origin for these and other *nyama*-controlling organizations may extend back over seven hundred years. According to the writings of a fourteenth-century visitor to the Mali court,

> When it is a festival day ... the poets ... come. Each one of them has got inside a costume made of feathers to look like a thrush with a wooden head for it and a red beak as if it were the head of a bird. They stand before the sultan ... and recite their poetry ... I was

informed this practice is old amongst them ...

Kono and Komo masqueraders during the twentieth century have worn feathered costumes, and the projecting jaws on the headdresses of Kono, Komo, and other male associations may be seen as resembling a bird's beak, although twentieth-century examples are not red.

Photographs of shrines used to store the *boliw*, staffs, and other sacred belongings of Kono and Komo are quite rare, for these sanctuaries were kept hidden from outsiders in sacred groves, or in the compounds of their leaders. The shrine photographed here was usually screened from view by a woven barrier; men can be seen removing its cover in the right background (fig. 4-23).

Kore, Secular Masquerades, and Puppetry

Like Kono, the men's association known as Kore seems to be disappear-

4-23. *KOMO* OR *KONO* SHRINE, MALI. PHOTOGRAPH BEFORE 1960

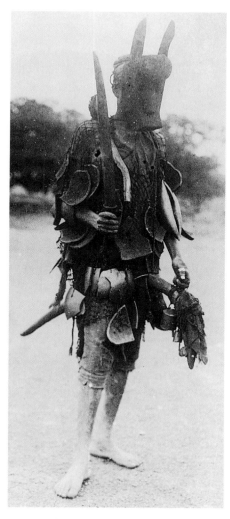

4-24. BAMANA *KORE DUGA* ("KORE HORSE") MASQUERADER, SIKASSO REGION, MALI. 1931

Researchers in the middle of the twentieth century wrote that a man would need to join five major Bamana associations (Ntomo, Tyi Wara, Komo, Kono, and Nama) before being initiated into Kore. They believed that Kore masquerades such as this represented the culmination of a man's education, and served as the foundation for a just society. Although this research cannot be verified today, it does indicate that Kore masqueraders once played an important role in Bamana culture.

ing in Bamana communities. Kore once sponsored a vibrant form of theater, challenging immoral authority and hypocritical morality through the sexually explicit gestures and buffoonery of its masquerades. Dancers promoted common decency by mocking irresponsible and outrageous behavior. Kore performances seem to have featured both puppets and masqueraders, the latter wearing wooden face masks in the shape of the lazy or wily animals they portrayed.

A rare photograph of a Kore horse, *kore duga*, shows the dancer wearing a heavy wooden mask with long mule-like ears, a domed forehead, pierced eyes, and a square muzzle (fig. 4-24). In one hand he carries a long wooden imitation of a sword, and in the other he manipulates his beribboned penis-like "mount." The long slit in the oval object against one shoulder is a clear reference to female genitals. The rest of the net costume holds discarded objects and refuse. The

kore duga is clearly the antithesis of a polite Bamana person.

Kore's role in exposing human frailties, and in reinforcing the common values of society, is partially filled today in Mande-speaking regions by community age-grades. These associations, usually called Kamelon Ton, organize young men and women into groups by age, just as Ntomo or Tyi Wara once did. Yet they have no *boliw*, no altars allowing them to manipulate *nyama*. Their displays are open to all, and although individuals may enhance their performance skills with mystical substances and prayers, the festivities themselves have few religious overtones.

The most dramatic of the various performances presented by Bamana, Somono, or Bozo Kamelon Ton are those involving rod puppets (fig. 4-25). Consisting of carved heads or partial figures on sticks, the puppets may perform behind a screen or on a large mobile stage. The stage is conceived of

4-25. BAMANA PUPPETS AS BUSH ANIMALS IN PERFORMANCE, NIENOU VILLAGE, MALI. 1989

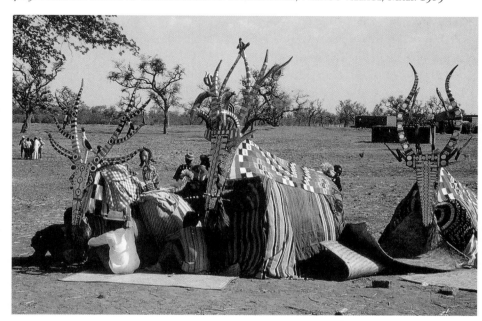

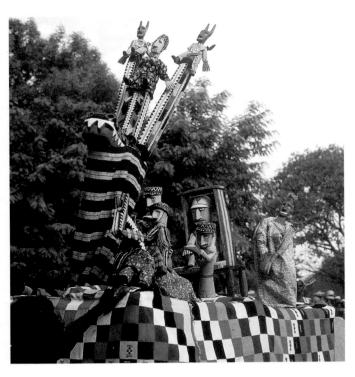

4-26. *KARANKAW*
("PEOPLE OF KARAN").
CARVING BY SIRIMAN
FANE, COSTUMES AND
PERFORMANCE BY
MEMBERS OF A BAMANA
KAMELON TON, SEGU
REGION, MALI.
PHOTOGRAPH 1980

mal's head is the visual focus of the performance. In some southern Mande-speaking areas, these huge animal masquerades are considered secret, and may not be viewed by women. Usually, however, female singers in the audience provide important verbal, visual, and musical accompaniment.

Boundaries between secular and sacred performances in Mande-speaking communities are not always as clear as this discussion might suggest. The gaily colored animal who dips and swings and raises its head is able to do so in part because of the *nyama* of the dancers. A Komo masquerader who emits strange noises, breathes fire, and rises high into the air can entertain as well as inspire his audience. In both private religious ceremonies and public spectacles, displays of art lead communities to reflect upon their values and their history.

ARTS OF THE HOME

The puppetry, masquerades, and statuary described above are displayed at festivals and ceremonies, and then

as a large animal, constructed of wood, cloth, and plant fiber and fitted with a carved, moveable head. Performers hidden within manipulate both the puppets and the stage itself.

Karankaw, meaning "people of Karan," is an elaborate puppet show carved and painted by Bamana blacksmith Siriman Fane (active c. 1925–85). It was commissioned, dressed, and staged by a Kamelon Ton in the Segu area (fig. 4-26). *Karankaw* puppets depict former president Musa Traore of Mali flanked by two armed soldiers, a colonial officer on horseback, and a farmer. The stage itself has the long neck and head of a giraffe, and the horns on its head are surmounted by a lovely lady and two horned creatures. When *Karankaw* was performed in the early 1980s, these brightly colored characters acted out various plots and subplots whose specific political references were couched within more generalized messages

about leadership, heroism, and community relationships.

Age-grades and other theatrical groups among some Mande-speaking peoples may present only the animated stage itself, without puppets. This is especially the case in southern Mali and Côte d'Ivoire, where the stage-ani-

4-27. BEDROOM OF
A HOME,
OULOUMBINI,
MAURITANIA. WALL
PAINTING BY
HABOU CAMARA

returned to storage. While these dramatic art forms impress locals and outsiders alike, well-made items used in everyday life are often overlooked by visitors. These household arts include the large ovoid water storage pots and other impressive ceramic vessels made by Mande-speaking *numumusu* and by other female potters in neighboring groups. In some Mande-speaking regions, domestic art forms made by women also include the painted and sculpted ornamentation of houses and compounds.

Soninke women who live along the Senegal River in southern Mauritania and eastern Senegal paint the interiors and exteriors of their homes. The bedroom of Mme. Habou Camara is an excellent example of this vibrant art (fig. 4-27). Unlike the more tightly organized shapes of Bamana women's *bogolanfini*, which are monochromatic, this mural uses a range of yellows and reds. Other Soninke women also use bright blues and greens in their energetic designs. Their murals may offer protection and blessing as well as beauty, just as the wall paintings created by Soninke-speaking Harratin women for patrons in the oasis city of Walata, Mauritania, relate to ideas of prestige, fertility, increase, and community (see fig. 1-26).

Men and women throughout Africa hang photographs on their walls both to embellish their homes and to honor family members. The practice began during the early twentieth century, when wealthy Africans in the cities of Dakar, St. Louis, and Bamako began to commission portraits from local photographers. One of the most talented photographers working in Bamako during the mid-twentieth century was Seydou Keita (born 1923),

4-28. *Untitled*. Seydou Keita. 1958. Black and white Photograph. Contemporary African Art Collection–The Pigozzi Collection, Geneva

who produced thousands of portraits between 1949 and his retirement in 1977. A photograph from 1958 demonstrates his meticulous craft (fig. 4-28). Keita has posed his pensive subject with a flower, created an interesting range of textures and patterns with his cloth backdrop, and selected an exposure which enhances the range of light and dark in this black-and-white composition. The subject chose her own hat and her dress, which reflect both contemporary French fashion and Malinke preferences for elaborate headdresses and bright cloth.

Muslim families display devotional images as well as photographs in their homes and businesses. In Senegal, views of Mecca, figures of holy men, and inscriptions from the Qur'an are often painted on glass, as are satirical and proverbial scenes criticizing misbehavior. *Les Amoreaux*, a painting on glass by Gora M'bengue (1931–88), depicts a contemporary couple (fig. 4-29). The

4-29. *Les Amoreaux*. Gora M'bengue. 1983. Ink and enamel paint on glass, 13 x 18¾" (33 x 48 cm). Collection of Mr. and Mrs. M. Renaudeau

4-30. *ROYAL COUPLE.* PAPA
IBRA TALL. TAPESTRY, 7′3½″
X 5′1′ (2.22 X 1.55 M).
COLLECTION OF THE
GOVERNMENT OF SENEGAL

The philosophical ideas of Négritude are evident in the poetic title, the mask-like figure, the simplified shapes, and the bright colors of this tapestry. Négritude, a philosophy espoused by Léopold Sédar Senghor, sought to build a modern Africa by drawing upon an idealized, pan-African past. Senghor believed that abstraction, rhythm, and expressive color were authentically African contributions to the world's art, music, and literature. He therefore encouraged these tendencies in Senegalese painting.

generation of artists, who produced stylized images of African scenes and African art forms using imported fibers and European weaving techniques. Tall's *Royal Couple* is a masterful example of one of these woven wall hangings (fig. 4-30).

Iba N'Diaye (born 1928), who also studied in France, joined Papa Ibra Tall from 1959 to 1967 as a department head at the École des Beaux-Arts in Dakar. Working in oils, N'Diaye employs a layered, painterly technique that looks back to the seventeenth-century European artists Diego Velázquez and Rembrandt van Rijn. His iconography, however, stems from his observations of contemporary Africa. *La Ronde—à Qui le Tour?* (The Round—Whose Turn is it?) places three African sheep around a decapitated and partially butchered animal (fig. 4-31). One sheep turns to look at the dead relative, while the other two float toward the corners of the canvas. Sheep are sacrificed at Muslim festivals, but N'Diaye is not celebrating his cultural and religious beliefs here. Rather, he means to remind us of the violence and discord now shaking African nations, and of our ability to ignore the suffering of others in the hope that our turn has not yet come.

During the 1980s dozens of young Senegalese artists attracted critical acclaim in Europe. One of the most successful is Fodé Camara (born 1958), whose luminously beautiful canvases have addressed painful issues such as the slave trade. *Le Vieux Nègre, la Statue et la Médaille* (The Old Man, the Statue, and the Medal; fig. 4-32) explores identity and the past. Wearing the white beard and cap of an elder, the old man of the title

man wears typically Senegalese robes and a French pith helmet, announcing his ability to work within both worlds. His wife wears granulated gold earrings made by Wolof or Toucouleur jewelers, while her large pendant is similar to the fourteenth-century pectoral disk found in a burial near Rao. The black outlines filled in with flat, bright colors are typical of Senegalese paintings on glass.

ART FOR THE INTERNATIONAL MARKET

Glass painters such as Gora M'bengue who sell their work in local markets and streets rarely attend art school, but rather learn their trade by apprenticing themselves to an established artist.

Formally educated artists, in contrast, often work with the international art world in mind, with its network of galleries, museums, collectors, and critics. The art schools and institutions of Senegal flourished under the patronage of President Léopold Sédar Senghor during the two decades following its independence from France in 1960. Perhaps the most influential artist of the Senegalese academies of this time was Papa Ibra Tall (born 1935). Tall studied painting and tapestry in France. Upon his return to Senegal, he taught at Senghor's École des Beaux-Arts in Dakar, and in 1965 he founded the Manufactures Nationals des Tapisseries in the town of Thies. This unusual art school and manufacturing center trained and employed a

4-31. *LA RONDE—À QUI LE TOUR?* (THE ROUND—WHOSE TURN IS IT?). IBA N'DIAYE. 1970. OIL ON CANVAS, HEIGHT 4'11" (1.5 M). COLLECTION OF THE ARTIST

4-32. *LE VIEUX NÈGRE, LA MÉDAILLE ET LA STATUE* (THE OLD MAN, THE MEDAL, AND THE STATUE). FODÉ CAMARA. 1988. COLLAGE AND OIL ON CANVAS, 47¼" X 78¾" (1.2 X 2 M). COLLECTION OF ABDOURAHIM AGNE

turns to look at the statue, its face an elegant, Senufo-like mask (see fig. 5-30). Pieces of tape attach him to the canvas and seal the mask's mouth. A medal lies upon his chest. We assume that the old man is a veteran, one of the thousands of African soldiers who fought for the French in Europe and Indochina. His relationship to a colonial past and a pre-colonial belief system is ambiguous.

Ousmane Sow (born 1935) is a sculptor whose work has also been exhibited widely in Europe. He has created series of figures, most larger than lifesize. Some series referred to Nuba wrestlers from Sudan, or Fulani herders. A recent work presents scenes from the nineteenth-century American battle at Little Big Horn (fig. 4-33). His modeled and painted figures dramatically capture intense expressions, tightened muscles, and shifting centers of gravity. Their rough, organic surfaces, reminiscent of Bamana boliw, convey a sense of immediacy.

4-33. Two figures from *Battle of Big Horn*. Ousmane Sow. 1999. Mixed media. Installation in Dakar, Senegal

4-34. *Untitled*. Mor Faye. 1983. Gouach and India ink on paper, 19½ x 25½" (50 x 65 cm). Collecton of Diokhane and Lee

Senegalese artists who now work in Dakar have lived through very difficult times. The government patronage, art schools, and tapestry workshops of the past are now greatly diminished or gone completely. Sculptors and performance artists recycle found objects in their art, in part from economic necessity. They exhibit their work in banks, in their homes, and in street fairs, to make them visible to the urban population. During Set Sétal, an anti-corruption and "clean-up" campaign of the late 1980s, academically trained artists worked with sign painters, amateurs, and children to create murals and other art works addressing the problems of urban Senegal.

Such events played a role in the tragic career of Mor Faye (1947–1985), a painter who left his position as an art professor in Dakar to paint in freedom and poverty. Fits of depression, during which he

destroyed his work, brought him to a mental institution. After his death, friends discovered that he had left over eight hundred paintings, all in an intense and personal style. One particularly vivid example appears at first glance to be a rapidly executed abstract work (fig. 4-34). Closer inspection reveals it to be an image of the Senegalese icon al-Buraq, the winged horse with the crowned head of a woman who is believed to have transported Muhammad through the night. Her wings have here become the wings of an airplane; her crown and robes are made of flames. Bamana *numuw* might interpret Mor Faye's struggles in terms of his inability to harness his *nyama*, his own inner creative powers.

Personal responses to contemporary problems and references to the heritage of the past may also be seen in the cinema created in Senegal, Mali, and Burkina Faso. Oumar Sissoki used sets and costumes designed by Bogolan Kasobane for his epic film, *Guimba*, a tale of despotism and revolt (fig. 4-35). Just as the puppets of a Kamelon Ton incorporate references to the past into images of the present, the cinema of these modern nations uses the heritage of the Mande peoples to address the concerns of the modern world.

4-35. STILL FROM THE FILM *GUIMBA. THE TYRANT*. OUMAR SISSOKO, DIRECTOR. 1995

5

THE

WESTERN

SUDAN

THE WESTERN SUDAN IS THE region embraced within the great arc of the Niger River. To the north, it extends to the edges of the Sahara; to the south it borders the forested lands of the Atlantic Coast. The ancient West African empires of Ghana, Mali, and Songhai all extended into this region, as do the Bamana people discussed in chapter 4. The ancient empires were partially Islamicized from about the tenth century AD. Like the Bamana, however, most of the peoples examined in this chapter—the Dogon, the Senufo, and four of the Burkinabe peoples—resisted Islam and its way of life for centuries, preserving their religions and other cultural traditions into the twentieth century.

Linguistic borders in the Western Sudan tend to mark artistic borders as well, with each language group cultivating its own forms and styles. Dogon, Senufo, and Burkinabe peoples speak mutually incomprehensible languages. But the complete linguistic picture is still more complex, for the Dogon language includes several diverse dialects, while the Senufo actually speak several languages— even a single Senufo village will contain occupational groups with varied origins and different languages. This situation reflects a long history of political decentralization, migrations, and interchanges with neighboring peoples, and it has led to a great variety of styles and substyles in the arts.

Despite such artistic and linguistic complexity, however, the peoples of the Western Sudan share belief systems, economies, and cultural institutions. Dwelling largely in rural towns and villages, they are farming

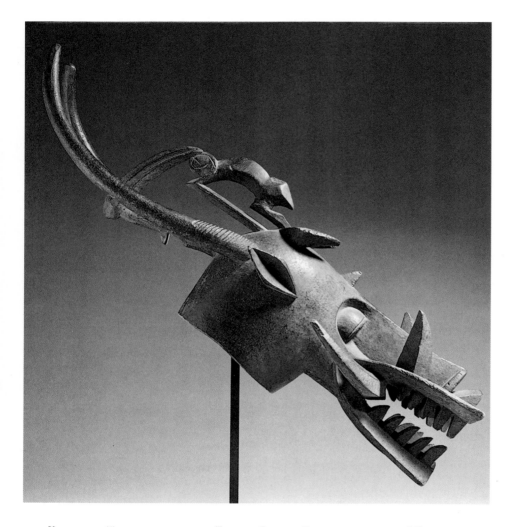

5-1. *Kponungo* ("funeral head mask") mask. Senufo. Early 20th century. Wood, length 41" (1.04 m). University of Iowa, Iowa City. University of Iowa Museum of Art. The Stanley Collection

In parts of Senufo country these masks belong to mens' antiwitchcraft associations outside of Poro. Both Poro and non-Poro masks of this form call upon spiritual powers that can be invoked against witches or criminals, the marauding spirits of the dead, or malevolent bush spirits. As the kinds of masks "sent by death" in legends, these powers engage in a kind of psychological and supernatural warfare, combating any forces that might disrupt the well-being of the community.

peoples who raise subsistence crops in the rather dry climate of the savannah and semi-desert sahel. With the exception of the Mossi, a Muslim Burkinabe people, they have neither kings nor any other kind of centralized political system. Their most common building material is clay or mud, and their architecture generally has a sculptural, earthbound quality. Some groups embellish their buildings inside and out with visually striking, symbolically rich designs, invariably painted by women. Almost all of them focus great attention on masquerades, ritual, competitions, and display. Across the region masquerades aid in transform-

ing deceased people into productive and helpful ancestors and dramatize the crucial importance of good harvests in areas of poor soil and relatively little rainfall.

Finally, throughout the Western Sudan as in much of the rest of Africa, sculpture and masks are less literal representations of life forms than they are embodiments of complex ideas. Countless altars and shrines throughout the region are dedicated to nature spirits and ancestors, which are embodied in wood, metal, or mixed media sculptures. Blacksmiths are often the primary sculptors, and their wives are responsible for other art

forms, especially pottery. Along with other artisan groups such as carvers and weavers, blacksmiths are usually segregated within the community and accorded considerable ritual power.

THE TELLEM

Running parallel to the Niger on its northward swing through present-day Mali is the Bandiagara escarpment (fig. 5-2). A spectacular cliff some 125 miles long and up to 2000 feet in height, it presides over an austere and dramatic landscape. For several centuries the cliff region has been home to the Dogon people, discussed later in this

5-2. The Bandiagara escarpment, Mali. Photograph 1979

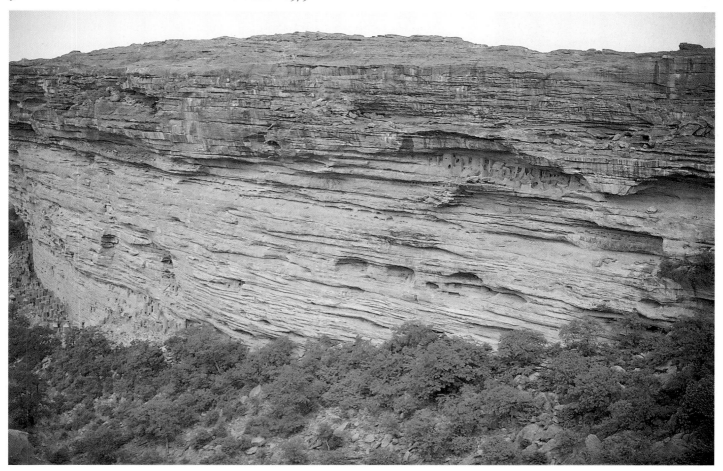

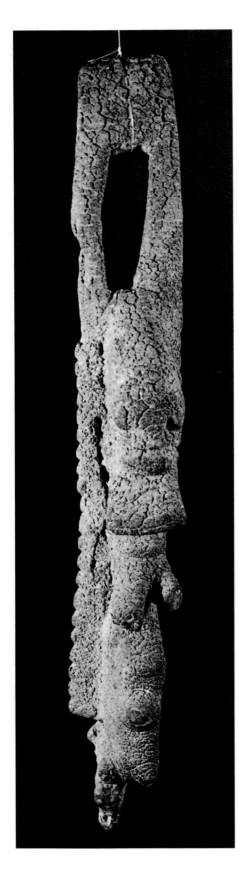

chapter. The Dogon were preceded in the area by a people known as Tellem, whose burials and granaries have been discovered in the numerous caves that dot the cliff.

The Tellem seem to have flourished from about AD 1000 until the arrival of the first Dogon migrants some five hundred years later. Artifacts testifying to Tellem culture include carved figures and neckrests, pottery, implements such as hoes and knives, and the earliest known examples of woven stripcloth in West Africa. The artistic boundaries between Tellem and Dogon cultures are improperly understood. Several sculptures thought to be characteristically Dogon have recently been shown to date from the Tellem era, while a particular style long associated with the Tellem now seems to have continued into the twentieth century (see fig. 5-5). Clearly, Tellem and Dogon sculpture cannot be distinguished on the basis of style alone, and what the relationship was between the two cultures remains a mystery.

By virtue of an early radiocarbon date, the fragmentary sculpture illustrated here is almost certainly Tellem (fig. 5-3). The body is simplified, showing an enlarged navel, pendulous breasts, and a proportionately very large head with a projecting chin or beard. Widely spaced eyes and a shelf-like mouth define the otherwise indistinct face. The legs are partly missing. The figure projects in high relief from a flat, partially notched

5-3. FIGURE WITH RAISED ARMS. TELLEM. ENCRUSTED WOOD, HEIGHT 18⅞" (48 CM). KONINKLIJK INSTITUUT VOOR DE TROPEN, AMSTERDAM

plank (broken off on the right side) which, in its upper portion, becomes the figure's raised arms, connected at the hands. The entire surface is covered with hardened sacrificial materials. Undoubtedly a shrine figure, the carving cannot be further identified as to use or meaning, although its raised-arm pose is common in other Tellem statuary and is often repeated in later Dogon figures.

THE DOGON

The Dogon migrated into the Bandiagara region mainly in the fifteenth and sixteenth centuries. Oral history traces their origins to the Mande territories to the southwest. Linguistic and cultural evidence, however, points to origins in the southeast, in the Yatenga region of Burkina Faso. Both theories may be correct, as the Dogon may well have multiple origins.

In earlier centuries the Dogon built their villages on the top of the Bandiagara escarpment, on its rocky bluffs, or snuggled up under the vertical cliff faces on its steep talus slopes (see fig. 5-2). Such difficult-to-reach locations afforded some protection from periodic invasions by Mossi and Fulani cavalry. After the French colonial government established control over the region in the first decade of the twentieth century, many Dogon left the cliffs for the more welcoming Seno plain. Today, a Dogon population of nearly 300,000 is dispersed through some 700 villages, most of them averaging fewer than 500 people. Dogon country once supported abundant wildlife—leopard, lion, antelope, crocodile, and other animals—which the Dogon hunted and depicted in their art. The wildlife has largely

disappeared, however, and like other people in the region, the Dogon now rely on agriculture. Excellent farmers, they manage to wrest subsistence grain crops from poor soil in an area that receives little rain.

The Dogon have been among the most intensively studied of all African peoples. Led by the French anthropologist Marcel Griaule, who first visited the region in the 1930s, scholars have constructed a vision of Dogon life and thought in which every detail of the culture can be seen to reflect the symbolism of elaborate creation legends. This cosmology, ripe with many layers of meaning, has provided a fertile resource for theorizing about Dogon art, and many compelling interpretations have been based on it. Recently, however, many such interpretations have been called into question. Field workers among the Dogon have been unable to verify earlier findings, while on-site observations of how the Dogon actually use and think about their art have suggested less complex symbolic readings. In light of these disputes, many scholars now advocate a more conservative approach to interpreting Dogon art, relying on documented evidence of use and referring only cautiously to creation legends.

Sculpture

Most Dogon sculpture is created by blacksmiths, who work in wood as well as metal. As elsewhere in West Africa, Dogon smiths comprise a hereditary occupational group, respected and often feared for their deep learning and occult powers, and living somewhat apart from Dogon farmers. The works of these artists are visually compelling as well as diverse in form and style.

Their exact functions and meanings, however, often remain obscure. Virtually all scholars agree that Dogon sculpture was made for shrines. Most agree as well that the figures themselves are altars in the sense that they serve as consecrated repositories of sacrificial materials, which may be left nearby or dripped or rubbed over the figures for solutions to such problems as illness, infertility, or drought. On some images these materials have built up a thick crust, as on many Tellem figures.

As in most African cultures, the human figure is the most frequent sculptural motif. Such works have often been referred to as ancestor figures, yet the degree to which they actually represent legendary or historical ancestors is contested. It may be that they were originally created to represent shrine owners or other living petitioners *to* ancestors. If this is true, then most Dogon sculpture can be interpreted as orants, or praying beings, whose purpose was to intercede with the spirit world on their owners' behalves.

The most distinctive Dogon motif is a single figure standing with one or both arms raised, illustrated here by one of the largest Dogon sculptures known (fig. 5-4). Although the right arm of the sculpture has been broken off above the elbow, clearly it too was raised. The raised-arm pose has usually been interpreted as exemplifying prayer, especially for rain. Yet a variety of other meanings also may be implied. For example, the gesture may indicate penance for having caused a drought by breaking ritual law. It may relate as well to the ceremony of casting grain from shrine roofs at the beginning of the planting season, and

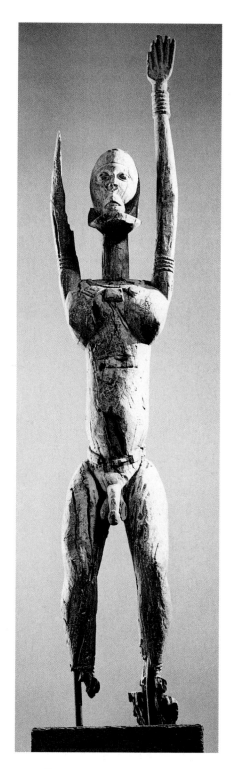

5-4. Standing figure with raised arms. Dogon. 16th–20th century. Wood, height 6"10⅛" (2.1 m). The Metropolitan Museum of Art, New York

it also resembles a ritual motion made to ward off evil sorcery or danger.

Dogon sculptural styles vary from region to region, though all sculpture cannot yet be assigned confidently to a particular regional tradition. The naturalistic, fleshy style of this life-size statue is associated with the Tintam region of northern Dogon country. Despite slightly bent knees, the figure stands with a stately erectness further emphasized by its elongated neck and strong oval head. Ample pectoral swellings, strongly suggestive of female breasts, undercut the clear masculinity of the figure's genitalia and beard. Bisexual images occur with some frequency in Dogon art, and so this figure too can be seen as androgynous. As such it may relate to aspects of Dogon thought about beings called *nommo*.

The essence of *nommo* in Dogon belief is not altogether clear. Long understood by scholars following Griaule's lead as primordial, prehuman ancestors, *nommo* has recently been translated as "master of water," and may refer as well to a collectivity of powerful water spirits. Either way, *nommo* are bound up with ideas about couples, twin-ness, and sexual duality, all of which are important in Dogon thought. Like *nommo*, androgynous beings are associated with two presocial states of being, infancy and childhood. The Dogon practice both male and female circumcision; they believe these operations remove the female element from males and vice versa. Circumcision thus creates a wholly male or female person prepared to assume an adult role without the ambiguities of childhood. Androgynous sculptures may thus refer to ideas of precultural, primordial beings—

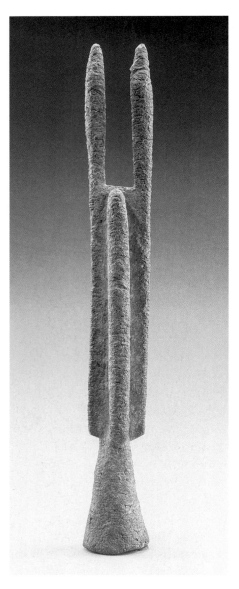

5-5. FIGURE WITH RAISED ARMS. DOGON. 19TH CENTURY OR EARLIER. WOOD AND SACRIFICIAL MATERIALS; HEIGHT 16¾" (42.6 CM). MUSÉE DAPPER, PARIS

The simplicity and encrustation of this figure, formerly enough for scholars to label it as Tellem, are no longer deemed sufficient for such an attribution, although the possibility of its having been made by Tellem peoples remains.

perhaps *nommo*, perhaps children—who preceded civilized institutions as they are now known. At the same time the figure's beard, as well as the jewelry worn on the arms and around the neck, suggest that the statue represents a personage—whether divine or human—of a social stature that matches its great size.

Dogon styles have surely varied over time, as well as from region to region. While not enough works have been scientifically dated for the construction of a chronology, tests conducted thus far indicate that simpler, more abstract figures are generally older than more detailed and naturalistic works. Thus the nearly abstract, encrusted figure in figure 5-5 is probably older than the life-size carving in figure 5-4. Here the torso is radically reduced to an elongated cylinder projecting from a flat, rectangular back and shoulders. Two more cylinders project upward as arms. Rising from a conical base, the work exerts an upward thrust that seems to embody the force of the gesture itself.

Another especially unusual figure is also strongly abstracted (fig. 5-6). Here the carver has reduced the body to a simple, elongated, plank-like form. A featureless head seems almost to float in front of the body. This figure, too, is sexually ambiguous, for while an oval depression in the lower center suggests female genitalia, breasts are noticeably absent. On the reverse side of the image is attached a far smaller and more naturalistic figure, also with raised arms, which may represent a child. The ensemble may thus be a schematic depiction of a mother carrying a child on her back, another recurring Dogon motif.

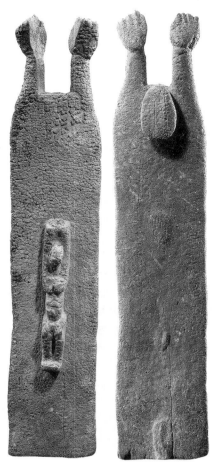

5-6. PLANK FIGURE WITH RAISED ARMS. DOGON. 16TH–17TH CENTURY. WOOD AND SACRIFICIAL MATERIALS; HEIGHT 17¾" (45 CM). MUSÉE DAPPER, PARIS

The motif of a couple is so pervasive in Dogon art that it most probably has symbolic significance. Yet while it is tempting to link couples to themes of twin-ness and primordial couples featured in creation legends (as has often been done), we have no testimony from the Dogon themselves that such readings would be valid for this fine sculpture.

Human couples are the second most prevalent theme in Dogon sculpture. One of the finest of known Dogon sculptures depicts a couple seated side by side on a single stool (fig. 5-7). The figures are virtually identical, to the point of near androgyny. The male is slightly larger and dominates by virtue of his apparently protective gesture, his right arm around the woman's neck, fingers resting on her breast. The man's left hand is connected to his genital area, suggesting references to procreative powers. The woman carries a child on her back (not visible in the photograph) signaling her role as a nurturing mother. The man similarly wears a quiver, which implies his role as hunter, provider, warrior, and protector. Both torsos are elongated tubular shapes, and their articulations are schematic and rectilinear rather than organic. Facial features too are highly conventionalized. Lightly incised straight lines, recalling scarification, appear on the faces and torsos, reinforcing the rectilinear composition. This schematic, geometric style is associated with the southern Dogon region.

The work appears to be an idealized model of a nuclear family. Man and woman are here seen as interdependent and complementary, ideas expressed by their nearly identical portrayal, their unity on a common base, the visual bridge of the man's arm, and the rhythmic alternation of positive and negative spaces of equal weight, as in the arm's-width space between arm and torso or the torso-width space between man and woman. At the base of the sculpture, four smaller figures help support the stool the couple rests on. These may refer to the support that ancestors or other spirits are believed to provide for the living.

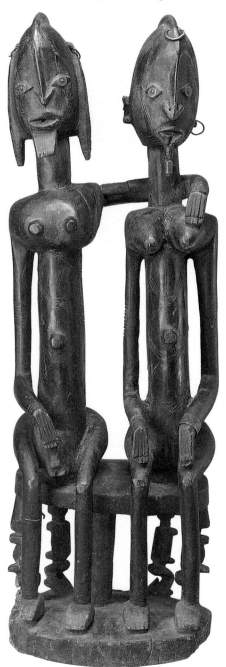

5-7. SEATED COUPLE. DOGON. 19TH CENTURY OR EARLIER. WOOD AND METAL; HEIGHT 28¾" (73 CM). THE METROPOLITAN MUSEUM OF ART, NEW YORK

Equestrian figures are a third common theme in Dogon art (fig. 5-8). As here, horses are usually rendered more simply than their riders (compare, for example, the horse's curved, seemingly boneless legs with the rider's clearly articulated joints). Horses are generally associated with wealth and power in West Africa. Rare and expensive, they are often owned by leaders. One of the few members of Dogon society likely to own a horse is the *hogon*. Priest of the worship of Lebe, a legendary ancestor and deity concerned especially with agricultural fertility and crop growth, the *hogon* is the most powerful person in the community. Dogon equestrian figures are thus often believed to depict *hogon*s. Yet historically the Dogon have also known riders as invading warriors and as emissaries of foreign leaders, and these possible meanings should be kept in mind as well. The rider here wears a sheathed knife on his upper arm, and both rider and horse are adorned with carefully rendered ornaments. These signs indicate that the subject is an important personage, while the large size of the sculpture indicates that it is itself an important work.

An equestrian image more firmly associated with the office of *hogon* forms part of one of the more complex Dogon figural carvings known (fig. 5-9). This lidded bowl was owned by a *hogon* and was used to contain food at his rites of investiture. Elaborate embellishment marks it as a prestige vessel, possession of which indicated high status and probably wealth. The lower section, carved from a single block of wood, comprises a bowl ringed by eight seated figures and supported by two horses standing on a flat base. The separate lid is ornamented with small figures in relief and crowned with a large equestrian, which may invoke the first *hogon*. Horses are often depicted on food containers. They may represent the primordial

5-8. HORSE AND RIDER. DOGON. 19TH CENTURY OR EARLIER. WOOD, HEIGHT 31¾″ (81 CM). MUSÉE DAPPER, PARIS

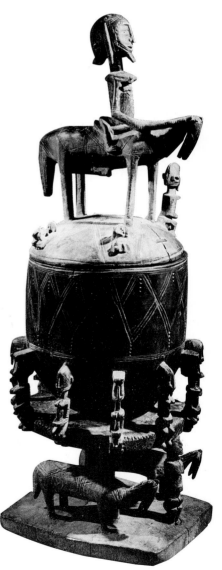

5-9. LIDDED CONTAINER WITH HORSE AND RIDER. DOGON. 19TH CENTURY OR EARLIER. WOOD WITH METAL STAPLES, HEIGHT 33⅔″ (85.8 CM). THE METROPOLITAN MUSEUM OF ART, NEW YORK

beings described in legends as having guided a sacred vessel to earth during creation time. This vessel contained everything needed for life, including eight original prehuman ancestors descended from the first *nommo*. It is tempting to interpret this sculpture, which contained life-sustaining food,

5-10. DRAWING OF WRAPPED FIGURE WITH RAISED ARMS. DOGON. 20TH CENTURY OR EARLIER. IRON, COTTON THREAD, COTTON CLOTH, HIDE THONG, FIBER CORD, SACRIFICIAL MATERIALS; HEIGHT 9⅞" (25.1 CM). THE LESTER WUNDERMAN COLLECTION OF DOGON ART

as a metaphorical extension of that original sacred vessel. The eight encircling figures would represent the eight ancestors, the figure between the two horses on the base would depict the original *nommo*, the equestrian on the lid would be the original *hogon*. All we

can be sure of, however, is that the container is a virtuosic display of the woodcarver's art.

The iconography and use of wrought-iron figures are apparently similar to those of wood figures, although even fewer contexts for them have been recorded in field research. They are known to have appeared on shrines to Lebe, ancestors, and other spirits. The majority are (or were) attached to stakes, hooks, or canes that were both carried and inserted into the earthen bases of shrines.

Most iron figures, whether human or animal, are highly simplified, economical renderings, which stems partly from the difficulty of working iron. The wrapped iron figure

5-11. STAKE WITH ANTELOPE HEAD. DOGON. 20TH CENTURY OR EARLIER. IRON, HEIGHT 8¼" (21 CM). MUSÉE DAPPER, PARIS

with raised arms illustrated here is typical in its spare treatment (fig. 5-10). This is a power figure, consecrated with ritual acts of wrapping and tying. By analogy to a documented, similarly wrapped iron sculpture, this may have been part of an altar to Lebe. While a number of very simple wrought-iron horses exist, antelopes, like the one shown here, are rare (fig. 5-11). Here the smith has created a delicate but forceful sculpture with a few twists and bends, omitting the animal's body entirely, and playing with the fanciful neck curves.

Architecture

Like much clay or mud architecture, especially in the African savannah, Dogon buildings are strongly sculptural. Some structures emphasize rounded, organic forms, while others are more severely rectilinear and geometric. The most fluid, organic Dogon structures are sanctuaries (fig. 5-12). Sanctuaries are dedicated to *binu*, immortal clan or lineage ancestors. *Binu* cults and their priests have several roles, but in the largest sense they are concerned with achieving and maintaining a balance between the supernatural world and the present world, itself divided into the two realms of untamed nature and human culture. The rounded forms and fluid lines of sanctuaries may be interpreted as a manifestation of the natural realm, while the rectilinear checkerboard design often painted, as here, on the facade may refer symbolically to the ordered realm of culture.

Scholars have for some time pointed to such oppositions between the realms of nature and culture in various Dogon structures and

5-12. DOGON SANCTUARY WITH SACRIFICE IN PROGRESS ON THE ROOF

Visible at the far left is a granary. Typically tall, flat walled rectangular buildings with circular thatched roofs, granaries are numerous in all villages. Each family has several, as if to indicate the importance of life-sustaining grains—and sometimes family shrines—contained within. Some reports accord granaries an elaborate symbolism derived from creation legends. These legends see the granary both as an anthropomorphic female and as a cosmological structure formed by god, with dozens of references to natural and man-made events and things. Regrettably, however, this intriguing and complex symbolism has not been confirmed in recent research.

symbols. While these interpretations can surely be taken too far, aspects of them seem to hold up under scrutiny. The mystical flow of water and energy in nature, animated by supernatural forces, is associated especially with women in Dogon thought, and is shown graphically as flowing or zigzag lines. These are seen to contrast with the finite and crafted order of culture, which is associated with men and is represented in the geometry of weaving, the orderly divisions of cultivated fields, and such rectilinear structures as lineage leaders' houses, *ginna* (fig. 5-13). Here, numerous rectangular niches create a grid pattern on the facade. As the residence of the elder lineage head and the site of shrines to lineage ancestors, the *ginna* can be seen to represent order and wisdom

which are considered to be especially the province of elder males.

Similar geometrical concerns inform the men's meeting houses, *togu na* (fig. 5-14). Literally a "house of words," the *togu na* is considered the head of the community. Often sited in a high place overlooking the village, the *togu na* is an exclusively male domain; it is here that men convene for work and rational deliberation, the essence of civilized life. An open building supported on numerous vertical posts, its layered roof is made of stacked millet stalks laid down successively at right angles. The geometry of the *togu na* contrasts with the oval, closed adobe structures that women retreat to during their menstrual periods. These are organic, womb-like containers that suggest the promise of fruitfulness.

Many of the supporting posts of the *togu na* illustrated here are carved in symbolic representation of women, with simplified facial features, abbreviated bodies, and large pendulous breasts. *Togu na* posts are frequently carved or decorated, with the female form appearing as the most common motif, especially on older structures. One *togu na* originally had an astonishing 105 posts, each one carved with large breasts. Since only a fraction of this number of posts would be needed to support the roof, the repetition must be essentially symbolic. While the *togu na* is a male domain, it is said that female ancestors visit at night to share in the deliberations, and the female posts can be said to represent this feminine presence. More subtly, multiplied female symbols in such a male context reinforce the gender reciprocity and balance seen in other areas of Dogon culture. A quintessential example of such interaction is a motif that can be seen equally as a female head on a long neck with breasts, or as a male phallus with testicles. Visible on several of the posts in figure 5-14, this striking visual

5-13. *Ginna* (lineage leaders' house) overlooking a village, Bandiagara escarpment, Mali. Dogon. Photograph 1979

5-14. *Togu na* (men's meeting house), Mali. Dogon. Photograph 1989

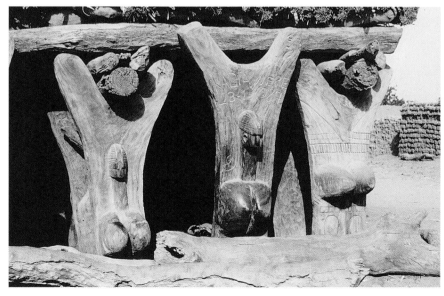

pun simultaneously refers to male sexuality and female nurturing.

Other Dogon architectural sculpture includes doors or shutters to granaries, shrines, and *ginna*. These may be carved from a single plank, or formed from two or three boards connected with wrought-iron staples. Motifs include lizards, birds, human figures, breasts, and geometric motifs, often in multiples. Older doors most commonly feature rows of simplified, vertical, attenuated figures (fig. 5-15). This door also includes a lock carved with a pair of figures that seem to be sitting atop the bolt case. The figures have been interpreted as male and female lineage founders, while the twelve figures on the lock case panel (the left panel) are said to be six pairs of male and female twins, symbols of fertility. This reading is not based in field information, however, and we cannot be sure of its accuracy. Working against it is the visual evidence that the figures do not seem to be differentiated in gender, nor are they depicted in pairs. Although the exact symbolism of this door eludes us, we may still see it as a valued marker of a passageway to an important enclosure. Thresholds are often viewed as a vulnerable transition points. Here the transition is probably on some level guarded by multiple symbolic ancestors or spirits.

Recent Dogon art embraces aspects of contemporary artistic practice notable in many parts of the continent. *Togu na* posts erected since about 1980, for example, often feature more descriptive, even episodic and narrative scenes, sometimes brightly colored with imported oil paints (fig. 5-16). Greater naturalism and realism are evident here, along with writing and numerous small motifs, including airplanes, cars, iron plows, equestrians, hunters and their prey, and even a mosque. It is as though the singular and symbolic motifs that served an older, more self-contained world have given way to a kind of multicultural collection of images showing contact with wider and more diverse worlds. The artists responsible for these modern posts want recognition for their work, and competitions among them have been held in a few instances.

Masks and Masquerades

Dogon masking ostensibly has a funerary function, but it touches upon many aspects of life and thought. Masquerades are performed by a powerful corporate body called Awa, into which virtually all men are initiated.

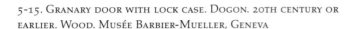

5-15. GRANARY DOOR WITH LOCK CASE. DOGON. 20TH CENTURY OR EARLIER. WOOD. MUSÉE BARBIER-MUELLER, GENEVA

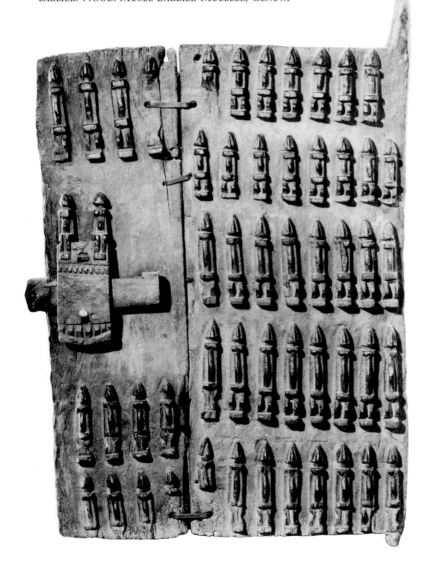

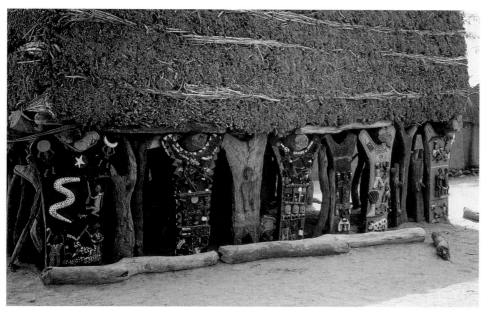

5-17. GREAT MASK WITH ATTENDANT, MALI. DOGON

Awa itself is led by elders, or *olubaru*. The *olubaru* initiate youths and are masters of *sigi so*, the ritual language of the bush spirits that the masqueraders make manifest. All Awa initiates learn *sigi so* along with mask rituals, dances, and gestures.

Awa has as its principal shrine a thirty- to fifty-foot tall Great Mask, also called the "mother of masks" (fig. 5-17). The mask commemorates the first death in Dogon culture as recounted in legend, the death of a personage named Lebe Serou, who was transformed into a snake that is symbolized by the mask's towering superstructure. Having absorbed the spirit power released by death, a Great Mask is exceptionally powerful. Stored in natural rock shelters outside the village, it is essentially an altar. It is not danced in the usual sense of serving as part of a transforming disguise, but rather is called upon to energize all Dogon masquerading.

When an adult man dies, for example, the Great Mask is brought from its cave and stood against the *ginna*, where the body lies. A live chicken is attached to the top of the mask, and the death is announced to the mask as though it were a living being. After sacrifices are made to this mask-altar, several men dance collectively with it before returning it to the bush. Public rites take place after actual burial and after the *ginna* has been purified. There are mock battles by men, wailing by women, and mimicry of wild animal behavior. The next day, a procession of mourners moves into the bush, symbolically expelling the dead man from the village. On the following day a masking sequence called *bago bundo* is performed by five masked dancers, four with masks of fiber and cowrie shells called *bede*, representing women, and one with a tall male mask named *sirige* (fig. 5-18).

Bago bundo has been interpreted as a symbolic reenactment of male and female roles, at the same time

5-18. *SIRIGE* BEING DANCED, MALI. DOGON. 1988 OR 1989

stressing the chaos and destruction brought on by death. *Sirige,* which dominates *bago bundo,* appears to be the public and visible representative of the Great Mask, though it also has other associations of its own. Smaller than the Great Mask and usually painted with triangular motifs, *sirige* features orderly, repeated, grid-like vertical openwork on its long plank, a motif which has been interpreted as the many generations of a great family. The mask is called the "tree" or "big house" (*ginna*), which it symbolically represents.

A far more elaborate Dogon masquerade is a collective funerary rite called *dama.* A complex, multifaceted art form, *dama* takes place over a period of six days once every several years (thirteen is average). The rite effects the permanent expulsion from the human community of the souls or spirits of those who have died since the last *dama,* and their incorporation into the supernatural realm as ancestors. Dozens, even hundreds, of varied masked spirits participate (fig. 5-19). The wealth and prestige of both the living and the commemorated dead are expressed by the size of the *dama* masquerade and its audience, and a village may accumulate costly resources of food and drink over a period of many months or even years in preparation. Awa members are secluded in rock shelters for a period prior to the start of *dama* to prepare and renew their masks, musical instruments, and costumes. With pigments containing sacrificial blood, they paint designs on the walls of the bush shelter and touch the masks to them. *Olubaru,* who make sacrifices to the Great Mask for each *dama,* oversee this activity.

Dama begins with a serpentine procession of several dozen masked spirits from the bush into the village, made sacred by the presence of *olubaru* and the Great Mask. The power, danger, and ritual knowledge lodged in the bush now enter the village. Women, who may not wear masks or even come close to maskers, watch only from a distance. The community is transformed for six days by the authority of these masked supernaturals, called into action by drums. On the first day maskers dance around the ritual seats of the deceased in the village plaza, and the legend of the Awa society's founding is recited. On the second day masked dancing alternates between the village square and the roofs of *ginna.* On the third day maskers dance on or near the *hogon*'s fields, as well as in the plaza, while further individual and group dances mark

the remaining days, often to huge audiences from surrounding communities. The liminal mourning period ends when the initial processional route is reversed: the maskers return to the bush, the Great Mask is returned to its shelter, and the many masked spirits leave the village. The classic three-part structure for rites of passage is followed here, for as the dead, ritually separated from the living, are incorporated as ancestors, the living community is reincorporated into ordinary time (see Aspects of African Culture: Rites of Passage, pages 424–5).

The masqueraders in the foreground of figure 5-19 wear masks made of fiber and cowrie shell representing maidens of the Fulani people, identified by their high-crested hairstyles. The tall masks in the background are known as *kanaga.*

5-19. DOGON MASKERS WEARING *KANAGA* MASKS (BACKGROUND) AND MASKS REPRESENTING FULANI WOMEN (FOREGROUND), SANGA REGION, MALI. 1959

Kanaga and *sirige* have been seen as a conceptual female–male pair. Like *sirige, kanaga* is unusual in its abstraction, and again like *sirige*, it has several interpretations. With its four-part, cross-like superstructure, *kanaga* is considered both a female spirit and a bird, possibly a stork. It is also interpreted as a lizard or a hand. *Kanaga* masks are supposed to be carved by individual Awa initiates and are linked to circumcision rites. The dances and gestures of *kanaga* and *sirige* are unique in that their super-structures are vigorously whirled and swung down in an arcing motion to touch the ground. The meaning of the gesture is unclear, though it appears to signify direct communication with earth spirits.

Kanaga and *sirige* take their place in an impressive array of Dogon mask types. Marcel Griaule recorded more than seventy-eight types of masks representing animals, male and female characters from within and outside Dogon culture, and abstract ideas. Recent scholarship has analyzed this large corpus into several concep-tual sets, emphasizing dualistic but not necessarily parallel oppositions between male and female, wet and dry, death and rebirth, nature and cul-ture, bush and village, destruction and order, predatory and non-predatory, masks of fiber and wood, masks danced and not danced. Thus head-conforming fiber masks such as those representing the Fulani maidens in figure 5-19 are associated with birds, water, and rebirth. Other fiber masks embody intermediaries between this world and the supernatural realm: *hogon*, priest, blacksmith, and doctor. Wood masks do not conform to the head, but rather project forward in front of the face. They largely repre-sent human or animal characters. Almost all are male, and associated with dryness, death, and transforma-tion. Masks that do not actually dance usually embody negative, aggressive, or liminal characters—foreign men, priests, bandits—who interact with the audience by talking, begging, and pro-voking fear or anger. Yet no maskers actually speak, for these are bush crea-tures, who can only utter animal-like cries, and who are spoken to not in Dogon, the language of civilized peo-ple, but in the secret spirit language of the bush, *sigi so.*

Satimbe ("sister on the head") is the only wooden mask to depict a spe-cific type of Dogon woman, the *yasigine* (fig. 5-20). These few female members of Awa stand for the collec-tive women who, in origin stories, first discovered masks. This occurred in pri-mordial time before men took over the privilege for themselves exclusively, barring all women except *yasigine* from contact with maskers or the mask society. Notably, these are the only Dogon women whose deaths are hon-ored with a *dama. Satimbe* masks display a simplified, schematic, large-breasted woman who stands atop the vertically slotted, rectangular facial covering common to most Dogon wooden masks. Three stick-like exten-sions of equal length signify two up-stretched arms and a head on a much distended neck. We may suppose that in addition to representing *yasig-ine*, such dramatically female carvings also refer to the nurturing role expected of all Dogon women.

Dama is a dry-season rite that commemorates death. But it is also a festival in which varied levels of male–female opposition, embodied in a kaleidoscopic array of maskers, human and animal spirit characters, and other participants who sing and dance, cele-brate life, which will resume again once the rains begin. Multiple forms of bush power and wisdom, materialized in the masks, have entered the village as if to revitalize it. *Dama* is therefore

5-20. *Satimbe* ("sister on the head") mask. Dogon. 20th century or earlier. Wood, 4" (10.5 cm). The Metropolitan Museum of Art, New York

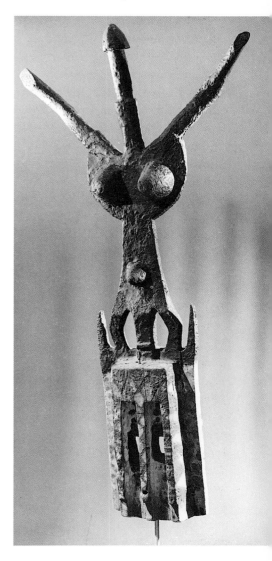

also a rite of hope, renewal, and fertility, an artful melding of masquerade, symbol, song, dance, prayer, and sacrifice that evokes the complexities of life itself. Notably, men are the performers, as if to say that they, not women, are in charge of power and fertility.

Masking and other art forms have been affected by the encroachments of Christianity and Islam, of course, as well as truncated drastically in "authentic" entertainments performed many times a year for tourists in Dogon villages. Some Islamicized communities have ceased *dama* rituals altogether. But masking is still strong, and will continue to be buoyed up by Dogon cultural pride. New mask forms representing such characters as learned Muslim, Mossi horseman, and white man have appeared, reflecting forceful outside influences. The earliest "white man" masks depicted French colonial officers; today such masks depict tourists, and jostle through the crowd taking pictures with wooden video cameras. Men carve extra masks these days because tourists want to buy them. So while *dama* today is probably less orderly than this discussion has made it seem, it is a ceremony that continues in many Dogon communities.

THE SENUFO

Nearly a million and a half people who live in northern Côte d'Ivoire, Mali, and Burkina Faso are known collectively as Senufo. Village communities are the principal social units in this large area. Each community is divided into distinct residential areas, or wards. A single community may contain two or three wards for farmers. In one of those wards, the women make pottery.

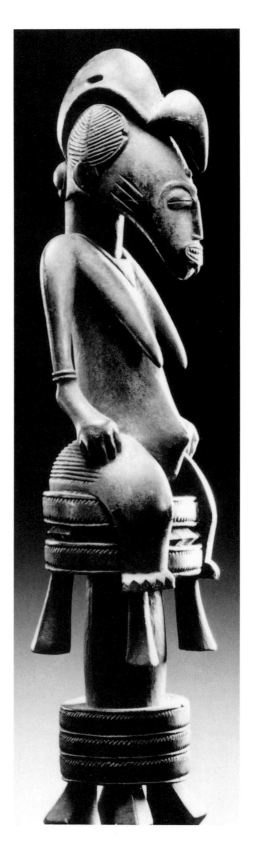

Their husbands may be blacksmiths, weavers, or leatherworkers. At least one ward is reserved for Jula weavers or traders, who are Muslim and who speak a Mande language. Another ward houses Kulebele woodcarvers. These farmers, artisans, and traders have diverse origins and speak separate languages, yet all are considered Senufo.

The multiculturalism of a Senufo community is reflected in the varied forms and styles of Senufo art. Yet common institutions and common themes link art works and their performance contexts throughout the Senufo area. In numbers, at least, farmers are dominant in most villages. The great importance of farming in Senufo life is signaled by a carving called a "champion cultivator's staff." Most of these works depict a seated girl in the bloom of youthful beauty (fig. 5-21). Full-breasted, perhaps pregnant, she is a clear symbol of abundance and potential productivity.

The calm repose of the carved maiden is a deliberate contrast to the active, striving work of the male farmers. Annual hoeing competitions are multimedia events, at once ritual and play, that celebrate values of strength, skill, and endurance among young men. Drums and *balafon*s (xylophones with wood sounders and calabash resonators) establish rhythms for these grueling physical contests, which are accompanied by displays of one or more decorated staffs, carried by

5-21. Champion cultivator's staff. Senufo (Kulebele). 20th century or earlier. Wood, height of figure 13⅞" (35.5 cm). Musée Barbier-Mueller, Geneva

young girls from row to row. The winners of the competition bring honor to themselves, their lineages, and their wards. Heroes of the community, they gain high respect, an opportunity to marry the finest women, and the right to the most elaborate funerals. The staffs are held in trust by elders for successive champion cultivators in each age set, and are displayed at the funerals of champions and their mothers.

The relationships manifest in the cultivating contest between youthful male farmers and young girls are aspects of larger male–female relationships also manifest in the art of the two central Senufo institutions, the male Poro society, and the female Sandogo. In both of these institutions, sculpted images of couples play important roles.

Poro

Poro provides the principal framework through which men learn and practice their social, political, and spiritual roles in society. Each occupational group in a Senufo community has its own Poro society, and all men belong. Males enter and pass through Poro in age groups. The solidarity and brotherhood of each group is sealed by the shared rigors of the protracted initiatory process, which takes place in three phases over the course of some twenty years. Young women participate in the first two initiatory phases but are excluded from the third. Graduation from the third and final phase of initiation signals that a man—now aged twenty-eight to thirty-two—is ready for leadership roles in the community.

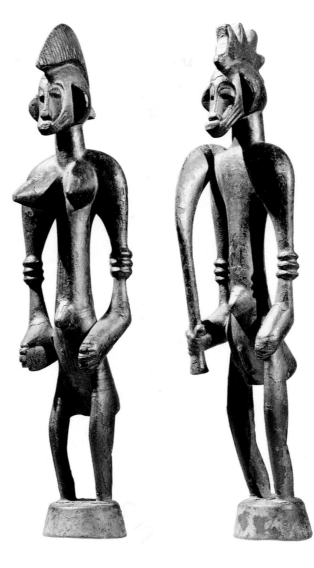

5-22. Pair of figures ("children of Poro"). Senufo (Kulebele). 19th–20th century. Wood, height of female 23¾" (60.2 cm), height of male 23½" (59.7 cm). The Metropolitan Museum of Art, New York. Michael C. Rockefeller Memorial Collection. Bequest of Nelson A. Rockfeller

Art plays important roles in Poro activities; it is used and stored in the society's sacred grove, *sinzanga*. Located outside of but adjacent to the village, this grove is usually fenced off, or surrounded by huge and ancient trees. Access is restricted to members, who, over the course of their own and others' initiations, will attend countless rituals, ordeals, and instructions within its borders.

Among the art belonging to Poro societies are pairs of large or medium-size carved figures (fig. 5-22). Each pair portrays a male–female couple. Often called Poro, the spirit figures are brought out to reinforce the teachings of the society at initiations, and they appear as well at funerals of Poro members and their wives. The instructional uses of the figures are probably many. Few, however, have been confided to outsiders. We know that the paired figures are emblems of marriage, that they represent as well the primordial founding ancestors spoken of in creation legends, and that they also represent twins, which are sacred to the Senufo.

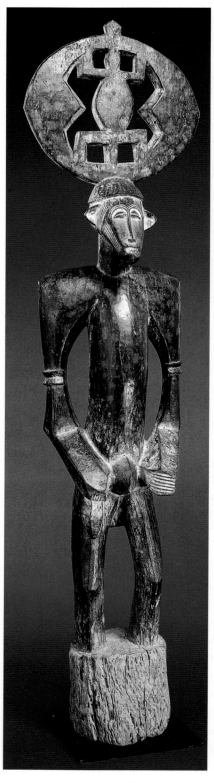

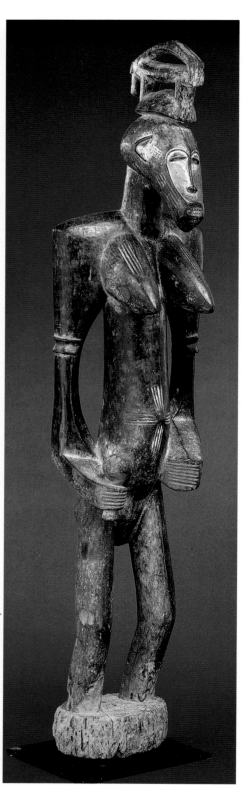

In some regions paired images—which are also spirit figures—are carved with particularly massive bases (fig. 5-23). Known as "rhythm pounders," such figures are carried in procession by initiates, who swing them from side to side, striking the ground rhythmically. This is said to purify the earth and to call ancestral spirits to participate in the rites. The male figure here wears a Poro age-grade emblem headdress. While the headdress and extended base make his figure the taller of the two, his actual body is portrayed as smaller than the woman's. Senufo society is matrilineal, and the dominant female presence often found in such paired figures reflects the importance of females in Senufo life and thought.

The importance of women is explicitly acknowledged in statues of a personage known as Ancient Mother, who is typically depicted holding a small child on her lap (fig. 5-24). Ancient Mother is considered the head of Poro, as exemplified by the saying: "Poro is a woman." The sacred grove is considered to be her ward, or compound. She represents the female aspect of creation and is the founder and guardian of the matrilineage. She is the spiritual mother of all Senufo males who pass through Poro, and, metaphorically, the mother of the community itself.

According to some scholars, carvings of Ancient Mother are deliberately non-naturalistic so as to emphasize her symbolic rather than her biological roles in Senufo culture. A statue of Ancient Mother is shown to novices during the Poro learning process, in part as an indication that beyond the obvious lies the hidden, an idea also exemplified by the secret Poro

5-23. Pair of "rhythm pounder" figures. Senufo (Kulebele). 20th century. Wood, height of male 45⅝" (115.9 cm), height of female 38⅛" (96.8 cm). Collection of Milton and Frieda Rosenthal, New York

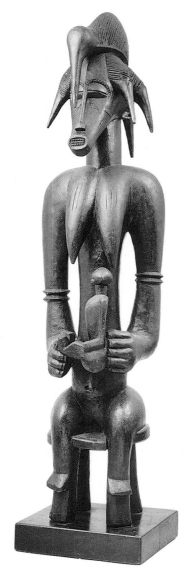

5-24. Figure of Ancient Mother. Kulebele carver for Senufo patrons. 20th century or earlier. Wood, height 36¾" (93.5 cm). The Walt Disney–Tishman African Art Collection

language learned by novices. Initiation begins with boys being taken from their biological mothers to enter a period of dislocation in the compound of Ancient Mother and under her care. Ancient Mother absorbs the young novices, who are not yet seen as human. She will symbolically give birth to them many years later, after their initiation is complete. New initiates undergo a symbolic death through such rituals as crawling through a muddy tunnel. They are reduced to a kind of emptiness, a liminal or in-between status. Over the long course of their initiation, they confess their breaches of acceptable behavior, and undergo intensive instruction in the male arts of living and in the Poro language and other lore. They submit to numerous ordeals and tests, including small cuts inflicted by Ancient Mother's "leopard." At one point, they pass through a narrow opening called "the old woman's vagina" to enter a symbolic womb. At the end of the process, tutors lead graduating initiates out through an actual door, signaling their rebirth as issues of Ancient Mother. Now fully socialized men and complete human beings, they have been nourished by the "milk of knowledge" at their Mother's breast, as is keyed in the carving's iconography. Only superficially a biological nursing mother, then, an image of Ancient Mother is a veiled and rather abstract sign of the systematic body of knowledge acquired by Poro initiates.

Sandogo

The women's parallel to Poro, Sandogo, is a society that unites the females of a Senufo community. Its members, called *sando*, are trained as diviners. Collectively, they protect the purity of the several community matrilineages and maintain good relations with a hierarchy of supernatural beings.

Diviners' shrines, which function as consulting chambers, are themselves works of art and they contain others. Shrines are small, round houses barely large enough for the diviner, her client, and her apparatus (figs. 5-25, 5-26). Invariably there will be images of the sacred python, *fo*, the principal messenger between humans and supernaturals. Pythons appear in shrines as relief sculpture in mud, always on the inside and often outside, as well as on diviners' metal bracelets and rings. There will be a calabash rattle for calling the spirits, too, and an important set of small objects—castings, stones, bones, shells, and assorted other items that are sifted and "read out" by the diviner to determine the needs of a client. Shrine statuary nearly always includes a fairly small female and male couple in wood, and sometimes one or more small brass figures. These represent nature spirits believed to inhabit the bush, streams, and fields beyond the village. Ambiguous and capricious, these spirits both cause and cure sickness and other problems, and it is they who order, through the diviner, a course of action for the client.

The spirits may order a client to commission and wear one or more brass amulets (fig. 5-27). Made by the lost-wax process, these small sculptures are the work of brasscasters who live in their own ward in the community. Amulet motifs include chameleons, turtles, crocodiles, snakes, birds, various quadrupeds, and twinned images. The motif of twins presents another aspect of the male–female duality that permeates Senufo thought. As is the case among many African peoples, the birth of twins is an auspicious yet equivocal event for the Senufo. Twins are considered lucky, but of course they bring

5-25. Interior of a Senufo
diviner's shrine, Côte d'Ivoire.
1979

*Fo, the messenger python, is
modeled and painted on the wall
behind a group of carved figures
depicting male and female bush
spirits. The figures wear
garments made of a sacred fabric
called* fila, *which is woven of
cotton and dyed with mud and
vegetal pigments by Jula
craftsworkers. Making their will
known through the diviner,
spirits might order a client to
wear a similar* fila *tunic for
protection or to heal. The pile of
objects in the foreground
includes varied symbols of the
bush spirits consulted by
diviners, including metal jewelry
such as bracelets and rings.*

5-26. Senufo diviner with client.
1975

special burdens to their mothers,
who are more susceptible to disease
and mortality than mothers of a sin-
gle child. Following creation stories
about the first Senufo couple giving
birth to identical twins, a girl and a
boy, twins should be of opposite sex,
as paired diviners' carvings are. If
they are of the same sex, or if one or
both twins should die, their spirits
can bring either danger and misfor-
tune or, if properly placated,
blessings and prosperity. Thus many
people in families that have or in the
past had twins take various precau-
tions to acknowledge and invoke
twin spirits, including the wearing of
twin amulets.

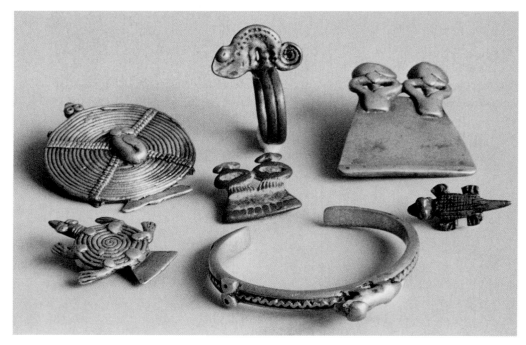

5-27. Amulets and *yawiige* charms. Senufo. 20th century or earlier. Brass. Private Collection

*These divination ornaments are worn as protective charms as prescribed by Senufo diviners.
Animals especially associated with spirits of land and water, and as messengers to God, include
from upper left to right: tortoise with mudfish, chameleon ring with a twins band, twins; lower left
to right: tortoise, twins, python bracelet, crocodile.*

Many forms of Senufo personal adornment, including scarification, amulets and other jewelry, and certain garments, serve multiple purposes. Pleasant to wear and behold on the one hand, they are also a form of communication with unseen spirits and reminders or reiterations of basic values or cosmology. Women, for example, wear four sets of three scars radiating from their navel, like those depicted on the statue of the woman in figure 5-23. Called "male–female twins," the scars celebrate each woman as a source of life and the guarantor of lineage continuity. They link her with Ancient Mother and with the primordial couple, whose first children were twins.

Sandogo and other shrines were occasionally fitted with finely carved doors (fig. 5-28). The motif on the central panel of this example seems to have multiple interpretations, all of which reflect upon each other. At the most abstract level, it evokes the four cardinal directions that order the cosmos. It can also be seen as a bird's-eye view of the orderly divisions of a farmed field, a symbol of human culture. The circle at the center has also been convincingly interpreted as a navel, and the radiating elements as evoking a woman's scarification pattern and its attendant symbolism. In the lower panel are depicted at least four, and perhaps all five, of the primordial creatures that shared the earth's beginnings with the original couple: python, tortoise, hornbill, crocodile, and chameleon. This lower panel may also be seen as portraying the idea of wilderness, competing supernatural forces, or untamed nature. The upper panel in contrast appears to present the spheres and symbols of civilized

5-28. Door with relief carving. Senufo. c. 1920s. Wood, 67 5/16" x 25 9/16" (171 x 65 cm). Collection Helmut Zimmer, Zürich

human life: a hunter and a leader (or warrior) on horseback, and face masks exemplifying Poro, the main unifying and socializing institution in Senufo culture. Creation stories credit the hunter with separating the humanized world of the village from the wilds beyond. If this interpretation is correct, doors like this marked the potentially dangerous threshold between the profane world outside and the sacred interior of a shrine by portraying several levels or types of order, power, and knowledge, including as well the essential creatures that populate these worlds.

Masks and Masquerades

The male–female dialogue so evident in Poro and Sandogo arts is implicit as well in Senufo masking. The Senufo have a large corpus of masks. Most masking is directed by Poro, and much of it is involved with the progress of initiation in its various phases. Maskers also perform at funerals and other public spectacles, and it is these contexts that are explored briefly here.

The most recurrent type of mask is a small face mask with clear, refined features (fig. 5-29). Danced by men, these masks perform as female characters. They exist in hundreds of variations, with many different names. Their symbolism is usually both rich and esoteric; invariably they represent far more than meets the eye. Many encode Poro knowledge, and appear in restricted Poro dances as well as in public dances that anyone may attend. Still others are owned by non-Poro organizations. Different versions, too, are made by carvers, blacksmiths, and brasscasters for their separate Poro groups, as well as by Jula weavers. For these reasons, it is normally impossible to understand the full symbolic ramifications of any one mask without complete field data.

The masquerader shown here wears a mask made of brass. He was photographed at the funeral of a female elder in a blacksmith Poro, one of several maskers, all initiates of the middle grade, who danced at this event. Funeral dancing is competitive, yet it is most essentially a celebration of the life and family of the deceased. The youthful energy of the dances is reinforced by the bright

One popular female character, called "Beautiful Lady dance mask," wears a wooden mask with glistening black surfaces (fig. 5-30). Performed by a man, the dance incorporates women's gestures. A masker, for example, might rest "her" horsetail flywhisk on a ruler's shoulder to honor him, as a woman would do.

The other most recurrent Senufo mask type is the zoomorphic helmet mask, a form common to many West African peoples (fig. 5-1). Viewed as male, these composite, horizontal masks usually play more spiritually forceful, even violent and threatening roles. Like their female counterparts, they exhibit many variations in name, style, animal references, and symbolism, and they appear in both Poro and non-Poro contexts. Generically, the Senufo call them "funeral head mask," or "head of Poro," *kponungo*. Some types walk through, spit, or otherwise manipulate fire, giving rise to the name "firespitter," an outsider's designation that should be used cautiously, as many other masks of similar form have nothing to do with fire.

The mask illustrated here includes many iconographic details that relate to the origin of the world, to important legends, and to the roles of certain animals in carrying out obligations to both ancestors and nature spirits. Quintessentially composite and even deliberately ambiguous, it fuses elements of antelope or buffalo (horns), crocodile (jaws), hyena (ears), bush pig or warthog (tusks), and humans (eyes), while incorporating a stylized hornbill and chameleon between the long horns. The latter two animals, present at creation, refer to specific sorts of knowledge to be mastered by Poro initiates. Combined, the animals are an

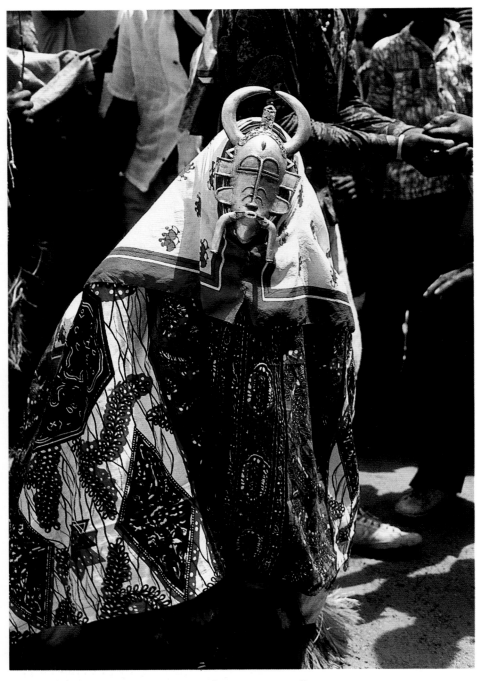

5-29. BRASS MASK IN PERFORMANCE AT A SENUFO FUNERAL, BOUNDIALIANA. 1950S; PHOTOGRAPH 1984

scarves and cloths worn by the masker as emblems of civilized life, and by active arm movements. In contrast, the mask itself is meant to remain nearly motionless. These forms, materials, and gestures are all considered

nayiligi, "freshly beautiful," by the Senufo, and it is the complete character in motion that needs to be understood as a work of art, not its individual elements of mask and costume.

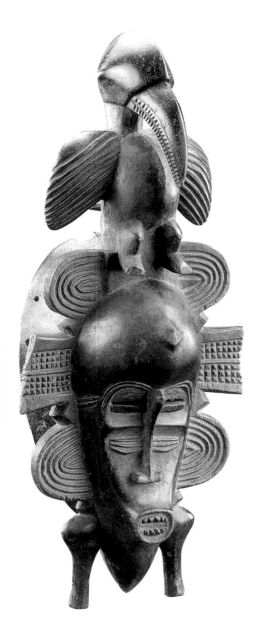

5-30. "Beautiful Lady" mask. Senufo. Wood. Musée Barbier-Mueller, Geneva

embodiment of aggressive supernatural power associated especially with the wilderness, powers which are reinforced in Poro through blood sacrifices and incantations.

These bristling masks are critical participants in certain funerals conducted by Poro, when they help to expel the soul of the deceased from the living community. The mask seen walking over the wrapped corpse in figure 5-31 is a variant called *gbon*, an antelope–baboon composite. The soul of an important dead person is believed capable of escaping from the body during the period between death and burial to wreak havoc among the living. Thus maskers, along with drummers and other supernatural forces marshaled by Poro, must control the soul until it is expelled. While other masqueraders attend, *gbon* straddles the cloth-wrapped corpse and,

moving from head to foot three times over, effects the expulsion of the soul. The soul is sent to the ancestral village; the body is buried. Interestingly, the same maskers are also present at the symbolic death of new Poro initiates. Here, their purpose is to aid in the creation of a new being; there it is to create a new ancestor. In both instances maskers guard and guide dangerous and uncertain liminal periods, times when human beings are transformed from one status to another.

Secondary or more popular masqueraders dance for the large crowds attending important funerals, often attended and urged on by musicians and a dozen or more initiates who collect the cowrie shells showered on the masked dancer in honor of his skill. Principal maskers also greet elders, chiefs, and other

5-31. *Gbon* and other maskers performing at a Senufo funeral, Dikodougou district. 1970

..

Gbon is accompanied in this illustration by several non-Poro fiber masks (in the background) called nafiri. *The latter are owned by a particular woman and her family, commissioned by her according to the instructions of bush spirits, as conveyed through divination. In addition to appearing at funerals, these masks go to the agricultural fields annually with their owner and her family to sacrifice to the bush spirits. Very similar* nafiri *may be owned by a Poro association.*

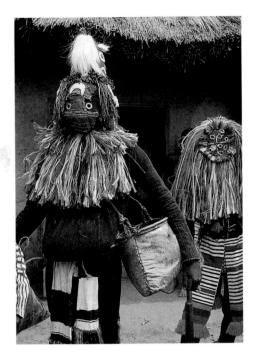

5-32. *YALIMIDYO* MASKS IN PERFORMANCE, DIKODOUGOU DISTRICT. SENUFO. 1970

important onlookers. Masquerades therefore provide entertainment at the same time that they fulfill ritual obligations on behalf of Poro and the ancestors.

Quite a few other mask types are danced by Senufo men both within and beyond Poro and funeral contexts. Various types of fiber masquerades (with fully concealing costumes) are important beings in all Poro groves, and are normally renewed for each initiation cycle by members of the senior grade (fig. 5-32). The maskers shown here, called *yalimidyo* (or *yarajo*), speak through a voice disguiser for Ancient Mother, the ancestors, and the elders. At once satirical clowns and serious spokesmen of Poro values and wisdom, these spirit beings have multiple and crucial roles in initiations, funerals, and as an instrument of policing and social control. The mask wearer must be par-

ticularly adept in aphorisms, punning, and other eloquent uses of Poro language. His costume is variable, being reinvented periodically and within a spirit of aesthetic competition: a harlequin-like assemblage of colorful stuffed fibers and bright textiles with metal and cloth appliqué, braiding, yarn, and other decorative flourishes. The masking ensemble represents well the Senufo aesthetic of *nayiligi*, which references vigorous youthful beauty, a much sought after quality. At funerals *yalimidyo* extorts money from participants and mocks those wearing Western clothes or otherwise flouting accepted behavior. Part of his ritual duty is to challenge the men present, in the secret Poro language, to determine which among them may remain for the burial rites restricted to Poro initiates. The masker also blesses people in the name of the ancestors, calling for good health, prosperity, and many children. His deliberately pregnant belly refers metaphorically to the rebirths signified in both initiation and funerary rituals.

Places of Assembly and Celebration

The foregoing discussion of Senufo arts may mislead readers into thinking that art is present and constant in everyday life, which would strongly distort the true picture. In fact, day-to-day life is rather dull and repetitive here as in much of the world. Whatever art may be present is largely hidden away in diviners' chambers, in shrines, and in Poro groves for occasional use. When displayed during funerals or initiations, art forms emerge as transient and ephemeral phenomena, affective and striking

breaks from the relative monotony of normal life, providing color, drama, vibrant action, music, crowds, and feasting.

Festivals compress into short compass and expressively integrate the most revered values of Senufo life. Funerals reiterate and make public arts normally restricted within Poro groves, adapting them to public spaces and assemblies. Overt displays of *balafon* and drum music, singing and dancing, costuming and masquerading, drinking and feasting may prevail in these relatively brief public versions, but many of the more covert and esoteric symbols and gestures are there too, as if to remind Poro initiates and elders of the cosmology, history, and values of their people. Dangerous bush spirits are there, though controlled, in the open jaws and sharp-quilled accumulations of composite masks, and guests present for the funeral are tested in their knowledge of Poro traditions by the only apparently jocular *yalimidyo*. The founding couple of the senior matrilineage is there symbolically (or at least was before such figures began to be stolen and sold to art dealers, around 1960), in the carved female and male figures displayed near the *kpaala*, Poro's public shelter in the center of northern Senufo villages (fig. 5-33)

The roof of the *kpaala* illustrated here is strikingly reminiscent of roofs on Dogon *togu na* (see fig. 5-15). The similarity suggests historical relationships between regional segments of these two Gur-speaking peoples. Ideally stacked with six and one-half layers of logs laid down at right angles, the *kpaala* roof alludes to the Poro initiatory process, each phase of which lasts six and one-half years. The roof

*In addition to wood sculpture
by Kulebele and other
carvers, figures made by
brasscasters are also popular
with tourists, along with
paintings on cloth of animals,
simplified versions of local
masks, and adaptations of
sacred* fila *cloth. Some of
these wares are also visible
on and hanging behind the
trader's table here.*

reminds the elders who convene there,
and indeed all members of Poro, of
their obligations and of their rebirth as
men from Ancient Mother.

Tourist Arts

By the middle of the twentieth cen-
tury, continuing modernization,
conversions to Islam and Christianity,
and local iconoclastic religious move-
ments had diminished local demand
for the works of Kulebele carvers. At
the same time, the arts of Africa, espe-
cially those of Côte d'Ivoire, began to
attract a broader audience in Europe
and the United States. More recently,
tourism has brought increasing num-
bers of these outsiders to West Africa.
The Kulebele and other Senufo artisan
groups have responded by creating art
works for this new and growing mar-
ket. Since the 1950s, they have in all
likelihood produced more art works
than were created during the entire
nineteenth century. Art has come to

serve as a kind of "cash crop," generat-
ing income, sometimes even wealth,
for thousands of people.

The expanding city of Korhogo, in
Côte d'Ivoire, has been the main center
for this production and its trade, and it
was there that this photograph of
wares was taken (fig. 5-34). Tourist arts

vary widely in quality. At the lowest level are great quantities of hastily and crudely carved renditions of "traditional" forms. Visible across the back of the table, they are often bought cheaply in bulk by traders who take them to large cities to sell. At the highest end are beautifully carved works, some of which depart from earlier forms. The comparatively small number of skilled men who carve on this high level are often innovators, inventing new forms as well as continuing earlier ones. They work mainly on commission, and, as one might expect, their output is small. They fill commissions for Poro and they make replacement images for older carvings that have been bartered, purchased, or even stolen from shrines or Poro groves. Some carvers, or their kinsmen, have also become rich selling objects known as "antiquities," a word that in this case simply means "used in a traditional context, and often with a surface or patina that betrays apparent age."

5-35. Figure of Kafigelejo. Kulebele. 20th century. Wood, feathers, quills, cloth; height 28¾" (73 cm). Musée Barbier-Mueller, Geneva

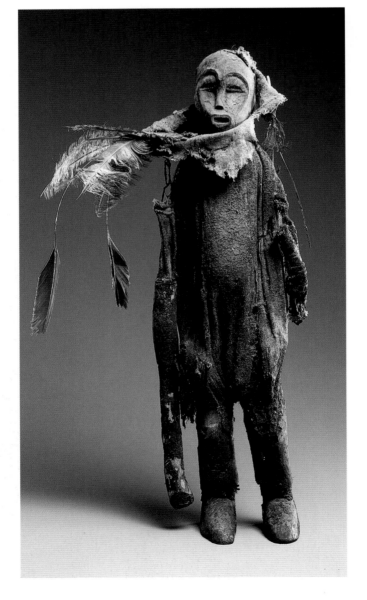

Two factors have helped Kulebele carvers cultivate this market for their work so successfully. The first is their traditional control of carving woods, that is, their long-standing asserted right to fell trees and use their wood without payment to people whose land they grow on. This assumed prerogative links with the second factor, control by Kulebele of supernatural sanctions located in a powerful deity called Kafigelejo, who is materialized as a wooden image wrapped in cloth soaked with supernaturally charged substances (fig. 5-35). Threats of Kafigelejo's powers have been enough to instill fear in many who deal with carvers, giving them an advantage in many transactions. This supernatural sanction, not available to anyone but Kulebele, has helped protect the carvers' control. It also represents the quite recent introduction of a kind of power figure—a wooden form with composite additions that we might easily assume was "old and traditional" if we were not aware of its history.

One of the results of these fairly new markets and the lively full-time artistry they support is an increased level of competence on the part of many artists, along with experimentation and innovation in the effort to create new sales. Thus many of the objects coming out of workshops differ from earlier forms. Ironically, Western collectors who purchase them probably do so in part because they assume them to be "traditional." In fact, African art has always been subject to change. The main reason that European and American collectors think of some African objects as "the most real and authentic" is because these were the arts that flourished

when they were first recorded in the late nineteenth and early twentieth centuries. The creative additions made to the Senufo corpus since about 1950 should be seen as continuing long-established patterns of change. The major change, of course, is from local to international patronage, with many implied differences in the meanings and values of the arts to both their consumers and their producers.

RELATED PEOPLES OF BURKINA FASO

The various peoples of Burkina Faso are agriculturalists, and most speak Gur languages. Formerly known to scholars as the Voltaic peoples (after the former names of the three rivers that drain the region, the Black, Red, and White Voltas), they are today increasingly referred to collectively as the Burkinabe. Among these are a dozen or more groups, some quite small, with distinctive art forms and styles. Aspects of the arts of four of these peoples will be surveyed briefly here: the Lobi, the Bwa, the Mossi, and the Nankani.

Lobi Sculpture and Metalwork

About 160,000 Lobi live in Burkina Faso, Côte d'Ivoire, and Ghana. Formerly warlike, even among themselves, they occupy defensible compounds with narrow openings and fairly high walls. They are primarily agriculturalists, like other groups examined here, with millet, sorghum, and corn fields surrounding their somewhat randomly dispersed compounds. These houses from about a dozen or so people to sixty or eighty members of an extended family under

the leadership of one older man, the family head.

The boundaries of Lobi communities are difficult to discern visually, for there is no center. Villages are comprised simply of several compounds living under the rules, protection, and beneficence of a particular deity, *thil* (plural *thila*), associated with their land. Each family compound too has at least one presiding *thil*. Social behavior is regulated and adjudicated by these *thila*, whose will is passed to ordinary

people by priests and diviners. It is *thila*, for example, who order sculptures and other art forms to be made. The most important of these forms is the clay or wood sculpture called *bateba* (fig. 5-36). Human-like in form, a *bateba* acts as an intermediary between a particular *thil* and the human community.

Lobi carvers derive no special status from their work, perhaps in part because anyone can carve without specialized training. They are paid little;

5-36. FIVE *BATEBA* FIGURES. LOBI. WOOD, HEIGHT 10¼–18″ (26–45.5 CM). MUSEUM RIETBERG, ZÜRICH

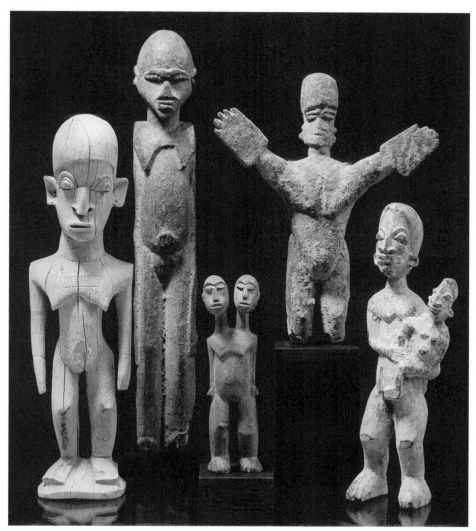

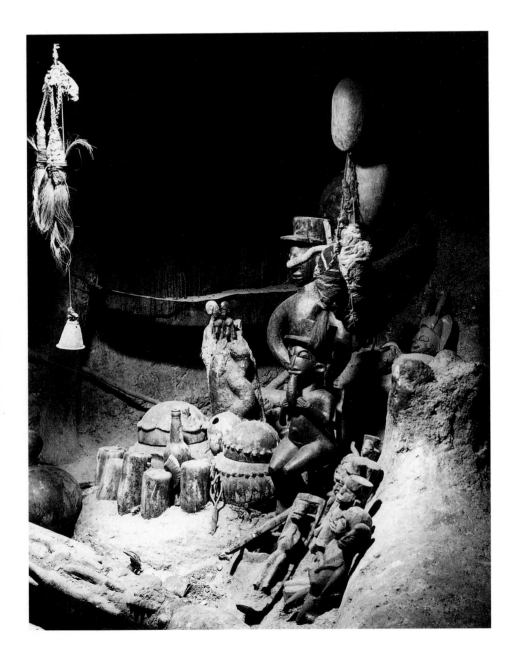

5-37. Shrine with *bateba* figures of wood, clay, and terracotta, Midebdo region. Lobi. 1980

indeed, some *thila* are said to adversely affect a carver who takes any money at all. As a result, Lobi carvings are highly variable in style and degree of finish, a fact that does not in the least hinder their effectiveness in shrines. What seems to be more important to the Lobi, or better, to their *thila*, is that a *bateba* act, for it is considered a living being able to see, communicate, and intervene on behalf of its *thil*. While stylized, *bateba* are complete in having the usual body parts, although most are highly simplified in their artistic renderings. Normally, as here, heads are enlarged, perhaps so the work of the god will be more effective. Other features may reflect specific powers. *Bateba* expected to fight for their owners, for example, have big hands. Others, considered dangerous, block entrance to harmful forces such as disease or witchcraft, and are depicted with one or both arms held up. Still others have sad expressions because their function is to mourn for their owners. Figures with two heads represent deities whose ability to see in several directions at once makes them exceptionally dangerous and powerful. Images without any specially defining posture or expression, and considered "ordinary" by the Lobi, nearly always have faces that can be seen as grim or angry, for it is thought that only in such a state can the *bateba* act forcefully. Such visual clues to meaning are not always clear, however; the Lobi themselves have conflicting and ambiguous interpretations of their imagery, and regional variations complicate things further. Thus it is always preferable to have data from specific shrine contexts.

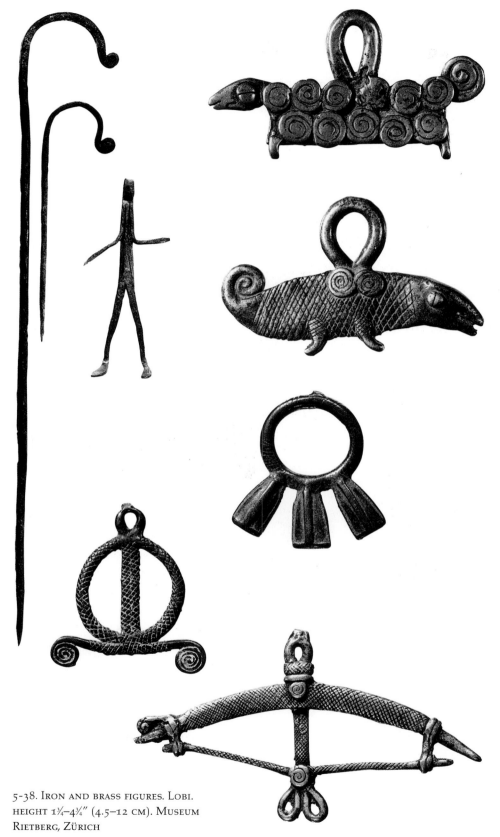

5-38. Iron and brass figures. Lobi. height 1¾–4¾" (4.5–12 cm). Museum Rietberg, Zürich

Thila may be "found" or "taken." A deity is "found" when it appears as a piece of iron in the bush or when it affects someone strongly, usually through sickness or misfortune. A deity is said to be "taken" when its *bateba* is bought from the original owner and set up in a new shrine, where it continues its work. While shrines may be similar in appearance, each is in fact the unique result of orders received from the resident *thila* through a diviner. Some *thila* first want a roof terrace shrine, for example, and later request another inside the house or in a small separate building. The *thila* order what sorts of things the shrine must be equipped with; these often include sculpted figures of wood, clay, or metal, implements such as canes or bells, and ritual pottery. Many of these are present in the shrine in figure 5-37, which also includes bottles, other containers, and seashells, all as ordered by the god. A deity's request can be quite detailed: material, size, pose or gesture, facial expression, and other attributes may all be specified. Many of these differences are meaningful in the context of the god's shrine, priest, and work. A god is believed to work for its owner/finder and his or her family after sacrifices have been made, and it will continue to work (protect, injure, heal, hinder, etc.) so long as its regulations are followed.

Lobi arts also include a wide variety of small human and animal images, implements, and more abstract symbols in copper alloy and iron (fig. 5-38). Some of these are worn as jewelry—ordered by a deity and for the most part protective (as among the Senufo)—and some appear on shrines. Their iconography is not fully known,

but at least some of these small sculptures have fairly specific work to do for the *thila* who ask for them on behalf of their owners, whether custodians of shrines or the people who wear them as charms. Small human figures of iron ("black metal") or brass ("red metal") fight against witches, sorcerers, or other invisible dangers, while chameleons bring riches and prosperity. Snakes appear in many sizes and shapes in both metals, worn on different parts of the body— strapped to lower legs, for example, as bracelets or chest ornaments; they are especially common "workers" for the *thila*, and serve many offensive and defensive roles. Spears, knives, or bows-and-arrows are weapons used by *thila* on behalf of their owners, and similarly, miniature pliers are tied around childrens' necks so the *thila* can "hold"—that is, protect—them well.

Notably, the Lobi are surrounded by people who devote much energy to masquerades, but they themselves have no masks. The reasons for this are not clear but may relate to their lack of age-grade organizations.

Bwa Masquerades

The Bwa people inhabit a region in northwestern Burkina Faso and extending into Mali. Each Bwa village is governed independently by male elders. Communities comprise three occupational groups: farmers (in the majority); smiths, who forge tools and cast brass, and whose wives make pottery; and bards and musicians, who also weave and dye cotton and work leather.

A religious organization called Do, a Mande-derived term for "secret"

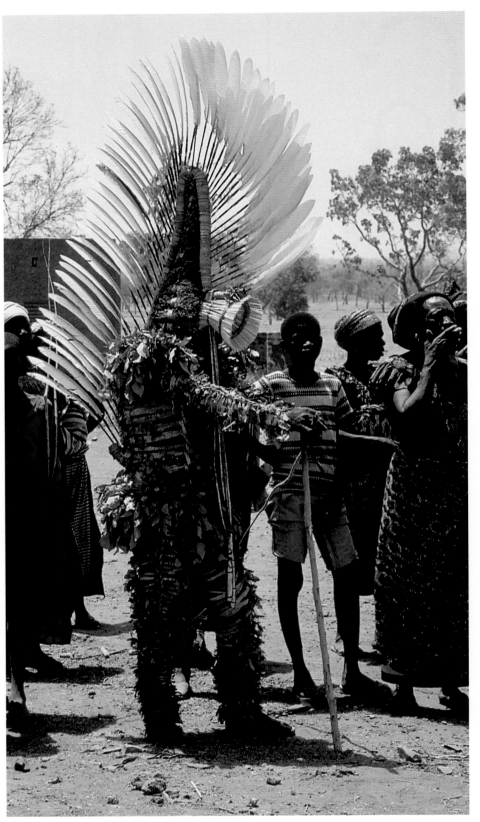

5-39. Do grass mask in performance, Boni village. Bwa. 1985

or "spiritual," is a major unifying force in Bwa life. Each community has a Do congregation, led by the earth priest. Do is at once an organization and an anthropomorphic being, the son of the remote creator god. Considered androgynous, Do represents and embodies the life-giving powers of nature, especially the untamed bush. Do is incarnated at initiations and village purifications, held just after crops are planted, by an otherworldly spirit masker whose "skin" is vines, grasses, and leaves (fig. 5-39). In some areas, the vivid leafy green body is topped, as here, by an arcing crest of brilliant white eagle feathers. A conical tube of basketry in front forms a kind of mouth. Deliberately and radically non-human in shape, color, and behavior, these sacred organic maskers celebrate life and help renew the forces of nature. Their power extends also to human fertility. The use of fresh verdant plant material in Do's costume directly evokes its function of regeneration. In wooden masks, on the other hand, a more abstract form of symbolism prevails

Bwa wooden masks embody bush spirits, who are invoked to benefit humankind and the natural forces on which life depends (figs. 5-40, 5-41). Some masks depict creatures of practical or ideological importance more or less directly. The tall mask leading the procession in figure 5-40 represents a serpent. A monkey and a buffalo follow. A hawk mask, conceived as a beak projecting off a horizontal plank form, performs its twisting routine at the center of figure 5-41. Other creatures depicted in masks include fish, antelope, bush pigs, roosters, and butterflies. A second type of wood mask is more abstract, and consists of

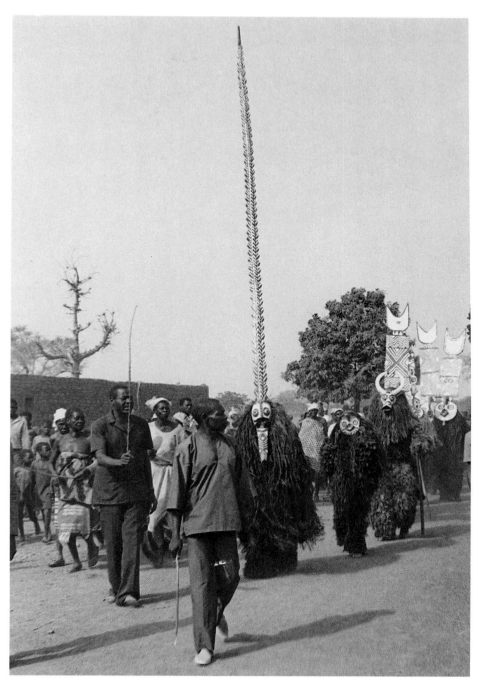

5-40. Serpent, monkey, and buffalo masks in performance, Pa village, Burkina Faso. Bwa. 1984

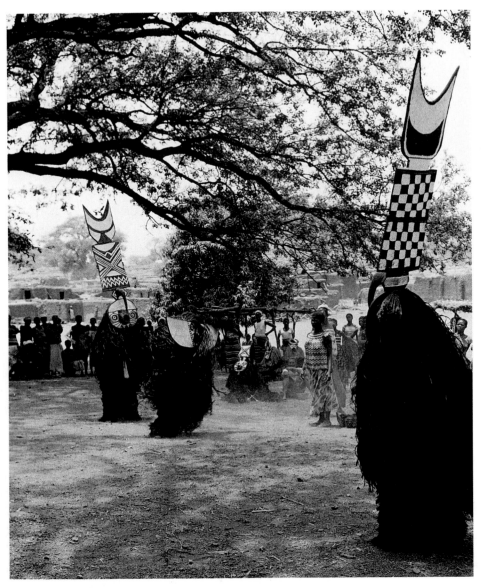

5-41. Hawk mask in performance, watched by two plank masks, Dossi village, Burkina Faso. Bwa. 1984

together). It seems that at first only relatively simple meanings are imparted; more esoteric content is revealed as the initiates mature. Thus the interpretations of graphic signs vary according to age and initiatory level, as well as region. Few meanings, though, are codified or shared over time or space, even if the signs themselves—chevrons, zigzags, X's, crescents, checkerboard patterns, concentric circles, sculpted hooks, and others—are widely distributed not only among the Bwa but also among neighboring Gurunsi peoples such as the Nuna and the Winiama, with whom many mask types originated. Similar signs appear as well on Mossi and Dogon masks. It would seem that the symbolic interpretation of mask motifs is deliberately left open among the Bwa, enabling a tutor to incorporate the latest or most important local teachings, thereby best preparing novices for adult life at that particular place and time.

Bwa wooden masks stand in some degree of tension to Do leaf masks. Leaf masks are clearly the more ancient and indigenous form, and it is acknowledged that wooden mask types have been borrowed or purchased from neighboring peoples. In addition, wooden masks act as a divisive force in that they tend to foster competition, with families or clans vying fiercely to create the most elaborate, innovative displays. Leaf masks, on the other hand, cut across family or lineage divisions and act as a unifying force. Where leaf and wood masks coexist in the same communities, they perform separately and belong to rival religious associations. In some southern Bwa villages where both types appear, leaf mask owners consider wood mask

shaped, partly openwork planks surmounting a normally circular facial section. Visible at the right in figure 5-40 and watching the hawk dance in figure 5-41, these masks embody ideas such as "the spirit of growth," dwarf spirits, or other supernatural forces not readily apparent visually.

Nearly all wood masks are painted in black, white, and red with high-contrast geometric signs. In general these are symbols of cultural order, whether economic, political, or spiritual. Their meanings are imparted by older initiates to male and female novices (Bwa boys and girls in the same age-grade undergo initiation

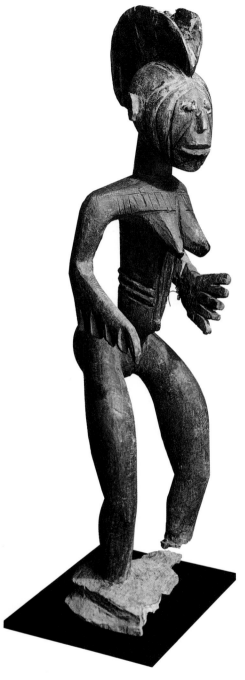

5-42. STANDING FIGURE. MOSSI. 19TH–20TH CENTURY. WOOD, GLASS, METAL BEADS. PRIVATE COLLECTION

users as heretical parvenus and forbid them to participate in Do rites. In the northwest, however, the two mask types embody a beneficial nature/culture interaction. There, leaf masks foster growth in the spring, while wooden masks perform after the harvest to help integrate people into village culture by promoting respect for the rules of proper social behavior.

Mossi Sculpture and Masking

Far more numerous than the Bwa are the Mossi people of Burkina Faso, whose society is organized into states. Mossi states were founded during the fifteenth and sixteenth centuries, when horsemen arriving from a region to the southeast, in what is now Ghana, superimposed a language and centralized political systems onto the indigenous farming peoples, called *tengabisi*, "rulers of the land." This dual aspect of Mossi culture is recognized today in that the king, called the Mogho Naba, and other rulers called the Nakomse, descendants of the original equestrian invaders, hold themselves apart from earth priests, land owners, and elders, descendants of the original farming groups. Mossi arts too record this double heritage, as figural sculptures are owned and used ritually by Nakomse rulers in political contexts, whereas the *tengabisi* farmers dance masks owned by clans and lineages. Figures therefore represent political power and culture, leaning toward the secular, whereas masking invokes spiritual power, associated with the earth and other aspects of nature. However, the varied styles of Mossi masks and figures signal a more complex history of ethnic and cultural mixing in this region.

Most Mossi figures are carved in dynamic styles of simplified naturalism and in active poses (fig. 5-42). Most depict females. Some wear jewelry and cloth wrappers. The expressive pose of this figure, with bent legs, arms akimbo, and dramatic hand gestures, may emulate characteristic dance gestures of this area. The usual annual public outing of such rulers' figures is the year-end sacrificial rite, when royal ancestors are commemorated by dancing and feasting. In some places elders of local families bring tribute in the form of millet or other foodstuffs to the ruler, reinforcing their allegiance to him, while in other areas rulers ride out to their subject villages after sacrifices have been made to ancestors through the figures. As is common elsewhere, ancestors are believed to reward proper behavior with human and agricultural fertility and productivity, or, alternatively, to punish transgressors with disease or misfortune.

Ownership of such figures, including those that belonged to earlier leaders, affirms a king's or other leader's secular right to rule. Mossi masks, in contrast, embody spirit powers, nature spirits of the sort found among many farming peoples. In some regions masks are housed within ancestral shrines during periods when they are not being danced, to be augmented by ancestral powers that control the earth and productivity, all in the service of the well-being of the people and their natural environment. Although they do not evoke ancestors strictly speaking, the spirit masks partake of and seem to contribute to ancestral power. A typical mask from the Mossi Yatenga region

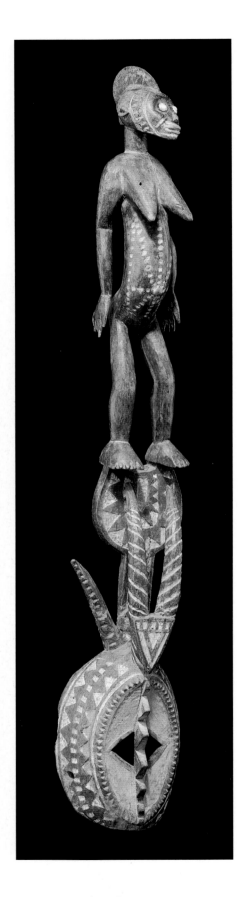

5-43. MASK WITH STANDING FIGURE. MOSSI. EARLY 20TH CENTURY (?). WOOD, HEIGHT 42¹⁵⁄₁₆″ (1.09 M). MUSEUM RIETBERG, ZÜRICH

Other masks in this style have tall openwork rectangular planks similar to Dogon sirige *masks. Since the Dogon live only about thirty miles away from this region of Mossiland, historical interchange is evident. Prior to the twentieth century, the Mossi tried repeatedly to conquer parts of Dogon country, but obviously shared art forms indicate that peaceful exchange has occurred as well.*

has a head section faced with an oval (fig. 5-43). The oval is bisected vertically by a notched ridge, with triangular eye holes on either side. Two sets of animal horns spring from the top, and behind them rises a short plank on which stands a finely carved female figure. The mask embodies a merging of bush and human powers, and suggests that human powers may be dominant. The human or animal figures or parts represented on such masks are spoken of by some scholars as "totemic," in that they represent sacred characters that participated in origin legends told by the clans or families that own the mask. At the same time they seem also to represent nature spirits responsible for the well-being of the land and people. The masks dance at funerals, agricultural rites, and other important community events.

Nankani Architecture

Most of the peoples of the Western Sudan live in mud or adobe compounds that vary in size, configuration, decoration, and content, just as the cultures themselves vary. In fact architecture and spatial concepts are strong cultural markers, and a shift in architectural style often signals even to casual travelers that they have entered a quite

different culture. Like the mask styles of Burkina Faso, which tend to share a geometric design vocabulary along with animal and human references, the built environments of the region have an overall earthbound, organic sculptural quality, emphasizing horizontality, but with local cultural and stylistic inflections. This chapter closes with a brief look at a domestic compound and its decoration among the Nankani, a Gurunsi people who straddle the border between Burkina Faso and Ghana.

The Nankani live in dispersed settlements. Surrounded by cultivated fields, their walled compounds are spaced between one and three hundred yards apart, and appear as if scattered across the landscape. In response to a long history of raiding and attempts at conquest, Nankani architecture evolved to become cleverly defensive. The plan in figure 5-45 depicts a relatively small compound, though it incorporates all the forms and ideas of larger versions. A single narrow entrance faces west. Outside the entrance in a cleared area is the open men's shelter. Immediately inside the entrance is the cattle corral. Dwellings are at the eastern side of the compound, their entrances oriented on a direct sightline to the single compound entrance. A low barrier just inside the entrance to each house

enables defenders to shoot arrows from the dark interiors at invaders advancing across the corral without themselves being seen (fig. 5-46).

The creation of living areas is a cooperative yet gender-specific venture. Men do most of the building, while women decorate wall and building surfaces inside and out. The compound itself is also viewed as gen-dered. Areas outside the compound are male-oriented, as is the corral inside; the further interior courtyards and dwellings are female-oriented. Visitors thus pass from public and male realms to increasingly private and female ones. Approaching the compound from the public realm out-side, the farm, they pass the exterior men's area or shelter. Passing the ancestor shrine to the left of the opening, they enter the corral, but must climb over a wall to reach the domestic, female-oriented court-yards. From these open areas, in which much activity takes place, they gain access to women's or men's houses, as well as to the roof (also much used), bathing area, and out-door kitchen.

5-44. NANKANI COMPOUND, SIRIGU, GHANA. 1972

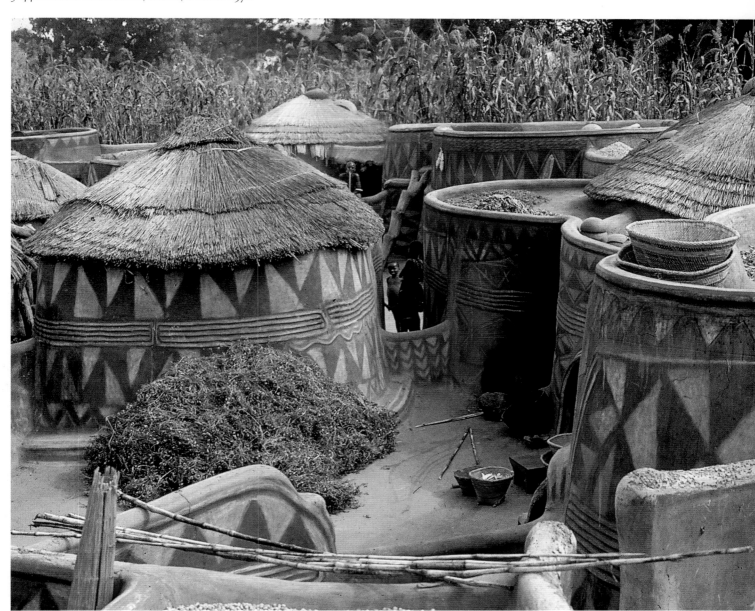

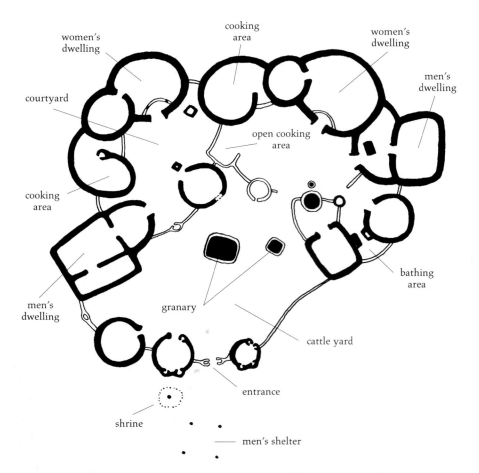

5-45. PLAN OF NANKANI COMPOUND. DRAWING AFTER J.-P. BOURDIER AND T. T. MINH HA

5-46. SECTION OF NANKANI COMPOUND, SHOWING SIGHTLINES FROM DWELLING ENTRANCE TO CORRAL. DRAWING AFTER J.-P. BOURDIER AND T. T. MINH HA

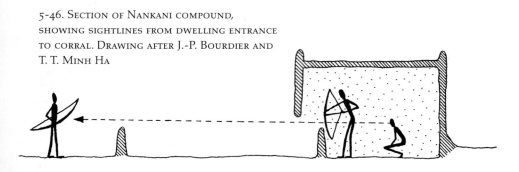

The Nankani recognize symbolic correspondences among house, woman, and pottery, stressing the woman as childbearer and nurturer. Women's houses, then, are also wombs, and indeed, the plan shows well the rounded, organic, even fetal shapes of both women's houses. In contrast, the two houses occupied by men in this compound are rectangular. A woman's house is a place of fertility and regeneration, where a woman conceives and nurtures her children, stores and prepares food, and enshrines her most revered possessions. Notably, these houses (and others) are built much as pots are, in courses, as if coiled. Like pots, too, their exterior surfaces are burnished with smooth stones and waterproofed after geometric patterns have been incised and pigments applied. Entries to houses and compounds are spoken of as "mouths"; doorways on women's houses are also called genital openings. Doorways are thus recognized as liminal spaces, vulnerable thresholds between places of contrasting quality and purpose.

Life transitions, too, are articulated architecturally. A woman's sideboard is called the "face of the deceased," for the senior woman, after death, is placed on her bed facing this carefully sculptured storage unit. Her death rituals also involve the breaking of her most revered calabash and her small personal, sacred pot. After a senior male's death, a hole is made in the house he slept in for the removal of his body directly to the farm area; thus the compound entrance itself remains undefiled by death.

The entire compound is embellished with and protected by richly meaningful, essentially geometric patterns (fig. 5-44). The single most

The protected interior spaces of women's houses include more private, intimate features: bed, food storage wall (a sort of "sideboard" where pottery is stacked and food stored, fig. 5-47), grindstone and sacred calabash net (fig. 5-48), interior cooking area, and shrines. A strongly sculptural quality, along with refined geometric decoration, marks the interior mud furniture, as it does the whole compound. A few representational motifs may appear inside houses, such as the birds perched on serpents and the crescent moon located behind the grindstone in figure 5-48, but most of the surface embellishment is rectilinear and abstract.

5-47. INTERIOR OF A NANKANI WOMAN'S DWELLING, WITH FOOD STORAGE WALL AND STACKED POTS; SIRIGU, GHANA. 1972

and people reinforces the symbolic relationships among them. The prevailing design vocabulary has a consistency across object types, a style that the Nankani and their neighbors know and recognize. The Kassena, the Nuna, the Kusasi, and other nearby peoples have similar yet distinct styles. Thus it is abundantly clear that art participates directly, even crucially, in ethnic and cultural identity here, as it so often does on the continent.

5-48. CALABASH NET AND GRINDSTONE IN A NANKANI WOMAN'S DWELLING, SIRIGU, GHANA. 1972

important decoration is a more or less continuous median band, ridge, or series of lines running horizontally around each structure. This is called *yidoor*, "lines running straight," a word that also means "rows in a cultivated field" and is used as well for the two parallel wooden base supports that strengthen the bottom of most baskets. The motif is also called "long eye," which signifies longevity, and it is sometimes rendered as a snake turning back on itself, probably suggesting eternity. All together these various associations state or imply continuity, unity, and long life for the family and dwelling so encircled. The decoration is also practical, as it deflects the course of rainwater and thus impedes erosion.

Other patterns are notable. A bisected lozenge design, visible on the dwelling to the right in figure 5-44, is called *zalanga*, the name for the braided sling that holds a woman's private calabash collection and her most revered objects and amulets, including her personal shrine (see fig. 5-48). Shapes are sometimes filled in with close cross-hatched grooves, producing a field of countless nubs called (and resembling) guinea corn. Additional patterns are named broken calabash, cane, potsherd, triangular amulet, men's cloth, and cloth strips, among others. The same triangular motif is called both filed teeth and neck of the dove, depending on how it is read, apexes pointing down or up. A few rounded motifs may occur, and occasional representational ones—usually animals considered family totems or familiars—but the overwhelming design vocabulary is angular and straight lined. The same rectilinear patterns are woven in baskets and applied to pottery. Analogous dense patterns are incised on men's and women's faces. The similar embellishment of houses, containers,

II. Western Africa

OSHUN FESTIVER
BATIC by NIKE
OSHOGBO
NIGERIA
1978

MAURITANIA

SENEGAL

THE
GAMBIA

Gambia

MALI

NIGER

JOLA BASSARI

Bissau

GUINEA
BISSAU

BIDJOGO

*Bissagos
Islands*

BAGA

GUINEA

BURKINA
FASO

BENIN

NUPE

TEMNE
SIERRA
LEONE
MENDE

Freetown

KISSI

CÔTE
D'IVOIRE

GHANA

Tada

NIGERIA

*Sherbe
Island*

TOMA

GURO

BAULE

Kumasi

YORUBA

Esie

Oshogbo
Ilesha

Niger

MANO
DAN

LIBERIA

Monrovia

Abomey

Ile-Ife

Ise
Owo

ATLANTIC

OCEAN

WE

KRU

LAGOONS

Abidjan

Tano

EWE

FANTE

Accra

Allada

FON

Wydah

Lagos

IBO

Benin
City

▲ *Igbo Ukwu*

Cross

URHOBO
KALABARI
IJAW

IBIBIO

ORON

CAMEROON

GULF OF GUINEA

0 400miles

0 700km

Kingdom of Benin
Kingdom of Dahomey
Yoruba Kingdoms
Asante and Akan Kingdoms
NUPE Peoples mentioned in text

6

WEST
ATLANTIC
FORESTS

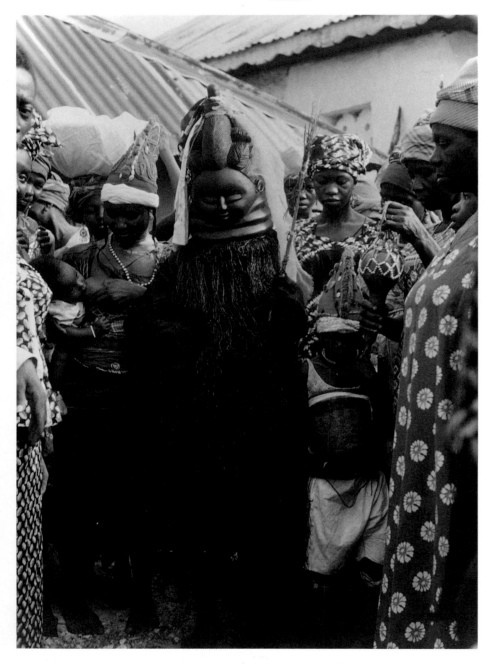

6-1. TEMNE *NÖWÖ* MASQUERADE WITH ATTENDANTS, SIERRA LEONE. 1980

IFTEENTH-CENTURY
Portuguese adventurers sailing
south along the arid coastline of
northwestern Africa came to the lush
green shores of a region they named
Guinea. For centuries to follow, Euro-
peans used the term "Guinea" to refer
to most of the West African coast (and
to the coins whose gold originated
there). Today Africa's westernmost
lands are often known as the West
Atlantic region, and its forested coasts
are divided between the nations of
Senegal, Gambia, Guinea Bissau,
Guinea, Sierra Leone, Liberia, and Côte
d'Ivoire.

Although all the peoples of the
West Atlantic coastal forests speak lan-
guages of the great Niger-Congo
family, those who speak West Atlantic
languages are believed to have been
the first inhabitants of the region.
Over the past five centuries these early
cultures have been displaced and
absorbed by the expansion of inland
cultures related to the Mande-speaking
peoples described in chapter 4. The lan-
guages of these later immigrants are
known as "core Mande" or "peripheral
Mande," depending upon their degree
of relationship to the speech of the
Malinke and Soninke. During the
nineteenth century, former slaves from
other lands of Africa, and settlers from
the Americas, added to the ethnic com-
plexity of the West Atlantic coasts.

Perhaps in response to these eth-
nic interrelationships, religious
associations in the region cross lin-
guistic and cultural boundaries. Art
forms connected to these associations
are shared by neighboring cultures
even when their languages are unre-
lated. On the other hand, peoples with
similar languages and cultural origins
may use very different types of art, or

use them in differing contexts. Thus the history of art in this part of the African continent is particularly difficult to reconstruct; even if the name and usage of one specific art object has been documented, similar undocumented works may have served a very different function in other places and in other times.

The arts of the West Atlantic forests include bold murals, elegant ceramic vessels, ornaments and instruments of metal, intricately woven fabrics, and dyed bark cloth. However, the region is particularly famous for its masquerades. This chapter shall therefore focus upon these multimedia performances, which in some groups address almost every aspect of life. Although women elsewhere in Africa are sometimes excluded from participation in masking, and they are usually barred from performing in wooden masks, here they may own particular types of masquerades, or even wear the masks themselves.

Masquerades bring together the creative efforts of sculptors, performers, attendants, musicians, and spectators. The artist who carves a wooden head or face for a masquerader may sometimes paint or embellish it, but usually the mask is ornamented and costumed by its owner. The dancer who performs a mask must be sensitive to both the expectations of its empowering spirit (as perceived by the performer and the audience) and the aspirations of its owner.

The ability to create art forms addressing many different needs has allowed artists from the region to sculpt art forms for foreigners with great success. During the fifteenth and sixteenth centuries, coastal artists carved works in ivory for Portuguese patrons, which found their way to the courts of Europe. During the nineteenth and twentieth centuries, new forms of art and architecture have been made for Muslim communities and foreign settlers. These inventive and innovative art works meld foreign traditions with the aesthetic heritage of the West Atlantic forests.

EARLY ARTS

Very few archaeological excavations have taken place in the westernmost forests of Africa, and thus little is known of art produced in the region prior to European contact. Yet significant works of art, including figurative sculpture in stone and ivory, were being made at least as early as the fifteenth century, when the Portuguese first arrived in the region.

Stone Figures

For generations, farmers in Sierra Leone and adjoining portions of Guinea and Liberia have unearthed small figures carved of soapstone and other types of rock. The imagery and the styles of these sculptures are quite varied, especially among those found in the lands now inhabited by the Kissi and Kono people. In lands now owned by the Mende people, farmers place excavated stone figures or freestanding heads in their rice fields or palm groves. Regarded as the representatives of previous owners of the land, the objects are given offerings and asked to bring abundant harvests. Unsuccessful, ineffective statues may be cursed or whipped.

The Mende call these stone images *nomolisia* (sing. *nomoli*) or *mali yafeisia*, "found spirits." When they find buried caches of metal rings, or of figures and heads adorned with rings, both the metal and stone objects are called "spirits of leaders," *mahei yafeisia* (sing. *maha yafei*). *Mahei yafeisia* are treated with great respect, and may serve as the visual and spiritual centerpieces of shrines and other assemblages of sacred material where important oaths are sworn.

Some art historians have chosen to use the Mende term *nomoli* for one distinct style of these stone figures, even though many examples come from non-Mende areas. Perhaps a better term would be "coastal style," since most are found less than a hundred miles from the ocean. Coastal-style (*nomoli*-style) figures have domed foreheads, full noses and mouths, and eyes which are precisely carved as spherical globes. An unusually long figure in this *nomoli* style may perhaps represent a corpse lying on a bier (fig. 6-2). The lines across the figure's mouth may depict a beard, common on figures in this style, or refer to the

6-2. RECLINING FIGURE. COASTAL NOMOLI STYLE. C. 15TH–17TH CENTURY. SOAPSTONE, LENGTH 14 3/16" (36 CM). THE BRITISH MUSEUM, LONDON

6-3. Head. c. 15th–17th century. Soapstone, height 10¼" (26 cm). The Metropolitan Museum of Art, New York

6-4. Bearded Rider. Inland/Pomtan style. After 16th century. Musée Barbier Mueller, Geneva

While the coastal ("nomoli") style apparently ceased to be carved after the cultural disruptions of the late sixteenth century, we have no way of dating objects in the diverse inland ("pomtan") styles. Some inland styles may be as old as the coastal style itself, yet others must be more recent; there is some evidence that Kissi and Temne artists carved stone images into the early twentieth century.

practice of binding a king as part of his installation ceremony, a ceremony still found among the Temne people today.

The sculpted stone head from Sierra Leone in figure 6-3 could have been called a *maha yafei* if it had been found by a Mende farmer. It is set upon a firm base formed by a thick, almost conical neck. Like other examples, this head was made as an independent work and did not once form part of a more complete figure. Although it shares some features with the coastal-style figures described above, some of its characteristics, such as the sharp division between head and neck and the upturned position of the face, are found only in other stone heads. As is common in these heads, the hair is sculpted in a topknot, and large rings are shown in the ears. The heavy eyelids, almost closed, give the oval face an expression of reserved calm.

When the Kissi of Guinea and parts of Sierra Leone unearth stone figures (including those in a coastal style), they identify them as "the dead," *pomtan* (sing. *pomdo*). A Kissi farmer who finds a carved image has dreams linking it to a deceased family member. The dreams allow him to name it, and to place it, together with smooth uncarved rocks, in a community altar dedicated to the ancestors. It may be first adorned with beads or coins and surrounded by cloth wrappings or a wooden case. Since a corpse carried on a plank by mourners is believed to cause the plank to move in response to questions, a swaddled stone ancestor figure may be placed on a piece of wood and carried on the head of its guardian during divination ceremonies. In addition, a stone sculpture identified in a dream as the spirit of a powerful man may also be placed in a circumcision camp to protect and assist

his descendants and the other boys undergoing initiation.

All stone figures in non-coastal styles have been given the Kissi names *pomtan* and *pomdo* by art historians, even if they were not found in Kissi territory. It would be better to refer to them as "inland styles." Some of these styles consist of simple cylinders with rudimentary faces, or spherical heads attached to cylindrical bodies, but others are quite detailed. A particularly compelling inland ("pomdo") style is exemplified by a seated figure with an open mouth and long teeth, who seems to be astride a mount whose horns or reins he holds (fig. 6-4). As is typical in this style, the eyes have the shapes of grains of rice, and the forehead merges with an elaborate hairstyle or crown.

Stone sculpture from the West Atlantic forests cannot now be dated by physical analysis. An eroded wooden figure in the coastal style has been given radio-isotope dates of approximately AD 1200 to 1400, suggesting that the stone figures of this style may be contemporary to Jenne- and Sao-style terracottas (see chapters 3 and 4). Additional support for these dates comes from a remarkable body of art carved by Africans for European clients. These objects are known as the Sapi-Portuguese ivories.

Export Ivories

Portuguese explorers of the fifteenth century landed on the coastal sand bars northwest of the hills they were to name Sierra Leone. There they encountered a cluster of peoples they referred to as the Sapi. Apparently the Sapi extended from the central coastline of present-day Sierra Leone to the central coastline of present-day Guinea. The ancestors of the Bullom (some of whom were also called the Sherbro), the Temne, and the Baga, they were related as well to the Kissi and to other groups speaking West Atlantic languages. A Portuguese book written by Valentin Fernandes and published in the early sixteenth century characterized the Sapi as peaceful and prosperous, and recorded that "the men are very ingenious, and they make ivory objects that are wonderful to see."

Portuguese sailors may have collected ivory objects as souvenirs during their first visits to the Sapi

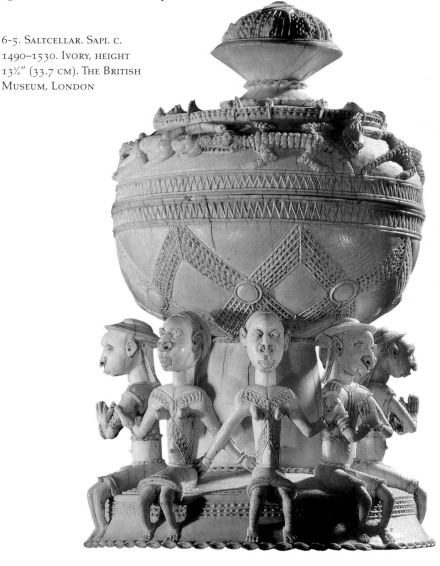

6-5. SALTCELLAR. SAPI. C. 1490–1530. IVORY, HEIGHT 13¼" (33.7 CM). THE BRITISH MUSEUM, LONDON

region. By the last decades of the fifteenth century, they were commissioning works of art from Sapi sculptors to bring home to Europe. Sapi-Portuguese ivories included spoons, cylindrical boxes, hunting horns, and covered bowls, all carved with detailed images.

Covered bowls such as the one in figure 6-5 resemble European lidded chalices in their overall shapes. However, written inventories of the sixteenth century show that these art objects were used as saltcellars. Salt

was a valuable commodity in Renaissance Europe, and elaborate containers for salt were popular with wealthy European merchants and aristocrats. The shape of this ivory saltcellar may have been based upon tableware owned by captains of Portuguese ships. Yet its geometric patterns may be derived from Sapi designs used for scarification, calabash decoration, pottery, or housepainting. On the lid of the vessel, crocodiles carved in shallow relief attack a nude figure not visible in the illustration. The crocodile is a potent image in coastal arts of Guinea today, and this gory scene may have been related to religious beliefs of the period. However, it may also have been an exotic or titillating element added primarily to interest European patrons.

The ring of figures encircling the vessel are carved in the coastal style; their heads are only slightly more delicate than that of the reclining stone figure (see fig. 6-2). The female figures wear only short wrappers or skirts, and appear to be Sapi women, while the male figures (with long straight hair, shirts, and trousers) join their hands in the position used by Europeans for prayer and appear to be Portuguese. The supportive or possessive gestures of the female figures remind us that sixteenth-century marriages between Portuguese traders and African women were creating prosperous family partnerships in new settlements along the western coasts of Africa.

Today leaders of many communities in Sierra Leone and Liberia are accompanied by heralds blowing ivory horns when they appear at important events. Centuries ago such instruments may have inspired Portuguese visitors to request Sapi artists to carve imitations of European hunting horns, or olifants (fig. 6-6). Unlike instruments carved for local African usage, olifants (named for the elephants supplying the ivory) were blown from the tip of the tusk rather than from a hole on the concave surface. This Sapi-Portuguese olifant displays hunting dogs, stags, and other beasts. Its huntsmen have tiny coastal-style faces. These images were evidently taken from illustrations in Portuguese books which were given to the Sapi artists as models. Braided, ridged, and twisted bands of ornament separate the scenes into registers, just as the pages of the books were framed by designs. The coat of arms and mottoes of the kings of Spain are accurately reproduced here, indicating that the horn may have been intended for a Spanish aristocrat. As Fernandes noted, "whatever sort of object is drawn for them, they can carve in ivory."

Sapi artists created such faithful renditions of European images that eventually these ornate horns were attributed to European artists; some have only recently been reidentified as African art. These Sapi-Portuguese ivories were able to lose their African identity so easily because they are the earliest West African examples of what art historians have termed "tourist art"; they were made to satisfy foreign visitors rather than to be used in their culture of origin.

Portuguese records indicate that Mande-speaking warriors arrived on the coast in the middle of the 1500s, disrupting and destroying Sapi communities. By the end of the sixteenth century, Sapi artists were no longer making ivories for export. Although many peoples of Sierra Leone now carve wooden figures, the modern styles are quite different from those of the Sapi.

6-6. OLIFANT. SAPI. C. 1490–1530. IVORY, LENGTH 25″ (63.5 CM). WALT DISNEY–TISHMAN AFRICAN ART COLLECTION

MASKING AND RELATED ARTS

While some sculpture of the West Atlantic forests can be dated to the sixteenth century, masks are not mentioned in European accounts until the seventeenth century. Masquerades were apparently documented first in the northern portions of the West Atlantic forests. The following brief survey of regional West Atlantic masquerades thus begins in the north and moves southward.

Initiations of the Jola, the Bidjogo, and their Neighbors

An engraving of a man wearing a horned cap or mask, described as "the dress of the circumcised [men]" (fig. 6-7), illustrated a book of the late seventeenth century by a European traveler named Froger. The illustration was based upon Froger's verbal description (and perhaps even a rough sketch). He reported seeing this masquerader in the town of Barra, on the banks of the Gambia River. Europeans knew the region south of the Gambia River as the Casamance, after the Kassa Mansa or king of the Kassa people, and the Kassa (a small West Atlantic-speaking community) still live in the Casamance region. Although the Kassa do not perform masquerades today, several neighboring groups do.

Most information on masking in the Casamance region comes from the Jola (Diola) people. A researcher showed Jola elders photographs of woven, horned headdresses in European collections (fig. 6-8), some of which were as old as the example illustrated by Froger. The Jola identified them as a *kebul*, an older version of a rare horned mask called *ejumba*.

6-7. "Dress of the circumcised." Illustration to François Froger, *Relation d'un voyage fait en 1695, 1696, et 1697.* 1698

An *ejumba* may sometimes appear in Jola communities when the young men of an age-grade return from the ordeals and training period which have prepared them for adulthood. It is only worn by the spiritual leaders of the graduates, for the tubular eyes are associated with clairvoyance, their ability to perceive invisible supernatural forces. The fiery red color of the seeds affixed to the woven surface of the mask may assist these young men in their battles with sorcerers, while the white seashells are those used by diviners to predict the future.

Horned face masks like the *ejumba* seem to be much rarer today

6-8. *Kebul* (horned mask). Jola or neighboring people. Before 1942. Horns, red seeds, shells, raffia. Musée Barbier-Mueller, Geneva

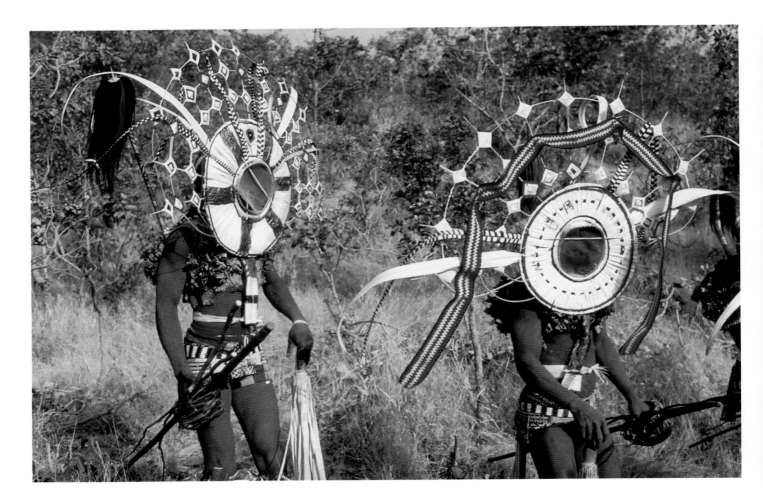

among the Jola than they are among neighboring groups such as the Balanta. Yet in several Casamance groups (including the Jola), youths still dance in caps supporting a pair of cow's horns at the beginning of their initiation, and some of these horned headdresses are elaborate constructions hung about with mirrors and cloth.

Horns on both headdresses and face masks could once have been tangible evidence of the young men's success in cattle raids, for throughout the Casamance region of Senegal (and in the neighboring nation of Guinea Bissau), age-grades were expected to steal their neighbors' cattle. These cattle raids allowed them to accumulate enough wealth to marry, and provided

proof of the age-grade's military abilities. Today the horns testify to the generosity and prosperity of the community supporting the initiates, for they are taken from the cattle slaughtered to provide meat for the feasts given on behalf of these young men.

These horned masks and headdresses have their counterpart in the dramatic age-grade displays of the Coniagui and the Bassari (Balian), who live to the southeast of the Jola on the border between Guinea and Senegal. Circumcised boys of the Bassari are supervised by two older age-grades as they are symbolically killed and reborn as men, and each of the supervisory grades appears in elaborate finery. A series of photographs shows one of the

Photographs of the spectacular arts related to the male age-grades of the Coniagui and Bassari peoples are not accompanied by documentation, while published descriptions of art forms from the region (including the crested roofs of the age-grade's dormitories, masks for male associations, and images carried by girls) were not illustrated by their authors. The Coniagui and Bassari are thus examples of the many African peoples whose varied and beautiful arts are virtually unknown to outsiders.

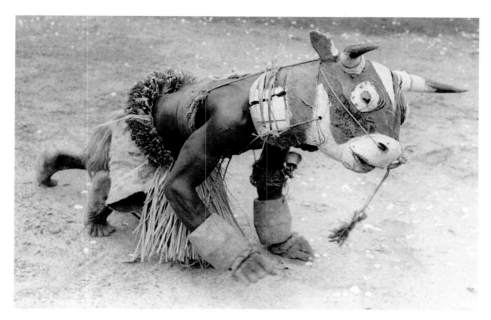

6-10. Bidjogo cattle masquerade, Urcane Island, Guinea Bissau. 1978

three age-grades in a Bassari community wearing woven disks with radiating attachments of fabric and fiber; in some cases their faces are hidden behind veils of green mosquito netting (fig. 6-9). Evidently these boys are the younger supervisors; the older supervisors wear huge headdresses, crests woven of colored palm fiber.

The male age-grades of the Bidjogo, a West Atlantic-speaking group who live on the Bissagos Islands off the coast of Guinea Bissau, are also known for their striking costumes and masquerades. Just as Casamance boys wear horned caps to show that their age-grade is preparing for initiation, some Bidjogo boys wear horned headdresses when their age-grade is formed. Whereas Casamance groups identify the young men with the bulls sacrificed so that the ceremonies may begin, the youngest Bidjogo age-grade is dressed as calves. The Bidjogo boys may also wear headdresses linking them to non-threatening species of fish.

When a Bidjogo age-grade has passed through this first level, its members become warriors, and may prepare for initiation into mature adulthood. The new warriors wear heavy headdresses and other wooden attachments (feet, fins, etc.) to mimic the appearance of swordfish, sharks, hippopotami, or crocodiles. All these wild animals are extremely dangerous for the ocean-going canoes of the Bidjogo, and the large heavy costumes demonstrate the courage and strength of the dancers.

Particularly evocative helmet masks allow some Bidjogo warriors to become untamed and ferocious bulls (fig. 6-10). The Bidjogo once sent their youths to the mainland to raid cattle, and (like the peoples of the Casamance) they associate bulls with this type of warfare. Cattle masqueraders imitate the bellowing charges and wild behavior of untamed bulls, and must be held back with ropes.

When Bidjogo youths die before their age-grade has been initiated into mature adulthood, they are believed to become restless spirits, ghosts who must be laid to rest by the girls who undergo initiations on their behalf. During the final initiation ceremonies of the male age-grade, young women wear headdresses similar those worn by the boys for their first age-grade displays. Each young woman is possessed by the spirit of a youth, and during the ceremony the deceased son and brother speaks to his family through her chants and her gestures. The rites are a vivid reminder of each individual's value to his relatives and to the community.

The spectacular and theatrical nature of Bidjogo masquerades was once matched by the age-grade displays of peoples on the mainland. In the 1930s, Papel initiates dressed as enormous sea snails were photographed wearing models of sailing ships on their heads. Other photographs of the era show Papel and Manjaka youths wearing constructions in the shape of airplanes. Today these peoples no longer have such elaborate age-grade ceremonies, but create wonderfully inventive masquerades for Guinea Bissau's Carnival celebrations.

Carnival in Bissau, the capital of the nation of Guinea Bissau, is linked to celebrations in the Cape Verde Islands and Brazil. Although inspired by the Christian calendar, the festival has a distinctly secular focus. Papier-mâché costumes that appeared in a 1987 Carnival procession publicized the need for inoculations (fig. 6-11). One took the form of a syringe, and another the child to be inoculated. The expansive and bulbous shapes of the enormous faces and stomachs were

adds aesthetic and economic interest to the sculpture.

A similar type of sacred object is found to the southeast of the Bidjogo, along the coasts of northwestern Guinea. These lands are inhabited by small groups of West Atlantic speakers, including Baga groups, the Nalu, and the Landuman. Here the protective image is known by a variety of names. Most of the Baga call it *a-tshol* (plural *tshol*), a word they translate as "medicine," although other terms (such as *elek* or *nach*) may also be used by Baga and Nalu communities.

Like the *iran* of Orebok-Okoto, an *a-tshol* has a cylindrical base with an opening or openings where spiritually charged substances and regular sacrifices can be placed (fig. 6-13). However, the human forehead, ears, and nose of the head of the *a-tshol* merge into a long, curved, bird-like beak. It is said to be a composite creature, capable of traveling through air, water, and earth. An *a-tshol* also refers to wealth, elegance, and leadership through its expensive metal studs, its elaborate crested coiffure, and its base, which resembles the stools used by leaders.

A-tshol is owned by the head of a clan, and may be seen as a manifestation of God. It is judge, healer, and supreme authority within the clan. A Baga leader guards it in a shrine, together with an assemblage of relics, a powerful helmet mask, and substances containing supernatural power. Some of these potent materials may be inserted into the geometric holes in the head and cylindrical base. During important events in the life of clan members, the head of an *a-tshol* can also be detached from the base. It can even be worn as a headdress by a dancer. These events include planting

enhanced by elephantine ears. Although these masqueraders may appear completely modern in both style and imagery, they are direct descendants of the sailing ships and airplanes of early twentieth-century masquerades.

Performed Art of the Baga and their Neighbors

Just as age-grade masquerades link the Bidjogo to peoples on the mainland, certain protective art works seem to be shared by West Atlantic speakers as well. The Bidjogo use hollow cylinders covered with red cloth to house guardian spirits; both the sacred object and its indwelling spirit are often known by the Krio (Creole) term *iran*. The most important of these spirit beings is the divinity who oversees a town or lineage, known as Orebok-Okoto. These images are owned by the male leader of the community, but both an *iran* and its shrine are cared for by a woman. One *iran* for Orebok-Okoto is surmounted by a human head wearing the nineteenth-century European top hat favored by coastal leaders (fig. 6-12). The imported metal set into the eyes

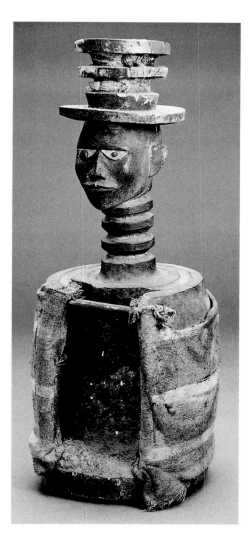

and harvest ceremonies, and the settlements of major disputes. Before the peoples of this coastal region were governed by outsiders, they had no kings, judges, lawyers, police, or prisons; their lives were regulated by elders, prophets, and the sacred powers embodied by art objects such as this.

Tshol are joined by a large number of other masquerades in this section of the West Atlantic forests. A particularly impressive type is called *a-mantshol-nga-tsho* ("master of medicine") in one Baga group. Outsiders often refer to it by the foreign name *basonyi*, taken from the neighboring Susu people who have admired its performances. This is a serpent-like being, apparently danced by Nalu and Landuman peoples in addition to the Baga. Although each masquerade may be sponsored by a specific lineage, all are inspired by a serpent spirit common throughout the region, who is identified with the water and the rainbow, with fertility, and with wealth.

6-12. *IRAN* (SHRINE FIGURE) FOR OREBOK-OKOTO. BIDJOGO. WOOD, PIGMENT, METAL, CLOTH; HEIGHT 17¼″ (43.8 CM). FOWLER MUSEUM OF CULTURAL HISTORY, UNIVERSITY OF CALIFORNIA, LOS ANGELES

6-13. *A-TSHOL* ("MEDICINE"). BAGU OR NALU. WOOD AND BRASS UPHOLSTERY TACKS; LENGTH OF HEAD 31½″ (80 CM). STANLEY COLLECTION, UNIVERSITY OF IOWA MUSEUM OF ART, IOWA CITY

Although sacred art forms such as a-tshol *were outlawed by the Marxist government of Guinea at the nation's independence in 1958, some shrines seem to have survived in secret. Since the fall of that government, some* a-tshol *have come out of hiding, and others are being carved by young men intent on reviving past traditions.*

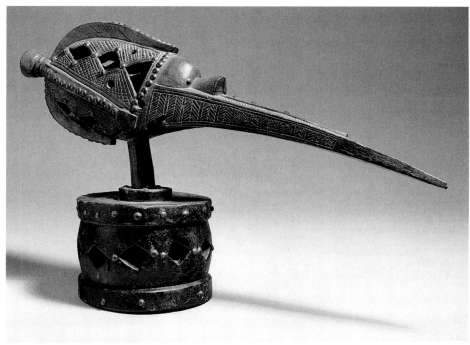

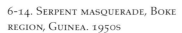

6-14. Serpent masquerade, Boke region, Guinea. 1950s

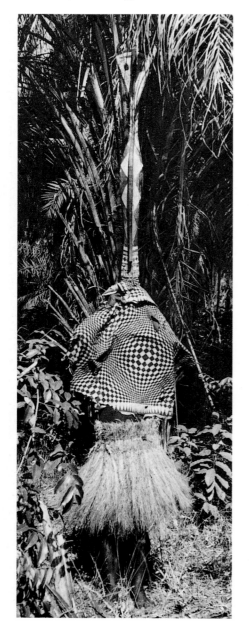

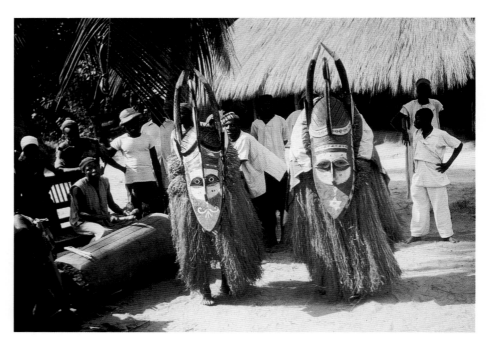

6-15. Nalu *banda* masquerades, Koukouba, northern Guinea. 1950s

These banda *masqueraders danced for a photographer in the 1950s in the Nalu town of Koukouba, in Guinea. He may have provided the dancers with masks, since one of the masks is now in a European collection. Performances by the Nalu for outsiders were not new; an older photograph shows a group of four* banda *masqueraders dancing in Paris in 1912.*

Just as the rainbow is a beginning and an end, the serpent masquerade appears at boys' initiations into adulthood.

In one example, the diamond-shaped markings on the undulating surface of the wooden snake balanced by the dancer are heightened by the patterns on the cloth surrounding its base and covering the dancer's raffia cloak (fig. 6-14). The round eyes of the serpent, always mentioned as frightening or piercing, are isolated and emphasized by their placement at the very top of the serpent. Even though this photograph was not taken during a performance, it shows that the heavy wooden form was balanced on the dancer's head. However, peoples in the region describe the towering red, white, and black serpent as gliding smoothly over rice paddies as it leaves the forest to appear on the outskirts of the community.

Yet another dramatic masquerade is known as *banda* among the Nalu and *kumbaduba* among the Baga (fig.

6-15). The heavy wooden mask of *banda* combines the jaws of a crocodile, the horns of an antelope, the sensitive ears of a forest creature, and the tail of a chameleon (located between the horns of the masks here). The prominent nose recalls that of *a-tshol*, although the other surfaces on the larger headdress are flatter and more geometric. The elaborate crested hairstyle of *a-tshol* also appears on *banda*,

but here the incised details of scarification and coiffure are emphasized by painted decoration rather than by metal tacks. Some of the floral or stellar shapes ornamenting *banda* are similar to those found on imported dishes and other trade goods, and may be related to motifs on textiles once woven in Senegal, Guinea Bissau, and the Cape Verde Islands for African and European patrons.

Banda is renowned for its spectacular dance movements, its ability to spin high in the air and low to the ground. Its acrobatics are extraordinary when we consider the enormous weight of the mask itself. In the nineteenth century, *banda* seems to have appeared at initiations, harvest ceremonies, and funerals, but today this dramatic masquerade is danced primarily for entertainment.

Recent masquerades in this area are often associated with Islam. One well-documented form, named *al-B'rak* (or *al-Barak*), was invented by a Baga artist named Salu Baki (died 1993) in 1955 (fig. 6-16). *Al-B'rak* is a loose adaptation of the mysterious, winged, woman-headed mare who is believed to have carried the prophet Muhammad on a mystical flight. The body of the horse has been transformed into a box, while the female head is now male. Like the serpent masquerade and the danced *a-tshol*, *al-B'rak* is a three-dimensional wooden sculpture placed atop a narrow stem enveloped in raffia and covered with cloth. Salu Baki's son had learned to create shapes with rulers and compasses at school, and the artist adapted these for the designs on his masquerade. However, the multicolored shapes on the white surface also recall those of earlier *banda* masks.

At the time *al-B'rak* was invented, Muslim missionaries were converting many of the coastal peoples of Guinea, and destroying the sacred art objects of the past. This iconoclasm continued during the Marxist regime of 1958 to 1984, when most non-Muslim art forms were banned. Only ostensibly new masquerades associated with Islam, such as *al-B'rak*, could be danced without fear of reprisal.

One of the masquerades suppressed by Muslim leaders and the Guinean government was the famous *d'mba* (or *nimba*) of the Baga. *D'mba* had been a monumental image of a strong, mature woman. During masquerades her enormous wooden

6-16. BAGA *AL-B'RAK* MASQUERADE, NORTHERN GUINEA. 1990

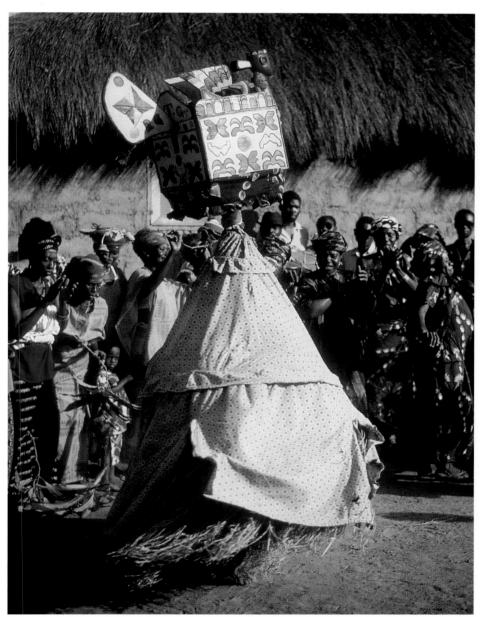

head towered over the celebrants (fig. 6-17). Her flattened breasts identified her as the ideal mother, who had suckled many children and tied them to her back. Her full body was composed of the raffia substructure common to other Baga masquerades, while her elaborate hairstyle (emphasized with shiny metal studs) was similar to the ornamentation of *a-tshol*.

Simply carrying the enormous sculpture would have been a feat of strength; only exceptional performers could have made this feminine ideal move gracefully and serenely

through the town. *D'mba* greeted important visitors, and her image could be seen on other art forms (such as figures and drums) associated with female leadership. She appeared during harvest festivals and other celebrations, and was showered with rice. Women who touched her breasts, or her swirling fiber skirts, were blessed with healthy children and productive fields.

Since 1984, non-Islamic religious arts are no longer illegal, and masquerades can now be danced more openly. Revivals of *d'mba* may now join a host of newer performances,

including several smaller and more naturalistic versions of female busts atop a cloth and raffia base. She is once again civilized, beautiful, and an inspiration to the women of a community. Of all the masquerades of this portion of the coastal region, *d'mba* is closest to women's masks of Sierra Leone and western Liberia.

Women's and Men's Societies: Sande/Bondo and Poro

Powerful pan-ethnic associations for women and men are an important feature of much of the West Atlantic forests. The following descriptions of these widespread organizations are based upon extensive research, conducted prior to the civil wars and anarchy of the 1990s, which destroyed many communities of Sierra Leone and disrupted most of Liberia. Despite our use of the present tense, readers should be aware that the survival of all cultural practices, like the survival of the peoples themselves, is in question.

The women's society known as Bondo or Sande is found among West Atlantic-speaking peoples (including the Gola and Temne), Mande-speaking peoples (including the Mende, Vai, and Kpelle) and the Kru-speaking Bassa. Sande or Bondo officials take female children into a shelter in the forest, where the girls learn the secrets of womanhood, and undergo a clitoridectomy. When the initiates have completed their training, they are presented to the community as fully mature women. In all of these groups, carved wooden headdresses are danced by leaders of the women's association to make manifest the spirits who guide them. A masked spirit (*ngafa* among the Mende) is seen as one embodiment

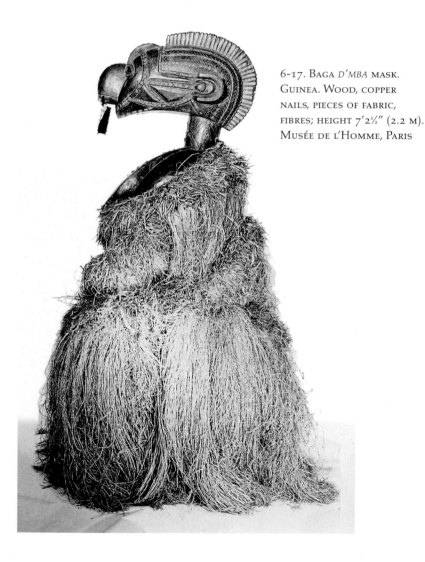

6-17. BAGA *D'MBA* MASK. GUINEA. WOOD, COPPER NAILS, PIECES OF FABRIC, FIBRES; HEIGHT 7'2½" (2.2 M). MUSÉE DE L'HOMME, PARIS

of the mystical power (sometimes translated as "medicine") of Sande/Bondo. Although each masquerader has her own individual name and identity, generic terms can also be used, including *zogbe* (among the Gola), and *sowei* or *ndoli jowei,* "the Sande leader" or "the expert leader who dances" (in Mende communities). These general references stress the masquerader's role as a lead dancer and as a high-ranking official of Sande/Bondo.

In a photograph taken during a Bondo ceremony of the Temne people, an important masquerader (here known as *nöwö*) is surrounded by her attendants (fig. 6-1). Every aspect of the masquerade is linked to the character of her spirit, and to the roles and values of the Bondo association. The white scarf tied to the central projection at the top of the helmet-like head of the *nöwö* shows her solidarity with the initiates, who are covered in white pigment during their initiation as a demonstration of their liminal, otherwordly status. The concentric bands at the base of the mask are compared by the Temne to the ridges ringing the hard black chrysalis of a species of moth. Since the *nöwö* is responsible for the transformation of children into fully feminine, sexually mature women, it is the equivalent of a chrysalis which protects the metamorphosis of a winged creature.

Among many Mende groups, the encircling ridges are also references to the origin of the mask. When a particularly wise and respected Sande official is renowned for her abilities as a dancer and choreographer, she dreams of plunging into a pool or river, the dwelling place of female spirits. As the leader emerges from this watery realm,

she brings with her the conical head of the Sande spirit. The ripples formed on the water as she surfaces appear as concentric rings around the base of the mask.

Other features also refer to the miraculous creation of the mask. The Sande official falls unkempt into the water, but emerges with beautiful clothing and elaborately braided hair. The coiffure of the wooden headdress is therefore complex and crisply carved. Girls who appeared to their communities at the conclusion of Sande and Bondo initiations once wore similarly elegant hairstyles.

The surface of the mask is a glossy black, the color of the mud on the river bottom (as is the costume of thick strands of raffia palm fiber). Black is also the color of clean, oiled, healthy, and beautiful human skin, and initiates are praised for their glossy complexions when they exhibit their virtuosity as dancers during the concluding ceremonies.

The delicacy and the reserved expression of the face of *nöwö* (mirrored in the demeanor of the attendants) are the result of the training girls receive during Bondo and Sande. The initiates learn wisdom, beauty, grace, and self-control, all of which they will need within the multigenerational, polygamous households of their future husbands. The antithesis of these values is demonstrated by the masked and unmasked clowns who accompany the *nöwö, sowei,* or *ndoli jowei.* A clown (known among the Mende as *gonde*) wears an ugly and disfigured version of the leadership masks, or a beautiful mask which has become old and damaged; it dances in an uncouth, clumsy manner.

A small, sculpted version of the lovely head of a Bondo or Sande masquerader appears on staffs and other objects used by officials of the association, reminding observers of the spiritual source of the women's authority. Freestanding figures may also be stored with the masks and other materials which act as a group's spiritual power ("medicine").

However, some masks and images have been used by the religious associations of the Mende and their neighbors which are open to both men and women. A lovely female figure collected on Sherbro Island in the 1930s was probably used by the Yase society of the Bullom people (fig. 6-18). The Mende or

6-18. DIVINATION FIGURE. BULLOM OR MENDE. BEFORE 1936. WOOD AND ALUMINUM STRIPS; HEIGHT 17¾" (45.1 CM). UNIVERSITY MUSEUM, UNIVERSITY OF PENNSYLVANIA, PHILADELPHIA

Bullom artist who carved this sacred figure gave subtle curves to the forehead and torso, but clearly delineated the eyes, mouth, and the elegant hair. As in some Bullom and Mende helmet masks for Sande, a thin strip of metal divides the hair from the face. The figure sits in a bowl, and could easily be carried during the interrogation of individuals who had broken the moral code established by the Yase association. Her counsels, as revealed to Yase officials, allowed them to grant absolution and healing to those who were being punished for their transgressions.

In many areas, Sande associations alternate their training sessions with those of the men's association, known as Poro. During the period set aside for Poro, a *sowei* or *ndoli jowei* may only appear for the funeral of an important Sande official, or when men break the sacred laws of the association and must be judged and punished. Poro masquerades are only performed during Sande training periods if the same conditions apply.

Poro circumcises young boys and initiates them into adulthood, just as Sande excises young girls and prepares them for their sexual maturity. Yet Poro leaders in Sierra Leone and Liberia often do not wear wooden masks, and in some cases do not even wear concealing costumes; the presence of the fearsome but invisible spirit, the Great Thing, of Poro is thus made known through its voice alone.

However, Poro groups among the Mende people own powerful masquerades such as *goboi* and *gbini* (fig. 6-19). *Goboi* appears for regional governors and other important leaders, and for the initiation of their sons into Poro, while *gbini* can be seen at many Poro

6-19. *GBINI* MASQUERADE. MENDE. LEATHER, LEOPARD SKIN, CLOTH, COWRIE SHELLS, RAFFIA

events. Both make manifest the spirit of Poro, and emphasize Poro's role in supporting political authority. Unlike the masquerades of Sande, neither incorporates a wooden mask. They are constructed of leather, fabric, and layers of white (rather than blackened) raffia fiber. Cowrie shells, leather, leopard or monkey skin, mirrors, and wooden tablets inscribed with Qur'anic verses may be attached to the cylindrical headdress and the tiers of fiber. All swing out into space as the dancer spins, or shake with his dance steps.

In the northeast portion of the territory controlled by Poro, Sande masquerades are relatively rare. Here Poro associations of the Gbandi, Kpelle, Kissi, and Toma (Loma) peoples allow the Great Thing of Poro to be made manifest through a frightful masquerade. Called *landai*, this masked being has a heavy wooden headdress with a great beaked nose, open jaws with jagged teeth, and a full crown of feathers (fig. 6-20). Its eyes stare upwards.

Landai's general shape recalls the *banda* masquerade of the Nalu and Baga, but here the effect is terrifying. The voluminous raffia fiber costume is white, but the mask is black with a bloody red mouth.

Everywhere the Poro spirit is said to eat boys alive before spitting them out as adult men, so that the scars borne by Poro initiates are the marks of his teeth. *Landai* gives this concept a physical presence, for red juice of the kola nut can drip from his mouth after he has "consumed" a youth. While both *gbini* and *landai* are non-human forms, *landai* belongs much more emphatically to the fearsome world of the forest. It reflects the influence of peoples living to the east, whose masquerades make manifest a variety of supernatural forest beings.

Poro masquerades are not always frightening. In many Kono and Mano communities of northeastern Liberia and southernmost Guinea, the guardian of Poro initiation is a beautiful

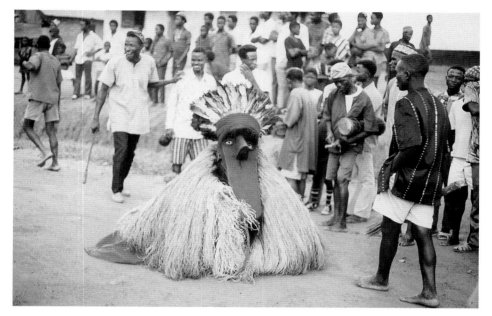

6-20. Toma *LANDAI* MASQUERADE IN PERFORMANCE

A powerful masculine masquerade known as *go* may also visit Liberian youths being initiated into Poro. In some areas, the masqueraders are members of the Go, or Leopard, society, a closed association drawing its members from several different ethnic groups. Elsewhere, *go* is merely a respectful title for a particularly powerful masquerade. *Go* masks exaggerate the features of the female Poro spirit; soft cheekbones become sharp triangles, small noses spread outward and upward, closed oval eyes become tubular protrusions, and the delicate chins and lips are transformed into wide muzzles.

female masquerade, honored as the mother of all other masked spirits, who appears to boys as they enter the Poro enclosure. She gathers food and supplies during the boys' seclusion, and may convey news to their families. Even though this female spirit is animated by a man, it is usually owned by the woman who is the only female elder allowed within the initiation center.

One of these female masquerades appeared in a Kono community, probably when the photographer commissioned a group of masked dances (fig. 6-21). The mask itself is polished a shiny black, and has subtly modeled eyebrows and cheekbones. The rounded forehead of the top half of the mask, and the slightly uplifted chin of the bottom half of the mask, form two tilted planes intersecting at the eyes. The eyes themselves are painted white, possibly as a reference to the far-sighted gaze of Poro, while the pursed lips seem to be drawn into a silent whistle.

6-21. Kono *NOYON NEA* MASQUERADE, SOUTHWESTERN GUINEA. 1950s

Miniature versions of the mother of Poro may be given to Poro graduates as a sign of their spiritual identification with the association. In a similar fashion, Dan men and women (who live to the east of the region under Poro authority) may own miniature masks to show that their families are linked to a specific masked spirit.

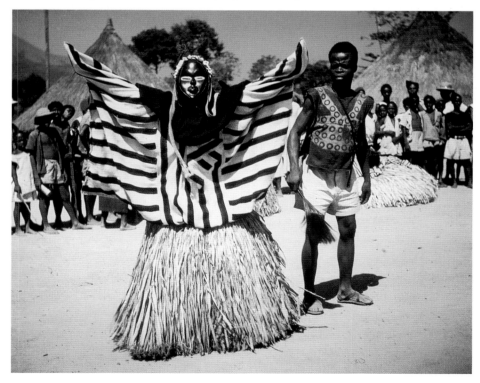

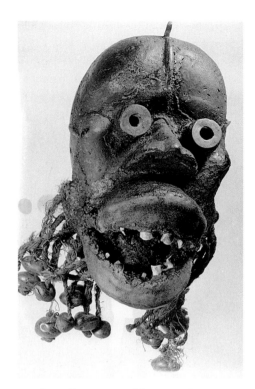

6-22. *GO GE* MASK. MANO. C. 1850.
WOOD. HARLEY COLLECTION, PEABODY
MUSEUM, HARVARD UNIVERSITY,
CAMBRIDGE, MASSACHUSETTS

*In the late 1930s, Liberian
administrators forced judgment and
lawgiver masks, such as this* go ge,
*into retirement; all governing
authority was to be in their hands.
The mask thus came into the
possession of George Harley, an
American medical missionary who
was a friend of the owner and his
family.*

A *go ge* (ruling spirit, or lord, of
Go) was carved in the middle of the
nineteenth century for a Mano judge
and lawgiver (fig. 6-22). It was conse-
crated with human sacrifice and
smeared with the blood of executed
criminals; the uneven teeth may be
those of a dead man. It was once owned
by a respected Mano blacksmith
named Gbana, who had inherited it

from his grandfather. When the elders
of neighboring communities assembled
secretly at night to settle an urgent
problem, Gbana would bring his mask,
wrapped in black cloth. At the appro-
priate hour he unwrapped the object,
laying it before him on a mat and ask-
ing it to support the decisions of the
elders. Gbana alone was able to petition
the mask and to interpret its response.
The number of attachments hanging
from the mask tallied persons killed by
the mask's supernatural power or exe-
cuted in its name.

6-23. HORNBILL MASK. MANO. 19TH
CENTURY. WOOD, METAL, TEXTILE,
FIBER, INK; 12 X 5¾ X 15″ (30.5 X 14.6
X 38 CM). DE YOUNG MEMORIAL
MUSEUM, SAN FRANCISCO

Although only a few Mano mas-
querades have the status of a *go ge*,
masks and costumes are kept in a shel-
ter located within a sacred enclosure
near the community's meeting place,
and brought out to bolster the author-
ity of its leaders. Some masquerades
judge disputes between families or
individuals, collect debts, or supervise
the distribution of food at funerals and
other feasts. One of these important
Mano masquerades is in the form of
the hornbill (fig. 6-23). The nose and
mouth merge into a graceful, curving
beak, ridged here into rhythmic lines.
Small striations along the open beak
possibly represent teeth. Even though
the hornbill is an ungainly bird, this
mask is an elegant, elongated composi-
tion, incorporating many features
(such as oval eyes and smooth brows)
found in the feminine masks of Poro.
Still, both the sacrificial material on
the top of the head, and the protective
grid of Arabic verses written in ink on
the mask's interior, remind us of its
supernatural power.

Masks and Sacred Authority:
the Dan and their Neighbors

Hornbill masquerades are also popular
among the Dan peoples, who are
related to the Mano and also speak a
peripheral Mande language. However,
Dan hornbill masks are not necessarily
revered as sacred messengers or
obeyed as police officers; they are often
the joyous companions of women, and
appear at festive gatherings. In fact,
forest spirits are believed by the Dan
to inspire a wide variety of masquer-
ades, including those that entertain a
community.

According to the Dan, forest spir-
its select a human partner when they

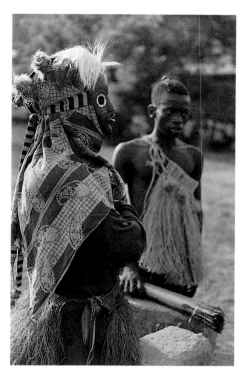

6-24. NORTHERN DAN *GUNYE GE* (RUNNING MASQUERADE) WITH ASSISTANT BEFORE A RACE, WESTERN CÔTE D'IVOIRE. 1975

wish to participate in the world of mankind. They reveal to him or her which masks, costumes, and dance styles will allow them to become manifest. While masquerades may bestow fame upon the human associates of these supernatural beings, an old and powerful masked spirit may give a human leader the power to regulate human conduct and punish evildoers.

Except in northern areas, Dan groups do not participate in Poro, and their feminine masqueraders are generally considered to be minor spirits. Smooth, oval feminine masks are usually worn by young men whose spirits allow them to perform as singers, poets, gymnasts, or dancers. These female masquerades may be sponsored by wealthy individuals (or by the masquerader's friends) both to please supernatural forces and to enhance the prestige of the patrons.

A few female masquerades take on a supervisory role in a Dan community; round-eyed masks with bright red surfaces are worn to chastise women who have lit illegal fires during the dry season. Another type of feminine round-eyed mask, with a smooth, dark face, is a running mask, *gunye ge* (fig. 6-24). The youth who wears the mask has won a series of races, proving that he is worthy of the masquerade; he will celebrate further victories with its blessing. In the past a *gunye ge* such as this would allow the champion runner to lead raids upon enemy camps, for it bestowed supernatural powers for speed and protection upon the wearer.

Similar athletic skills are needed by a youth who animates the *kagle* masquerade, danced with an angular mask seen as masculine (fig. 6-25). *Kagle* appears at the performances of more serious masked beings, and steals the possessions of onlookers with his hooked stick. Those in attendance must keep their sense of humor and be willing to ransom their belongings with small sums of money. Every plane of this trickster mask is a clearly defined geometric form, and even the eyes are empty triangles.

Minor masquerades, such as a female singing mask or a masculine *kagle,* may become more important over the years as the wearer acquires stature in a Dan community, and becomes more deeply involved with masquerade spirits. In time an entertaining masquerade may become a *go ge,* modifying the wooden mask and

acquiring a new costume to reflect this new rank. On the other hand, important warrior masquerades have lost status over the last generation, for in Côte d'Ivoire, the men who inherited their masks from the mighty soldiers of the past are now only capable of dancing.

Warrior masquerades are also danced by peoples who live to the south of the Dan along the coasts of Liberia and Côte d'Ivoire, populations who speak languages of the Kru family (from the English word "crew," for

6-25. *KAGLE* MASK. DAN OR WE. WOOD, COINS, IRON, BEADS, FIBRE; HEIGHT 17" (43.2 CM). JOSS COLLECTION, FOWLER MUSEUM OF CULTURAL HISTORY, UNIVERSITY OF CALIFORNIA, LOS ANGELES

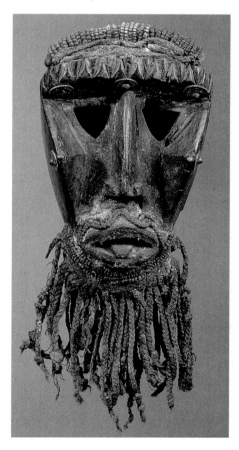

extraordinary series of tubular projections to represent several sets of extra eyes (fig. 6-26).

Between these coastal peoples and the Dan live the Kru-speaking We peoples, also known as the Gere, Kran, and Wobe. Like the Dan, the We use a wide variety of masquerades, which hold important regulatory positions within their small, egalitarian communities. In the words of a scholar who is herself We, "the masquerade is a spirit which God has given to men to organize and discipline them ... the sacred masquerade is thus the stabilizing element of society."

Like the Dan, We groups rank masquerades according to their masks, costumes, and performance styles. Beggars (the We equivalent of *kagle*) often have zoomorphic faces in the shape of warthogs, forest buffaloes, or other wild creatures. Singers are usually highly decorated versions of Dan feminine masquerades (fig. 6-27). Dancer masks and warrior masks have tubular eyes, broad triangular noses with prominent nostrils, arched tusks at each side of the face, and an immense curved forehead.

After several generations, as among the Dan, one of these masked spirits may be transformed into a more powerful being. Eagle feathers and the hair of a sacrificed ram on the mask's headdress announce that a mask is able to resolve disputes or locate evildoers. More layers of leaves or palm fibers for the voluminous skirts, additional panels of leather or fur, and a fringe of brass bells or cartridges may indicate that a mask has become the assistant, or the bard, of a great mask.

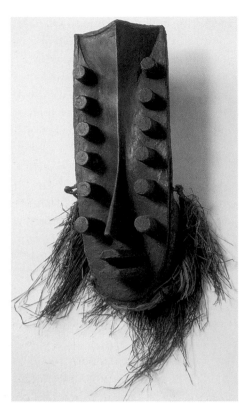

6-26. MASK. KRU (UBI GROUP?). 20TH CENTURY. WOOD AND VEGETABLE FIBER; HEIGHT 16½" (42 CM). MUSÉE ETHNOGRAPHIQUE DES ARTS D'AFRIQUE ET D'OCÉANIE, PARIS

6-27. WE MASQUERADE, WESTERN CÔTE D'IVOIRE. 1950S

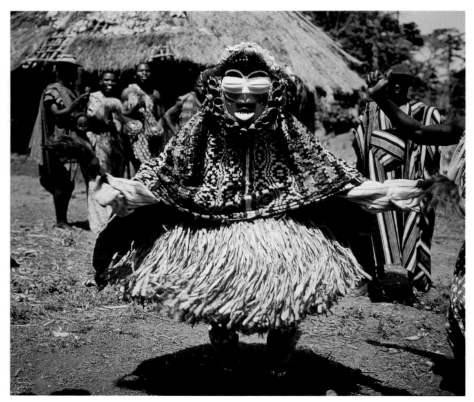

those who served on their ships), and who did not identify themselves as distinct ethnic groups until the colonial era. Warriors of the peoples now known as the Grebo were once greeted by masqueraders after successful raids, and similar military masquerades inspired them to fight. Military masks taken from Grebo communities and other Kru-speaking areas are brightly painted, and display features which are attached onto (rather than carved into) the long, plank-like face. European artists were entranced by the reversals of positive and negative forms on these bold, arresting objects. One example in a uniform grayish brown rather than the usual polychrome uses an

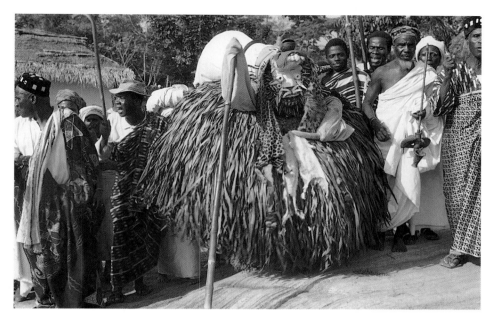

6-28. We peacekeeping mask (*JI GLA*), western Côte d'Ivoire

The *ji gla*, the great masquerade itself, is shrouded in white (fig. 6-28). White is the color of bones, and of the ancestors who first knew and served the mask spirit. The original bright colors are whitened, and the projecting tusks, horns, and eyes are hidden in the mass of protective and medicinal materials now placed on the mask. Raffia forms an enormous base for the *ji gla*, and it appears to roll or float above the ground. It only appears during times of great need, and no one may sit, or cough, or chat casually in the presence of this awesome power. The staff or spear it holds could once be thrown between two opposing armies and they would cease to fight.

Women's Arts Among the Dan and the We

We women accompany masked dancers, and may even perform as masqueraders by painting bold designs upon their faces and dressing in a full raffia fiber costume and a headdress of shells and fur. Although they are able to bring a powerful spiritual presence to a community, these women never have the rank of a great masquerade, *ji gla*, because they are too easily recognizable behind their face paint; the men who lend their bodies to the most important masked beings need complete anonymity.

Like the girls of Sande and Bondo, We and Dan girls wear white pigment for their initiation into womanhood. Yet the faces and upper torsos of We and Dan girls are painted in particularly striking ways (fig. 6-29). Some groups cover girls' faces in diverse colors, or in glittering white designs in crushed shell and chalk. Talented painters paint the face and torso of each girl in a slightly different way, complementing her individual features.

The gleaming white patterns of We female initiates may also be related to the use of white in We masquerades, for their clitoridectomy is a dangerous operation which brings them close to death and the ancestors; white is the color of the ancestral world. White is also a symbol of purity and spiritual power, both of which are believed to result from the operation. The important role these girls will play as mothers and providers is emphasized by the chairs they carry; these delicately curved seats (seen on the head of the girl in figure 6-29) belong to a grandfather or uncle, and are normally only used by elders. For this period in their lives, girls are honored as the sources of a family's wealth and continued survival.

Women also have an important role in preparing a community for the arrival of masked spirits. When a We or Dan family invites a masquerade to appear in a community, its leaders must be sure that the women of the lineage will be able to provide food for

6-29. We initiate, western Côte d'Ivoire. 1976

the accompanying feast. Women of the lineage cook the rice stored in their own granaries, and prepare the sauce. Female farming abilities, organizational talents, and culinary skills are therefore necessary if the spiritual beings of the masquerades are to be properly welcomed and celebrated.

When a woman has been selected as the main hostess for such a feast, she is thus acknowledged as the most hospitable woman of her lineage. She parades through town with her female friends and family, carrying a large serving spoon as an emblem of her status. An assistant walking behind her carries the ceramic vessel which will contain the most important serving of rice for the feast.

The sculpted rice spoons or scoops of the hostess are the equivalent of a wooden mask. A woman who aspires to become the principal hostess of her lineage may see the spirit belonging to a carved spoon in a dream, just as a man may dream of a masked being when he is ready to offer his services to a spirit as its masquerader. When the custodian of a spoon (or mask) dies, or is no longer able to handle the responsibilities connected with its care, a successor will be chosen by the spirit.

The spoon has a handle in the form of the head, the head and breasts, or the hips and legs of a beautiful woman (fig. 6-30). In a sensuous visual analogy, it honors the hostess (and women in general) as a source of food and life; the hollowed spoon becomes the body or womb of a female figure. The curves of this example would fit comfortably in a hostess's outstretched hands, and be a lovely extension of the owner herself. The artist who carved the spoon took great liberties with the proportions of the hips, legs, and feet, emphasizing the calves and knees so that they balance the bowl of the spoon both visually and physically.

Artists throughout eastern Liberia and western Côte d'Ivoire have also carved freestanding figures of important women in wood, and cast jewelry and images for them in brass. The most famous woodcarver of the region may be Zlan of Belewale, a We sculptor who worked for clients in several ethnic areas during the middle of the twentieth century. The female figures he carved for wealthy patrons, often idealized portraits of the wife of the man commissioning the work, were prestige items, and Dan owners charged fees to visitors who wished to see them.

Even though these portraits were carved primarily for the aesthetic pleasure of their owners, they share the styles of masks and spoons, sacred objects housing supernatural beings. The shiny dark surface and bands of ornamental designs on one particularly

6-30. RICE SPOON. DAN OR WE. 19TH–20TH CENTURY. WOOD, LENGTH 18⅓" (46.4 CM). THE METROPOLITAN MUSEUM OF ART, NEW YORK

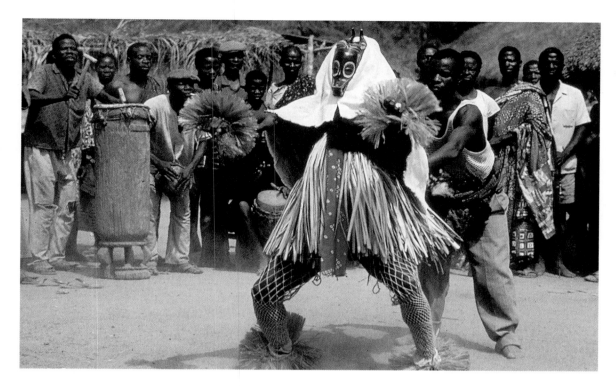

strong figure by Zlan (fig. 6-31) are also found on feminine masks. Both the refined aesthetics of these figures, and the artistic inventiveness of masks of the region, are also seen in the art of the Guro, another peripheral Mande group who live to the east of the Dan in central Côte d'Ivoire.

Masquerades of the Guro

Guro families of high social standing may establish relations with a sacred triad of forest creatures who appear as masquerades. The first of these three characters is Zamble, whose sleek and shiny mask is said to combine the graceful horns of an antelope with the powerful jaws of a leopard (fig. 6-32). The sweeping curves flowing from the tip of the horns along the high forehead to the narrow muzzle are typical of Guro face masks. The costume worn by the athletic young dancer joins a scarf made of expensive and attractive cloth (a product of the orderly Guro

community) with a cloak formed of the hide of a wild beast, a further juxtaposition of wild and civilized forces. A green and fragrant skirt of palm fiber and thick fiber ruffs at his wrists and ankles vibrate as he dances with small rapid steps. Bells on his wrists provide a counterpoint to the beats of the tall drums accompanying the masquerade.

Zamble is usually followed by his wife and consort, Gu. Her mask (worn, of course, by a male dancer) is a simple oval female face crowned with horns or an elaborate hairstyle (fig. 6-34). Today the mask is often brightly painted in red or yellow. Gu is not accompanied by drums, but dances gently and elegantly. Rattles around her ankles are the equivalent of Zamble's bells, and the animal skin upon her back is normally that of an antelope rather than a leopard.

The uninhibited and uncouth Zauli (fig. 6-33) is the antithesis of both Zamble and Gu. Often identified

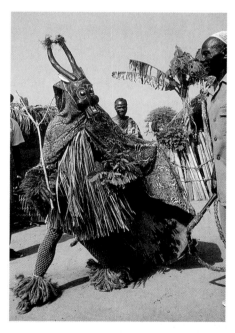

6-33. Zauli mask addressing an elder, Tibeita, Côte d'Ivoire. Guro. 1983

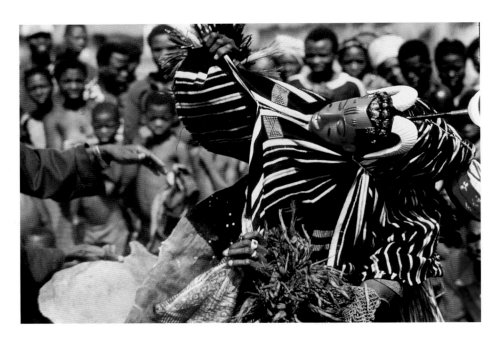

6-34. Gu dancing with an attendant, Zraluo, Côte d'Ivoire. Guro. 1975

Brightly colored, delicate female face masks of the Guro people can be danced in very different masquerades. This example is the prestigious being known as Gu. Virtually identical masks are used in masquerades danced primarily for entertainment, while others appear in potent masquerades seen only by men.

(*dye*), and bring forth a host of human-like and animal-like beings. The zoomorphic face masks identify a spirit being linked to a single wild beast, such as an elephant, a hippopotamus, or an antelope (fig. 6-35), and masqueraders dance in a manner appropriate to the animal they resemble. Anthropomorphic masquerades lead the *je* group, who appear in voluminous layers of dried raffia fiber.

Both Gye and *je* are strictly limited to male participants and observers. According to widespread legends concerning the origin of these masquerades, the spirit beings they impersonate were once snubbed by women. As a result, the Guro believe, any contact with the masqueraders is normally very harmful for women and children. Yet the power of the greatest *je* mask in human form is based upon ceremonies conducted by old women. They carry this "mother of masks" to the site of girls' excision, and let the blood and tiny bits of tissue from the operation fall upon its face. The mask is then carefully wrapped and returned to the men of the *je* association.

In addition to Zamble, Zauli, and Gu, Guro communities may call upon other types of masquerades, some of which are danced primarily for entertainment, and some of which are sacred and mysterious. In northern Guro areas a highly revered being called Gye wears a heavy horizontal helmet mask with the powerful horns of a forest buffalo and wide, gaping jaws. Sacred masquerades in the southern Guro regions are known as *je*

6-35. *Je* antelope masquerade in performance, Dabuzra, central Côte d'Ivoire. 1975

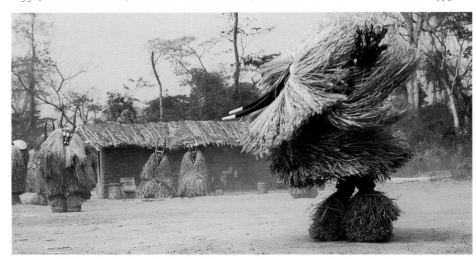

as the brother of Zamble, he has bulging cheeks, prominent horns, and protruding eyes. His behavior is unpredictable, and he may interrupt his dance to tease or even whip female spectators. His costume is a cheaper, unkempt version of that worn by Zamble. These three Guro masquerades are all sacred beings, whose altars receive sacrifices when individuals call upon them for supernatural assistance. Yet they also delight a family's guests at funerals and feasts, and bring prestige to the leaders of a lineage.

CROSS-CURRENTS AND HYBRID FORMS

All of the masquerades and portable art forms described in this chapter have traveled across ethnic boundaries and have changed over time. Yet the art forms of some coastal ports are even more multicultural in their origins and in their patronage.

American-African Architecture

Over the past four hundred years, marriages and alliances between Europeans and local entrepreneurs on the coast have created Creole (or Krio) communities, whose homes and business establishments are fascinating hybrids of foreign and African architectural forms. A distinctive domestic architecture was also developed by Americans of African descent who settled in Liberia.

In the decades surrounding the American Civil War, several thousand former slaves left the United States to found a new nation in Liberia. Many of these settlers were experienced in the construction techniques of the

New World. On southern plantations they had erected the homes of their former masters, and had built more modest kitchens, shops, dwellings, churches, and schoolhouses for their own use.

This imported technology was used to construct Macon Hall House during the late nineteenth century (fig. 6-36). Like many homes of American Liberians, it was constructed of a wooden frame covered with sawn planks. The roof was made of imported metal sheets, and given a wooden trim. Shuttered windows help cooling breezes circulate through the structure, and entrance steps lead to a covered verandah and central front door. Honored guests are taken upstairs to the second-story reception room of the shuttered second-story porch. This formal parlor, often called the "piazza" by Liberians, is thus similar to the library of a wealthy Jenne merchant (see fig. 4-7ii), particularly since both the Liberian and Malian rooms overlook the central entrance and are graced with openwork windows.

When the Macon Hall House as being built, it was strikingly different

from the homes of important families in neighboring Vai, Gola, or Temne communities. For example, the space set aside for social gatherings of the Liberian Americans was located within the Macon Hall House itself; in neighboring towns social activities took place in a separate covered enclosure serving the entire community. To both the American immigrants and the earlier inhabitants of Liberia, homes such as the Macon Hall House were symbols of modernity and of imported cultural values.

Festival Arts

Foreign settlers have also played an important historical role in Freetown, the capital of Sierra Leone. The city was founded by English, Canadian, and American immigrants of African descent during the late eighteenth century, and Maroons from the Caribbean came to Freetown as soldiers and policemen. When the British outlawed the slave trade, they brought liberated captives to Freetown as well. Although the freed prisoners came from many areas of Africa, most had been enslaved during civil wars in the area now known as Nigeria. Yoruba, Nupe, and Igbo immigrants from Nigeria thus joined Mende, Bullom, and Temne peoples in a city overlaid with European and New World influences.

Some masquerade groups in Freetown are affiliated with Bullom, Mende, and Temne communities, and dance with masks of Bundu and Poro. Other religious associations, such as Gelede and Egungun, remain fairly close to their Yoruba roots, even though they admit men and women of many ethnic and religious

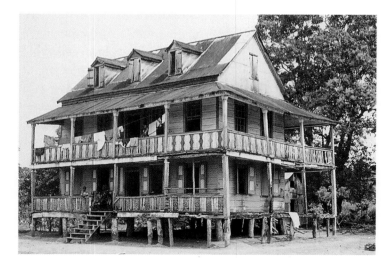

6-36. MACON HALL HOUSE, FORTSVILLE, LIBERIA. LATE 19TH CENTURY. WOOD AND TIN. PHOTOGRAPH 1973

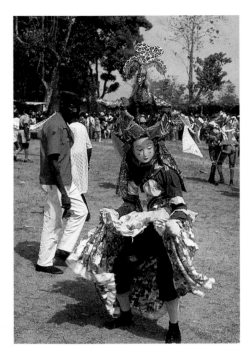

6-37. KAKA DEVIL SECRET SOCIETY MASQUERADE, FREETOWN, SIERRA LEONE

of large tissue paper constructions. Although they need not be lit from within by candles or lamps, all are known as lanterns. These ornate assemblages are given the shape of ships, of animals, or of a variety of fantastic images, and may be as large and as whimsical as American parade floats. The history of lanterns is obscure; similar movable paper sculptures have been recorded in Gambia, Senegal, Morocco, and the Caribbean.

A lantern in the shape of a cylindrical house or domed tomb (fig. 6-38) seems to be related to the brightly colored, multitiered, temporary structures paraded through the streets elsewhere in the Islamic world which evoke the tomb of the seventh-century Islamic martyr

Hussein. Although little is known about these lanterns, this photograph suggests that lantern processions in Sierra Leone are similar to masquerades in that they are accompanied by assistants; the two female attendants appear to be mimicking nurses. The visual variety introduced by the layers of different textures and colors reminds us of the Carnival mask of Guinea Bissau as well as the Ode-lay mask of Freetown.

CONTEMPORARY INTERNATIONAL ART

The artists of Liberia and Sierra Leone usually receive their training in local workshops rather than in art institutes or universities. In Guinea and Guinea Bissau, promising artists have sometimes been identified and sent abroad for training, often to Cuba. Côte d'Ivoire has provided the most opportunities for artists, for it has more art schools, exhibition spaces, and informal art markets than any of the other countries in this region.

One of the most interesting groups of artists active in Côte d'Ivoire named themselves Vohu-Vohu, from the Guro word for "earth" or "mud." Consisting of about a dozen artists from several regions, the group was formed by young men and women studying in Abidjan, the Ivorian capital, during the 1970s. As their name implies, they sought to be firmly grounded in the African tradition and to produce an art rooted in their own land.

Christine Ozoua Ayivi, born in the Guro region in 1955, was one of the Vohu-Vohu artists who studied at the Institut des Beaux-Arts in

backgrounds. Yet some appear to be blends of older sacred masquerades, and are joined by young men who live in the same neighborhood and who share common problems.

One of these spectacular masked forms, robed in imported cloth, is danced for the group of youths known as the Kaka society (fig. 6-37). The feminine face of the masquerade, and its colorful, elaborate superstructure, identify it as a "fancy" (showy, attractive, and flashy) rather than a "fierce" (dangerous and menacing) Kaka society performer. Little is known of its specific history, but it may have participated in the riotous processions which marked Christian and Islamic holidays.

Islamic festivals in Freetown and other towns in Sierra Leone are often celebrated with displays or processions

6-38. DISPLAY SCULPTURE FOR RAMADAN CELEBRATION WITH TWO PERFORMERS, ROKPUR, SIERRA LEONE. 1967

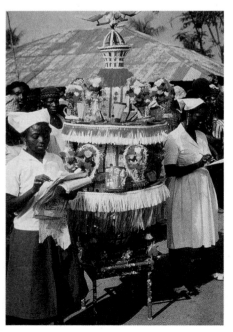

Abidjan before earning a degree in art from the Académie des Beaux-Arts in Paris. One of her paintings from the 1970s is untitled (fig. 6-39). Bound with glue and applied directly to cloth woven in Côte d'Ivoire, the pigments were taken from minerals and plants located and prepared by the artist. Some lines were created by gluing lianas and other plant fibers to the surface of the painting. Ozoua Ayivi insists that the artists of Vohu-Vohu, although known for their unusual media and techniques, were primarily interested in the nature of the creative artistic process; their use of natural pigments was but a by-product of their fresh approach to painting.

Perhaps the best known contemporary artist of the West Atlantic forests was not trained in an institute or university. Frédéric Bruly Bouabré was born in 1923 in a Kru-speaking Bete community in central Côte d'Ivoire. As an elderly man, he began to write down the philosophies and beliefs of his people, as filtered through his vivid personal vision. He draws scenes from Bete legends in colored pencil on sheets of paper, creating mysterious and repetitive images (fig. 6-40).

Critics may complain that Bouabré's visionary art has been so popular with European patrons because he conforms to their stereotypes of the naive, untutored, or uninhibited African artist. Yet even

6-39. *Untitled*. Christine Ozoua Ayivi. Natural pigments on cloth

6-40. *Untitled* from *Knowledge of the World* series. Frédéric Bruly Bouabré. 1991. Colored pencil and ball point on cardboard, 6 x 3¾" (15 x 9.5 cm). The Pigozzi Collection

cynics must concede that Bouabré's work is original, direct, effectively and even dramatically composed. It may be these qualities which attract buyers from other lands and other cultures. Just as Renaissance courtiers admired Sapi ivories over four hundred years ago, foreigners today can find much to admire in contemporary art of the West Atlantic coast.

7
AKAN
WORLDS

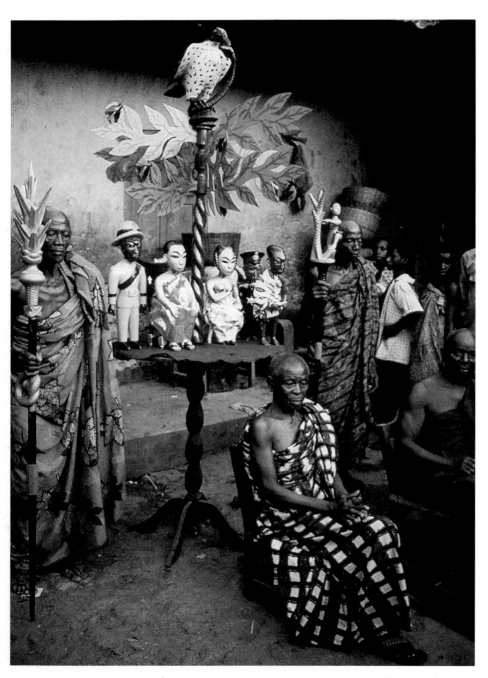

7-1. FIGURAL GROUP BY OSEI BONSU (SEATED RIGHT), ASANTE REGION, GHANA. PHOTOGRAPH 1976

MOST OF THE PEOPLES WHOSE art we explore in this chapter speak Akan languages, which proves a history of relationships. The Baule of Côte d'Ivoire and the Asante and the Fante of Ghana, the two largest groups, speak dialects of Twi, the major Akan language. The dialects are not mutually intelligible, however, indicating long periods of separate linguistic and cultural development. These main Akan groups, the Baule and the Asante/Fante, thus have quite separate identities today. The egalitarian Baule also have been influenced by non-Akan neighbors to the north and west, helping to give Baule culture a character in part different from that of their more hierarchically organized Akan relatives to the south and east. Nevertheless, these Akan groups share important cultural forms, spectacular gold jewelry and regalia among them. These forms are shared as well by the peoples of the neighboring Lagoons region in southeastern Côte d'Ivoire, whose art is thus also included in this chapter.

As the southernmost participants in a trading network that extends across the Sahara to North Africa, the Akan have been in contact with Muslim traders and holy men for many centuries. Several centralized polities emerged among the Akan of Ghana during the fifteenth or sixteenth century, partly as a result of wealth derived from the gold that these people mined and traded northward. The most famous of these is known as the Asante Confederacy. Formed around 1700 under the Asante ruler Osei Tutu, the Confederacy depended on tribute from conquered Akan kingdoms such as Akwamu, Akyem, Denkyira, and Bono. Craftsmen and artists from the

conquered kingdoms were conscripted to the Asante capital at Kumasi, where they initiated an artistic flowering that lasted for almost two centuries.

While the Akan have long resisted adopting the Islamic faith, they have assimilated technologies, art forms, and styles from the Islamic north. European influences have also been absorbed and thoroughly "Akanized." Direct contact with Europeans, their artifacts, and institutions began for the Fante and the Lagoons peoples on the Atlantic coast in the 1470s, when Portuguese ships first reached these shores. The many European trading forts and castles built along this "Gold Coast," as the area was known and later named by the British, signal the impact of outside artifacts, ideas, and institutions over more than five centuries of interaction with Europe.

The artistic culture of pre-Islamic and pre-European Akan peoples is not well known, but surely there were many purely local developments. Wood and terracotta objects for ritual and everyday use, in particular, probably evolved early. Thus three major historical currents—internal and locally generated creative developments, influences from the Islamic north, and appropriations from Europe—and several minor ones merge in Akan arts.

THE VISUAL–VERBAL NEXUS

A distinctive feature of Akan culture is the dynamic interaction of visual motifs and verbal expression. The Akan, until recently oral and without writing, have a special reverence for elegant, colorful, subtle, and allusive oral discourse and particularly for the use of metaphorical speech. Akan arts include a repertoire of several thousand visual motifs, from abstract symbols to representational objects and scenes. Each motif is associated with one and often more verbal forms, sayings, or proverbs. A spiral shape recalling a ram's horn, for example, calls forth the maxim, "Slow to anger [like the ram] but unstoppable when aroused." A ladder motif, when seen on ceramic funerary vessels, elicits the saying, "Everyone climbs the ladder of death," meaning that death is inevitable as well as democratic (see fig. 7-16).

Nearly all forms of Akan art have evolved so as to include one or many of these visual signs. Indeed, interest in visual–verbal relationships appears to have stimulated the deliberate development of objects that incorporate such subjects and the continuous invention of new visual motifs with a corresponding wealth of spoken meanings. The cast gold objects illustrated here are sword ornaments (fig. 7-2). Some are merely emblematic. The lion (a) symbolizes bravery and power, for example, and the head (d) stands for a defeated (and decapitated) enemy. Others, however, have more complex or multiple verbal associations. Mudfish or crocodiles eating mudfish (b) have several interpretations: "When the mudfish swallows something, it does so for its master," meaning that a chief benefits from the success of his subjects, or, "When the crocodile gets a mudfish it does not deal leniently with it," referring to the awesome power of

7-2. Sword ornaments. Asante. 19th or 20th century. Gold, length of the longest ornament 13" (33.02 cm). Nsuta Treasury, Ghana

a chief or king, or, "If the mudfish tells you the crocodile is dead, there is no need to argue about it," signifying (somewhat cryptically to us) that two people can report on each other's behavior. The "night bird" (e) elicits the saying, "If you kill a night bird, you bring bad luck; if you leave it alone, you lose good fortune," the equivalent of our "damned if you do and damned if you don't." The powder keg (c) and fanciful interpretation of a European sugar bowl (f) show how readily Asante artists incorporated (and modified) outside motifs into their body of imagery.

REGALIA AND ARTS OF STATECRAFT

Regalia—adornments and implements worn or carried by kings, chiefs, queen mothers, and other royals and court members—help to create and legitimize royal authority as well as show it off (see Aspects of African Culture: Art and Leadership, pages 196–7). Under the patronage of powerful and wealthy chiefs and kings, weavers, umbrella makers, goldsmiths, leather-workers, carvers, and others put much imaginative effort into fashioning regalia.

Ensemble and visual overload govern the aesthetics of regalia in southern Côte d'Ivoire and Ghana. Ensemble refers to the massing of several elements, each often a work of art in its own right, but depending for their rich, dazzling impact on their assemblage, which becomes a whole greater than the sum of its parts. Composed upon and set in motion by the armature of the human body, a sumptuous profusion of jewelry, textiles, and hand-held implements

Aspects of African Culture

Art and Leadership

Across history and in societies throughout the world, art has been used to support the authority of sacred and secular leaders and to legitimize the concept of leadership itself as a social institution. Leaders commission art, dispense it, send messages with it, and use it instrumentally both to perpetuate the status quo and to effect change. Leaders in African societies may use art in ways that are bold or subtle, active or passive, obvious or veiled, yet what is everywhere clear and sometimes surprising is the extent to which African art is leadership art—conceptually dense, layered with meanings, and concerned with power of various kinds.

Contrasted with popular arts, leadership arts are immediately seen to be richer, more elaborate and complex, more durable, detailed, and monumental. These ideas are expressed with special force by the regalia of the kings of Africa such as the *oni* of Benin, the *fon* of the Cameroon grasslands, the Yoruba *oba*, the Kuba kings, and those of the Zulu and the Swazi. Sandals, footrests, stools, chairs, and raised platforms serve to isolate these rulers and give them prominence. Their stature and bulk are expanded by sumptuous, expensive, symbolic materials such as eagle feathers, leopard skins, special cloth, and beads. A hand-held weapon may extend their reach. Other held objects—flywhisk, pipe, staff, scepter—magnify any gesture they make. Flanking or surrounding artifacts such as drums, vessels, statuary, or houseposts contribute to their centrality and visibility, as may a cloth backdrop or a hierarchical surround of courtiers. Umbrellas, fans, weapons, or shields provide both physical and spiritual protection. Regalia thus creates a presence magnified to the point where the man himself seems almost overcome, even immobilized, the temporary holder of an office almost disappearing into the eternal idea of the office itself.

Moving outward from the person of the leader we can see his influence in palace architecture as well as in the spatial complexity of royal towns or villages, which hedge the ruler about both materially and spatially, protecting him, centering him, or focusing attention on him within a ranked hierarchy. These ideas extend also to royal shrines such as those of Benin, where spatial and compositional

THE LAP OF NANA DIKO PIM III, WEARING ASASIA KENTE AND GOLD JEWELRY, AND HOLDING A FLYWHISK, EJISU, GHANA. 1976

principles mirror those used to emphasize the sacred king. More subtly, such ideas apply as well to palace associations, ranks of lesser chiefs and titled nobility, craftsmen's guilds, and other support groups and structures. In most centralized and hierarchical states there is a proliferation of offices, with each rank given distinct visible markers of identity.

In less centralized societies, control may be exerted through titled men's associations and masquerades. Here leadership arts become more subtle and indirect, yet the masks, carvings, and title attributes characteristic of these institutions are no less effective than the regalia of kings. Less centralized polities are commonly marked as well by strong religious organizations whose authority is buttressed by art and architectural forms. Before the imposition of colonial rule, executive and judicial roles in some societies were in the hands of male (less often female) associations that employed anonymous masked spirits. Such maskers operated under the aegis of powerful, much-feared deities to enforce the will of the leaders, often groups of elders. Marshaled for social regulation, the mysterious drama of a masquerade can be every bit as powerful as a regalia-laden king, and often far more instrumental.

So whether a culture organizes itself into a large state or a lineage-based, segmentary society, its leaders bring visual, kinetic, and aural arts to bear in creating pageantry and mystery, which in turn orchestrate a spectacle that both figuratively and literally moves people, profoundly and irrevocably affecting their lives.

creates a dizzying sense of visual overload and reiteration that has been aptly called "intentional design redundancy."

Regalia in Ghana

Chiefs and especially paramount chiefs or kings in Ghana wear rings on every finger, yards of heavy cloth, dozens of beaded bracelets and necklaces, not one but several amuletic charms above the elbow or ankle, as well as multiple castings or goldleaf symbols on hats and sandals (fig. 7-3). Individual beads as well as small charms strung together or larger talismans packaged in gold, silver, leopard skin, and leather pouches render supernatural power to their wearer, at the same time protecting him or her against jealous rivals or threats from evil spirits. Not surprisingly, the Akan say of kings, "Great men move slowly."

The cumulative weight and effect of regalia ensembles make statements about political authority and financial superiority as well as spiritual protection, while specific verbal messages may also be projected by visual motifs. It is not that individual motifs are specifically read by the viewer, who then recalls the associated proverbs or emblematic maxims. Rather, shared knowledge among actors and audience alike carries richly layered collective messages: dignity, military might, endurance, wisdom, affluence, spiritual protection, and above all, power.

Little Ghanaian Akan regalia is personally owned. Rather, it belongs to the state and its collective ancestors. A chief or king is the custodian of these treasures for the duration of

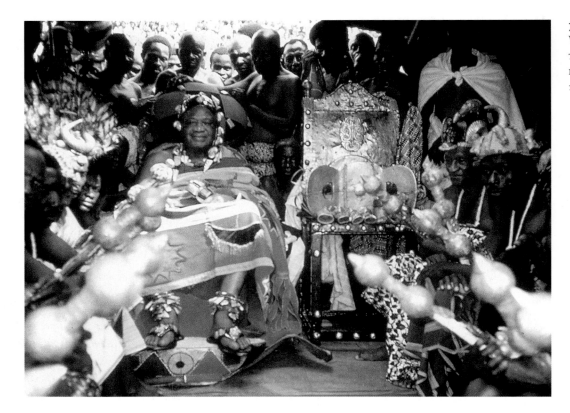

his reign, and he is expected to add to the legacy of gold and textiles for his successors.

Stools and Chairs

To signal its ownership by the state, regalia is spoken of as "stool property," for stools are the central symbols of Akan polities. The practical and ritual use of stools is almost certainly ancient in Akan culture, and most probably predates contact with Islam and Europe. Throughout the Akan area, important persons commission carved stools for daily or ceremonial use. At a great man's death, his soul is transferred to his personal stool, now blackened and consecrated for the purpose. In each Akan state, the blackened ancestral stools of kings and other royals are kept in a special shrine called a stool room,

where collectively they represent the state's dynastic soul and history.

Most Akan stools consist of a rectangular base from which a partly open central column and four corner posts rise to support a saddle-shaped seat. The entire stool is carved from a single piece of wood. Many stool types exist, and like Akan culture itself they are hierarchical. The ceremonial stool displayed in figure 7-4 clearly belongs to a prominent and wealthy chief, for it is decorated with silver strips.

The most famous African stool, which has never actually been used as a seat, is the Golden Stool of the Asante, displayed on its own chair in figure 7-3. Oral tradition relates that the stool came into existence around 1700, during the reign of Osei Tutu, the first *asantehene*, the Asante paramount chief or king, and founder of

the Asante Confederacy. Osei Tutu had a clever priest, Anokye, whose power caused the Golden Stool, which was said to contain the spirit of the Asante nation, to appear from the sky, whereupon it fell onto the lap of Osei Tutu.

Although it has never been blackened, the Golden Stool is considered spiritually powerful and even alive. It symbolizes to this day the unification of many Akan peoples under the Asante. It is still much revered, as may be inferred from its position on its own chair, higher than the Asante king beside whom it appears when both are seated "in state." It has both locally cast and European bells attached, which are rung to announce its presence on the rare occasions when it is seen in public.

Chairs, like other forms and motifs ultimately of European origin, entered the Akan artistic repertoire

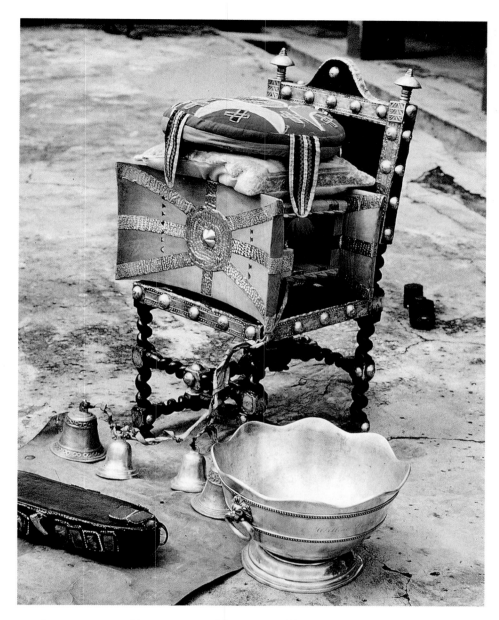

7-4. AKAN STOOL ON A HWEDOM CHAIR. MAMPONG. 1986

An Akan silver appliqué stool sits on a European-derived Hwedom chair, with an appliqué pillow on top. Nearby are a European silver bowl and a footstool with Muslim amulets attached. The silver patterns (on the stool) may also derive from Islamic prototypes.

through coastal trading contacts. At least three types of seventeenth-century European chairs have been thoroughly assimilated into Akan leadership arts. Reworked and of local manufacture for centuries, these elaborately decorated chairs never supplant Akan stools, which remain primary objects, but they do contribute measurably to occasions of state. One type of chair is seen here in two versions, as the seat of an important paramount chief in figure 7-4, and supporting the Golden Stool in figure 7-3. Called *hwedom*, which is interpreted to mean "facing the field (or enemy)," this type was used during declarations of war and for judicial deliberations. Some *hwedom*, such as the one in figure 7-4, have spiral turned legs, uprights, and stretchers; most are painted black, with silver finials and other embellishments.

The most common type of chair is called *asipim*. Meaning "I stand firm," the name refers to the chair's sturdy construction and to the strength of the chieftaincy. *Asipim* are constructed (construction itself being a European rather than a native Akan technique) of heavy wood. The taut leather seat and back are attached with imported brass upholstery tacks. Backs are further embellished with locally cast finials and patterned repoussé panels, showing the extent to which the Akan have transformed their models. An example is depicted later in this chapter, carved as part of a statue of a queen mother (see fig. 7-24).

State Swords

After the blackened ancestral stools of deceased royals, the most important material symbols of statecraft are

The specific functions and forms of swords vary from state to state. In general, swords are (or were) used for swearing oaths, as symbols of ambassadorial rank and safe passage, during purification rites of chiefs and ancestral state stools, and for display

7-6. Fante linguists with staffs, Fante region, Ghana. 1974

swords. Like stools, these swords pre-date the Asante Confederacy, even if wealthy Asante kingdoms appear to have the most visually and symbolically elaborate examples. Also like stools, swords originated as practical devices, then passed during the eighteenth and nineteenth centuries through a period of aggrandizement, taking on various non-practical yet even more valuable ideological and ritual roles.

Several of the most important swords in Asante states have their own names, histories, and appointed custodians; one, called Responsibility, has its own set of protective amulets. Many swords thus have spiritual and political associations taking them well beyond mere weaponry. Formal embellishments and dull blades, sometimes with openwork, parallel these ideological qualities.

The basic sword form is a simple, slightly curved iron blade with scabbard and a hilt shaped like a dumbbell. The grandest swords have cast gold

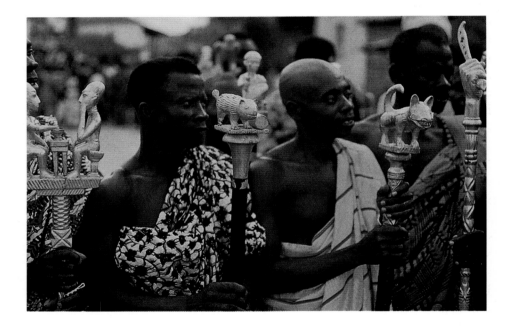

figural ornaments attached, as well as other matching regalia worn by their bearers for ritual and festive events. The swords illustrated here, for example, are displayed with matching caps (fig. 7-5). Gold ornaments take many forms, most with corresponding verbal expressions. Visible in this photograph are many of the orna-

ments singled out earlier in the discussion of the visual–verbal nexus (see fig. 7-2)

Linguist Staffs

"We speak to a wise man in proverbs, not in plain speech," goes an Akan expression. Nowhere is refined

speaking, embellished with proverbial wisdom, more apparent than in the institution of the linguist, a principal counselor and spokesman for a chief (fig. 7-6). More than a translator, he is also an advisor, judicial advocate, prime minister, political trouble shooter, and historian of state law, lore, and custom—of course chosen for his sagacity, wit, and oratorical skill. Many kings have several linguists, in which case one will be designated chief among them. In the 1970s the *asantehene* had thirteen linguists, and he may well have more today.

Since around 1900 linguists have carried carved, gold-leafed wooden staffs of office (fig. 7-7). Each staff is topped by a figural sculpture that elicits one, and more often several, proverbs. These multiple, overlapping meanings are available for use by the quick and witty linguist, who may have several staffs to choose among, enabling him to use the one whose imagery seems most appropriate for the situation at hand. Akan linguist staffs may have been stimulated by figural staffs from the Lagoons area, where as early as the seventeenth century metal-topped staffs or canes were carried by messengers. But their immediate prototype would appear to be British government staffs given during the late nineteenth century to chiefs, who used them to designate authorized representatives in dealings with the colonial government. Some of these had figural finials.

Hundreds of linguist staff finials have been carved since 1900, comprising a rich corpus of imagery with verbal allusions, most of which uphold or comment upon chieftaincy or the reciprocal responsibilities of

chief and subjects. One frequently carved subject consists of two men sitting at a table of food (see fig. 7-6, left), evoking the proverb, "Food is for its owner, not for the man who is hungry." Here food serves as a metaphor for chieftaincy, which belongs to the rightful heir to the stool, not to anyone who hungers for the office. Many staff finials aggrandize the powers, wisdom, and grandeur of the chief and state. A cock (see fig. 7-7, third from left) or a cock and hen recalls the proverb, "The hen knows when it is dawn, but leaves it to the cock to announce," which distinguishes between the decision-making power of the chief (cock) and the wisdom of the elders and counselors (hen). The

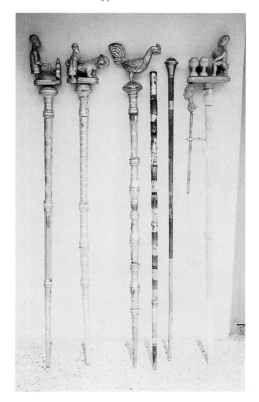

7-7. LINGUIST STAFFS OF THE PARAMOUNT CHIEF OF ADANSI, FOMENA, GHANA. PHOTOGRAPH 1976

imagery also reinforces accepted gender roles, and at the same time exalts a strong state (cock) at the expense of an inferior neighbor (hen). And it represents well the great importance of animal metaphors in Akan thought.

Many staffs address the power of the state, war, and peace. A hand grasping a sword (fig. 7-6, far right) signifies that "without the thumb (chief) the hand (state) can hold nothing," and of course this is a threatening, aggressive gesture. Some staffs recall historical episodes. An Adansi staff depicts four heads before a seated chief (see fig. 7-7, far right). The heads represent the four Akan states dominated by Adansi during the sixteenth and seventeenth centuries. A fifth head hangs from the staff, to which a long bead is attached; this motif represents Adansi as the "grandchild of beads," a reference to this people's miraculous origin from a bead in the ground and to the independence Adansi claimed from other Akan states in 1927, the year the staff was carved. The carver was Osei Bonsu (1900–1976), an artist whose work will be examined more fully later in this chapter.

Baule and Lagoons Regalia

Baule and Lagoons societies are mainly egalitarian, and for the most part the independent village is the largest political unit. Relatively affluent, influential village "notables" or "dignitaries"—words that set them apart from the chiefs and kings of the centralized Akan states of Ghana—nevertheless distinguish

themselves with gold and fine cloth (fig. 7-8). Most, though not all, forms of Baule gold regalia were developed during the twentieth century, while Lagoons regalia goes back further in time. In contrast to the regalia of Ghana, which is "stool property," Lagoons regalia is family or individual property. Rather than inheriting an office or high status, Lagoons dignitaries have accumulated their own influence and much of their wealth, some of which is shown off in "gold exhibitions" displayed at village festivals and age-grade celebrations.

Family heirloom gold is shown separately, emphasizing what the man himself has amassed.

Lagoons cast regalia includes varied beads, pendants, or crescents, depictions of animals and human heads, as well as rings, miniature masks, eyeglasses, and other ornaments (fig. 7-9). Motifs may refer to the hard work and veiled processes of acquiring wealth and to the faces of ancestors who helped, but not in the extensive verbal–visual manner so distinctive of Akan arts in Ghana. Lagoons and Baule carved regalia,

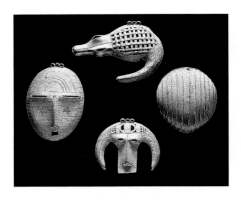

7-9. ORNAMENTS. LAGOONS PEOPLES. 20TH CENTURY OR EARLIER. GOLD. MUSÉE BARBIER-MUELLER, GENEVA

7-8. LAGOONS (ADIUKRU) DIGNITARY AND HIS WIFE, YSAP, CÔTE D'IVOIRE. 1990

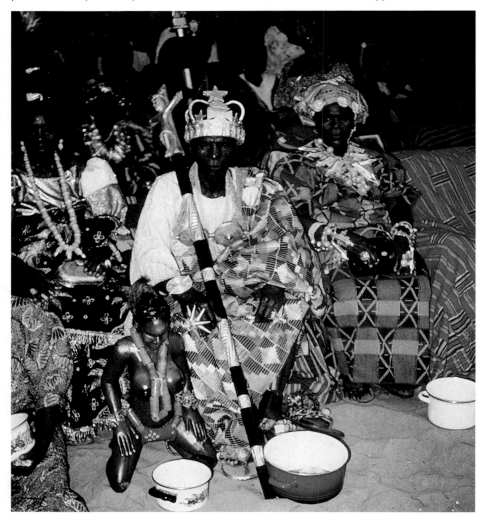

often gold-leafed, includes flywhisks and fan handles, animal and human statuary, batons, staff finials, weapons, and crowns. Many different Akan peoples have employed goldsmiths and carvers over the past few centuries, and the wealthy have often purchased items of regalia from outside their own ethnic group. Thus many regalia ensembles include objects in various styles, the origins of which are not always firmly known.

Staffs with sculpted finials serve in Côte d'Ivoire as emblems of authority and status. The earliest known examples date to around 1850, and may thus have inspired the linguist staffs of the Ghanaian Akan. The three carved ivory finials illustrated here, attributed to the Lagoons area, probably once surmounted leaders' canes or staffs (fig. 7-10). The items of European-inspired dress and the adapted European chairs featured in all three were typical possessions of affluent Lagoons men. The two sets of paired figures on the most elaborate ivory (center) represent Lagoons people, as does the man holding the gin

7-10. Three staff finials. Lagoons peoples. 19th century(?). Ivory. Musée Barbier-Mueller, Geneva

bottle and glass (left). The casually posed man on the third ivory is more likely a European, who may have commissioned the piece or received it as a gift. All three are confident, refined carvings.

METAL ARTS: THE CULTURE OF GOLD

The technology of lost-wax casting came from the Western Sudan into the northern Akan areas during the fourteenth or fifteenth century, probably brought by the Jula, an Islamized Mande trading people. Islamic formal influence was accepted as well, and Akan casters adapted Islamic prototypes for their most important type of container, the *kuduo*. They were owned by states and by particularly wealthy and powerful shrines, individuals, and

chiefs. As expensive heirloom vessels, *kuduo* were interred, dug up, and reused in several contexts. In shrines, they occasionally—and perhaps more commonly three or four centuries ago—house the sacred ingredients

considered the heart and essence of a deity.

Kuduo exist in several distinctive shapes, many of which can be traced to prototypes originating in fourteenth- or fifteenth-century Mamluk Egypt (fig. 7-11; compare with fig. 2-30). Indeed, at least six copper alloy containers of Mamluk origin still do service today in northern Akan shrines. The imported vessels are believed to possess supernatural power, though they are not considered gods. All have panels of Arabic writing alternating with circular patterns, a type of decoration that was adapted by Akan goldsmiths when they cast their own versions. Yet the "writing" on Akan versions is not legible. We may suppose the panels of pseudo-writing and circular devices were believed by early Akan to provide protection for the contents of the vessels so decorated. The Asante employed Muslim amulet makers and record keepers at the Kumasi court, yet much evidence also suggests they were employed before 1700 by other Akan leaders, perhaps as early as the fifteenth or

7-11. Group of three cast *KUDUO*, a spoon, and a hammered brass *FOROWA* cosmetic box (far right). 18th–19th century. Fowler Museum of Cultural History, University of California, Los Angeles

sixteenth century. Early Akan *kuduo* were probably cast before the sixteenth century in Bono or other northern Akan towns, but those with heads or figural groups on their lids—purely Akan creative additions—appear only later, during the eighteenth and nineteenth centuries, and most seem to come from Kumasi, the Asante capital.

It was gold that stimulated the greatest creativity in Akan metal artists. For the Akan gold had inherent power and mystery; it was feared and magical, and was believed to grow and move in the earth. Sacred and numinous, gold was used in gods' power bundles and human burials, for medicine and protection. A show of wealth and artistic taste was essential to projecting the image of a spiritually sanctioned, prosperous, and powerful state, so vast amounts of energy and wealth were expended on gold regalia, which gives the art of this region its distinctive, radiant character.

Among the most intricate of Akan gold regalia were beads, each one individually modeled and cast, no matter how small (fig. 7-12). Huge gold circular beads are worn singly on the chest by swordbearers, by other young men designated as "soul people," or by court servants who may be present at the purification, also called "washing," of chiefs and ancestral stools. Called "soul washers' badges," these disks can also be worn by other court officials or members of a royal family. Some, like smaller gold beads, have geometric subdivisions and their overall design may again relate to protective Islamic patterns. Analogous rosettes are common in leatherwork across the Western Sudan, and may derive ultimately from North African Islamic motifs that protect against the "evil eye." Similar circular motifs are central in the silver (and rarely gold) appliqué patterns on some important state stools that again recall Islamic magic squares (see fig. 7-4).

Goldsmiths also created copper alloy counterweights, which were used on balance scales for the weighing of gold dust and nuggets, the main currency in precolonial times (fig. 7-13). Called goldweights, these small sculptures were each made to conform to a precise weight standard in a system that may have entered the Akan region, again from the north, probably during the fourteenth century and certainly by the fifteenth, when Jula traders came south in search of goldfields. The earliest Akan goldweights are mostly rectangular and round shapes with nonrepresentational geometric decorations. Like early Akan weighing systems, these weights were

7-12. ASSORTED GOLD BEADS, RINGS, BRACELETS, AND OTHER ORNAMENTS. AKAN. PRIVATE COLLECTION

Members of royal families wear an astonishing variety of cast (and occasionally hammered) gold ornaments both abstract and representational in form (such as bells, locks, teeth, bones, and replicas of glass beads.) Circular gold beads range in size from half an inch to six inches in diameter. Beads are the most common and universal form of personal decoration in Africa. Beads of stone, bone, vegetal matter, glass, or metal were worn by all classes of Akan people. They were decorative but also meaningful socially and ritually. Like gold itself, many beads were ascribed amuletic, protective properties. Some were worth more than their weight in gold. Others were thought capable of reproducing under ground (where caches of beads, buried earlier, were sometimes found), and certain beads were ground into powder with which royal children were washed to make them grow.

7-13. GOLDWEIGHTS, SCALES, AND GOLDDUST BOX. AKAN. 17TH–19TH CENTURY. BRASS, LENGTH 1–3″ (2.54–5.08 CM). FOWLER MUSEUM OF CULTURAL HISTORY, UNIVERSITY OF CALIFORNIA, LOS ANGELES

Gold-weighing equipment included a set of approximately thirty standard weights for ordinary traders, although rich merchants and state treasuries might have had double that number. In addition to simple balance scales, each trader had small boxes, some finely cast with birds or other tiny motifs, as well as small cast or hammered spoons and larger scoops for handling gold dust. In spite of the charm of figurative, representational weights, the vast majority consisted of geometric forms, very few of which had verbal associations. Direct casts of a beetle and a peanut are at bottom left.

of Islamic inspiration; analogous geometric forms have been found by archaeologists in the Western Sudan, some with Arabic, Egyptian, and even Roman prototypes. Akan goldsmiths, perhaps by the sixteenth or seventeenth century, began to cast fairly simple figurative motifs such as birds, fish, and human beings. This representational sculpture is certainly of Akan inspiration and use, owing nothing whatever to outside sources. By the eighteenth century the corpus of

realistic weight motifs numbered in the thousands.

Goldweights fell out of use around 1900, when Ghana (then the Gold Coast Colony) went off the gold standard and ceased using gold for currency. Nevertheless, in their astonishing number and rich variability they remain one of the marvels of West African art. Individually modeled (first in wax), each weight is a study in miniature sculpture, and quite a few show virtuoso artistry. Nearly all

locally available creatures, plants, and objects were cast into goldweight form. Weights in the form of human beings show an enormous variety of poses and activities, including many chiefs riding horses or seated in state, the gold weighing process itself, and a great range of genre scenes, vignettes of everyday and ritual life. Most of these date from the eighteenth and especially the nineteenth centuries. A number of objects such as beetles, crab claws, peanuts, and other seed pods were cast directly, that is, with the original model being burned up inside the clay mold, which was then filled with molten metal.

Many goldweight motifs belong to the vast lexicon of the visual–verbal nexus. A fascinating aspect of the transactions in which they once figured is the role played by the

recitation of proverbs or other sayings prompted by specific weights. Few detailed reports exist on the use of proverbs in commercial transactions. Yet since buying and selling in Africa is usually a social process elaborated by extensive greetings and discussion, and since the Akan are well known for eloquent and metaphorical speaking, it is not hard to visualize the extended dialogue that must have accompanied transactions—an indirect, embellished discourse in which proverbs played a role, stimulated partly by each trader's collection of weights.

TEXTILES

Three principal types of cloth are worn by Akan, Ewe (a neighboring group), and other nearby royals for occasions of state: strip-woven cloth popularly known as *kente*, appliqué, or embroidered cloth called *akunitan*, and stamped *adinkra* cloth (fig. 7-14). Also worn are amulet-laden cotton tunics called *batakari* (fig. 7-15). Some of these textiles are worn for specific occasions or to identify particular social roles. Often they are made in a hierarchical range of qualities. Simple versions of *kente*, for example, are available to anyone who can afford them, while heavier, more elaborate, labor intensive, and costly *kente* are (or were) reserved for kings, chiefs, or specific members of royalty. Akan men typically wear huge cloths (six or seven feet by twelve or thirteen feet), toga fashion, without belt or other fastener, and with the right shoulder bare. Women wear two or more smaller fabrics, one a skirt wrapper (worn these days with a blouse), a cover cloth, or shawl, and often a cloth for tying a baby to its mother's back.

The technology of strip weaving appears to have been introduced from the Western Sudan to the Akan area during the sixteenth century, perhaps somewhat earlier, by the Mande Jula. Narrow strip weaving on horizontal looms, worked exclusively by men, is widely distributed across West Africa, yet it takes on particularly elegant and complex form among Akan and neighboring Ewe weavers, whose *kente* cloth is made from two- to three-inch strips

sewn together, selvage to selvage. *Kente* range from plain striped cotton weaves, owned by most people, through an extensive hierarchy to dense, color-rich fabrics with complex geometric patterning in fine units (see fig. 7-8). Most *kente* alternate plain weave and inlay designs in more than three hundred named patterns, organized as checkerboards, stepped diagonals, or asymmetrically, sometimes in random compositions. Ewe *kente* may also

7-14. DETAILS OF A STAMPED *ADINKRA* CLOTH (TOP) AND AN *AKUNITAN*, "CLOTH OF THE GREAT," WITH EMBROIDERED MOTIFS OF A LION, PORCUPINE, STOOL FLANKED BY SWORDS, AIRPLANE, STAR, AND ELEPHANT. ASANTE. 20TH CENTURY. FOWLER MUSEUM OF CULTURAL HISTORY, UNIVERSITY OF CALIFORNIA, LOS ANGELES

7-15. *BATAKARI* WITH AMULETS AND MAGIC SQUARES. PROBABLY AKAN. 20TH CENTURY. COTTON, LEATHER, PAPER; 33 X 48¼" (84 X 124 CM). THE BRITISH MUSEUM, LONDON

incorporate pictorial symbols such as drums, birds, and human figures. Verbal–visual correspondences are present, as they are in most Akan arts, and many royal cloth patterns and colors are associated with specific social roles or ritual roles. The richest *kente* are often primarily silk (early examples having been woven partly with thread unraveled from European cloth), and woven on looms with six heddles rather than the normal four. Asante versions of this richest *kente*, called *asasia*, have a shimmering, twill-like texture and were exclusively royal weaves. The greatest *asasia* cloth was reserved for the *asantehene* or those whom he permitted to wear it (see page 197).

Stamp and comb-line designed *adinkra* probably originated as mourning cloth among the Asante. Typical mourning *adinkra* are dark brown, brick or rust red, and black, worn differentially depending on the mourner's closeness to the deceased. Most *adinkra* are patterned in numerous squares that

are again subdivided by combed or stamped designs (see fig. 7-14, top). Patterns are stamped with carved calabash stamps and combs using a dye made from a tree bark boiled with iron-bearing rock or slag. Most known *adinkra* use European milled cotton yardage as the base fabric. White and many other bright colors, called "Sunday" or fancy *adinkra*, are probably late additions to this cloth tradition and can be worn for most festive occasions or even daily, though not for mourning.

Most *adinkra* designs are named after natural or crafted things, but many appear to be abstract (fig. 7-16).

7-16. *ADINKRA* STAMP MOTIFS

Adinkra *stamps are carved from pieces of calabash:*
a Aya, *"fern," and the word also means "I am not afraid of you"*
b Ram's horns
c Nyame dua, *"except God" meaning tht the wearer is afraid of nothing except God*
d Musuyidie, *"something to remove evil," and probably based on an Islamic charm shape*
e Ladder

A B C D E

Nearly all have linked verbal maxims or proverbs. As many as two hundred different stamp designs exist, though some have fallen out of use and others are added periodically.

The Asante may have borrowed the idea of *adinkra* cloth from the Gyaman, a small group to the northwest who had a seventeenth-century chief named Adinngra and another early nineteenth-century leader named Adinkra. A prominent Akan scholar, on the other hand, glosses *adinkra* to mean "to be separated" or "to leave" or "to say goodbye" (from *di*, "employ," and *nkra*, "message left on departing"), an interpretation that strongly supports the mourning function. Still a third theory links *adinkra* cloths to Islamic-derived protective magic squares of the sort seen on some *batakari*. The Bamana, Senufo, and other Western Sudanic peoples make protective garments with rectilinear painted patterns, but these do not closely resemble either each other or *adinkra*. Still, *adinkra* may be part of a large complex of West African cloths with mystical, protective properties, perhaps inspired in part by Muslim technologies of inscription and pattern-making with magical inks.

Chiefs often wear locally produced or designed fabrics such as *kente* or *adinkra*, but they also own rich European textiles such as brocades, velvets, and damasks. At some point after imported cloth became more plentiful, probably during the nineteenth century, Akan-designed appliqué or embroidered chiefs' cloths were invented. Called "cloth of the great," *akunitan*, these are divided literally or implicitly into a checkerboard, each square of which contains an appliqué or embroidered motif (see fig. 7-14, bottom; see also fig. 7-3). Motifs range from abstract or geometric through pictorial, and many have verbal associations. Clearly each "cloth of the great" is a more or less systematic set of allusions to chiefly power, responsibility, and wealth.

Many peoples in West Africa wear tunics made of coarse cotton strips woven by men. Called *batakari* among the Akan, these tunics feature pendant amulets, and sometimes other attachments such as horns and claws, which have been prepared by spiritual adepts and are believed capable of protecting and empowering their wearers. While elsewhere they are made by blacksmiths, most among the Akan seem to have been prepared by Muslim charm makers. It is said that each charm includes an inscription from the Qur'an (though some have been opened to reveal only powder, presumably also viewed as spiritually effective), thus invoking the powers of Allah to serve people who are not in fact Muslims. The Akan are nevertheless impressed with Islamic technologies, including writing. Some *batakari* from Ghana are inscribed with both writing and subdivided rectilinear patterns called magic squares, which also are believed to have mystical power (see fig. 7-15). The very pigment with which Islamic script and symbols are drawn is believed powerful (and thus is drunk in liquid form), and drawn magical patterns are even more so. These garments are worn by hunters, warriors, and their leaders, not just Akan royals, and some have had their efficacy increased with blood sacrifices. "Great" *batakari* worn by Akan chiefs and kings for mourning festivities and other rites are especially laden with charms, sometimes hundreds of them. Many amulets are cased in gold and silver as well as animal horn, leopard skin, red cloth, and the more common leather. The metal cases are usually further ornamented with embossed or repoussé patterns, as if to redouble their mystical potency.

TERRACOTTA FUNERARY SCULPTURE

Until recently, many ethnic groups in the southern parts of this area commemorated deceased family members and royals with terracotta figural sculpture (fig. 7-17). Heads such as these, often broken from full figures, or from vessels with figurative elements, all had funerary contexts. These traditions go back at least to the sixteenth century. Writing in 1602, for example, Pieter de Marees, a Dutchman who had voyaged to the coast, described elaborate royal Fante burials that included painted clay figures portraying the deceased leader and all the members of his entourage.

Terracotta images were occasionally adorned with fine cloth and seated in state on chairs for royal second burial ceremonies, surrounded by both terracotta and actual human attendants. The dressed sculptures were later paraded through the streets of the community to the royal graveyard in a festive procession, drawing crowds of people who shouted farewells to the departed. In some areas annual rites of commemoration were held at such sites as the "place of pots," adjacent to an actual graveyard (fig. 7-18). In other areas, however, little attention was paid to the figures after their initial presentation.

7-17. Heads. Clockwise from left: Kwahu, Ahinsan, Krinjabo, Twifo-Hemang. 18th–19th century. Terracotta, average height 6" (15.24 cm). Fowler Museum of Cultural History, University of California, Los Angeles

Most terracotta images were made by women, in keeping with the almost universal African association of females with clay and pottery. While to outside eyes the sculptures do not appear to be descriptive portraits, artists who were interviewed insisted that they took special pains to model a close likeness of the deceased.

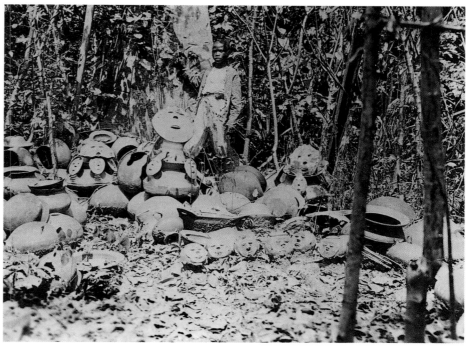

7-18. "Place of pots," probably Kwahu region, Ghana. Photograph late 19th century

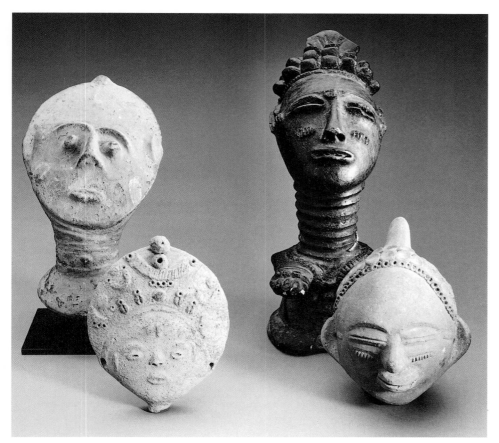

The people of most areas recognize these terracotta heads or figures as portraits. As in other African portraiture until the last few decades, however, this did not involve descriptive imitations of actual human models, but rather generic renderings of heads with a few individualizing details such as scarification or hairstyles. Many sculptors followed the widespread Akan convention of flattening the head, a reference to idealized beauty. Such heads are often schematic, quite flat and thin, with simplified features applied or incised. Other heads are fully round and quite naturalistically modeled, although simplified and idealized in showing neither age marks nor blemishes. Many styles and types of heads are known, a variety that suggests both regional developments and changes over several centuries.

WOOD SCULPTURE AND SHRINES

Akan deities are thought of in human terms: kind or angry, generous or withholding, neither always bad nor good. Invisible bush spirits—lesser deities who meddle constantly in human life—may be considered dirty and ugly, hostile dwarfs with skin disease and backwards feet, but they are nevertheless carved as handsome, well groomed, and highly civilized in order to avoid their wrath and charm them into benevolent behavior. Thus they are rendered with long necks, often ringed, precisely carved scarification on torsos, necks, and heads—called "marks of civilization" by the Baule—finely plaited hair, erect posture, and other attributes of ideal men and women. These attributes vary regionally among the Akan; whereas the Baule appreciate bulging calf muscles, for example, the Asante and other Ghanaian Akan admire long, flattened, sloping foreheads. Exaggerated in many images, they were formerly effected on actual people in a mild form when, as infants, their cranial bones were gently modeled by their mothers.

Shrine sculptures are sometimes requested by the deities themselves, or they may be given by grateful devotees or by a priest or priestess seeking to create a more impressive environment. Adding to a shrine's mystique, some figures are ascribed miraculous origins: they were found in the forest, fell from the sky, or appeared in flames. But of course most are products of professional though part-time sculptors whose individual styles can often be recognized within a larger framework of regional Akan styles and major iconographic types.

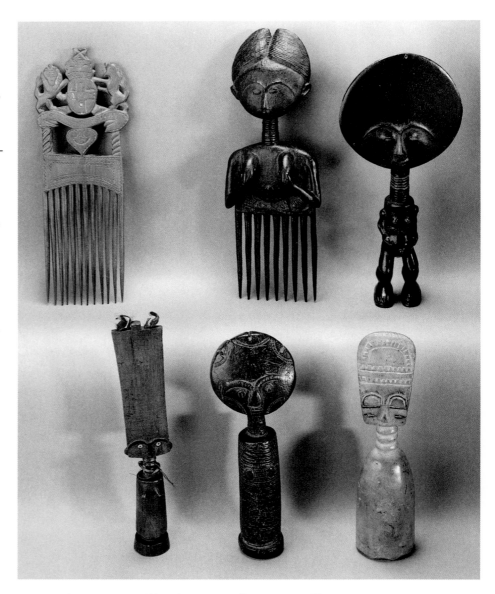

7-19. AKAN *AKUA MA* ("AKUA'S CHILDREN") AND COMBS. TOP ROW: EARLY 1960S COMB WITH GHANAIAN COAT OF ARMS; TO RIGHT, FIGURAL COMB AND FULL FIGURAL *AKUA BA* FROM A KUMASI WORKSHOP, CARVED 1980; BOTTOM ROW: THREE *AKUA MA*, EARLY 20TH CENTURY: LEFT IS FANTE, MIDDLE ASANTE, AND RIGHT BRONG-AHAFO. WOOD, AVERAGE HEIGHT 8" (20.32 CM). FOWLER MUSEUM OF CULTURAL HISTORY, UNIVERSITY OF CALIFORNIA, LOS ANGELES

The comb and figure to the upper right were artificially aged to fetch higher prices and can rightfully be called "fakes." Such figures are usually called Asante fertility dolls, an unfortunate phrase on two counts. First, while the Asante perhaps originated the form and surely have made thousands, all other Akan make them too. Second, since most such images start out their life as spiritually activated power figures, the word "doll," so secular in modern usage, is probably not the most accurate descriptive noun, even if in some cases children are later allowed to play with them.

Akua Ma

Small disc-headed wood figures on a cylindrical torso, with or without arms, are among the best known images from all of Africa (fig. 7-19). Most have thin flat heads, suggesting that their sculptors carried to an extreme the sloping forehead convention evident in the terracotta heads discussed above. The figures are called "Akua's children," *akua ma* (sing. *akua ba*). Oral traditions (now of course written) recall a woman named Akua as the first woman to own and care for a consecrated human figure on instruction from a priest. Barren, and mocked for carrying a surrogate baby made of wood, Akua is said to have gotten pregnant nevertheless, eventually giving birth to a healthy baby girl. Female children are preferred among the matrilineal Akan, and *akua ma* are almost always carved as female. Having learned from the experience of the legendary Akua, other Akan women desiring children, ever since, have ordered small figures from artists, had them consecrated at shrines, and waited hopefully, often carrying the "child" tied at their back the way real children are carried.

Many regional styles of *akua ma* exist, just as one carver's version of the figure will differ from another's.

Asante Carvings and Shrines

Shrines are locations of deities and their symbols, often considered their "homes." In former times, shrines were housed in splendid buildings dating back at least to the nineteenth century (figs. 7-20, 7-21). A few of these have been restored and preserved as Ghanaian national monuments. Some have openwork screens or reliefs with interlace patterns of Islamic origin. Specialized Muslim builders were often brought in from the north to create these temples, whose decoration was intended to protect the sacred contents housed within.

Shrine rooms or buildings contain smaller or larger ensembles of varied sacred materials together with props such as furniture, utensils, regalia, and offerings. They may also

7-20. Plan of an Asante shrine. Drawing after M. Swithenbank

7-21. a. Section of an Asante shrine building. Drawing after M. Swithenbank
b. Detail of openwork panel from an Asante shrine building. Drawing after M. Swithenbank

Large shrines such as this one address a host of community issues under the auspices of a resident priest or priestess. Atano deities, deriving their power and identity from the River Tano, are tutelaries considered responsible for the health and general welfare of the people, their animals, and crops. Ultimate power, however, comes from the high god, Oyame, who is prayed to but is more remote and not represented in figural sculpture.

Also here are *akua ma* in varied styles and forms. Akan shrines are likely to have six or ten or more *akua ma*. Most of the twelve figures visible on this shrine were consecrated there, then later returned to it as thank offerings after their owners successfully gave birth. A few are full figures, with more naturalistic arms and legs; these are more recent than the abstracted versions. The figure positioned highest among the *akua ma* (between the state swords) is made of terracotta, and was carried by a woman in the ceremony in which her *akua ba* was empowered by the god Tano.

The *kente* cloth and state swords here are examples of chiefly regalia, which is often stored in shrines so that it may absorb the spiritual powers that render leadership more effective. Evidence of the wealth of the deities and their shrine, regalia

contain figurative images. Figure 7-22 shows the interior of an *atano* shrine housing several separate altars, all dedicated to the powerful deities associated with the Tano River. Visible are three brass pan altars arranged hierarchically on stools draped with *kente* cloth, two pans flanking an elevated third. Each pan contains a different manifestation of the deity, the sacred materials that comprise the essence or heart of the god. Formerly, these ingredients were sometimes housed in *kuduo* vessels. Brass pans have long been more commonly used, however, and such shrines are called "brass pan shrines" after this feature. The shrine shown here also houses several other lesser brass pan altars.

7-23. ASANTE *ABOSOMMBRAFOO* ("WITCH CATCHING") SHRINE, NEAR KUMASI REGION, GHANA. PHOTOGRAPH 1976

The priest of one witch-catching shrine had named each of its numerous, sacrifice-encrusted figures, implying its and its deities' powers. Names included Judge, Big Man, Daughter (who helps with fertility), Policeman (who guards the shrine), and Executioner, among others.

also serves to partially anthropomorphize the god(s), who "wear" these items. Shrines may also include musical instruments, containers of gourd or ceramic and other kitchen equipment, as well as books, diplomas, photographs, and other "modern" artifacts that signal the literacy or progressive outlook of a priest or custodian.

A second type of shrine prevalent among the Ghanaian Akan, referred to as "witch catching," *abosommbrafoo*, is normally less carefully ordered than most *atano* shrines (fig. 7-23). Indeed, many have a negative or inverse aesthetic quality, with elements haphazardly placed and blood spattered, as if disorder were deliberate. These too may house a variety of figural carvings, often the same kinds of images seen in *atano* shrines. While such shrines share general tutelary qualities of Atano, their special province, as their name indicates, is to identify witches—pathologically disruptive or socially deviant people—and bring them to trial and, if found guilty, through ritual exorcism which is in effect a purification, back to health and productivity.

The Asante, Fante, and other Akan people in Ghana refer to all human figural sculpture as *akua ma*, although not every image was used to help bring forth children. Larger, more elaborate statues were commissioned for direct use on shrines, in palace stool rooms, and for some secular purposes (fig. 7-24). Unfortunately no data survive on the original context and purpose of this masterful, virtuoso carving. The stately woman, shown seated upon a European-derived *asipim* chair with her sandaled feet elevated on a footstool, is clearly a queen mother. The carver worked in a

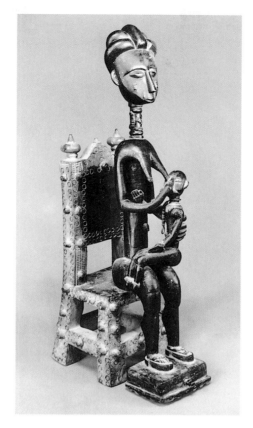

7-24. QUEEN MOTHER AND CHILD. ASANTE. LATE 19TH–EARLY 20TH CENTURY. WOOD, PIGMENT, GLASS, BEADS, FIBER; HEIGHT 22¼" (57 CM). COLLECTION OF MR. AND MRS. ARNOLD J. ALDERMAN

7-25. PAIR OF FIGURES. BAULE. 19TH–EARLY 20TH CENTURY. WOOD, HEIGHT OF MALE 21¾" (55.4 CM), HEIGHT OF FEMALE 20½" (52.5 CM). THE METROPOLITAN MUSEUM OF ART, NEW YORK

detailed and attenuated, thin-limbed style; the figure has long slender legs, proportionally a still longer torso, and an enlarged and somewhat flattened head on a long, scarified neck. She sits proudly erect, her back cut well away from the chairback. In keeping with Asante preferences for glistening dark skin, the figure was painted a shiny

black, while the chair was left the natural color of the wood. An absence of facial expression adds to the impression that this woman is aloof, that she is not emotionally involved with the child she is suckling. Yet impassive faces are common in African sculpture, so it would be a mistake to read a temporary emotion into it. Rather, it is the permanent quality of human dignity that is emphasized.

Baule and Lagoons Carvings and Shrines

Baule statuary is among the most celebrated of West African art traditions by virtue of the subtle refinements and careful detailing of many older carvings, such as the confidently rendered male/female couple shown here (fig. 7-25). These images, nearly identical apart from the clear indications

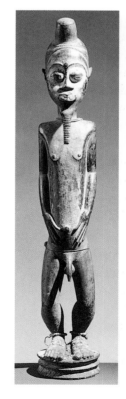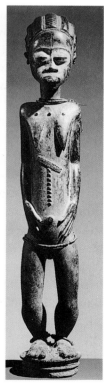

of gender, show the absolute control a master carver had of his tools, his ability to create exactly the figure he intended. In keeping with other spirit representations, the faces are impassive. The surfaces of both figures have been modified by ritual use and jewelry has been added. Their original use is uncertain, although the somewhat "messy" surface, resulting from sacrificial libations (now partly cleaned), suggest they may have represented nature spirits or diviner's spirits.

The area beyond and outside the village and the Other World are, for the Baule and some of their neighbors, the locations of two important classes of spirits with whom people maintain contact on a daily basis. Unlike the creator god, often considered too remote to affect everyday lives, these nearby spirits intrude themselves more or less constantly. Earth spirits, *asie usu*, for the Baule are among the kinds of nature spirits also feared and revered across much of West Africa. Some are associated with the sky or earth, others with water, still others with the uncut forest, or "bush," as it is commonly called. Sickness, infertility, crop failure, and other misfortunes are attributed to the actions of *asie usu*. Alternatively, personal difficulties—especially those involving marriage, the family, children, or finances—are often ascribed to the jealousy or unhappiness of a person's "otherworld spirit lover." The Baule hold that all adults have a mate of the opposite sex living in the Other World, and that his or her activities and thoughts affect the person of this world, and vice versa.

Both *asie usu* and otherworld lovers can ask, through a diviner, to be materialized as a "person of wood," a statue, and thus to be honored in this

7-26. OTHERWORLD-SPOUSE SHRINE OF SCULPTOR KOFFI NIAMNIEN, TOUMODI REGION, CÔTE D'IVOIRE. PHOTOGRAPH 1981

7-27. OTHERWORLD WOMAN. BAULE. C. 1950. WOOD AND PIGMENT. FOWLER MUSEUM OF CULTURAL HISTORY, UNIVERSITY OF CALIFORNIA, LOS ANGELES

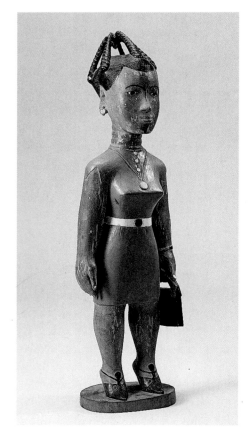

world. A carver is sought and commissioned. The spirit, the diviner, or the client determine the specific attributes of the figure—pose, type of clothing or hairstyle, whether or not a female will carry a child, and so forth. The completed image is consecrated through sacrifice, and the client or specialist must subsequently make periodic food offerings and follow other procedures. The shrine of the otherworld woman illustrated here contains gifts of eggs and a mound of white chalk requested by the spirit (fig. 7-26). Persons with otherworld spirit mates normally dedicate one night per week to him or her, when they will not sleep with their this-world spouse. The spirits may also dictate other prescriptive activities that enable clients to gain satisfaction or regain health and equilibrium.

The fashionable spirit-spouse in figure 7-27 is adorned with imported paint. The upscale dress, high heels, watch, handbag, and finely plaited hair all suggest the kind of urban sophistication sought by some Baule people around the middle of the twentieth century. The man who commissioned this spouse figure, for example, might have been seeking employment in the capital city of Abidjan, spurred on by

his decidedly stylish, rather affluent otherworld mate. Her presence in his household shrine might well have pointed to such desires, suggesting underlying marital problems. A functionalist explanation for such helping and healing shrines sees the spirit figures as scapegoats whose tangible presence facilitates change or recovery (from job loss, for example) because they help the client to externalize his or her desires or problems.

Figures created among the Lagoons peoples serve many of the same functions as those of their Baule neighbors. The carving in figure 7-28, made among the Ebrie, a Lagoons people, may have been the seat of a supernatural force—bush spirit,

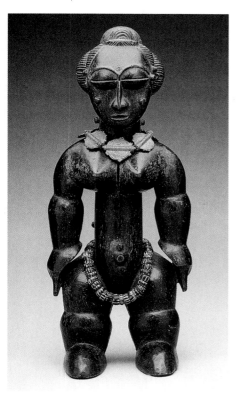

7-28. STANDING FIGURE. EBRIE. 20TH CENTURY. WOOD, GLASS, BRASS BEADS; HEIGHT 9½″ (24.5 CM). MUSÉE BARBIER-MUELLER, GENEVA

otherworld mate, or diviner's helper—or it might have been a more secular "guardian of the dance," awarded as a prize to an excellent performer. Throughout this region the use of a figure can rarely be discerned simply by looking at it; one also needs to collect its history. Despite the functional continuity between Lagoons and Baule sculptures, the Ebrie figure is very distinctive in style. The rhythms of bulges and constrictions in the symmetrical figure's legs and arms build up to emphasize a greatly enlarged head, which itself has much enlarged eyes. Another distinctive feature is the presence of small pegs—sometimes for the insertion of medicines—placed on the torso to emulate decorative keloidal scars.

Secular Carvings

Among the people of both Ghana and Côte d'Ivoire, the very same sorts of figures found in shrines may serve as secular figures displayed by age-grades (in the Lagoons area) or popular drumming bands (among the Akan). Figural groups and other secular forms were a specialty of the famous Asante carver Osei Bonsu. During his long and distinguished career, Bonsu created examples of virtually every type of Akan wooden object, including carvings later goldleafed as regalia for three Asante kings. He also taught carving at a British colonial school and carved for colonial administrators and for early tourists who visited the Gold Coast. Bonsu's figure ensembles usually feature a chief, queen mother, linguist, swordbearers, and other members of a royal entourage under an umbrella, often painted in bright imported enamels (fig. 7-1). Such works were ordered

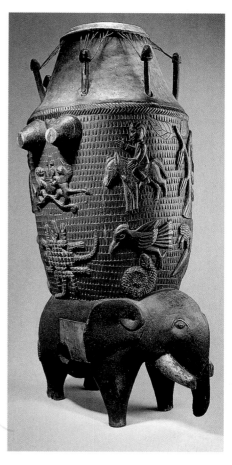

7-29. DRUM. OSEI BONSU. EARLY 1930S. WOOD AND HIDE; HEIGHT 44″ (111.7 CM). FOWLER MUSEUM OF CULTURAL HISTORY, UNIVERSITY OF CALIFORNIA, LOS ANGELES

as display pieces by popular drumming groups during the 1930s and 40s. Bonsu's personal style is recognizable in his naturalistic treatment of somewhat enlarged facial features beneath a sloping forehead.

The same performing groups also commissioned elaborately carved drums (fig. 7-29). The example shown here was carved by Osei Bonsu during the early 1930s. Two breasts (now partially broken) signal that the entire drum is in some way to be understood as a female body. Between them is a

carved heart, and beneath, the British royal arms. Female gendering of such drums is typical, and while the exact meaning is not known, it accords with the fact that the largest, most important drum of an ensemble is known as the "mother of the group." This and other similar drums are further aggrandized by being carved as though supported on the back of a strong animal—in this case an elephant, in others, a lion. The images carved in low relief represent aspects of daily or ritual life, material culture, and the natural environment. Many of them are linked to proverbs or other verbal forms.

One possible inspiration for the female drums that became so popular among the Fante during the 1930s is a drum depicting Queen Victoria of Great Britain (ruled 1837–1901). One of the earliest documented "human" drums, it was probably carved during the late nineteenth century. The roll-out drawing in figure 7-30 catalogues

the many motifs carved in low relief on the drum's body. The largest figure depicts Queen Victoria herself. At a level with her head are five Native Authority policemen, each holding an object associated with control. To her left is a seated Akan chief, holding a state sword and shaded by an umbrella. Beneath him in turn are figures holding symbols of Akan power: stool, state sword, linguist staff. Elsewhere are tools, implements used for personal grooming, a building (probably meant to be a castle) flying a British flag, and numerous animals and insects. The imagery has to do with British power, Akan chieftaincy, and suggestions that the drum group is well dressed and groomed and has many up-to-date material objects. The animals are a rich source of traditional wisdom, because nearly all of them are associated with sayings that cover a wealth of social, political, economic, and spiritual issues. All told, the complicated embellishment of this

instrument is a compendium of many historical, colonial, and local Akan references, almost a microcosm of life around the turn of the twentieth century.

ROYAL FESTIVALS IN GHANA

If there are many fine sculptures and other objects in Ghana considered works of art from our point of view, the largest and most significant art forms from the Akan perspective are surely the elaborate royal festivals held annually in most states, which bring together regalia, art objects, music, and dance to renew the state spiritually and politically. Important rituals are carried out, including purifying the king and the ancestral stools, feeding the local gods with sacrifices, mourning the dead of the past year, and reaffirming political loyalties and allegiances. There are also lavish public shows of personal decoration and state regalia, dancing and drumming, singing and speech making. Formalized dress and behavior prevail, along with feasting, for the gods and the people alike are offered the "first fruits" of the agricultural year.

Multiple processions surge through the streets, set in motion by state orchestras whose master drummers beat out praise poems glorifying chiefs and state history on "talking drums" whose tones reproduce speech patterns. A dozen or more chiefs and their entourages participate. Some chiefs walk while more important ones ride in palanquins gesturing with flywhisks or weapons to the crowds (fig. 7-31). Dozens of colorful umbrellas with golden finials pass by, including the double dome of the king (fig. 7-32).

7-30. Roll-out drawing of motifs carved on an Akan drum

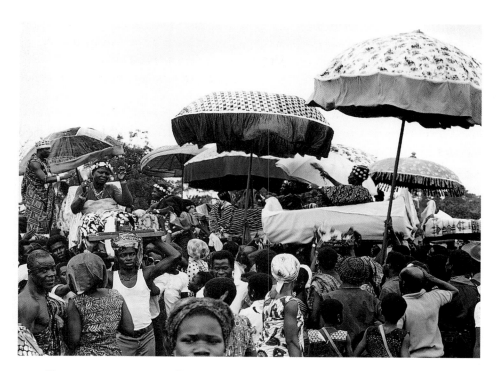

7-31. The paramount chief of Enyan Abaasa riding in his palanquin during a royal festival, Ghana. 1974

Several drum orchestras plus groups of elephant tusk trumpeters supply rhythm and tonal vibrancy, while many voluntary organizations whose members dress and move as one add color and texture to the whole.

Great festivals are well staged and precisely choreographed, as much by history and tradition as by individuals. Events are composed in space and time, framed by beginning and closing rituals, with intricately orchestrated themes, colors, textures, rhythms, patterns, and dramatic thrust—the same elements present in any art object, such as a sculpture or a complex *kente*. Scenes and rites are

7-32. King Kwame Fori II under his double umbrella at the royal festival of Akuropon, Ghana

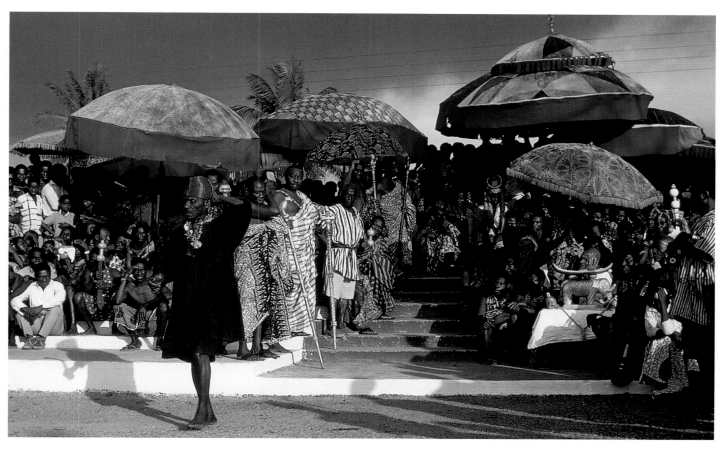

acted out, tempos and moods are established, working toward climax and resolution, all in the service of meaning. The strength and unity of the state are reaffirmed, gods and ancestors are honored and thanked, major concerns of royals and the people at large are aired and resolved. At least these are sought ideals. The atmosphere is dignified and cool for restricted or solemn rites, vibrant and pulsating for public displays. Excess and confusion are frequent visitors, as many activities happen simultaneously in different places, overlapping and coalescing, with hundreds, even thousands of people taking part. The entire spectacle as a unity subsumes its parts—people, arts, events—into a whole of magnificent intensity and scale.

BAULE MASKS AND MASQUERADES

If the Ghanaian Akan channel great aesthetic energy into regalia and the festivals that make them visible, the Baule in contrast seem to focus much of theirs in an array of masquerades. Some Baule masquerades are major village events involving the whole community. Based on rituals yet elaborated beyond spiritual concerns to become public entertainments, they are of considerable artistry and rich meaning. Others are (or were) almost exclusively ritual, and unfold before a restricted audience.

Goli

Goli is the most popular Baule masquerade, substantially secular today but with serious social commentary implied and a basis in beliefs about supernatural powers, their sources, effects, and hierarchies (figs. 7-33, 7-34). The goli masquerade was adapted from the Wan, a Mande people contiguous to the northwest, and expanded upon by the Baule around the turn of the century. The discussion here combines Wan and Baule versions, which in any case vary from village to village.

The most usual venue for goli is the funeral of a prominent person, for which the all-day masking sequence provides both protection and entertainment. More powerful "forces of nature," amwin, in earlier times, goli masks in recent decades have become progressively weaker as supernatural vehicles. Still, the masks are ritually activated and their bearers wear empowering substances and must obey dietary and other restrictions.

The ideal sequence of Baule goli dances includes four successive male–female pairs of virtually identical masks, one usually black, the other red. All are danced by men. The mask pairs, along with metaphorical associations made for each by some Baule (and outsider) analysts, are:

mask pair	associated with
kplekple (junior male)	weak youthful wild animal/boy/goat
goli glin (senior male)	strong elder bush spirit/messenger/ bushcow
kpan pre (junior female)	girl merges bush and village/soldier/ antelope (?)
kpwan (senior female)	idealized village woman/chief/ leopard

7-33. BAULE *KPLEKPLE* (JUNIOR MALE) MASKERS, BOKPLI, AITU REGION, CÔTE D'IVOIRE. 1982

7-34. *GOLI GLIN* (SENIOR MALE) DANCES VIGOROUSLY, CÔTE D'IVOIRE. 1978

For the Baule there is no logical inconsistency in the fact that each mask name, seemingly single and gender-specific, actually describes a male–female pair of masks. Indeed, the couples imply marriage, family, and children—all fostered by the masquerade.

Through their sequential appearance, the masks trace a progression from foolish youthfulness to stronger, more aggressive danger, then from youthful female grace to fully realized womanly beauty and wisdom. The first two pairs, essentially animalistic, signify unruliness and bush power, contrasting with the second two civilized human pairs, who represent the dignified order of the village. The progression, though, is not inviolate. The Wan dance only three masks (omitting junior female), and their masks are not pairs but single. Nor does every Baule village dance all eight. Nevertheless the sequence and its associations are generally observed.

Each masked presence combines several sometimes ambiguous traits, exemplified with particular force in the senior male, *goli glin* (see fig. 7-34). The formal complexity of this mask— curved and straight lines and planes, voids and solids—implies its complex meanings. The mask is a composite of bush-cow, antelope, crocodile, and perhaps bird, as feathers of a powerful bird are attached and "eagle" is one of the mask's praise names. It is painted with red medicinal pigment, implying blood, danger, trouble, aggression. The masker executes a rapid, aggressive, and difficult dance. *Goli glin* is feared and linked with killing and death, yet he is also protective, his fresh young palm fiber cape symbolizing life and continuity.

Junior females, the penultimate pair, wear face masks surmounted by horns. The final and hierarchically highest mask, eagerly awaited throughout the day, is *kpwan*, senior female, the embodiment of cool, pure,

life-giving womanhood. Her mask is small, with balanced harmonious features. The costume emphasizes whiteness, which implies peace and well-being. Yet the mask is considered difficult to wear and dance, even dangerous, and carries numerous restrictions. A man without children may not wear it, and an error in the dance could bring on a poor harvest. Here artistry and ritual purpose merge. In some areas, at the end of the sequence the senior male returns to the arena to enact a love scene with the senior female. Then she departs the dance ground; he sets out later to find her, angry that she has left. Together they then retreat to their sacred bush sanctuary. There, well away from the audience, the masks are retired.

Goli meanings are layered and metaphorically rich. The sequence, while entertaining and dramatic, with elaborate costuming, well-carved masks, clever songs, and affecting dances, is at the same time a compressed version of Baule/Wan values, a cameo of age, gender, aesthetic, knowledge, and bush/village commoner/chief hierarchies and oppositions. Performing at a man's funeral (more rarely a woman's), to which ancestors are invited so as to welcome their newest member, the maskers celebrate life, beauty, elders, wisdom, and women. Thus the masquerade comments upon human existence and many of its essential categories, and at the same time it enriches and deepens that life by its allusions, its drama, and its art.

Bonu Amwin and Do

While all Baule masks are *amwin* ("power" or "force"), there are some that even today generate fear and

7-35. *BONU AMWIN* MASK. BAULE. BEFORE 1939. WOOD, 19¼" (49 CM). MUSÉE BARBIER-MUELLER, GENEVA

threaten danger. Such are the sacred *bonu amwin*, a series of similarly shaped bush-cow/antelope composite masks probably of Mande origin (fig. 7-35). Most villages have at least one of these, some seven or eight, each with a different name and related if discrete purposes. Activated and empowered by sacrifice when donning costume and mask in the bush sanctuary where they live, the masks require strict precautions of their wholly male mask society members, and especially their carriers, before entering a village. The maskers (one or several) have come out for the past several decades at dry season festivals and for funerals of respected elders, but earlier they appeared whenever something seriously threatened village order. At death celebrations they attend the preparation of the corpse and the vigil, returning again at the end of the

mourning period, thus helping to banish death from the community, just as analogous Senufo composite masks do (see chapter 5). Announced by bush-cow horns believed to be their voices, *bonu amwin* maskers, with costumes of bush materials, carry whips and lances to terrorize the crowds, menacing people with wild, erratic behavior. Women, who are especially threatened, retreat to their houses.

Bonu amwin operate—and especially did some decades ago—to protect communities against hidden or overt dangers such as witchcraft, disease, or threats of warfare or catastrophe. These masks are also purifiers, judges, and settlers of conflict. Through intimidation and threatened or actual violence, this masquerade represents the male ethos of dominance, pointing out by contrast the restraint and order preferred in village life. Significantly, the only *amwin* stronger in Baule life

7-36. FANTE DO MASKERS, CAPE COAST, GHANA. 1979

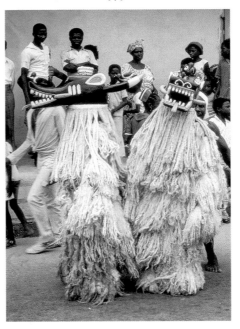

belongs to women, who never use masks, and this is invoked only when men's efforts to avert misfortune have failed.

The Baule have Do masks quite similar in form and function to *bonu amwin*, and indeed the Do masking cult is distributed widely among Mande and Mande-influenced peoples. For Do is a word of Mande origin, and in some places it refers to a Poro-like initiatory organization (see chapter 5). Like *bonu amwin*, many Do masks are part of a complex of horizontal masks found across much of West Africa. The Do masks illustrated here both fit this paradigm and are an exception that prove the rule, for they are from the Ghanaian Akan, the Fante, who for the most part do not engage in masking (fig. 7-36). These masks belong to a Fante military company in the town of Cape Coast. Several Do masks have been recorded too among western Akan and Lagoons peoples. While detailed data are lacking for many, at least some were used to protect against sorcery and witchcraft, a function coincident with others in the tradition of composite horizontal masks.

AGE-GRADE ARTS OF LAGOONS PEOPLES

Community leaders and age-grade associations are the primary users of visual arts in the Lagoons region. Age-grades, an institution not found in Ghana, are formal divisions by social age of the male population. Formerly, initiation prepared younger men to be warriors; their age-grade proved its courage and unity to men of the elder age-grade in dancing displays. Monumental drums were visual and

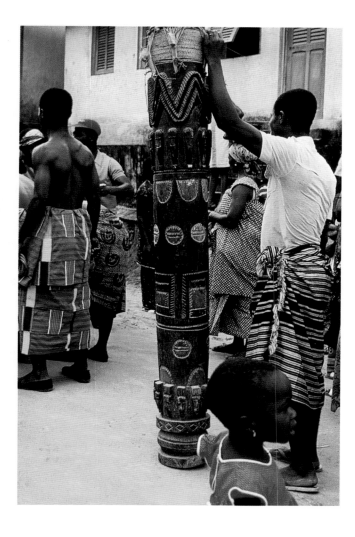

spiritual focal points in these cere-
monies (fig. 7-37). In some areas each
new grade commissioned its own
drum; in others, the new grade had to
capture the drum of the seniors they
were seeking to replace. Such elon-
gated drums, with various relief
carvings, are believed to embody the
spiritual power of ancestors and local
nature deities. Their powerful rhythms
still inspire their age-grades. Formerly
they called men to war and led them to
battle; today, they still summon people
to age-grade members' funerals, which
are also occasions for displays of per-
sonal decoration and regalia discussed
earlier (see figs. 7-8, 7-9, 7-10).

ARTS OF FANTE MILITARY COMPANIES

Living along the former Gold Coast
and in adjacent inland areas, the Fante
share with other Akan the religious
and state arts explored above, but they
also have distinctive arts of their own
belonging to their military companies,
Asafo. While Akan kinship is matrilin-
eal, Asafo membership is patrilineal,
and the groups are essentially egalitar-
ian even though they have
leaders—commanders, captains, and
other officers. Both men and women
thus join their father's Asafo company.
Having been in constant contact with

European powers along this coast since
the late fifteenth century, and having
served as reluctant hosts to European-
designed trading and slaving forts and
the garrisons that staffed them, Fante
military organizations have absorbed
and adapted European ideas, motifs,
objects, and technologies into their
own artistic culture.

For many decades now Asafo
groups have been "fighting with art,"
for first the British, then the Ghanaian
government usurped military func-
tions once performed by Asafo
members. Otherwise they are essen-
tially social organizations, which still
serve as a democratic counterbalance to
royal hierarchies, playing a role for
example in selecting and enstooling a
paramount chief. Each state and most
larger communities have from two to a
dozen Asafo companies, setting up an
automatic rivalry played out in festi-
vals and their arts. Each company owns
certain exclusive colors, motifs, musical
instruments, and other insignia, with
any violation of such prerogatives by
another company being considered an
act of aggression. Art, then, may and
does cause disputes, which in the old
days erupted into virtual warfare.

For many Asafo companies, a con-
crete shrine, building, or monument
serves as a rallying point. Called
posuban, these structures developed
during the 1880s, slowly replacing pre-
vious rallying points such as fenced
shrine mounds or sacred trees. Over
the course of the twentieth century
they have been elaborated into fanci-
ful, even flamboyant civic markers in
an otherwise rather dull architectural
landscape. *Posuban* are built of
European-introduced concrete and
related materials, drawing upon local
castles and Christian churches for

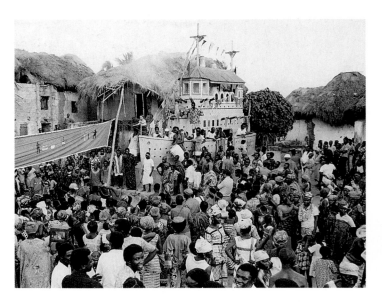

7-38. Asafo *POSUBAN* and flag during a festival, Anomabu, Ghana. 1976

7-39. Military shrine, *POSUBAN*, Etseu Jukwa, Ghana. 1976. Height c. 35′ (1.07 m)

Primarily sculptural monuments, posuban brag repeatedly about martial powers, often including cannon (real or mock) and cement sculptures of officers and soldiers. The sculpture of the elephant pulling down the palm tree that surmounts this posuban recalls the proverb that the strongest animal can pull down the strongest tree, i.e., that this company (elephant) can best any other (tree), no matter how strong. Clocks, chains, padlocks, and keys are other imported motifs employed here to signify the control of time, space, and people, which Asafo companies claim.

some of their architectural elements and from native Akan impulses for their essential and sometimes whimsical visual character. A *posuban* houses its company's sacred drums and symbols. Although most have little interior space, they serve as centerpieces for meetings, funerals, and festivals, and as ostentatious flagships for Asafo activities—sometimes literally (fig. 7-38). This warship is one of five in Fanteland, where two other *posuban* take the form of airplanes.

Most *posuban*, however, are built as multistoried structures (fig. 7-39). Many have this example's wedding-cake stack of progressively smaller stories, and most are ornamented with sculpture. As with other Akan arts, sculptural subjects may be emblematic, or they may be linked with proverbs. Motifs generally aggrandize

the company, often while belittling rivals at the same time. A common proverb for lions, for example, is "A dead lion is greater than a living leopard," meaning "Even at our worst we are stronger than you." Notably, the lion became a popular Akan motif in part because of its use in British heraldry and commercial logos.

The same types of imagery, with the same origins, are seen in two dimensions in flags, an Asafo company's most important portable

symbol. Inspired by flags of European visitors, Asafo flags have been aggrandized in form, use, and meaning. Many of their appliqué motifs are linked to verbal expressions, giving them a particularly Akan inflection. As with *posuban* imagery, these expressions commonly vaunt the strength of the owning company, often at the expense of the diminished and weaker rival. Generally measuring about four feet by six feet, flags are sewn and appliquéd with bright cotton cloth by male artists.

0 5 10 ft

0 1 2 3 m

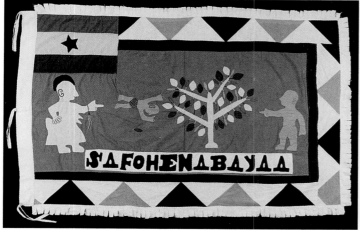
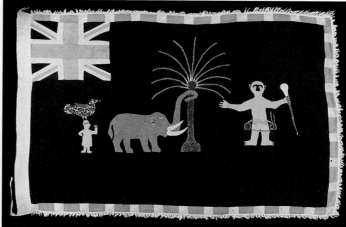

7-40. Asafo flags. Left: Boy and pepper plant flanked by male and female officers, sewn by K. Badowah. 1978. Cotton, 64 x 42¾" (163 x 106 cm). Right: Elephant grasping palm tree, man with bird on head, and bystander, by A. Achempong. c. 1935. Cotton. Fowler Museum of Cultural History, University of California, Los Angeles

In the left flag, the boy who picks a ripe pepper will learn wisdom when it gets into his eyes. Rival companies are like the inexperienced boy. In the right flag, the palm is credited as the strongest plant, the elephant, the strongest animal. "Only the elephant can uproot the palm" asserts the superiority of the elephant, the animal kingdom, and the company that owns the flag. "When no trees are left [elephant got the last one], birds will perch on a man's head," or when you see something unusual—such as a bird perching on a man's head—something caused it. This reminds the company to look for reasons behind the strange behaviour of others. The linguist with the staff, to the right, explains all this.

7-41. Asafo company flag sewn by Mr. McCarthy in 1952. Drawing by Patrick Finnerty

Currently in the collection of the Fowler Museum of Cultural History in Los Angeles, this flag was originally made for display by Asafo No. 6 Company in Anomabu, Ghana. A rival Asafo successfully challenged its maroon background color in court, however, and the company was prohibited from using it (which is why it could be purchased by the museum). No. 6 Company eventually had a duplicate flag made on a correct bright red background which they still legally display (see fig. 7-44). The flag is almost 100 feet (30 m) in length Its nineteen motifs do not form a continuous narrative, but they variously refer to the strength, wisdom, preparedness, and invincibility of the company and the foolishness, timidity, and weakness of competitors.

The British Union Jack occupies an upper corner of earlier flags (fig. 7-40), replaced by the Ghanaian flag after independence in 1957. Asafo flags have been made for at least three hundred years. Each new officer commissions one that later enters his or her company's collective property; many groups had several dozen until these flags became popular among European art collectors and were sold off to dealers. Such has been the fate of all too much African art. Less easily alienated are those locally invented flags, some as long as 300 feet, with thirty or more appliqué motifs, that are a playful, almost illogical, extension of the flag maker's art (fig. 7-41). Unlike *posuban*, which are of course permanently on view, flags and uniforms come into their own when animated in festivals.

Many Fante states celebrate an annual festival largely given over to Asafo displays, though their ritual base points up the traditional civic

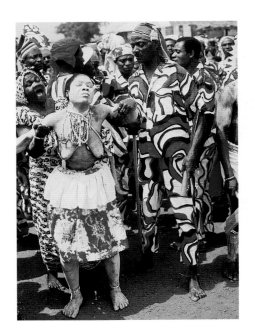

7-42. FANTE PRIESTESS WITH UNIFORMED DANCERS FROM No. 1 COMPANY, LEGU, GHANA. 1974

Religious specialists, such as the priestess here, are either members of the Asafo company with whom they parade, or their deities are given special protection by the military group.

and spiritual responsibilities of these military groups. One such is the path-clearing festival, *akwambo*. The paths are those to local shrines and water sources. After company members have cleared these overgrown trails, which may be a mile or more long, rituals are performed for major deities to placate and thank them for granting and pre-serving prosperity (fig. 7-42; see also 7-38).

The principal source for the example of *akwambo* described here is Legu, a coastal fishing community with two rival Asafo companies. This *akwambo* transforms the town with costumed marching groups, singing, skits, flag dancing, chanting, and danc-ing for some six hours, with each

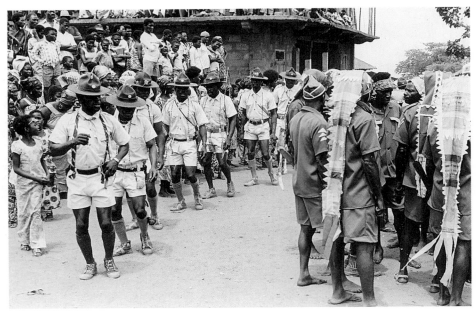

7-43. A SUBGROUP OF ASAFO No. 2 COMPANY DRESSED AS BOY SCOUTS DURING THE *AKWAMBO* FESTIVAL, LEGU, GHANA. 1976

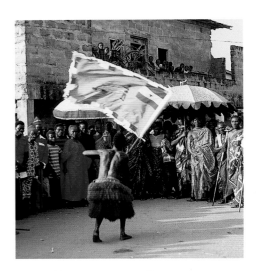

7-44. FLAG DANCER AT A FANTE *AKWAMBO* FESTIVAL, ANOMABU, GHANA. 1972

A typical flag dancing sequence, actually a brief martial drama, unfolds to the rhythms of drums and gongs, and with the support of uniformed divisions. The dancer proudly carries his banner into a skirmish. Then he hides it, rolls it up, and tosses it to another soldier for protection. He later retrieves it, unfurling it victoriously.

company allotted equal time. Up to eighteen subgroups of each company appear, with vibrant, distinctive uni-forms in company colors: red, white, and blue for one company (see fig. 7-42), and yellow, orange, green, and purple for the other. Some subgroups dress as soldiers, boy scouts, girl guides, and police, with uniforms faithfully copying the originals (fig. 7-43). The two companies compete in outdoing one another in the brightness and numbers of uniforms, in marching and chanting, and in skits interspersed in the flow of subgroups entering and leaving the main town plaza in quick succession. Thus an officer mimics sounding the water's depth with a lead line, a mock police officer directs the truly heavy traffic in the plaza, two sol-diers speak to each other over string telephone wires stretched between their wooden handsets, and a flag dancer acts out a brief scene.

Flag maneuvers and elaborations figure strongly in Asafo displays.

7-45. MEMORIAL SCULPTURAL GROUPING. CEMENT AND PAINT

Specially trained flag bearers twirl, throw, protect, and otherwise dance their flags, which graphically broadcast their company's military prowess (figs. 7-44, 7-45). Companies with long flags may suspend them from their *posuban* or carry them in serpentine processions through town streets, as if clearing away anything in their path. These spectacular banners have names such as "river" or the "runoff of rainwater," metaphors for the company's power to sweep obstacles away as they inundate their outclassed enemies.

Competition between companies is serious, yet playfulness also pervades Asafo imagery and martial activity. Since the Fante understand well that actual warfare is a thing of the past, they let imagination, humor, and a spirit of play enliven their "fighting with art."

LIVES WELL LIVED: CONTEMPORARY FUNERARY ARTS

Second burials are a widespread West African custom. Colorful, joyful celebrations commemorating the lives of the prominent dead, they usually occur several months or even a few years after interment. Vast sums of money are channeled into commemorative sculpture and lavish festivities, consonant with a belief that amounts to a formula: status in the world of ancestors is directly proportionate to social position, generosity, and great expenditure in the living world. Much in keeping with the accommodations that Fante Asafo companies have made over the centuries with European ideas, materials, and images, second-burial arts too have been modernized to keep pace with the changing cultural conditions in contemporary Ghana and Côte d'Ivoire.

The early decades of the twentieth century saw the rise of cement memorial sculpture, a direct legacy of the terracotta memorials discussed earlier. Stimulated in part by European mausoleums and graveyard statuary, Ivorians and Ghanaians (also many others in West Africa) began to erect monumental sculptural groups in permanent materials, often polychrome. By the 1960s and 70s, such monuments were common.

Cement memorials range from single figures to rather large sculptural groups, some in abbreviated architectural settings (see fig. 7-45). In addition to the commemorated man, and often his wife, sculpture may depict other family members, drummers, angels, police or other guards, equestrians, lions, or leopards, all more or less symmetrically and hierarchically arranged. Inscriptions on the monuments record the relevant names, community, and dates, sometimes along with biblical passages if the family is Christian. These extensions of earlier commemorative traditions accord with overall tendencies of contemporary art in Africa toward permanent materials, vibrant colors, descriptive portraiture, and artists who want to be known and appreciated for their considerable skills.

During the 1970s in Accra, the capital of Ghana, a carpenter named Kane Quaye (1924–1992) began a parallel tradition, the construction and marketing of a remarkable series of fancy coffins (fig. 7-46). His subjects—cocoa pod, Mercedes Benz,

7-46. MERCEDES BENZ-SHAPED COFFIN. KANE QUAYE. 1989. WOOD AND ENAMEL PAINT; LENGTH 8' 8" (2.65 M). MUSEUM VOOR VOLKENKUNDE, ROTTERDAM

onion, rooster, outboard motor, and many others—catalogued both aspects of everyday life and current concerns with prestige and wealth. Coffins were painted with bright enamels and lined with sumptuous fabrics. The very piecing together of objects with shaped wood, nails, and glue is introduced technology (seen earlier in adapted European chair construction), earlier wood sculpture having been carved from single pieces of wood.

Kane Quaye died in 1992, but his son and his former apprentices carry on an expanding business in this burgeoning art form, which accords so well with long-established lavish sendoffs for the respected dead. Such expensive coffins are commissioned by middle-class or wealthy families, and their cost is only a fraction of the outlay for an entire funerary celebration. The coffin subject generally refers to the dead person's special concerns. A farmer of onions might commission an onion

coffin, for example, or a wealthy fisherman a boat or fish (fig. 7-47). A globe-trotting businessman might ask for an expensive car or an airplane to reflect his hard-earned status and wealth. Coffins stressing traditional regal motifs—leopard, eagle, elephant, stool, state sword—are popular with chiefs and other leaders. The choice of subjects is dynamic, and new images are constantly invented by the workshops.

An ongoing, quasi-traditional aspect of Akan arts is the quantity of figural images such as *akua ma* and figural combs that are being made expressly for an outside market. Some of these are freshly carved, canonical figures—the mother and child icon is favored—whereas others have been made with the intent to deceive (see fig. 7-29, two top right figures). Some of the latter fetch five-figure prices on the international market, only a small proportion of which the carvers

themselves get. Several quite prolific workshops are found in southern Ghana. They are run by or employ master carvers capable of fine original work and several different styles. Some of the same shops also have groups of young boys busily rubbing dirt or sand on figures to give them the illusion of age so that they will fetch higher prices. Throughout Africa today the need for art by "traditional" religious practitioners and shrines is negligible, nor is there much local demand for masks. Most works being made in early or "traditional" styles are reproductions, tourist carvings, or fakes destined, perhaps ironically, for homes a long way from Africa. These sculptures, of course, need to be differentiated from expressly modern works being made by professional academic artists.

INTERNATIONAL ART

Both Ghana and Côte d'Ivoire have many contemporary artists whose work is more international than local, and who exhibit in Europe and the United States as well as in Africa. Many are academics, and/or were trained in art schools, colleges, or universities in Africa or abroad. One such artist is El Anatsui (born 1944), an Ewe sculptor born and educated in Ghana but for many years a resident of Nigeria, where he teaches. He works primarily in wood, the most "traditional" of materials, which he literally assaults, mostly with power tools, as if to violate deliberately the conservative canons of more traditional woodcarving (fig. 7-48). A "power saw tearing rough-shod through organic wood at devastating speed, to me constitutes a metaphor of

7-47. FUNERAL PROCESSION WITH FISH-SHAPED COFFIN, NEAR ACCRA, GHANA. 1992

7-48. *The Ancestors Converged Again*. El Anatsui. 1995. Installation, wood, and tempera; 40 x 107 x 15" (102 x 272 x 15 cm). National Museum of African Art, Smithsonian Institution, Wahington, D.C.

In this work the artist alludes to otherworldly ancestor figures in rough, schematic forms, with enlarged heads. He picks details out with polychrome tempera. The (usually) enlarged eyes seem to refer to the ancestors' ability to look into (and affect) life here on earth.

the hassling, rat-racing, hypertensive pace of present day living," the artist explains. He incises, burns, gouges, drills, and saws planks or logs, which he often combines or arranges in series, as in this work. El Anatsui's motifs are often abstract, though they may refer to formal patterns in earlier arts such as figural carvings, textile designs, or wall painting motifs. He thus explores African history and spiritual values as well as contemporary life, often with satirical humor and irony.

Ouattara (born 1957) is an Ivorian artist of Senufo heritage now living and making art in New York. He too casts a wide net in subject matter, managing to combine recognizable earlier African forms or motifs (including actual masks and other artifacts), an earthy palette, and rough drawing with strong, often geometric compositions in paintings and constructions which sometimes have the look of altars or the facades of houses. In an assemblage entitled *Nok Culture* (fig. 7-49), Ouattara self-consciously refers to the African past (Nok terracotta figures are the earliest known sub-Saharan sculpture; see chapter 3). At the same time, he creates cryptic

7-49. *Nok Culture*. Ouattara. 1993. Acrylic and mixed media on wood, 9'8½" x 6'7¾" (2.96 x 2.03 m). Collection of the artist

symbols, such as the "figure" comprised of concentric ovals and, perhaps, raised arms. The overall rectangular format of the piece is architectonic, with two pairs of projections recalling Sudanic architectural motifs, from the top and front, a painted dentate frieze across the top, and a window-like opening in which hangs a Muslim prayer board, replete with Arabic writing and symbolic devices. Abstract and deliberately puzzling overall, *Nok Culture* seems to be a metaphorical window, a threshold, into the mystery and symbolism of ancient African thought, but expressed in a thoroughly modern way.

8
THE YORUBA
AND THE
FON

THE YORUBA PEOPLES OF SOUTH-western Nigeria and southern Benin are perhaps the most urban of all African groups. By the eleventh century AD, their founding city, Ile-Ife, was already a thriving metropolis, the center of an influential city-state. Over the ensuing centuries, numerous other Yoruba city-states both major and minor evolved, all claiming descent from Ile-Ife. This urban tradition continues to the present day, when Yoruba cities may number in the hundreds of thousands.

To the west of the Yoruba, in southern Benin and Togo, live the Fon and their relatives the Ewe and the Popo, collectively called the Aja peoples. Fon traditions claim close relationships to the Yoruba. The first of several Aja kingdoms was Tado, located in present-day Togo. Some versions of Aja origins claim that the king of Tado was Yoruba. According to legend a Tado princess had union with a leopard spirit and gave birth to Agasu, the ancestor of the Fon kings. By 1600 Agasu's descendants had founded the kingdoms of Allada and Ajase-po on the coast of present-day Benin and the kingdom of Dahomey to the interior.

Although Yoruba and Fon cultures are distinct from each other, they have interacted for centuries through both trade and warfare, and many elements of Yoruba culture are shared by the Fon, including the institution of centralized kingship and a system of divination for communicating with the spirit world. The two cultures also acknowledge a similar pantheon of gods and spirits, with some Fon divinities seemingly variants of Yoruba originals. Artistic influence has also flowed from the Yoruba to the Fon, and Yoruba artists are known to have worked in Fon courts.

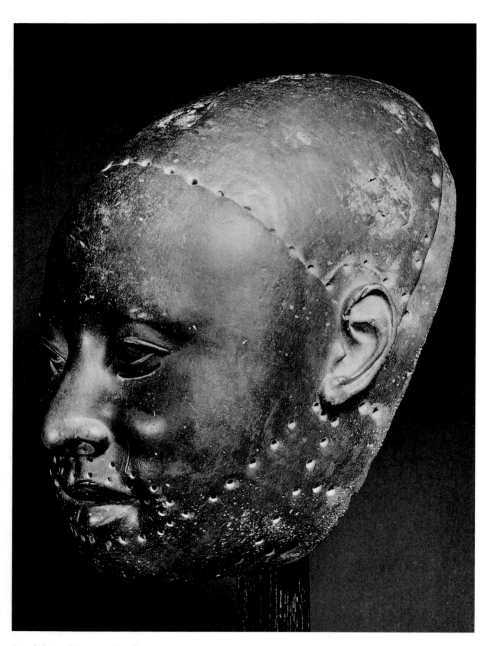

8-1. MASK. YORUBA. IFE, PAVEMENT PERIOD, 12TH–15TH CENTURY. COPPER, HEIGHT 13″ (33 CM). MUSEUM OF IFE ANTIQUITIES, IFE

EARLY IFE

In Yoruba mythology the city of Ile-Ife is "the navel of the world," the place where creation took place and the tradition of kingship began. There it was that the gods Oduduwa and Obatala descended from heaven to create earth and its inhabitants. Oduduwa himself became the first ruler, *oni*, of Ile-Ife. To this day Yoruba kings trace ancestry to Oduduwa.

The largest and most coherent body of artistic and archaeological evidence for early Ile-Ife dates from the centuries between roughly AD 1000 and 1400, an era known as the Pavement period. Numerous finds predate these centuries, however, and there is evidence that the site was occupied by at least the eighth century AD. While little is known about these earlier centuries, scholars have proposed two broad periods of development, an Archaic period, to about AD 800, and a Pre-Pavement period, from about AD 800 to 1000.

Archaic and Pre-Pavement Periods

Among the most remarkable works to have survived from the Archaic period are a number of stone monoliths. A dramatic granite gneiss monolith known as Opa Oranmiyan is the largest of these, rising to a height of over 18 feet (fig. 8-2). Opa Oranmiyan is set with spiral-headed iron nails in a trident pattern. There is no way to know exactly what the monolith represents. Its name dates from recent times and means "the staff of Oranmiyan." Mythical son of the god Oduduwa, Oranmiyan is associated with the founding of the dynasties of both the

kingdom of Benin (see chapter 9) and the Yoruba city-state of Oyo.

In contrast to the abstract or radically simplified forms of Archaic sculpture, Pre-Pavement figures depict human and animal subjects in more naturalistic styles. One of the most famous Pre-Pavement works is known to present-day inhabitants of Ile-Ife as Idena, "gatekeeper" (fig. 8-3). Exaggerated columnar legs provide a stable base for the bare-chested male figure, which stands with its hands clasped at the waist. Spiral-headed wrought-iron nails embedded in the head suggest the texture of hair while linking the figure back to the iron-and-stone works of the Archaic period. The heavy collar of

8-2. Monolith known as Opa Oranmiyan ("staff of Oranmiyan"), Ife, Nigeria. Yoruba. Archaic period, before c. AD 800. Granite and iron

Similar monoliths ranging from one to twelve feet in height can be found at several sites in Ile-Ife. Today, many of the monuments are associated with Ogun, the god of iron. The combination of iron and stone in Opa Oranmiyan and other Archaic objects suggests that they were created during a period that witnessed the transition from a Neolithic technology to a technology based on iron. Metal would have enabled not only more effective farming implements but also more effective weapons, and it has been suggested that monuments such as Opa Oranmiyan served to commemorate the victories of an early warrior-ruler and acknowledge his association with Ogun.

8-3. Figure known as Idena ("gatekeeper"), Ife, Nigeria. Yoruba. Pre-Pavement period, c. AD 800–1000. Granite and iron. Museum of Ife Antiquities, Ife

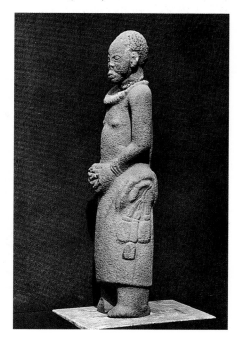

beads, the bracelets, and the intricately tied wrapper suggest a person of high rank.

Pavement Period

During the eleventh century Ile-Ife blossomed into a substantial urban center. Beginning in the thirteenth century, as rivalry between Yoruba city-states intensified, Ile-Ife began to fortify itself with a defensive moat and earthen ramparts. Intermittent warfare between Yoruba city-states continued well into the nineteenth century and is probably in part responsible for the Yoruba cultural pattern of living in densely populated, walled cities surrounded by radiating farmlands.

Excavations suggest that early Ile-Ife was laid out in an orderly plan (fig. 8-4). Like most Yoruba cities it was roughly circular, with the palace at the center. Two concentric systems of walls surrounded the city. Near the palace, but also sprinkled throughout the city, were shrines to the deities. Major roads radiated outward, linking Ile-Ife to neighboring cities—Ondo to the south, Ijebu to the southwest, Ede to the northwest, Ilesha to the northeast, and the city-states of the Ekiti region to the east. Marked by a large gateway that likely housed guards, each opening in the moat and wall complex was both a military post and a ritually consecrated space.

The basic unit of architecture seems to have been a thatch-roofed verandah surrounding a courtyard. Most homes would have been formed of several such courtyards, while the palace probably had great numbers of them. At least one palace courtyard of great size accommodated a large portion of the population for ceremonies. The most important courtyards in palaces, shrines, and gateways were decorated with elaborate mosaic pavements of stone and pottery shards (fig. 8-5).

Paved courtyards were sacred spaces. The semi-circular voids at the top and bottom of the diagram indicate where raised altars made of packed earth would have stood, their sides inlaid with shard mosaic designs. Ritually buried pottery has been recovered from such courtyards. One courtyard yielded fourteen buried pots set into the earth along the pavement's border and fitted with lids depicting the heads of various animals (fig. 8-6). The ram's head, at the left, wears a royal crown, suggesting that the animal served as a metaphor for kingly power. Other animals such as the elephant, leopard, or what may be a hippopotamus on the pot at the right, may also refer metaphorically to the *oni*, for they too are depicted wearing elaborate beaded headdresses with a royal crest and forehead pendant.

A single vessel was often set into the center of the courtyard, its position emphasized, as in figure 8-5, by a circular arrangement of stones and shards around the protruding neck. One of the most interesting of these vessels to have been recovered is shown in figure 8-7. Typical of such vessels, the bottom was broken prior to its burial so that libations poured into it would penetrate directly into the earth. Decorations in high relief depict a series of undoubtedly potent symbols, among them an altar such as those that probably stood in the semi-circular spaces framed by the courtyard pavement. Enclosed by posts that support a roof of palm fronds, the altar is set with three sculpted heads. The central head is in a fully naturalistic style, while the flanking works are abstract. Both styles closely resemble works that have been found at Ife.

8-4. Plan of Ile-Ife. The letters indicate where works illustrated in the text were found or are located:
A Oni's palace (see fig. 8-1)
B Ita Yemoo (see figs 8-8, 8-11)
C Wunmonije (see fig. 8-10)
D Opa Oramiyan (see fig. 8-2)
E Ore grove (see fig. 8-3)
F Obatala shrine
G Odiduwa shrine
H Olokun grove
I Obalara's land (see fig. 8-7)
J Lafogido (see fig. 8-6)

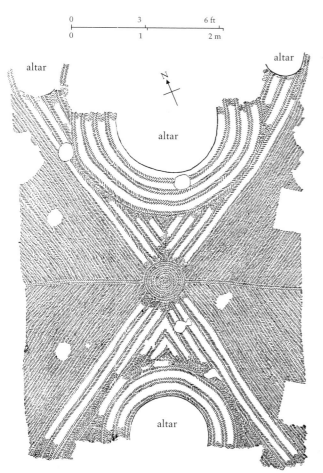

8-5. Pattern of a pavement excavated at Ile-Ife. Drawing by Peter Garlake

Short lines indicate pottery shards set into the earth on edge in herringbone patterns. Small ovals indicate stones that filled the spaces between rows of shards.

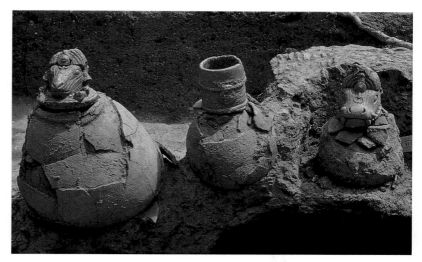

8-6. Animal-headed terracotta vessels excavated at Lafogido site, Ile-Ife. Yoruba. Pavement period, c. 1000–1400; photograph 1979

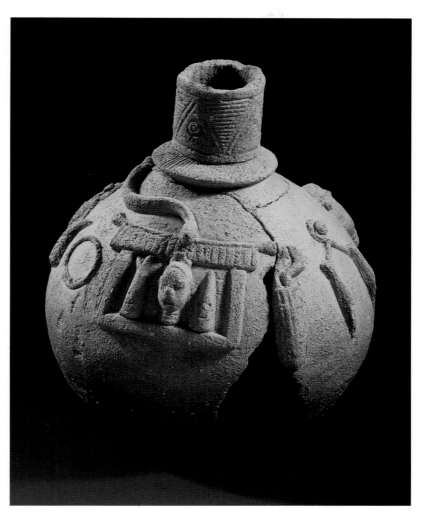

8-7. Ritual vessel. Yoruba. Ife, Pavement period, 13th–14th century. Terracotta, height 9¹³⁄₁₆″ (24.9 cm). University Art Museum, Obafemi Awolowo University, Ife

8-8. HEAD OF A QUEEN.
YORUBA. IFE, PAVEMENT
PERIOD, 12TH–13TH
CENTURY. TERRACOTTA,
HEIGHT 9⅞" (25 CM).
MUSEUM OF IFE
ANTIQIUTIES, IFE

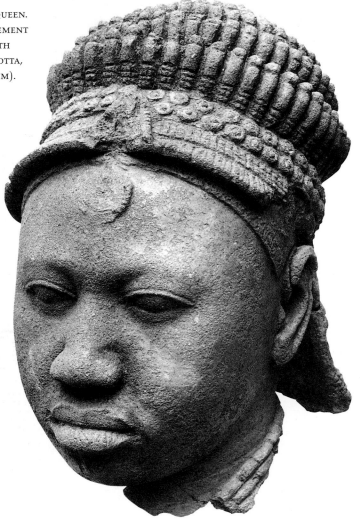

broken on this head, however, indicates that it once formed part of a larger, perhaps complete figure.

In modeling the face, the artist has faithfully rendered the way flesh and muscle lie over bone structure, yet this closely observed naturalism embraces a marked degree of idealism as well. Many parts of the anatomy are noticeably stylized, especially the lips, eyes, and ears. This restrained, idealized naturalism is characteristic of the early centuries of Pavement period

8-9. CYLINDRICAL HEAD. YORUBA. IFE, PAVEMENT PERIOD, 13TH–14TH CENTURY. TERRACOTTA, HEIGHT 6½" (16.2 CM). MUSEUM OF IFE ANTIQUITIES, IFE

As the descendant of Oduduwa, the *oni* of Ile-Ife was viewed as a god-king. Confined to the palace, his life was lived as a continuous set of rituals. Much of the art of ancient Ile-Ife was probably created for the royal court, including figures that may have been intended as portraits of rulers, officials, and their families. The naturalistic style of Pavement period sculpture is beautifully illustrated by the terracotta head illustrated here (fig. 8-8). The most elaborate terracotta head thus far found, it depicts a queen wearing a complex crown. Five tiers of beads comprise the major portion of the crown, while a row of feathers projects over the serene face. The crest that once adorned the front of the crown has broken off, leaving evidence of a circular pendant on the forehead. Traces of pigment suggest that the sculpture was once painted in bright colors. Many of the terracotta heads discovered at Ife are complete works in themselves and were destined for use on altars, as the vessel in figure 8-7 makes clear. The way the neck is

sculpture, which became freer and more expressive in later centuries.

A typical example of the abstract Pavement period style is the cylindrical head illustrated here (fig. 8-9). Two holes suffice for eyes, a simple wedge-shaped cut indicates the mouth, and rounded horn-like knobs sprout from the top. The simultaneous use of two such radically different styles may reflect the need to embody two quite different ideas. The inner head, *ori inu*, and the outer head, *ori ade*, are important concepts in Yoruba thought. The terms reflect complementary spheres of being. The inner head is spiritual and invisible. Perceivable only through the imagination, it embodies a person's fate and true being. The outer head is the physical entity perceived through the senses. The terracotta heads of early Ife are thought to embody this duality, with the abstract style depicting an inner, spiritual reality and the naturalistic style depicting the outer, physical reality. An altar such as the one depicted on the vase in figure 8-7 may have been used in blessing the inner head of the king, a custom that survives in present-day Yoruba courts.

Pavement period artists also produced works in cast metal. While these sculpture are often spoken of as bronzes, most were created from alloys of zinc, lead, and copper more properly classified as brass. A few are almost pure copper. The metals were likely obtained through trans-Sahara trade networks. Cast by the lost-wax process (see Aspects of African Culture: Lost-Wax Casting, page 234), these sculptures show the same idealized naturalism as the early Pavement period terracotta heads, and thus were probably produced during the same centuries.

The life-size brass head shown here stands on a cylindrical neck (fig. 8-10). As on the terracotta head earlier, the eyes, lips, and ears are stylized according to ideal models. Yet the

8-10. HEAD. YORUBA. IFE, PAVEMENT PERIOD, 12TH–15TH CENTURY. ZINC BRASS. MUSEUM OF IFE ANTIQUITIES, IFE

features are still strongly individualized, and the head may well have been intended as a portrait. The face bears the vertical striations found on many terracotta and brass heads at Ile-Ife. While these markings are often thought to represent scarification, the Yoruba in recent times have not been known to use this particular scarification pattern, and it is entirely possible that the striations are purely an aesthetic device.

Holes along the hairline were probably used to attach some kind of headgear, most plausibly a crown. Other heads feature holes along the lower part of the face, just above the jawline and across the upper lip. These may have been used to attach facial hair to heighten the effect of realism. More probably, however, they allowed a beaded shield to be attached, which hid the lower portion of the face. The custom of veiling a sacred ruler to protect him from the gaze of his profane subjects is found in many African societies. Yoruba kings in more recent times have held a fan over the mouth when eating or speaking and have hidden their faces during public appearances behind a beaded veil that falls like fringe from the rim of the crown.

Four large holes appear around the base of the neck. Like their terracotta counterparts, brass heads may have been placed on altars. The holes at the bottom of the neck may also have allowed the head to be attached to a carved wooden body, thus creating a full figure. A number of Yoruba funeral rites witnessed during the early twentieth century included an effigy of the deceased, and such ceremonies in early Ife may similarly have included effigies. It has also been

Aspects of African Culture

Lost-wax Casting

The lost-wax casting process, still in use today, was first employed in the ancient Near East during the fourth millennium BC. The technique was used early in China, and subsequently passed along as well to the many overlapping civilizations that ringed the Mediterranean, including Kemet. Although copper was cast in the southern Sahara by the seventh century BC, the earliest evidence for the process south of the Niger River is from the tenth-century site of Igbo-Ukwu.

The drawings below illustrate the steps used by sculptors in Benin. A heat-resistant core of clay is formed, approximating the shape of the sculpture-to-be. This core is then covered with a layer of wax, which the sculptor models, carves, and incises. Wax rods and a wax cup are attached to the base of the completed wax model to prepare it for casting. A thin layer of finely ground liquid clay is painted on the wax model, and the entire assembly is then covered with increasingly thick layers of clay. When the clay is completely dry, the assembly is heated to melt out the wax, leaving an empty image or mold of the sculpture for the molten metal to fill, and channels where the wax rods have been to allow the metal to be poured in. The mold is turned upside down to receive the molten metal, which is generally a copper alloy approximating brass. When the metal has cooled, the outer clay casing and inner clay core are broken up and removed, freeing the brass sculpture. After the pouring channels are filed off, the image is ready for final polishing. A sculpture produced with this method is unique, for the mold is destroyed in the process.

8-11. FIGURE OF AN *ONI*. YORUBA. IFE, PAVEMENT PERIOD, 13TH–15TH CENTURY. ZINC BRASS, HEIGHT 18½" (47.1 CM). MUSEUM OF IFE ANTIQUITIES, IFE

This small sculpture depicts an oni *in his coronation regalia, including a large collar of beads, cascading bead necklaces, abundant bead bracelets and anklets, and rings on the second toe of each foot. The two bow-like objects attached to beaded strands over the chest probably signify royal status, for similar emblems adorn other brass and terracotta figures. In his right hand he holds an* ashe, *a bead-covered royal staff; his left hand holds an animal horn signifying medicinal powers.*

8-12. SEATED FIGURE. YORUBA. 13TH–15TH CENTURY. COPPER, HEIGHT 21⁹⁄₁₀" (55.7 CM). NATIONAL MUSEUM, LAGOS

suggested that the heads served as mounts for displaying crowns during annual rites of renewal and purification when the ruler's inner head was blessed.

While many of the terracotta heads found at Ife originally formed part of a larger figure, most of these have survived only in fragments. One brass figure, however, has been found intact and undamaged (fig. 8-11). While details of anatomy may suggest a type of naturalism, the proportions of the figure with its outsized head are not naturalistic, further emphasizing the conceptual nature of Ife sculpture.

The most remarkable of all Pavement period sculpture was found not in Ile-Ife, but some 120 miles away in a shrine on the banks of the Niger River near the town of Tada (fig. 8-12). Dated to around AD 1300 and cast in almost pure copper, the figure is distinguished by its relaxed asymmetrical pose, the palpable sense of weight conveyed by rounded fleshy forms, and the more naturalistic proportions of head to body.

The face wears an attentive and dignified expression. A patterned wrapper around the waist falls over the thighs and is fixed on the left hip with an elaborate tie.

How this extraordinary work came to be in Tada is a subject for speculation. It may have been sent from Ife as a token of authority, and may thus mark a boundary of Ife's influence at a certain moment. It may also have been carried off as a trophy of war. The sculpture is one of eight metal figures found around Tada and nearby Jebba Island. According to oral histories of the Nupe people, the present-day inhabitants of the region, the works were stolen from Idah, the capital of the Igala people, by the Nupe folk hero Tsoede. During the sixteenth century the Nupe were in fact involved in wars with the Yoruba city-state of Oyo, which was then extending its boundaries. Oyo claimed close ties with Ife, and it may well be that the statue was taken by the Nupe from Oyo. As many as four different styles are represented by the eight works, which supports the theory that they were imported into the area from various sources. The variety of styles also suggests that casting technology was known outside Ife, though these other ancient casting centers remain to be discovered.

In view of the widespread use of masks and masquerades in African art, the discovery of masks at Ile-Ife is particularly fascinating. Two masks are known, one of terracotta, the other, shown here, cast in pure copper (fig. 8-1). Copper is exceedingly difficult to cast, and the flawless casting of this mask is a tribute to the high level of technical skill attained by Ife artists. The mask is said to represent Obalufon II, the third ruler of Ife, who is credited

with introducing the techniques of casting. Narrow slits below the eyes suggest that the mask was made to be worn. Holes along its back were likely used to attach a costume. The work is kept on an altar in the palace of the present-day *oni* of Ife, where it is believed to have resided since its creation some five hundred to seven hundred years ago.

EARLY OWO

The city of Owo lies about 80 miles to the southeast of Ile-Ife. In centuries past it was a powerful city-state whose influence extended over a broad area. Owo traditions maintain that the kingdom was founded from Ife and that the first ruler, *oba* or *olowo*, was the youngest son of Oduduwa. Archaeological evidence suggests strongly that Owo indeed had material ties to Ife.

Excavations in Owo have unearthed a number of terracotta sculptures, some of which were concentrated in an area that may have served as a storehouse for important shrine objects. The figures have been dated to the early fifteenth century, making them roughly contemporaneous with the Pavement period in Ife art. Some of the Owo terracottas share characteristics with those from Ife, including idealized naturalism and vertical striations on the face. Some Owo objects, on the other hand, seem to be in a distinct style, while still others reflect contact with the kingdom of Benin to the south (see chapter 9).

The fragment of a male figure shown here consists of a carefully modeled head placed on a more coarsely treated body (fig. 8-13). The face differs from those of Ife in that the eyes are more widely spaced and

the corners of the lips are pressed firmly into the cheeks. The pose is dynamic, with the arms raised to the chest. Jewelry includes a complex necklace of beads and tassels, large bracelets covering the forearms, and a band of beads at the waist. A wrapper would have covered the lower portion of the body, now broken off and missing.

Sacrifice is a persistent theme in the early art of Owo. A great variety of sacrificial offerings are depicted—a chicken being carried under an arm, for example, or an animal head proffered by two hands. Sacrifice was and is an integral part of Yoruba religious practices. In the past, no sacrifice was considered too costly if it brought peace and prosperity. To this end, it was sometimes necessary to make human sacrifice. Since it was forbidden to sacrifice a native of one's own town, strangers or slaves taken in war would

8-13. FIGURE OF A MAN. YORUBA. OWO, EARLY 15TH CENTURY. TERRACOTTA, HEIGHT 9⅞" (25 CM). NATIONAL MUSEUM, LAGOS

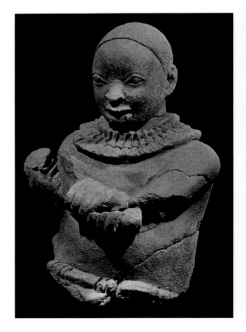

be offered to the deity. Among the most remarkable of Owo sacrificial representations is a terracotta sculpture depicting a basket of decapitated heads, strangers who had been given as a precious gift to one of the gods (fig. 8-14).

Owo stories of origin maintain that the first *olowo* was not only the son of Oduduwa but also the brother of the ruler of Benin. The cultural and artistic traditions of Owo and Benin have clearly been intertwined for centuries. A strong overlay of Benin tradition is apparent in Owo, and Benin was receptive to Owo styles and forms. Early Owo was a major ivory carving center, and great numbers of objects once attributed to Benin are now believed to have been made in Owo itself or by Owo carvers working in Benin.

The ivory sword shown here is of obvious Owo manufacture (fig. 8-15). It is an *udamalore*, a prestigious type of ceremonial weapon still worn by the *olowo* and high-ranking leaders in

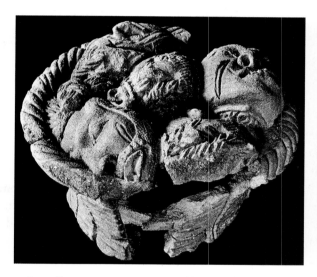

8-14. Basket of human heads. Yoruba. Owo, early 15th century. Terracotta

8-15. *Udamalore* (ceremonial sword). Yoruba. Owo. Ivory. The British Museum, London

Depicted on the elegantly carved hilt is a human head, its graceful neck encircled with royal beads. Motifs on the openwork blade include a man grasping a sword and a bird perched on a tall headdress. The human figure refers to the wearer of the udamalore *himself or to his position in the hierarchy. The bird alludes to the supernatural powers of women that he must use for the good of his people. The interlace patterns on the blade symbolize aristocratic position.*

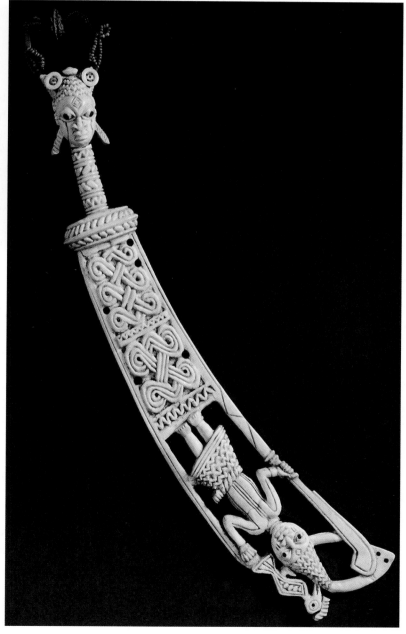

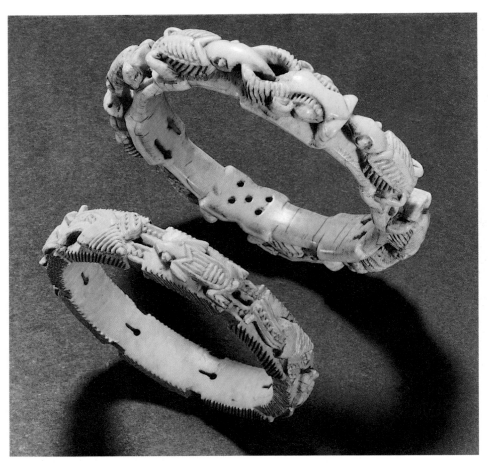

8-16. Bracelets. Yoruba. Owo (?), 17th century. Ivory, diameter 3⅛" (8 cm) and 3⅞" (10 cm). Ulmer Museum, Ulm

trained by Owo artists. At the very least, their presence suggests that the skill of Owo carvers was recognized over a broad area and that their works were sought after and valued.

ESIE

While archaeology, oral histories, and cultural continuity have helped scholars gain some insight into the art and history of Ife and Owo, many other aspects of the Yoruba past remain shrouded in mystery. Such is the case with the largest group of stone figures ever found in West Africa, a mass of over one thousand works that until recently stood in a field outside the Yoruba town of Esie, some sixty-two miles north of Ile-Ife (fig. 8-17).

The carvings range in height from a few inches to several feet. Some depict animals, but the majority are of humans, both male and female, often with elaborate coiffures and ostentatious headgear. Many of the figures are seated. Some play musical instruments, while others are armed with weapons. Such attributes suggest that the figures represent dignitaries, perhaps royalty. Intriguingly, numerous facial types and scarification patterns are portrayed, suggesting that the personages are drawn from diverse cultures and groups. The distinctive style of the works and the high level of artistic development they reflect suggest they were made by a group of people who were socially stable and politically organized.

The present-day inhabitants of Esie, a Yoruba people who arrived from Old Oyo during the fifteenth or sixteenth century, claim to have had nothing to do with making the images or with moving them to the site.

important festivals. The sword indicates that the wearer is from a respected family, that he is a man of maturity and influence, and that his power is felt throughout the kingdom. Although an *udamalore* can be made of a number of materials such as iron, brass, or bead-covered wood, the most prestigious material is ivory.

Two ivory bracelets of probable Owo origin were collected by Europeans during the seventeenth century in the Fon coastal kingdom of Allada, west of the Yoruba city-states (fig. 8-16). Such status objects helped differentiate titled leaders from lesser personalities in Owo. They were worn with ostentatious costumes that called

attention to the wearers, underscoring their aristocratic lineage and the authority they had been granted by the *olowo*. The larger of the two bracelets is carved in high relief with motifs that represent a cow or bull head, probably a reference to sacrifice, and a bird-like creature, perhaps a reference to the powers of women. The smaller bracelet, carved in low relief, is covered with abstractions of aquatic creatures. How the bracelets came to be in Allada is not known. They may have been presented as ceremonial gifts to the king of Allada by a ruler from Owo or Benin. They may have been carved by itinerant Owo carvers working in Allada, or even by Allada carvers

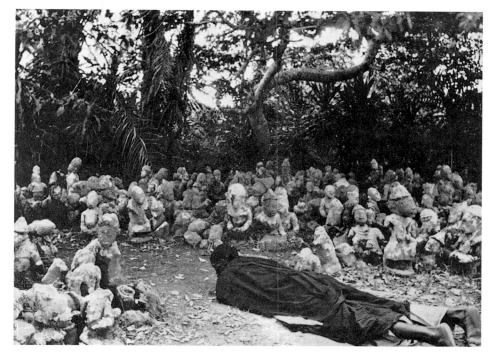

8-17. Priest paying homage to soapstone figures, Esie, Nigeria. 12th–15th century; 1930s

crowd, emphasizing instead his mysterious, sacred nature.

The king shown in figure 8-18, Ariwajoye I, *oba* of the Igbomina Yoruba, wears and carries a number of references to his position as sacred descendant of Oduduwa. Bead embroidery is normally reserved for the *oba*. The beadwork on the king's robe, on the cushion that elevates his feet above the earth, on the tall staff in his right hand, and on the intricate crown signals that this is the sacred ruler, descendant of gods.

The crown is the foremost attribute of the sacred king. Yoruba crowns are made of a wickerwork cone covered with stiff fabric or canvas. Glass trade beads are strung and

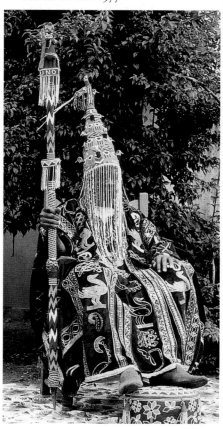

8-18. Ariwajoye I, ruler of Orangun-Ila. 1977

Several stories have arisen to try to explain their presence. One tells of how people from various distant lands came together in search of a place to stay. A misunderstanding with the ruler of Esie sent them in a state of rage back to their camp on the outskirts of town, where they were turned to stone by a Yoruba deity. Today housed in a museum, the stone figures continue to play an important role in the religious beliefs of the local people, who view them as the owners of the land, overseers of general welfare, and providers of fertility.

RECENT YORUBA ART

From the early times of Ife and Owo a wide range of objects, forms, art styles, and art events developed in a number of Yoruba centers. Many are still used today to underscore the leadership systems of the royal court and the society

of elders known as Ogboni, while others address the spirit world and facilitate communication between the humans and the realm of gods and spirits. Some of these forms are found throughout Yorubaland, while others are purely local.

Royal Arts

Much of the art produced in the Yoruba region calls attention to the king and his court. As a visible symbol of the deity, the king is the high priest of the community. Although Yoruba kings are free to appear in public today, in the past they were confined to the palace and made public appearances only when the welfare of the state required them to participate in public worship or festivals. Even in those instances, the individual who held the office was not really seen, for his royal garb concealed his identity from the

attached to cover the entire surface in boldly colored designs. The beaded fringe veil, the prime symbol of kingship, is worn only by those kings who can trace their lineage to Oduduwa. In the past, the sanctity of his being prevented the king's being seen by ordinary people, and the fringe protected him from the gaze of the profane when he made appearances in public.

The body of the crown is decorated with three tiers of abstracted faces (their staring eyes are clearly discernible). The faces depict royal ancestors, ultimately Oduduwa, and refer to the mystic union of the living king with his deified predecessors. As delegate of the ancestors, the king relies on their wisdom and powers. The multiplicity of faces may allude to the all-seeing nature of ancestors and spirits and thus to the role of the king whose supernatural vision allows him access to such authority.

Attached between the faces are small, three-dimensional beaded birds. A larger beaded bird ornamented with actual tailfeathers tops the crown. Birds are another important element on Yoruba crowns. The great bird at the top is said by some to represent the egret, the bird of decorum, a symbol of orderliness and settler of disputes. Others suggest it is the paradise flycatcher, a royal signifier whose tail sports extremely long tail feathers, or the pigeon, a symbol of victory and political power. Still others see the birds as a reference to the special powers of "Our Mothers," a collective term for all female ancestors, female deities, and elderly living women. Our Mothers are believed to have special powers and to be able to transform themselves into birds of

the night. Kings cannot rule without drawing on their powers.

When the king wears the sacred fringed crown, his being is modified. His outer head is covered by the crown, and his inner head becomes one with the sacred authority and power, *ashe*, of the ancestors. He cannot touch the earth, and thus stands on a mat or cloth. Seated in state, his feet rest on a decorative cushion or footstool. His own face disappears behind the veil, and the faces of the royal ancestors stare out instead. It is the vision of dynasty that is emphasized rather than the individual who wears the crown.

Commissioned by the king of Ikere, a small Yoruba kingdom in northeast Yorubaland, the beaded sculpture shown in figure 8-19 is an extraordinary example of display art intended to call attention to the position and power of the king. A royal wife with a crested hairdo, exaggerated conical breasts, and a child on her back presents a lidded offering bowl. Perhaps she symbolizes the powers of women and their importance to the kingdom. Smaller figures of attendants are attached to the conical armature of stiff fabric that serves to represent her body. One female attendant assists in lifting the offering bowl on her head, while three others carry fowl, perhaps alluding to sacrificial offerings. Below, four male figures brandish guns. The face of an ancestor stares from the lower portion of the central cone (its nose and chin alone are visible in this photo). The entire surface is alive with designs made of thousands of richly colored glass beads. In addition to alluding to the mysterious powers of women, this piece expresses the balance of power

between male and female. While the external powers of men are symbolized by their weapons, the inner and hidden forces of women, the ability to give birth and to nurture life, are alluded to by the child on the mother's back.

The king dwells in the *afin*, the royal palace. The most imposing architectural structure in a Yoruba city, the *afin* is also the site of the most sacred worship and celebrations. As in early Ife, the palace stands in the center of the city, and all roads lead to it. The king's market, usually the most important market in town, lies at its door. An *afin* consists of numerous courtyards of varying sizes, most of them surrounded by verandahs. Steep roofs, once thatched, are today covered with corrugated steel. At least one especially large courtyard serves as a gathering place for citizens during public rites.

Artists are kept busy fashioning wonderful objects that enhance the splendor of the palace, record the exploits of the kings and chiefs, and display religious symbols and metaphors to the public. In making such commissions, kings historically sought the most skillful artists from their own realms and beyond. The best artists achieved the title *ari*, which literally means "itinerant," suggesting that they moved from kingdom to kingdom accepting work from a number of patrons.

One such artist was Olowe of Ise (died 1938), one of the best-known Yoruba sculptors of the twentieth century. Praise poetry still chanted in his memory calls him "the leader of all carvers," one who carves the hard wood of the iroko tree "as though it were as soft as a calabash." Olowe was born during the nineteenth century in Efon-Alaiye, famed as a center of carving. He

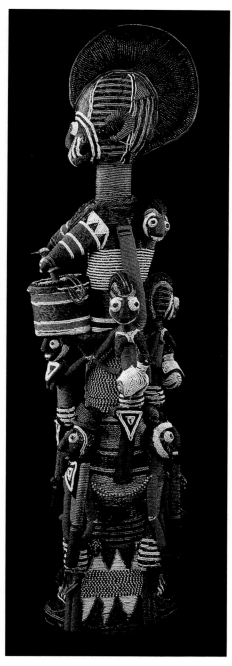

8-19. DISPLAY PIECE. YORUBA. EARLY
20TH CENTURY. CLOTH, BASKETRY,
BEADS, FIBER; HEIGHT 41¾" (1.06 M).
THE BRITISH MUSEUM, LONDON

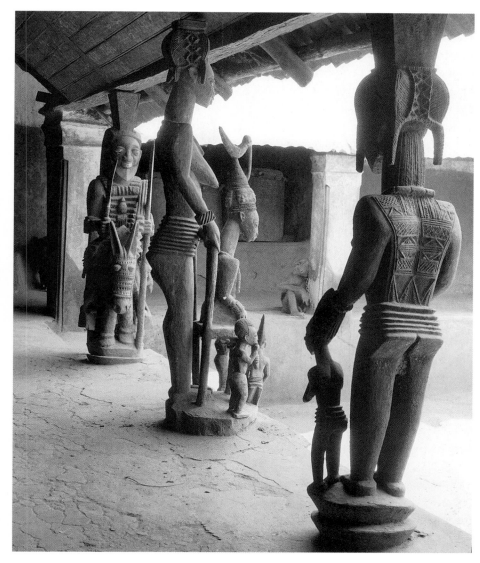

8-20. VERANDAH POSTS, IKERE PALACE, IKERE, NIGERIA. OLOWE OF ISE. 1910–1914. WOOD AND
PIGMENT. PHOTOGRAPH 1959

grew up in Ise, to the southeast. Over
the course of his career he produced
doors, posts, chairs, stools, tables, bowls,
drums, and ritual objects for palaces
and shrines in the kingdoms of Ijesa
and Ilesha and in various smaller king-
doms of the Akoko region of
Yorubaland.

Between 1910 and 1914 Olowe
worked at the palace of the king, *ogoga*,
of Ikere, in northeastern Yorubaland.

The *ogoga* was probably familiar with
the works that Olowe had carved for
the palace at Ise and wanted to make
his own *afin* equally magnificent.
Among the works Olowe created at
Ikere are three verandah posts that
once stood in the courtyard in which
the *ogoga* sits in state for ritual and
ceremonial occasions (fig. 8-20). The
central group, a freestanding sculp-
ture only appearing to serve as a post,

represents a king seated in state. A woman kneels before him. To his immediate left a palace servant carries a fan, to his right a herald blows a whistle. Behind his throne stands a tall and stately queen, whose bulk frames his figure when the grouping is seen frontally. Compared to his queen, the king is quite small. Seated on his throne, his feet dangle in mid-air. By adjusting the scale of his figures, Olowe evokes two concepts. The first is that the power of a Yoruba king is not in his physical stature but in the mystical powers that he derives from his royal ancestors. These powers reside in the crown, which dominates the composition. Repeating textured bands, ancestral faces, and an enormous bird whose beak touches the crown just above the central ancestral face all draw our attention to the crown, whose carefully textured surface contrasts with the more plainly carved form of the king.

The second concept Olowe evokes is the power of women. The imposing bird atop the crown concedes that the king relies on forces that women control. The large, physically imposing figure of the queen, painted a startling blue, also alludes to the supporting power of women. Although the power of the king is overt, that of women is hidden. The king and all creation rely on the energies that women command.

Two weight-bearing posts flank and face the central group. To the right, another queen, wearing an elaborate coiffure, presents her twin children. To the left, a warrior on horseback approaches, holding a cutlass in one hand (not visible in the photograph) and a spear in the other. A European gun rests at his waist. A small herald to his left side announces

8-21. DOOR FROM THE PALACE AT IKERE. OLOWE OF ISE. 1910–14. WOOD. THE BRITISH MUSEUM, LONDON

Such works of art were not entirely the work of one individual, for like other artists of his stature, Olowe of Ise maintained a workshop staffed by assistants and apprentices. Patrons had a say in the creation as well, and advisors to the ogoga *probably deliberated with each other and the artist on the subject matter of Ambrose's visit and the symbols that would most effectively convey the appropriate message. In addition, Yoruba communities are known to have had critics. Their criteria for evaluating art works would have been known to an artist such as Olowe, who would have tempered his work in response to their judgments.*

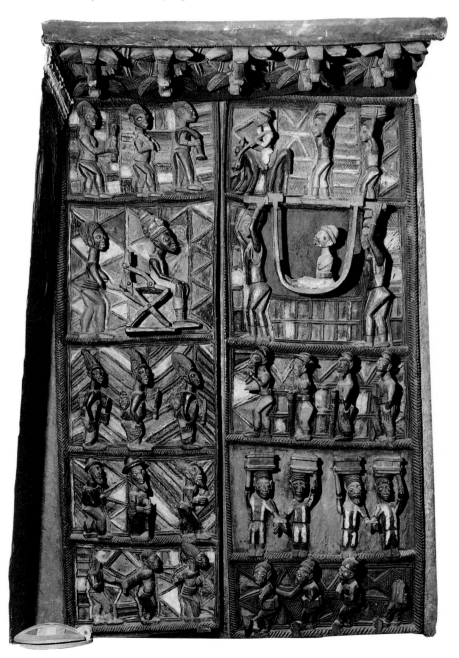

him with a Y-shaped whistle. The horse is perhaps the most profound of his attributes, for it is symbolic of great cavalries in the days of Yoruba warfare. The secret powers of dynasty, the military might of men, and the hidden and reproductive energies of women are all evoked in this set of three posts.

Olowe also produced a door for the same courtyard at Ikere (fig. 8-21). A remarkable example of palace art, it depicts the *ogoga*'s reception in 1897 of Captain Ambrose, the British Commissioner of Ondo Province. Each of the door's two vertical panels is divided into five registers. In the foreground, figures carved in high relief carry out the action of the story; the backgrounds are carved in low relief and the patterns are picked out in color. On the left, in the second register from the top, the king is shown seated on his throne, wearing his great crown, his senior wife standing behind him. The registers above and below depict other wives, palace attendants, and slaves. To the right, in the corresponding register, Captain Ambrose sits rather uncomfortably in a litter carried by porters. His retinue fills the other registers—an equestrian figure, porters with loads on their heads, and shackled prisoners also bearing loads. The contrast between the two panels may be a conscious comment on Yoruba and European ways. On the left, free people go about everyday tasks and honor the king. On the right, the uneasy European is accompanied by attendants forced into service.

The Ogboni Society

Yoruba kings rule with the assistance of a number of councils and associations. Ogboni, an association consisting of both male and female elders, is one of the most prominent. As with many organizations in African communities that are limited in membership and not open to public scrutiny, there is much debate about the meaning of Ogboni and its purposes. It is understood, however, that the organization serves to check the abuse of power by rulers, for the collective moral and political authority of these eminent citizens is as great as that of kings and chiefs. In the past Ogboni acted as a judiciary in criminal cases and was responsible for removing despots from office. Although its authority has been diluted, Ogboni still exercises significant power in traditional Yoruba politics, and its leaders still control the choosing, inauguration, and burial of kings.

Ogboni has a special relationship with Earth, who is seen as a deity. Earth is both the giver and taker of life, both mother and father. Earth as the land is the abode of numerous spirit forces and beings, *irunmole*, as well as of ancestors, *osi*. Ogboni connects those who live upon the earth and those who dwell within, acknowledging the omnipresence of spirits and ancestors, who observe all acts of the living and hear every spoken word.

Ogboni employs a variety of art forms in its work, foremost among them paired male and female figures. Large, freestanding paired figures placed on altars are referred to as "owner of the house," *onile*. Hidden away within the Ogboni lodge, they are accessible only to the most senior members. The pair of *onile* is treated as a single unit, referred to as Mother, *iya*. They perhaps allude to dual aspects of Earth, on the one hand hard, negative, and masculine, on the other soft, positive, and feminine. Normally cast in copper alloys, *onile* are created under ritual circumstances and prepared with sacred substances. Considered to have great sacred authority and power, *ashe*, the figures emphasize the importance of men and women working together within Ogboni and in the community at large.

A large Ogboni *onile* from the Ijebu Yoruba region is unusual in that it is made of terracotta (fig. 8-22).

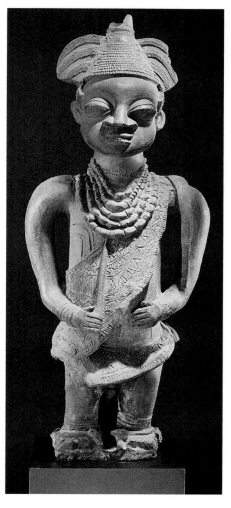

8-22. Male *ONILE* ("owner of the house") figure. Yoruba. Terracotta, height 30½" (77.47 cm). The Walt Disney–Tishman African Art Collection

Scarification marks on the figure's chest indicate membership in Ogboni. Beaded necklaces acknowledge office in the organization. A cloth lushly decorated with geometric patterns, probably representing a textile called *itagbe*, is draped over the left shoulder. The conical cap recalls the Yoruba royal crown, and its arching feathers are reminiscent of those that adorn the heads of kings. The visual play between the intricately textured headgear and cloth and the smooth surfaces of the body produces a lively effect.

The large wooden Ogboni drum, *agba*, shown here was probably carved during the 1890s (fig. 8-23). The hollow, tapered cylinder of its body was carved from the trunk of a tree. An animal skin membrane is stretched and pegged into position at the top. The belly of the drum is carved with images in sharp, low relief. The central

8-23. *AGBA* (OGBONI SOCIETY DRUM). YORUBA. 1890S. WOOD AND SKIN; HEIGHT 3'6½" (1.1M). THE BRITISH MUSEUM, LONDON

figure has a large triangular head with imposing eyes. The conical cap and drooping feathers recall those of the large terracotta *onile* in figure 8-22. The figure holds aloft its own legs, which have been transfigured into stylized catfish.

This *agba* would have been part of a group of such drums, thought of as a family. As the largest, it would have been called the "mother" drum. The smaller drums that accompanied it were likely carved with similar or related motifs. An *agba* functions in a variety of ways. On a practical level, it is played to announce the meetings of the Ogboni lodge every seventeen days. It is also seen as a sacred object, and in yearly rituals the blood of sacrificial animals is rubbed into its sides. Because of its sacred character, the intricate iconography of this drum would never have been seen by anyone other than initiated members. In nocturnal but public memorial services for deceased elders, for example, the sides are ritually covered to ensure that the surface designs are not seen by the uninitiated.

Four small heads, connected in pairs, are carved on the body of the central figure as though tucked into its belt. Two more heads at the tops of stakes can be seen just beneath the arching feathers of the headdress. These images refer to another type of Ogboni sculpture called *edan*. Although *edan*, like *onile*, are filled with *ashe*, they can be seen by non-

members. *Edan* serve as public symbols of the power and presence of Ogboni. They also refer to the male and female founders of the community and express the cooperation between men and women in society and the need for a balance of power between them.

The Ogboni elder shown here (fig. 8-24) wears a brass *edan* over his shoulders as an emblem of his office. The male and female figures are connected by a chain. Like the *onile* pair, they are considered to form a single entity. Commissioned for a new member at the time of his or her induction into the society, *edan* are a more personal art form than *onile*. They serve as a badge of membership and an indicator of status within the organization.

8-24. OGBONI SOCIETY MEMBER WEARING AN *EDAN* (PAIR OF FIGURES) AND A TITLE-CLOTH, NIGERIA

They may also be used to convey messages and as protective devices for their owners.

Many Yoruba rituals that acknowledge advancement in position or membership in an organization include the tying on of a distinctive cloth. A number of such special textiles, generically called title-cloths, are closely associated with the Ogboni society. The elder in figure 8-24 wears a title-cloth around his waist. Created by a woman on an upright loom, it is embellished with richly colored geometric designs based on natural forms. Although weavers of such cloths are certainly familiar with the designs and symbols they are asked to create, they are not privy to their underlying meanings unless they too are members of the society, for interpretation is reserved for those who have the right to wear them. Even outsiders, however, know that Ogboni robes celebrate the richness and diversity of their owners' experiences.

The way the Ogboni cloth is finished also carries meanings. For example, the fringes at the end of this example (seen at the right of the photograph) are divided and wrapped with threads to create seven tassels. Seven is a ritually significant number in Ogboni. The way the cloth is draped or worn is also meaningful. Here the elder wears the cloth around his waist.

A large Ogboni cloth was collected in the Yoruba kingdom of Ijebu in 1886 (fig. 8-25). Fields of concentric diamonds alternate with motifs based on abstractions of animal forms. Many such motifs are associated with the powers of leadership or with spiritual forces. Abstracted designs based on the crocodile, the frog, fish heads,

and the snake refer to water spirits. Two variations on the interlocking fish-head motif are symbolic of Olokun, the goddess of the sea. The whiskered catfish carries special meanings for both royalty and for the Ogboni. The cloth would have been worn over the left shoulder of an Ogboni elder, as depicted on the *onile* in figure 8-22, for the left side is sacred to Ogboni.

Art and the Spirit World

The Yoruba venerate a perplexing number of gods, *orisha*. Some *orisha* are primordial, created in the beginning of time by the Great God, Olorun. Among those we will discuss here are Orunmila, Eshu, and Ogun. Some natural powers such as rivers, mountains, stones, or thunder and

8-25. OGBONI SOCIETY TITLE-CLOTH. YORUBA. BEFORE 1886. COTTON, 9'7" X 5'8" (2.93 X 1.75 M). STAATLICHE MUSEEN ZU BERLIN, PREUSSISCHER KULTURBESITZ, MUSEUM FÜR VÖLKERKUNDE

lightning may be perceived as *orisha*, and heroes may be apotheosized as well. The god Shango embodies both of these ideas in that while he is the personification of thunder, he is also a deified culture hero, the fourth king of the Oyo empire. The very concept of *orisha* suggests an endless number, and there is always the possibility that new ones will make themselves known to a particular human community or even to a particular family or individual. Thus an *orisha* acknowledged in one part of Yorubaland may not be known elsewhere, or may be thought of quite differently.

Orunmila and Eshu

Two primordial *orisha*, Orunmila and Eshu, serve as mediators between gods and humans. They may be seen as embodiments of the principles of certainty and uncertainty. The twosome are intimately connected in the minds of the Yoruba, for order does not exist without disorder, and disorder requires order by definition. Orunmila, the *orisha* of destiny, embodies certainty, fate, equilibrium, and order. In Yoruba belief, each person chooses his or her destiny in the presence of the Creator God prior to birth. Orunmila can help people to gain knowledge of their destinies as they live them out. Through him, they can learn which forces control their future, and how to manipulate these forces in their favor. Uncertainty, chance, violence, and trouble define Eshu. Ironically, the disorderly and mischievous Eshu is also the messenger of the gods, and to gain Orunmila's attention, one must first approach the trickster Eshu.

A diviner, *babalawo*, mediates between Orunmila and the human

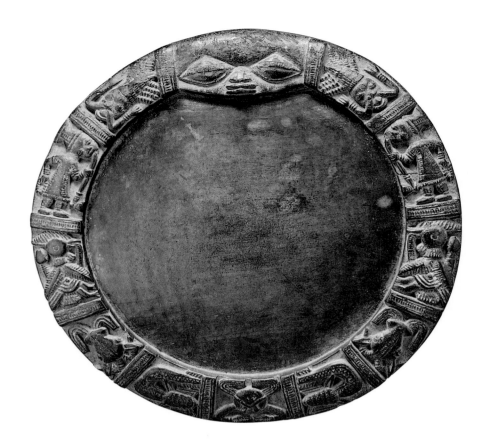

community through the divination process known as *ifa*, which is understood to have been instituted by Orunmila himself. A *babalawo* employs numerous art objects in communicating with the spirit world. The essential sculptural object for *ifa* is a divination board, *opon ifa* (fig. 8-26). Like most Yoruba *opon ifa*, this one is circular in design, and its flat plate-like surface is surrounded by a raised border filled with an assortment of images carved in low relief. The stylized face of Eshu fills the top center portion of the border. Five additional motifs appear left and right in mirror image, creating a bilaterally symmetrical composition. Opposite Eshu is a crab, itself bilaterally symmetrical. The motifs were probably chosen by the carver, though they are not specifically linked to the divination process or to Orunmila.

8-26. *OPON IFA* (DIVINATION BOARD). YORUBA. 19TH–20TH CENTURY. WOOD, HEIGHT 15" (38 CM). THE WALT DISNEY–TISHMAN AFRICAN ART COLLECTION

Flanking the Eshu face are heads with conical caps, each with four radiating forms issuing from the side, recalling the crown-like forms seen on Ogboni paraphernalia. From the nostrils of each head issues a pair of arms. A full figure wearing a gown and cap and holding a long pipe to his mouth appears in the next zone. Among the Yoruba, the pipe is an image closely connected to Eshu, and such figures may represent either the trickster god himself or one of his worshipers. A rooster holding a snake in its beak appears next, followed by a horned animal with curving forms issuing from its nostrils. A dried, skewered catfish, a reference to sacrifice, is the final repeated motif before the single crab.

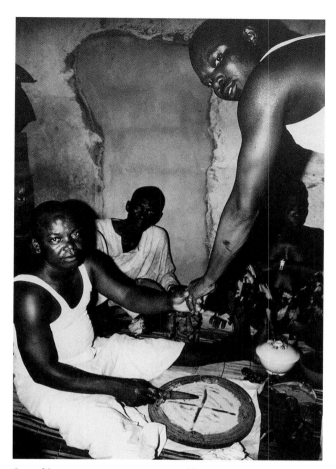

8-27. YORUBA DIVINATION SESSION, NIGERIA

In use, the tray is sprinkled with dust from a special wood (fig. 8-27). The *babalawo* throws sixteen palm nuts to determine a configuration of eight sets of signs. He draws the signs in the dust, then erases them. Each of the 256 configurations that can occur is known by a name and is associated with a body of oral literature. As the *babalawo* chants the appropriate verses, clients interpret them to apply to their own situation. The *babalawo* shown here is in the process of attracting the attention of Orunmila and Eshu by rapping a special tapper, the *iroke*, on the border of the *opon ifa*, and at the same time reciting verses to acknowledge and honor Eshu, the messenger.

8-28. *IROKE* (DIVINATION TAPPER). YORUBA. IVORY. FIELD MUSEUM OF NATURAL HISTORY, CHICAGO

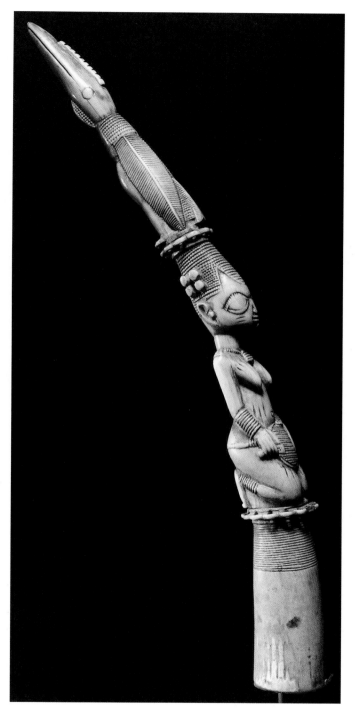

A woman and bird, a hornbill, are depicted on the beautiful ivory *iroke* shown here (fig. 8-28). Finely carved textural areas contrast with smooth forms, providing the eye with a tactile experience. The woman's kneeling pose suggests worship and supplication, while her fan and jewelry indicate aristocratic status. The coiffure or crown-like headdress adds

Other divination paraphernalia may be stored in large, multi-compartmented, lidded containers known as divination bowls (fig. 8-30). One of the masterpieces of Yoruba art, the extraordinarily complex and dynamic bowl shown here was created by Olowe of Ise. The bowl is completely covered with abstract, geometric designs carved in low relief and painted. Four female figures dance arm in arm atop the lid, their arched coiffures adding height and movement. The bowl itself is presented by a spectacular elongated female figure, whose head is held high on a splendidly long neck. Her baby, held against her back by a cloth tie, peers to the side. A retinue of male and female assistants, painted in various earth colors, lean precariously from their positions on the base to help lift the bowl. A free-rolling head is ingeniously carved in the space beneath the bowl, imprisoned within the group of supporting figures.

While Orunmila is never depicted in shrines or on divination paraphernalia, Eshu is portrayed repeatedly. The only Yoruba *orisha* consistently represented, Eshu appears on houseposts, lintels, doors, and bowls. As a go-between for gods and humans, his image embellishes many shrines. As the god of the market place, the gateway, and the crossroads, he is often represented in these places as well. Figural representations in public places, however, are rare. Instead, a piece of unworked stone usually suffices to represent the god, and even then it may be buried beneath the earth or in a wall. Occasionally a figure carved of wood or more rarely of stone may be set up in a marketplace (fig. 8-31). The figure

emphasis to the head, recalling the Yoruba philosophical concept of *ori*, which may be interpreted as "head" or "destiny," and which embraces a person's past, present, and future. A reference to *ori* is thus also a reference to fate, the concern of divination.

The palm nuts used in *ifa* are kept in a carved container called *agere ifa* (fig. 8-29). Fashioned of wood or more rarely of ivory, *agere ifa* vary greatly in form and may range in height from a few inches to over a foot. The exquisite example here is supported by figures of a mother and child. The mother kneels in supplication, her prominent breasts project to repeat the

forms of her knees and to serve as counterthrusts to her arms, which reach back to encircle the child tied to her back. The disc upon which she kneels repeats the circular form of the cup-like container above, whose rim is enhanced by an incised pattern of repeated triangles. The dark, worn wood has been rubbed with a light-colored substance that fills and defines the crevices of the carving. The maternity figure is but one subject among many that might support such a cup. Also in the carvers' repertoire are human, animal, and abstract forms, and the iconography often reflects the needs of a *babalawo*'s clients.

shown here was photographed in the center of the town of Igbajo, some 35 miles from Ile-Ife. At least two other stone Eshu figures had once graced parts of the town. The style is not like that of the early stone figures of Ile-Ife, but it is more reminiscent of more recent Yoruba woodcarving. The trickster god is depicted with a large head. A necklace with a pendant gourd container for medicinal substances hangs from the neck. His right hand holds what may be either a club or a larger calabash of medicines.

Although Eshu is called upon by the followers of other *orisha,* he has a special congregation of worshipers who make use of a number of types of

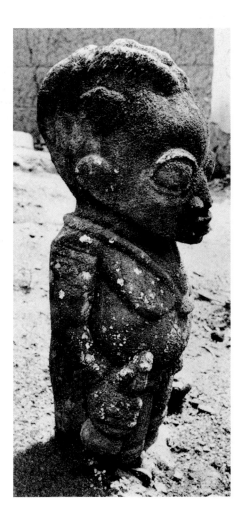

8-30. DIVINATION BOWL. OLOWE OF ISE. C. 1925. WOOD AND PIGMENT; 25¹/₁₆″ (63.7 CM). NATIONAL MUSEUM OF AFRICAN ART, SMITHSONIAN INSTITUTION, WASHINGTON, D.C.. BEQUEST OF WILLIAM A. McCARTY-COOPER

8-31. STONE FIGURE OF ESHU, IGBAJO, NIGERIA

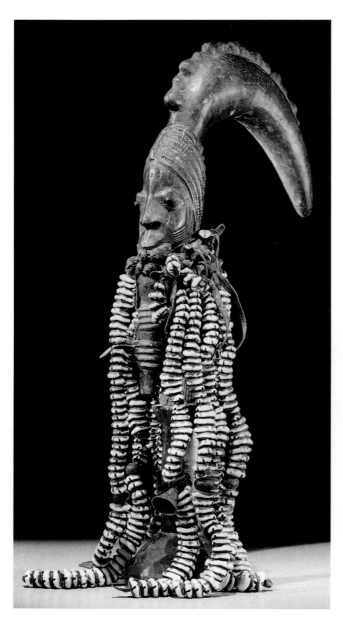

8-32. Dance wand in honor of Eshu. Yoruba. Wood, leather, cowrie shells, brass, bone; height 19¾" (50.7 cm). Indiana University Art Museum, Bloomington. Raymond and Laura Wielgus Collection

8-33. Devotee with assemblage in honor of Eshu, Ila-Orangun, Nigeria. 1977

reference to the wealth brought by this god of the market-place. The long, projecting hairdo, common to most Eshu figures, arches up and away from the head. Such phallic or blade-like coiffures refer to Eshu's involvement in male sexuality and romantic entanglements. Miniature gourds along the crest of the hair allude to the powerful medicines at Eshu's disposal. The whistle or Y-shaped flute held to the lips suggests Eshu's role as supernatural herald. Although this figure is male, similar ones may be carved as female, for the enigmatic Eshu may be represented as either sex.

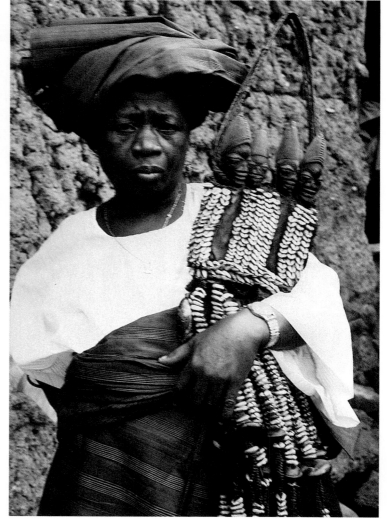

objects including dance wands, assemblages, and altar figures. The dance wand shown here once decorated a shrine for Eshu (fig. 8-32). It would have been used in processions and festivals, danced with by a worshiper in honor of the god. While such wands are usually carved with a figure of a worshiper, the figure here may actually represent Eshu himself. Long strands of beads and cowries, once used as money by the Yoruba, cascade from the neck in

The devotee of Eshu shown in figure 8-33 carries an assemblage made of multiple figures that would have been used on an altar to the god. This distinctive form is made of male and female pairs grouped within a fabric and cowrie encasement. Like the dance wand, it is decorated with long pendant strands of cowrie shells. Black seed pods are added to the strands of white cowries. The juxtapositions of male and female and black and white, the colors of Eshu, acknowledge the extremes associated with this paradoxical deity.

The gods Orunmila and Eshu make us aware of the possibility of change in Yoruba society and art. Eshu is a dynamic *orisha*, one who cannot be pinned down to remain the same. The very fact that Orunmila is sought on every occasion and that *ifa* is cast every four days suggests that change is vital, even in thinking about fate or destiny. Such change must be seen as a part of Yoruba artistic expression as well.

Ogun, Osanyin, and Eyinle

Ogun, the lord of iron and war, and Osanyin, the source of herbal medicine, are also primordial *orisha*, having come to earth at the time of creation. Like Eshu, each is a paradox. For although Ogun is the ferocious and vehement bringer of war, he is also the founder and champion of civilization, a maker of paths, tiller of the soil, builder of towns. The tiny Osanyin, visualized as having but one eye, one arm, and one leg, and having numberless problems of his own, is the bringer of healing, completeness, and well-being to the human community. Eyinle is a local

orisha of hunting, rivers, and healing leaves, a companion of Osanyin.

As the god of iron, Ogun's impact is ubiquitous, for metals affect every facet of civilization. As warrior, Ogun moves forward and conquers, expanding frontiers. As the defender, he uses weapons to protect and shield his own. As master blacksmith, he is sponsor of smiths, makers of tools and weapons. He is the ultimate artist, and any who manipulate adzes and knives are indebted to him. He is the consummate farmer, and all farm implements are made of his iron. In modern times he continues to gather adherents, for all who use steel are his, including hunters, soldiers, truck drivers, and auto mechanics.

Many symbols or signs point to Ogun. His embodiment in shrines may merely be a bit of metal, raw or carefully worked, or a sacred plant or a stone. Several art forms are specifically identified with Ogun, among them ceremonial swords, staffs, iron pokers, and axes (fig. 8-34). This ax is typical of those used in Ogun's worship in eastern Yorubaland. A beautifully rendered human figure adorns the handle, complete with markings of civilization and aristocracy: a well-coiffed head, jewelry, poise, and dignity.

As maker of roads and penetrator, Ogun readies the way for all the *orisha*, and references to Ogun are thus present in the

shrines of many gods. Diminutive forged iron implements—hoes, knives, arrows, swords, and bells—announce the intervention of Ogun in the work of healing deities, for his slashing blades permit healers to venture into the depths of the forest for curative materials. Iron staffs also enhance the worship of healing deities, while expressing their link to Ogun.

Iron staffs are commonly dedicated to the *orisha* of curative

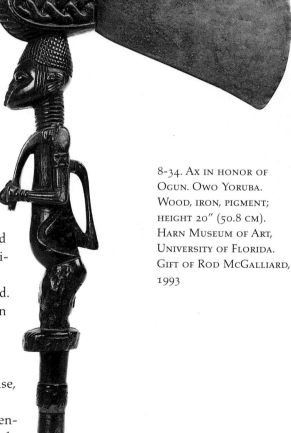

8-34. Ax in honor of Ogun. Owo Yoruba. Wood, iron, pigment; height 20" (50.8 cm). Harn Museum of Art, University of Florida. Gift of Rod McGalliard, 1993

medicine, Osanyin and Eyinle (fig. 8-35). This graceful staff refers to the vitality of Osanyin and evokes his relationships to Ogun and to Our Mothers. The powers of Our Mothers may be represented here by a large bird hovering over a circle of sixteen smaller birds raising their heads toward the larger. Osanyin has the ability to negate the combined negative powers of Our Mothers or to work

8-36. Vessel in honor of Eyinle. Agbedeyi Asabi Ija. c. 1900. Terracotta

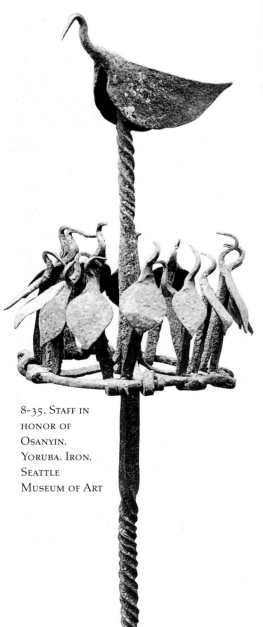

8-35. Staff in honor of Osanyin. Yoruba. Iron. Seattle Museum of Art

in harmony with them, encouraging them to cure rather than hurt. At the same time, the cluster of bird forms may recall leaves on a tree. The herbalists who depend on Osanyin create their medicines and curative drugs from leaves, barks, and roots from the forest, where the metal tools of Ogun have allowed entry.

The terracotta receptacle in figure 8-36 honors the god Eyinle. It was created around 1900 by Agbedeyi Asabi Ija (died c. 1921), a highly regarded ceramic artist of the Egbado Yoruba. Like her mother before her and her daughter after, Agbedeyi was renowned for her Eyinle vessels, and her reputation spread far beyond the confines of her own town. The large central figure on the lid is said to rep-

resent Eyinle's royal wife. The strap-like forms that serve as her abstracted body can also be perceived as a crown, referring to her royal status. She is surrounded by four of her children, one on her back, and three before her. The largest of the children holds a miniature bowl for offerings of kola nut and cowries. Studded with small conical projections that allude to river stones and decorated with symbolic images in low relief, the vessel serves to hold stones, sand, and water from the river, all of which contain and protect the *ashe* of Eyinle. Such containers are placed on sculpted earthen platforms stained with indigo and spread with white sand from a river. Iron staffs of Eyinle's companion Osanyin may be placed nearby.

Shango and Ibeji

Shango, who controls thunder, is associated with the expansion of the Oyo empire in western Yorubaland. The historical personage Shango was a descendant of Oranmiyan and the tyrannical fourth king of Oyo. Oral traditions maintain that he was a despot, coerced into surrendering his crown and committing suicide. His supporters denied his death and declared that he had become a god, merged with the forces of thunder and lightning, which they could call down on their enemies. The Shango legend illustrates a significant aspect of Yoruba *orisha*: they are not idealized. Shango was a sacred king, but he can still be presented as a remorseless despot whose need for control overstepped the boundaries suitable to political authority. In his attempt to control mystical and magical powers, he was unable to master them, and was eventually controlled by them. Once a

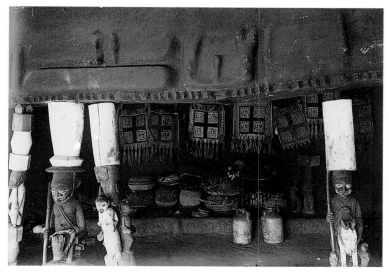

appliqué panels with images of Eshu.
Called *laba shango*, the bags are used
by priests to transport thunderbolts
from their archaeological resting
places to Shango's altar. On the plat-
form an upside-down wooden mortar,
ceramic containers with painted and
relief ornamentation, and calabash
containers all serve as repositories for
the stone axes that contain Shango's
ashe. Other objects include cloths,
prayer rattles, figures representing
twins, and rams' horns. The ram is an
animal closely associated with
Shango. To the right, a sculpted figure

mortal, Shango did not die, but he
commands great powers of nature as
an *orisha*. In dreadful storms he hurls
flashes of lightning upon those who
do not respect him. These thunder-
bolts take the form of ancient stone
axes that are exposed on the surface
of the earth after heavy rains.

The Agbeni Shango shrine in
Ibadan, shown here, was pho-
tographed in 1910 (fig. 8-37). As with
other sanctuaries for *orisha*, the altar
houses numerous objects that cele-
brate and help communicate with the
deity. The Y-shaped forms sculpted in
relief on the exterior frieze represent
double axes, the symbol of Shango. A
long row of fifteen brightly painted
houseposts braces the massive clay
frieze. Allusions to Shango's royal
status, the posts were carved to depict
devotees, *orisha*, images associated
with the ancestors, and other subjects.
Two of the posts visible here depict
figures on horseback, evoking
Shango's role as a hot and violent
warrior.

Within the shrine brightly col-
ored, fringed leather bags hang from
the rear wall. Each bears four

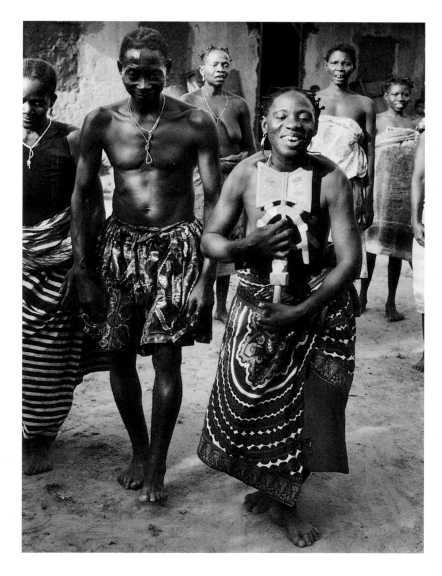

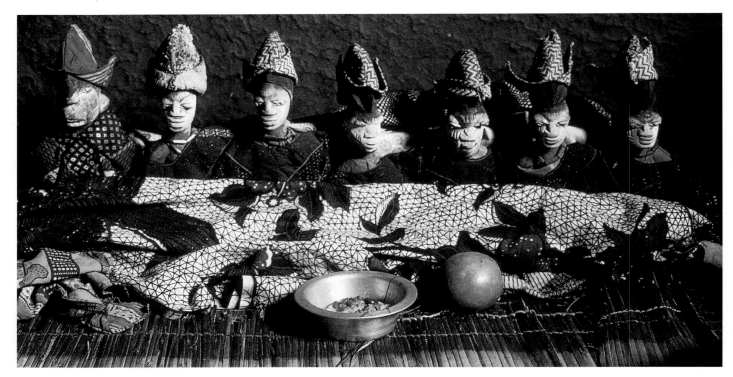

8-39. *ERE IBEJI* (TWIN FIGURES), NIGERIA

of a female devotee with double ax forms sprouting from her head has been offered as a gift to the deity. To her left is a carving of the dog of Shango. Two imported stoneware jugs stand before the altar.

In figure 8-38 a female priest holds an *oshe shango*, a carved dance wand that is carried, cradled, waved, and thrust by devotees during dances in Shango's honor. Among the most abundant of objects consecrated to the *orisha*, *oshe shango* most often bear the image of a female worshiper, her head supporting the double ax form (the figure on the example here is hidden by the priest's hands). The ax is thus related to the head, the symbol of the inner being, *ori inu*. Here the double ax motif is treated as a broad flat form with a raised border. Three oval forms suggestive of scar patterns are carved in relief into each

panel. Naturalistically carved representations of stone ax blades appear to be pressed between the double ax motif and an arching form held aloft by the kneeling worshiper carved on the staff handle.

Twins, *ibeji*, sometimes called "children of Thunder," are consecrated to Shango, and small carvings called *ere ibeji* are likely to be found in any Shango shrine. (Several *ere ibeji* can be seen lying in the container just to the left of the pottery jugs in the shrine in figure 8-37.) *Ere ibeji* are created to venerate the spirits of deceased twins, and they are normally cared for within the home (fig. 8-39). Here seven small *ere ibeji* have been dressed in tiny garments and caps, fitted with necklaces of beads related to various deities and organizations, rubbed with cosmetics, placed on a mat, and covered against cool weather.

A small dish of food and an orange have been placed before them.

The Yoruba perceive twins as spirited, unpredictable, and fearless, much like their patron *orisha*. Seen as spirit beings themselves with exceptional abilities, they bring affluence and well-being to those who respect them, and their lives are filled with sacred acts. Mothers of twins, even the most prosperous and dignified, must beg for their special offspring in public places, singing their praises and dancing with them. People who give them token gifts are blessed.

Twins, however, have a high infant mortality rate. When a twin dies, its parents consult a *babalawo* to learn what must be done to placate the spirit of the dead child, for neglect may cause a dead twin to tempt its surviving sibling to join it. The *babalawo* normally advises the parents to

procure an *ere ibeji* of the same gender as the deceased twin, to serve as a dwelling place for its spirit.

The mother attends to the *ere ibeji*, handling it with tender care to pacify the soul of the dead child and to ensure its benevolent presence. She bathes it and feeds it, clothes it, and applies cosmetic powders, oils, and indigo. When she begs and performs for the surviving twin, she carries the *ere ibeji* and begs for it too. Eventu-

8-40. YORUBA WOMAN WITH AN *ERE IBEJI* FIGURE TO HER DECEASED TWIN, NIGERIA

When a surviving twin such as this woman dies, her ere ibeji *may be placed in a shrine to Shango, or it may be taken over by a "mother of twins," iya'beji, who cares for twin figures who have lost their caretakers. Still another possibility is that heirs may sell the intriguing little figure to traders, and it will become an object for sale on the international art market.*

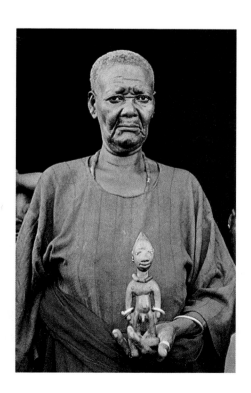

ally, the surviving twin may assume custody of the figure (fig. 8-40). Here an elderly woman poses with the carving representing her long-dead twin. Over the years, as she has accumulated objects showing her affiliation with various *orisha*, she has provided her twin with similar objects. The blue and red beads and the white metal bracelets on the *ere ibeji* match those she wears herself.

Masks and Masquerades

Perhaps the most thoroughly dynamic art form of the Yoruba are masquerades. As elsewhere in Africa, Yoruba masks are not created or perceived as static sculptural forms but as components of a larger, multimedia art of performance that includes costume, dance, music, poetry, and interaction with a participating crowd of onlookers. A variety of masks and masquerades aid Yoruba communities in communicating with the spirit world while they entertain the living.

The most widespread masquerade is *egungun*, found throughout Yorubaland. Many Yoruba associate *egungun* with the veneration of ancestors, who are believed capable of helping the living community if they are properly honored. Some *egungun* masquerades impersonate the spirit of the recently departed, returning to ensure that all is in order within the family prior to making the final journey to the spirit world. In other situations the *egungun* merely appears to entertain when ancestors are venerated. *Egungun*, like the ancestors they are associated with, are identified with specific families. They play a regulating role in the family and serve as a link between the living and the dead.

There is an air of the sacred attached to the *egungun* and to the rites and celebrations of which they are a part. They are prepared for action within a sacred grove. Prayers are said, *ifa* is cast, and charms are attached to the body of the masker and placed within his costume. Donning the costume, the masker is depersonalized, ritually transformed into a human repository for the spirit of the returning ancestor. When he enters a state of possession, he speaks with the voice of the deceased.

The categorization of *egungun* varies throughout the Yoruba region, occasionally based on style, sometimes by seniority or status, and at other times by deportment. As with other art forms, styles and types of *egungun* may be transferred from one area to another, allowing for the blending of styles. In fact, several styles may be seen side by side, even within a single community.

The group of *egungun* in figure 8-41 are from the southern Yoruba, in the Remo area. Like all *egungun* from that region, they are fashioned of cloth. Costumes of brilliant patchwork panels trimmed in red move and flare, rise and fall, as the dancers whirl. Surmounting the head is a box-like construction covered with matching fabric. Such *egungun* are intended to be beautiful to the eye. In some areas wooden face-masks or headdresses top the masquerades, while tray-like forms embedded with charms and animal skulls complete others. Two types of *egungun* appear in figure 8-42. To the right is a fabric *egungun* of traditional type. Its costume is made of pieces of

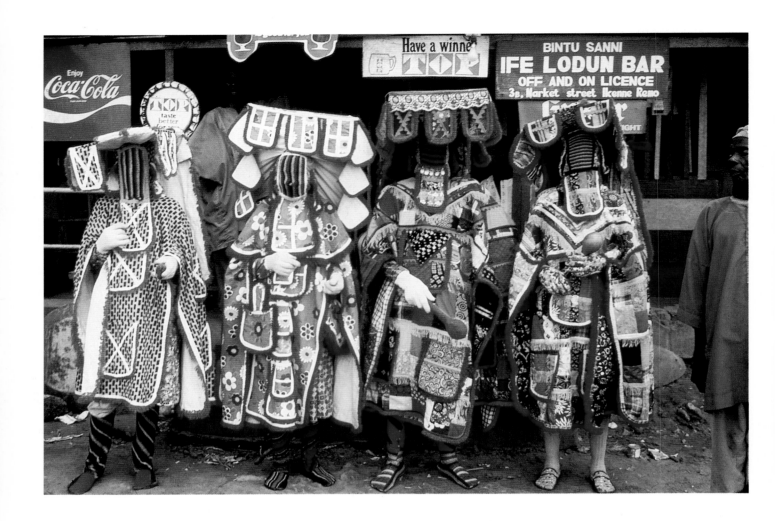

textile sewn in a dizzying assort-
ment of colors. A crocheted
rectangle of black and white bands
covers the masker's face while still
allowing him to see. The two carved
wooden masks to its left parody a
European couple. Dressed in con-
temporary clothing, they carry
accouterments associated with these
strangers to the community—a
large purse and watch for the
woman, a ball-point pen and a pad
of paper for the man. These satirical
egungun do not wield a great deal of
power but are there to add a note of
levity to the festival. Their perfor-
mance here began with the man
kissing the woman on the cheek and

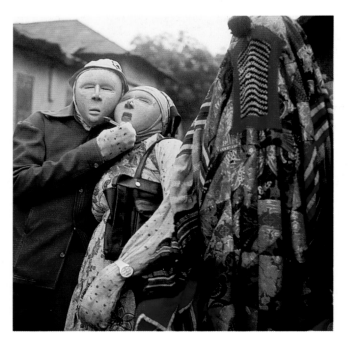

8-41. FOUR *EGUNGUN*
MASQUERADES, NIGERIA

8-42. TEXTILE *EGUNGUN*
MASQUERADES, NEAR
REMO (SOUTHERN
YORUBALAND), NIGERIA

The behaviors of egungun *are as different as their forms. Some cavort passionately with the vigor of youth, while others move with the reserved stateliness of elders. Some move sympathetically with the throng of onlookers, while others threaten their watchers with canes, beating all who come too close. Attendants may hold them back and attempt to control their actions. Many* egungun *serenade the crowd with a litany of their powers and their actions, some chant poetry, and others speak in throaty spirit languages. Some alter their shapes magically in the midst of the crowd, turning their outfits inside-out to become some other creature.*

pretending to write over her heart with the pen. Occasionally he feigned taking notes on the pad, for Europeans seem to write everything down. The couple waltzed slowly to frenetic drumming and then performed a get-down disco number, after which they mimed copulation. They were followed by *egungun* representing a properly behaving Yoruba couple. The moral is that although Europeans are associated with literacy, they are too demonstrative in public and are promiscuous. Yoruba, by no means stodgy, at least know how to act appropriately in public.

The *egungun* masquerades in figure 8-43, from the far northeastern region of Yorubaland, are made entirely from shredded plant materials. Such fibers from the forest and other ritually meaningful materials such as feathers, shredded palm fronds, or other plants allude to the mystical and supernatural powers of the *egungun*.

Whereas *egungun* is manifested all over Yoruba country in one form or another, there are other masquerade types that are restricted to specific regions. Such is the case with the masquerades of the Gelede society, limited to the southwestern region of Yorubaland. Made up of both men and women and led by an elderly woman, the society organizes a lavish masquerade as an offering to Our Mothers. The aesthetic power of sculpture, dance, and song is intended to persuade Our Mothers to use their special powers for the good of the entire community, instead of wielding them destructively.

During these festivities, an important singing masquerade named *oro efe* emerges for a night-long presentation of songs, proverbs, praise poems, riddles, and jokes (fig. 8-44). The *oro efe* pictured here is typical. The performer's face is concealed by a veil that allows him to see. Atop his head sits a complex mask painted a cool white,

with eyes, lips, and scarification patterns in contrasting colors. A multi-colored, towering superstructure consists of a perplexing juxtaposition of curving, spiraling forms that allude to pythons and other animals, the crescent moon, a turban, a cutlass, and interlace motifs. Themes of aggressive action persist. Hoops beneath the costume and layers of cloth panels expand the size of *oro efe* and magnify his physical appearance. Ornate embroidered and appliqué panels display an abundance of colorful motifs, and mirrors are set into the fabric to reflect light in the night performances.

Oro efe, perceived as a male leader of the society and a servant of the Mothers, imparts an image of physical and supernatural power, position, and spiritual authority. His songs include humor and sarcasm, but they are filled with vital power, *ashe*. They act as an invocation, calling on the

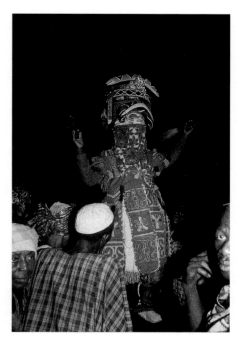

8-45. GELEDE SOCIETY DAYTIME MASQUERADES RESTING BEFORE PERFORMANCE, IDAHIN TOWN, KETY REGION, NIGERIA. YORUBA. 1971

The widespread conviction that women, especially older women, control extraordinary powers, perhaps even greater than those of the gods and ancestors, is acknowledged in Yoruba songs that refer to them as "the gods of society," and "the owners of the world." Women hold the secret of life itself. They possess the knowledge and distinctive capacity to bring human life into being, and conversely they have the potential to remove life. With these powers, Our Mothers can be either beneficial or harmful. They can give vitality, prosperity, and productivity to the earth and its inhabitants, or they can bring cataclysm, disease, scarcity, and plague.

powers of Our Mothers. They teach precepts advocated by ancestors, gods, and the Mothers through ridiculing and condemning the actions of those who violate their objectives.

The following afternoon, after a morning of rest, numerous masquerades appear in sequence. The youngest performers dance first, dressed in partial costumes and striving to equal their elders. Older children take their turn, followed by teenagers. Finally master dancers appear as identically dressed pairs in an extensive cast that includes male and female characters as well as animal masks. All are played by men. In the example shown here, the beautifully carved masks are painted an astonishing blue (fig. 8-45). The elaborately carved and painted headdresses represent the fancy headties worn by women and give an appearance of stately height. The faces of the wearers are covered but not necessarily concealed by colorful scarves, providing the illusion of a

long and graceful neck. The costumes are constructed of colorful appliqué cloths and vie with the costumes of other Gelede maskers for magnificence. Shown at rest here, the performers dance to an orchestra of drums, with iron rattles around their ankles repeating the complex rhythms as they compete for the admiration of the crowd. At last a single masquerade representing a deified female ancestor appears to reassure the crowd of her blessings. The spectacle is over. The extended two-day display has entertained the crowd, but more meaningfully it has pleased Our Mothers, who will now exercise their powers to bring success and goodness to the community.

In the northeastern regions of Yorubaland, among the Igbomina and Ekiti Yoruba, maskers celebrate social roles in celebrations referred to as *epa* (fig. 8-46). Costumes of palm fronds cascade from the bottom of each brightly painted mask, and snail-shell rattles encase the dancer's lower legs. The lower part of an *epa* mask is a large, pot-shaped form with a minimally represented, abstracted human face. Considered to be the actual mask, it is associated with mystical powers. On top of the mask sits an exuberant superstructure, which represents the social role honored by the mask and draws praise from the crowds. Superstructures depict a range of subjects—a leopard pouncing on its prey, a warrior mounted on horseback and surrounded by a retinue of soldiers and praise singers, a herbalist priest, a hunter, a farmer, the king enveloped by his entourage, or the mother surrounded by her many offspring. With the orderly appearance of *epa*

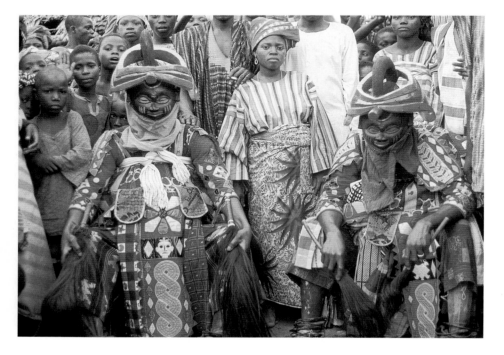

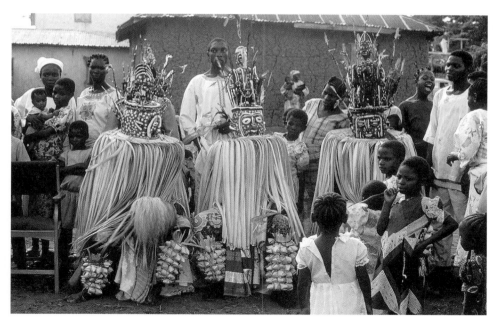

8-46. THREE *EPA* MASQUERADES, NIGERIA

masks in performance, the various social roles of farmer, hunter, soldier, priest, king, and mother are established, gender roles are acknowledged, and cultural achievement is celebrated.

The superstructure over the *epa* mask in figure 8-47 is a sculptural tour de force. The work of Bamgbose (died c. 1920), one of the great carvers at the turn of the twentieth century, it celebrates the "mother of twins," *iya'beji*. Bamgbose portrays the mother as a dignified woman holding a twin on each knee. Each twin touches the mother's breast with one hand and holds forth a tray for receiving gifts with the other, reminding us of the begging *iya'beji* must perform. At the base, four female figures offer gifts to the *orisha* who have given blessings to the mother. Such grand accumulations of images around a large central figure can be seen as visual praise poems in honor of the character, a celebration of the role played by that personage in the cultural organization.

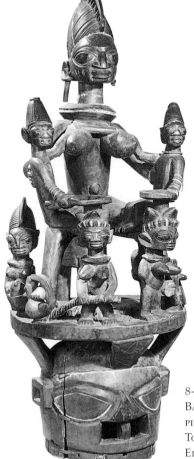

8-47. *EPA* MASK. AREOGUN BAMGBOSE. 1930S. WOOD AND PIGMENT; HEIGHT 49½" (1.26 M). TOLEDO MUSEUM OF ART. GIFT OF EDWARD DRUMMOND LIBBEY

DAHOMEY

The neighbors of the Yoruba to the west are the Fon and other Aja peoples. While the Fon and Yoruba share a number of cultural characteristics, many are distinctly Fon. The Fon kingdom of Dahomey was founded around 1600 in what is now the Benin Republic. By the eighteenth century the kingdom had become a leading regional power. King Guezo, who ruled from 1818 to 1858, achieved economic and political freedom from the Yoruba nation of Oyo, to which Dahomey had paid tribute since the early eighteenth century. He also guided the transition from an economy based on the slave trade to one grounded in the selling of palm oil. Guezo's son Glele, who reigned from 1858 to 1889, continued to maintain Dahomey's independence and attacked the Yoruba at every opportunity. Glele's son Behanzin was imprisoned by the French conquerors of the region. In 1900 the French abolished the kingship, thus ending the line of kings who had dominated the area for some three hundred years.

Royal Arts

Like the Yoruba, the Fon used art to praise and reinforce royal authority and to address superhuman forces. Art forms and subject matter were largely determined by a divination process known as *fa*, the Fon equivalent of the Yoruba *ifa*. The ongoing use of divination and the reciprocal relationship of Fa, the god of divination (the Fon equivalent of the Yoruba god Orunmila), and Legba, the god of change (the Fon equivalent of the Yoruba god Eshu, shortened from his full name, Eshu-Elegbara), worked together to make change itself an important aspect of Fon life and art.

Upon taking the crown, a Fon king was given a unique sign that had been divined for him. The sign was known as his *fa* name or strong name. Verbal images drawn from the great body of oral literature surrounding that name were translated into art forms that enhanced the glory of the court and the magnificence of the palace. Artists in the royal city of Abomey were organized into palace guilds according to the medium in which they worked. Members of the textile workers' guild designed pavilions, canopies, umbrellas, and banners embellished with symbolic appliqué designs. Metal workers constructed images of deities and symbols of state in iron and brass and may have produced small ornamental figures and tableaus for the aesthetic pleasure of the elite. Wood carvers created metaphorical portraits of the king and symbolic sculpture based on their *fa* names.

The exterior walls of the palace were ornamented with painted clay reliefs that heralded the exploits of the king and referred to a pantheon of gods, many of them shared with the Yoruba (fig. 8-48). The example here depicts a ram-headed figure with a double-headed ax issuing from its mouth, an image that portrays and honors the god of thunder, Hevioso. The two double-headed ax forms in the background of the piece are reminiscent of the dance wands used by the worshipers of the Yoruba thunder god Shango.

Quasi-architectural forms made of fabric called attention to the members of the court and provided splendid backgrounds for festive occasions. The drawing in figure 8-49 depicts an event described by a visitor to Dahomey in 1849. In a setting of massive architecture, a pavilion of crimson fabric soared to a height of forty feet, emblazoned with appliqué images of human heads, bulls' heads, skulls, and other motifs. From beneath it the king and dignitaries watched the proceedings as some six thousand carriers processed through the market and back to the palace, each carrying some portion of the king's wealth to be displayed before the public. Numerous colorful umbrellas marked the places of chiefs and their entourages.

8-48. PAINTED CLAY RELIEF PANEL FROM THE PALACE AT ABOMEY, REPUBLIC OF BENIN. FON. CLAY, PIGMENT. PHOTOGRAPH 1964

8-49. Procession before the royal pavilion at Abomey, illustration to Frederick Forbes, *Dahomey and the Dahomans*, 1851

8-50. *Bocio* in honor of King Glele. Sosa Adede. Late 19th century. Wood, brass, silver; height 5'7" (1.7 m). Musée de l'Homme, Paris

Sculptural forms, *bo*, were considered empowered objects in Dahomey. They were believed to work in conjunction with the energies of the gods, *vodun*, to protect against evil, sorcery, illness, theft, and to provide power and success. *Bo* took on various shapes. Those carved to represent a figural form are generically known as *bocio*.

Royal *bocio* served to protect the king and to bolster his authority. A range of human and animal forms appear in *bocio*. Some animals can be seen as representations of the kings themselves, for Dahomean kings were said to be able to transform themselves into a variety of powerful animals so as to spy on their enemies or flee problematic situations in battle. One of the best-known *bocio* is a large anthropomorphic lion carved during the late nineteenth century by the artist Sosa Adede (fig. 8-50). Apparently this lion-man, which once carried a sword in each hand, was dragged on a cart into battle to create an image of royal fury and strength. As tall as a man, bran-

dishing weapons in a dynamic pose, the sculpture embodies Glele's power, strength, and courage. Lions appear frequently in art used in Glele's court, on reliefs on the walls of the palace, in royal scepters, in wooden carvings sheathed in sheet brass or silver, in copper staffs used in memorial shrines, and in appliqué banners, pavilions, and umbrellas. They draw on such phrases as "No animal displays its anger like a lion" and "Lion of lions," which are embedded in the poetry composed for his *fa* sign.

Spiritually charged materials secreted within such royal *bocio* were believed to empower it, rousing the figure and giving it the ability to walk around and to speak. When not being carried into battle, this sculpture was kept in a temple dedicated to Gu, the god of war (cognate with the Yoruba god Ogun), and displayed in magnificent processions during annual ceremonies commemorating the royal dead.

One of the most striking works from Abomey is a magnificent life-size iron warrior striding forward on long, sinewy legs and huge feet (fig. 8-51). Forged for Glele by the artist Akati Akpele Kendo, this *bocio* is known as Agoje ("watch out above"). The sculpture served to protect the king and his kingdom in time of war and unrest, and its massive headdress of iron weapons and tools refers to Gu. Like the lion-man figure, Agoje holds aloft a

8-51. *BOCIO* KNOWN AS AGOJE. AKATI AKPELE KENDO. 1858–89. IRON, HEIGHT 5'5" (1.65 M). MUSÉE DE L'HOMME, PARIS

At the time it was taken by the French, the bocio had been transported by Glele's troops to Wydah, a coastal city, probably in anticipation of a run-in with the French.

8-52. BANNER IN HONOR OF KING GLELE, detail. FON. APPLIQUÉ. MUSÉE HISTORIQUE, ABOMEY

heroic sword, further recalling Gu and yet another phrase associated with Glele's *fa* signs, the "audacious knife that gave birth to Gu." In response to this phrase, Glele received as another of his strong names Basagla, the name of a special type of sword that he chose as a visual symbol of his reign. Images of such swords are found in many reliefs, banners, and sculptural forms of Glele's court. To emphasize the connection between this *bocio* and the strong name it referred to, Glele commissioned the same Akati Akpele Kendo to forge a group of gigantic swords to encircle this figure while it was displayed in the palace. The swords vividly evoked the role of vengeance in Glele's reign.

Another *bocio* commissioned by Glele is known from drawings by European visitors and its depiction on textile banners that were used in the

8-53. Lion *bocio* in honor of King Glele. Allode Huntondji. 1858–89. Silver on wood, height 11¾" (30 cm). Musée Dapper, Paris

figures. An *asen* made to honor the memory of Glele is crowned with an openwork cone of spoke-like supports (fig. 8-54). Pendant elements hang from the disk above, which serves as a platform for a complex and enigmatic figural grouping: a dog shaded by an umbrella stands on the back of a horse, at whose shoulder a small bat flies. The umbrella is a metaphorical reference to kingship. The dog alludes to Glele's sponsoring ancestor, whose patronage was arrived at through divination. The first syllable of one of

8-54. *Asen* (memorial altar) to King Glele (detail). Tahozangbe Huntondji. Fon. 1894–1900. Iron. Musée Historique, Abomey

court at Abomey (fig. 8-52). Known as Daguesu, the *bocio* depicted a being with the head of a ram or buffalo (both are called *agbo* in Fon) and a human body. Dagueso invoked the Fon thunder god Hevioso, who, like his counterpart the Yoruba god Shango, is associated closely with the ram. The *bocio* accompanied Glele's troops into battle, calling on Hevioso's power to speak through the thunderous blaze and blast of guns.

Many royal *bocio* were carved of wood and covered with thin sheets of beaten brass or silver (fig. 8-53). These were not taken to the battlefield but were displayed during annual rites for the New Year and at other state events. This brass-sheathed *bocio* depicts a striding lion who opens his great mouth in a roar that reveals his sharp teeth, thus recalling a variation on Glele's strong name, "the lion of lions

grew teeth and fear arrived in the forest." It was carved for Glele by the artist Allode Huntondji during the last few years of the nineteenth century.

Art and the Spirit World

The Fon believe that the living and the dead remain closely linked. Spirits of the departed must be revered by their descendants in order to continue their lives serenely in the other world. In return, they protect the living and grant them access to a realm of higher powers. An art form that expresses this connection is the memorial altar, *asen.* Asen take the form of an iron staff topped with an inverted cone that supports a lid-like disk, which may in turn serve as a platform for cast and/or beaten brass

the names of this ancestor is the same as the word "dog." The word for "horse" alludes to the name of the quarter in which the ancestor lived. When the words for "dog" and "horse" are combined, they form the word for "bat," whose image thus becomes a double reference to the ancestral sponsor and the quarter of Abomey in which he lived.

Until 1900 almost all artists were in the employ of the royal court, and *asen* are said to have been used exclusively in Abomey shrines honoring deceased members of the royal family. After the French abolished the court, however, wood carvers, metal workers, and textile artists sought new patrons for their work in the general populace and among foreigners. The precise meanings of many hitherto royal art forms were diluted as they became items of trade. *Asen*, however, not only continued to have ritual meaning, but they proliferated in response to the patronage of commoners, who had previously used plain iron objects to commemorate ancestors.

The collection of *asen* shown here (fig. 8-55) belongs to a single family. Each *asen* commemorates a deceased family member, and in theory every deceased family member is represented by an altar. A family's *asen* are ranged in a one-room structure called a *dehoho*, which opens onto the central courtyard of their home. It is within the sacred space of the *dehoho* that communion between the living and the dead takes place. Offerings of water are poured to summon the spirits to listen to the living, sustenance is offered in alcoholic drinks, food, and the blood of sacrificed animals. The altars, too, serve as a sort of offering.

Several styles of *asen* can be seen here. On some the supporting cone is formed of spoke-like elements, whereas in others it is rolled from a solid sheet of metal. Some disks support figures, while others do not. Pendants dangle from some of the rims, identifying the artist who made the altar. Like the figures atop royal *asen*, figures on *asen* for commoners are enigmatic and can generally be read several ways. In fact, the Fon

8-55. INTERIOR OF A FON *DEHOHO* (FAMILY SHRINE) WITH *ASEN* (ALTARS) AND *BOCIO* FIGURES

8-56. *BOCIO* FOR A COMMONER. FON. 19TH–20TH CENTURY. WOOD, BONES, SHELLS, FIBER; HEIGHT 15″ (38 CM). BROOKLYN MUSEUM, NEW YORK

8-57. DIVINATION TRAY. AJA OR FON. BEFORE 1659. WOOD, 13½″ x 21½″ (34.7 X 55.5 CM). WEICKMANN COLLECTION, ULMER MUSEUM, ULM

maintain that only the donor and the maker of the *asen* can fully interpret the mixture of messages on it. Some figures depict the deceased, accompanied occasionally by surviving family members. Other images may depict the *fa* sign or *fa* name of the deceased. Some motifs evoke values of Fon culture through references to deities or allusions to proverbs and praise songs. Others, like the dog on the royal *asen* discussed earlier, are meant to be read as a rebus.

Displayed among the *asen* here are several roughly carved *bocio*. Unlike other forms that became available to commoners only after the abolition of the court and its patronage, *bocio* had always been used by non-royals. Royal and common *bocio* serve similar purposes, yet their aesthetic is markedly different. In Fon culture, things that are considered attractive are ornamental, delicate, refined, decorative, dressed, and tidy. The *bocio* of commoners contrast markedly with such ideals (fig. 8-56). Disorderly, rough, and incomplete, they seem to be concerned with an

anti-aesthetic. Empowering materials, generally secreted inside royal *bocio*, are here often attached outside, in full view. These materials, including metal, beads, bones, hide, rags, fur, feathers, and blood, are selected for their physical and symbolic potency. Likewise, the techniques of knotting, binding, and tying used in their manufacture provide both actual and metaphysical strength. Materials and techniques are deliberately revealed to make the object visually powerful, shocking, and astonishing. The grotesqueness and ugliness of such *bocio* are part of their strength.

Among the Fon as among the Yoruba, divination and the gods associated with it have inspired a variety of art forms. A beautiful divination board collected as early as the mid-seventeenth century in the Aja kingdom of Allada is among the oldest of African objects in European collections (fig. 8-57). With its flat, plate-like surface surrounded by a raised border it is similar to boards used today in Yoruba *ifa* (compare fig. 8-26). The carving of the many motifs, however, and

especially of the human forms, is more reminiscent of the work of the Ewe and Akan peoples to the west.

The unknown artist of the board has used both symmetrical and axial balance in the service of a system of ideas. The board is symmetrical in its major forms, a circle centered within a rectangle. The stylized face carved at the center of the upper border depicts Legba, the Fon equivalent of the Yoruba Eshu, the trickster messenger god. As in Yoruba iconography, small medicine gourds top Legba's head, in reference to his powers. The face of Legba is symmetrical, as are the vertical chains of cowrie shells at the center of the lower border opposite. The remaining border motifs, however, do not mirror each other exactly across the vertical axis, but rather provide interesting variations on either side, seemingly rotating them around the central point. Broadly carved animals, birds, and various accouterments are all crowded together. This radial

approach to symmetry brings opposing and dissimilar objects into equilibrium in a way that may be parallel to the way the dissimilar gods Fa and Legba work together in the lives of the Fon. Zigzag patterns decorate details of most of the images on the board, helping to unify the disparate motifs.

The attention to detail and the beauty of the harmonious design suggest that this object was carved by a professional artist who was likely employed by the court. In contrast, an earthen figure representing Legba has been created with less evident care lavished on its surface (fig. 8-58). Seated in a palm-leaf shrine, it seems to have been made more directly, almost crudely. In Fon thought, the strong object does not have to be beautiful or even attractive in order to work effectively. In fact, many forms used by the Fon show a type of roughness and inelegance that suggests the raw power associated with the work of the spirits they are made for.

MODERN ARTS

The late nineteenth century is seen by some as a time when the political, cultural, and artistic underpinnings of Yoruba and Fon culture were crumbling in the face of European colonial presence and the drastic changes it brought about in Africa. It is true that numerous art forms declined in importance or ceased to be made at this time. In many ways, however, the period was also one of redirection and renewal, a time for exploring new possibilities. In Dahomey, we have seen, artists who had been tied to the palace found new markets and modified their products for new patrons. Yoruba artists also found new patrons and markets. Wood carvers, for example, accepted commissions for works destined for Christian churches and governmental buildings. In addition, new materials and techniques introduced through contact with European culture enabled new art forms and styles.

Brazilian Architecture

Toward the end of the slave trade, great numbers of Yoruba were taken to the Caribbean and South America to work in the sugar industry. In Brazil and Cuba they became a dominant force in the local African cultures that developed. As slaves gained their independence, many Yoruba returned to Sierra Leone and Nigeria. The architectural ideas they brought back with them changed the urban landscape in West Africa.

Yoruba taken to Brazil were both *orisha* worshipers and Muslim; many during their time in the New World adopted Christianity. During the 1890s a Muslim repatriate, Muhammad

8-58. PALM-LEAF SHRINE WITH EARTHEN FIGURE OF LEGBA, ABOMEY. LATE 19TH CENTURY

8-59. Central Mosque, Lagos, Nigeria. Joao Baptist Da Costa. 1908–1913 (destroyed 1980)

Commercial buildings and homes were also constructed in the new style. The Ajavon House in Wydah, Benin, was constructed in 1922 (fig. 8-60). Polygonal towers flank the recessed central section of the facade, providing a sense of movement. The entrance is marked by a grouping of three posts, repeated on the second level by pilasters. Immediately above, a projection with relief ornamentation carries the name of the house and the year of its construction. Built of brick, the house was plastered and painted with whitewash colored with ocher. Relief patterns decorate the pilasters, and balustrades fill the spaces between the pilasters and below the windows on both levels. A fence of posts and wrought iron sets the house off from the street.

Ajavon House is purposefully theatrical and ostentatious, an expression of the wealth of its owners. Such buildings were not used simply as dwellings, but were actually places of

Shitta Bey, commissioned two mosques in Lagos. The work was entrusted to a Yoruba Brazilian Catholic architect, Joao Baptist Da Costa. Until its destruction in 1980, the Central Mosque, the second of Bey's commissions, stood as a splendid example of the new Brazilian style (fig. 8-59). Here Da Costa drew on the architectural vocabulary of the Portuguese Baroque colonial churches and administrative buildings he had known in Brazil. The ornate and dynamic style, with its arches, pilasters, curves, and volutes, reaches ultimately back to seventeenth-century Europe, and its appearance in Africa marks the second time it crossed the Atlantic.

8-60. Ajavon House, Wydah, Benin. 1922

business. Shops opened off the veran-
dah at street level. The domestic
portion of the building was in the
story above and to the rear, around an
open courtyard, recalling the Yoruba
architectural tradition of verandahs
surrounding an open space.

As the Brazilian style caught on
along the west coast of Africa and
moved inland, creative variations fil-
tered from it into vernacular
architecture. In the modern portion of
the palace at Ado Ekiṭi, in northern
Yoruba country, a grand staircase calls
attention to an entrance (fig. 8-61).
Most noticeable is the symmetrical
gateway at the top of the stairs. Here a
cement openwork form is decorated
with two heraldic lions above a group
of three figures. The walkway along
the upper level is protected by a
balustrade in which the balusters have
been replaced by ornamental cement
latticework and a rising sun. Tradi-
tional Baroque balusters support the
staircase railing, while another cement
openwork design takes their place on
the small projecting balcony at the
landing. Yoruba popular architecture
quickly made use of such openwork
inspired by Brazilian prototypes, espe-
cially in balcony railings. In many
instances, abstract architectural
designs gave way to figural forms and
words. For example, the cost of con-
struction might serve as a motif in a
building's decorative openwork.

8-61. EXTERIOR OF THE PALACE AT ADO EKITI, NIGERIA. PHOTOGRAPH 1960

Movements in Oshogbo

Two of the best-known cultural explo-
sions in Yorubaland was centered in
the city of Oshogbo, where two
groups of artists began working in the
1960s, both inspired by expatriates
from Europe. One group crystallized
around Suzanne Wenger (born 1915),
an Austrian artist who became a
priestess of the god Obatala and a
senior member of *ogboni*. When
Wenger arrived in Oshogbo in 1958,
she involved herself in reconstructing
and refurbishing Yoruba shrines col-
laboratively with several artists who
developed under her leadership. A sec-
ond group centered around an
organization called Mbari Mbayo,
grew from the theater company of the
Nigerian playwright Duro Ladipo. Ulli
Beier (born 1922), a German professor
of literature who was married to
Wenger at the time of their arrival in
Nigeria, was a leading force in the
organization. In both groups, artistic

work took on an interdisciplinary focus as writers, playwrights, actors, musicians, and visual artists combined their skills in an atmosphere of excitement and innovation.

In an effort to preserve the shrine of the goddess Oshun, Wenger re-erected the wall that marked the sacred precinct. Carpenters and bricklayers working for her added their own personal creative efforts in the forms of reliefs and carved posts. Adebisi Akanji (born 1930s) started as a bricklayer on the project, and although a Muslim, he was inspired to add his own relief touches to the wall (fig. 8-62). Here, an expressively formed fence is the ground for an equally lively representation of Ogun, god of war, on horseback with his gun in hand. Akanji was inspired during this period to respond to a competition sponsored by Ulli Beier to design an openwork balcony in the Brazilian style, which Beier was hoping to revive. Successful in the competition,

Akanji went on to become a master of sculptural screenwork for balustrades and balconies. He expanded the form to create entire openwork walls, and his works were installed in such prestigious locations as the palace at Otun, the University of Ibadan, and the Nigerian Embassy in Washington, D.C.

Georgina Betts (born 1938), an artist who had been working in Zaria to the north, came to Oshogbo and married Beier. Together, they organized workshops led by Georgina Beier herself or by visiting artists such as the Dutch artist Ru van Rossen and the Americans Denis Williams and Jacob Lawrence. A number of well-known Oshogbo artists developed from this workshop, including Muraina, Oyelami, Adebisi Fabunmi, Twins Seven-Seven, Rufus Ogundele, Jacob Afolabi, and Jimoh Buraimo.

Buraimo (born 1943) started out as an electrician, developing the lighting system for Duro Ladipo's National Theater. After he took part in a 1964

workshop led by Georgina Beier, Buraimoh began to draw and paint. He eventually developed a type of "bead painting" technique by attaching stings of beads to the canvas or hardboard and eventually "poured" loose beads into epoxy adhesive on the painting surfaces. *Obatala and the Devil* is typical of Buraimo's work (fig. 8-63). The surface is alive with brilliant areas of color and the texture of the beads. Although it is not directly related, the technique recalls the tradition of beadwork on the cloaks and crowns of Yoruba royalty. Like artists working in both groups in Oshogbo, Buraimo's sources include Yoruba mythology, Christian and Muslim stories and events, daily life in Nigeria, and Yoruba stories and proverbs.

Yoruba women have long practiced a form of resist dyeing called *adire* (fig. 8-64). In *adire*, the design is painted onto the fabric using a starchy paste made from the cassava yam. The

8-63. *OBATALA AND THE DEVIL*. JIMOH BURAIMO. 1970S. BEADS AND OIL ON HARDBOARD; 37¾ x 25½" (96 x 65 CM). CENTER OF AFRICAN MIGRATION STUDIES, UNIVERSITY OF BREMEN

fabric is then dyed in a bath of indigo made of the leaves of a forest vine. The yam paste repels the dye, leaving the design in white against an indigo background. The pattern here is a traditional design called Olokun, after the sea goddess. Such *adire* patterns have been passed from mother to daughter, as have the techniques of stenciling, painting, and tying used to create them.

Drawing on a heritage of textile arts in both weaving and dyeing, Oshogbo artists, both men and women, experimented with fabric and dye techniques. A later Oshogbo group artist, the textile artist Nike Davies-Okundaye (born 1951), learned textile arts and related skills from her family. Her great grandmother, the *iyadole* or head of the women in her home town, practiced weaving as well as *adire* dying with indigo. Her father, a traditional musician, was a basket weaver and leather worker. Davies-Okundaye was also among the many who worked in the theater and art groups in Oshogbo. Inspired by Georgina Beier's workshops of the 1960s, Davies-Okundaye later established the "Nike Center for Arts and Culture" in Oshogbo in order to create job for young Nigerians and to encourage Nigerian women into the arts.

In her own *adire* and batik work, Davies-Okundaye often includes a moral lesson, warning against the intentions of ill-willed persons or suggesting that the poor can be rich. Yoruba stories provide a wealth of subject matter, although Davies-Okundaye was raised a Catholic, she often refers to Yoruba *orisha*. Many of her batiks present Oshun, *orisha* of the Oshun River (fig. 8-65). In this

8-64. *ADIRE* CLOTH. YORUBA. 20TH CENTURY. COTTON AND INDIGO; WIDTH 5'9" (1.75 M). THE BRITISH MUSEUM, LONDON

8-65. *OSHUN GODDESS*. NIKE DAVIES-OKUNDAYE. BATIK WALL HANGING. NIKE CENTER FOR ART AND CULTURE, OSHOGBO

work, the focus of attention is centered on the sacrifice to the river goddess balanced on the head of a woman. To the far left, a priest rings bells for the *orisha*, while drummers on either side of the carrier beat rhythms for the goddess, who apears as an apparition over the drummer on the right.

The Ona Group

Founded in Ile-Ife in 1989, the Ona group unites a number of university-trained artists. Fully aware of Western artists and Western traditions of art making, they grapple with the issues raised by the transformation of their society, which is in the process of recreating itself in response to its cultural roots, the colonial experience, and modern international urbanism. Their art consciously challenges ideas about modernism, about being African, about being modern artists in Africa.

The founder of the group is Moyosore Okediji (born 1956), then a professor of art at Obafemi Awolowo University. Holder of undergraduate and graduate degrees in art and a Ph.D. in art history, Okediji works primarily as a painter. To establish links between this practice and his own cultural heritage, he has made an intensive study of the images painted on the walls of shrines by women. Yoruba shrine paintings are rare today, and little has been recorded about them. Okediji visited shrines that his grandmother helped to paint and observed the painting techniques. One of the problems Okediji assigned himself was to come to grips with the color palette used by Yoruba shrine artists. Following their lead, he learned to work with the natural colors that are present in the environment or available in the local

8-66. OPENWORK FRIEZE, OBAFEMI AWOLOWO UNIVERSITY, IFE, NIGERIA. AGBO FOLARIN. ALUMINUM

markets of Yorubaland. He mixes them with commercial binders for greater permanency. For Okediji the use of a Yoruba natural palette is a political statement, a conscious rejection of dependence on supplies from former colonial sources. In the process, he ties himself more closely to the earth and its products.

Okediji used such pigments, which he calls "terrachrome," in the large painting entitled *Ero* (fig. 8-67). The work raises issues that have to do with Yoruba ethnicity, but it also goes beyond such local concerns. The word *ero* means "propitiation." The central

image is the giant snail, which is used in all rituals of purification in Yoruba culture. Ceremonial objects are washed with snail liquid at the beginning of each year to cleanse them of all evil and malevolent powers to which they may have been exposed. Most Yoruba medicinal preparations include the liquid for its prophylactic and therapeutic qualities. The awe with which the snail is regarded as a magical creature is exemplified in the saying, "With neither arm nor leg, the snail patiently climbs even the tallest of trees." The metaphor alludes to the

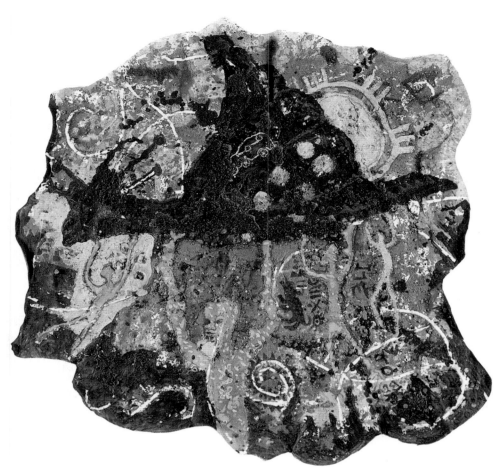

8-67. *ERO*. MOYOSORE OKEDIJI.
TERRACHROME ON CANVAS, 5'11" X
5'10" (1.8 X 1.78 M). COLLECTION OF
THE ARTIST

The painting suggests that the snail, as a purifying agent, cleans Africa of the impurities and maladies resulting from colonial contact and contamination.

Another Ile-Ife artist is Agbo Folarin (born 1936). Like many Nigerian artists, Folarin's experience in the arts is inclusive. Holder of graduate degrees in both fine arts and architecture, he has also designed sets and costumes for films, Olympic Games performances, and theatrical productions. In the tradition of such Yoruba masters as Olowe of Ise, and like the Oshogbo school artist Akanji, Folarin produces sculptural works that become part of an architectural structure. He creates shapes in fiberglass, aluminum, steel, or copper, riveting or welding them together.

Folarin constructed a large-scale, riveted aluminum screen for a former sports building at Obafemi Awolowo University, where he teaches (fig. 8-66). A parade of figures involved in student protest, soccer, net ball, calisthenics, and weight training recall figural compositions on door panels created by Yoruba masters of the past. Although the subject is modern and the techniques are foreign, Folarin is able to create an art that melds the Yoruba past and present together.

way disadvantaged people challenge and even surmount the most difficult problems.

Around the snail are images from the everyday lives of Africans, including some introduced and adopted following the colonial encounter, such as cars and bicycles.

9
THE LOWER
NIGER

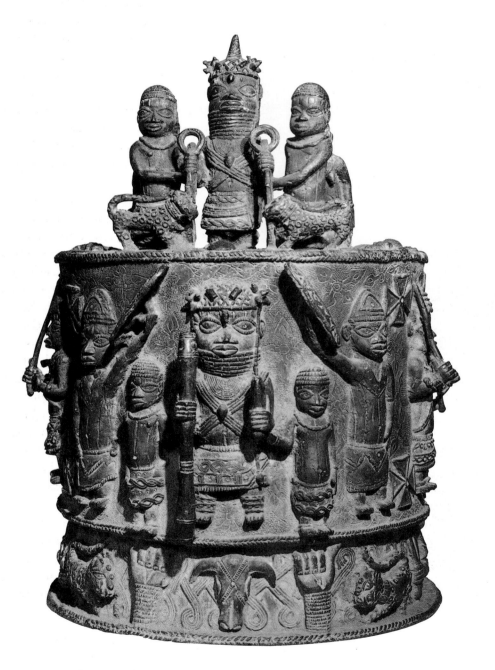

9-1. *IKENGOBO* (PERSONAL ALTAR). BENIN. 18TH CENTURY. BRASS, HEIGHT 18" (45.7 CM). THE BRITISH MUSEUM, LONDON

THE LOWER REACHES OF THE great Niger River embrace diverse cultures as well as varied topographical and ecological features. The lowlands and mangrove swamps of the delta region, where the river fans into the Gulf of Guinea, are home to the Ijaw peoples. Immediately northward, in a region of tropical rain-forest now largely cleared for farming, live various Edo, Igbo, and Ibibio groups. Further north the forest shades into hilly grasslands, home to still other Edo peoples and to the Igala and the Idoma.

The notable artistic diversity of the area, however, appears to stem less from environmental factors than from social and political institutions and historical experiences. Lower Niger societies range in structure from the egalitarian, largely chiefless communities of the Igbo to the hierarchical, centralized Edo kingdom of Benin, an important regional power that received European envoys from the late fifteenth century onward. The Ijaw, too, have traded with Europeans for most of their known history. A fishing people, their society is organized into trading houses, also called canoe houses, whose leaders are quite powerful. Fewer European influences were evident in the northern grasslands until recently. There Edo and Idoma farmers are grouped in chieftaincies, while the Igala form a kingdom that was in contact with, and at times a vassal to, Benin.

IGBO UKWU

The earliest art yet discovered in the Lower Niger region comes from an archaeological site in the heart of Igbo territory named Igbo Ukwu, after a

nearby village group. Excavations at a single family compound there have uncovered a rich burial, a shrine-like cache of prestige goods, and a refuse pit with additional artifacts. The objects form an extraordinary corpus of copper-alloy (mostly leaded-bronze) sculpture and decorated pottery in a refined, meticulous style that has no parallel elsewhere in tropical Africa. On the evidence of several radiocarbon samples, the finds date to the tenth century AD, making them the oldest known firmly dated copper-alloy castings south of the Sahara. The earliest castings from the Inland Niger Delta were also produced around this time (see chapter 4), and that region may have been the source of the Igbo Ukwu casting technology.

Archaeological evidence combined with recent ethnographic work indicates that these superb works were associated with an early specialized clan of ritual leaders, the Nri, an Igbo people whose direct descendants still live in the same area. The Nri today continue to perform some of the rituals that they apparently did during the tenth century. They also pay allegiance to a king, or *eze*, who was probably then, as he is now, more a ritual leader than a political one.

A painting by archaeologists reconstructs the probable original appearance of the burial uncovered at Igbo Ukwu (fig. 9-2). The deceased was seated upright. If he was not the king of the Nri peoples, he must have been a very high official, judging from the sumptuous regalia he wore and the fine artifacts that accompanied him. His feet were raised on an elephant tusk, and another lay nearby. Cast and hammered copper-alloy ornaments adorned him or were placed nearby, including a fan-like object and a headdress, both probably once decorated with eagle feathers. The burial contained more than one hundred thousand beads, many of which had been imported from beyond Africa. Considered valuable, beads often serve as a form of currency in Africa, and such a vast accumulation suggests that tenth-century Nri peoples were very

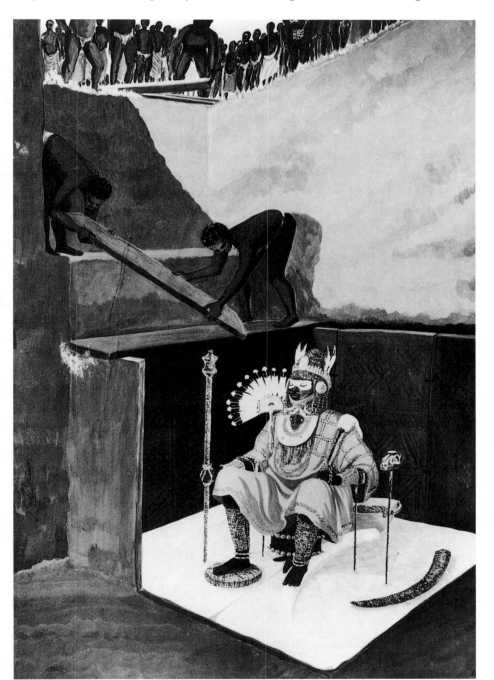

9-2. BURIAL CHAMBER AT IGBO UKWU, SHOWING WORKERS SEALING THE TOMB. RECONSTRUCTION PAINTING BY CAROLINE SASSOON

wealthy. Clearly they were engaged in long-distance trade.

One small casting found with the burial implies both travel and trade (fig. 9-3). Depicting an equestrian figure, it served as either a flywhisk handle or a staff finial. Horses still are prestige animals associated with leaders and title-taking among the Igbo and their northern neighbors, the Igala, who are related to the Nri. In recent centuries, and probably earlier, all horses were imported, as sleeping sickness precluded a long life for them in the forest zone. The rider's face displays scarification patterns called *ichi*, which are still linked with both titles and the Nri people. In all likelihood, then, the horseman represents an early Igbo leader. The rendering of the mount, which may be a mule or donkey, is schematic, as if the wax model had been composed of many small rope-like and chevron units. The rider's

body too is simplified, and his head is disproportionately large. The skillful handling of detail is remarkable on so small a casting.

The Igbo Ukwu shrine or repository, seen in a second reconstruction painting (fig. 9-4), yielded dozens of items, including containers, staffs and ornaments, jewelry and regalia, and finely decorated pottery. Among its treasures, visible in the back right of the drawing, was a hollow cylindrical stand depicting a pair of human figures amidst openwork arabesques (fig. 9-5). One of the figures has facial scars like those of the horseman. This elegant stand was probably used to raise a ritual vessel off the ground. The couple may recall Nri creation legends about the first male and female, children of the first legendary king. The king was ordered by God to scarify his children's faces, then to decapitate them and bury their heads as if planting a garden. The

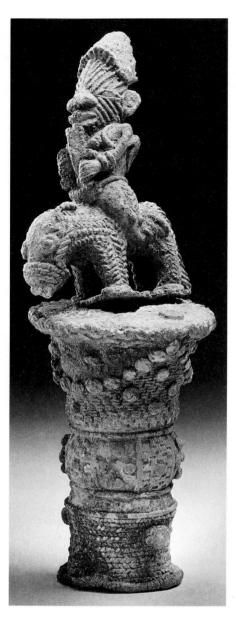

9-3. STAFF FINIAL OR FLYWHISK HANDLE. IGBO UKWU, NIGERIA. 9TH–10TH CENTURY AD. LEADED BRONZE, HEIGHT 6³⁄₁₆" (15.7 CM). NATIONAL MUSEUM, LAGOS

9-4. DISPLAY OF OBJECTS AS FOUND WITHIN AN IGBO UKWU SHRINE-LIKE CHAMBER. RECONSTRUCTION PAINTING BY CAROLINE SASSOON

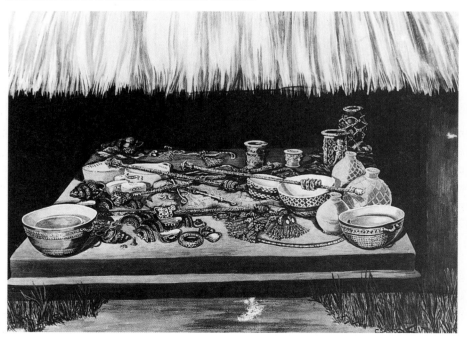

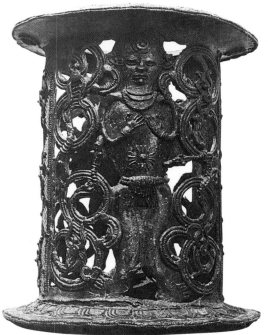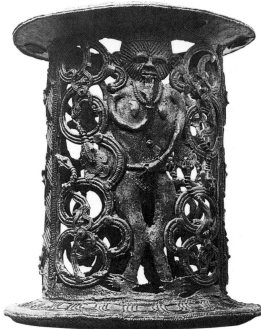

9-5. Altar stand (two views). Igbo Ukwu, Nigeria. 10th century ad. Bronze, height 10⅞" (27.4 cm). National Museum, Lagos

The two human figures stand in an openwork cylinder depicting delicate, curvilinear tendrils—perhaps stylized yam vines—and snakes that grasp frogs in their mouths. It is tempting to associate the amphibians with the putative powers of the Nri king to cause or prevent swarms of harmful insects, birds, and snakes, as well as to stimulate the fertility of plants and animals. Oral traditions report these as ancient Nri powers.

planted heads later grew to be the first yams. Thus the technology of agriculture was invented along with yams, the most important Igbo prestige crop. Yam medicines are still prepared by Nri ritualists. The same creation legends relate that Nri people were given the right to confer *ichi* facial scars, grant titles, and purify the community. While *ichi* have recently fallen out of favor, contemporary Nri Igbo still grant titles and ritually purify communities.

Another particularly fine although puzzling Igbo Ukwu find depicts a pair of joined eggs with a bird attached on top of and between them— an image that can also be read as male genitalia (fig. 9-6). A number of flies are cast on the eggs and other parts, and eleven bead-decorated chains ending in small bells are attached to the base. The virtuosity and delicacy of this casting would be an accomplishment in any period, but it is particularly remarkable at such an

early date. Eggs commonly appear as fertility symbols in Igbo and other West African rituals, and although the meaning of this particular object remains uncertain, a plausible interpretation is that the egg/bird/genitalia motifs symbolize human (and perhaps animal) fertility and productivity. The sculpture is also a visual pun, and no doubt an intentional one. It was probably used in rituals of increase of the sort more recent Nri kings are known to have conducted.

9-6. Double egg with pendant bells and beads. Igbo Ukwu, Nigeria. 9th–10th century ad. Leaded bronze, height 8½" (21.6 cm) overall. National Museum, Lagos

Also found at Igbo Ukwu was a hollow casting in the form of a shell with an integral pedestal supporting a stylized leopard (fig. 9-7). This was probably a ritual drinking vessel. Leopards and elephants are among the continent's most pervasive, recurrent,

9-7. VESSEL IN THE FORM OF A SHELL. IGBO UKWU, NIGERIA. 9TH–10TH CENTURY AD. LEADED BRONZE, LENGTH 8⅛" (20.6 CM). NATIONAL MUSEUM, LAGOS

The delicacy of Igbo Ukwu style is evident here. Dots, chevrons, concentric circles, and lozenges appear in rectilinear zones defined by thread-like lines in low relief. Two other cast-metal shell containers from the repository have similar fine-unit, zoned decoration, but no leopards. One features small flies, crickets, and snakes with frogs in their mouths. Insects and amphibians are found as well in several other Igbo Ukwu works, and may have been used in rituals addressing the fertility and productivity of nature and humankind.

and important symbols of authority and power. A casting depicting a leopard skull was also unearthed near the buried leader (see fig. 9-2). Small pendants depicting leopard, elephant, ram, and human heads were among other regalia unearthed. These leopards and elephants undoubtedly tie in with Nri spiritual leadership and with the practice of title-taking.

RECENT AND CONTEMPORARY IGBO ARTS

Many of the ideas, motifs, and probable rituals that originated at Igbo Ukwu a thousand years ago have persisted into twentieth-century Igbo art and life. The Igbo today constitute a large, diverse group of agricultural, trading, and professional peoples living

in contiguous territory just north of the Niger delta. Though linguistically related, the Igbo (Ibo in earlier publications) were not otherwise unified until grouped together by British colonial officers after the turn of this century. Egalitarian and individualistic, they strongly resisted pacification and domination by the British. Various Igbo groups have long histories of warfare against both outsiders and each other. Much of Igboland, too, is heavily populated, and in the past this caused some groups to expand outward, taking over the lands of their neighbors. In precolonial times, then, the Igbo were an aggressive, expansionist people receptive to change, qualities that translate today into the dynamism and progressivism evident in their embrace of Western education and enthusiastic entry into the market economy.

Igbo political structures vary considerably from one area to another. A cluster of villages claiming common ancestry is nearly everywhere the largest political unit. Most of Igboland has never embraced centralized political authority, or even the idea of a single ruler, preferring to vest political power in councils of elders and titled men. The oldest, core area of Igboland (which includes the Igbo Ukwu village group) usually bestows the title "king," *eze*, not on one person alone, but on several who earn the highest title in a society called Ozo. A few regions, however, have long had chiefs, and a few towns, such as Onitsha and Oguta, have chiefs and kings modeled in part on those of the kingdom of Benin. Even in these areas, though, people normally distrust any individual who gathers very much power. Igbo

arts similarly retain a regional character, for apart from personal shrines, most Igbo art is associated with institutions rather than individuals. Art forms are commissioned mainly by members of title societies, by members of religious groups for their shrines and compounds, and by masquerading organizations.

Title Arts

Igbo men and (to a lesser extent) women seeking stature and prestige join graded title societies. These societies are hierarchical in nature, and only a few individuals will reach the

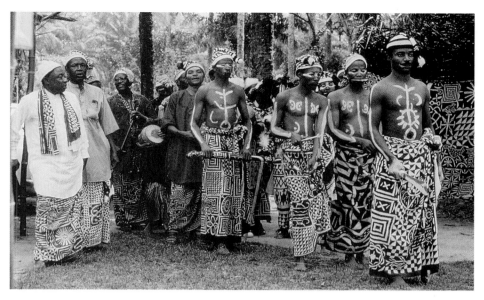

9-9. EKPE MEMBERS IN PROCESSION WEARING *UKARA* CLOTH, IGBO REGION, NIGERIA. 1988

9-8. IGBO MAN WITH TITLE INSIGNIA, OGUTA, NIGERIA. 1983

The man shown here, a chief in the Benin-influenced town of Oguta, near the Niger, wears and holds insignia typical of high titles of the central region: an elephant-tusk trumpet, leopard teeth on a necklace, eagle feathers in his knit cap, and a distinctive garment.

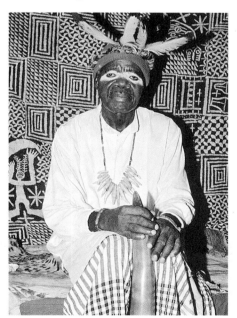

highest levels in any one community. Visual forms are prerogatives of most ranks, and a person's status is therefore evident from his or her dress, personal adornment, and possessions. The styles and some of the object types are different from those found at Igbo Ukwu, but the practice of visually setting off titled individuals remains the same.

Titled men and women possess such art objects as stools, staffs, elephant tusk trumpets, leather fans, and flywhisks, which are carried on ceremonial occasions (fig. 9-8). They wear distinctive garments, eagle feathers, and jewelry made from elephant tusks and leopard teeth. Until recently they wore *ichi*, the facial scarification patterns that appear on faces depicted in Igbo Ukwu arts. In most areas, the architecture and decoration of domestic compounds continues to be an indication of status.

In Igboland to the east, toward the Cross River, there exists a different form of title society called Ekpe

(or Ngbe). *Ekpe* means "leopard," and graded men's leopard societies are found among a number of Igbo and other ethnic groups living near the Cross River, where at least in earlier times they constituted the government of their communities (see chapter 10). Nearly all freeborn men of this eastern Igbo region join Ekpe. As in the Ozo society in central Igboland, grade and status levels of Ekpe are marked by art objects and varied sorts of privileges. Among Ekpe's most distinctive insignia is indigo-and-white *ukara* cloth, worn here by a procession of ranking members (fig. 9-9). *Ukara* are designed by male Ekpe members, then sewn and dyed by women, whose remarkably precise and detailed work embraces representational motifs, cryptic ideographs called *nsibidi* (see fig. 10-5), and geometric designs. Most are secret Ekpe emblems.

Celebratory dress for both men and women also includes cursive indigo patterns called *uli*, which are

9-10. OZO TITLEHOLDER AND HIS
WIFE, MGBALA AGWA, NIGERIA. 1983

9-11. IGBO *ULI* PATTERNS. DRAWING AFTER WILLIS

Uli *patterns may be abstract and non-representational, but many are also named by their female painters. Named patterns here are: (a) kite's wing, (b) cloth, (c) lizard, (d) head of kola nut, (e) lightning/thunder*

painted on visible parts of the body. In figure 9-10 they are worn by a man and his wife on the day he achieved his high Ozo title. *Uli* designs are painted by women, who also paint similar and other motifs in earth colors on the walls of domestic compounds and shrines. Both body and wall patterns are named for various natural and crafted objects in the local environment, and while the designs are rarely overtly symbolic, a full catalogue of them includes many things of value, and the extensive corpus of named patterns thus reveals aspects of the Igbo worldview (fig. 9-11).

Until recently, the walls of both domestic and deity compounds were also often painted by women using colored-earth pigments (fig. 9-12). Sometimes, as in this wall, simplified representational images were included along with abstract motifs: a pair of lizards, a coiled python, a humanoid form. This wall was decorated by a

team of women each of whom painted one or more rectangular section. The entire surface is unified by the rhythmically repeated sections, the four repeated colors, and the uniform speckling of many larger surfaces. By the

1980s and 90s, both wall and body painting were deemed "old fashioned" and were abandoned.

It is with a certain irony, then, that *uli* and other body and wall patterns have been making a strong

9-12. EXTERIOR COMPOUND WALLS, AGBANDANA NRI, NIGERIA. IGBO. PHOTOGRAPH 1983

appearance in the recent work of a small group of artists based in the town of Nsukka, site of the University of Nigeria. Representative of this group is the work of Obiora Udechukwu (born 1946). In his painting *Our Journey* (fig. 9-13), Udechukwu uses the common Igbo motif of a python, shown both stretched out, as if on a journey, and coiled, as if at home. The coiled snake evokes a common proverb, "Circular, circular is the snake's path," which refers to the cyclical, repetitive aspects of life; the stretched out body symbolizes the road of life. Showing faintly through the python's yellow wash are finely drawn scenes of people and events on this road. At the center of the large, three-part canvas are two four-pointed black *uli* motifs called "head of kola." The motif depicts the four-lobed kola nut, which is considered auspicious when shared at hospitality ceremonies.

Other motifs present in this work include both curvilinear body patterns and more rectilinear patterns of the sort carved on the wooden portals of titled men's houses. Until the 1970s the compound portals of men of high title in the central region featured finely painted mural decoration as well as carved and painted doors and side panels (fig. 9-14). As in this example, doors and panels were carved with largely geometric patterns, usually rectilinear, comprised of closely spaced grooves in shallow relief in clay or wood. This technique or style in wood is called chip carving, and its hard-edged, tight geometric character contrasts with the looping, cursive quality of women's designs on wall and body surfaces. Motifs visible on this portal appear in Udechukwu's

9-13. *Our Journey*. Obiora Udechukwu. 1993. Acrylic and ink on four panels of canvas, 6'6¾" x 21' (2 x 6.4 m). Collection of the artist

9-14. Portal to the compound of a titled Igbo man, Nnokwa, near Onitsha, Nigeria. Photograph 1966

painting *Our Journey* (see fig. 9-13). Inside the compound, a lofty thatched roof marked the meeting house, where the man's title regalia and personal shrines were stored. Such architectural elements have been replaced in recent decades, however, by huge wrought-iron gates with fancy decorations and, inside, a palatial reinforced concrete or cement-block house. Yet the principles of making status visible remain the same, even when the materials and styles change.

Shrines and Shrine Figures

Men in many Igbo regions sacrifice to personal altars (see Shared Themes in Lower Niger Arts, page 296). The most artistically impressive Igbo altars, however, are those that were erected until recently within shrines for deities worshiped either by entire communities or by large segments of them (see Aspects of African Culture: Shrines and Altars, page 283).

In the central Igbo area, such shrines were little different from the embellished compounds of titled men, although their portals were sometimes more elaborate (fig. 9-15). The shrine portal shown here has side panels carved in low relief and painted with bold geometric patterns, yellow and white on black. Two carved posts flank the entry, and across the top is an openwork panel called "eyes of spirits," which signals the presence of a shrine within and aids the portal in protecting the contents of the compound. Facing and visible to the profane outside world, the panel warns passersby of the powers beyond the threshold. Implied, as people pass beneath, is the process of spiritual and moral cleansing advisable for those who approach

9-15. PORTAL TO AN IGBO SHRINE COMPOUND, NNOKWA, NIGERIA. PHOTOGRAPH 1966

9-16. IGBO SHRINE ALTAR WITH SCULPTURE, OBA UKE, NIGERIA. PHOTOGRAPH 1983

powerful deities. Similar openwork panels serving the same purpose formerly appeared on the facade of a titled man's meeting house, facing the compound entrance.

Within such walled enclosures are one or several buildings dedicated to the deities considered to be dwelling there, and inside one of them, a shrine or altar containing from a few to upward of twenty sculpted figures, images of the gods and their children (fig. 9-16). The more figures, the more wealthy and powerful the main deity and shrine. Some such gods are well known, often as oracles, far beyond the village group where they are located. The village group shrine illustrated here houses about a dozen carvings, including personal altars for the two senior male deities and a four-headed image called *ezumezu* ("completeness"), representing the four days of the Igbo week and their markets, the four directions, and the auspicious, "complete" number four so prevalent in Igbo ritual. There are also "power bundles" of protective materials and

Aspects of African Culture

Shrines and Altars

Shrines and altars are specially constructed sites of ritual objects and activity. They promote communication between humans and their gods, radiating spiritual energy from the earthly realm to worlds beyond. A charm worn on the body, for example, is a small altar whose single message, usually about personal welfare, beams constantly outward. Figural sculptures are often altars, as are power images such as those of the Fon and Bamana of West Africa and the Kongo of Congo, which assemble diverse materials. All shrines and altars are instrumental; they exist to accomplish something, to offer a charged site from which petitions and sacrifices are channeled to ancestors, spirits, and deities on behalf of people needing help.

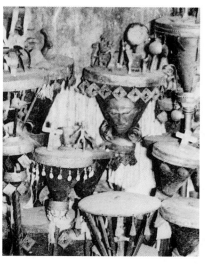

Interior of a Fon *DEHAHO* (SEE FIG. 8-55)

Altars and shrines range from small portable objects to entire buildings full of sacred materials. Small altars such as figural sculptures among the Igbo and Baule may be invoked for personal or family benefit. Many shrines maintained by lineages focus on ancestors, both those who have actually lived and died and founding ancestors whose historical existence may or may not be factual, but whose moral force is unquestioned. Ancestral shrines contain symbols—stones, ceramic vessels, trees, figures, or accumulations—which focus ritual and often involve sacrifice. Larger, composite shrines serve entire communities and incorporate specific and general powers. The gods in such shrines are often called tutelary, meaning protective. They are often associated with various aspects of the natural world (local rivers or forests, the earth, the sky, thunder, iron, or other phenomena) and watch over human and agricultural productivity and the people's health and welfare.

Consecration rituals bring community shrines into worshipers' "lives," and rituals again activate their powers when worshipers need them. These rituals are generally overseen by a permanent priest or priestess who is believed to have close ties with the god and has been trained in its needs and actions. Such rituals normally involve sacrifice, from an offering of coins or a splash of wine to blood from a ritually killed animal. Sacrificial blood is seen as food for the god. The rest of the animal is suitable only for mere mortals, and is later divided ceremoniously and shared out among worshipers to be eaten.

A self-conscious, artistic arrangement of furnishings is common, although many shrines have what appear to outsiders to be disorderly arrangements. Large accumulations of offerings such as chalk, broken pottery, or metal blades are common. Blood and chicken feathers are the most usual sacrificial residue, proof that the gods have been well fed. Today, some shrine sculptures have been removed, often sold. Yet shrines remain active, proof that most cultures understand such images to be symbolic, and not deities in themselves.

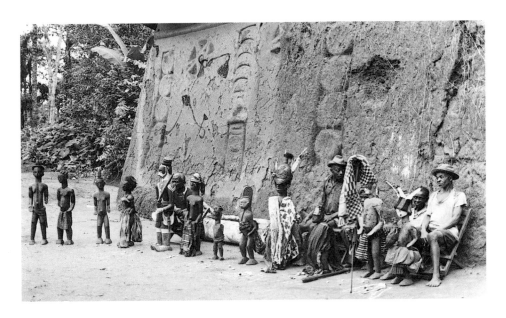

This photograph shows twelve of the nineteen figures assembled for this particular festival. Some date from the nineteenth century, others were carved as recently as the 1950s. The figures were cleaned, repainted, and dressed up for the event. Sacrifices of kola nut, chalk, and coins were offered to them, and libations were poured. Animals were sacrificed to the gods as well, providing a major feast for devotees, who through the priests and priestesses offered thanks to the gods for the blessings of the past year and prayers for prosperity, many children, abundant crops, and good health in the year to come.

staffs for the deities, who are considered to be titled. Ozo status is indicated by depictions of *ichi* scars on the figures' foreheads; the anklets carved on the central male figure also signal status. The Igbo are clear about these figures being representations, not true embodiments. Through them

the unseen gods receive small sacrifices periodically and major ones annually.

The Igbo gods are understood through the model of the family. Larger sculptures represent the more important male and female gods, often considered to be "married" to one another and to be "parents" of lesser deities. These gods are approachable tutelaries, nature gods such as earth, rivers, and forests, or other features of the local environment such as markets, weekdays, and cardinal directions. These deities provide, protect, and heal in return for respect, sacrificial food, and adherence to their rules. The gods are beneficent or malevolent, depending on how humans treat them, as indicated in central region Igbo style in part by the ambiguous gestures of the figures' forearms and hands: extended to receive gifts, open to show their open-handed generosity. The gesture also

9-18. DISPLAY OF SHRINE FIGURES, OWERRI IGBO REGION, NIGERIA. PHOTOGRAPH c. 1928

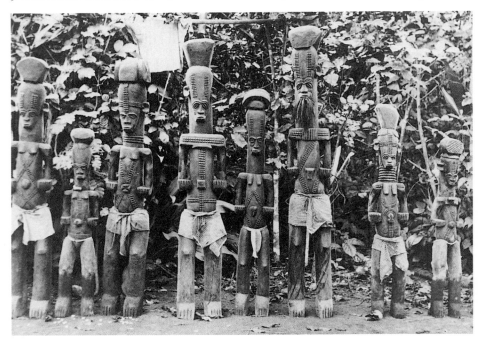

means "I have nothing to hide," implying honesty. Carved from hardwoods by men, the figures are painted by women, who also renew their surfaces prior to major annual festivals for these gods.

As recently as the 1960s these annual celebrations were often quite elaborate, involving the convergence of all major and minor deities, by means of their carved images and their worshipers, in the main plaza of the village group. Images housed in several small village shrines were brought together for this event, carried to the clearing outside the compound of the most powerful deity. It was a "festival of images" (fig. 9-17).

Similar festivals are (or were) also held in other Igbo regions, where the figural style, however, may be quite different. In the area around the town of Owerri to the south, for example, carvers developed a rectilinear, geometric style (fig. 9-18). Shoulders are squared off, and overall the images are blocky.

Mbari

Also in the Owerri region, the most powerful local deities occasionally call for an extraordinary sacrifice in the form of a building called *mbari*. *Mbari* are usually built in response to a major catastrophe, such as a plague of locusts or an especially high rate of infant mortality. Filled with painted sculpture, *mbari* houses require enormous commitments of human effort, money, and time, and thus are never lightly undertaken. In fact, people often put off starting one until reminded again by some misfortune, interpreted by a diviner as supernatural impatience. *Mbari* may be

dedicated to one of several local tutelary deities, but the majority of them are made for Ala, goddess of the earth, often the most powerful local deity. The plan in figure 9-19 records the *mbari* erected to Ala at Umofeke Agwa, Nigeria, in 1963. Between its central building and outlying cloister-like structures, it housed seventy-five painted figures.

An important aspect of *mbari* houses is their ritualized construction process, which may last from several months to over a year. The construction of a large *mbari* involves at least three professionals, including the priest of the deity demanding the *mbari*, a diviner who is consulted often about the desires of the gods, and an artist/master builder who

9-19. PLAN OF THE *MBARI* TO ALA IN 1963 AT UMOFEKE AGWA, NIGERIA. DRAWING BY HERBERT COLE

1 Ala's husband; 2 Ala; 3 Ala's child; 4 Ala's first son; 5 Ada, Ala's first daughter; 6 tortoise; 7–8 daughters of Ala; 9 police (bodyguard); 10 mbari worker; 11 guitar player; 12–3 guinea fowl; 14 Mamy Wata; 15 python; 16 hunter; 17 Chief Emederonwa (Ala's brother); 18 mbari worker; 19 football player; 20 initiated female mbari worker with mirror; 21 a lady (onye missus); 22 female tailor; 23 a lady; 24 Ala's queen among women (ezenwanyeala) with four children; 25 viper; 26 a father; 27 his son; 28–9 white men; 30 Oriefi Ala (a deity); 31 police for Ala; 32 snake; 33–6 Amadioha Ala (the god of thunder associated with Ala), his wife, his son, his daughter; 37–41 delivering mother, her child (emerging), midwife, standing nurse, standing nurse; 42–5 four spirit mbari workers; 46 orphan; 47–9 leopard, lion, ape man; 50–2 drummer and two dancers; 53–8 musicians and dancers; 59–60 hunchback copulating with a woman displaying herself; 61–2 goat man copulating; 63 man writing a book at desk; 64–5 motorcyclist and dog; 66–7 Odube Ala (a god) and his wife; 68–9 diviner's wife, diviner; 70–1 masker, pretty woman; 72–3 telephone officer, businessman; 74 court messenger; 75 airplane pilot; 76 telephone switchboard; 77 telephone pole

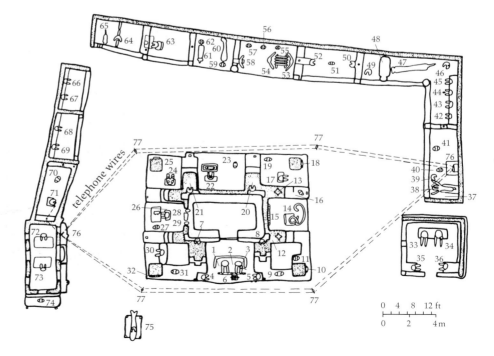

designs the building and models much of its sculpture. Most of the physical labor is done by two groups, a small group of hired laborers and a larger group of "spirit workers." The hired laborers dig literally tons of earth from nearby pits and with it form the core *mbari* buildings. The spirit workers, representatives of the town's major lineages, are initiated into the ritual process and work for free. When these workers first enter the *mbari* enclosure they are symbolically killed as humans. Reborn as spirits they dedicate themselves to serve the god, remaining isolated from their families for six four-day Igbo weeks at the beginning of the project.

The construction process includes an extended series of rites and events that recall the founding of the human community and its institutions: peace is declared, symbols of the gods are established, a farm is planted, and the cycle of life—birth, death, and rebirth—is reenacted metaphorically through the spirit workers, who also take spouses (often only as "joking partners") within their ritual group. Numerous sacrifices of goats and fowl mark the progress of the project inside the fence that shrouds the secret activity from the rest of the community, though of course everyone knows that an *mbari* is taking shape within. After the core building is erected, imported

9-20. THE *MBARI* TO ALA AT UMUEDI NNORIE, NIGERIA, DURING CONSTRUCTION. PHOTOGRAPH 1967

The enclosing fence to the mbari *compound is visible at left. The central figure of Ala is as yet unpainted. The two figures modeled in relief on the pillars symbolize spirit workers. A figure of a white man sits at a table on the left, while a village woman is portrayed on the right. Painting materials, including a stone for grinding clay pigments, can be seen at the lower right.*

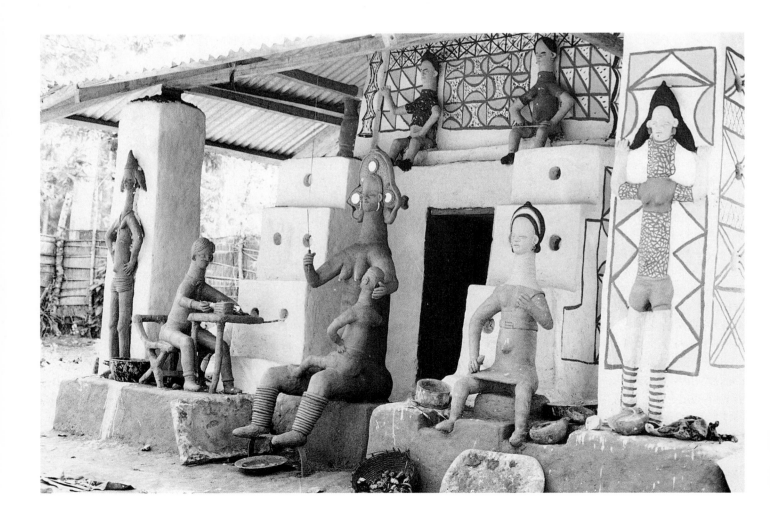

white china plates are embedded in its earthen walls, columns, and stepped buttresses. This process, called "pushing in *mbari*," signals the true beginning of the sacrificial activity. Large *mbari* may be embedded with more than four hundred plates, given by all the major families in the community. It is now announced that "people are dancing *mbari*." During this time, at night, the spirit workers go in procession to the "farm" to harvest "yam." In fact they go to a huge termite hill nearby, where they dig deep within to procure its clay.

Anthills and their clay are sacred to the Igbo, who call these spectacular structures, often six or even eight feet tall, the "porches" of the spirit world. Deceased ancestors are said to reincarnate from anthills, which are held to be both dangerous and numinous, as are all abodes of spirits. Masquerade spirits are said to emerge from anthills when they visit the human community. Notably, too, termite hills are marvelously fertile colonies in which queens produce about thirty-six thousand eggs a day, or thirteen million eggs per year. Termites also tunnel as far as 120 feet under ground for water, and the resulting subterranean passages attract pythons—sacred as Ala's messenger—and other animals. Termite hills, then, are quintessential symbols of fertility and proliferating new life, which are major goals of the *mbari* effort.

The harvested termite clay is soaked, then pounded in mortars just as real yam is; the balls of pounded clay "yam," called *fufu*, are given to the professional artists, who mold the figures on light wooden armatures. Twice processed, first by sacred termites and then by sacred workers, the clay is both spiritually charged and an excellent medium. *Mbari* artists, like Igbo wood carvers, sometimes achieve local recognition and respect for their considerable skill (normally called "handwork" in Igbo) but neither they nor their patrons care much about the distinctions of individual style, even though these are quite evident to outsiders.

Intended as the "crown of the god," an *mbari* must be beautiful, good, and ritually effective, so it must be a consciously artistic monument. Preferably it will be grander than any recent *mbari* in neighboring communities, for the Igbo are fiercely competitive in the arts, as in other arenas. The figures are carefully modeled, and every square inch of wall and pillar surface is neatly decorated with geometric patterns or illusionistic paintings of celestial bodies, cloths, or imaginary scenes. No sloppiness is tolerated in modeling or painting. Figure 9-20 shows the *mbari* erected to Ala in 1967 at Umuedi Nnorie during construction. The figures and pillar to the right have been painted, but the central, seated figure of Ala and the elements to the left still await their colors.

As the *mbari* nears completion, a day is set for its inspection by representatives of the community. Any flaw they find must be corrected before the *mbari* is unveiled to the world. This unveiling takes place in two stages. The first stage is a nocturnal ritual at which the spirit workers denounce their role in the process, cast off their clothes, and run out through a hole in the fence to waiting family members, who give them new clothes and take them away, reborn as people. A few minutes later the fences are torn down, heaped into piles, then lit, so the new *mbari* is first publicly seen lighted by bonfires. The second stage occurs later, on the day of a major nearby market. The spirit workers reassemble at the *mbari* site, then lead a cow to the market. There they are given small gifts and are praised for their long efforts on behalf of the community. Upon their return to the *mbari*, the cow is killed in a final sacrifice, after which feasting, drumming, and dancing open the *mbari* to the public. Visitors come from miles around. A village group will build only one large *mbari*, on average, per generation, so an opening is a major event. The deity has embraced the sacrifice, the community has regenerated itself; it has erected a prodigious and richly inhabited house in honor of its most powerful goddess or god.

Despite its ritualized building process, a completed *mbari* is a secular monument, at once a microcosm, an art gallery, a school, and a competitive boast. It is really not a shrine, since it is offered in sacrifice, not to be altered once accepted by the god. In fact, once finished, it is left to disintegrate. As a monument, it reverses our expectations of closed interior rooms, foregoing an enclosing exterior wall to reveal a series of niches containing figures and scenes. The one interior space is at the core of the central building, a small room whose high walls support the roof (see fig. 9-19). On the outer walls of this room a second story is often depicted, complete with sculpted figures looking out of windows. A gift for the deity, a *mbari* is meant to be the grandest house in the community. As such, many *mbari* had metal roofs in the 1930s before local people had them. Ala herself, sculpted larger than

(human) life-size, presides over the principal building (fig. 9-21). At her side and scattered throughout the *mbari* compound are smaller depictions of community members, spoken of as her "children."

That large *mbari* are also microcosms is proven by the sun, moon, and rainbow sometimes painted high on the central second-story wall, and by the great variety of modeled subjects. About these an elder said, "You will come to understand that they put four things into *mbari*: very fearful things, things that are forbidden, things that are very good [and/or] beautiful, and things that make people laugh." Here then is the richness of life itself, for what cannot be included in one or more of these categories? The *mbari* to Ala at Umofeke Agwa (see fig. 9-19) contains among its seventy-five figures an office building with a telephone operator nearby and four telephone poles wired with strings, an airplane (on stilts), several birds and animals, and a maternity clinic with nurses and a woman giving birth.

Mbari imagery is drawn from real life, artists' dreams and imaginations, history, folklore, and the times of the ancestors. Some subjects are clearly didactic; parents bring children to *mbari* houses expressly to teach them about the past, about the gods, and about unacceptable behavior. Things only heard about or hoped for are also included. The maternity clinic modeled in the *mbari* to Ala at Umofeke Agwa was built in that community a few years after the *mbari* was unveiled.

During the late 1960s the building of all but very small *mbari* ceased due to both extensive conversions to Christianity and the Nigerian Civil War (1967–1970). Exceptions to the virtual demise of the *mbari* tradition are two middle-sized *mbari* houses built during the 1970s out of cement. Commissioned by the government rather than asked for as sacrifices by local gods, these two *mbari* preserve some of the forms of earlier ones but few of their spiritual values, except as "illustrations." One, for example, contains a cement image of a termite hill, as if to remind the largely Igbo

9-21. ALA FLANKED BY HER "CHILDREN" AND SUPPORTERS, DETAIL OF AN IGBO *MBARI*, UMUGOTE ORISHAEZE, NIGERIA. EZEM AND NNAJI, SCULPTORS. PHOTOGRAPH 1966

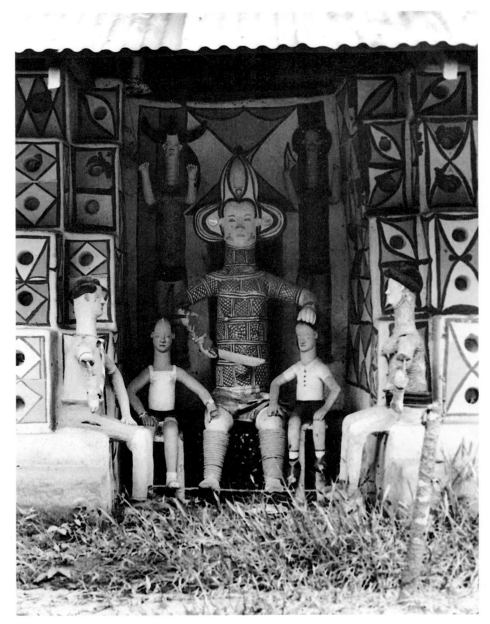

audience of the materials from which *mbari* figures used to be made and of their spiritual symbolism. Unlike earlier *mbari*, these cement compounds will not decompose, returning their sacrificial "yam" to the goddess Earth to complete the cycle of birth, death, and regeneration. Nevertheless, they are manifestations of efforts being made in many parts of the continent to preserve or revitalize earlier cultural patterns that the engagement with modernity has suppressed or eliminated.

Ugonachonma

Mbari houses, made only in the Owerri area, can be considered artistic displays because their patrons are explicit about wanting beautiful works of art. Artists in the central Igbo region (around the Igbo Ukwu sites) also created display figures, in this case carving them from wood (fig. 9-22). Called *ugonachonma*, meaning "the eagle seeks out beauty," these wholly secular figures contrast with those carved for shrines in this area (see fig. 9-16) in being far more lifelike, although the exaggeratedly long neck, considered by the Igbo an attribute of great beauty, indicates that *ugonachonma* are not without their conventions. Also considered signs of beauty are the delicate raised keloidal scars that are depicted running from the girl's neck to her navel and the distention of the navel itself. The figure has the ample fleshiness of a marriageable teenage girl. The carved versions of brass leg coils, armlets, and hair mirrors indicate that she comes from a wealthy family. She carries a mirror in a carved frame in one hand and what was originally an umbrella in the other, both linked with vanity and prestige. The white face exaggerates the Igbo preference for light-colored skin and evokes the practice of washing dark skin with a chalky solution to create a contrasting ground for indigo *uli* patterns, which are also painted here. The figure's crested hairstyle is of the sort celebrated in countless masks.

9-22. *UGONACHONMA* (DISPLAY FIGURE, "THE EAGLE SEEKS OUT BEAUTY"). IGBO. WOOD, PIGMENT, GLASS; HEIGHT 50" (1.27 M). SEATTLE ART MUSEUM, KATHERINE WHITE COLLECTION

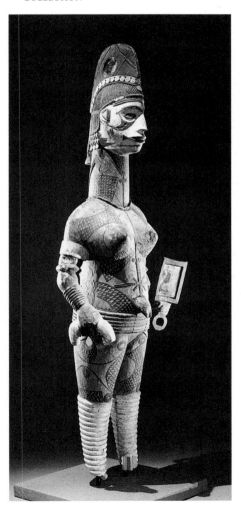

Ugonachonma served as centerpieces for largely secular age-grade dances. Some figures depict male–female couples, but most, like the example here, depict a beautiful young woman. In Igbo thought there is a connection between such youthful maidens and older titled men. Both are beautiful, in their respective ways; both too are linked with eagles. The man is "the eagle that strengthens kinship," a praise name for titled men. He is also "the eagle that has flown very high seven times," a proverb which alludes to the sevenfold cycle of killing that an eagle is said to undertake to achieve its radiant whiteness, which in turn is a reference to the successive moltings eagles undergo, starting out gray, ending up pure white as they grow older. Maidens, on the other hand, are praised by being called "eagle's kola," after the rare, light-colored, most highly prized form of the kola nut shared at every Igbo ceremony.

The titled man, then, is the predatory eagle, king of the sky, aggressive warrior, competitive and ruthless in his quest for trophies and stature. He wears white eagle feathers to show his ritual purity, strength, and high status. His is the "beauty of power," whereas the maiden, serene and cool, shows off the "power of beauty," for she is ripe and ready for motherhood and finely painted with *uli* designs. Both power and beauty are desirable ideals, and both are achieved, if differently, in these complementary male and female notions and the art forms that embody them—the *ugonachonma* for women, and title arts for men. Notably, the Igbo combine the

instrumental and the contemplative in their aesthetic notions, as exemplified by the reciprocal phrases, the "beauty of power" and the "power of beauty." The same ideas are seen in masquerades.

Masks and Masquerades

Igbo masking has become progressively more secular with the march of the twentieth century. Before 1900 and early in the colonial era, powerful masked spirits, deputized by councils of elders, frequently had broad governmental authority, policing, fining, judging, and even occasionally executing criminals. Most of these roles were taken over by British colonial authorities; after the recognition of Nigerian independence in 1960 they passed to the Nigerian government. Yet some masks radiate an aura of power even today, and many still have locally effective regulatory roles. Masks satirize unacceptable behavior, for example, and provide models of both male and female ideals. Indeed, if there is an overriding theme in Igbo masking it is gender relations. Even though nearly all masquerades are male constructions and instruments, many idealize women, praising their grace and beauty in contrast to a somewhat ironic celebration of masculine aggression, power, and even ugliness. Masking thus clearly separates the genders. Excluded from most masquerade activity and oppressed by certain masquerade characters, women generally keep their distance when maskers are abroad.

One masquerade that is still performed over a fairly broad area near the southern town of Owerri is *okoroshi*. There are several regional

variants of the masquerade. The version discussed here opposes two classes of masks: white or light masks, and dark ones (fig. 9-23). The small light masks, carved with refined delicate features, manifest female spirits. The larger dark masks, often carved with grotesque features, manifest male spirits. This dualistic, complementary opposition characterizes much masking among the Igbo and their neighbors in southeastern Nigeria. The masks are further associated with similarly opposing realms. In the communities where this particular version of *okoroshi* is danced, for example, the masks evoke these contrasting overtones:

female (light)	male (dark)
beauty, purity	ugliness, dirt
village, safety	bush, wilderness
daytime, daylight	nighttime, dark
order, clarity	chaos, obscurity, mystery
peace, calm	danger, conflict

Okoroshi maskers appear sporadically during an annual, six-week masking season. Female masks, water spirits said to be descended from benign white cumulus clouds, normally dance prettily in large arenas for people of all ages. Their lyrical songs are about love and money and beauty. Only a few of these masks appear during the six-week season, and then only on a few days. In contrast, dozens of dark masks, representing water spirits said to be descended from threatening gray rain clouds, appear day and night, rain or shine, nearly every day. The forms of these dark masks and the names of the spirits they manifest are markedly diverse. In this one community alone, they are variously named for plants, birds, animals, and insects, for natural phenomenon such as rivers and lightning, for human types or behaviors, for artifacts, emotions, abstract ideas and conditions, and for proverbs such as "Earth swallows beauty" or "Death has

9-23. FEMALE (LIGHT) AND MALE (DARK) IGBO *OKOROSHI* MASKERS, AGWA, NIGERIA. 1983

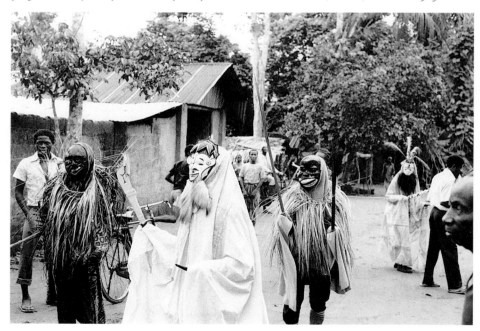

no friend." Taken together these names embrace very broad swaths of human life, activity, and nature. They constitute a kind of verbal text that expresses the breadth of ideas found in *okoroshi*, at least in this one community.

Most dark masks are runners and chasers, worn by younger men who direct their energies toward women and children (fig. 9-24). Near the end of the season, several ritually powerful, "heavy" dark masks come out, often with an entourage of male followers carrying clubs and singing dirges about war and conquest. These masks are three or four times as big as other dark masks, and most have strongly distorted, enlarged features, perhaps with snaggle teeth or open sores.

Rarely do light and dark masks appear together as in figure 9-23, so their "beauty/beast" opposition is mostly a conceptual one played out over the course of the masking season. This opposition is also deliberately violated in several ways. One of the white masks has horns, a black beard, and wears short pants, so he is a male among females. A few of the dark masks are named for women. And on the final evening of the season a masker called Paddle appears, wearing a white mask and long pants. He/she is the only masker to sing or speak, and in contrast to other white masks who dance in bright daylight, he/she emerges at night. Considered both a wise old man and a foolish young virgin, Paddle sings praises of the great families of the community while moving from compound to compound blessing all pregnant women. Paddle and other ambiguous spirit characters appear to blur neat categories, as if to suggest that life is composed of varied

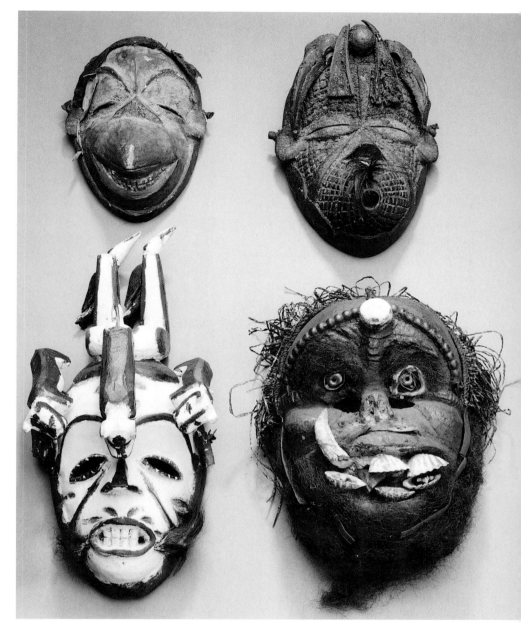

9-24. *Okoroshi* dark masks. Igbo. Clockwise from top left: Kingfisher, Nkelu. c. 1972. Wood and animal fur; height c. 9" (23 cm); Darkness, Itiri. c. 1978. Wood, skulls, kola nut, nails; height 10¾" (27.5 cm); Chimpanzee, Nwaozo. c. 1960. Wood, shells, plastic, porcelain; height 12" (30.5 cm); Sprouting, Agiriga. c. 1975. Wood, nails, pigments; height 15½" (39.5 cm). Fowler museum of Cultural History, University of California, Los Angeles

shades of gray rather than overly simple white/black, good/bad oppositions.

The six-week *okoroshi* season occurs at the height of the rainy season. *Okoroshi* water spirits bless the ripening yam crop and prepare the community for the ritual presentation of new yam, which is ceremonially eaten on the day after all *okoroshi* have departed for their homes in the clouds. Local people say, "*Okoroshi* marks the calendar." While its major purpose seems to be to foster productivity of both the fields and women, at the same time it comments on gender behavior and roles. Men say that women are honored by the masquerade, yet they are also chased and harassed, so the women themselves find masking more tiresome than adulating. Through the masquerade, men characterize themselves as dark and often ugly, and life itself as both complex and difficult—more dark or shades of gray than pure white.

About 100 miles north of Owerri, in the core central Igbo region, an analogous masking tradition conceptually opposes pretty maiden spirits to horned, grotesque, masculine masks known generically by their most prevalent name, *mgbedike*, meaning "time of the brave." The white maiden masks, all danced by men, have superstructures of several types, indicating spirit characters of different ages (fig. 9-25). The eldest daughter, called Headload because of her mask's large figured superstructure, leads the others. Her younger sisters, following, have elaborate crested hairstyles and small pointed breasts. All wear bright, polychrome appliqué cloth "body suits" whose patterning loosely recalls monochromatic designs painted on youthful females in the area (see fig. 9-22). Other characters in the drama are a mother, a father, sometimes an irresponsible son, and a suitor costumed as a titled elder, whose amorous, often bawdy advances to one or more of the "girls" are invariably rebuffed. The play unfolds predictably, with the maidens' dances becoming ever faster and more virtuosic as the maskers compete with one another for audience approval and even financial reward.

Mgbedike are large masks with bold, exaggerated features, usually including open, snaggle-toothed mouths and horned superstructures (fig. 9-26). While they do not dance in

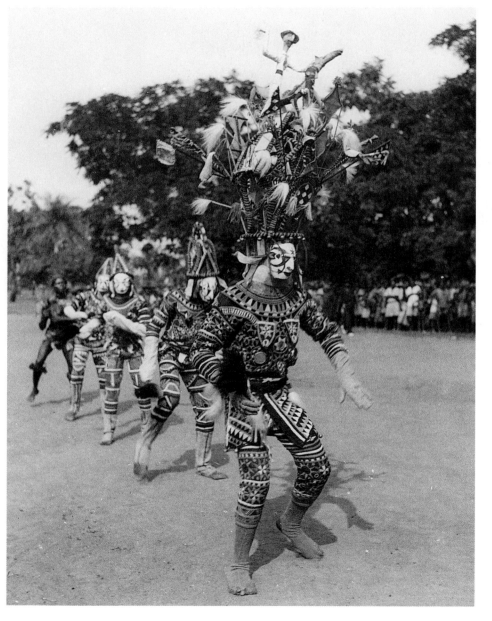

9-25. IGBO MAIDEN-SPIRIT MASKERS NEAR AKWA, NIGERIA. C. 1935

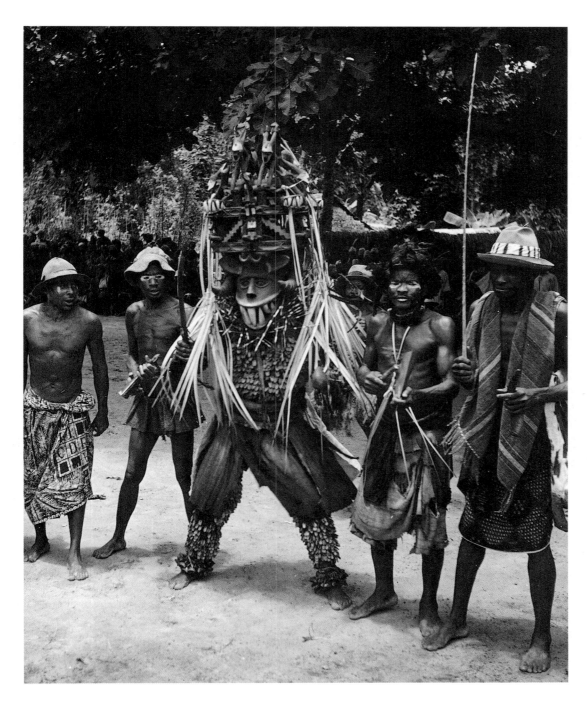

the play described above, in evoking aggressive and powerful spirits and being danced by middle-aged men, they are linked with—and oppose—the maidens. As in the opposition discussed earlier of titled men and *ugonachonma* figures, power here contrasts with beauty. Power is implied by the horns and teeth of the *mgbedike* mask, by its enlarged features, and by its ponderous, aggressive dancing style. Beauty in the female masked characters is expressed by their more elegant, lyrical dancing and by the masks' refined facial features and delicate openwork hairstyles. As in *okoroshi* to the south, these masqueraders play out gender roles, at times caricaturing them, at times idealizing or mirroring them, in dances calculated primarily to entertain. There is no strong ritual component to this masquerading, even though the maskers are considered spirit beings.

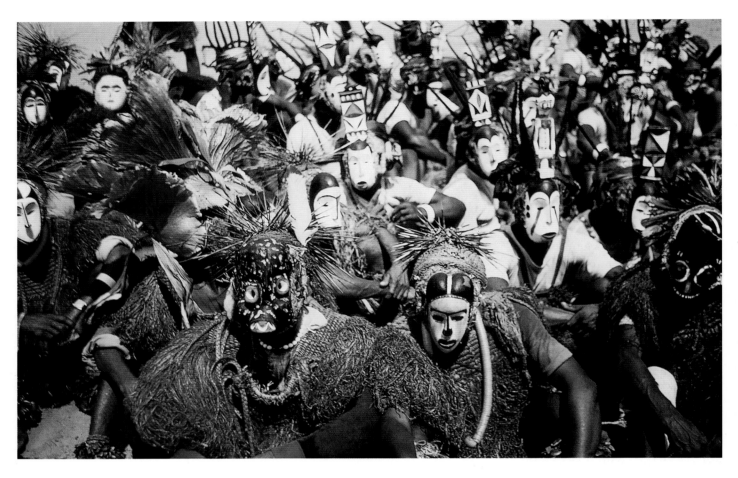

9-27. Igbo masking festival,
Mgbom Afikpo, Nigeria. 1960

Literally hundreds of distinct Igbo masquerades exist, so it is surely a misrepresentation to reduce them to oppositions between dark males and light females. Among the eastern Afikpo Igbo communities, for example, more than a dozen kinds of masks are danced in several separate masquerade types, some for an audience of men only, others for splendid public festivals (fig. 9-27). All masking is sponsored by male initiation societies. There are skits providing topical social commentary and criticisms of elders'

behavior. Other playlets address foolish, dishonest, or greedy men or women, naming individuals, who are even supposed to reward the masked players with money! Some songs and dialogues are set pieces repeated from past years, while others are newly composed. Another masquerade presents a parade that, like *okoroshi* and the iconographic programs of *mbari* houses, represents an exceptionally broad range of local types past and present, including foreigners such as Muslims, Hausa cattle herders, and white district officers. Afikpo initiations also involve extensive masking; sometimes leaf, fiber, and grass masks are used, or masks made from gourds, while carved wooden versions cover a range of human and animal types. The

diverse masks of Afikpo comprise but one of more than a dozen regional mask traditions, each with dozens of spirit characters.

One truly exceptional Igbo mask can be seen as the "crown" of all other masquerades from the lower Niger area. This is *ijele*, whose praise names include "great spirit," "elephant," "king of masks," and "*ijele*, the very costly" (fig. 9-28). Constructed of light wood and covered in multicolored cloth, *ijele* may be sixteen or eighteen feet tall and seven or eight feet in diameter. It weighs about 200 pounds, yet it is danced by a single individual. The base is a disk of wood that ultimately rests on the dancer's head. On this disk sits a red cloth cone, from which a slender mast, understood as

the trunk of a tree, projects upward, stabilized by two openwork arches intersecting at right angles at the top. Densely crowded into the "branches" of this metaphorical tree are many mirrors, hundreds of tassels, streamers, flowers, and dozens of multicolored, stuffed figures. Figures of an elephant, leopard, and eagle are usually found, as well as a variety of human types, genre scenes, and small versions of other masks danced in the region. The assemblage, constructed by male tailors, is completed by a long stuffed cloth python tied on to encircle the wood base, from which hang more tassels and twelve appliqué panels. These in turn recall the bright "body suits" of maiden maskers also featured in these communities (see fig. 9-25). *Ijele* moves in quite a spirited fashion, with dips, shakes, and twirls, its panels flying outward. The effect is dazzling.

In times past an *ijele* came out only for the funeral of an exceptionally well-respected, wealthy, and prolific titled man. The mask's great stature and status are suitable for such an event; its iconographic program brings together several metaphors of human leadership and spiritual power. First, it is an aggrandized version of the colorful crowns worn by rulers in the city-state of Onitsha (along with Oguta, one of the few Igbo communities traditionally ruled by a single chief). The red cloth cone, out of which the "tree" grows, simulates an anthill with all its attendant symbolism and spiritual associations. Trees, especially large old ones, are multidimensional symbols of leaders, who customarily convene councils of elders and titled men beneath their sheltering branches. Impressive trees are often the sites of shrines to nature deities as well. When

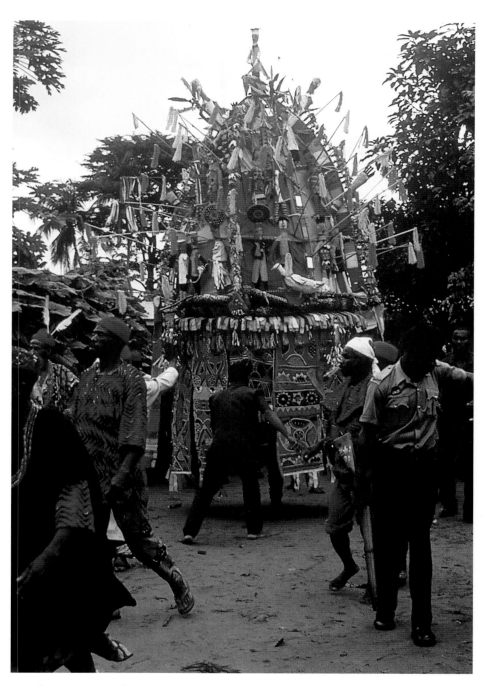

9-28. *IJELE* MASK AT AN IGBO SECOND-BURIAL CEREMONY, ACHALLA, NIGERIA. 1983

In its dazzling complexity and size, an ijele *combines most of the important or "root" symbols of Igbo thought either explicitly (images of elephant, eagle, leopard, python) or metaphorically (great sheltering trees with flowers and fruit, high human status and titled leadership, ancestor veneration, spirit anthills and their abundance, wealth and the richness of nature and everyday life). Foreign ideas and materials too, so readily embraced by the Igbo, are present in mirrors, imported cloth, images of colonial officers, and the horseman (or, recently, an airplane) that surmounts most* ijele.

an important person dies in this region it is said that "a mighty tree has fallen." Trees provide many human needs, from building materials to edible fruit, and as "trees of life" they are prominent symbols of growth. An *ijele* is usually anthropomorphized, with a stylized face on one of its panels and two large arms projecting outward from the tree. In this guise, *ijele* is a great ancestral spirit who has emerged from an anthill to honor the deceased elder, to welcome him to the land of spirits. *Ijele* has a dozen or more black and white "eyes," called "danger," that recall the multifaceted eyes of insects. It is as if the many watchful eyes of the spirit world are there to survey the living human community.

Ijele are such strong magnets for crowds that they have recently been commissioned by politicians, who hire maskers to dance them expressly to rally supporters. The symbolic presence of *ijele*, then, has changed, yet they retain commanding powers in contemporary Nigerian life.

SHARED THEMES IN LOWER NIGER ARTS

In addition to their own distinctive art forms, two of the largest ethnic groups of the lower Niger, the Edo of Benin and the Igbo, have several important forms in common, which they share as well with many smaller neighboring groups such as the Ibibio, the Ijaw, the Urhobo, the Isoko, the Igala, and the northern Edo Okpella. These shared forms include personal shrines or altars, light/dark mask complexes, and hierarchical groupings of figural sculpture.

Personal Altars

Men among several ethnic groups commission (or used to commission) personal altars, to be dedicated and consecrated to their personal strength, success, and accomplishments, and sometimes as well to their protection. Warriors, farmers, traders, smiths, and others prayed and sacrificed to these altars before important undertakings, offering further gifts after meeting with success (or sometimes berating the altar after failure). The Igbo, who have the greatest numbers and most variable forms of personal altars, call them *ikenga*, the Igala know them as *okega*, and among the Edo of Benin the term is *ikengobo*. That these names are cognate virtually proves a historical relationship, even if scholars are uncertain which of the three groups originated the idea.

Personal altars among these three groups are dedicated to the hand, specifically the right hand (and arm) among the Igbo and the Igala. Strong hands and arms are agents of physical prowess, necessary for success in such activities as hunting, farming, and warfare. The iconography of many altars reflects these associations. Igbo *ikenga*, for instance, typically show a horned warrior holding a knife in his right hand and a human trophy head in his left, symbols probably established long ago when the Igbo were active head hunters (fig. 9-29). Similar iconography appears in some Igala *okega*, although the one shown here, like many Igbo examples, depicts only a horned head above a geometrically abstracted, spool-like body (fig. 9-30).

Sharp horns are the most essential feature of Igbo and Igala altars to the hand. Some are straight, others are

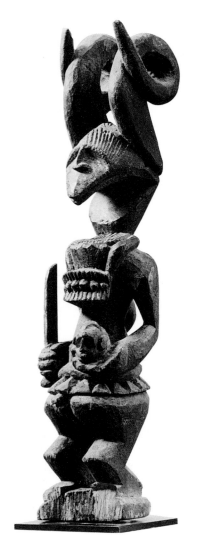

9-29. *Ikenga* (personal altar). Igbo. 20th century. Wood, height 19½" (49.53 cm). The Metropolitan Museum of Art, New York. Gift of John H. R. Blum

spiral, still others are fancifully curved and elaborated with perching animals. All are commonly referred to as ram horns, even though they often do not resemble them. Yet since virtually all animal horns are power symbols, an identification with a specific animal hardly seems imperative, for it is animalistic aggression in general that is evoked.

A richly figured, texturally sumptuous, cast copper-alloy *ikengobo* from the court of Benin includes depictions of right and left hands in its lower zone, where they alternate with the heads of miniature leopards and cows, the latter sacrificed to help insure success (fig. 9-1). The figures depicted in relief on the side of the altar, as well as the three that crown its top, depict the king flanked by attendants, a typical motif from this culture's courtly tradition, which repeatedly emphasizes the centrality of its ruler.

Lesser Benin chiefs and ordinary men also used to commission *ikengobo*. These were generally carved of wood, although several cast metal examples are known. Most are crowned with a spike on which an elephant tusk was almost certainly displayed, echoing again the theme of the animal horn familiar from Igbo and Igala examples.

Among the Isoko and the Urhobo, Edo-speaking peoples living south of Benin, personal shrines prominently display the horns and teeth of imaginatively conceived (and unidentifiable) quadrupeds. These altars, both called *ivri*, explicitly merge human and animal imagery. In Urhobo altars, the animal is often dominant (fig. 9-31).

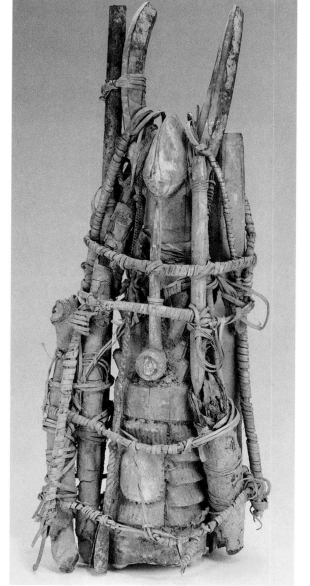

9-30. *OKEGA* (PERSONAL ALTAR). IGALA. EARLY 20TH CENTURY. WOOD, FIBER, PIGMENTS, KAOLIN, STRING, IRON; HEIGHT 24½" (62.2 CM). NATIONAL MUSEUM OF AFRICAN ART, SMITHSONIAN INSTITUTION, WASHINGTON, D.C.. GIFT OF ORREL BELLE HOLCOMBE IN MEMORY OF BRYCE HOLCOMBE

This particular okega *retains the heads of some animals that were sacrificed to it. The heads were probably lashed on to advertise and increase the altar's powers.*

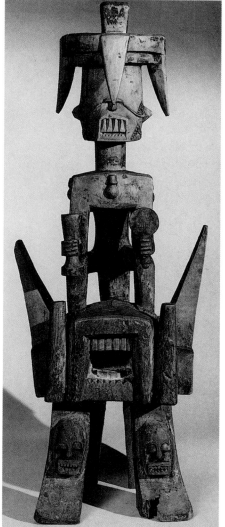

9-31. *IVRI* (PERSONAL SHRINE). URHOBO. 20TH CENTURY. WOOD. THE BRITISH MUSEUM, LONDON

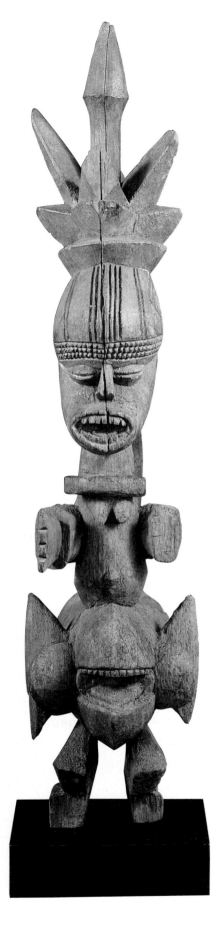

9-32. *IVRI* (PERSONAL SHRINE). ISOKO. 19TH–20TH CENTURY. WOOD, HEIGHT 28" (71.1 CM). THE WALT DISNEY–TISHMAN AFRICAN ART COLLECTION

Here the animal prevails because of its size, whereas the comparatively larger human dominates the animal in the stunning Isoko example shown in figure 9-32, a masterful composition whose sculptural power is appropriate to its (former) job as a protective, aggressive combatant for its owner. The teeth and horns on these images—sharp, bared, and exaggerated—signal their pugilistic purposes. Both carvings are symmetrical on the vertical axis. The Urhobo *ivri* is weighted and more stable on its animal base, whereas the Isoko figure, built up as a rhythmic series of bulges and constrictions from bottom to top, points upward and almost seems to soar.

Light/Dark Masking: Beauties and Beasts

The discussion of Igbo masquerades earlier in this chapter stressed the complementary opposition of light and dark masks and their associated qualities. Nearly all the neighbors of the Igbo also have versions of this light/dark, beauty/beast masking concept, yet it is uncommon beyond this area. Clearly these varied manifestations represent shared historical traditions, probably of considerable antiquity. Each masquerade has its own characteristics and nuances of both form and meaning, however, often indicating many decades or perhaps a century or more of separate,

local development. The density and multiple variations of the theme in Igboland, as well as occasional oral traditions, suggest the Igbo as the originators, but this is far from proven in all cases.

Apart from the many Igbo variations, the clearest examples of this theme are *ekpo* masks of the Ibibio, a rather small population southeast of the Igbo. *Ekpo* is the Ibibio word for "ancestor," as well as the name of the principal masking society, its masks, and the dances that commemorate the deceased. White- or yellow-faced masks, *mfon ekpo*, come out during daytime second-burial festivities honoring the recent dead, and also at annual agricultural festivals (fig. 9-33). Their dances are slow and graceful, with costumes made of many bright-colored cloths. Considered good and beautiful, *mfon ekpo* masks embody the souls of people whose lives on earth were productive and morally unblemished. These are not named ancestors, but rather the collective community of souls whose positive influence is welcome among the living. Complementing these in form and concept are the more numerous black *idiok ekpo*, representing corrupt, amoral, ugly, and evil souls sentenced at death to perpetual ghosthood (fig. 9-34). They appear only at night, well after the pretty masks have retired. Costumed in unruly hanks of black-dyed raffia, they dance erratically, at times with deliberately wild movements, to inspire terror in those they encounter. Some shoot arrows, apparently quite randomly, as if to reinforce their reputations as unreliable, capricious spirits. Many dark Ibibio masks have skillfully carved, distorted facial

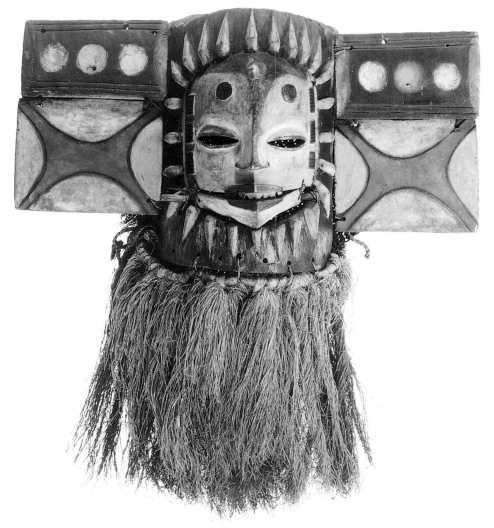

in the diverse masquerades of the Okpella peoples, Edo speakers who live north of Benin and northwest of the Igbo. Here, in fact, we have direct evidence of Igbo influence in the person of a mask carver and costume tailor who came into the Okpella area from the Igbo–Igala borderland around 1920. He introduced several forms and ideas that became localized over time, mixing them with preexisting mask traditions, some of which also originated among other peoples.

The influence of Igbo originals can be seen on both sides of the Okpella beauty/beast opposition. Appliqué body suits with crested cloth masks, as well as wood masks, often but not always white, with carved hair-crests and superstructures featuring

9-34. *Idiok ekpo* (dark mask). Ibibio. 20th century. Wood, height 11″ (28 cm). Fowler Museum of Cultural History, University of California, Los Angeles

9-33. *Mfon ekpo* (light mask). Ibibio. Before 1915. Wood and pigments; width 20″ (51 cm). Field Museum of Natural History, Chigago

features, sculptural exaggerations that parallel their behaviors. These grotesque faces are interpreted as advanced states of disfiguring tropical diseases such as yaws, leprosy, and ulcers. Such punishing deformities, people are told, await those who willfully or continually violate the moral codes on which orderly society is based.

The symmetrical balance and relative naturalism of *mfon ekpo* contrast markedly with the expressive distor-

tions and asymmetrical twists of many dark *idiok ekpo*. Unfortunately, detailed information on the full range of names and meanings of light and dark Ibibio masks is lacking. The variety of forms in the surviving corpus of masks suggests that a broad spectrum of human and animal spirits is represented. Many examples are beautifully carved.

More is known, on the other hand, about beauty/beast oppositions

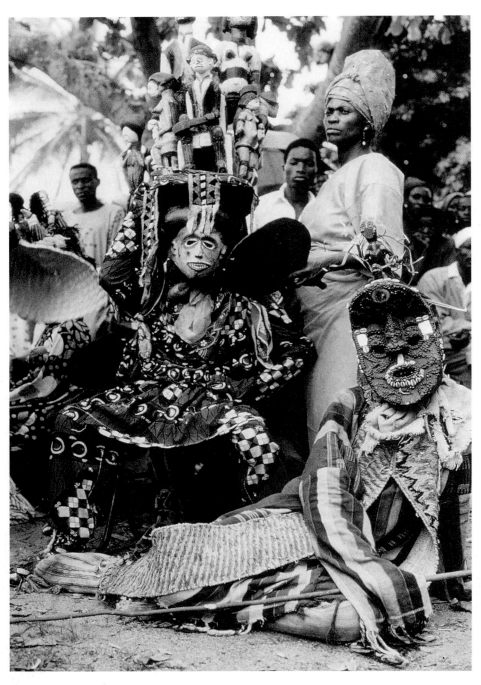

9-35. OKPELLA "DEAD MOTHER" (LEFT) AND *ANOGIRI* (RIGHT) MASKS IN PERFORMANCE,
OKPELLA, NIGERIA. C. 1973

*Crested masks such as the one on the left embody "dead mothers." They are
commissioned and owned by Okpella women and take women's names. Though they are
danced by men, women accompany them. The older women who own and sponsor these
masks take expensive festival titles and are inducted as members of the largely male
masking society. They are powerful and usually quite wealthy. After a woman dies, her
mask is still danced to commemorate her useful, productive life, and it continues to bear
her name.*

multiple figures appear on the "beauty" side of the equation (fig. 9-35). Such masks recall the maiden masker called Headload and her sisters, among other Igbo forms (see fig. 9-25). On the "beast" side is the large bush-beast mask called *idu*, with several horns, large snaggle teeth in a rough face, and a costume of seed-pods bristling with quills (fig. 9-36). Clearly *idu* is a variation on the Igbo *mgbedike* (see fig. 9-26). A local Okpella grotesque mask, not of Igbo origin, is *anogiri*, a festival herald. Visible at the right in figure 9-35, *anogiri* is a dark, often misshapen mask decorated with seeds, cowrie shells, and mirrors. A single flat plane with a heavy overhanging forehead often serves for the face, and human features are minimally suggested.

The Edo peoples are most famous for the royal arts of Benin, discussed later in this chapter. Yet Edo villages outside Benin city and its court have long had art forms linked with cults and shrines dedicated to nature spirits, heroes, and ancestors. These are of local and non-royal origin, and in fact many of them came to prominence partly because they opposed and criticized the imperial power of Benin kings, whose persisting efforts to dominate and extract allegiance and tribute from outlying villages understandably aroused resentments.

The Ekpo masking society and cult found in many Edo communities to the east and south of Benin city was founded during the eighteenth century or before by a strong village chief and warrior, a rival of the king of Benin. There had been a debilitating outbreak of infectious diseases, and it was believed that they had

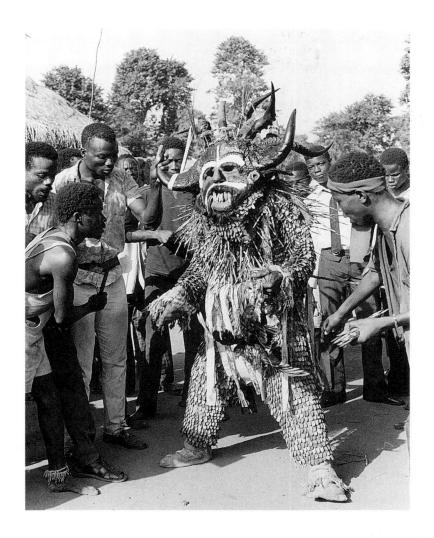

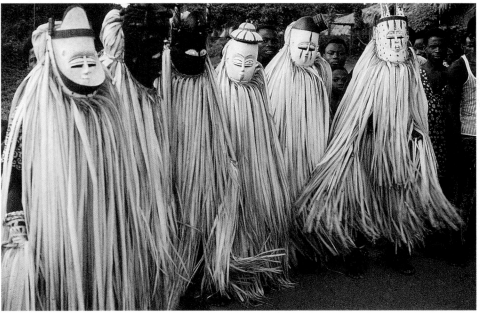

been caused by the Benin king's witchcraft. In a dream, the chief envisioned his late grandmother as a masker curing his people. The dream provided a model for the Ekpo shrine and masquerade. The chief ceased waging war to concentrate on healing, which was successful thanks to the shrine, its masking spirits, and the sacrificial and purifying rites they brought about. Viewed as effective, the masking cult was exported to other communities. (Note that the Edo Ekpo cult is distinct from the Ibibio society of the same name discussed above.)

The photograph in figure 9-37 shows six Ekpo maskers. The two black masks represent the chief who founded the cult (third from the left) and a local doctor. The color black here manifests varied sorts of power: physical, magical, medicinal (for healing and warfare). In some rites these dark masks, clearly male, act as flanking supporters of a taller, chalky white, two-faced mask called "mother of

9-36. OKPELLA *IDU* MASK IN PERFORMANCE, NIGERIA

9-37. EDO EKPO MASKERS, AVBIAMA, BENIN REGION, NIGERIA. 1967

The Ekpo masquerade is the province of warrior age-grades, vigorous men who sometimes fought for the Benin king and yet had ambivalent feelings about his great power. So while the masquerade expresses a number of royal ideas, it also stands in opposition to courtly imperialism. Partly for this reason, presumably, the masquerade is not allowed to perform in Benin City.

9-38. BINI (EDO) *IYEKPO* ("MOTHER OF EKPO") MASK. DRAWING AFTER PAULA GIRSHICK BEN AMOS

Ekpo," *iyekpo* (fig. 9-38). The most senior mask in Ekpo, it commemorates the founder's grandmother. Together, the three senior masks—the two black masks and *iyekpo*—express the main concerns of the Ekpo cult: healing disease, ritually purifying the community, and assuring abundant human fertility. The other white masks in figure 9-37 represent a benign chief, a helpful white man (a district officer), a policeman, and a leopard. The role of the leopard is to scare away disruptive evil forces. Additional Ekpo masks that may appear on other occasions include Olokun (Edo god of the sea), various chiefs, a horned animal, and a handsome man. Clearly the white masks here are not all female, yet they seem to have been whitened as an expression of the goodness and beauty of their characters. For the Edo (as for the Igbo and Ibibio), white chalk symbolizes goodness, beauty, abundance, and health, and as such it figures strongly in Ekpo rituals. Pregnant women praying for a safe delivery and barren ones begging for children bring white chalk to *iyekpo*, for example, who places it within the shrine as a gift.

Light/dark, beauty/beast masking is both more complex and more widespread than this brief overview may suggest. Ethnic groups not surveyed here, such as the Ogoni, the Igala, and the Idoma, have their own variants, and the traditions of the Ibibio, the Okpella, and the Bini are richer and more nuanced than their presentation here has been able to convey.

Hierarchical Compositions

Many African arts, indeed many world arts, have developed conventions for conveying social, political, or spiritual hierarchies (see, for example, the discussion of hierarchical proportion in ancient Egypt, page 51). The arts of the lower Niger are interesting in that several cultures share the same compositional strategy for showing hierarchy, creating figural groups that are triangular, symmetrical, multi-unit, detailed, and heraldic. These hierarchical groupings, moreover, all make analogous ideological statements and seem to be related to one another on spiritual, psychological, and economic levels as well. Each features a magnified, exaggerated, weapon-bearing central figure with an enlarged head, who is clearly a leader. He or she is flanked by two or more smaller supporting people, some of whom may be brought forward or pushed back in space. The central leader is largest in scale, reflecting his or her spiritual and ideological focus as either a sacred king, a strong deity, or a revered ancestor. Receding three-dimensional space is implied, and is often made explicit.

Looking back through this chapter, this composition can be seen in the central sculptural groupings of Igbo *mbari* houses, where the goddess Ala is shown flanked by her smaller "children" (see figs. 9-20, 9-21). The composition appears again in *ikengobo* from the Benin court, where the king, depicted in full round on the top and in relief on the side, is flanked by smaller attendants (see fig. 9-1). The composition is implied as well in the Ekpo masquerade of the Edo, where the white "grandmother" mask may appear flanked by the two black masks, next in rank (see figs. 9-37, 9-38). Later in this chapter, the composition can be seen again in the Kalabari ancestor screen (see fig. 9-47) and implicitly in the photograph of the king of Benin,

whose royal costume purposefully enlarges him, giving him visual prominence over his flanking courtiers (see fig. 9-50). Many more examples could be culled, both from within the cultures treated in this chapter and from other neighboring peoples not discussed here.

While it may never be proven that these compositions are historically related, their geographical proximity to Benin, and the power of this kingdom, where such groups recur in widely varying situations, strongly suggest a single original source: Benin. Such commonality does not, of course, preclude separate meanings. While all these compositions have spiritual dimensions and represent people of wealth and stature who command an entourage, those from Benin are strongly political, while Igbo *mbari* groups, which take the domestic family as their model for a revered deity, link the social and spiritual. Kalabari screens seem to lie between the two others, combining family and political references.

IBIBIO MEMORIAL ARTS

Ibibio Ekpo masquerades, touched on above (see figs. 9-33, 9-34), may appear publicly to commemorate deaths of prominent persons. Two other, less transient Ibibio arts that also memorialize the dead are figures sculpted of cement and pictorial cloths called *nwomo*. Both art forms appear to have developed during the twentieth century, with *nwomo* probably the earlier practice.

Nwomo were hung as "facades" on shrines erected during second-burial rites, which occurred as long as three years after interment (fig. 9-39).

9-39. Ibibio *NWOMO* (FUNERARY CLOTH), Nigeria. c. 1973

They were created for an elite clientele, prominent male members of a warrior society. Sewn by professional male artist-tailors, the cloths usually depict the deceased person and members of his family in festive dress, carrying prestige objects. Although the earliest *nwomo* cloths appear to have been painted, as were the interiors of the earliest shrines, most known *nwomo* cloths were pieced together from industrially woven cloth. They are often multicolored, although red, black, and white are normally stressed. The images are sewn to a background cloth of contrasting color so that they stand out boldly when viewed from a distance. The skulls of animals sacrificed during the opening festivities were hung from the structure itself or a fence in front of it, and within the shrine were placed the gun and some clothing and household goods of the deceased, as if to add to the "portrait" implied by the *nwomo* motifs.

For much of the twentieth century, cement sculptures have honored the gravesites of respected Ibibio men and women, a broader public than was served by *nwomo*. Since the 1950s and 60s, they have been erected in increasingly large numbers, largely supplanting the *nwomo* tradition. In part this is because Christian sects banned *nwomo* while encouraging the cement works, which are modeled to some extent on European graveyard sculpture. Some cement figures are set in open enclosures rather like *nwomo*, while others are conceived as freestanding monuments, often raised on pedestals. Though they were often inscribed with the name and dates of the deceased they commemorate, most have until recently depicted generalized humans, without

9-40. MEMORIAL FIGURE, UYO IBIBIO, NIGERIA. SUNDAY JACK AKPAN. C. 1984. CEMENT AND OIL PAINT; HEIGHT C. 50" (1.27 M)

individualizing detail. Since the 1970s, however, the artist Sunday Jack Akpan (born c. 1940) has led a movement toward highly realistic, imitative portraiture (fig. 9-40). Working from photographs and using imported cement and commercial oil paints, Akpan and others are following a trend toward closely observed naturalism also evident elsewhere on the continent. During this recent period, contemporary African arts finally began to reach an international audience. Akpan's work, for example, has been featured in both European and American exhibitions.

ORON ANCESTRAL FIGURES

The Oron, a relatively small clan related to the Ibibio, produced a striking series of hardwood sculptures to commemorate their ancestors (fig. 9-41). Presumably carved by a number of artists and over several decades mostly before 1900, the figures are varied, yet they subscribe to a consistent set of conventions. The human form is presented along a strong vertical axis. Some body parts, such as heads, beards, and torsos, are emphasized by exaggeration, while others, such as legs, are minimized or reduced. Most figures hold their beards or a status implement such as a horn, and most have hats. The carving of these figures apparently ceased around 1900, but sacrifices have been continually offered to the group, assembled in a sanctuary called *obio*, twice annually. Regrettably, several figures were stolen from the site in the 1970s, after this field photograph was taken.

9-41. ORON COMMEMORATIVE FIGURES, NIGERIA

KALABARI IJAW FESTIVALS AND MEMORIAL ARTS

The Kalabari Ijaw peoples, fisherfolk and traders who have lived for centuries in the mangrove swamp lowlands of the eastern Niger delta, have various art forms that bear the imprint of their long exposure to European ideas and materials. Prominent features of Kalabari society are corporate trading houses, also known as canoe houses. Led by strong chiefs, these houses have traditionally assimilated outsiders (slaves and members of other ethnic groups) as well as cultural patterns from outside the delta region.

Kalabari festive dress, for example, includes Igbo and Yoruba textiles along with a number of European garment types and artifacts such as shirts, hats, walking sticks, and mirrors (figs. 9-42, 9-43). Few sartorial ideas are adopted wholesale. Rather they are adapted and reworked, especially in their combinations and color schemes.

The Kalabari accord extraordinary cultural value to cloth, even though, or perhaps because, they do not weave their own. Family wealth is measured in part by the numbers and "depth" of heirloom cloth boxes, which contain literally hundreds of textiles imported from within and beyond Africa. Funerary commemora-

tions are occasions for displaying family riches and good taste in cloth and the accessories of dress, both as worn by mourners and as displayed in the house of the honored dead person. Rooms and the beds within them are decorated with elaborate, sumptuous textile ensembles, arranged by the women of the deceased person's family (fig. 9-44). Some displays are sculptural and abstract; some may form an anthropomorphic tableau together with jewelry, a hat, and other accessories. Guests at these funerals comment on cloth juxtapositions and qualities, and their aesthetic judgments have much to do with the reputation of the family in question. It could almost

9-42. KALABARI IJAW MEN IN FESTIVE DRESS, AMABRO, NIGERIA

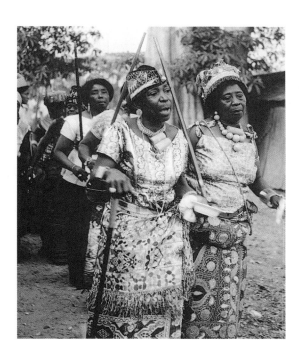

9-43. Kalabari Ijaw women, Buguma, Nigeria. 1967

be said that imported cloth rules the Kalabari aesthetic system.

In addition to processions of variously dressed groups of mourners and visitors, funerary festivals mounted for prominent Kalabari persons also feature water-spirit masquerades favored or danced by the deceased person's family. Masking is the province of the male Ekine society, also known as Sekiapu, "the dancing people." Water spirits are believed to control the rivers and estuaries, and thus both fishing and trading, as well as creativity and innovation. The spirits, materialized by masks, are invited into the community during funerals both to honor

9-44. Kalabari Ijaw funerary textile display in the "jellyfish" pattern, Buguma, Nigeria. 1983

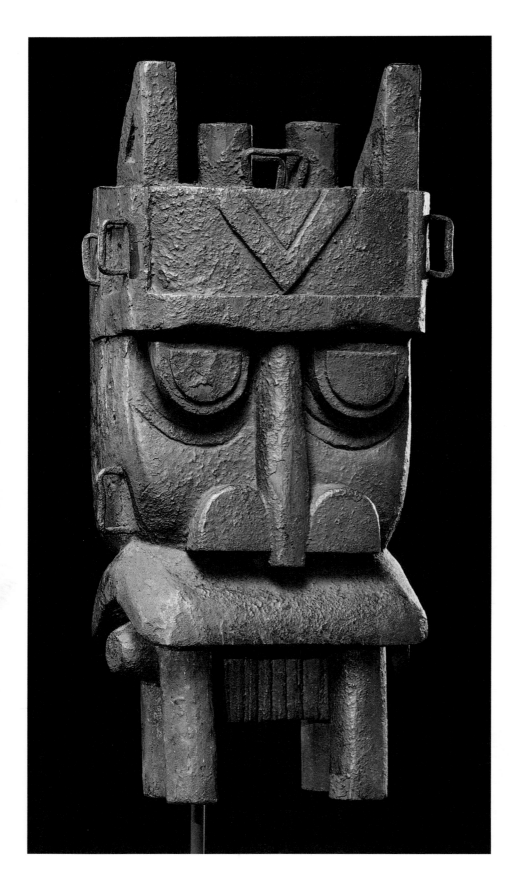

9-45. *Otobo* mask. Kalabari Ijaw. 19th–20th century. Wood, pigment, and encrustation; height 18½" (47 cm). Collection of Raymond Weilgus

them directly and to honor the deceased. Several dozen water-spirit mask characters exist, so many in fact that it takes fifteen to twenty-five years for all of them to manifest themselves in the community, as only a few appear at each annual festival. (Funerary festivals are separate events.) Some are culture bringers, others legendary heroes, still others the spirits of animals—crab, tortoise, crocodile, shark—that populate the environment.

One mask, called *otobo*, formally a loose interpretation of a hippopotamus head, is actually a composite spirit, for it mingles animal and human features (fig. 9-45). In performance, *otobo* is worn on the top of the dancer's head, facing the sky. The costume again dramatizes the importance of cloth, which is believed to be one of the gifts of the water spirits to the Kalabari people. Although we may admire the buildup and play of geometric forms in an *otobo* mask when it is displayed frontally as a sculpture in a museum setting, this is notably an outsider's point of view. The Kalabari neither ascribe beauty to such forms nor do they make them very visible to dance audiences. Many masks or headdresses in performance are obscured by feathers or raffia, or are oriented to the sky rather than the audience. More important to the local viewing public is a masker's skill in dancing and gesturing, his virtuosic

responsiveness to subtle changes and signals in the music that drives and gives meaning to the performance. Dancing skill, not carving, is appreciated and discussed in aesthetic terms by the Kalabari, as are cloth ensembles.

It is the animated quality of a masquerader in motion that the contemporary sculptor Sokari Douglas Camp (born 1958) so convincingly evokes in her welded steel sculpture (fig. 9-46). Camp, a Kalabari woman who grew up in the delta region and now resides in London, recreates several Kalabari cultural forms in her work, returning often to images of the vibrant, dynamic masquerader. Working in metal enables her to capture a masker's airy, spatially activating essence. She freezes action in mid-motion with light openwork. She plays with wavy cloth and other projections, creating a delicate equilibrium between form and the space it enlivens. As an artist working in metal who creates masqueraders from a culture where only men make sculpture and dance masks, Camp is something of an anomaly among her own people, yet both the artist and her art are embraced today in international art circles. Ironically, perhaps, the Kalabari people themselves have never accorded either sculptors or their products much respect.

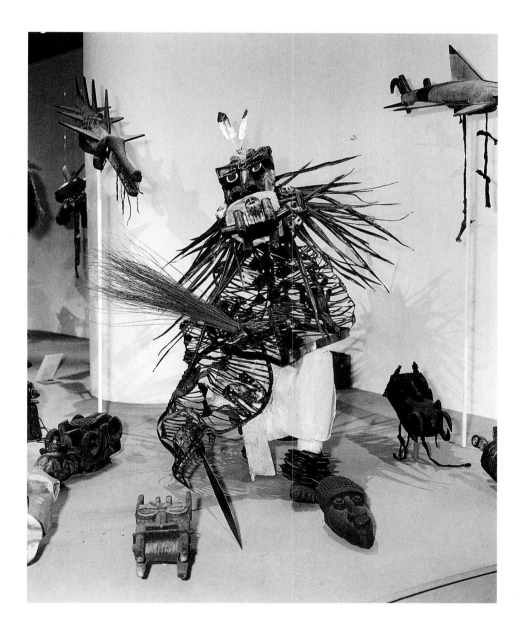

9-46. *OTOBO MASQUERADE*. SOKARI DOUGLAS CAMP. 1993. WOOD, STEEL, PALM-STEM BROOMS; HEIGHT 6' (1.83 M). SEVERAL WOODEN MASKS OF THE KALBARI AND OTHER NIGER DELTA PEOPLES ARE DISPLAYED AROUND CAMP'S SCULPTURE. THE BRITISH MUSEUM, LONDON

9-47. *NDUEN FOBARA* (ANCESTRAL SCREEN). KALABARI IJAW. WOOD, SPLIT VEGETABLE FIBER, PIGMENT, TEXTILE, FIBER; HEIGHT 45½" (1.16 M). THE BRITISH MUSEUM, LONDON. DONATED BY P. A. TALBOT

The work is constructed of many individually shaped wood parts lashed, pegged, nailed, and stapled together, creating a densely textured surface which was then painted. Ritually consecrated and placed in the meeting room of a trading house, ancestral screens are visible points of contact between the house's living members and those revered men who continue to influence life from the afterworld.

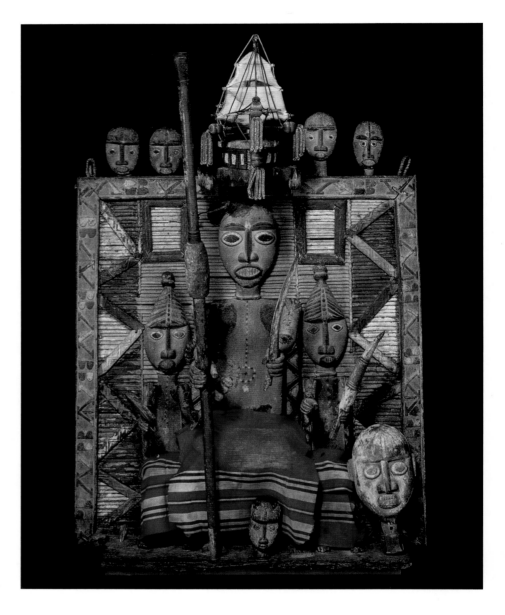

Another form of Kalabari Ijaw sculpture much appreciated outside of Africa is the ancestral screen, *nduen fobara* (fig. 9-47). A *nduen fobara* commemorates the deceased chief of a trading house. The chief is depicted at the center, flanked by smaller images of his attendants. Carved trophy heads of conquered rival chiefs sit at the base of the rectangular screen, while heads representing house retainers or slaves are attached to its top. The chief's facial features are subject to the same conventionalized rendering as the heads of retainers or enemies; trading house members know who is represented in each screen, so naturalistic renderings are quite unnecessary. Chiefs are partly individualized, on the other hand, by the prestige and power implements they wield, here a silver-topped trader's staff and a curve-bladed knife, and by the masquerade headdress they wear, which evoke the water spirit they identified with (or actually danced). The headdress here is proba-

bly the one known as "white man's ship." A model of a nineteenth-century European sailing vessel of the sort that came to the delta region, the headdress implies successful trading. Outside contact is seen too in the rectangular, framed form and pieced construction of the screen itself, which are probably adapted from European conventions and techniques, while its hierarchical composition may have been influenced by the arts of Benin.

BENIN: SIX CENTURIES OF ROYAL ARTS

The kingdom of Benin became centralized during the thirteenth or early fourteenth century under a dynasty that is now considered mostly legendary. It was further consolidated under a second dynasty, founded from the Yoruba city of Ife by a prince named Oranmiyan (see page 229). This second dynasty, which is believed

310 CENTRAL AFRICA

to date to the late fourteenth century, continues to the present day. During the fifteenth century Benin became an imperial power, conquering several neighboring peoples and extending the borders of her empire in several directions. In part with the help of the Portuguese, who established relations beginning in 1485, the empire reached its greatest geographic extent during the sixteenth century.

Viewed as sacred, the king, *oba*, of Benin is at the ideological center of Benin culture, even today, just as his palace is at the geographical center of much of the Edo-speaking world. Most Benin art forms feature the king and, secondarily, his court officials, chiefs, warriors, or musicians. The king is also the principal patron of the arts, and oral histories remember specific kings in part for the sorts of art objects they introduced.

While some archaeology has been conducted, the art of Benin survived primarily through its continuous residence in the royal palace and in chiefs' houses. Its presence today in museums and private collections in Europe and the United States is a result of the notorious events of 1897. In January of that year a British officer wanted to visit the king in Benin City during a period when he was offering sacrifices to his ancestors. Deeming a visit at this time inauspicious, chiefs warned the officer to stay away, to return later. He pressed on, however, and as he neared the city warriors ambushed and killed him and most of his party. The British navy quickly retaliated with an attack known as the Benin Punitive Expedition, which destroyed or burned much of the palace and city, looted and exported thousands of art objects, and

exiled the king (see fig. ix). In 1914 the king's son was allowed to restore the monarchy and to begin rebuilding the palace. The art was not returned, however, and Benin as an empire was a thing of the past.

The arts of the Benin court have been active instruments and more passive mirrors of leadership, ritual, belief, policy, and propaganda for over five hundred years. Interpretations of the place of art in the worldview and belief system of Benin, and of this art's historical and stylistic changes, are the focuses of this section. The very extensive literature on Benin art and culture, the corpus of several thousand known works of art, and this art's historical

depth, all militate against any one interpretation being definitively true, and the interpretations offered here are similarly tentative.

Art, Ideology, and the Benin World

The map on page 167 indicates both the extent of the Benin empire during the sixteenth century, the time of its greatest territorial reach, and the location of the capital city, also called Benin, roughly at its center. A seventeenth-century Dutch engraving gives a view of the city at this time, showing several steepled buildings within an enclosing palace wall (fig. 9-48).

9-48. *The City of Benin*, engraved illustration to Olfert Dapper, *Naukeurige Beschrijvinge der Afrikaenshe Gewesten* (Amsterdam, 1668)

Leopards, chained and controlled by handlers, lead a state procession. The king appears near the center, elevated on horseback amid royal musicians and dwarfs. According to the Dutch text that accompanies the engraving, he is followed by some four hundred chiefs and warriors, some mounted, others on foot.

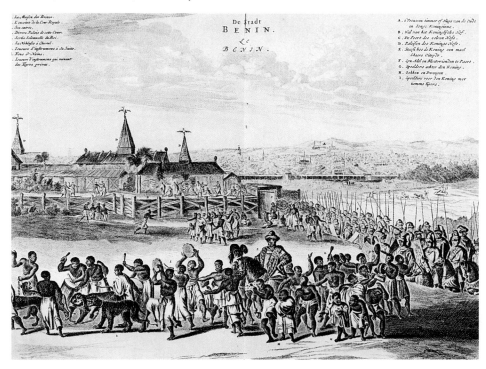

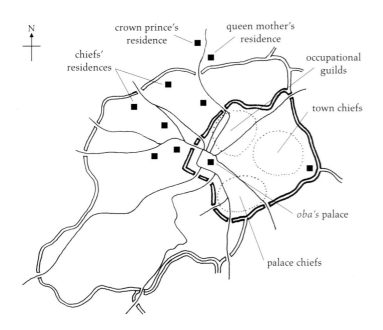

N

crown prince's residence

queen mother's residence

chiefs' residences

occupational guilds

town chiefs

oba's palace

palace chiefs

hoop skirt creates a wide conical base, expanding him to monumental size, as befits a divinity. His headdress points upward to the celestial realm while adding height to the regal image. The result is a living version of the hierarchical composition notable in such art objects as the *ikengobo* discussed earlier (see fig. 9-1). The seventeenth-century procession depicted in the engraving in figure 9-48 also stresses the monumental nature of the *oba*, shown elevated on horseback and wearing a voluminous costume.

The king is also at the center of his world viewed as a vertical continuum, for he and his visible earthly palace stand between the sky world of Osanobua, the remote creator god, and the underworld of ancestral and other spirits, including powerful Olokun, god of waters, wealth, and fertility. As seen in figure 9-48, the palace turrets, vertical transition points where the terrestrial realm touches the celestial, are pyramidal, a stable form that evokes the mass of

A plan of Benin City prior to its sack in 1897 in turn shows the palace at the center, surrounded on most sides by the compounds of lesser chiefs, craftspeople, and other court members (fig. 9-49). The map and the plan, both of a roughly concentric design, bear out Benin ideology. In Benin thought, the sacred king is the center point. From him, a sequence of circles radiates outward. The first circle includes his chiefs, protectors, and supporters; the next embraces guilds of craftspeople and artists. Next are villages that pay allegiance and tribute. Farther out still are hostile or enemy peoples, and beyond these are the unknowable realms of the gods, imagined by the Edo as coextensive with the ocean which they believe encircles their world.

In processions and other ceremonies, the *oba* is central among his court members, flanked by, with his arms often supported by, designated titleholders (fig. 9-50). He is transformed by his costume and regalia into a work of art, a walking pyramidal

assemblage of symbolic materials and emblems. He wears cloth woven by his weavers' guild and embellished with many regal motifs. His tunic and headdress are fashioned of coral beads, his armlets of ivory. His

9-50. OBA AKENZUA II (RULED 1933–78) IN REGALIA, BENIN CITY, NIGERIA. 1960S

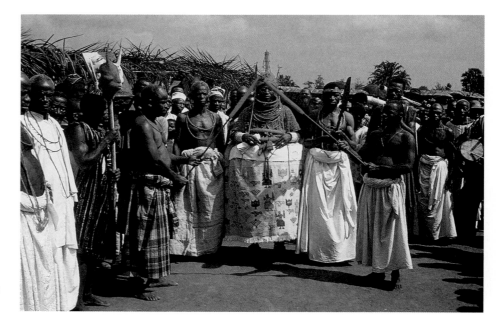

the *oba* in his ceremonial regalia. Both shapes recall a segment of the *igue* ceremony, an annual rite dedicated to purifying and renewing the king, when an official attempts unsuccessfully to physically move the seated *oba*. Symbolically, both the person and the office are to be seen as unshakable. During *igue*, the sacred king is both proven to be enduring and reenergized so that he, and his kingdom, can carry on.

The pyramidal shapes of steeples and king appear to be linked symbolically to the towering termite hills found in this region of Africa. One of the king's praise names is "Anthill," an allusion to his mysterious, fertile, and impregnable nature. In Benin belief, as in the belief system of the Igbo discussed earlier, anthills are held to be numinous and spiritually powerful. Their sundried, cement-hard clay is a metaphor for the king's invulnerability. Long snakes of cast copper alloy were affixed to the sides of palace turrets (although not shown in the engraving in figure 9-48, they are documented in photographs of the palace taken just after the British raid, see fig. ix; one is depicted on the plaque in figure 9-51). At the top of each steeple stood a figure of a bird with outstretched wings, also cast in a copper alloy (several of these can be seen in the engraving in figure 9-48; a bird, since broken off, was originally depicted atop the turret on the plaque in figure 9-51). The roof snakes undulate downward, as if connecting the bird's sky-world with the king's earth. Anthills connect the earthly world with the land of spirits, as does the king, perhaps with snakes as messengers.

The identity of both the snakes and the birds is uncertain. Most scholars refer to the snakes as pythons; a few believe them to be puff adders. The rock python, which occasionally reaches a length of thirty feet, is a more logical ornament for a large architectural element than the much shorter adder. Yet the Edo associate the adder with accumulating wealth, and wealth in Benin is accumulated by the king. Still another serpent, the red-lined snake, is often associated with the gentle deity Olokun because of its beauty, aquatic habits, and non-poisonous nature. Pythons too are considered beautiful and are said to be the rainbows that arc through

9-51. Plaque depicting architectural facade and figures. Benin. 16th–17th century. Bronze, 21 x 14" (53.3 x 35.6 cm). The British Museum, London

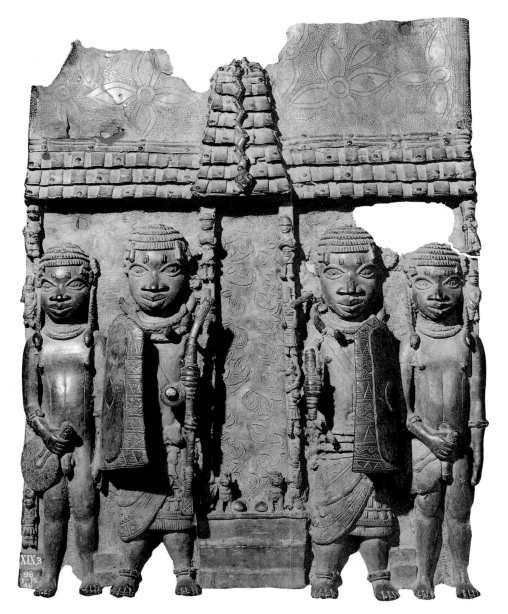

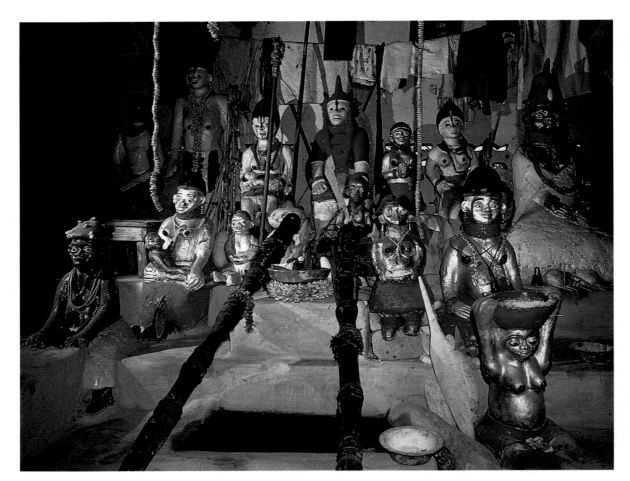

the sky, another phenomenon associated with Olokun. Clearly, different snakes enact various metaphorical roles. Benin artists were not always concerned with anatomical accuracy in their renderings, and their snakes may have stood for multiple species.

The birds, for their part, may well be fish eagles, emblems in Benin of high rank, achievement, wisdom, and dignity. These noble birds may be raised within the palace (as they are among the Oguta Igbo); they are sacrificed during *igue*, formerly along with a pair of leopards, considered kings of the wilderness. The bird is typically shown grasping a snake in its talons. The bird–serpent combat may be another instance of a motif distrib-uted widely in the world, often with cosmological implications. Here in the Benin palace, specifically because of the king's superhuman and mediating powers, "the snake and eagle meet— the world's foundations tremble," in the words of the English poet Percy Shelley, who was not referring, of course, to Benin iconography.

Anthill clay is employed in many rituals. It is among the mystical ingredients used, for example, to construct shrines to Olokun. The name *Olokun* means "owner of the ocean." He is the popular, benign god of childbirth, water, wealth, harmony, purity, and goodness. He is worshiped largely by women. His principal color is the white of chalk and cowrie shells, both given as offerings, both seen in abundance in his shrines (fig. 9-52). In the shrine shown here, the stepped platforms and some of the figural inhabitants are painted white; strings of cowries hang from the ceiling, while others adorn the platform and the offering bowl in front of the deity. Cowries, a form of currency in this region, stand for Olokun's wealth.

The reciprocity between Olokun and the Benin king is layered and complex. The red coral beads worn by the king were originally Olokun's. The fifteenth-century king Ewuare is said to have wrestled them away from the deity during the period when the Portuguese were in fact

trading them into the kingdom. The king's coral, part of his vast wealth, is said to be stored in Olokun's underwater palace. The deity's earthly shrines, like his image, imitate Benin royal precepts: hierarchical composition, an entourage of supporters, elaborate regalia, a rich palatial environment. The shrine figures are modeled by devotees from a combination of river mud, white sand, and anthill clay. In addition to a representation of the deity, shrine figures often include Olokun's wives, some with children, and his servants. As with his worshipers, more women than men are represented, for Olokun's special concerns are women's fertility and

productivity. In the shrine shown here, a coral-bedecked Olokun sits high on the left, while off to the right is an unusual, white-robed image of Osanobua, Olokun's father. Several figures in the shrine have been adorned with silver and gold pigments, as if to emphasize the god as a font of wealth and abundance.

Another ritual object may represent aspects of the ideological Benin world in both its horizontal and vertical aspects (fig. 9-53). This brass throne or stool is believed to have been commissioned by the eighteenth-century king Eresonyen; it is also said to have been modeled on a throne made by the Portuguese for Oba Esigie two centuries

earlier. Notably, the stool is reversible, consisting of two tops or seats (and therefore two bottoms) connected by a large snake, or two worlds mediated by a serpent. Its complex iconography calls out to be read as a visual text on Benin cosmology and thought.

The drawing in figure 9-54 reproduces the motifs from the top seat in figure 9-53. Since the two seats have different imagery, they probably represent distinct realms. The seat shown here seems to represent the earth, with sky references. Most objects in its central zone are products of human craft: state swords, blacksmith's tools, and two square forms

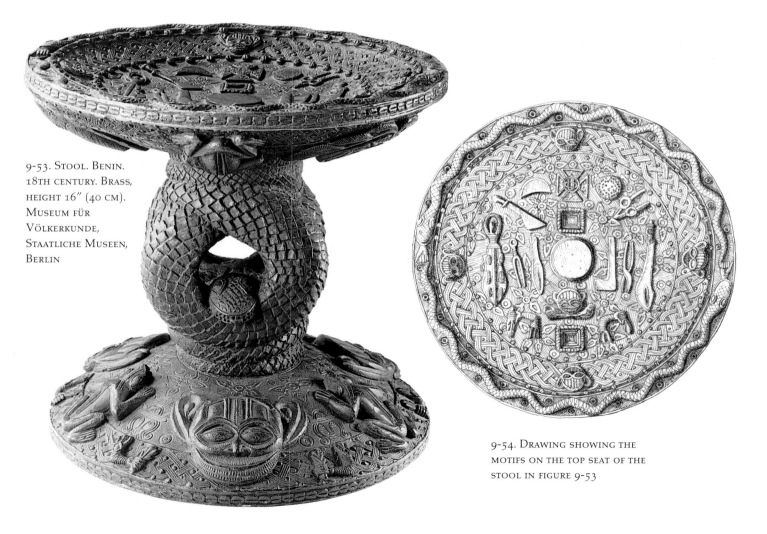

9-53. Stool. Benin. 18th century. Brass, height 16" (40 cm). Museum für Völkerkunde, Staatliche Museen, Berlin

9-54. Drawing showing the motifs on the top seat of the stool in figure 9-53

that may be miniature plan-view versions of compounds with interior courtyards (like those of the palace). These motifs signify the order of earthly civilization. The two elephant trunks ending in hands holding leaves may refer to *ikengobo* personal altars. Three symbols at the top appear to be celestial: a moon, a sun, and a four-lobed cross, a motif interpreted elsewhere as recalling the four phases of a day: morning, afternoon, evening, and night. The geometric interlace band surrounding the central zone features four monkey or chimpanzee heads, probably indicating the four directions, the four days of the Edo week, and the wilderness beyond civilization. The peripheral rim depicts two snakes that encircle the earth at its edge, keeping it separate from the mysterious surrounding ocean.

The other seat depicts either the underworld of spirits or the sea, abode of Olokun and other spirits. Motifs include crocodiles and mudfish. The undersides of both seats are also richly strewn with various motifs: a bound pangolin, frogs, fish, Portuguese heads, monkey heads, elephant trunks ending in hands, and a skull. Most could be references to various royal powers that derive from people or zones outside Benin City.

The central mediating snake, perhaps a messenger of Olokun and symbolic of the *oba*'s power, unites upper, earthly, and lower worlds. Possibly a python, the snake is more likely a puff adder, by virtue of its rough scales. As the throne's largest motif, a poisonous puff adder suggests again the power of the *oba* to take human life, as well as his rule over all realms, whether wild or civilized, seen or unseen. The puff adder has other

characteristics as well that make its symbolic identification with the king persuasive. It is a stout, slow, heavy creature that waits for its prey; food comes to it. It is placid, but with deadly venom. The *oba*, slow because weighted down by regalia, waits in the palace for tribute and visiting dignitaries to come to him. Indeed, before the twentieth century the king rarely left the palace. Thus the puff adder is a symbol of good luck and abundance and, specifically applied to the king, a metaphor for his ability to sit placidly, if grandly, inside the palace, where he receives precious goods, medicines, and tribute. The palace entrance is called "rushing gate" for precisely this reason. On this throne, it would seem, the coiled puff adder as king rests between his domestic world and the outside realms from which his riches and his sacred powers come.

Other readings of this elegant casting are certainly possible, for its meanings have not been clearly articulated to recent researchers by people from Benin. Indeed they may have forgotten aspects of its symbolism during the four or five hundred years since its form was first conceived.

Plaques

Prominent in the artistic legacy of Benin are brass plaques that depict various motifs and scenes in relief. Nearly one thousand plaques are known, many of them masterful lost-wax castings. Most plaques depict royals, chiefs, court members, warriors, musicians, and sometimes Portuguese men, who traded with and aided Benin in the late fifteenth and sixteenth centuries. Figures are usually modeled in high relief on a comparatively neutral,

textured background. They appear standing in a stiffly frontal pose, as if in a kind of ceremonial posture, with all the details of their regalia or dress carefully portrayed. Not many plaques appear to have any narrative content, although a few seem to record important historical events.

Scholars have suggested that the plaques served as mnemonic devices, recording the dozens of ranks and many ceremonies at the Benin court. They may indeed have done this, but probably as a secondary function. Their primary purpose appears to have been to embellish the pillars and perhaps the walls of the palace. Most plaques are dated to the sixteenth and seventeenth centuries, when contact with the Portuguese was intense. It was the Portuguese who brought quantities of metal used by the royal brasscasters' guild to make plaques and other court objects. Some scholars believe the rectangular plaque format to be a Portuguese influence, derived perhaps from illustrated books.

The *oba*'s identification with Olokun is dramatized in a plaque that portrays the king in a mystical, spiritual aspect (fig. 9-55). The king is shown grasping apparently docile leopards by their tails and holding them aloft in a heraldic pose. Another of the king's praise names is "leopard of the house," a reference to his authority as the only person in the kingdom who can take human life or authorize the taking of it. This symmetrical balancing act—one nobody wants to attempt even with domestic kittens—is clearly metaphorical, an expression of the king's control over the leopard, ruler of the forest, and thus over all creatures. The king

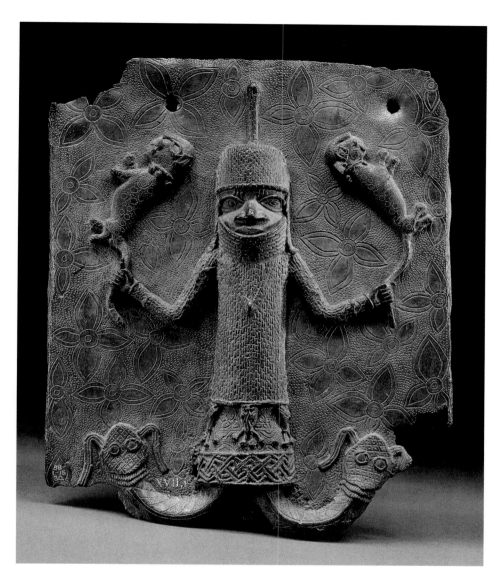

9-55. PLAQUE DEPICTING AN *OBA* WITH MUDFISH LEGS. BENIN. 16TH–17TH CENTURY. BRONZE, 16 X 12½" (40.6 X 31.75 CM). THE BRITISH MUSEUM, LONDON

sacrifices a pair of leopards at his installation and formerly sacrificed them as well at *igue*, the rite that reaffirms his powers. For ideological purposes in aggrandizing the king, the leopards here are rendered the size of house cats.

From the bottom of the king's robe extend two mudfish where we would expect legs. On a simple symbolic level, the fish suggest the king's identification with Olokun, whose realm is water. A more complex interpretation derives from oral traditions

about the fifteenth-century king Ohen, who apparently was paralyzed. To hide his deformity in a culture where this would have been taken as indicating infirmity in the kingdom itself, he had himself carried into public audiences. To shorten the full legend, which has at least two versions, Ohen made it known that Olokun had possessed him and that his miraculously transformed legs, now resembling mudfish, were divine and ought never be exposed. This version honors Oba Ohen as a promoter of Olokun worship. Notably as well, some species of mudfish give off an electric charge, which would be appropriate in symbolism of the king. In any case the plaque must be seen as a means of visibly declaring the *oba* to be divine, mysterious, and of superhuman strength, notions reinforced elsewhere in Benin iconography. An alternative interpretation focuses on the king's dual powers to take human life, symbolized by his control over the leopard, and to create or produce life, suggested by his identification with Olokun, god of fertility and wealth.

Another plaque apparently reproduces the interior of a palace courtyard shrine with its sloping steepled roof (see fig. 9-51). Two posts flank what seems to be an altar, and two more support the roof at its ends. On the altar's top step between the two center posts are two stone axes and two guardian leopards. Warriors holding shields and spears flank the altar, with slightly shorter attendants beside them. The posts are decorated with even smaller figures in relief. Interestingly, these figures probably represent plaques as they were once displayed.

9-56. Plaque depicting a leopard
hunt. Benin. 16th–17th century.
Bronze, height 21" (53.3 cm).
Staatliche Museen zu Berlin,
Preussischer Kulturbesitz, Museum
für Völkerkunde

Another plaque depicts a leopard hunt in a stylized landscape (fig. 9-56). The plaque is triply unusual, for not only is its composition *not* hierarchical, but it appears to record a scene from daily life, a rarity in African art. The scene, moreover, takes place outdoors, in a landscape. A long vine repeats the plaque's rectangular shape to establish the forest environment. Among the leafy tendrils are two large leopards and five Portuguese hunters. Cleverly, the artist has shown the men as if emerging from the underbrush, a background comprised of three- and four-leaf clusters. The vines' higher relief makes them appear closer. Three hunters grab the leopards by the tail and legs, respectively, suggesting their intention to capture rather than shoot the animals, although several hunters carry weapons. Why the hunters here are Portuguese rather than members of the Benin leopard hunters' guild is not clear. Certainly live leopards were required by the king for sacrifice and other ceremonial purposes and as features of state displays, where sculptural stand-ins of cast copper alloy or ivory were also used.

Royal Altars

"Great Head" is another of the king's praise names, and one that serves well to introduce royal altars, which are dedicated to the heads of past kings as well as that of the current ruler. The head leads the body; it is the body's most important part, the seat of wisdom and judgment and well-being, just as the Great Head leads the Benin body politic. In depicting full figures, Benin sculptors emphasize the importance of the *oba*'s head by enlarging it

proportionally to about one-third the total figure height (see, for example, the *oba* depicted on the altar to the hand in figure 9-1).

Royal altars are composite complexes of charged materials and objects arranged on a semi-circular clay platform (fig. 9-57). The one shown here is that of the early twentieth-century king Eweka II (ruled 1914–1933). Its dramatic impact comes mainly from the four sculpted heads and the great carved elephant tusks that seem to sprout from their crowns. These four elements frame the shrine and focus attention inward. The dark cluster of ancestral staffs stacked against the wall, and especially the figurative

In 1897, at the time of the sack of Benin, there were seventeen such altars. In earlier times there were still more—in theory, an altar for every deceased oba. Since the 1914 restoration, a single altar has served as the collective shrine for all past rulers except for the last four, each of whom has his own altar, as does the living king. There is also a shrine to queen mothers in the palace, and at least one more in the queen mother's compound north of the palace. Most of the sculptural components that once furnished these many shrines are now dispersed among the museums of Europe and America, raising questions about the ownership of cultural property and the repatriation of war booty. Who truly owns heads that were once essential to a sacred altar? The question is not easily answered.

centerpiece in front of them, add visual interest, depth, and further support to the overall hierarchical structure, which the centerpiece reiterates in its own composition. Several bells and other small objects add further texture, as do the state swords leaning against the wall. Even the sacrificial blood dripping down the front of the platform contributes to the visual experience, leading the viewer's eye up and back to the sculptural group. Horizontal ridges on the wall behind effectively stop one's view, directing it to the center or perhaps laterally, to other altars nearby. All these components have constellations of meaning that contribute variously to the importance and enduring value of Benin kingship, which is what this and similar altars are all about. It is here that ancestral kings are fed (with sacrificial blood) and prayed to, so that they will protect the kingdom and aid in its prosperity. The main officiant is the living *oba*, whose power derives from these ancestors and from the coral beads they have passed down to him.

Many sculpted heads are known from Benin, created variously of brass, ivory, terracotta, and wood. The materials are used hierarchically, with brass heads reserved exclusively for altars to kings and queen mothers, for cast brass is enduring; like kingship, it does not rust or corrode. In earlier times, brass heads were polished to a brightness appreciated as beautiful and inviting, yet simultaneously to a color considered red, and thus threatening. The

king too attracts people with his beautiful garments, but he also repels with the power of his red coral beads, which are said to have been consecrated with blood. Similarly, the imposing tusks on these altars are the weapons of the mighty elephant, who, like the ferocious leopard and predatory eagle, is a metaphor for the king and his powers. "Wherever the elephant faces is the road" is a proverb about the elephant's, and the king's, military might. But here the tusks have been tamed, as it were, transformed into works of art by the detailed relief carvings that cover their surfaces. The drawing in figure 9-58 catalogues the motifs carved on one such tusk, which include the *oba*, royal supporters, metaphorical animals, and other key symbols. The *oba* is often shown multiple times on carved tusks; here, a column of kings extends along the central axis. Each king once commissioned a set of tusks for the altar he consecrated to his father's head and memory. Ivory itself was a valued commodity in external trade and brought much revenue to Benin, especially to the king, who received one tusk of every elephant killed in the kingdom. Tusks on altars were often bleached and sometimes chalked to pure whiteness, another reminder of the king's relationship to Olokun.

Each newly installed king also pours the first crucible in casting the central altarpiece that becomes the focal point of his father's shrine, the figural group that depicts his father with major courtiers and chiefs. In the centerpiece on the altar in figure 9-57, the former king is shown in full ceremonial regalia, including the powerful garment made of Olokun's coral beads. He holds aloft a ceremonial sword, *eben*, with which he dances to honor

9-58. MOTIFS ENGRAVED ON AN ELEPHANT TUSK FROM BENIN. DRAWING BY JOANNE WOOD

HEIGHT 8¼″ (21 CM)

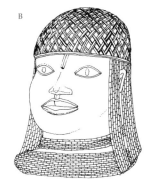

HEIGHT 9¼″ (23.5 CM)

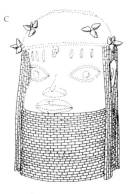

HEIGHT 13″ (33 CM)

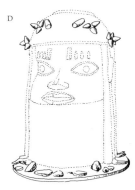

HEIGHT 18″ (45.7 CM)

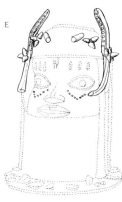

HEIGHT 21″ (53.4 CM)

9-59. STYLISTIC CHRONOLOGY OF BENIN BRASS HEADS PROPOSED BY W. FAGG AND P. DARK. DRAWINGS AFTER C. VANSINA

Solid lines indicate new, distinctive elements. The progression from the earliest head (a) to the most recent (e) may span as much as four centuries.

his ancestors. An actual sword leans against the back of the shrine.

Both a certain redundancy and a multi-referential quality pervade Benin shrine complexes, as they do other aspects of art in this kingdom. The small brass altarpiece echoes the larger altar, which is composed from many materials and objects. One commemorative head or tusk is not enough, there must be four or six. Not a few beads, but an entire garment of them. Not one bell to call the ancestral spirits, but several, most being miniature versions of palace steepled roofs. Not one wooden staff, but many, which together—each with its piling up of bamboo-like segments that signify the piling up of generations—represent the temporal depth of the dynasty as well as its multiple powers.

The many extant cast brass heads also represent more than four hundred years of commemorating Benin kings and queen mothers, from the fifteenth until the late nineteenth centuries. While an exact chronology is not agreed upon, the historical progression of styles shown in figure 9-59 is generally accepted. According to this rough chronology, the most naturalistic heads, which are also the thinnest castings, are the earliest (fig. 9-60). Facial

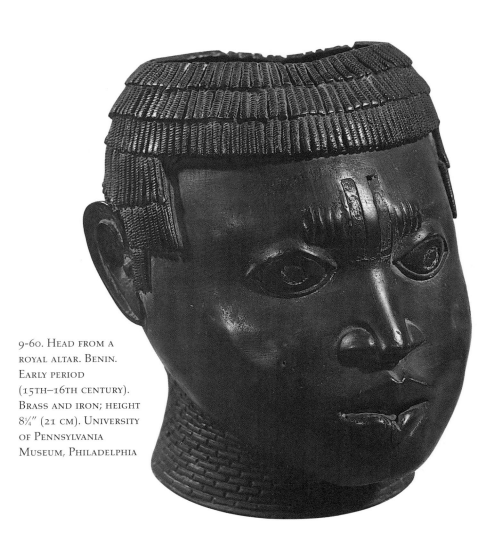

9-60. HEAD FROM A ROYAL ALTAR. BENIN. EARLY PERIOD (15TH–16TH CENTURY). BRASS AND IRON; HEIGHT 8¼″ (21 CM). UNIVERSITY OF PENNSYLVANIA MUSEUM, PHILADELPHIA

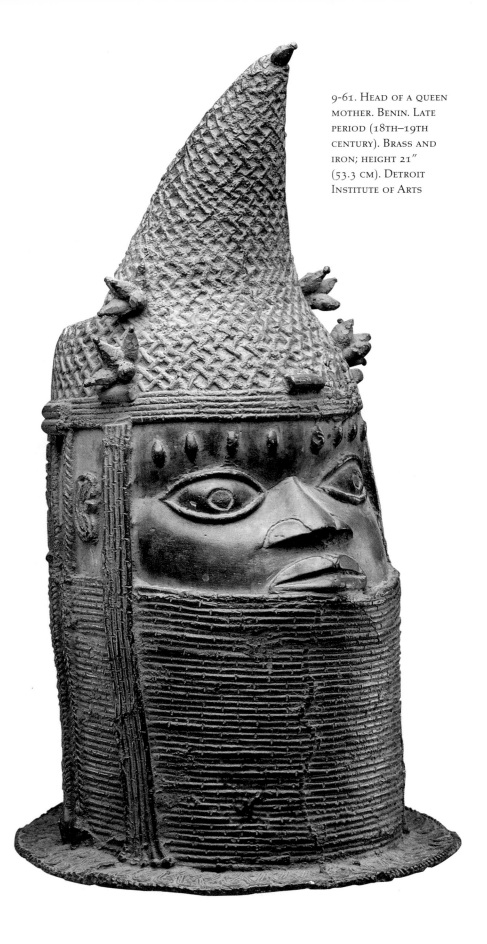

9-61. HEAD OF A QUEEN MOTHER. BENIN. LATE PERIOD (18TH–19TH CENTURY). BRASS AND IRON; HEIGHT 21″ (53.3 CM). DETROIT INSTITUTE OF ARTS

features on these early works have a somewhat fleshy look, but none is realistic enough to be called an imitative portrait. Lips, noses, ears, and sometimes eyes are conventionalized. Overall, however, the heads are quite sensitively modeled. Some scholars believe that many early period heads do not commemorate Benin kings but rather depict conquered rulers, and that they were displayed on war shrines as trophies of victory.

Late period heads, usually dated to the late eighteenth and nineteenth centuries, are heavier, bulkier, and taller than early examples (fig. 9-61). Beaded collars, which on early period heads conform with the neck, now form a massive cylinder from which the head seems to emerge. This head represents a queen mother with her characteristic conical hairdress. The plate-like flange at the base of the collar is often found on late period heads. Facial features are both larger and more rigidly conventionalized than those of early periods. Male heads from the late period include extensions upward from the temple, probably representing coral versions of eagle feathers (see head *e* in figure 9-59). The heads on the altar discussed earlier are late examples, cast after the 1914 restoration of the monarchy (see fig.9-57). Heads with collars of intermediate height and without basal flanges are assigned to a middle period.

The origins of the custom of casting commemorative heads and the source of the casting technology itself are uncertain. Oral traditions record that the current dynasty of Benin was founded by a Yoruba prince from Ife, and reciprocal ritual relations have long been maintained between the two

kingdoms. Some scholars believe that the techniques of lost-wax casting and the relative naturalism of early period heads derive from Ife (see chapter 8). Others accept the Yoruba origins of casting technology but dispute the stylistic links. Judging from the evidence of the art works themselves, it seems unlikely that the Benin heads, confidently cast but stylized, are the direct descendants of the supremely lifelike and naturalistic heads of Ife, however idealized both sets of castings may be.

Portuguese Presence in Benin Arts

Portuguese ships arrived on the Atlantic shores southwest of Benin in the 1480s, and immediately a trading relationship was established for mutual benefit. From the Portuguese Benin received cloth, cowrie shells, coral, brass, and eventually weapons, offering in return ivory, spices, and later slaves. For some years scholars have postulated that these light-skinned foreigners arriving over the ocean in huge ships bearing exotic kinds of wealth may have been perceived by the Edo as emissaries or even relatives of their popular deity Olokun. The apparently warm reception given the Portuguese, and especially their dynamic integration into Benin art forms, most of which are adjuncts to ritual, would seem to confirm this theory.

Images of Portuguese in brass, ivory, and wood appear on regalia, on plaques, and even as freestanding statuary probably displayed on altars. The finely detailed Portuguese soldier illustrated here almost certainly stood on a royal altar prior to its removal

from Benin in 1897 (fig. 9-62). The man holds a matchlock at the ready and wears precisely rendered military garments of a style dated to the sixteenth century. The alert, slightly bent-kneed stance and the position of the arms give the figure a more dynamic posture and more anatomically correct proportions than those in which Benin officials are usually shown. Notably, the Portuguese man's head is not enlarged. Such rendering suggests that Benin artists were clear in their ideological distinction between their own and foreign people, and that they in no way discriminated against the Portuguese outsider. No hint of criticism or caricature is visible here. Rather, as in nearly all Benin art, the Portuguese are depicted with the

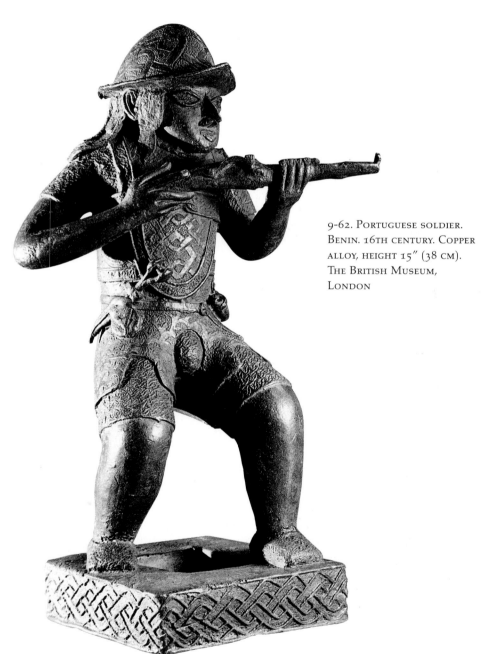

9-62. PORTUGUESE SOLDIER. BENIN. 16TH CENTURY. COPPER ALLOY, HEIGHT 15″ (38 CM). THE BRITISH MUSEUM, LONDON

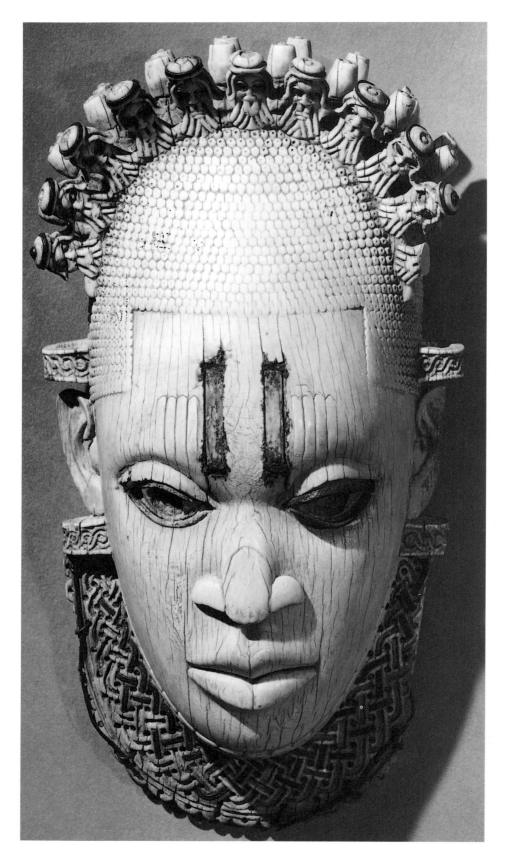

kind of objective neutrality that
implies their full acceptance and par-
ticipation in Benin despite, or
perhaps because of, their "stranger"
status.

Images of Portuguese even
appear on rare and precious objects,
such as two sensitive and exquis-
itely carved ivory "masks" (fig.
9-63). Four such ivory works are
known. All are believed to have been
carved in the early period, around
1500, and are said to be representa-
tions of the queen mother. On two
of them, Portuguese heads appear in
a kind of corona above the forehead.
Judging from recent ritual practice,
they were worn at the king's waist
along with a pendant ivory leopard
head and several plaque-like hieratic
motifs, also carved of ivory. The
exact meanings of these pendants is
not known. They may have been
protective, or they may have identi-
fied the king with certain powers:
the queen mother's mystical procre-
ative force, the leopard's military
ferocity, Olokun's wealth.

Masks and Masquerades

Although this ivory face, along with a large number of copper-alloy pendants representing human and animal heads, is often referred to as a "mask," none is the sort of mask worn over the face to create a new persona, in the manner of most masks discussed in this book. Only one type of face-concealing mask is danced in Benin City, a mask known as *odudua* (fig. 9-64). In keeping with the materials so frequently used for court-related art forms, *odudua* masks are brass. They appear as part of the new yam harvest and first fruits festival in a ritual entitled *ugie odudua*, named after the Ife king whose princely son Oranmiyan founded the current dynasty. The masquerade itself was initiated by Oba Eresonyen (ruled c. 1735) to represent and commemorate the founding members of that new line. A quintessentially royal masquerade in history, form, and purpose, *ugie odudua* features seven maskers who gesture with ceremonial swords as they dance back and forth seven times before the king. Masking officials are important chiefly titleholders and caretakers of deities brought from Ife. Their dancing expresses their loyalty to the living king and his protection by them and by the dynastic ancestors embodied in the masks.

No other masquerade is allowed to perform in the palace or in Benin City. At the same time, chiefs of all ranks wear (or once wore) mask-shaped brass pendants at their waists, as the king himself wears one of ivory. By banning all "true" masking apart from *ugie odudua*, which so explicitly supports the king, the Benin hierarchy keeps the sorts of power embodied in typical masquerades at a non-threatening distance. It would seem that the king wants to keep away the kinds of anonymous and often unruly maskers who, elsewhere, sometimes take both spiritual and political power into their own hands. The wearing of mask-like pendants at the waist would seem to express royal control of powers elsewhere embodied in true masks.

Today, the king of Benin is still a viable, powerful leader of his people despite—and perhaps because of—the existence of the national and state governments. The king and the rituals he still conducts, such as *igue*, which annually revitalizes the very concept of sacred kingship, provide focus, continuity, and stability for the Edo people and their neighbors.

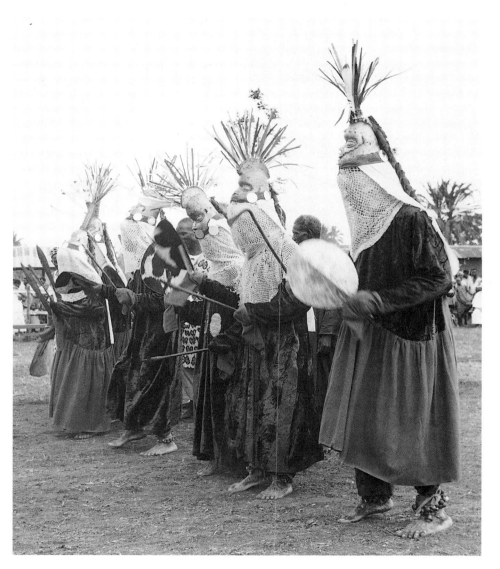

9-64. *ODUDUA* MASKERS AT THE COURT OF BENIN. C. 1960

9-65. Igbo shrine to Mamy Wata, Owerri region, Nigeria. 1974

MAMY WATA

A deity worshiped over much of southern Nigeria and indeed much of West Africa, Mamy Wata is a kind of modern, upscale, female equivalent of the Edo god Olokun. While literally thousands of Mamy Wata shrines are found in Africa, and with them many interpretations of her nature and what she is able to do, there is general agreement that she is a foreign, exotic, light-skinned, charismatic, and very beautiful woman with a penchant for seduction. Although she has the abilities of general tutelary gods, namely providing protection, health, productivity, and prosperity, her special provinces are riches in money and kind, which she can bring or take away, and mental disease, which she can cause or cure. Her concerns are contemporary sorts of problems such as improving employment opportunities, passing exams, upgrading from a motorbike to a car, or dealing with a marital problem brought on by money or jealousy. What Mamy Wata does for a person depends on how she is treated, which is another way of saying what kind of offerings are made to her and her shrine.

A Mamy Wata shrine is an assemblage of items that her priestess (or priest) has collected for her, in part to enrich her environment and attract clients (fig. 9-65). It also includes objects her devotees have given in supplication or thanks. The chromolithograph responsible for her imagery is nearly always present (central and on the back wall in the illustration). This print was based on a photograph taken in the late nineteenth century, in Germany, of a Samoan circus performer, a female snake charmer. Since then, this print has been reproduced thousands of times and is now distributed all over the African continent. Sculptures of Mamy Wata based on the color print—with her straight hair, light skin, and entwined snakes—are favored shrine decorations, along with red and white cloth and an array of imported goods having to do with vanity and personal beauty, for

example, glittery jewelry, perfume, talcum powder, pomade, and soap. A mirror is usually included, both so Mamy Wata can admire herself and to represent the miraculous surface of water from which she appears and into which she can disappear. Mamy Wata also likes sweet drinks and rich foods, candles and flowers, and almost anything of European or American manufacture, from plastic dolls and enamelware to books and bottles. The shrine shown here is a rich constellation of these and other things. Several wood sculptures painted in bright colors are visible on a table at the back of the room. A carpentered table, indeed, is usually the central altar, in keeping with the goddess's desire for foreign things.

Hundreds of colorful offerings and aids to worship are arranged on the floor in front of the table, with bowls for gifts and food toward the front. Successful and beautiful shrines attract both Mamy Wata herself and more worshipers whom she will ask, through her priestess, for more presents including devotional images and objects from Christian, Hindu, and various occult practices. These are absorbed and reinterpreted as further evidence of Mamy Wata's exoticism and power.

Some Mamy Wata specialists conduct group seances or collective waterside rituals, meals, and dances, using paddles, boats, nets, and model snakes or fish as props and aids. Devotees often become possessed by the deity while singing and dancing her praise. Other forms of worship are more private and meditative. Priests or priestesses may consult Mamy Wata as an oracle, much in the manner of a diviner, and some worshipers "visited" by the deity will be asked to establish Mamy Wata shrines of their own. So the worship of this charismatic modern "outsider" is enormously varied, and it continues to spread yet further afield. Supremely syncretistic in its ability to absorb and rework varied local and foreign spiritual symbols and practices, belief in Mamy Wata serves many current needs as Africans deal with foreign problems, products, values, and people.

III. Central Africa

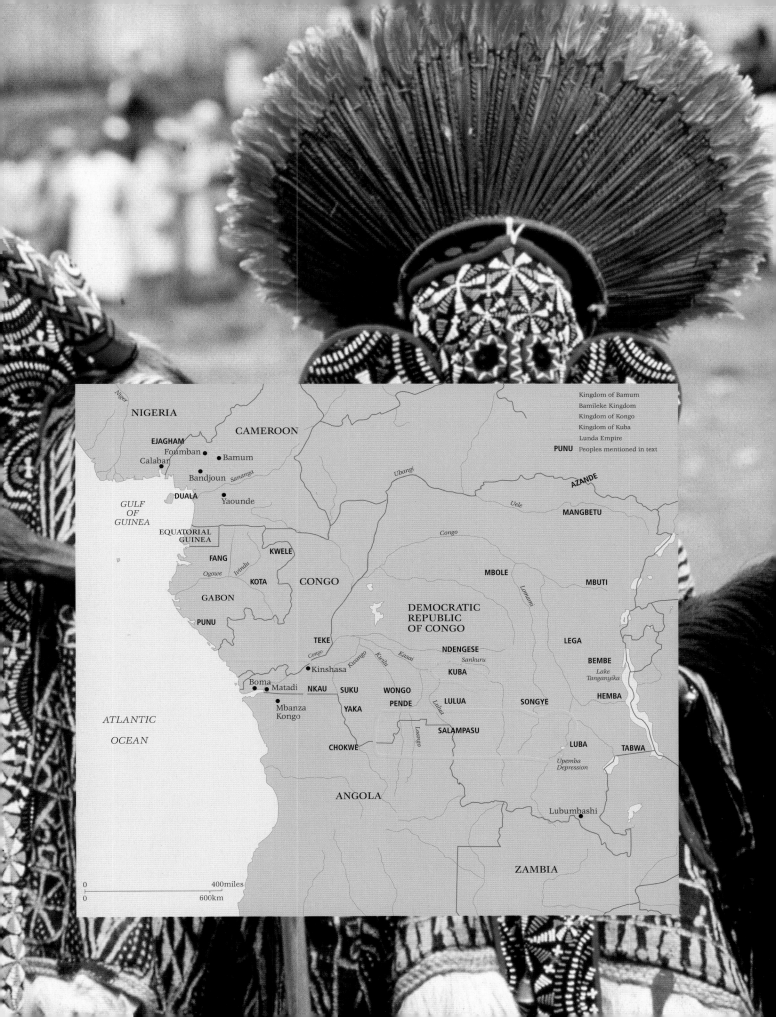

NIGERIA

CAMEROON

EJAGHAM
Foumban •
Calabar • • Bamum
Bandjoun • *Sananga*
DUALA
Yaounde

GULF
OF
GUINEA

EQUATORIAL
GUINEA

FANG

KWELE

Ivindu

KOTA

Ogowe

CONGO

GABON

PUNU

Kingdom of Bamum
Bamileke Kingdom
Kingdom of Kongo
Kingdom of Kuba
Lunda Empire
PUNU Peoples mentioned in text

Ubangi

AZANDE

Uele

MANGBETU

Congo

MBOLE

MBUTI

DEMOCRATIC
REPUBLIC
OF CONGO

Lomami

LEGA

TEKE

Congo

Kwango

Kwilu

Kasai

NDENGESE

Sankuru

KUBA

BEMBE

*Lake
Tanganyika*

Kinshasa

Boma •
• Matadi

NKAU SUKU WONGO
PENDE

YAKA

Lulua

LULUA

Loango

SALAMPASU

SONGYE

HEMBA

CHOKWE

LUBA

TABWA

*Upemba
Depression*

ATLANTIC

OCEAN

ANGOLA

Mbanza
Kongo

Lubumbashi •

ZAMBIA

0 ———— 400miles
0 ———— 600km

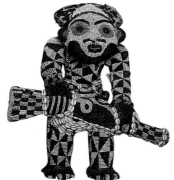

10

CROSS RIVER, CAMEROON GRASSLANDS, AND GABON

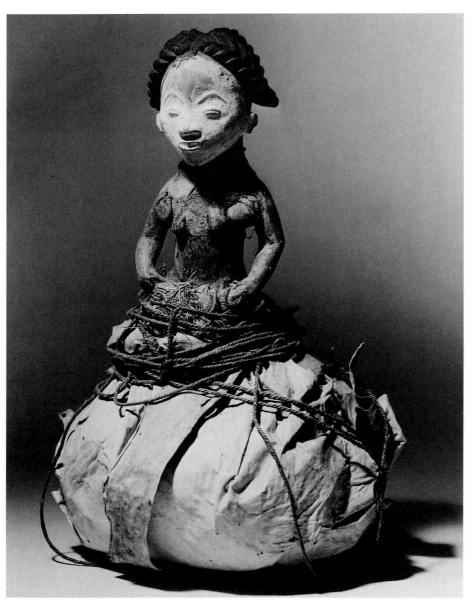

10-1. RELIQUARY FIGURE. PUNU. WOOD AND RATTAN; HEIGHT 11⅘" (30 CM). MUSÉE DE L'HOMME, PARIS

THE AREA TREATED IN THIS chapter is diverse both geographically and culturally. Beginning at the Cross River basin, which overlaps Nigeria and Cameroon, it extends into the mountainous grasslands of western Cameroon, along the estuaries and rivers of the Cameroon coast, and into the equatorial forests of Gabon, Equatorial Guinea, and Congo. Numerous peoples live within this sweep of the continent. Perhaps the most consistent cultural element is the small scale of the communities in the forest zones, most of them organized only at the village level and governed by groups of elders or men's organizations rather than by chiefs or kings. An exception are the kingdoms in the mountainous grasslands of western Cameroon. Yet these realms, too, are small in comparison to the territories ruled by the *oba* of Benin (see chapter 9) or the Yoruba kings (see chapter 8).

All of the societies discussed in this chapter were profoundly affected by European presence, though in different ways. European trade along the Cross River brought wealth and increased the importance of local men's societies, many of which became commercial organizations. The small kingdoms of the Cameroon grasslands imported prestige materials such as beads, brass, and fabric, which were used to create ever more luxurious art objects for the royal treasuries. In the coastal region of Cameroon, individuals involved in European trade were acknowledged as headmen or chiefs, leading to a new type of political leadership supported by new forms of prestige art. In the equatorial forests of Gabon, on the other hand, fundamental cultural practices were banned

by the colonial administration, and the art forms linked to them survive only in museum collections.

CROSS RIVER

From its origins in the hills of western Cameroon, the Cross River runs westward into Nigeria then curves to the south to flow toward the Gulf of Guinea, which it reaches some 90 miles later. Navigable by local craft for much of its length, the river has historically served as a means of transportation and trade for the many peoples who live within reach of its banks. Most of these peoples speak languages known as semi-Bantu. Culturally as well as linguistically related, they share a number of political, religious, and economic institutions in which art plays an important role.

Early Arts

In recent times, artists of the Cross River region have worked primarily in wood. The earliest known works from the region, however, were formed from more durable materials such as stone, brass, and terracotta. Unfortunately, few of these works have been dated or even accurately described, for they have usually been unearthed by accident rather than in controlled and documented archaeological excavations. They may have been made by ancestors of the current populations, in which case they represent artistic traditions that have been discontinued. Or other peoples who preceded them in the region may have made them. Until more is known, they can only be appreciated as mute and mysterious evidence of an unknown past.

The two stone monoliths in figure 10-2 belong to a group of eighteen stones that stand at the site of a deserted village in the area occupied by the Nnam group of the Ejagham peoples. Some three hundred such monoliths have been documented in Ejagham territory. Ranging from one to six feet in height, they are usually found in groups, often in a circular arrangement. All were probably at one time associated with habitation sites, which have since been abandoned. Scholars believe that some of the monoliths may date back as far as the sixteenth century, and that their manufacture may have continued into the nineteenth century.

The makers of these works selected roughly columnar stones from riverbeds, then used abrasives—most probably other stones—to further

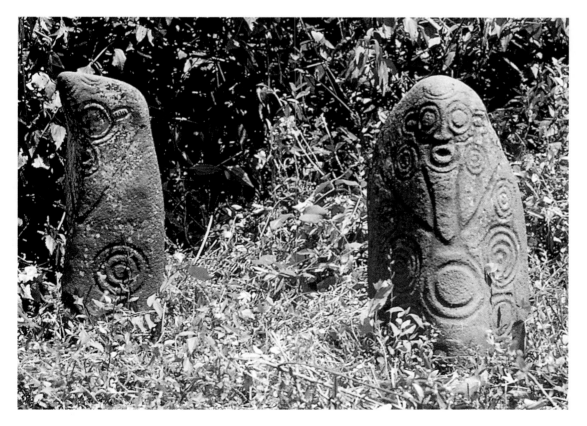

10-2. Carved monoliths, Akwanshi, Nigeria. 16th century (?); photograph 1974. Basalt

The Ejagham people refer to these monoliths as akwanshi, "dead person in the ground," and revere them as special objects. In some areas, the monoliths are given the names of former ntoon—priestly leaders whose role was largely ceremonial and religious. During annual ceremonies acknowledging past ntoon, offerings are given to the akwanshi as village ancestors. Interestingly, the akwanshi are asked for blessings and protection even though the system in which the ntoon worked has disintegrated.

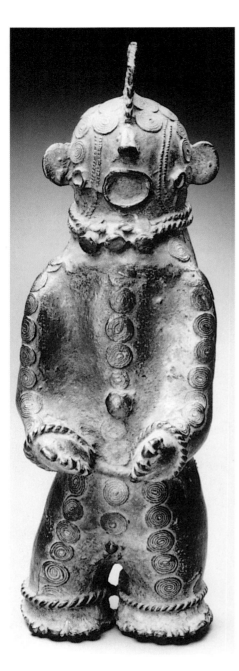

10-3. STANDING FIGURE. CROSS RIVER REGION, NIGERIA. COPPER ALLOY. MUSÉE BARBIER-MUELLER, GENEVA

shape and incise them. All of the stones depict bearded figures, usually, as here, including a navel rhythmically emphasized with concentric circles. Several regional substyles have been identified, some of which coincide with subgroups of the Ejagham peoples. The Nnam style, shown here, is distinguished by its especially profuse and elaborate decoration. Sculptors working in this style altered the natural shape of the stone itself less than sculptors of other regional styles, who often smoothed the stones to a more symmetrical columnar form, sometimes explicitly phallic.

Sculpture cast in copper alloy using the lost-wax process has also been found in the Cross River region (fig. 10-3). The works belong to a sizeable body of cast metal objects recovered across a broad area extending from Cross River in the east to embrace both sides of the Niger River in the west and northward to the confluence of the Niger and Benue rivers. Stylistically diverse, they include figures of humans and animals as well as such objects as bells and staffs. Collectively, they are often referred to as products of a "lower Niger bronze industry," but where the centers of this industry were and what culture it belonged to we do not know. Some works are clearly linked to the Benin court in subject matter, suggesting that they may have been made by outlying groups of Edo-speaking peoples (see chapter 9). Others seem related to copper alloy objects from the Igbo site of Igbo Ukwu (see chapter 9). The Yoruba (see chapter 8) have also been posited as the possible creators of some of the objects, as have several other regional peoples. The sculpture here depicts a human figure wearing a rope or

twisted metal necklace with bell pendants and anklets and bracelets. The surface of the figure is embellished with spiral decorations.

The lower Cross River is rich in pottery production that was traded over a wide area into the Niger delta region. The small terracotta sculpture in figure 10-4 was fashioned like an upside-down jar (the opening is on the bottom). Features, including brows and ears, were made separately and attached prior to firing, as was the crown of the head, which depicts a hairdo. The front of the body has vertical grooves and ridges along with other decorative elements that set off a protruding navel. Small holes in the crown may have been made for

10-4. ANTHROPOMORPHIC POTTERY FIGURE. CALABAR, CROSS RIVER REGION, NIGERIA. 17TH–18TH CENTURY (?); PHOTOGRAPH 1977. TERRACOTTA

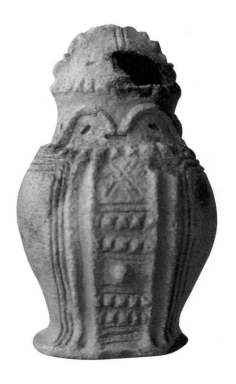

10-5. *Nsibidi* signs.
Drawing after
E. Waynell

Recent Arts of Secret Societies

attachments (such as feathers), or they may have simply served as air vents during the firing process. This figure and numerous others like it were recovered during the digging of foundation trenches in Calabar, a town near the mouth of the Cross River. They were found buried in specially prepared pits two to six feet deep, together with richly decorated pottery vessels, round white pebbles, metal blades, and other materials. Charcoal particles found at the bottoms and at the tops of these pits suggest that they may have been places for the safekeeping of ritual objects, consecrated before and after with fire. Some pits contained im-ported porcelain plates, glass bottles, and beads, suggesting that the objects were buried sometime after European traders arrived in the seventeenth century. But as with other early arts of the Cross River region, we do not know who made them or what purpose they served.

Cross River communities are usually governed by groups of elders. The power of each elder is in turn enhanced by membership in various societies. A typical community includes numerous societies, each with its own purpose. In the past, these included warrior societies, ancestor societies, hunting societies, anti-witchcraft societies, and entertainment societies. Many societies continue into the present day as fraternal, political, or commercial associations. Women as well as men belong to societies, though rarely to the same ones.

Society members communicate through a complex system of secret gestures and *nsibidi*, a repertoire of ideographic signs (fig. 10-5). *Nsibidi* embody power as well as signify meaning, for mastering the obscure system of signs and symbols is one way in which leaders of the organizations establish their authority. *Nsibidi* symbolize ideas on several levels. Most people, even those not initiated into a society, recognize signs that have to do with human relationships, communication, or household objects. At another level, "dark" signs of danger and extremes, often actually bolder in form and darker in value, have to do with moral judgment and punishment. Finally there are complex signs whose meaning and use is vouchsafed only to the most privileged levels within the associations. These indicate rank and secrecy. Considered a vital force in itself, *nsibidi* is often considered to be the very essence of a society. The most powerful signs are intricate diagrams drawn on the surface of the earth in times of crisis or as sacred acts. Only those who have the proper rank and knowledge are authorized to see such powerful signs. *Nsibidi* signs are also used as an aesthetic enhancement on fans, trays, drums, cloths, masks, and other objects used in Cross River associations.

The oldest Cross River secret society may be the all-male Ngbe society of the Ejagham people of Nigeria. In Ejagham, *ngbe* means "leopard." Ngbe seems to have begun as a warfare society, possibly among peoples on the Cameroon side of the Cross River. Its emphasis later became trade, however, and it grew to play important political and commercial roles.

Each Ejagham community has a Ngbe lodge, usually the most impressive structure in the community, where secret meetings are held and secret objects stored. A rectangular assemblage made of cane, covered with animal skulls, horns, sticks, leaves, carved objects, pieces of rope, brooms, and drums, and fringed with raffia is

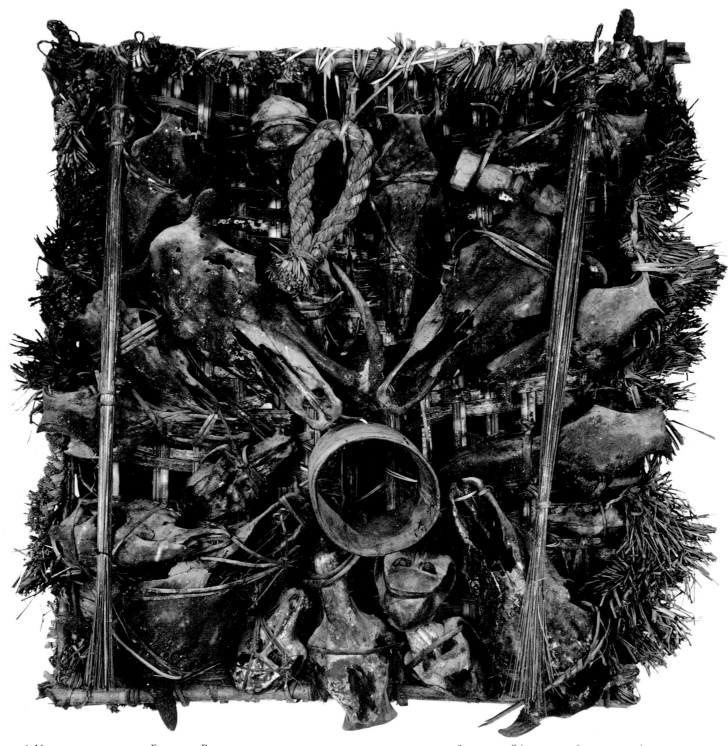

10-6. Ngbe society emblem. Ejagham. Raffia fiber, animal skulls, caning wood, rope; 48 x 42 x 11″ (121.9 x 106.7 x 27.9 cm). New Orleans Museum of Art. Museum purchase

Although Ngbe members are secretive about the function of such objects, researchers have been able to discover some information. Skulls and bones are the remains of animals eaten in rituals. Brooms are used for sweeping away hostile magical substances from the lodge. Drums are of the type used in Ngbe masquerades and for making announcements to the community. The sticks are memory aids used in Ngbe deliberations. Rope coils invoke those placed on the tops of the stone pillars within the lodge to restrain the leopard spirit. Thus the assemblage is a visual reminder of the role of the society and its actions.

typical of objects prominently displayed inside the lodge (fig. 10-6). In addition to the objects that belong to the lodge as a group, each grade has a distinctive set of costumes, rituals, dances, and masks. The elaborate trading network along the river formerly involved the selling of rights to Ngbe and other associations, including the right to perform their various masquerades (see Aspects of African Culture: Masquerades, pages 336–7). The group selling the rights would perform the masquerade in the village of the buyer group, then return home, leaving their masks and costumes behind. The river trade thus helped to spread related art events and art objects among diverse peoples over a broad area, though changes in both form and meaning took place as local copies of masks and costumes were made and time passed.

Masks of secret societies appear in performances by accomplished dancers at funerals, initiations of new members, and other events sponsored by the association. Two types of masks dominate: helmets masks and crest masks. The helmet mask in figure 10-7 covers the entire head of the wearer like an inverted bucket reaching to the shoulders. When the mask was made, fresh animal skin was stretched and tacked over the soft wood from which it was carved. After the skin dried, it was stained with pigments made from leaves and barks. The opposing sides of the double-faced mask represent male and female faces. The male face is normally stained dark all over, while the female side has portions left in the natural color of the animal skin. Similar masks may have three or more faces. Feathers, quills, and other objects would have ornamented the

mask in performance. On many masks, messages are painted in *nsibidi* markings.

Crest masks do not cover the head but rather sit on top of it. They are attached to a basketry cap, which is held on the wearer's head by means of a chinstrap. The long neck and towering coiffure of the elegant crest mask

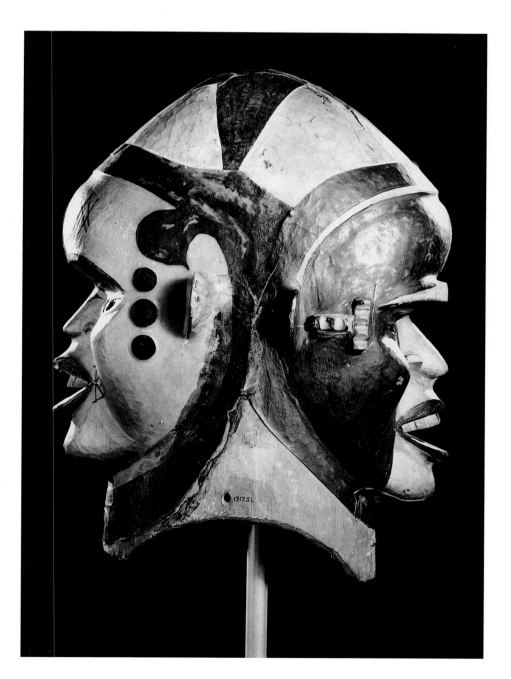

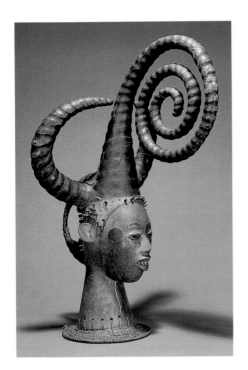

10-8. Crest mask. Cross River region, Nigeria. Wood, stained animal skin, basketry. Fowler Museum of Cultural History, University of California, Los Angeles

in figure 10-8 would have emphasized the height of the masked character who wore it. The skin sheathing gives the mask a startling realism, and in performance it appears to be an actual human head. In some masks attaching real hair to the scalp may heighten this effect. Inserts of metal pieces for eyes, wooden pegs for pupils, and the use of bone, ivory, metal, or small pieces of palm rib for teeth may add further to the realistic impact. The dark-stained round areas in relief on the temples represent scarification patterns. Such a mask would have been worn with a flowing, elaborate gown. The skin-covered crest mask shown

Aspects of African Culture

Masquerades

Masks are among the most widely known, collected, and admired of African arts. Outside of Africa they are generally displayed and appreciated as sculpture. Their dazzling inventiveness, expressive form, and evident craft certainly reward that form of attention, yet the isolated and inert public display of sculpture is utterly alien to an African point of view. A mask is never seen publicly in Africa except in performance, in motion, at which time it is not an object called "mask" at all, but the head or face of an otherworld being that has appeared amid the human community. In fact, most African languages do not have a word that can be accurately translated as "mask." Instead, the name for a particular mask is generally the word for the being that the mask helps make manifest.

The masker—the human wearing a mask and its associated costume—is a transformed being: not a person imitating a spirit, but a person whose identity is subsumed into the otherworld being who is now truly present. The appearance of such beings is not casual or undertaken lightly. Instead, maskers appear in the context of a masquerade, a ritual or performance art which takes place in a time and space normally isolated from the routine of daily life. Played for an audience, a masquerade is usually activated by music and includes dancing or other dramatic action and sometimes singing and other verbal arts. Each spirit masker has its characteristic gestures and movements, which are also part of its essence. While virtually all African masks are used to manifest spirits—usually spirits of nature or ancestors—a continuum exists from those characters that are largely secular, on the one hand, to those that command, manipulate, and represent powerful spiritual, natural, and social forces, on the other.

Masquerades are normally performed as an element of still larger rituals, especially rituals of human passage, the passing of seasons, or the stages of the agricultural year. Yet they are also considered by Africans themselves as discrete ceremonies in their own right, indicated by the fact that each masquerade generally has a

name. Since most masks are worn only by males and most masquerades are male dominated, they are an especially fruitful arena for invoking gendered values and behavior. At the same time roughly half of all maskers embody female characters. Many maskers also evoke animals or more abstract, composite powers of nature.

In all cases masquerades are performed not simply to entertain, however entertaining they may be, but to effect change in their communities. Indeed, a prime characteristic of the African masquerade is its capacity to get things done. As active agents of transformation and mediation, spirit maskers help effect many kinds of change: children into adults, nominees into leaders, elders into ancestors, seedlings into productive crops, sickness into health, or crime into judicial resolution. Such occasions are the masquerade's most frequent contexts. Even the expressive, entertaining aspects of masquerading *move* the community: away from the humdrum of everyday life toward the excitement, excess, and release of festivity and spectacle.

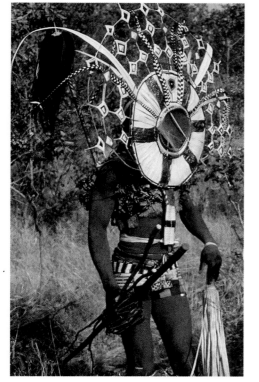

Bassari male initiate (see fig. 6-9)

For all of these reasons, it is appropriate to speak of masking as an "embodied paradox." The masquerade is symbolic and allusive, but tangible. It is an illusion, but at the same time real. The characters are invented, yet are quite capable of inflicting damage. The masquerade will affect its audience on one level, its participants on others. Masking always has both emotional content and some degree of instrumentality; it is affective as well as effective, and one of the continent's most expressive and content-rich art forms.

10-9. Skin-covered crest mask in performance, Bamenda, Cameroon. 1932

in performance in figure 10-9 depicts an entire human figure. The limbs of such figures are sometimes moveable, suggesting that the figures were used as a type of puppet.

In addition to masks that represent human heads, there are also those that represent skulls and animals. The mask in figure 10-10 combines the features of a crocodile's head with a woman's elaborate coiffure. Again, the head is covered with animal skin and stained dark brown. The hole in the forehead probably once held a crown. Dark masks such as this one are performed in torn and dirty dresses made of rough materials in drab colors. They are related to a type of mask that suggests deformity and that has distorted features such as flopping ears, huge or disfigured noses, or long hanging tongues. All of these animal masks and grotesque masks are seen as fierce and frightening.

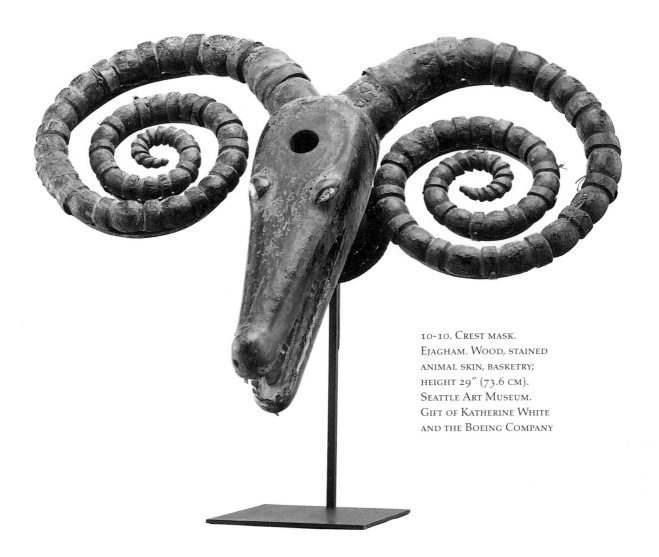

10-10. CREST MASK.
EJAGHAM. WOOD, STAINED
ANIMAL SKIN, BASKETRY;
HEIGHT 29″ (73.6 CM).
SEATTLE ART MUSEUM.
GIFT OF KATHERINE WHITE
AND THE BOEING COMPANY

CAMEROON GRASSLANDS

To the east of the Cross River, in western Cameroon, lies a mountainous region known as the Cameroon grasslands. Numerous small groups of disparate origins spread throughout this region prior to 1900. Stateless societies as well as highly centralized kingdoms arose and participated in a flourishing trade network. The rulers, or *fon*, of the numerous kingdoms used art to bolster the prestige and authority of their courts, and alliances among kingdoms involved exchanges of art objects identified with the royal

structure. Over time, these exchanges caused many cultural features to be shared among grasslands courts, which has permitted scholars to speak of an overriding "grasslands art style."

The development of grasslands courts reached a peak in the nineteenth century during a period of flourishing trade that increased the availability of imported materials and luxury goods. Believed to be divine, kings were religious as well as secular leaders. Beneath the king, society was comprised of commoners and a hierarchy of titled nobility. Nobility was

further divided into those descended from the sons of kings (nobility of the blood) and those descended from commoners rewarded for their service to the king with a title (nobility of the palace). In a typical grasslands community, a large percentage of the population was considered noble. Commoners had no claim to any art, which was used exclusively by the king and, by his grace, the nobility. Whether it was employed directly in the king's service or used by a retainer or a prince to exhibit his own rank, all art theoretically belonged to the king who also had a monopoly on

all precious materials—brass, imported fabric, and imported beads. Theoretically he also owned the hides, teeth, and claws of animals such as the leopard, the elephant, the buffalo, the crocodile, and the serpent as well as the right to use them as symbols.

The authority of the king decreased with colonial domination in the early twentieth century and has been regarded with suspicion by modern governments. However, each king remains the symbolic sovereign and acts in a fundamental ceremonial capacity in his realm today. Art is still used as a means of bolstering the authority of the elite.

Palace Architecture

The most conspicuous symbol of kingship was the royal residence. Although many palace compounds have fallen into disrepair or have been replaced by tinroofed, concrete block buildings, some have been maintained, and a few have been proclaimed national monuments by the Cameroon government.

Numerous domed units made up the palace at Foumban, the capital of Bamum (fig. 10-11). By the end of 1910, this magnificent building had been destroyed, but photographs and detailed descriptions exist. Long straight rows of tall, domed houses connected by saddle-like roof sections

created a complex of several distinct areas, each centering upon a courtyard. The portion shown in the photograph here is but a small segment of the palace. The basic building unit was a square room surmounted by a domed roof. Lattice walls made of three layers of palm rib were assembled on the ground and lifted to be joined together. Frameworks for the ceiling and roof sections were similarly completed on the ground and hoisted into position. The completed roof was topped with thatch and the walls were sometimes plastered with clay. In addition to the multiple units that served as domiciles for members of the court, there

10-11. The palace at Foumban, Bamun, Cameroon. Photograph c. 1910

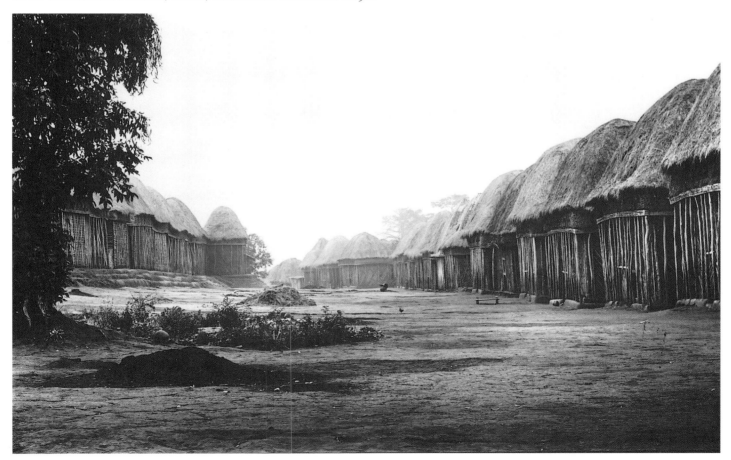

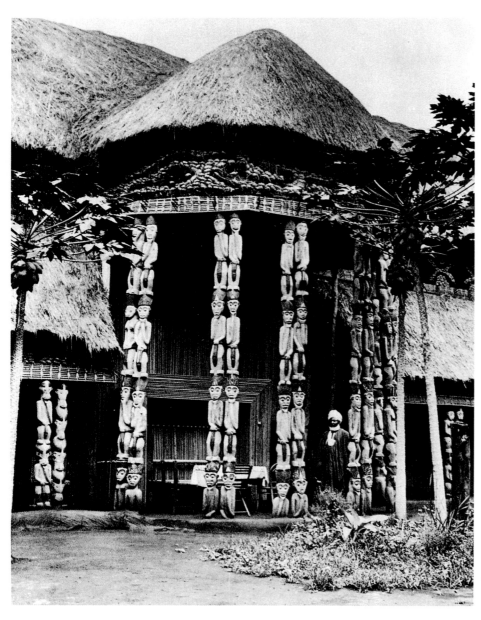

10-12. INTERIOR COURTYARD OF THE PALACE AT FOUMBAN, BAMUM, SHOWING RECEPTION AREA AND CARVED PILLARS. PHOTOGRAPH 1907

were granaries and entrances or gate-houses. Larger separate buildings served as audience halls, clubhouses, and market buildings. The great courtyards served as settings for a variety of palace activities. Upwards of three thousand people were housed in the palace and its adjoining buildings, including the king's 1200 wives and 350 children.

A photograph taken in 1907 shows Njoya, king of Bamum from 1885 or 1887 to 1933, standing in the inner courtyard of the palace near the reception hall (fig. 10-12). Under a tall, semi-circular porch is a reception area furnished with European-style chairs. The carved pillars that support the roof of the porch and its adjoining verandahs depict paired male and female retainers dressed in loincloths and headdresses indicating high status. A double-headed serpent motif is burned into the grass frieze over the columns. As royal symbols, double-headed serpents suggest that the king can assure military victory by striking on two fronts simultaneously.

The palace in the kingdom of Bekom also clusters individual buildings to create a sprawling complex. A distinctive feature here is a horseshoe-shaped grouping of basalt monoliths that served as the symbolic seat of justice and as a reference to the continuity and stability of the people (fig. 10-13). Similar stones in other grasslands palaces marked the graves of deceased kings and formed the sacred center of the kingdom.

Sculpture plays an important role in the decoration of grasslands palaces. Structural elements such as houseposts and doorframes are often carved, sometimes with considerable

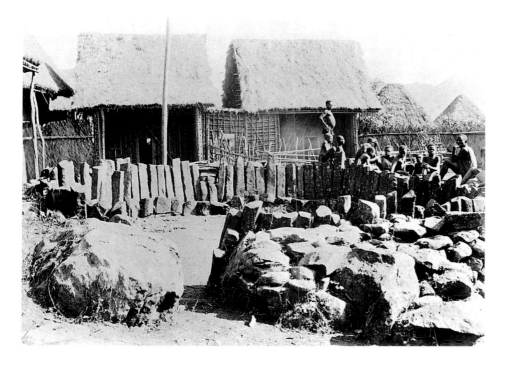

depth and openwork. Carving also decorates the homes of dignitaries and the lodges of secret societies.

Grasslands doorways are raised from the ground and resemble windows set low enough to step through. Their frames are usually carved in relief and sometimes painted in polychrome. Figure 10-14 shows Obemne, king of Baham, seated at the door to a building within his palace. His predecessor, Poham, commissioned the doorframe. Compared to the more restrained posts in the Bamum palace (see fig. 10-12), the doorframe here is a lively, dynamic composition in which voids interact with solids to suggest energy and movement. The carvings tell a cautionary tale about Poham

10-13. COURTYARD OF THE PALACE AT BEKOM, CAMEROON. 1908

10-14. OBEMNE SEATED BEFORE A PALACE DOOR, BAHAM, CAMEROON. 1937

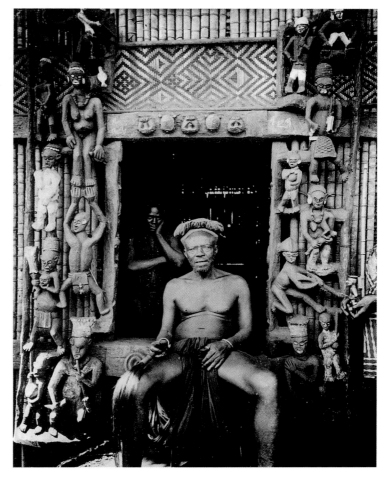

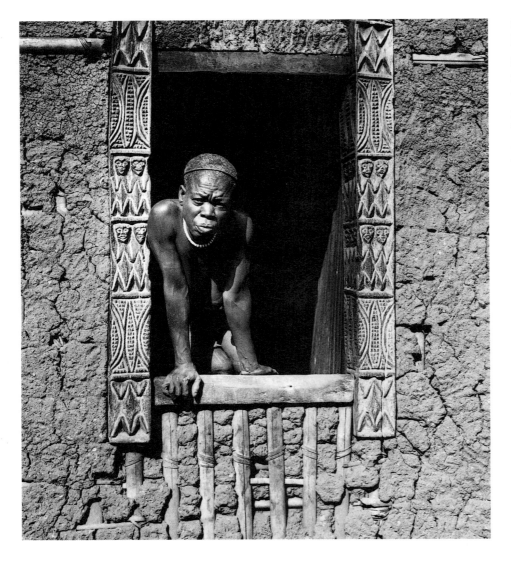

himself, whose unfaithful wife left his court to have a child with one of his subjects. Poham, depicted seated and smoking his pipe at the lower left of the composition, ordered the punishment of the immoral couple and the beheading of the unfortunate child.

A doorframe from the small kingdom of Fungom shows a less flamboyant style (fig. 10-15). Here the frame is manifestly solid, its rectangular beams carved in low relief with human, animal, and abstract geometric forms. While the carvings add to the architectural beauty of the building, they also offer symbolic protection against evil and unwelcome callers by referring to the power of the king and his royal ancestors.

Arts of the Royal Treasuries

In the palace, the king surrounded himself with elaborate, sometimes massive visual displays that declared his economic, socio-political, and religious authority. These constituted the royal treasury, a rich accumulation of textiles, clothing, portable objects, furnishings, sculpture, and masquerades. To create his treasury the king brought together great numbers of artists, the best of whom might be rewarded with noble status for their work. The availability of brass, beads, cloth, and other luxury goods in the nineteenth century inspired artists of the time to develop great numbers of spectacular royal art forms. During the colonial period, the abundance of royal art decreased dramatically and its quality diminished. Today, artists still create some forms, although they have ceased making others.

Perhaps the most significant status symbol in the grasslands area is the carved stool. A typical grasslands stool has a ring base, a central and often cylindrical supporting portion, and a disk-shaped seat. Nearly everyone in the region owns a stool, however humble. The most impressive stools are carved for the king and serve as thrones. Grasslands artists lavished considerable inventiveness on royal thrones, which are often embellished with the likenesses of leopards, pythons, elephants, and buffalo—all animals symbolizing sovereignty.

At some point, probably at the beginning of the eighteenth century, a larger version of the cylindrical stool-throne, one that included a back, was introduced. One of the finest examples is the throne of Nsangu, who ruled Bamum c. 1865–1872 and c. 1885–1887 (fig. 10-16). The cylindrical openwork support depicts interlaced double-headed serpents. Rising from the back of the seat are two figures representing

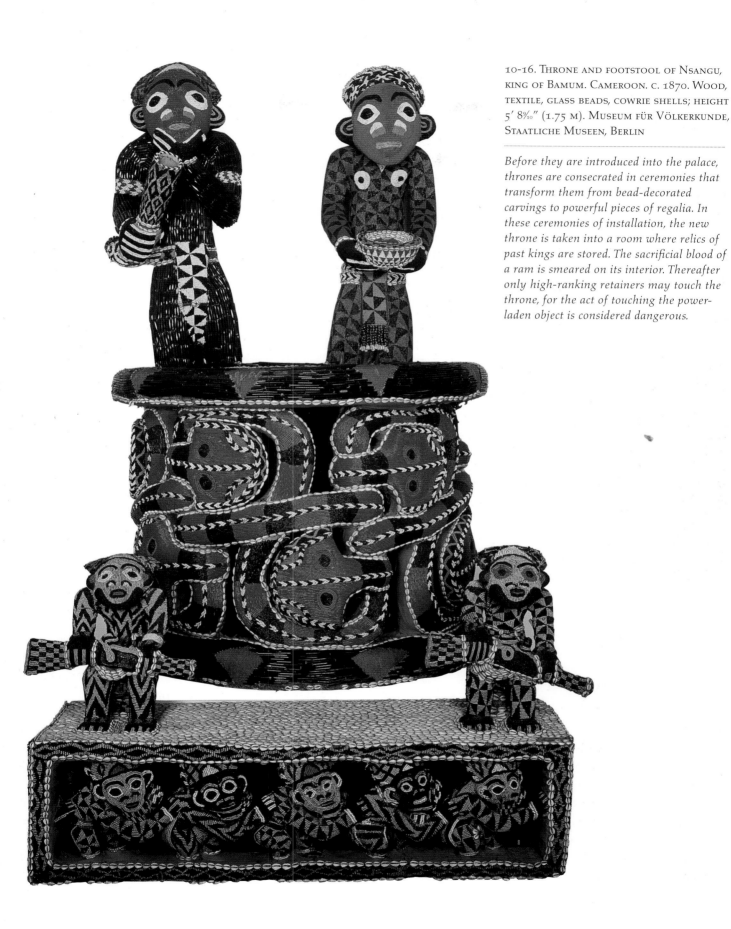

10-16. Throne and footstool of Nsangu, king of Bamum. Cameroon. c. 1870. Wood, textile, glass beads, cowrie shells; height 5' 8%₀" (1.75 m). Museum für Völkerkunde, Staatliche Museen, Berlin

Before they are introduced into the palace, thrones are consecrated in ceremonies that transform them from bead-decorated carvings to powerful pieces of regalia. In these ceremonies of installation, the new throne is taken into a room where relics of past kings are stored. The sacrificial blood of a ram is smeared on its interior. Thereafter only high-ranking retainers may touch the throne, for the act of touching the power-laden object is considered dangerous.

high-ranking retainers waiting on the king. The male retainer holds a royal drinking horn, the female retainer holds a bowl. At the base of the throne sits an openwork, rectangular footstool. Two figures of warriors carrying flintlock guns stand atop it. Dancing retainers are carved in sunken relief on the front panel. The entire ensemble is covered with heavy fabric richly embroidered with cowrie shells and colorful beads.

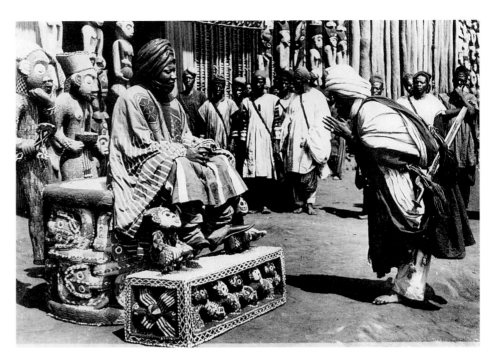

10-17. KING NJOYA SEATED ON HIS THRONE, BAMUM, CAMEROON. 1912

10-18. A KING SEATED IN STATE BEFORE A TEXTILE BACKDROP, DSCHANG REGION, CAMEROON. 1930

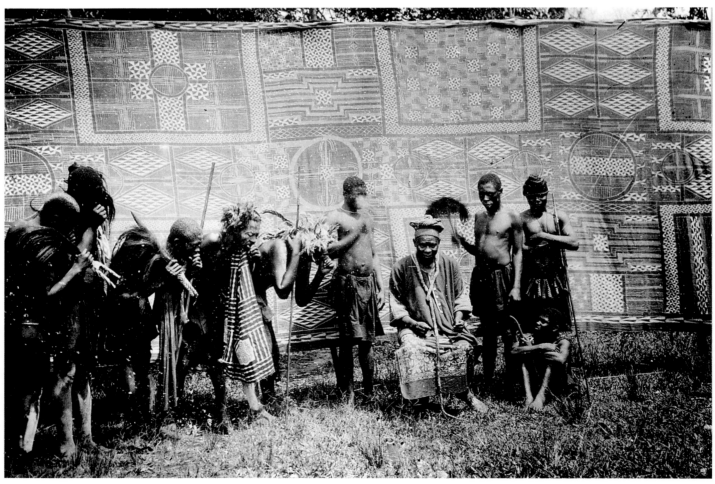

Royal thrones are believed to receive life force from their owners. Thus at the death of a king, his throne dies as well, and it may be buried with him or exposed to the elements to decay. Some thrones are given away as gifts to visiting dignitaries. Some seem to have been inherited by a successor, but a king rarely uses a predecessor's throne as his state seat. Instead, soon after his coronation, a king orders the creation of a new stool, specifying the motifs to be associated with his reign. In this spirit, Nsangu's son Njoya commissioned a new throne for his own use (fig. 10-17), and gave Nsangu's throne to German associates as a gift. Interestingly, the photograph shows that Njoya requested a duplicate of Nsangu's throne, instead of specifying a new iconography.

Textiles are included in the royal treasury as well. Indigo-dyed cloths are often draped within the palace or in an outdoor arena to provide a backdrop for an appearance by the king (fig. 10-18). The royal cloth is rich in patterns with specific meanings, some of which are also used as bead-embroidery designs on thrones. Many grasslands kingdoms import such cloths from the Jukun people of Wukari in northeastern Nigeria. The kingdom of Kom was long the exclusive importer of Wukari cloths into the grasslands area.

Drums, sculpture, stools, and numerous smaller objects from the treasury may be displayed around a king seated in state. These smaller objects may be held by retainers or by wives of the king. Figure 10-19 shows the king of Babungo attended by four of his wives, each of whom holds a portable object from the royal treasury. The woman to the left lifts a decorated calabash used as a container for palm

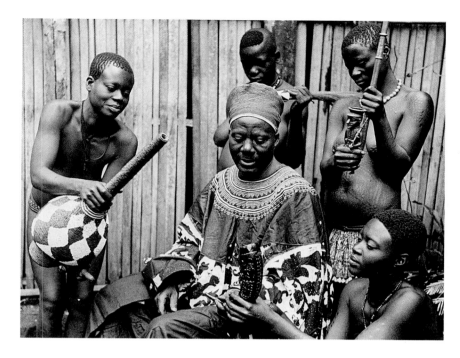

wine. An important item of regalia, the calabash often appears as an attribute in royal portraiture, where it may be shown in the hands of a wife. The wife to the right foreground holds a drinking vessel carved from buffalo or cattle horn and adorned with abstract designs that allude to status. The wife to the rear holds a ceremonial flywhisk whose handle is worked with bead embroidery. The woman at the king's shoulder carries a brass pipe, a symbol of high status and an important ceremonial object. Cast using the lost-wax technique, the pipe depicts a German officer, a reminder of Germany's colonial presence during the early twentieth century. Almost everyone in grasslands society smokes tobacco, but the pipes associated with important men are extravagantly different from the everyday types used by ordinary people. While ordinary pipes are usually made of terracotta or wood, royal ceremonial pipes may be made of brass, stone, bone, or even ivory.

10-19. A KING OF BABUNGO WITH ROYAL WIVES HOLDING OBJECTS FROM THE TREASURY. CAMEROON

The king had the privilege to use such objects at all times. Other titleholders, such as some royal women, princes, high-ranking heads of lineages, and court functionaries, inherited the right to use regalia, but such rights had to be confirmed for each generation by the ruling king. Granting entitlement to such objects intensified the alliance between the king and his favorites.

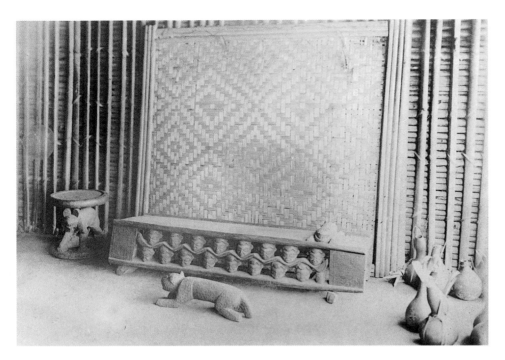

10-20. ROYAL BEDCHAMBER, CAMEROON. PHOTOGRAPH 1908

side allude to trophy heads taken in war. A leopard, symbol of royalty, supports the seat of the stool to the left of the bed, and another leopard figure positioned in front of the bed probably served as a footstool.

A photograph taken in 1908 documents a number of royal bowls used in the Bamum palace at Foumban during Njoya's reign (fig. 10-21). Such bowls served a variety of purposes. Some are food bowls, while others supported calabashes filled with beverages. Sacrifices were also placed in such bowls to propitiate supernatural or ancestral powers. Some are kola nut receptacles, which were kept near kings so that the kola was ready to be offered to guests.

The terracotta bowl shown in figure 10-22 was used in the palace at Foumban as a container for sauces. Grasslands artists employ a number of abstract, sometimes geometric motifs derived from depictions of various symbolic animals. The openwork base of this bowl is carved in a motif of bands and knobs known as the spider

Within the palace, furniture was ornately carved with motifs that alluded to rank and power. The royal bed shown in figure 10-20 was carved from a single piece of wood. A raised portion serves as a pillow. The human head motifs depicted in relief on the

10-21. BOWLS DISPLAYED IN A COURTYARD OF THE PALACE AT FOUMBAN, BAMUM, CAMEROON. 1908

Most of the bowls shown in this photograph are hemispherical containers carved in relief and with openwork bases. Some, such as the one in the center foreground, have figural bases, in this case a leopard. The bowl to its right has handles carved in the form of a human figure on one side and an animal figure on the other.

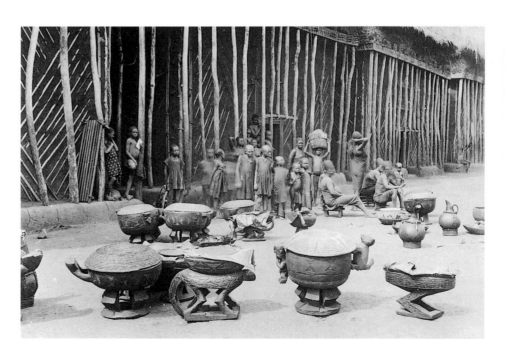

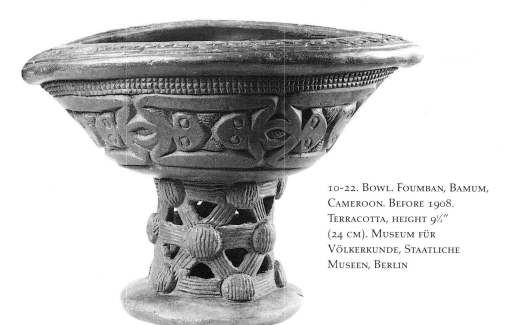

10-22. Bowl. Foumban, Bamum, Cameroon. Before 1908. Terracotta, height 9½" (24 cm). Museum für Völkerkunde, Staatliche Museen, Berlin

frog with human fertility, a concept that is central to ideas of strength and power as measured in the numbers of people that support the king and provide his kingdom with a work force and an army.

It is customary in the grasslands for a king to have his portrait carved during his reign, along with portraits of titled women such as the more important royal wives and the queen mother. In some regions, a king's portrait is carved during the reign of his successor. The artist Bvu Kum carved a portrait of Bay Akiy, king of the kingdom of Isu, in the early twentieth century (fig. 10-23). The ruler is shown

motif. The motif evokes the large earth spider, which lives in a burrow below the ground and is thus believed to connect the realm of humans (above ground) with that of the ancestors (who were buried in the earth). Active at night, it sees things humans cannot see, such as wandering spirits and nocturnal beings. The spider is seen as a symbol of supernatural wisdom and auspicious power, and as such it is consulted by specialists who interpret the disturbances it makes to leaves cut with openwork designs and placed near its lair. Ultimately, then, the spider motif refers to the importance of ancestral spirits who guide the king and his people. The spider motif is also noticeable on the end of Njoya's footstool (see fig. 10-17), where it served to remind the court that Njoya was an agent of the royal ancestors. It is the most frequently used motif on prestige arts bestowed on others by the king.

The belly of the bowl and the upper portion of its rim are decorated with the frog motif. More directly

representational than the spider motif, the frog motif depicts the heads and forelegs of two frogs joined back-to-back to a single, abbreviated body. The motifs are linked together by joining the forelegs of each unit to the next. The frog is the second most frequently used motif on grasslands prestige arts. Grasslands belief systems associate the

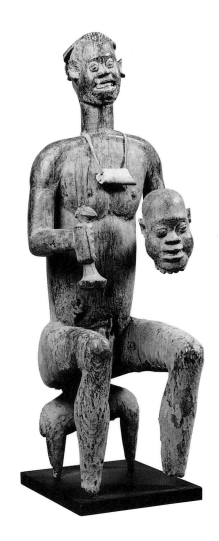

10-23. Portrait figure of Bay Akiy. Bvu Kum. Early 20th century. Wood. The Walt Disney–Tishman African Art Collection

A portrait figure of a king is sometimes displayed surrounded with portrait figures of wives and retainers, just as a living king is surrounded by wives and retainers in court to reinforce his power and to indicate his rank and position. A portrait figure of a king is intended to preserve the kingdom's history, its genealogies, and its legends. It has a narrative function in telling the lore of the group. Groups of such figures will often be placed near the doorway of the king's residence to signify the origins and the future of his people.

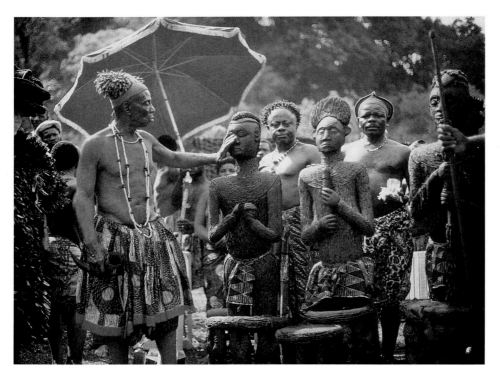

10-24. KING JINABOH II AT HIS ENTHRONEMENT WITH THE *AFO-A-KOM* ("THING OF KOM") AND SUBSIDIARY PORTRAIT FIGURES, KOM, CAMEROON. 1976

Jinaboh, his body ritually colored with camwood or red ocher, reaches out to touch the representation of a titled wife of Yu. She wears her hair in a style associated with the palace, and clasps her hands in respect for her husband and the queen mother, the figure on the far right. The office of queen mother is held by a woman of especially high status in court, and her effigy is carved wearing a royal coiffure and carrying a royal staff. The figures have been covered with wrappers of printed fabric for the occasion.

seated on a four-legged animal. He lifts a cutlass with his right hand and holds in his left hand the head of the king of a small neighboring state, a trophy of his victorious triumph over the enemy. The expressive facial features are accentuated by the addition of ivory teeth. The head turns to the right, helping to activate the vigorous figure. A cord with a huge bead and a piece of human femur hangs from the neck. Attitudes of victory, rejoicing, and ferocity are all encompassed in the figure, which was carved to serve as a symbol of Bay Akiy's reign as well as to evoke the power of his office and his family.

Grasslands portraiture does not stress physical likeness. It is not so much the physiognomy of the individual that is depicted but the position the person holds and his character. The individual is recognized by attributes rather than by physical appearance. Several features suggest that this image is a symbolic portrait of a king. The pose of the figure indicates status, for sitting suggests rank. Normally, a person of great status sits in the presence of his lessers, who must stand. The ceremonial knife and the trophy head that the figure holds are likewise indicators of royal authority.

In the kingdom of Kom, portrait figures include a representation of a royal stool. The stool serves as a base from which a standing figure, shown from the thighs up, seems to be emerging. Often referred to as throne figures, they are not used as chairs but rather serve the same purposes as other commemorative portrait figures elsewhere in the grasslands region. The stool can be seen as an attribute, a reference to status, much as trophy heads or calabashes in other royal portraiture traditions.

Kom figures were carved in sets that included the king and some of his wives and retainers. Three figures of one set are still used in Kom (fig. 10-24). A king of Kom named Yu carved the set, which originally included six

figures, in the first decade of the twentieth century. Carving is seen as an honorable profession in the grasslands, and some kings have had considerable reputations as carvers. Yu, who reigned from 1865 to 1912, is said to have organized a group of his fellow sculptors to produce a prodigious amount of art for his court. A number of these artists are still remembered in Kom by name.

The central figure in the photograph is known as the *afo-a-Kom*, or "thing of Kom." The people of Kom consider it to be an effigy of Yu himself, and thus a type of self-portrait that now serves as a memorial ancestor figure. Yu is depicted wearing a cap and holding a short staff. Although a photograph of Yu himself with at least two of these Kom figures shows their surfaces to have been unadorned, the bodies have since been covered with cylindrical beads. The rose-colored beads covering the *afo-a-Kom* evoke the reddish color of the camwood cosmetic that ritually covers the body of the king during his installation.

Royal Spectacle and Masquerade Arts

Not only was the grasslands palace a work of art and a repository for numerous art forms, but it also served as backdrop for special events that reinforced the idea of central control and hierarchy. A particularly striking festival called *nja* formerly occurred annually in the kingdom of Bamum during the dry season, usually in December. Prestige and beauty seem to have been its focus. All the king's subjects met at the palace dressed in their finest raiment. The facade of the palace was festooned with royal textiles, and the ceremonial site before the palace was enhanced with objects from the treasury, including the royal throne. The king made an appearance before his subjects as the incarnation of wealth and might.

During the festival, which was an art of spectacle, the king, his retainers, his councilors, indeed, all significant persons of the kingdom, danced in special dress. Some retainers appeared in

disguise, wearing masks, followed by councilors in batik dress and wearing headdresses similar to the king's. Princes, descendants of former kings, followed in their own elegant dress, holding symbolic flywhisks.

Njoya's costume for the *nja* festival was photographed in 1908 (fig. 10-25). In posing for the photograph, Njoya himself chose to wear a colonial uniform and to have a surrogate model the *nja* garment. According to the photograph, when Njoya appeared in the festival, he wore a fake beard of tubular beads. Armlets and anklets of beads weighed down his limbs. A voluminous loincloth of indigo and white cloth draped to the ankles in massive folds between his legs. From his hips hung bead-embroidered otter pelts. A belt with double serpent heads girded his waist. He held a white horsetail flywhisk in his right hand, provided with a bead-covered figure of a man for the

10-25. NJOYA WITH SURROGATE WEARING HIS COSTUME FOR THE *NJA* FESTIVAL, BAMUM, CAMEROON. 1908

handle. A necklace of beads and leopard teeth cascaded over his abdomen and chest. A ceremonial sword boasted a serpent head on the hilt. It was suspended from his shoulders by a scabbard covered in cloth and decorated with spider designs in beadwork. On his head Njoya wore a huge headdress known as *mpelet*, with flying fox figures made of cloth, beads, and feathers. A double train of indigo batik royal cloth draped from his waist, supported in this dramatic photograph by eleven retainers.

While masks and masquerades may appear in royal festivals, they are normally associated with a variety of men's societies, most of which are ultimately linked to the palace and the king. The societies are closed to outsiders, and only those who are authorized to participate in their activities may do so. Each society has its own special house, its own masks, costumes, dances, and secret language. Each acts on behalf of the king to establish order and to preserve the social and religious structure of the kingdom.

One such society is Kwifo. While the king hears complaints and counsels his people, it is the awesome Kwifo that acts as a police force, carrying out punishments and executions at night (*kwifo* means "night"). As an agent of the king's administration, Kwifo also mediates significant conflicts and pronounces sentence in both civil and criminal cases.

Each Kwifo society has a mask that serves as a spokesman and representative. Known as *mabu*, this mask presents the decrees of the society to

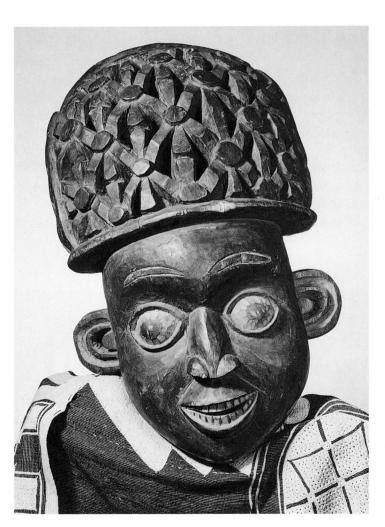

10-26. MASK WITH EARTH SPIDER MOTIF HEADDRESS. GRASSLANDS REGION, CAMEROON. BEFORE 1914. WOOD, HEIGHT 27" (69 CM). FIELD MUSEUM OF NATURAL HISTORY, CHICAGO

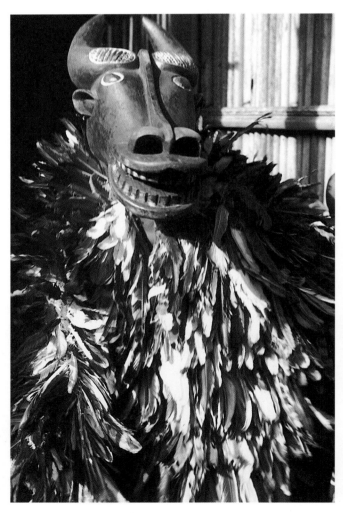

10-27. HORIZONTAL BUFFALO MASK FROM BABUNGO, CAMEROON. 1940

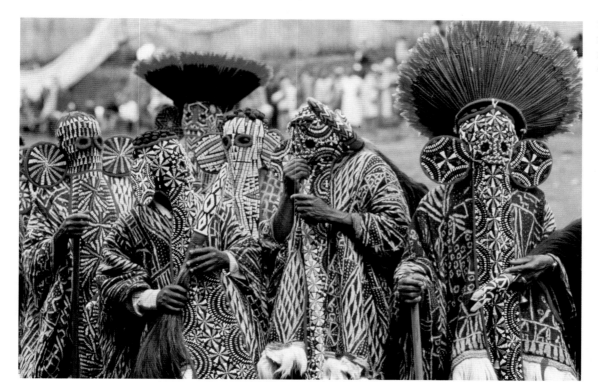

the community. It ushers the members
of Kwifo through the village, alerting
the people of the approach of the
group, and compelling them to behave
appropriately. Other masks are credited
with supernatural strength generated
by the "medicine" of Kwifo, and
embody the aggressive and terrifying
nature of the society. Because of the
gravity of the events surrounding their
arrival, their wearers do not dance.

The photographs in figures 10-26
and 10-27 are typical of Kwifo masks.
Such masks usually perform in groups
of eight to thirty, accompanied by an
orchestra of drums, xylophone, and
rattles. When they make special
appearances at the burial and com-
memorative death celebrations of a
member of the group, they are viewed
with awe and reverence.

The mask in figure 10-26 is typi-
cal of grasslands masks that depict
human-like male figures, with its

exaggerated features, open mouth, and
bulging eyes. Large and helmet-shaped,
it is worn at an angle on the top of the
masker, whose own head is covered
with a cloth through which he can see.
The headdress carved on the mask's
crown alludes to a prestige cap worn by
kings and titleholders, reminding view-
ers of the high status of the group
performing the masquerade, while the
repeated earth spider motif carved on it
alludes to the awesome powers of
ancestors and spirits. The forest buffalo
represented in figure 10-27, along with
the leopard, elephant, and serpent, are
royal icons symbolic of the privileges
and authority granted to the group by
the king. The mask here is worn with a
costume of feathers.

In the Bamileke region of the
grasslands, a society known as Kuosi
is responsible for dramatic displays
that involve spectacular masquerades.
Formerly a warrior society, its

membership is now composed of pow-
erful, wealthy men. The king himself
might even don a mask for appearance
at the Kuosi celebration, a public
dance sponsored every other year as a
dazzling display of the kingdom's
wealth. Kuosi elephant masks such as
those in figure 10-28 have large flaps
of cloth that cascade over the masker's
chest and down his back. Covered with
beaded designs, the flaps symbolize
elephant trunks. Costumes worn with
the masks include beaded garments,
indigo-dyed royal cloths, and leopard
pelts. Headdresses may be attached to
the masks or worn by themselves with
a costume. Some headdresses, great
expanding forms covered with red
feathers, look like extravagant flowers.
Leaders of the Kuosi society report
directly to the king, and may be
allowed to wear beaded sculptural
crests that represent leopards or ele-
phants, both royal animals.

10-29. MASK. GRASSLANDS REGION, CAMEROON. 18TH CENTURY. WOOD, HEIGHT 18½" (47 CM). MUSEUM RIETBERG, ZÜRICH

The mask represents a face with extravagantly exaggerated brows, their towering forms emphasized by parallel striations. Large, almond-shaped eyes, their surfaces animated by numerous tiny holes, sit on voluminous cheeks that project outward like ledges over a broad mouth whose vertical striations indicate teeth. The nose, its gentle curve rhyming with the curves of the cheeks and eyes, is tipped with two dilated, cup-shaped nostrils, whose form is echoed in turn by the low-set ears. The mask sits on a hollow cylindrical neck which is pierced with a ring of holes, perhaps for the attachment of a garment. Just below the holes, a band of cowrie shells is carved in relief

Perhaps the most famous of all masks from the Cameroon grasslands is a sculpture so formally compelling that many scholars consider it to be one of the masterpieces of African art (fig. 10-29). This style of forcefully abstracted mask probably dates at least to the eighteenth century. While similar masks have been found in several grasslands kingdoms, the historical center of production seems to have been the kingdom of Bandjoun. There the masks, called *tsesah*, are instruments of a closed association known as Msop. They were brought out to participate in the enthronement of a king or to act in the mourning festivities of great personages. They also came out to perform the *tso* dance at the palace, accompanied by ritual flutes. The *tso* dance symbolized the sovereignty of the kingdom and took place at the funeral of a king or a queen, at annual agricultural rituals that marked the end of the harvest and the new year, at special rituals that had to do with transcendent power, and at certain meetings of Msop. As with most of the works from the grasslands kingdoms, the form of this headdress conveys something of the spiritual and social authority of its owners.

MARITIME ARTS: THE DUALA

Far to the southeast of the grasslands region, on the coast of Cameroon, a number of peoples live in close

relationship to the waters of the ocean, estuaries, and rivers. Both their economic and spiritual lives have long been connected to the maritime environment, and many of their arts reflect this tie.

When European ships first began to appear off the Cameroon coast some five hundred years ago, one of these peoples, the Duala, initiated a trading relationship that lasted for centuries. By canoe they transported such goods as ivory, palm oil, rubber, and slaves to European ships anchored offshore, receiving in return European goods which were quickly integrated into Duala culture. The long centuries of trade influenced Duala social structure as well. Among the Duala, as among others in the region, lineage leaders had governed small groups of people.

But because Europeans seemed to prefer negotiating with one recognized authority in any given area, the Duala came to raise certain lineage leaders over others, giving them the role of spokesman and creating a new position of chief. Objects such as the ornate stool shown here were created as prestige objects that supported the position and authority of these newly created chiefs (fig. 10-30). Duala stools typically have a wide horizontal base and a curving seat. Geometric motifs interspersed with animal images decorate the bases. Here, serpents and birds are worked into a symmetrical design.

The canoe and the arts associated with it have become a cultural metaphor for the Duala. Sacrifices to water spirits who controlled success in fishing in the rivers and estuaries were

offered from canoes, and it was canoes that enabled the Duala to carry on their European trade. This trade fostered the growth of prosperous families, who competed with each other not only in business but also in canoe races. Such competitions are still important to the Duala. Racing dugouts today measure about fifty to seventy-five feet long and some three-and-one-half feet across. Up to thirty paddlers, each with his own personally decorated paddle, help to speed these crafts in competition. The surfaces of the sleek canoes are painted in a variety of geometric patterns, and the name of each craft, carved in relief, is also painted in the same bright colors. An elaborate openwork ornament called a *tange* is attached to the prow. The *tange* shown here is painted in

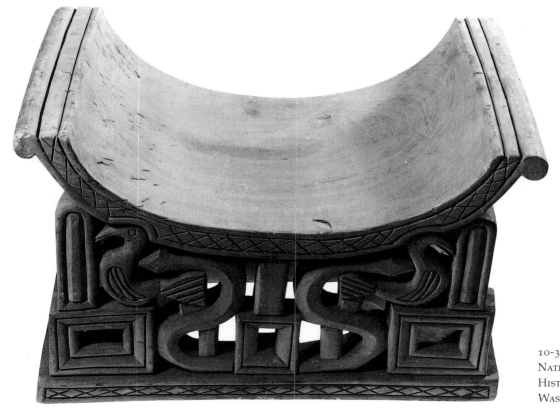

10-30. CARVED STOOL. DUALA. WOOD. NATIONAL MUSEUM OF NATURAL HISTORY, SMITHSONIAN INSTITUTION, WASHINGTON, D.C.

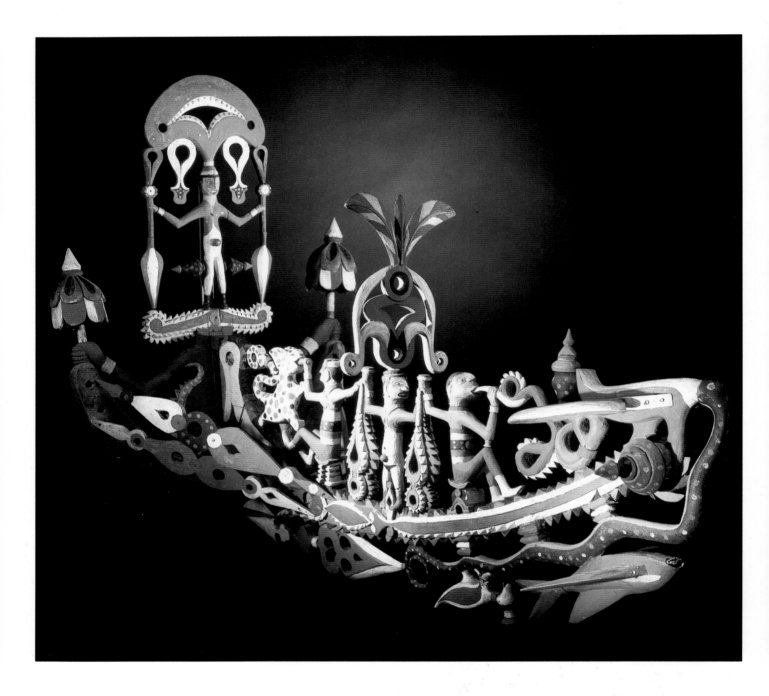

10-31. *TANGE* (PROW ORNAMENT). DUALA. 1890 OR EARLIER. WOOD, POLYCHROME.
THE NATIONAL MUSEUM OF ETHNOLOGY, STOCKHOLM

The tange is not merely a sculptural form. The canoe to which it is attached and the family to whom it belongs interact within the context of the race, where the symbols of power are not just seen but acted out in performance. Human beings working together as a team in concert with spiritual agencies activate the powers alluded to in the sculpture of the tange.

bright colors (fig. 10-31). Typical for the form, it is carved with an abundance of human and animal images engaged in a variety of activities. *Tange* iconography is chosen to intimidate rivals, and the figures depicted are usually expressions of power.

Serpents and birds dominate canoe iconography. Usually the two

are shown in confrontation. Here, a large snake writhes along the underside of the *tange*. Rising up over the tip, it has begun to swallow a bird standing on the upper side, even as it is being attacked by a second bird from below. The violent action underscores the superior strength of the canoe's owners. The lethal serpents symbolize a force that leaves no room for retaliation. Birds, on the other hand, may symbolize speed, suggesting rapid movement over the water. At the same time, they also signify power and strength. Other animals on the *tange* may refer to family totems or represent strength. They may also refer to Duala organizations. For example, the leopard depicted standing at the rear of the projecting section, while it is associated with leadership and connotes authority and chieftancy, may also refer to closed associations in the Duala area.

Images of humans on a *tange* may represent mortals of special rank or spirits in human guise. On both the long projecting element and the plaque-like crosspiece at its base, the central figures are dressed in European clothing and posed symmetrically. The man depicted on the crosspiece carries Duala dance wands; the man on the projecting section carries dance wands and wears an elaborate headdress indicating special status. Since both figures are dressed as Europeans but have non-European attributes as well, they may represent Duala persons of high rank, for Duala chiefs frequently greeted the ships of trading agents in European military garb. Europeans were associated with wealth and power, and it is possible

that the intent of such images was to suggest an economic alliance between the owner of the canoe and the powerful European traders that he controlled.

Seated secondary figures in this *tange* also wear European clothing and footwear, but they participate in non-European activities. One reaches out and grasps the tongue of the leopard, while the other grasps the tail of a serpent. This type of imagery, in which humans demonstrate mastery over animals without the apparent use of force, occurs repeatedly in Duala arts and suggests ritual activity and supernatural abilities. Such figures thus combine attributes of persons of power in two worlds, the economic world of the Duala with its European trade, and the spiritual world.

Duala artists often integrated European-inspired motifs into their iconography. Such motifs were carefully chosen and imbued with meaning. Images of trade goods, including weapons, European furniture, goblets, trays, oil lamps, decanters, and clothing, are references to social status, for example. On this *tange*, imported parasols serve as finials on either side of the crosspiece.

GABON

The dense rain forests of Gabon, which extend through Equatorial Guinea and into southern Cameroon as well, are home to at least forty ethnic groups that share a number of traits and similar institutions. They live in small, independent communities. Centralized political institutions such as those of the grasslands area of Cameroon are unknown. Instead, men's organizations help bring about social cohesion.

Reliquary Figures

Almost all these groups venerated the relics of ancestors, which were kept in containers with other objects that impart power. The bones and other relics of important relatives—those who were leaders, courageous warriors, village founders, artists or superior craftsworkers, and especially fertile women—were believed to be imbued with the powers that those extraordinary people had during their lives, powers that could be drawn upon to help the living.

French colonial officials banned reliquaries and the priests who controlled them during the first decades of the twentieth century. Until then, consultation of the ancestral relics preceded all significant events. Reliquaries took on different forms among various groups, but they fulfilled similar functions. A carved wooden head or figure often surmounted the container. Although museums display these sculptures unadorned, they were decorated with feathers and collars when they were in use. Such heads or figures were not understood as portraits of an ancestor or even as symbolic of ancestors. Instead, each was a protector of the relics, a warning to those who approached that sacred materials were within.

In these forest regions young men were introduced to the reliquaries of their family or association during the exciting and traumatic events surrounding their initiation into adulthood. The sharp divisions and rhythmic energy characteristic of reliquary figures helped youths understand the potent energy generated by the ancestral relics.

Among the best known of the regional reliquary traditions is that of the Fang people. The Fang and related groups are said to have migrated from the northeast over the past several centuries, entering the coastal areas of Gabon by the mid- to late nineteenth century. Historically, the Fang were itinerant, and it is only recently that they have settled into a broad area from the Sananga River in Cameroon, near Yaounde, to the Ogowe River in central Gabon.

The migratory existence of the Fang prohibited the creation of ancestral shrines at gravesites. Instead, the remains of the important dead, in the form of the skull and other bones, were carried from place to place in a cylindrical bark box, the basis of a transportable ancestral shrine called *nsek-bieri*. Within the container were represented a family's illustrious dead. Skulls were the most important of the relics, and the number of skulls in a

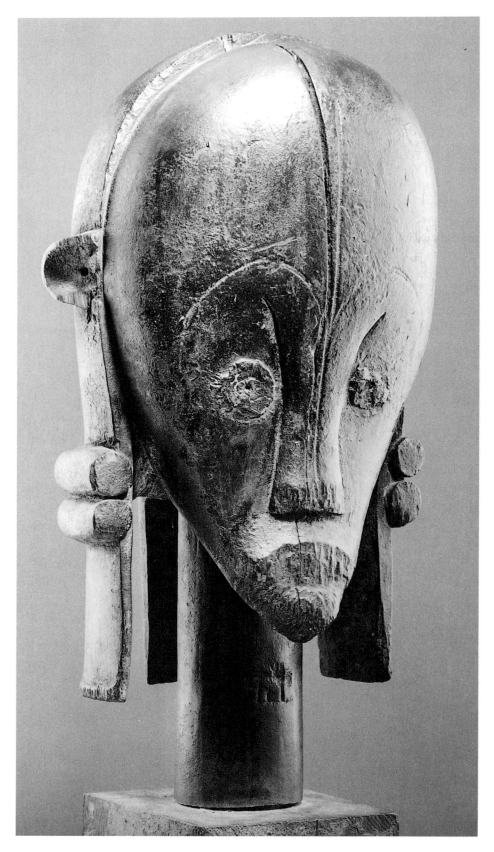

10-32. *Bieri* head ("Great Bieri"). Fang. 19th–20th century. Wood, height 18½" (46.5 cm). The Metropolitan Museum of Art, New York. The Michael C. Rockefeller Memorial Collection, Bequest of Nelson A. Rockefeller, 1979

Nsek-bieri *were consulted before any important undertaking. An old man considered close to the ancestors was in charge of the assemblage of relics and officiated at consultations. Such rituals usually took three to four days. The relics were taken out and covered with a substance to activate them. The* nsek-bieri *had to be fed to increase its strength and to stimulate fate when it was consulted. Animals were sacrificed to the ancestors and their blood smeared on the skulls.*

box was a tangible reference to the antiquity of the lineage; the more skulls, the older the lineage and thus the more power it manipulated.

The migratory history of the Fang has made it difficult to sort out stylistic groups. Individual artists moved from place to place, and styles were transmitted and absorbed easily. Moreover, reliquary figures collected from the region early in the twentieth century were routinely attributed to the Fang, even though they may well have been created and used by other groups. Nevertheless, a northern and a southern Fang style are easily discernible.

The imposing head with its ornate hairdo shown here is typical of the southern style (fig. 10-32). Standing over 18 inches tall, it is the largest such head known. The hairline across the top emphasizes a broad forehead. The hairdo recalls the wig-like headdress called *ekuma* which was worn by Fang warriors in the nineteenth century. The C-shaped ears are placed quite high, at a level with the arched brows. Discs of metal are attached for the eyes. The large mouth fills the narrow chin. The lustrous dark brown and black surface, typical of the southern Fang style, is the result of regular anointing with palm oil and copal resin. The long neck was originally attached to the lid of a bark container for relics, which would have been understood as the torso. Stylistic evidence suggests that the figure originated among the Betsi people, a southern Fang group located along the Ogowe River in central Gabon. The style of the object is very much like that of the heads of figures and half figures used for the same purpose in the region.

Fang artists from the north carved only full standing figures as reliquary guardians (fig. 10-33). The beautiful female figure shown here may once have been accompanied by a companion male figure on a second reliquary. It was created among the Mabea, who live on the southern coast of Cameroon and in neighboring parts of Equatorial Guinea and Gabon. The Mabea are part of a group of peoples who arrived in this part of Cameroon and Gabon before the Fang. Though linguistically unrelated to the Fang, they have nevertheless become Fang in culture.

This very accomplished work is typical of the Mabea substyle of Fang sculpture, in which the head is less than one-fourth the height of the elongated figure. A double-crested helmet form tops the forward projecting head. Almond-shaped eyes with their clearly defined pupils fit into slightly sunken orbits, while an open mouth with teeth exposed through thin lips juts forward over a negligible chin. Tall and thin, with an elongated torso and slender extremities, the body is naturalistically carved with rounded forms and well-modeled musculature. The elongated arms reach to the thighs, and the hands are separated from the thighs by carved projections. The distended belly is typical of all Fang-related figures. The navel is emphasized by its protrusion, and the slightly bent, powerful legs have swelling calf

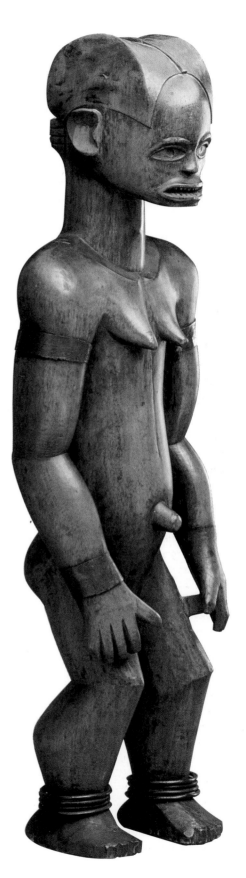

10-33. *BIERI* FIGURE. FANG (MABEA). WOOD. MUSÉE BARBIER-MUELLER, GENEVA

muscles. Like other Mabea-style figures this one has a light patina and smooth, well-finished surfaces. These surfaces contrast markedly with the brown-black, oozing surfaces of southern-style figures, and they suggest that the objects were treated differently when they were in use.

In addition to ancestral consultations, *bieri* figures were used during initiations. The rites included consumption of a plant with stimulant properties, which induced a trance lasting for several hours, and the "resuscitation of the ancestors," in which figures detached from the reliquaries were moved somewhat playfully from behind a raffia screen as puppets. In the heightened atmosphere of ceremony, music, dance, and altered consciousness, this show must have had a rather convincing effect of ancestral visitation.

Adjacent to the Fang in the Upper Ogowe River area of eastern Gabon and into the Congo Republic live the Kota peoples. The Kota are actually a number of groups of peoples with common cultural traits. Their present position is due to their movements under pressure from the Kwele peoples, who had been driven from their own territories between the seventeenth and nineteenth centuries by the Fang. Kota subgroups such as the Shamaye, Hongwe, Obamba, Mindumu, and Shake each stayed more or less together as entities during migrations over the past several centuries, but many others were broken up and scattered. Although they share many cultural traits, the groups are by no means homogeneous. They live in villages comprising two or more clans. Clans in turn comprise several lineages or family groups that trace their

descent from a common lineage ancestor. This is an important point related to their art, for like the Fang, the Kota revere the relics of ancestors.

The Kota keep bones and other relics of extraordinary ancestors in baskets or bundles called *bwete*. Bound into a packet and lashed to the base of a carved figure, the bones formed a stable base that allowed the image to stand more or less upright. The type of bundle varied according to location. The figures, called *mbulu-ngulu*, like the guardian figures on Fang *nsek-bieri*, served as protectors of the bundle.

At times a community brought all its reliquaries together in the belief that their combined power would offer greater strength against a danger. In some instances a group of families kept their reliquaries together under a small shelter erected away from the houses. The engraving in figure 10-34, published in the journal *Tour du Monde* in 1887 or 1888, depicts such a shelter in a community called Pongo.

There are several types of *mbulu-ngulu*, and a number of substyles can be identified. All are based upon the human face, even though they are abstracted and refer to nonhuman spiritual forces. All are carved

10-34. KOTA RELIQUARIES IN A SHELTER. 1888

Bwete *was called on in time of crisis to combat unseen agents of harm. Its intercession was sought in such vital matters as fertility, success in hunting, and success in commercial ventures. A husband could use it to guard against his wife's infidelity, for it was believed that if he placed pieces of her clothing in the reliquary, an unfaithful wife would be driven mad. Families took their* bwete *to ceremonies of neighboring villages to strengthen the allied community. The display of the bundles and their shiny, visually riveting figures was accompanied by feasting, dancing, and the making of protective medicines.*

of wood, then have copper or brass sheeting or strips applied to the surfaces. This shining material both attracts our attention and acts as a shield, and it is possible that it was seen as being able to "throw back" evil forces. The style of *mbulu-ngulu* depicted in the engraving has a number of variants. The forehead of the figure may complete the concavity of the oval face, as in the figure on the right, or it may bulge out in counter play, as in the figure on the left. The facial features are summarily indicated. Here, disc-shaped eyes were created by applying metal bosses and the nose is a slim pyramidal shape. The mouth is simply represented or left out entirely.

These stylistic features are also noticeable on the *mbulu-ngulu* from the southern Kota in figure 10-35. Emphasizing the plane of the face, it is almost two-dimensional in conception. A distinctly concave, oval face is framed by a transverse, crescent-shaped crest above and two lateral wings that suggest a hairdo. Cylindrical pegs drop from the wings, suggesting ear ornaments. Sheet metal in alternating segments of brass and copper forms a cross-shape on the face and completely covers the front of the crescent and the wings. A long, cylindrical neck connects the facial configuration to an open lozenge, which can be read as the arms of the figure, but which was once used to lash the *mbulu-ngulu* to its *bwete* bundle.

The smaller, very beautiful *mbulu-ngulu* in figure 10-36 is a variation on the theme. The transverse crest is much narrower than the crescent-shaped crest in figure 10-35. The lateral wings are curved, and there are no eardrops, though holes in the wings

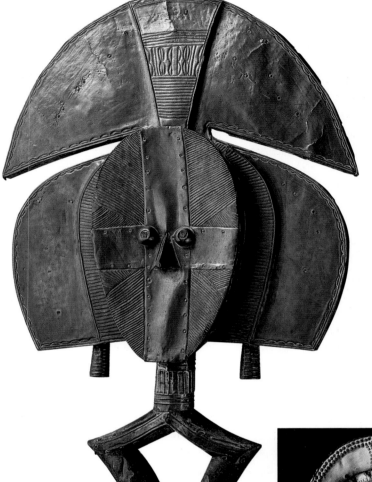

10-35. *MBULU-NGULU* (RELIQUARY FIGURE). KOTA. WOOD, BRASS, COPPER; HEIGHT 30¾" (78 CM). VÖLKERKUNDE MUSEUM DER UNIVERSITÄT, ZÜRICH

Metal, usually copper or copper alloy, formed the basis of currency in most of Central Africa prior to the colonial imposition of European coinage. Copper thus clothes these forms in prosperity and wealth, as well as giving them a reflective, gleaming surface.

10-36. *MBULU-NGULU* (RELIQUARY FIGURE). KOTA. WOOD, BRASS, COPPER; HEIGHT 16⁵⁄₁₆" (41 CM). MUSÉE BARBIER-MUELLER, GENEVA

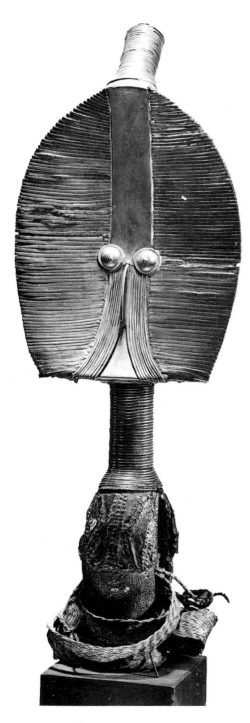

10-37. RELIQUARY FIGURE. HONGWE. BEFORE 1886. WOOD, BRASS, COPPER; HEIGHT 19¼" (49 CM). MUSÉE DE L'HOMME, PARIS

may have held earrings. The face of the figure is convex rather than concave, with a bulging forehead and eye sockets. Both sheet copper and sheet brass have been used to cover the form. A diadem motif frames the forehead, picked out in copper. The circular, projecting eyes are unusual for Kota figures.

Faces of reliquary figures sculpted by Hongwe artists are shovel-shaped (fig. 10-37). The Hongwe are one of the many groups who live in close proximity to the northeastern Kota. Hongwe reliquary figures consist of three distinct sections: the oval, concave face cut off at the bottom to produce a shovel-like form, the cylindrical neck, and an oval, openwork base. On the figure here, a vertical sheet-metal strip divides the face in two. Parallel strips of brass are hammered into the wood like long staples on either side. Eyes made of brass bosses are situated about two-thirds of the way down the central strip. The nose is a beak-like piece of brass below the eyes. Strips curve vertically from just below the eyes to the base, giving the appearance of a type of mustache. There is no mouth. A fillip at the top seems to represent hair projecting slightly to the rear. The cylindrical neck is wrapped in copper wire. The open oval base shape, which is covered with sheet metal, served to lash the figure to its *bwete* bundle.

Many other peoples in the region use figures to guard their reliquaries. These include a number of related peoples in southeastern Gabon such as the Shira, Punu, Vungu, and Lumbo. Although the guardian figures created by these groups are functionally akin to those of the Fang, the southern Kota, and the Hongwe, formally they resemble sculpture from the area of the lower Congo River (see chapter 11). One particularly fine example of a reliquary from southeastern Gabon is in the so-called white-face style shared by the Punu, the Lumbo, and a number of other groups (fig. 10-1). Here the delicate features of the guardian figure are picked out in white and accentuated with black markings.

Masks and Masquerades

Many of the peoples of the region use masks to initiate men into powerful fraternities. Some masks also establish the position of families within the larger community, and others acquire supernatural powers for their owners. This section looks briefly at the masks of three groups, the Fang, the Kwele, and the Punu.

While lineage groups organize most aspects of Fang life, a number of secret societies cut across lineage lines to address the community as a whole. One such society, now outlawed, was Ngil, a fraternity with judicial and police functions. Ngil settled disputes between clans, punished criminals, and searched for and destroyed witches and sorcerers who used their evil spells against the community. Within a town or village, Ngil represented several lineages and clans, but its impact reached beyond the family, and it could even be involved in the judicial affairs of several villages.

Spirits made manifest by maskers carried out the decrees of Ngil. Like the agents of Kwifo in the Cameroon grasslands, Ngil masks arrived at the home of a suspect in the dead of night, accompanied by a

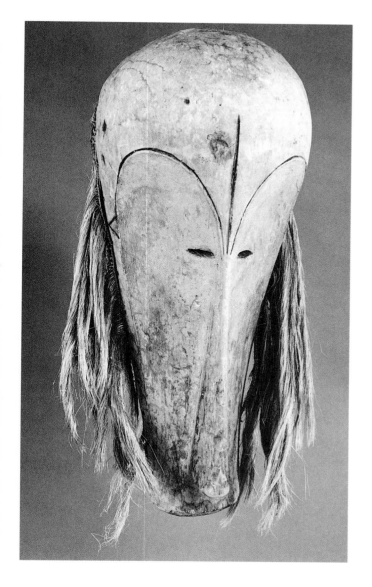

throng of members carrying torches. The masks were said to protect individuals against evil spells, poisonings, and recognition by outsiders. The word *ngil* means "gorilla," and masks worn by the association members shared the awesome size and fearsome features of this mysterious and powerful forest creature.

The abstract, elongated Ngil mask shown in figure 10-38 is almost two feet tall. Made of soft wood, it is whitened with kaolin, which for the Fang symbolizes the power of the spirits of the dead. Beneath a massive domed forehead, high arches over the eyes taper to a narrow chin, forming a heart-shaped face. A long, narrow nose separates the concavities of the cheek planes. The brows and eyes are picked out in black, burned into the surface with a red-hot blade. The serene countenance of the mask belies its terrifying role, for it represents a horrific being whose role was to eradicate evil. Ngil masquerades brought punishment to adulterers, thieves, debtors, poisoners, and those who were disre-

spectful in their dealings with society members. In use, a collar surrounded the mask, and a headdress made of feathers and raffia added to its size and bulk. The masker's body was painted black, white, and red, and he spoke in a raucous and forbidding voice.

The mask here was taken from a Ngil fraternity in 1890. Before French colonial officers banned Ngil in 1910, such masks may have aided in governing Fang communities for centuries. Ngil masks have not been used since the beginning of the twentieth century, but other styles and types of masks have succeeded them. Many of the newer masks seem to be modeled to some extent after the formal characteristics of Ngil masks such as the heart shape and the white coloring with black trim.

One newer type of Fang mask is *ngontang*. *Ngontang* masks were probably introduced in response to the coming of Europeans, for they began to appear in the 1920s, and the term *ngontang* literally means "young white woman." The mask is said to represent a female spirit from the land of the dead. Because Europeans are so pale, the Fang initially believed that they were spirits returning from the dead, and the link between white people and dead people is expressed in this masquerade. *Ngontang* masks are used in rituals aimed at locating sorcerers, those who misuse spiritual powers for their own gain. They also appear to entertain on the occasion of solemn family events involving the dead and ancestral spirits, such as death rituals, mourning, and birth celebrations.

The *ngontang* shown here is a cylindrical helmet mask ringed with

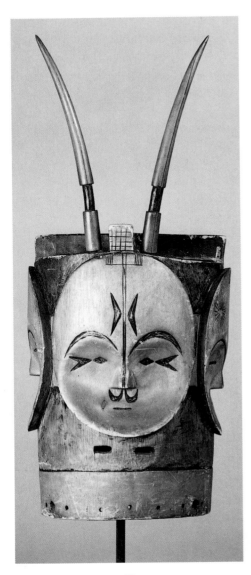

which remain. In the past when such a mask was worn, the masker's body was concealed with raffia fibers. Today, clothing, socks, and a fiber collar attached to the mask serve to conceal the wearer.

The Kwele are a fairly small group of forest people who in the early decades of the twentieth century moved from the headwaters of the Ivindu River into the Kota area, thus forcing the Kota into new territories. Like other peoples in the region, the Kwele formerly drew on the power of the relics of the dead for the benefit of the living, a practice they called *beete*. *Beete* was considered medicine for an ailing people. Relics were called upon in times of crisis, such as epidemic, famine, multiple deaths, or the deaths of great men or women. Disputes between family-based men's societies, *ebaaz* (sing. *baaz*), sometimes also required the healing power of ancestors.

The community was expected to reach a certain level of energy or

animation before the remedy of *beete* was applied, because medicine should be applied to something hot. In Kwele belief, hot people are less susceptible to illness. To bring themselves to the necessary heated state, the community invited forest spirits, *ekuk* (sing. *kuk*), to lead them in a dance. As neutral outsiders, *ekuk* could bring together a possibly riven community in a way

10-40. *KUK* (FOREST SPIRIT) MASK. KWELE. MUSÉE D'HISTOIRE NATURELLE, LA ROCHELLE

Such a mask would have been danced in a costume combining sumptuous loincloths of woven raffia, a product of the civilized world of men and women, with pelts of animal skin, used in witchcraft and associated with the occult world of the forest. The masker's body was fantastically patterned in red, black, and white. Nutshell anklets created rhythmic sounds as the ekuk *pounded their feet.*

10-39. *NGONTANG* ("YOUNG WHITE WOMAN") MASK. FANG. WOOD AND PIGMENT; HEIGHT 24⅜" (61.9 CM). THE UNIVERSITY OF IOWA MUSEUM OF ART. ON LOAN FROM MR. AND MRS. C. MAXWELL STANLEY

four oval faces (fig. 10-39). Each face, with its concave heart shape, is painted with white kaolin. Delicate designs in black burned into the surface vary from face to face. A dozen slender horn shapes once sprouted from the top of the head, only two of

painted white with kaolin. The eyes and nose are blackened, as is the area that surrounds the face. Superstructures indicate specific types of *ekuk*. The superstructure of this mask is a large zigzag form with four smaller renderings of the characteristic heart-shaped face carved in low relief.

Other types of Kwele masks belong to *ebaaz*. One of the most important of these is the *gon* mask, which displays the sagittal crest, triangular forehead depression, and canine teeth typical of the skulls of the adult male gorilla. Like other *gon* masks, the one shown here is stained dark and its fangs, mouth, and triangular forehead section are painted red (fig. 10-41). The *gon* masker darkened his body with charcoal and wore a minimal loin covering of mongoose skin. In his hand he held five javelins. His attendants controlled him and held him back by means of a rope around his waist. *Gon* ran around the village throwing his spears at anything in sight, trying to kill loose animals. The

ferocity of *gon* made him a "*kuk* of medicine." He was considered anti-social, acting the role of a leader of war. Aggressive, uncouth, and fearsome in his actions, *gon* was sent out by a *baaz* to test the mettle of others. He could be sent out for retribution, for punitive action, or to extort other *ebaaz* to participate in raids.

A number of groups in southern Gabon share a style of mask that has come to be known as the white-face style. Like the masks of the Fang, the Kota, the Kwele, and other peoples of Gabon, the faces of their masks are whitened with kaolin, the color of spirits and the dead. But while most masks in Gabon are abstractions of human and animal features, the white-face masks tend toward an idealized yet naturalistic human female face. Various groups make the masks, but those of the Punu and the Lumbo are probably the best known. The Punu mask shown in figure 10-42 is typical of these refined, lovely maidens. The rounded contours,

10-41. *GON* MASK. KWELE. WOOD AND PIGMENT. MUSÉE DES ARTS D'AFRIQUE ET D'OCÉANIE, PARIS

10-42. *MUKUDJ* MASK. PUNU. 19TH–20TH CENTURY. WOOD AND PIGMENT; HEIGHT 13″ (33 CM)

that human leaders, such as the leaders of rival *ebaaz*, could not. Maskers made the spirits manifest. Entering the village to the accompaniment of music, male spirits pranced rhythmically, while female spirits (also danced by men) shuffled slowly. Human followers mimicked their dance steps.

The mask shown in figure 10-40 is typical of the *kuk* masks used to lead dances in preparation for *beete*. The concave, heart-shaped face is

naturalistic proportions, narrow slit eyes with swollen lids, high arched brows, fleshy lips, and ornate coiffure distinguish these masks from other white-faced female masks such as the *ngontang* (see fig. 10-35) or the Igbo maiden-spirit masks (see chapter 9). The red scarification patterns—keloids in a lozenge formation just above the bridge of the nose and in rectangular formations at the temples—tell us that this mask represents a female character. The elaborate hairdo is painted black, while the sensuous lips are painted red. Such masks are called *mukudj* by the Punu and are still worn during public ceremonies and at funerals. The performance, which is extraordinarily beautiful, requires great skill, for it is accomplished on stilts that raise the dancer as much as ten feet above the ground (fig. 10-43).

While the mask performance brings joy to the community, underlying its appearance is apprehension and uneasiness. A talented dancer is vulnerable to envious adversaries who may attack him with sorcery. The *mukudj* performer must be continually vigilant and acutely aware of his surroundings to guard against mystical onslaught. The stilts provide him with a panoramic vista, permitting him to anticipate and dodge likely strikes by any who come with sinister schemes. The elevated position is also a reference to the source of his powers of agility and balance, which are said to be obtained from birds, which are also elevated above the earth. Symbolic acts such as throwing leaves or pouring water into the dancing arena and symbolically sweeping it are also used to offset mystical attacks. Additional mystical security is gained by wearing or holding protective "medicines" in the form of charms. Finally the performer must himself acquire mystical powers of clairvoyance. Snakes, with their flexibility and undulating movement, may also bestow agility on the dancer. Snakes' ability to scare potential antagonists is also a crucial attribute for the dancers, who draft a band of bodyguards and assistants.

10-43. PUNU *MUKUDJ* MASK IN PERFORMANCE, LOUANGO, GABON. 1993

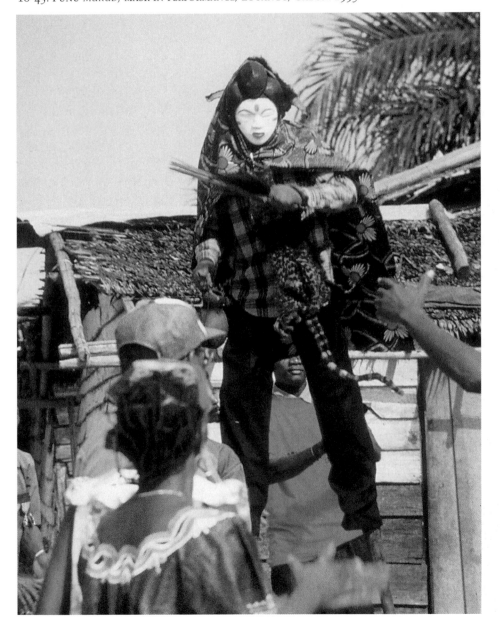

CONTEMPORARY INTERNATIONAL ARTS

Many artists in Central Africa today are self-taught or trained as sign painters. Others receive formal, academic training on the Western model

and produce art for an international clientele. While most of the great heritage of African art is three-dimensional, most international artists in Africa seem to prefer the medium of paint and two-dimensional forms. An exception is the sculptor Leandro Mbomio Nsue (born 1938), from the small country of Equatorial Guinea. Mbomio studied in Spain in the 1960s. He subsequently lived in exile for many years before returning to his native country, where he served as minister of culture. Mbomio's father and grandfather were both Fang sculptors who carved masks and *bieri* figures in wood. Mbomio, in contrast, casts his figures in bronze. Nevertheless, the rounded shoulders and overall proportions of the piece titled *Mascara bifronte* recall those of older Fang works (fig. 10-44). *Mascara bifronte* may suggest to Western eyes the types of sculpture that European artists of the first half of the twentieth century were producing in response to the inspiration of African forms. Perhaps a similar spirit of homage is at work in Mbomio's sculpture as well, for the artist has stated that "we have a human debt to make the ways and customs of our ancestors fruitful, prolonging them in time in keeping with new necessities."

10-44. *MASCARA BIFRONTE*. LEANDRO MBOMIO NSUE. BRONZE. FUNDACIÓN ESCULTOR LEANDRO MBONIO NSUE, MALABO

11
THE
WESTERN
CONGO BASIN

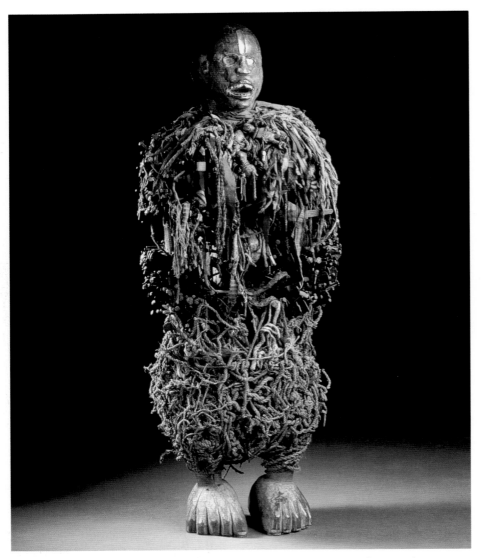

11-1. *Nkondi* figure. Lower Congo. Before 1878. Royal Museum of Central Africa, Tervuren

During the colonial period minkisi *played important roles in resisting foreign ways imposed from without. European missionaries saw them as evidence of paganism and had them destroyed or sent them home as evidence of idolatry. European military commanders captured them as documentation of an opposing political force. In spite of colonial repression,* minkisi *continued to be made and used and still work on behalf of Kongo people today.*

Central Africa is dominated by the Congo River and its numerous tributaries, which drain a vast region embracing several climatic zones and a landscape that varies from high-altitude tropical rainforests to savannah-woodlands and semi-arid plains. This huge river system has historically served as a primary means of transportation, and thus also of cultural diffusion and influence. The region's dense rainforests apparently discouraged human habitation for many centuries, for in comparison to other parts of Africa the Congo basin has been settled only recently. Linguistic studies suggest that Bantu-speaking populations from the northwest began to move into the area during the first centuries AD, possibly encouraged by new crops and the newly acquired technology of iron, which allowed them to make tools capable of cultivating the forested lands. Fanning outward over succeeding generations, speakers of Bantu languages came to dominate the region, as indeed through their various migrations they did the entire southern portion of the continent.

Art among peoples of the western portion of the Congo basin is used in leadership, funerary, and commemorative contexts, for the manipulation of mystical powers, and during rites of passage. These uses can be discussed in the context of several stylistic and cultural clusters. In the region known as the Lower Congo, which includes portions of the Republic of Congo, the Democratic Republic of Congo, and Angola, live subgroups such as the Vili, the Yombe, the Sundi, and the Kongo. KiKongo speakers, they were once part of the expansive kingdom of Kongo, an important regional polity

that arose during the fourteenth century. In the Kwango and Kwilu river valleys of southwestern Democratic Republic of Congo and the Angola border live the Yaka, the Suku, the Pende, and the Teke, while the lands along the Kasai and Sankuru rivers to the east in the Democratic Republic of Congo are home to the many peoples associated with the centuries-old Kuba kingdom.

EARLY ART

Iron implements were in use throughout the region by around AD 500, as were other technologies characteristic of settled agricultural life such as weaving and pottery. Gravesites from early periods suggest that material goods such as copper, iron, and beadwork were associated with status, and they point to the development of craft specialization, long-distance trade, and hierarchical political structures.

One of the oldest extant carvings from Central Africa was found in 1928 in Angola (fig. 11-2). Made of wood, it

11-2. ANIMAL HEADDRESS OR MASK. 8TH OR 9TH CENTURY AD. WOOD, 19¾" (50.5 CM). ROYAL MUSEUM OF CENTRAL AFRICA, TERVUREN

appears to be a headdress or a mask representing an animal of some sort, with tapered half-closed eyes, large nostrils, and pointed ears. The greatly simplified body suggests four tiny legs and a tail; engraved lines suggest the stripes of a zebra. According to radiocarbon dating it was made during the eighth or ninth century AD. The tradition of masking and the practice of creating beautiful art objects would seem to extend far back into the history of the area.

THE KONGO KINGDOM

One of the best known and best studied political units in all of Africa is the kingdom of Kongo. According to oral tradition, Kongo was founded toward the end of the fourteenth century by a ruler named Nimi a Lukemi, who established dominion over the area around Mbanza Kongo, his capital south of the mouth of the Congo River. The kingdom grew through the conquests and alliances made by his successors, and by the time Portuguese explorers arrived in 1483 it had become perhaps the largest state in Central Africa, a centrally organized nation with governors ruling over provinces on behalf of a king. A century later its expansion had ended. Nevertheless, during the sixteenth and seventeenth centuries the prestigious and powerful Kongo kingdom was known throughout much of the world and sent diplomats to Europe and Brazil.

Early Leadership Arts

Art proclaimed the authority of the Kongo kings, who were viewed as sacred. Luxury goods testified to their status, wealth, and privilege. Figures, stools, staffs of office, textiles, and other wonderfully embellished utilitarian objects set the king and his chiefs apart from commoners and established their right to rule. A beautiful textile made of raffia fiber was collected in Kongo in the seventeenth century (fig. 11-3). Such luxurious cloths were produced by a special weaving technique that created patterns of raised lozenges, some of which

11-3. TEXTILE. KONGO. EARLY 17TH CENTURY. RAFFIA, 9½ x 28¼" (24 x 72 CM). PITT RIVERS MUSEUM, OXFORD

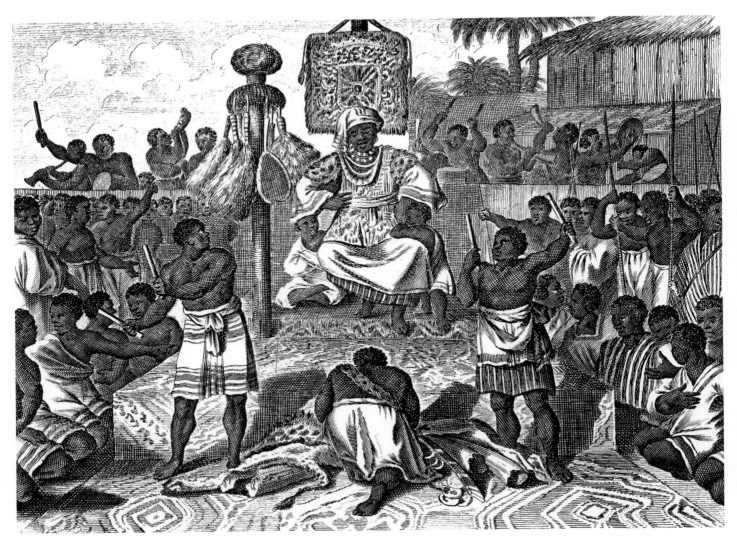

11-4. The court of the king of Loango, Lower Congo. c. 1668

Early drawings by European visitors were probably not based on scrupulous observation, yet they are still valuable witnesses to their time. Here the "king of Loango" is shown seated on a stepped and raised platform covered with a textile decorated with geometric patterns. Another textile is suspended on a frame from a pole behind the nobleman. Other typical leadership emblems are noted in the drawing as well. An orchestra of drummers and of trumpeters can be seen over a fence. The aristocrat wears the skin of leopards, symbolic of noble status. A man bows before him presenting bracelets, pelts of leopards, and ivory tusks.

were snipped after the weaving was completed to create a plush or pile effect. Most such cloths are monochrome, but here color has been applied to create a two-toned design.

Raffia textiles may be depicted covering the stepped platform in a seventeenth-century drawing of a Kongo ruler in his court (fig. 11-4). The indigenous weaving industry died out after European contact in favor of imported material, though many other decorative arts associated with Kongo nobility continued to be made. Ivory, for example, was carved into flywhisk handles,

scepters, and staffs. The staff for a Kongo ruler shown here may have contained spiritually charged substances thought of as medicines (fig. 11-5). Ritually invested rulers were themselves considered to be sacred medicine, *minkisi*, and to have extraordinary powers. The ruler shown seated in state in on this scepter holds a staff of authority in his left hand and chews on a special type of root associated with medicines of chieftainship held in his right hand.

Religious Arts: Christianity and After

In 1491 the Kongo king Nzinga aNkuwa converted to Christianity and was baptized as Joao I. His son and heir Afonso Mvemba a Nzinga established Christianity as the state religion, thereby fostering friendly relations with several European countries. Kongo artists began to work with the established iconography and artistic forms of the new faith, producing objects such as the crucifix in figure 11-6. Cast in copper alloy, the object follows the essential form of its European prototypes, and the proportions of the bodies seem to be based on European models as well. But the features of the faces are African, and the

11-5. ROYAL SCEPTER. YOMBE. 19TH CENTURY. IVORY, IRON, EARTH, RESIN; HEIGHT 18½" (47 CM). VIRGINIA MUSEUM OF FINE ARTS, RICHMOND, VA. ADOLPH D. AND WILKINS C. WILLIAMS FUND

11-6. CRUCIFIX. KONGO. BEFORE 1987. COPPER ALLOY, HEIGHT 12⅕" (31 CM). MUSEUM FÜR VÖLKERKUNDE, STAATLICHE MUSEEN, BERLIN

prayerful secondary figures, perhaps mourners, are severely abstracted. Their placement—one in relief on the base of the cross and two perched on its arms—is unusual as well.

With the destruction of the Kongo kingdom in 1665, Christianity was rejected, yet elements of Catholic ritual continued to be used in the context of local religious beliefs and practices. Similarly, some Christian images persisted, although their meaning shifted. Crucifixes, for example, became symbols for the meeting place of the worlds of the living and the dead, for cross forms were identified with crossroads, long an important concept in local philosophical and religious thinking.

One Christian saint who was turned to a new purpose was the Portuguese-born Anthony of Padua

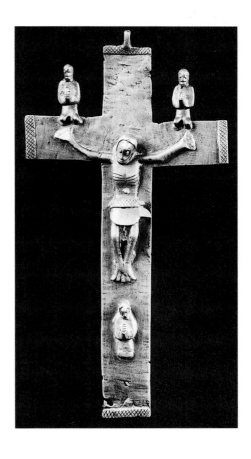

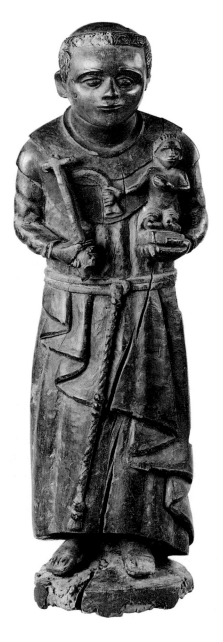

(c. 1193–1231). Called Toni Malau ("Anthony of good fortune") in the KiKongo language, he became popular in Kongo during the seventeenth century. During the early eighteenth century, a young Christian woman who declared that she was possessed by his spirit was convicted of heresy and burned at the stake. Her martyrdom signaled the beginning of a movement for the revival of the Kongo kingdom, and within the religious sect that honored her memory figures of Toni Malau found use as instruments of healing. The statue of Toni Malau shown here probably dates from the nineteenth century (fig. 11-7). Details such as the saint's tonsure and the robe with its folds of cloth and rope sash are clearly based on European prototypes and have been carefully reproduced. But the infant in his arms, a Christ child in European depictions of the

saint, here appears very African and carries a flywhisk, the traditional African symbol of leadership.

Another often-carved subject that may ultimately derive from the region's early exposure to Christianity is the mother and child. The beautiful mother-and-child carving in figure 11-8 is typical of numerous maternity images called *pfemba* produced along the Yombe and Kongo coast. Kneeling on a base and supporting a nursing child on one knee, the mother wears her hair in a mitered style that was once fashionable among both men and women in the region. Her teeth have been filed to points. Her body, adorned with richly textured scar patterns on the shoulders and across the upper breast, is further embellished with bracelets and a necklace of beads. The hairdo, filed teeth, jewelry, scarification, and the maternal pose suggest

11-7. SAINT FIGURE (TONI MALAU). KONGO. 19TH CENTURY (?). WOOD, HEIGHT 20¹⁄₁₆″ (51 CM). MUSEUM FÜR VÖLKERKUNDE, STAATLICHE MUSEEN, BERLIN

11-8. *PFEMBA* (MOTHER-AND-CHILD FIGURE). YOMBE. 19TH CENTURY. WOOD, HEIGHT 11¾″ (30 CM). MUSEUM FÜR VÖLKERKUNDE. STAATLICHE MUSEEN, BERLIN. GIFT OF WILHELM JOEST

11-9. DRUM. VILI. EARLY 19TH CENTURY (?). PEABODY ESSEX MUSEUM, SALAM, MA

ideal womanhood. Although mother-and-child figures are carved in many African cultures, the comparative naturalism of *pfemba* and the iconography of the nursing infant suggest that European depictions of Mary holding the infant Christ may have served as a distant model. The original function of *pfemba* is not known. Today, they are used in connection with women's fertility practices instituted by a famous midwife. The red coloring of the example here may reflect this, for red is related to birth and death, both of which are viewed in Kongo thought as transitional states.

It was not only in the area of religious imagery that the Portuguese made an impact: the Portuguese themselves became subject matter for the Kongo artist. The base of the drum in figure 11-9 depicts a Portuguese sailor holding a goblet and a bottle of gin. It was probably carved early in the nineteenth century, when the slave trade was still an important economic activity in the area. Depictions of Portuguese were also carved in ivory

or wood as mementos for visitors to take back to Europe.

Funerary and Memorial Arts

Many of the arts of the Kongo region have to do with honoring and commemorating the dead and communicating with their spirits. One complicated custom developed in which the departure of important persons was commemorated with offerings of cloth. The body of the deceased was prepared over a long period of time, as much as one year, during which it was dried and wrapped in special mats and locally woven cloths. When the burial bundle was displayed in state, numerous cloths were prominently displayed along with it.

An eighteenth-century engraving illustrates a ceremony surrounding the burial of an important person from the area (fig. 11-10). The body was covered with mats and raffia cloths. Imported linens, cotton prints, sheets, and silk goods wrapped

11-10. BURIAL PROCESSION FOR THE MA-KAYI OF CABINDA. 18TH CENTURY

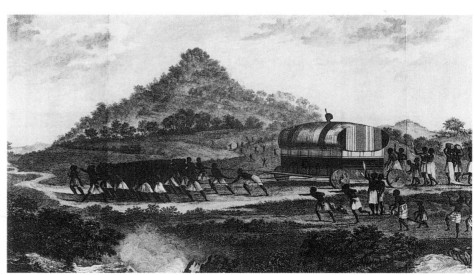

around the mummy created an enormous bundle. Fabrics, sewn together edge to edge on the exterior, create what might be considered the body of a huge figure, for it is topped by a head. In the drawing, the wheeled cart, constructed for the occasion by European carpenters, is pulled by straining men and followed by mourners. A description by a European visitor who saw the procession states that the bundle was at least twenty feet long, fourteen feet high, and eight feet thick. His description suggested that the small head on top represented the deceased ruler who was being buried.

Perhaps inspired by such funerary rites, the Bwende people of the Kongo area formerly transformed their most illustrious dead into ritually wrapped mummies called *niombo*. The custom of *niombo* burials apparently flourished during the late nineteenth and early twentieth centuries. On the death of an important chief, mats and cloths were collected. *Niombo* makers studied

the corpse carefully, noting such details as filed teeth or tattoo markings, for the work was to be a symbolic portrait. The body was smoked, dried, and wrapped, first in fine raffia cloth mats, then in brightly colored cloths and mats, both imported and locally produced. Hundreds of cloths might be used until a massive bundle swelled out. A reinforcing frame of canework was placed around it to create a trunk, arms, and legs, and the completed bundle was finished in red blanket fabric, red being a color associated with the mediating powers of the dead. The fabric portrait head topped the figure, stuffed with soft grasses and cotton. Occasionally an important man commissioned his portrait head prior to his death.

The *niombo* in figure 11-11 towers over the entourage transporting it to its final resting place. Within a strongly delineated lozenge on the chest a field of embroidered spangles suggests the spotted pelt of the

leopard, avatar of royal power. The lozenge symbolically indicates that the four corners of existence have been completed by the deceased. In combination the two motifs signify that the ruler now not only governs the clan but also has dominion over relatives in the world beyond. The open mouth of the figure indicates the speech of the deceased, uttered on behalf of the living in the world of the ancestors. The right hand up, left hand down gesture, called the crossroads pose, symbolically maps out the boundary to be crossed between the living and the dead. The gesture is that of a mediator, for the community believes that the honored *niombo* will intervene on their behalf with spirits in the other world.

In ordinary burials among the Bwende, dancing and singing builds to a level of high fervor. Everything was intensified even more in a *niombo* burial. Dancing took place for a number of nights in succession, not only in the village of the deceased but also in

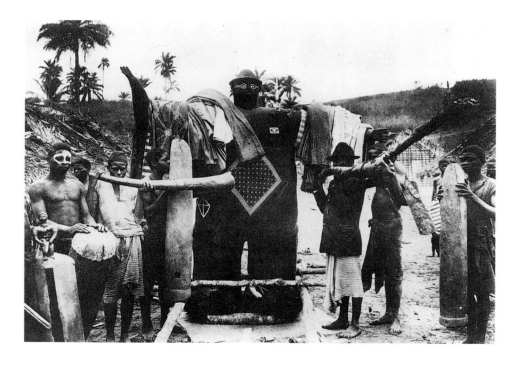

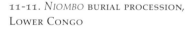

11-11. *Niombo* burial procession, Lower Congo

An orchestra plays as the niombo *processes to the grave. We see in the left corner of the photograph a beautiful slit gong,* nkonko, *carved with a human figure in mourning pose. Next to it is an* ngoma *drum. The eyes of its player have been symbolically "opened up" by circles of white clay, a sign that the musician becomes a medium whose drumming unifies the worlds of the living and dead. Side-blown trumpets and tall vertical trumpets are viewed as mediators who return the cries of the living. Oddly shaped flutes made of roots allude to the king. Roots are used for making medicines, and in this context the sounds produced on such instruments become medicine.*

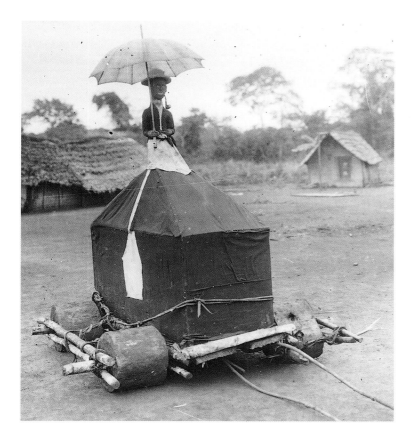

11-12. Yombe
funerary cart,
Maduda,
Lower Congo.
Photograph
1909

surrounding villages. On the day of the interment, the dancing suddenly stopped. After a generous feast in honor of those who provided cloths for the burial, the *niombo* was carried through the village to the accompaniment of a special orchestra. Hundreds of people may have been in the procession, dancing, singing, working, and joking as the *niombo* was guided to the grave. When it finally touched bottom, a great cry issued from the crowd as they simultaneously jumped into the air. Their mediator had entered the world of the dead.

A variation on the theme of representing the dead is seen in a photograph taken in 1909 in the Yombe town of Maduda (fig. 11-12). Here a corpse has been prepared and placed in a box-like bundle covered with cloth and surmounted by a carved

figure. The representation of the deceased, dressed in European clothing and smoking a pipe, holds a parasol in his hand, a mark of status and dignity. The cart on which it has been readied for the cemetery procession is made of sections of log.

The Bembe, another Kongo group, create cloth mannequins called *muzidi* for their deceased (fig. 11-13). Unlike the *niombo* of the Bwende, *muzidi* do not ready a body for burial but rather pacify a deceased spirit by serving as a reliquary for his disinterred bones. The Bembe bury their dead under a structure made of poles and thatch. Should the village subsequently experience misfortune, divination may reveal that the dead person is demanding a more fitting site. The body is disinterred, and its bones are wrapped and then placed in a *muzidi* made of a cane armature, sometimes stuffed with dried banana leaves, and covered with red and blue cotton cloth. The magnificent example shown here assumes the burial pose. A *muzidi* is kept in its own house, from which it might be taken out to serve as judge in disputes.

The cemetery itself is an important part of the community in Kongo thought. A grave was viewed as medicine, *nkisi*, an object, substance, or collection of materials that contains spirit powers and makes them available to humans. In fact, the entire cemetery with all its graves is considered to serve as protective medicine. It is placed near the entrance to a village as

11-13. *Muzidi* (mannequin for the deceased). Bembe. Before 1930. Cloth and plant material, 17¾" (45 cm). Musée de l'Homme, Paris

strong links to the spirit and bind the living and the dead. Also on the grave or in a small house nearby may be a carved wooden or stone figure called a *tumba* (plural *bitumba*). Serving as a guardian of the grave, the *tumba* represents the person who lies within, usually a distinguished member of the community. It provides a focus for those who come to the grave to consult the ancestor.

The *tumba* in figure 11-14 represents a ruler. He is portrayed in a meditative pose, one knee brought to his chin, his hands clasped over it. The pose is said to communicate sadness, both the sadness of the man who has left his family and his people and the reflected sadness that they experience in his loss. His downcast eyes focus his attention inward as he concentrates on his new role as mediator between the living and the dead. Painted tears convey his own weeping as well as that of those who mourn him.

Soapstone (steatite) *bitumba* were often referred to as *mintadi* (sing. *ntadi*). The marvelous example illustrated here shows a ruler seated cross-legged on a base, his head turned to the left, smoking a pipe (fig. 11-15). The pose reveals Kongo attitudes toward the role that the deceased dignitary was to play in the spirit world. As mediator between the living and the dead, he was to assume the role of listener and decision-maker that he had played in the world when he was alive. When a king smoked, all others were silent. Smoking was a sign demonstrating that the king needed distance from his affairs; it created time for thought and prevented things from unfolding too rapidly. In this sculpture, the ruler turns his head away from the ordinary. Further distancing himself from the everyday, he places his arm over his

11-14. *TUMBA* (FUNERARY FIGURE). BASUNDI. 19TH CENTURY. WOOD, HEIGHT 20″ (51 CM). MUSEUM RIETBERG, ZÜRICH. EDUARD VON DER HEYDT COLLECTION

11-15. *NTADI* (FUNERARY FIGURE). MBOMA. 19TH CENTURY. STEATITE, HEIGHT 23″ (58.4 CM). BROOKLYN MUSEUM, NEW YORK. MUSEUM EXPEDITION 1922. ROBERT B. WOODWARD MEMORIAL FUND

a shielding force and a source of ordering power for the community.

On a grave may rest an assemblage of possessions such as guns, umbrellas, vessels, hoes, and other objects that symbolically summarize the life of the deceased. Included is usually the last object that touched his lips before he died. The objects provide

11-16. MEMORIAL HOUSES WITH
BITUMBA, BOMA, LOWER CONGO.
PHOTOGRAPH 1908

11-17. FUNERARY CYLINDER.
LOWER CONGO. ROYAL
MUSEUM OF CENTRAL AFRICA,
TERVUREN

knee, creating a symbolic barrier between his inner thoughts and the world.

In Yombe country *bitumba* may be placed in shrines built for ancestors. A 1908 photograph of a Kongo shrine in the Boma area shows two of these small structures (fig. 11-16). These diminutive houses are walled with vertical posts that create a sort of surrounding palisade that protects the miniature city thus contrived. The shrine both shields the dead from forces without and protects the living. Visible in the foreground shrine are three wooden *bitumba* whitened with kaolin. The color evokes the white skin of the dead and is associated with moral correctness and spiritual perception.

Bitumba are made in a relatively restricted area on the left bank of the Congo River between the cities of

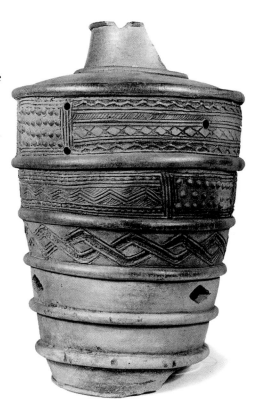

Matadi and Boma. In some neighboring areas, the illustrious dead are commemorated instead with funerary ceramics. The hollow ceramic cylinder shown here once marked the tomb of a wealthy and socially prominent person (fig. 11-17). Raised moldings divide its surface into five horizontal registers above a base. Meaningful patterns fill the three uppermost registers. The openwork lozenges in the fourth register from the top stand for the emptiness of death. The lozenge evokes the path of the sun, which in Kongo belief journeys between the living and the dead. Lozenges, although not open, in the running frieze in the third and uppermost registers, also refer to death in that they mark points of birth, life, death, and afterlife. The diamond shape is compared to a type of crystal which the Kongo view as a mystical lens through which the other world can be viewed. Rectangular panels filled with rows of small raised bosses and marked with a hole at each corner appear in the top two registers. The bosses in these panels suggest to the Kongo the counters in a traditional game called ding-dingo in which players jump through a maze of stones. While the game is beautiful to watch and requires skill, at a deeper level it is said to inform about the realities behind the apparent ending of life. Thus, the panel instructs viewers that death begins a new life in a new realm. In the uppermost register, contiguous diamonds with tiny bosses at their angles refer again to the cosmogram, this time marking the positions of the sun at dawn, noon, sunset, and midnight as it moves from the world of the living above to the nether world of the dead.

Minkisi

Close communication with the dead and belief in the efficacy of their powers are closely associated with another important art form used by the Kongo and many other groups throughout Central Africa. All exceptional human powers are believed to result from some sort of communication with the dead. Notable among people with such powers are agents known as *banganga* (sing. *nganga*), who are believed to be able to see hidden things. They work as healers, diviners, and mediators who defend the living against witchcraft and provide them with remedies for diseases resulting either from witchcraft or the demands of spirits, *bakisi*, emissaries from the land of the dead.

Banganga harness the powers of *bakisi* and the dead by making ritual objects called *minkisi* (sing. *nkisi*, "medicine"). *Minkisi* are primarily containers—ceramic vessels, gourds, animal horns, shells, bundles, or any other object that can contain spiritually charged substances. As discussed earlier, graves themselves are considered to be *minkisi*. In fact, *minkisi* have been described as portable graves, and many include earth or relics from the grave of a powerful individual as a prime ingredient. The powers of the dead thus infuse the object and allow the *nganga* to control it. *Minkisi* serve many purposes. Some are used in divination. Many are used for healing, while others insure success in hunting, trade, or sex. Important *minkisi* are often credited with powers in multiple domains. *Minkisi* may also take the form of anthropomorphic or zoomorphic wooden carvings, and it is these that have principally interested art historians. The group of *minkisi* shown here was photographed in 1902 in a Yombe community (fig. 11-18). The large *nkisi* in the center of figure 11-18 is a *nkondi* (plural *minkondi*), perhaps the best known of the many types of *minkisi*. Associated with formidable powers, *minkondi* are greatly respected. As hunters, they are said to pursue witches, thieves, adulterers, and wrongdoers by night. At the turn of the century, each Kongo region had several local varieties of *minkondi*. Most were activated by driving nails, blades, and other pieces of iron into them to provoke them into delivering similar injuries to the guilty.

The *nkondi* in figure 11-18 appears to be almost life-size. Centered on its abdomen is a bulging form where the substances that empower it have been sealed in with resin. The word used for belly also means "life" or "soul," and activating materials are most commonly placed there, though they may also be placed at the top of the head, on the back, or between the legs. Called *bilongo*, activating substances include three main types of ingredients: mineral from the land of the dead, items chosen for their names, and metaphorical materials. The most important minerals include kaolin, the white clay closely linked to the world of the dead, and red ocher, whose red color refers symbolically to blood and danger even as it signifies mediation of the powers of the dead to the living for both affliction and cure. Ingredients chosen for their names include certain leaves or seeds whose names are puns for the attributes and functions of the *nkisi*. Metaphorical materials include such things as the heads of poisonous snakes, the claws of birds of prey, and nets, all of which suggest the power to attack, to produce death or sickness. The *bilongo* in the belly of the smaller figure to the left are sealed with a mirror. Mirrors enable the *nkisi* to see witches approaching from any direction and thus serve as a sort of compass that tells the *nganga* where evil lies. The glitter of mirrors was also believed to frighten witches. The torsos

11-18. *Minkisi* FIGURES, BOMA, CONGO. 1902

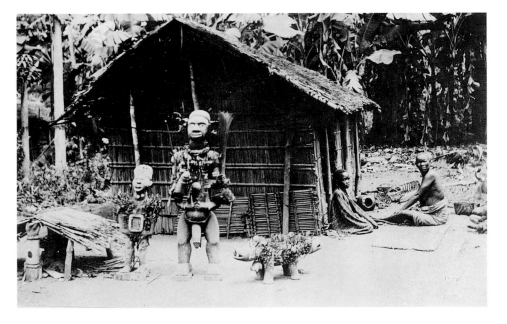

of the *minkisi* bristle with assortments of objects. A *nganga* petitions the *nkisi* by driving nails into it, and each blade thus represents an appeal to the figure's power. Other materials such as ropes, carvings, hides, and mirrors may be added as well. Without such an accumulation of materials, in fact, the figure is meaningless.

The form of a *nkisi*, then, is a record of its use, and results from the collaboration of the sculptor and the *nganga*. Their primary intention was not the creation of a work of art but the organization of a visual effect in the context of ritual use, augmented by songs, drumming, dancing, the heightened emotion of the occasion, and various devices reinforcing the amazement of onlookers. The sculptor did

not always know what purpose the figure was to serve, what powers it was to have. Sometimes the pose of the carved figure seems meaningful: For example, some *minkisi* have an aggressive pose, with the right arm lifted to hold a spear, or the hands placed defiantly on the hips. At other times the figure, while it may well have details that call attention to the carver's skill, seems conceptually neutral, a mere vehicle for the meaningful additions of *bilongo*, nails, and other materials.

Certain forms of *minkisi* have specific meanings. The small four-legged *nkisi* to the right in figure 11-18 takes the form of a two-headed dog. Known as *kozo*, this figure underscores the role of dogs in Kongo thought. As natural hunters, dogs live

both in the village and in the forest, which is associated with the home of the dead. They are said to have four eyes, two for this world and two for the spirit world (thus the figure's two heads). As a hunter, *kozo nkisi* helps the *nkondi* to track witches.

An especially striking *nkondi* was created before 1878 among the Boma people (fig. 11-1). Its role as hunter is emphasized by the actual hunting nets tangled around its legs. Its open mouth seems to have received food in activating rituals. Nails are especially noticeable at the mid-section. Twine, miniature carvings, knives, and other tokens of the figure's nocturnal violence astonish the viewer. Bits of fabric attached to such objects may be referred to as "dogs," further implying that this is a hunter who can track down and catch witches.

The *nkisi* in figure 11-19 has been identified as a *nduda*, a generic term associated with *minkisi* linked to warfare. In the minds of Kongo people, its feather headdress connects it with the sky and with violence associated with the "above," manifested often in such phenomena as rain and thunderstorms. These *minkisi* are usually small figures with mirrors attached for use in divination. The *nganga* was able to look in the mirror and discern a warrior's vulnerability on a given day. Packets of medicines surround the neck, and strips of hide that form a dress probably represent animals used as diviners' familiars. Such animals appeared in dreams to the *nganga*.

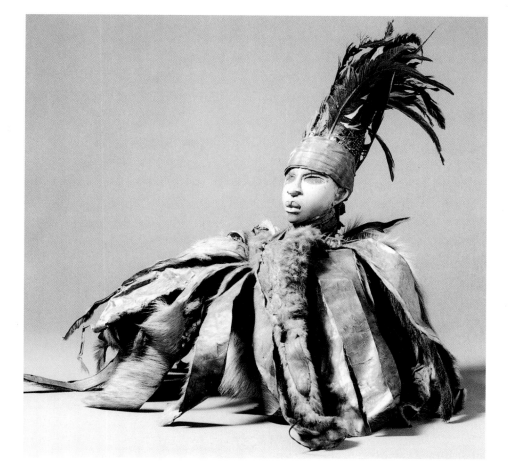

11-19. *NDUDA* FIGURE. LOWER CONGO. BEFORE 1893. WOOD, GLASS, LEATHER, FEATHERS, CLOTH; HEIGHT 13⅖" (34 CM) STAATLICHES MUSEUM FÜR VÖLKERKUNDE, MUNICH

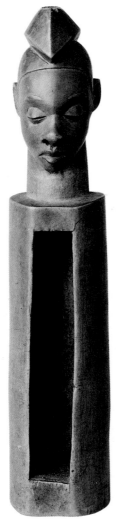

packets. The slit gong, a type of drum, shown here shows the finesse with which such instruments were carved (fig. 11-20). Here the gong has been hollowed from a length of wood, and a delicately contoured head has been carved on one end, much as a mourning figure tops the gong in figure 11-11.

THE TEKE

The Teke live near the Kongo principally in the area of the Congo Republic, formerly the French Congo. They too create sculptural forms to harness the powers of spirits, both nature spirits, who serve as intermediaries between God and humans, and spirits of ancestors, who may bring health and well-being to the living. Teke spirits, *mati* (sing. *buti*) or *bankiri* (sing. *nkira*), may be given material form either as containers or as carved wooden figures. Figures that represent *mati* and *bankiri* serve diverse functions, and may be used in divination, for protection against evil powers, to get revenge, or to gain in wealth and power. The stiff frontal pose of the example shown here is typical of Teke objects, as is the angular style (fig. 11-21). As with Kongo *minkisi*, a figure's function cannot be ascertained by merely looking at the object but in knowing what substances were used in its manufacture and what rituals surrounded it.

When an artist begins to carve such a figure, he conceptualizes the cylinder of wood as three more or less equal segments: head, torso, and legs. The head and neck are carved first. The features of the face are laid out as geometric forms with a protruding mouth and chin. The trapezoidal beard that

hangs from the chin is a sign of excellence in Teke society and a sign of the sacred as well. The facial striations represent a distinctive scarification pattern associated with the Teke. The torso is carved next. This area is usually more summarily carved, since it is destined in the normal life of the figure to be covered with substances

11-21. *NKISI* FIGURE. TEKE. ROYAL MUSEUM OF CENTRAL AFRICA, TERVUREN

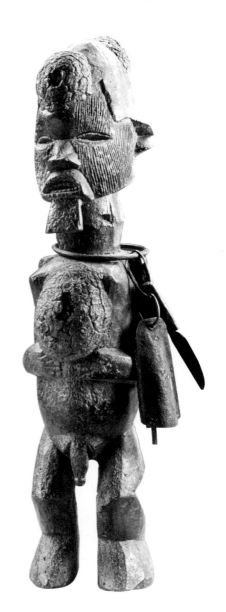

11-20. SLIT GONG. SARONGO. BEFORE 1897. HEIGHT 10½″ (26.67 CM). NATIONAL MUSEUMS AND GALLERIES ON MERSEYSIDE

Musical instruments such as those that accompany the burial procession of a *niombo* are also considered to be medicines (see fig. 11-11). Instruments such as double bells, rattles, slit gongs, and whistles are believed to facilitate communication between this world and the world of the spirits. Such instruments are often beautifully carved and made into *nkisi* themselves, with medicines embedded within them or attached as

or fabric. (That the arms are visible on this figure is unusual.) Lower extremities are carved last. Such figures are almost always male, and the genitals, as here, are often carefully carved and show evidence of circumcision. The legs are depicted as geometric abstractions with flexed knees.

Consecration ritual convinces a spirit to take up residence and transforms the figure from a mere object into a living presence and a representation of the ancestor. Protrusions from the chest and head of this figure contain consecrating substances, *bonga*. *Bonga* usually includes white clay or chalk, referring to ancestral bones, a powerful substance believed to counteract disease. Other materials may include leaves, plants, animal parts, and hair from venerated persons. In this object, resin was molded over the *bonga* to create egg-shaped forms. *Bonga* often cover the entire trunk from shoulder to hip and may be wrapped with fabric, making a powerful visual statement about the potency of both the materials and the object/being.

Objects attached to the figure may impart further meaning. The small iron bell here was probably used to call the indwelling spirit, and the knife perhaps assisted the spirit in annihilating a sacrificial victim. Kept in its (male) owner's room, its feet implanted in the soft earth of the floor, such a figure is considered personal property. Its specific power is a secret known to the owner alone.

IN THE SPHERE OF THE LUNDA EMPIRE

The area to the south and southeast of the Kongo kingdom was once dominated by the Lunda empire which flourished between the sixteenth and nineteenth centuries. According to legend, the empire was founded by Chibunda Ilunga, a prince of sacred blood, who came from the east where his father, Kalala Ilunga, ruled over the Luba empire (see chapter 12). A renowned hunter, Chibunda Ilunga traveled far, crossing into the area where Lunda chiefs led small groups under a ruler whose inherited authority was symbolized by a special bracelet. When Chibunda Ilunga arrived, the bracelet was in the possession of a woman leader, Lueji, who welcomed the aristocratic foreigner. After their marriage, she handed the bracelet of her rule over to him. Chibunda Ilunga imposed a new system of rule over Lunda lineages and introduced more efficient techniques for hunting. These new techniques established the Lunda as great hunters (especially for elephant) and helped them to expand their territory and power.

Although the Lunda were powerful and well organized politically until at least the mid-nineteenth century, there is no art style or form associated specifically with them. They borrowed extensively from their neighbors, and the art forms used to bolster their political authority and initiate their youth have long been provided by artists of the groups over which they established control. The Lunda who live to the east use art created by or in a style like that of the related Luba peoples (see chapter 12); those to the west use a style like that of the Chokwe peoples. The beautiful water pot shown in figure 11-22 is a good example. The basic form is found over a broad area. To the east, such pots are topped with heads in a Luba style, while the head here is reminiscent of Chokwe forms from the west.

11-22. WATER POT. SAKADIBA. BEFORE 1940. TERRACOTTA, HEIGHT 11⅜" (28.9 CM). NATIONAL MUSEUM OF AFRICAN ART, SMITHSONIAN INSTITUTION, WASHINGTON, D.C.

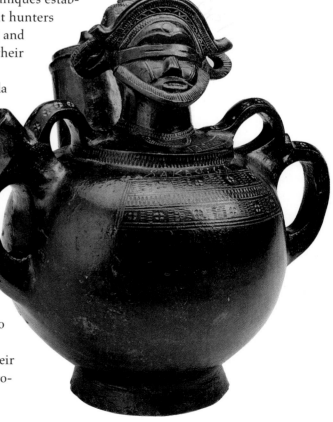

Chokwe Leadership and Initiation Arts

Local traditions maintain that when Lueji gave her sacred bracelet to Chibunda Ilunga, her brothers left in resentment and formed their own groups. They took with them, however, many of the cultural institutions that Chibunda Ilunga had introduced and transmitted them to the people they settled among. One of the resulting groups was the Chokwe, centered in northern Angola. Chokwe chiefs are descended from Lunda nobles who imposed their system of rule over the Chokwe during the seventeenth century. The Chokwe lived long under Lunda suzerainty, but during the mid-nineteenth century, in response to changing economic conditions, they expanded their territory, eventually populating the region between the upper Kwilu and Kasai rivers in southern Democratic Republic of Congo and northeastern Angola. Some spread into Zambia.

As Chokwe chiefs increased in wealth and influence, the arts associated with chiefdoms blossomed. Local peoples over whom they asserted their power had long traditions of woodcarving, and their artists produced utilitarian, leadership, and luxury objects in a powerful and refined style. With its swelling musculature and preponderance of curving elements, the figure of Chibunda Ilunga shown here is typical of Chokwe style from this time (fig. 11-23). Such idealized representations of ancestors and important historical personages were carved by professional artists and served to underscore the rank and position of chiefs. The legendary hunter and culture hero is portrayed in full hunting

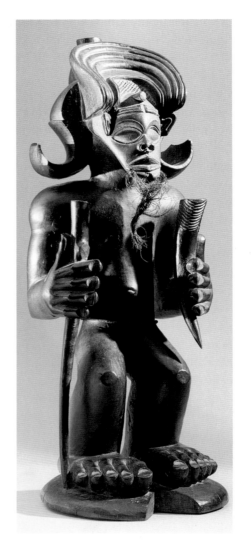

11-23. Chibunda Ilunga figure. Chokwe. 19th–20th century. Wood and human hair

gear. His muscular body, huge hands and feet, and broad facial features give a sense of power, while the delicate details of toenails and fingernails and other minute details give a sense of refinement. The sweeping, ornate headdress identifies him as a chief, and the long plaited and bound beard of

real hair alludes to his aristocratic position. His massive shoulders are thrown back and, from the rear, emphasize the concave forms of his back. The objects he carries refer to his role as hunter. In his right hand he supports a staff used for holding a sack of power substances. In his left he carries a medicine horn full of substances that assist the hunter, alluding to the role of the supernatural in hunting. Large hands and feet further allude to qualities of skill and fortitude that serve him during long ventures.

Chokwe society is matrilineal, and women thus play an essential role in extending, transmitting, and solidifying power. Carvings of female figures from the period of Chokwe expansion reflect the importance of the matrilineage and the transmission of power through women (fig. 11-24). Such a figure may represent the queen mother or the senior wife of a chief and refer to the memory of the female ancestor. The robust musculature and assertive forms of out-thrust chin, breasts, buttocks, and limbs give an impression of great vitality. The coiffure is made of real human hair.

Chokwe insignia of office include carved wooden staffs depicting past chiefs. Brought to Europe in 1876, the masterpiece shown here is one of the oldest Central African art objects known (fig. 11-25). The elaborate headdress of chieftancy with its ribbon-like volute frames the chief's broad head. It is placed over an ornately shaped panel sinuously decorated with angular and curvilinear elements. Tacks of brass, the metal of authority among the Chokwe, decorate a volute that projects from the front of the panel. Figures and faces incorporated in chiefly staffs were often seen

as symbolic portraits of the chief himself or a chiefly ancestor. Antelope horns on the back of the ceremonial headdress of great sweeping curves held magical ingredients and emphasized the role of the supernatural in the chief's reign. A page carried such a scepter as part of the regalia of the chief as he went about on state visits.

Hourglass-shaped stools served as seats of authority for ancient Chokwe

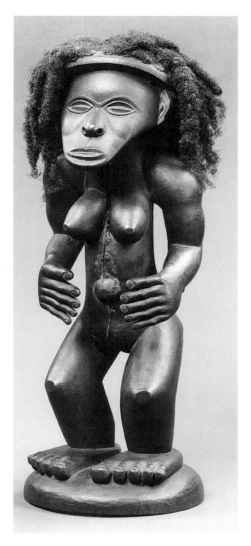

11-24. FEMALE FIGURE. CHOKWE. BEFORE 1850. WOOD, HAIR, RED RITUAL MUD; HEIGHT 13¾" (35 CM). MUSEUM FÜR VÖLKERKUNDE, STAATLICHE MUSEEN, BERLIN.

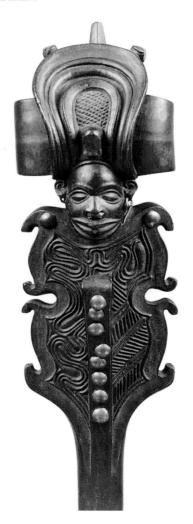

11-25. CHIEF'S STAFF. CHOKWE. BEFORE 1876. WOOD AND BRASS; HEIGHT 12⁹⁄₁₀" (32 CM). MUSEUM FÜR VÖLKERKUNDE, STAATLICHE MUSEEN, BERLIN.

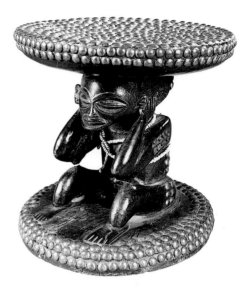

11-26. STOOL. CHOKWE. WOOD, HEIGHT 8⅜" (21.3 CM). ROYAL MUSEUM OF CENTRAL AFRICA, TERVUREN

and Lunda chiefs. The stool shown here preserves the circular top and bottom of such thrones and introduces a supporting figure between them (fig. 11-26). Such supporting figures are found only on Chokwe stools from the region between the Kwilu and Kasai rivers. The Chokwe expanded into this region during the nineteenth century, and the supporting figures may reflect the influence of their new neighbors to the east, the Luba and the Pende, whose carved thrones feature such figures. While some supporting Chokwe figures are depicted in a standing pose, most are as here: a female sitting with legs bent and hands to head, a pose of mourning and lamentation. European brass tacks cover the top and surround the base of the stool.

During the seventeenth century contact with European products inspired new leadership arts. The chair or throne, made of separate pieces of wood joined together rather than

Chokwe artists reinterpreted and embellished the European prototype with multiple figures from within the Chokwe sculptural tradition. The carved head wearing the headdress of chieftancy tops each upright on the back. Two birds drink from a shared vessel on the center portion of the top splat, while a scene alluding to initiation fills the lower splat. Frogs are carved on the front legs, and a variety of anecdotal images of daily life line the slats between the legs, such as women preparing food, a man leading an ox, and men carrying a pole. Brass tacks, the most precious of metals for the Central African region, decorate the legs, stretchers, and uprights.

Carved along the center splat of the chair is a row of seated masked figures. These depict *chikunza*, a mask associated with fertility and hunting.

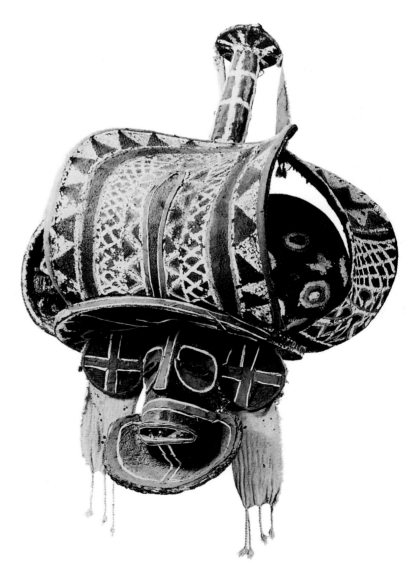

11-28. *CHIKUNGA* MASK. CHOKWE. CLOTH, TWIGS, RESIN; HEIGHT 46½" (1.18 M). MUSEU DO DUNDO

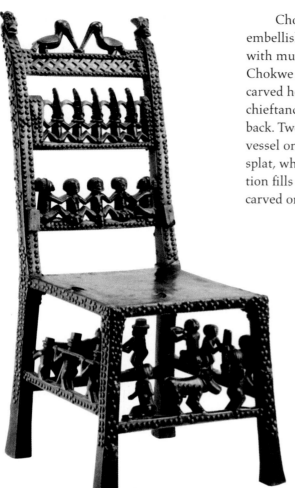

11-27. CHAIR, CHOKWE. WOOD, BRASS TACKS, LEATHER; HEIGHT 39" (99.1 CM). THE METROPOLITAN MUSEUM OF ART, NEW YORK. THE MICHAEL C. ROCKEFELLER MEMORIAL COLLECTION. PURCHASE, NELSON A. ROCKEFELLER GIFT

carved of a single block, developed from a type of Portuguese chair with leather seat and backrest (fig. 11-27). Carved for chiefs, they quickly became the primary symbol of chiefly authority. The form assumes important status in part because of its association with foreign holders of authority.

Chokwe masks are collectively called *mikishi* (sing. *mukishi*), after the spirits they are said to represent. The most powerful and important mask found among the Chokwe is known as *chikunga*. Highly charged with power and considered sacred, *chikunga* is used during investiture ceremonies of a chief and sacrifices to the ancestors. Intimately associated with both chiefly and ancestral authority, it is often represented on leadership arts.

The *chikunga* mask shown in figure 11-28 is made of barkcloth stretched over an armature of wickerwork, covered over with black resin and painted with red and white designs. Decorative red and white fabric attached to the surface refers to scarification patterns. The towering headdress is instantly recognizable as the complex ceremonial chieftancy headdress depicted on the figure of Chibunda Ilunga and the carved scepter discussed earlier (see figs. 11-23, 11-25). Said to look like a stern old chief, *chikunga* is worn only by the current chief of a group.

Chokwe masks also play a role in male initiation. The two masquerades in the photograph in figure 11-29 are associated with an initiatory institution called *mukanda*. *Mukanda* is found over most of Central Africa in one form or another; it is an institution through which religion, art, and social organization are transmitted from one generation to the next. *Mukanda* training lasts from one to two years. Boys between the ages of about eight and twelve are secluded in a camp in the wilderness, away from the village. There they are circumcised and spend several months in a special lodge where they

are instructed in their anticipated roles as men. As part of their instruction, the boys are taught the history and traditions of the group and the secrets associated with the wearing and making of masks.

Mukanda is organized and supported by village chiefs and may thus be seen as an extension of chiefly authority. Paraphernalia for *mukanda*, including masquerade materials, are stored across a square from the chief's house. The central square between the chief's house and the storage building is the setting for the opening and closing ceremonies of *mukanda*. The sequence of events serves to impress the boys with the rightness of the political status quo and teaches them the historical basis for class

11-29. TWO CHOKWE *MUKUNDA* MASKS WITH COSTUMES. CHIKOPA, SOUTHWEST KASAI, CONGO. C. 1935

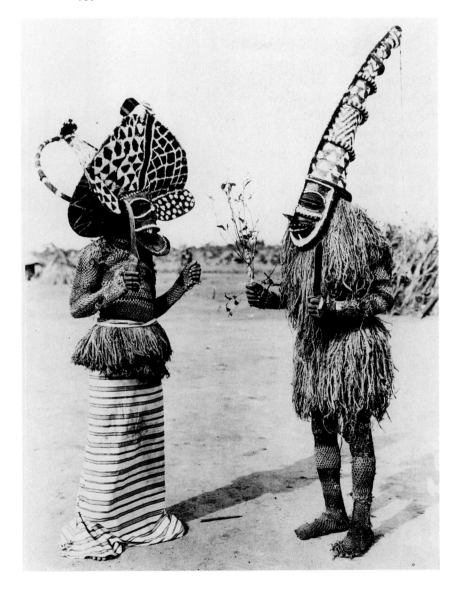

distinctions. Some thirty or so stock characters enacted by masks are considered to be the spirit guides for *mukanda*. Like the *chikunga* mask of chieftancy, *mukanda* masks are made of barkcloth over an armature of wicker. They are covered with a layer of black resin, which can be modeled to some extent before it is ornamented with pieces of colored cloth.

The most significant *mukanda* mask is *chikunza*, to the right in figure 11-29 and depicted on the chair in figure 11-27. It is topped by a tall conical headdress ringed by raised bands. The nose juts out from the face and curves upward, reaching all the way to the top of the headdress, from which a tassel dangles. The costume is made of close-fitting net with fiber skirt and collar. Like *chikunga*, *chikunza* represents a stern old man. He is praised as the "father of masks" and the "father of initiation." As the master of the *mukanda* lodge, he presides over the initiation events. Associated with goodness, plenty, success, and fertility, *chikunza* protects hunters as they move and women in childbirth. As such, he is often depicted on hunting whistles and on charms suspended from guns or worn by barren women. The mask to the left in figure 11-29, *kalelwa*, is modeled to some extent on the leadership mask, *chikunga*, as are numerous other *mukanda* masks.

While in former times they probably played important roles in religious beliefs and institutional practices, many other Chokwe masks have come to be used primarily for entertainment. Itinerant actors wearing these masks travel from village to village, living on gifts received at performances. Although a few entertainment masks are made of resin over wicker armatures, most are carved of wood, for wooden masks are more practical for traveling. The most popular and best-known entertainment masks are *chihongo*, spirit of wealth, and *pwo*, his consort.

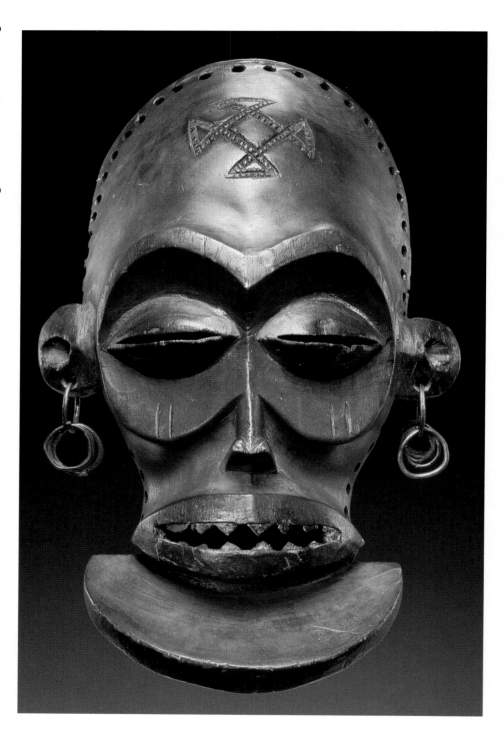

11-30. *CHIHONGO* MASK. CHOKWE. ROYAL MUSEUM OF CENTRAL AFRICA, TERVUREN

The gaunt features, sunken cheeks, and jutting beard of an elder characterize *chihongo* (fig. 11-30). *Chihongo* was formerly worn only by a chief or by one of his sons as they traveled through their realm exacting tribute in exchange for the protection that the spirit masks gave. Folklore suggests that *chihongo* has noble status, and this may be reinforced to some extent by the fact that the mask is worn with the elaborate headdress of the aristocratic chief. A net costume and a broad dance skirt made of mavundu fibers complete the masquerade. When it is not being worn, *chihongo* is kept in a safe place along with the mask associated with chieftancy, *chikungu*. Unlike a number of other Chokwe masks, these two masks have not spread to neighboring groups.

While *chihongo* brings prosperity, his female counterpart, *pwo*, is an archetype of womanhood, an ancestral female personage who encourages fertility (fig. 11-31). As an ancestor, she is envisioned as an elderly woman. The eyes closed to narrow slits evoke those of a deceased person. The facial decorations on the surface are considered female, as are the hairdo and material woven into it. The costume includes wooden breasts and a bustle-like appendage behind, allowing the male masquerader to imitate the graceful movements of women.

Recently *pwo* has become known as *mwana pwo*, a young woman, and has been adopted by neighboring groups. This reflects a change in Chokwe society in which young women have become more desirable than older, more mature women. *Mwana pwo* represents young women who have undergone initiation and are ready for marriage.

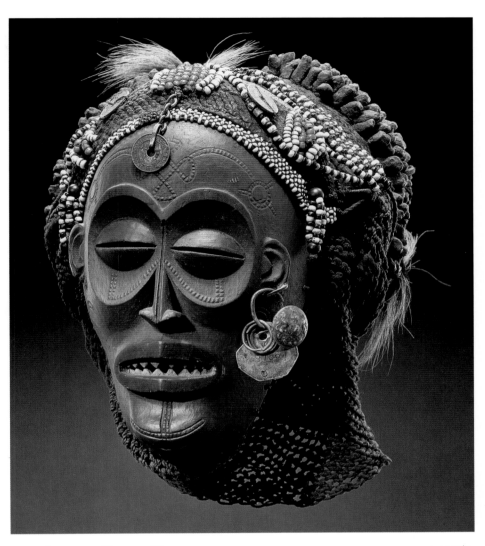

11-31. *Pwo* mask. Chokwe. Wood, raffia, camwood, pearls, coins, metal tax-tags, bird's legs, fur, insect's husk: height 9" (23 cm). Royal Museum of Central Africa, Tervuren

The Yaka and the Suku

During the eighteenth century Lunda chiefs came to dominate the area to the north of the Chokwe along the Kwango River, a tributary of the Congo River. They entered the region as adventurers in search of conquest and established administrative centers from which they exerted political leadership over local peoples, including the Yaka and the Suku, two culturally related groups.

Yaka and Suku societies are organized into strong lineage groups headed by elders and lineage headmen. Chiefs, including dependent village chiefs, regional overlords, and paramount chiefs, are believed to have extra-human abilities, ruling the underworld or spiritual realm as well as the ordinary world. A chief

11-32. CHIEF'S HEADDRESS. YAKA. BEFORE 1906. RAFFIA, HEIGHT 9⅞" (25 CM). THE BRITISH MUSEUM, LONDON

11-33. *KHAANDU* (CEREMONIAL ADZ) CARRIED BY MATRILINEAGE HEADMAN MANZITA WHILE VISITING KINSMEN, KIAMFU KINZADI CHIEFDOM, BANDUNDU PROVINCE, DEMOCRATIC REPUBLIC OF CONGO (FORMERLY ZAIRE). YAKA. 1976

The adz, normally carried with the handle to the front, is perhaps reversed here to show the object better in the photograph.

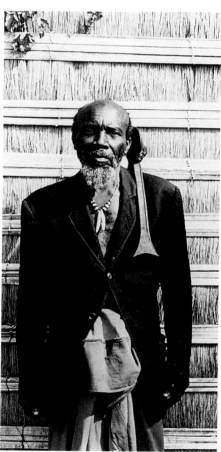

participates in the affairs of witches so that he can tap their powers for the good of the community. When the fertility of the chief is evident, his judicial authority is said to be strong and the relationships among lineages are secure. To this end he has many wives and children.

Regalia make manifest the legitimacy of a chief's authority and allude to his special powers. The most important elements of regalia are a bracelet and anklet inherited from predecessors, a special sword, and headdresses. Many other objects of regalia are produced as well to differentiate chiefs from ordinary men, including woven hats, adzes and axes, staffs of office, drinking vessels, combs, flywhisks, leopard skins, leopard-tooth pendants, musical instruments, and stools.

A chief's headdress of woven raffia, *bweni*, is considered a powerful object that must be worn continuously (fig. 11-32). Though their form may vary, many feature the central front-to-back crest, evident on this example. Linear designs, knobs, and a variety of textures may embellish such crests. Evidence suggests that the form may be related to a type of flower associated with male fertility.

Crested headdresses are often represented on objects associated with chieftancy such as the ceremonial adz, *khaandu*, shown in this photograph (fig. 11-33). Such adzes are carried over the left shoulder of chiefs, lineage headmen, and diviners as symbols of authority. The *bweni* headdress that tops the head carved on the handle alludes to rank and importance.

The forged iron blade issuing from the mouth symbolizes the decisive power and authority of words of the dignitary who carries the adz.

Another prestige object connected with leadership among the Suku is the two-mouthed vessel used for the ritual drinking of palm wine (fig. 11-34). Known as a *kopa*, it is carved from a single piece of wood, its outer surface carved with a lozenge filled with a field of smaller repeating lozenges. While today such cups are produced as novelties for tourists, the *kopa* was formerly one of the symbols of office presented to a new chief or lineage headman upon his investiture. No one else could touch it without proper authority. At the owner's death, a *kopa* was presented to his successor accompanied by a recitation of the names of its previous owners and admonitions on just rule. The *kopa* symbolically invested the new headman with powers of vigor and

fertility received from ancestors; it was henceforth his duty to bestow these powers on lineage members through blessing and sacrifice.

Another ritual container within the broad range of objects used by the Yaka to assert authority takes the form of a human being (fig. 11-35). Here the powerful female form is firmly planted with large and stabilizing legs and feet. Her upper body tapers to a head that serves as a stopper, opening to reveal a cavity in the torso for ingredients used in ceremonies of investiture. Imported glass beads surround the waist and neck. The headdress assumes the shape of an animal.

11-35. RITUAL CONTAINER. YAKA. HEIGHT 10¼″ (26 CM). FOWLER MUSEUM OF CULTURAL HISTORY, UNIVERSITY OF CALIFORNIA, LOS ANGELES

11-34. *KOPA* (CEREMONIAL CUP). SUKU. BEFORE 1906. WOOD, HEIGHT 3¼″ (8.5 CM). THE BRITISH MUSEUM, LONDON

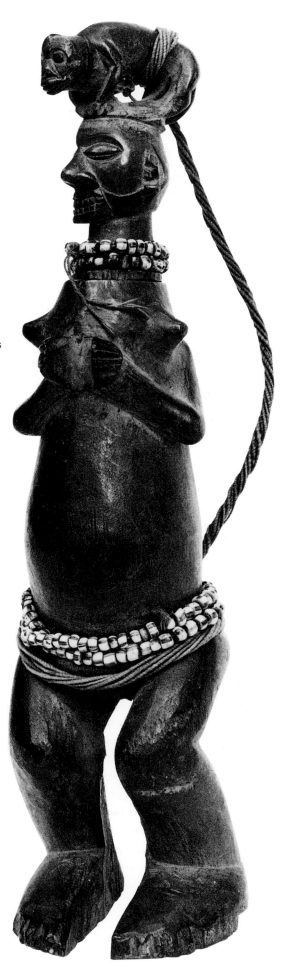

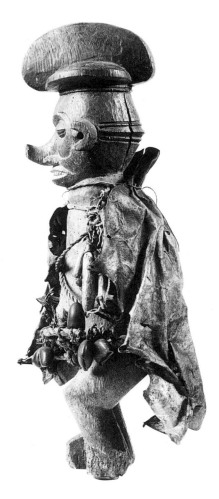

11-36. *BIKETI* FIGURE. YAKA. BEFORE 1919. WOOD, ROPE, SKIN, SHELLS; HEIGHT 16⅛" (41 CM). MUSEUM FÜR VÖLKERKUNDE, STAATLICHE MUSEEN, BERLIN.

cavity in the abdomen of this example once held power materials; other materials are attached to the surface. A figure without such power ingredients would serve no purpose and therefore have no meaning to the Yaka.

Power figures of various types are used by a number of institutions among the Yaka and the Suku. One fairly distinctive type of figure is *m-mbwoolo*. The photograph in figure 11-37 shows three *m-mbwoolo* displayed outside their ritual shelter, *luumbu*. Up to twenty such figures may populate a *luumbu*, which is perceived as a miniature socio-political system populated by groups of chiefs, each with a paramount leader and

11-37. *M-MBWOOLO* FIGURES OUTSIDE A *LUUMBU* (RITUAL SHELTER), KIMBUKU VILLAGE, BANDUNDU, DEMOCRATIC REPUBLIC OF CONGO. PHOTOGRAPH 1976

At the time this photograph was taken, this particular luumbu *housed one male and two female figures. The container with projections is for* tsyo. *Other* biteki *(statuettes) belonging to this series were on loan to lineage members. The lineage objects were under the supervision of a woman, Lumengo-na-mbanza of Kimbuku village, Ngowa chiefdom. The objects were temporarily placed outside their shelter for the photographer by the woman, presumably as they would have been at a new moon, which was regarded as a mystically dangerous and unstable time.*

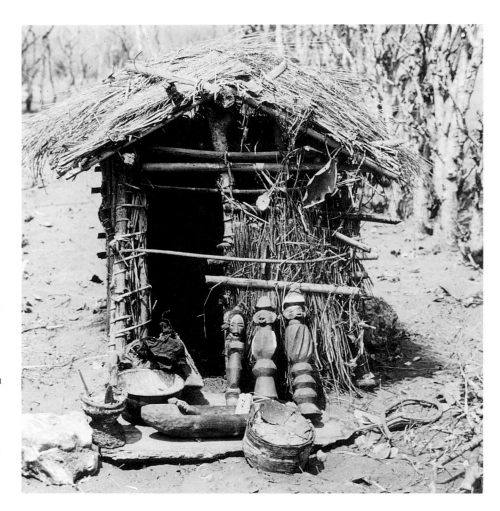

Like the Kongo, the Yaka and the Suku use power figures, here known as *biteki* (fig. 11-36). The exaggerated nose, the bulging downcast eyes, and the recessed area around the eyes are typical of some objects among the Yaka and Suku. The typically Yaka hairdo recalls the *bweni* headdresses worn by chiefs. Like the *nkisi* figures of the Kongo area, *biteki* serve as repositories for power ingredients and are manipulated by a ritual specialist, *nganga*. A

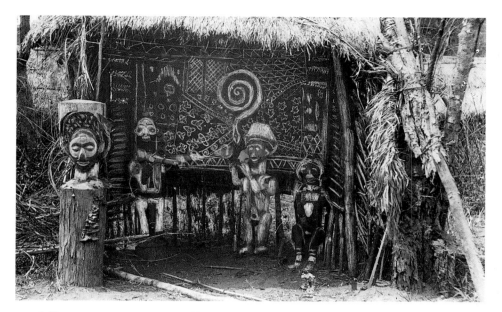

11-38. Yaka initiation structure, Nkanu region, Congo. Photograph 1903

the harm that is believed to be inherent in their initial contact with women, in forbidden foods, and in community discord. Masks in general can be seen as serving as a collective image of all the elders who have departed, the male ancestors and culture heroes who established circumcision. When the initiation camp is over, masks were formerly destroyed, although today many of them are sold.

One mask type, *mweelu*, found among both the Yaka and the Suku, is made of a head covering of twined raffia to which a great number of feathers are attached. In the example shown here the eyes are made of miniature gourds and the nose is the beak of a hornbill (fig. 11-39). A great ruff of

subordinate chiefs. *M-mbwoolo* figures may be individuated in a variety of ways. Some are carved with missing limbs, others with spiraling torsos, swelling body sections, or two heads. These anomalies seem to refer to situations or curses that the figures may be able to deal with.

As among the Chokwe, art among the Yaka and the Suku also finds a place in boys' initiation training, *mukanda* (more narrowly, *n-khanda* in Yaka and *mukhanda* in Suku). As elsewhere, the boys are separated from the sphere of women and removed from their influence. They are instructed over a period of one to three years by a ritualized community of males in a secluded camp. In some areas, as among the neighboring Nkanu, structures in an initiation camp are furnished with polychrome panels, some with relief carvings. A photograph taken in Nkanu country in 1903 shows a small open-front initiation structure (fig. 11-38). Inside can be

seen a display of panels. Human figures and a snake carved in relief rise from a ground of polychrome floral and foliate designs. An assortment of carved and painted wooden figures are also visible inside the structure. Themes of sexuality and procreation are often emphasized in the panels and figures, and lyrics in songs sung in the camp refer to gender differences and male dominance.

The large post in front of the structure is topped by a carving that represents an initiation mask. Masks among the Yaka and the Suku belong almost exclusively to the *mukanda* rituals and constitute the major art form within the context of the initiation camp. They include helmet masks and face masks as well as large assemblage masks that cover much of the body. Masks are seen as a means of protecting the boys while they are involved in this ritually hazardous period of their lives. They guard the future fertility of the boys as well as shield them against

11-39. *Mweelu* mask. northern Yaka. Before 1976. Raffia, feathers, gourds, hornbill beak. Institut des Musées Nationaux, Kinshasa

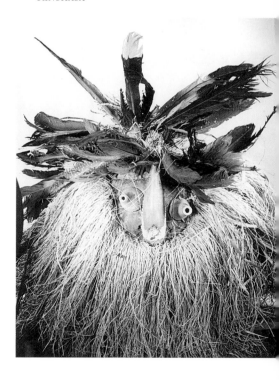

raffia falls over the wearer's chest. Some consider *mweelu* the most essential of *mukanda* masks and see it as playing a parental role. *Mweelu* is in charge of gathering food for the boys during their training, and eventually it is *mweelu* that leads the newly initiated boys back into the village.

Some of the most powerful masks are associated with the charm specialist in charge of the boys' training. These masks do not dance or entertain; their task is to terrorize. The most noticeable of them is the gigantic wooden mask known throughout region as *kakuungu* (fig. 11-40). Carved of wood, *kakuungu* may be almost three feet in height and often has a handle hidden under the raffia fringe for controlling its bulkiness and weight. The face is characterized by immense, bloated features, often including a swelling chin

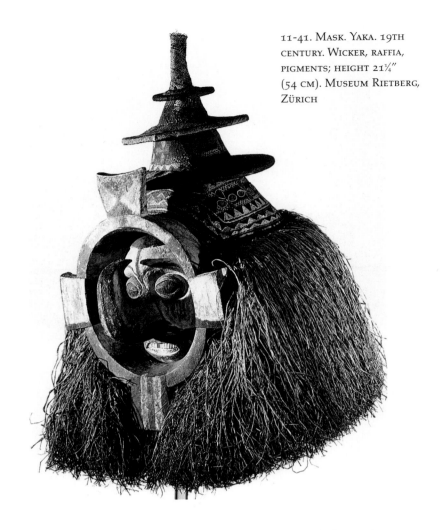

11-41. MASK. YAKA. 19TH CENTURY. WICKER, RAFFIA, PIGMENTS; HEIGHT 21¼" (54 CM). MUSEUM RIETBERG, ZÜRICH

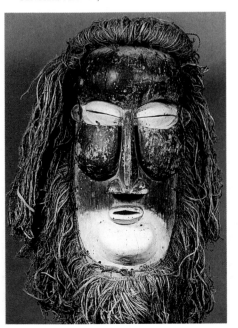

11-40. *KAKUUNGU* MASK. SUKU. WOOD AND RAFFIA; HEIGHT 3½" (8.97 CM). ROYAL MUSEUM OF CENTRAL AFRICA, TERVUREN

and ballooning cheeks. Red and white paint divides the face into zones. *Kakuungu* represents an apparition of an elder with anti-social powers. It appears on several key occasions to frighten the youth into submission and to gain their respect for the elders. It is also seen as a hazard to any who harbor evil designs against the initiates. Outside the context of initiation *kakuungu* may be used in a lineage for protection and to bring about human fertility .

The mask in figure 11-41 is a fairly low-ranking mask that dances and entertains. A projecting circular form with painted trapezoidal panels frames the boldly carved, polychromed face. The eyes bulge and an exaggerated, upturned nose curves and points back to the forehead. Its open mouth reveals bared teeth. The superstructure is a cone formed over a wicker armature stretched with raffia fabric or cotton cloth. The panels of the superstructure are painted with a variety of patterns in white, red, black, blue, and orange. A hanging raffia coiffure hides a supporting handle at the base of the mask. Sources suggest that the circle around the eyes and nose depicts the cosmic beginning of the sun. The eyes signify certain states of its procreative capacity, and the upturned nose, thought of as phallic, relates to the insemination of mother earth by the

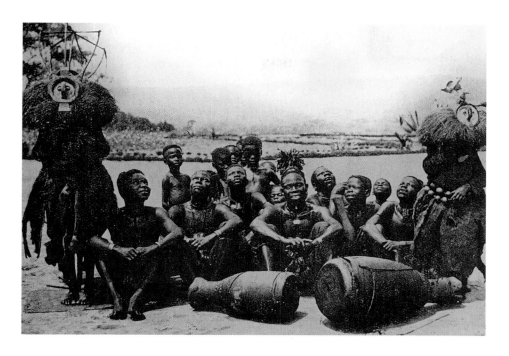

11-42. Yaka masks and dignitaries. Before 1930

sun. Other elements of the mask, such as the bulging eyes, pertain to the lunar cycle, alluding to the role of women. They also refer to the orifices in a woman's body. The mask appears in groups (fig. 11-42).

The Pende

The Pende originated in northern Angola but were forced into the Kwango region to the north of the Chokwe, in present-day Democratic Republic of Congo. In the course of their migrations they were split up into eastern, central, and western segments, all of which were eventually incorporated into Lunda political structures. Pende art styles vary widely, with a more abstract, geometric style in the east and a more naturalistic one in the central area and to the west. The function of art varies from one region to the other as well.

Eastern Pende chiefs have special houses designated for the performance of ritual acts critical to the lineages over which they preside. Great chiefs, those who control their own land and make land available to subordinate chiefs, have a ritual house called a *kibulu* (fig.11-43). Although ritual houses vary from region to region, the *kibulu* is usually a four-sided structure

11-43. Eastern Pende *kibulu* (ritual house), Mukanzo, Mbelenge, Congo. Photograph 1955

Before 1960 only chiefs of the very highest rank were allowed to use figurative architectural sculpture. Chief Kombo-Kiboto (ruled 1942–1987) commissioned two sets of sculpture during his administration, including the doorway panels and rooftop figure by Kasea Tambwe that grace this kibulu. *Kasea was the most sought-after carver of architectural sculpture during the 1950s and '60s. Commissions on this scale were rare, however, and thus Kasea, like other well-known artists, made his living by carving masks.*

with side walls about ten feet long and a central support pole about ten feet high. The dome-shaped roof is formed of supports configured to produce lozenge-shaped openings. Here the roof is covered with a heavy layer of straw thatch, although bark or palm fronds may also be used. The dome makes the *kibulu* distinctive among Pende structures.

Built in a single day by all the able-bodied men of a community, a *kibulu* is a symbolic structure. It alludes to the ancestors and their fertility-enhancing powers and it is associated with the well-being of the environment of the community. Seeds of the plants that the Pende cultivate are buried beneath its central pole. A small courtyard in front is defined by a fence of stakes or tree cuttings, whose sprouting indicates the approval of the ancestors. The fence defines the boundary between the royal sphere and that of the populace; it is also seen as a foyer to the spirit world populated by the ancestors. Passersby can only glimpse into the enclosure to the doorway. The door, distinguished by a projecting vestibule, is often guarded by panels carved in relief with male and female figures. The sculpted panel on this house is barely noticeable in the photograph, seen through the opening between stakes. Here an elaborate female figure stands on a plinth that projects from a relief panel beside the door. Both hands extend before her. White triangular designs sunk into the dark ground of the panel contrast sharply with the red of the figure.

From the rooftop a carved figure, *kishikishi*, warns persons of evil intent that the house and the village are safeguarded by the powers of the chief and by those spirits who protect him. A

variety of motifs have been carved as *kishikishi*. The sculpture shown here, by the celebrated Pende artist and blacksmith Kasea Tambwe Makumbi, depicts a mother and child. Kasea is credited with developing this motif, which since the middle of the twentieth century has become by far the most popular. This type of *kishikishi* is said to signal the death of a close female relative of the chief, usually a sister. In the matrilineal society, the loss of a sister is the ultimate loss, for it represents the loss of a generation, or in some cases the loss of future generations.

Within the *kibulu* two small rooms are filled with symbolic objects and materials. The outer room contains the chief's bed and symbols of his reign such as axes, bells, mats, skins, and royal garb. Such objects are believed to exert a direct influence on community health and well-being. The inner chamber contains his coffin and three masks associated with his rule, *pumbu*, *kipoko*, and *panya ngombe*.

Pumbu is considered the most fearful and dangerous. Called an executioner by some, it is used by only a few of the most powerful chiefs. The huge mask shown here is formed as a halved cylinder (fig. 11-44). Two enormous eyes project as tubes from the red upper third of the face, their white rims signaling great anger. Below, bands of black and white triangles alternate with registers of lozenges or interlace patterns, their busy geometry contrasting dramatically with the plain red upper portion. The long red nose on this example bridges the plain and patterned areas. A box-like mouth projects below the nose.

Pumbu serves as a symbol of the power of the chief. It dances only on

rare and terrible occasions determined by divination, such as when the chief himself is seriously ill or when epidemics or famines rage, indicating that ancestors may be unhappy. When *pumbu* dances, the mask, framed by raffia wig and beard, is so large that the chin is at the wearer's waist. He

11-44. *PUMBU* MASK. EASTERN PENDE. WOOD, RAFFIA, PIGMENTS; HEIGHT 29½″ (74.9 CM). THE WALT DISNEY–TISHMAN AFRICAN ART COLLECTION

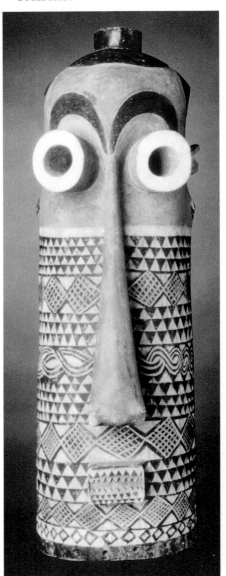

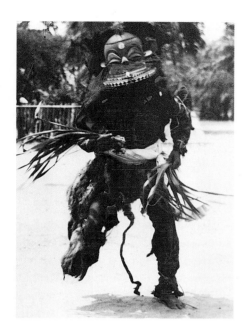

11-45. EASTERN PENDE *KIPOKO* MASK, KITANGWA, KASAI, CONGO, 1958

the chief and ancestral authority, but unlike *pumbu*, he is not terrifying. He embodies the nurturing side of the chief and his powers. The large ears, eyes, and nose remind the chief that he must be aware of all that goes on in his domain. The large tragus refers to a proverb that suggests the chief pay little heed to small slights or insults thrown his way. He listens thoughtfully, not responding to everything he hears. The small mouth, seen here as a tube-like form, but nonexistent in some examples, cautions *kipoko*, as well as the chief, to think before he speaks.

The third mask associated with the *kibulu, panya ngombe*, is more rare today than either *pumbu* or *kipoko*. *Panya ngombe*, like *pumbu*, is reserved only for the highest levels of chieftancy and appears in the dress of a high chief at the time of circumcision during initiation. Its rarity nowadays may have to do with the fact that since

holds weapons of war as he presents himself before the chief's subordinates to collect tribute. Young men restrain him with cords attached to his waist. Others in his company carry whips. Before he returns to the *kibulu, pumbu* must kill, so he finds a stray chicken or goat on the path. Back at the *kibulu, pumbu* spins around to face the crowd and dramatically cuts his restraining cords as onlookers flee. The threatening *pumbu* signifies the courage the chief must often summon to confront questions of life and death.

While *pumbu* rages through the village, *kipoko* takes charge of the *kibulu* (fig. 11-45). The pot-shaped *kipoko* sports a top-knot, ears that project outward, a narrow projecting nose, and a thrusting, plate-like beard. The face is usually painted red, while geometric designs in black and white cover at least the edge of the beard. *Kipoko*, too, symbolizes the political power of

the 1930s circumcision has taken place at birth.

While the masks of the eastern Pende as a general rule serve an administrative purpose, those of the central and western Pende are largely used in the context of the *mukanda* initiation (fig. 11-46). These fiber masks, called *minganji*, embody ideas of death, uncertainty, and darkness. They take on various forms, though all have protruding cylindrical eyes and netted fiber costumes. One mask, *gitenga*, is formed as a red-colored, rayed disk of fiber said to represent the sunset. *Gitenga* is said to be the chief of the *minganji*. In performance *gitenga* moves in a stately manner, while the rest of the *minganji* are emphatically aggressive. Although *minganji* appear at a number of functions, their most important role is as guardian of *mukanda*.

The wooden *mbuya* masks used in *mukanda* are perhaps better known

11-46. PENDE *MINGANJI* DANCERS INCLUDING TWO *GITENGA* MASKERS, GUNGU, KWANGO, CONGO. C. 1950

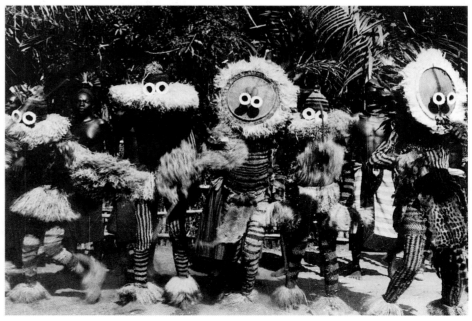

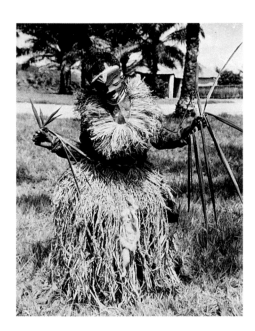

11-47. PENDE *MBUYA* MASKER, KILEMBE, KWANGO, CONGO. C. 1950

The mask is worn over the forehead of the dancer; his face is covered with raffia and a raffia cloth fringe. Here a skirt of raffia fiber completes the costume, but others may have clothing of imported fabric. Dancers carry objects in performance, here leaves from the palm frond. Others carry flywhisks as symbols of leadership or wear the skin of certain cats as signs of leadership and symbols of the hunt. The characteristics suggested by attachments and objects clutched in the hands are reiterated in songs and dances.

outside Pende country. Appearing alone or in pairs, usually at the end of *mukanda*, *mbuya* portray a wide variety of characters, including the sorcerer, the chief, the clown, and a number of types of women such as the chief's wife, the beauty, and the seductress. *Mbuya* masks are made in a variety of styles over western and central Pende territory. The mask shown in figure 11-47 is in the well-known

katundu style associated with the chiefdom of that name. Recognized by its bulging forehead, continuous V-shaped brow in relief over heavily lidded and downcast eyes, high cheek bones over tightly drawn cheeks, and a turned up nose with nostrils drilled as wide openings, the style seems to have originated between the Kwilu and Loango rivers. It has since spread widely, replacing many of the forms of neighboring groups. The mask shown here has a beard-like chin extension, perhaps a reference to the powers of the ancestors.

Delicate miniature versions of *mukanda* masks carved in ivory or hippopotamus bone are worn as pendants around the neck (fig. 11-48). Called *ikhoko*, they are scrubbed daily with sand to preserve their natural color, and their features thus appear

11-48. *IKHOKO* MASK-PENDANT. CENTRAL PENDE. IVORY, HEIGHT 2⅓" (6 CM). ROYAL MUSEUM OF CENTRAL AFRICA, TERVUREN

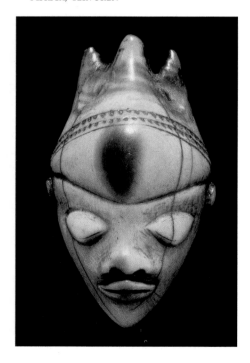

gently worn and smoothed. It has been suggested that these exquisite miniatures were created for purely aesthetic purposes, to beautify and to enhance the impression of elegance and style presented by its wearer. However, similar wooden miniatures seem to have been used in healing processes.

THE SALAMPASU

Differing from the peoples under the Lunda umbrella are a number of small, non-centralized peoples who live on the border of the Democratic Republic of Congo and Angola. One of the least understood of these are the Salampasu, a small enclave of loosely connected peoples who live to the north and east of the Lunda and the Chokwe in Kasai province. Although surrounded by peoples who do have some form of centralized political organization, the Salampasu have remained fiercely independent, and have succeeded in remaining aloof from the Lunda empire. In fact, the area in which the Salampasu live became a haven for those small groups that wanted to escape incorporation into Lunda polities.

Today, art among the Salampasu is made primarily for export, but in the past much of it seems to have been used in the Mugongo society. Although Mugongo today is seen as a collective instrument for governing, it may ultimately have been a variation on *mukanda*. Boys were initiated into the Mungongo society through a circumcision camp. They rose through its ranks by gaining access to a hierarchy of masks and the esoteric knowledge that they were associated with (fig. 11-49). The right to own and understand each next mask in the hierarchy was

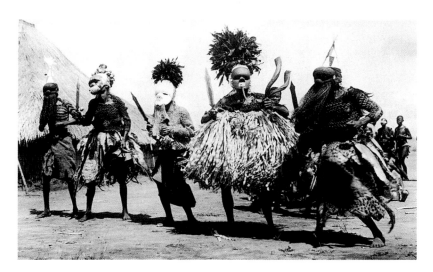

11-49. SALAMPASU MASKS BEING PERFORMED AT SALUSHIMBA, KASAI, CONGO. 1950

The Salampasu have experienced many social, political, and economic changes during the twentieth century, and these changes have directly affected their art. Local religious zealots traveled through the Salampasu region in the 1960s, destroying masks and sculptures. Nevertheless masks are still danced at male circumcision ceremonies.

11-50. MASK. SALAMPASU. COPPER COVER. FOWLER MUSEUM OF CULTURAL HISTORY, UNIVERSITY OF CALIFORNIA, LOS ANGELES

11-51. SALAMPASU DANCE ENCLOSURE, MUKASA, KASAI, CONGO. C. 1950

procured through specific deeds and payments. Mask performances were open only to those men who had the right to wear the mask. Owning many masks indicated the possession of wealth and knowledge. Lower-level masks are carved of wood and painted. The senior-most mask is covered with sheet copper (fig. 11-50). Most masks have pointed teeth, referring to the process of filing the teeth: this was a part of initiation and indicated the novice's strength and discipline.

Very little is known of the other art forms of the Salampasu. Dance enclosures about three feet high were surrounded by carved relief panels (fig. 11-51). Female figures and masks were carved in relief on the sides. The masks refer to the different titles a man could rise to, reflecting the acquisition of knowledge and the accumulation of metaphysical and material power along the way. Only select members of

Matambu, apparently a warriors' association, had the right to dance within the enclosure.

THE KUBA

The Kuba live to the east of the Yaka, the Suku, and the Pende in the area of central Democratic Republic of Congo bordered by the Sankuru, Kasai, and Lulua rivers. Traditions suggest that the leaders of several groups came from the north and established themselves over local farming groups of the Kete people. By the sixteenth century a number of large chiefdoms of various ethnic identifications had developed, and an amalgamated culture using elements of both invading and local groups emerged.

The Kuba are not by any means a cohesive group of peoples, but they have long been known for their complex political structure, a cluster of some nineteen ethnic groups of diverse origin, living under the authority of a king, *nyim*, from the Bushoong group. A council of ritual specialists and titleholders representing the capital and all territorial units formerly advised the Bushoong *nyim*. In addition a number of councils played a role in governance, and various sets of courts heard cases on behalf of the king, providing one of the most sophisticated judicial systems in Central Africa. The present Bushoong dynasty was established during the early seventeenth century. The kingdom reached the geographical limits of its expansion by the middle of the eighteenth century, and during the last quarter of the nineteenth century it reached a pinnacle of development and wealth.

Although today most Kuba ethnic groups are organized into independent chiefdoms, they still recognize the authority of the Bushoong king. Within each village, regardless of the distance from the capital, there are a large number of titles, and a huge number within the population are titleholders. One's standing within the hierarchy is perceived in terms of wealth and rank, and material possessions serve to express status. Each titled position has its set of emblems, symbols, and praise songs. Much Kuba

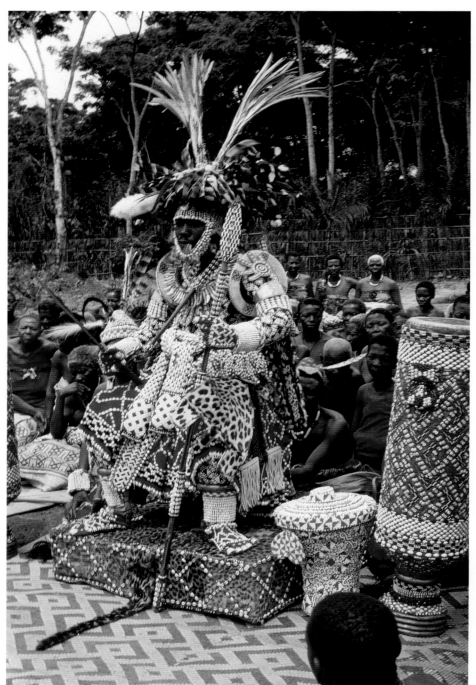

11-52. Kuba king Kot a Mbweeky III in state dress, Democratic Republic of Congo. 1971

art, then, is associated with leadership and prestige, making the king and the nobles of Kuba culture, both in the capital and in the faraway villages, the patrons of the arts.

Leadership Arts

Among the most important art forms for the king and titleholders are modes of dress, for garments, accessories, and held objects signal clearly the prerogatives and ranks of nobility and royalty. In a hierarchy of costumes, each ensemble is more sumptuous and splendid than the one before. At the apex of the hierarchy are the opulent garments of the king, a variety of weighty and complex ensembles that indicate his various roles. To the Kuba, these ensembles and their attendant ornaments and paraphernalia evoke the idea of sacred kingship, the continuity of dynasty, the individual who fills the position, and links to the original peoples of the area and to the land itself. Taken in 1971, the photograph in figure 11-52 shows the reigning king in state dress, *bwaantshy*. A raised dais covered with skins, cowries, and patterned mats separates the sacred king from the earth. To either side stand drums of office covered with beads and cowries in designs that mark his reign. He sits almost immovable in his massive costume which all but conceals the individual man from onlookers, who see instead an embodiment of kingship itself.

Each succeeding ruler commissions his own *bwaantshy*. He wears it on the most important occasions of state, and he will be buried in it. The sumptuous garment, an accumulation of some fifty symbolic objects, weighs as much as 185 pounds. The principal element is a tunic made of interlaced strips of raffia cloth covered with an abundance of beads and cowries. Thigh and arm pieces of beaded interlace further exaggerate the size of the king's body. A red skirt trimmed in cowrie patterns covers the lower portion of the body, while a raffia cloth belt some eight to ten inches wide and up to thirteen feet long, completely covered with cowries, wraps around the waist. Beaded and cowrie-covered sashes, bracelets, anklets, and shoulder rings add visual and actual weight, as do leopard skins, leopard-skin bags and satchels, and metal ornaments. Even the hands and feet are covered with gloves and boots decorated with cowries and ivory nails. The headdress supports a massive bouquet of feathers and long white plumes. A fringe of beads covers the forehead, and an artificial beard of beads and cowries encircles the face. In his right hand the king holds the sword of office; in his left, a cowrie-encrusted lance. These are always held when *bwaantshy* is worn. The virtual sheathing of the king in cowries reminds onlookers that he is a descendant of Woot, the mythical first king and founder of Kuba.

Ndop

Among the best known of Kuba art forms are royal portrait figures, *ndop* (fig. 11-53). The example shown here represents the seventeenth-century king Shyaam aMbul a-Ngoong, during whose reign many of the niceties of Kuba civilization were supposedly introduced, among them the tradition of royal portraiture. Like other *ndop* figures, this one is an idealized representation. The ruler is shown seated cross-legged on a rectangular base

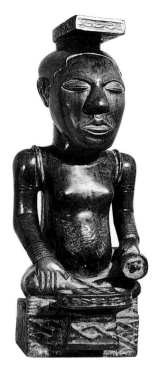

11-53. *NDOP* (ROYAL PORTRAIT FIGURE) FOR SHYAAM AMBUL A-NGOONG. KUBA. 18TH CENTURY. WOOD, HEIGHT 21⅝" (55 CM). THE BRITISH MUSEUM, LONDON

An ndop *was regularly rubbed with camwood and palm oil, giving it a reddish, glowing surface over time. It may have played a role in the installation of the king, and during his life it is said to have been not only a portrait but also the soul double of the king. Whatever happened to him was believed to happen to it as well. Closely associated with the king's fertility, the* ndop *was kept in the women's quarters, and was placed next to his wives during childbirth to ensure safe delivery. Some claim that at the death of the king the life force and power of kingship passed from the dying king to his* ndop *and subsequently to his successor during rituals of installation. Thereafter, the figure served as a memorial and was placed with his throne in a storeroom near his grave, to be displayed on important occasions.*

decorated with patterns that appear as well on certain textiles that allude to position. The base recalls the dais upon which the king sits in state, and the sword of office in the left hand reminds us of the weapons held by the actual monarch.

The costume represented on *ndop* concentrates on a few especially symbolic elements of the full royal panoply: crossed belts over the chest and cowrie-encrusted sash and arm bands. The headdress is a *shody*, a crown with a projecting visor worn only by the king or by regents. Projecting from the base in front of the figure is an *ibol*, an object symbolic of the king's reign. The *ibol* of Shyaam aMbul a-Ngoong is a board for a game of chance and skill, one of the many amenities of civilization said to have been introduced by this culture hero.

Kuba traditions maintain that if the *ndop* is damaged, an exact copy is made to replace it. It is probable that the original *ndop* representing Shyaam aMbul a-Ngoong was replaced by this figure at a later date, for this figure postdates the seventeenth century. Each king after Shyaam aMbul a-Ngoong theoretically had an effigy figure made. The most recent official *ndop* was carved for the king Mbop Mabiine maKyen (ruled 1939–1969). Many similar figures were carved during his reign and have been produced since, not for actual use but for commercial purposes.

Architecture

The Kuba capital at Nsheng has long been recognized for its sophisticated layout (fig. 11-54). The palace itself consists of numerous buildings arranged in distinct sections, the two primary sections being the *yoot*, where the king himself lives, and the *dweengy*, the section reserved for the royal wives. The *yoot* consists of the most beautiful buildings in a maze-like assembly of courtyards. Each structure and each courtyard serve a specific purpose. Each successive enclosure leads further into the inner portion, open only to the king and his most trusted advisors.

The structures themselves are not formally elaborate and consist of simple rectangular buildings with pitched roofs and gabled walls. What differentiates palace structures from those of ordinary people are their size and the decoration of the exterior walls (fig. 11-55). In architecture as in other arts, the Kuba seem to stress line and pattern over sculptural volume, and the surfaces of most luxury objects, including prestige architecture, are beautifully and elaborately embellished with geometric decoration, often modeled after designs associated with textiles. Walls of horizontally laid palm ribs are lashed with vines to create an assortment of designs. Bands of rather plain patterning, *mashooml*, alternate with bands of more ornate geometric designs, *mabaam*. Each *mabaam* pattern is named. The structure in figure 11-55 features two *mabaam* patterns.

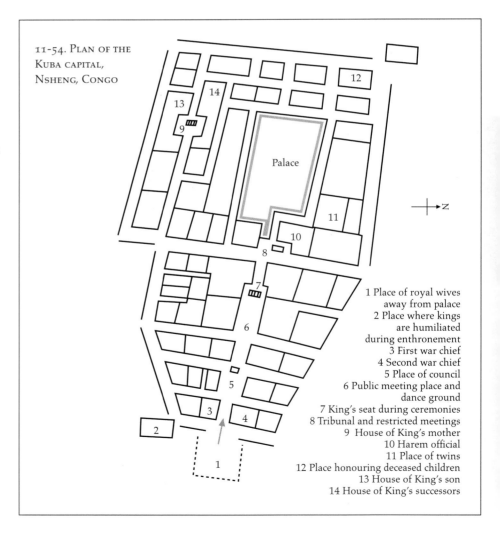

11-54. PLAN OF THE KUBA CAPITAL, NSHENG, CONGO

Palace

1 Place of royal wives away from palace
2 Place where kings are humiliated during enthronement
3 First war chief
4 Second war chief
5 Place of council
6 Public meeting place and dance ground
7 King's seat during ceremonies
8 Tribunal and restricted meetings
9 House of King's mother
10 Harem official
11 Place of twins
12 Place honouring deceased children
13 House of King's son
14 House of King's successors

11-55. Palace building, Nsheng, Congo. Photograph c. 1935–8

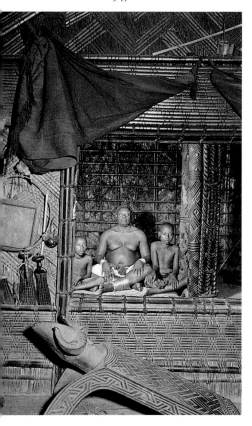

11-56. Interior of royal sleeping house, Nsheng, with King Mbop Mabiine maKyen. 1947

The lower- and upper-most bands of each wall are patterned in *mabuush*, "bundle," referring to the hourglass-shaped designs of lashings. The other *mabaam* bands, three on each wall and three on each gable above, are *mbul bwiin*, a pattern in which two angles enclose a small diamond shape, the module separated from its repeats by V-shapes. *Mbul bwiin* is reserved for the houses of high nobility, and its name derives from that of the woman credited with its creation, either a wife or a sister of a former king.

Palace building interiors are decorated as befits the home of a king. A 1947 photograph of King Mbop Mabiine maKyen shows him seated in his royal sleeping house, *mwaan ambul* (fig. 11-56). The *mabuush* pattern sets off the upper and lower portions of the wall, while the central section sports a design of diagonal patterning. Intricately carved geometric patterns cover the supporting post in the background, near which the king sits with his pages.

His cross-legged pose evokes the representation of the king on the *ndop* in figure 11-53.

Prestige Objects

Several prestige objects can be seen in this photograph of the sleeping house. Stuck in the wall to the left are short swords known as *ikul*. *Ikul* is perhaps the most commonly seen type of weapon among the Kuba, and it is said a true Kuba man is never without one. Tradition maintains that it was Shyaam aMbul a-Ngoong who introduced the form, with its sensuously curving blade of forged iron and carved wooden hilt. The most common type of *ikul* has an unadorned, leaf-shaped iron blade. The most sumptuous *ikul* belong to the high nobility or the king himself, and their blades are inlaid with red or yellow brass. Some royal *ikul* boast openwork designs on the blade. Kuba traditions suggest that some kings were themselves smiths, forging wonderful weapons that are even today part of the royal treasury.

On the floor in front of the opening into the sleeping chamber is a wonderfully designed backrest, whose rectangular face is covered with an elaborate pattern based on overlapping angles. Royal stools, chairs, platforms, mats, and backrests all ensure that the king will not touch the earth. The edge of the rest is covered with an interlace design known as *nnaam*. Used widely on carved objects, beadwork, and textiles, its name suggests an association with vines, perhaps based on the intertwining linear elements. A stylized ram's head projects from the top of the backrest. Rams' heads, which also appear on beaded items of regalia and

on luxury cups (see fig. 11-57) may be understood as a royal icon. Flocks of sheep were kept on the royal preserve, and the image of the ram is a visual metaphor of the relationship of the king to his subjects: he is strong, authoritative, and a source of fecundity.

Such wonderful utilitarian objects were prominent in the art forms that underscored kingship and the nobility who supported it. Other treasures of the kingdom included royal costumes and textiles, works in such precious materials as ivory and brass, and pipes, spoons, boxes, and other luxury objects. Some of the most spectacular Kuba prestige objects are cups for palm wine (fig. 11-57). The ram horns sprouting from the head indicate that the cup belonged to a senior title-

11-57. CUP. KUBA. WOOD, HEIGHT 10¹¹/₁₆″ (27.2 CM). INDIANA UNIVERSITY ART MUSEUM, BLOOMINGTON

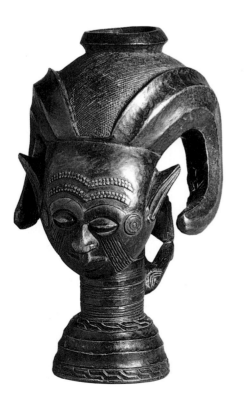

11-58. BEATEN BARKCLOTH. KUBA. BARKCLOTH, RAFFIA, EUROPEAN CLOTH; 58½ x 27½″ (149 x 70 CM). INDIANA UNIVERSITY ART MUSEUM, BLOOMINGTON. GIFT OF HENRY RADFORD HOPE

holder, again a reference to the royal prerogative of keeping sheep, which was occasionally extended to some members of the royal clan. The Kuba predilection for two-dimensional surface design is once more evident in the forehead scarification patterns and the bands of patterning on the base.

Textile Arts

The designs on architectural structures and utilitarian objects are closely related to those that appear on Kuba textiles. Textiles are one of the most widespread types of prestige goods. They figure prominently among the possessions of the elite, yet they are also created and used by all levels of society.

The Kuba have long placed a high value on producing fabric goods. Perhaps one of the oldest types of Kuba fabric is that made from the beaten inner bark of certain trees. In fact, the Kuba refer to felted barkcloth as the apparel of the ancestors. The most beautiful and prestigious barkcloths are made by sewing small sections together. The exquisite skirt shown here combines pieced barkcloth with a

border of raffia textile and imported European cloth (fig. 11-58). What at first seems to be an ordered and regular pattern within the central, barkcloth portion reveals itself on closer inspection as a complicated design with minor variations. Two triangular pieces of light, natural-colored barkcloth are sewn to two darker dyed pieces. The resulting small squares make up rectangular portions pieced to other rectangles of slightly varying hue.

The production of fabrics and the patterns associated with them reflect Kuba concepts of social creditability, ethnic unity, and religion. This is especially true of raffia textiles, where production and design are collaborative undertakings. Men cultivate the palm trees which produce fronds as long as fifty feet. The outer layers of the individual leaflets provide the raffia fiber, collected by men and woven by them on a diagonal loom into rectangular panels of cloth slightly more than two feet square. Both men and women decorate the textiles and sew them into garments. Men fashion men's skirts, and women create women's skirts. A number of decorative techniques are used by both genders, including

embroidery, appliqué, patchwork, and dying. In addition, women employ other decorative processes such as openwork and cut-pile embroidery.

Women's skirts may be up to nine yards long and are worn wrapped around the body. Men's skirts, bordered with raffia tufts, may be even longer, and are worn gathered around the hips, with the top portion folded over a belt. A woman's skirt like the one shown in figure 11-59, over twenty feet in length, may incorporate over thirty panels of cloth. Each dou-

bled, natural-colored rectangular panel is covered with lively appliqué designs in shades of tan and brown outlined in fine black stitching. Many women may have worked individually to produce the sections that make up the skirt. The result is an organic arrangement of quasi-geometric forms reflecting the repertoire of designs and the varying abilities of the many women who contributed to the project.

Women use cut-pile embroidery to create rich and varied geometric designs (fig. 11-60). In this example patterns

11-59. WOMAN'S WRAP SKIRT (DETAIL). KUBA. 19TH–20TH CENTURY. RAFFIA CLOTH, 20'9" X 31" (6.32 X 0.79 M). VIRGINIA MUSEUM OF FINE ARTS, RICHMOND, VA. KATHLEEN BOONE SAMUELS MEMORIAL FUND

11-60. CUT-PILE EMBROIDERY CLOTH. KUBA. LATE 19TH–20TH CENTURY. RAFFIA CLOTH, 50 X 19⅜" (128 X 50 CM). THE BRITISH MUSEUM, LONDON

based on triangles, lozenges, and rectangles placed on the diagonal predominate. Dark patterns of dyed raffia play against the light natural hues of the ground. As is typical of the cloths produced by women, sudden changes break the surface up into sections of striking differences in thickness and width of line. Bold, band-like elements in the central panel to the left contrast with the delicate, linear elements to the right. At least four contrasting border designs provide a restless and changing pattern of great visual immediacy.

Raffia cloth played an important role in Kuba society in the past. Squares of raffia cloth were once used as currency and figured in marriage contracts and legal settlements. The wearing of Kuba-produced cloth and the display of embroidered raffia squares was an important element in court ceremony and in funerals. Today, raffia cloth is still a reminder of loyalties, histories, and relationships, and it is considered the only appropriate burial cloth. The body of the deceased is dressed in a prescribed number of textiles of varying size and style. Multiple skirts placed on the body are a mark of prestige. Heirloom skirts are offered as memorial gifts by the spouse of the dead and by friends. The generosity of the surviving spouse may be questioned and the gift refused if the donated memorial skirt is not beautiful or fine enough to satisfy the family of the dead spouse. Additional textiles may be added in layers over the dressed corpse, especially squares of cloth decorated with cut-pile embroidery. Originally, cut-pile embroidered fabric seems to have been used largely in funerary contexts.

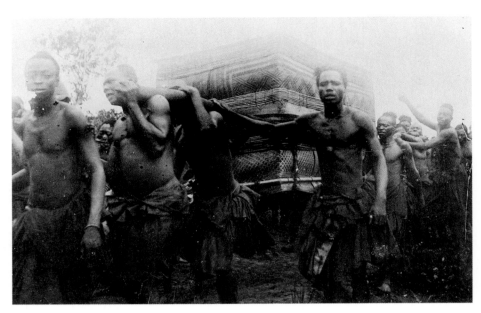

11-61. COFFIN OF THE MOTHER OF THE KUBA KING PETSHANGA KENA, NSHENG, KASAI, CONGO. 1926

During the burial ceremony, the dressed and decorated body is set upright for viewing before it is placed in an ornate coffin made of large decorated mats over a bamboo frame (fig. 11-61). The coffin of the mother of the Kuba king Petshanga Kena was decorated with horizontal bands of decorative patterns woven into the matting, evoking the buildings in the palace compound. Other coffins were made to imitate the pitched-roof houses of the Kuba, with meticulous attention given to architectural detail. At the grave, the coffin was lowered, and items such as carved drinking cups, costume elements, and more textiles were added to it—gifts to accompany the deceased into the world of the dead.

Masks and Masquerades

The striking masks of the Kuba are also wonderfully decorated with geometric surface designs in dazzling contrasts of color, pattern, and texture. Hide, animal hair, fur, and feathers further ornament the masks, and costumes of barkcloth, raffia fiber fabric, and beaded elements complete these manifestation of nature spirits, intermediaries between the Supreme Being and the people. Over twenty types of masks are used among the Kuba, with meanings and functions that vary from group to group.

A photograph taken in 1909 in the Kuba capital of Nsheng illustrates an important group of masks used in the royal villages of the central area (fig. 11-62). In Nsheng, all masks belong to the king and may not be danced without his express permission. The three masquerades seated together in the photograph have been referred to as the royal masks. From left to right they are *ngady a mwash*, *bwoom*, and *mwashamboy*.

Mwashamboy wears a large mask made of a flat piece of leopard skin. Eyes, nose, mouth, and ears are

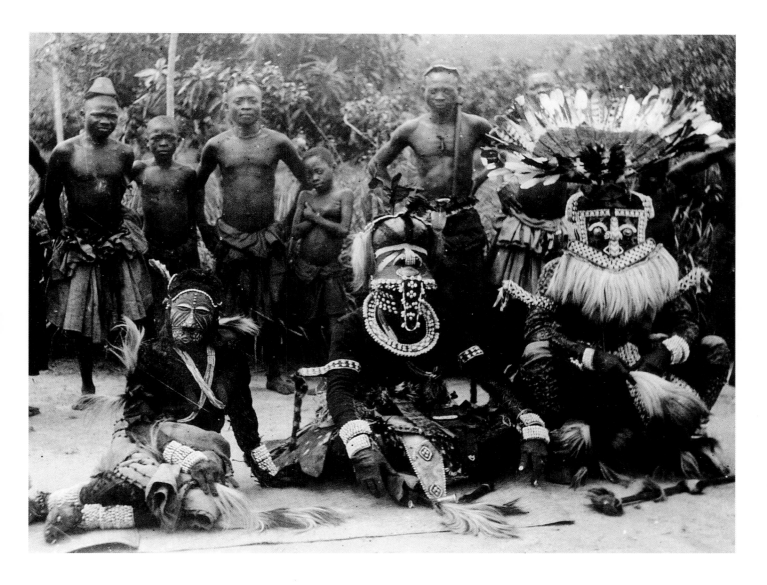

carved of wood and attached. Other details are added with shells and cowries. Animal hair provides the impressive beard, and a huge headdress made of eagle or parrot feathers, like that worn by the king himself, indicates the mask's royal status. The masquerader wears a costume made of barkcloth and raffia cloth with a variety of symbolic objects attached, also recalling the great beaded and cowrie-covered dress of the king.

Although the mask is referred to as the king's mask, the king does not wear it himself, but rather chooses someone to do so. The mask has no eyeholes, and thus *mwashamboy* dances a slow, dignified dance. A manifestation of Woot, the royal ancestor and founder of the Kuba kingdom, *mwashamboy* appears in three variants. In one version, shown here, the king's mask is crowned with a feather headdress. Another variant has instead a cone that extends forward to mimic an elephant's trunk. A third version is said to be placed over the face of a dead monarch before burial, transforming him symbolically into Woot, his founding ancestor.

11-62. ROYAL KUBA MASQUERADES, NSHENG, KASAI, CONGO. 1909

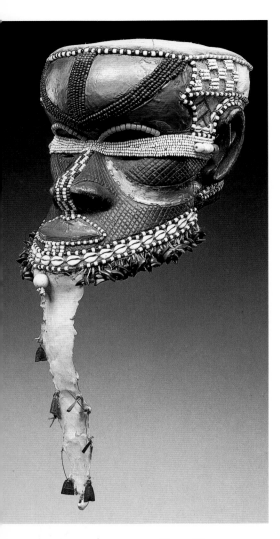

cowries. Bands of black beads divide the forehead into sections. A strip of blue and white descends the bridge of the nose to the lips. Like *mwashamboy*, *bwoom* has no eyeholes (its wearer sees through the bored nostrils when the mask is worn diagonally). A strip of beads covering the eyes like a blindfold accentuates the "blindness" of the mask. A beard of beads and cowries lines the lower portion of the mask, and a hide strip descends from it. *Bwoom* maskers are completely covered by the costume, which is less refined and not as ostentatious as that of the lordly *mwashamboy*.

With its distinctive bulging forehead, *bwoom* may caricature the face of a Tshwa pygmy. Some traditions say it manifests a hydrocephalic prince or a spirit. In Nsheng, *bwoom* is second in rank to *mwashamboy*. Although

bwoom is referred to as a royal mask and is seen as a brother of Woot, in performance it may present the image of a commoner, a prince, a pygmy, or a subversive element in the royal court. Events in the dance, in which the two male masks interact, are said to refer to the origin myths of the Kuba kingdom and to episodes of Kuba history.

Ngady a mwash is a carved wooden face mask with narrow eye-slits that allow the wearer to see (fig. 11-64). A wig of raffia cloth and cowries is topped by a cap form. A strip of beadwork covers her nose and descends over her mouth. Her face is entirely covered with bold geometric designs. Black and white triangles across the forehead, temples, and lower face represent the black stones of the hearth and domesticity. They also recall the triangles of dark and light

11-63. *Bwoom* mask. Kuba. Wood, sheet copper, beads, shells, hide; height 13″ (32.8 cm). Royal Museum of Central Africa, Tervuren

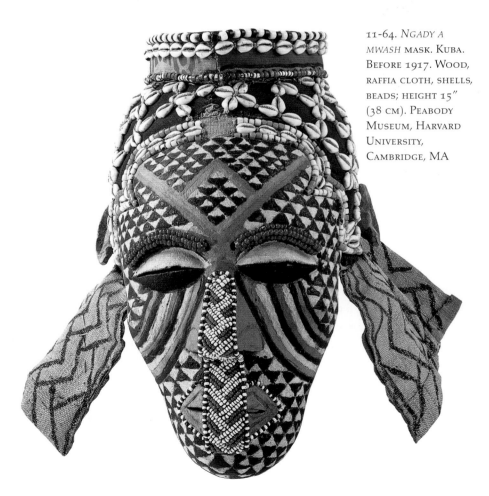

11-64. *Ngady a mwash* mask. Kuba. Before 1917. Wood, raffia cloth, shells, beads; height 15″ (38 cm). Peabody Museum, Harvard University, Cambridge, MA

Bwoom is a carved wooden helmet mask (fig. 11-63). Its wide forehead bulges above sunken cheeks, here covered with fine hatching. Sheet copper, associated with leadership in most Central African cultures, covers the forehead and decorates the cheeks. The lips, too, are covered with copper and outlined with red and white beads. As a royal mask *bwoom* is profusely decorated with imported beads and

barkcloth in pieced fabrics which are associated with ancestral clothing and still worn during periods of mourning (see fig. 11-58).

Said to be Woot's sister and his wife, *ngady a mwash* is the female ancestor and essence of womanhood. The use of the barkcloth motifs may be a conscious device to indicate the ideas of suffering and mourning and to allude to ancestral ties. Diagonal lines below *ngady a mwash*'s eyes symbolize tears and refer to the hardships of women. The juxtaposition of white, a color associated with the sacred but also with mourning, and red, associated with suffering and fertility, underscores these ideas yet again. The feminine attributes associated with the mythic character are accentuated not by outward physical signs but by her actions and carefully choreographed movements. In the mime acted out in the capital, *ngady a mwash* is fought over by the royal *mwashamboy* and the commoner *bwoom*. The name *ngady a mwash* means "pawn woman of *mwash*." She is a pawn in the sense that she was used by her lord to attract followers by granting access to her favors.

The royal context of masks has perhaps been over-emphasized in literature on the Kuba because early visitors documented the masking activities at the capital. In fact all Kuba groups use masks, and those beyond the area around Nsheng are less likely to have specifically royal connotations. One widespread context for masking is initiation. Every fifteen years or so a group of boys will be inducted into manhood through the *mukanda* event, which as elsewhere in the region transforms uncircumcised boys into initiated men who possess esoteric knowledge. The making and display of masquerades are fundamental components of induction, and a hierarchy of both male and female masked figures dominates the ceremonial performances, all danced by men.

Funerals are a second important context for masks throughout the Kuba area. A hierarchy of masks appears at funerals even of untitled men, though they are especially important at the funerals of titleholders. Senior titleholders, whether they live in the capital or in outlying areas, have the right to have important masquerades at their funerals.

IN THE SHADOW OF THE KUBA: THE NDENGESE, THE BINJI, AND THE WONGO

The forms and styles of Kuba art pervade the Kasai–Sankuru region, suggesting the intermingling and interactions that have taken place over long periods of time. Three peoples whose art has functional or formal parallels to Kuba works are the Ndengese, the Binji, and the Wongo.

The Ndengese, who live just to the north of the Sankuru River, seem to have preceded the Kuba into the region. Their early occupancy is perhaps suggested by the fact that when the Kuba *nyim* is installed, emissaries must go to the Ndengese to collect sacred earth for the ceremonies. Relationships between the groups are further entwined by the Ndengese myth that the first Ndengese king was the seventh son of Woot.

The elegant, elongated Ndengese figure shown here is called an *isikimanji* (fig. 11-65). It represents a chief or a king and is said to hold the power

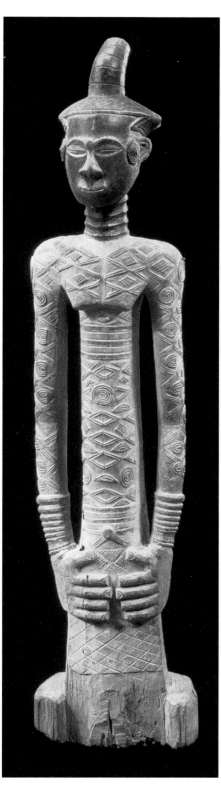

11-65. *ISIKIMANJI* FIGURE. NDENGESE. ROYAL MUSEUM OF CENTRAL AFRICA, TERVUREN

and clothing of a ruler after he dies. The flared shape of the head is not unlike that found on palm wine cups and on the *bwoom* masks of the Kuba. The headdress, a distorted cone, represents the one placed on the king's head during his installation and symbolizes understanding, intelligence, distinction, respect, and unity among chiefs. The placement of the hands on the belly refers to the common origins of the king's subjects, from whom he anticipates cooperation. Numerous symbols are carved on the neck and on the elongated torso and arms in imitation of scarification patterns. The patterns allude to aphorisms and praise phrases that encode the mysteries of Ndengese chiefly authority. For example, concentric circles pertain to the position of the chief in relation to the people he leads and also to the rela-

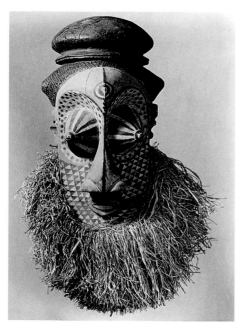

11-66. MASK. BINJI. 1910(?). WOOD, HEIGHT C. 25½" (65 CM). MUSEUM FÜR VÖLKERKUNDE, STAATLICHE MUSEEN, BERLIN

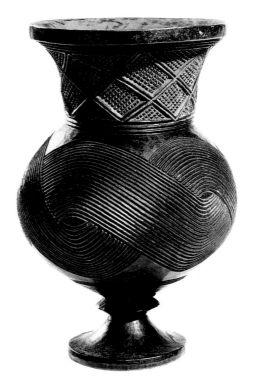

11-67. CUP. WONGO. BEFORE 1909. WOOD, 8¼" (21 CM). THE BRITISH MUSEUM, LONDON

tionship between the community and the cosmic sphere. Spirals allude to the saying "all that comes from the chief returns to the chief," referring to political authority. Lozenges on the arms indicate chiefly protection. Conceptually, Ndengese *isikimanji* invite comparison with Kuba memorial royal figures, *ndop*.

The Binji peoples are not organized into a political unit but share a language and cultural traits. Their origin myth suggests Kuba ancestry. Art forms such as pipes, cups for palm wine, and oracles in the shapes of animals are very like those of the Kuba. Masks used in initiation are powerfully formed, and it has been suggested that one type may be the prototype for the *bwoom* type of mask of the Kuba

(fig. 11-66). The swelling forehead, the shape of the nose and mouth, and the triangular patterns on the lower portion of the face are all suggestive of the masks of the eastern Kuba. Powerful cone-shaped eyes announce the great force within the mask.

The Wongo are not formally part of the Kuba cluster, though they share many artistic and cultural features. Collected in 1909 in the Wongo area to the west of the Kuba, the elegant cup shown in figure 11-67 invites comparison with the aesthetic of Kuba cups in its pairing of elaborate surface patterning and simple, elegant form. Masterful control of adz and knife are evident in the cup's almost perfect symmetry and in the precision of its finely carved decoration.

THE LULUA

Lulua is an umbrella term which refers to a large number of heterogeneous peoples who populate the region south of the Kuba between the Kasai and Sankuru rivers. They have never united as a political entity, and the name itself merely reflects the fact that they live near the Lulua River. Luba incursions from the east and north forced these peoples to the south, driving them into places where contact with many neighbors, among them the Kuba, the Pende, the Chokwe, and the Songye, promoted an active interchange of cultural characteristics.

The Lulua are celebrated for elegant and graceful figurative sculptures. Complex raised patterns carved on the neck, abdomen, face, and limbs recall old Lulua customs, now long gone, of beautifying the body through elaborate scarification. Most figures are

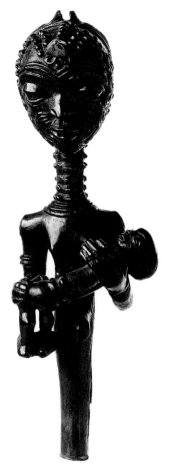

11-68. MOTHER-AND-CHILD FIGURE. LULUA. 19TH CENTURY. WOOD AND METAL; HEIGHT 14" (35.6 CM). BROOKLYN MUSEUM, NEW YORK. MUSEUM COLLECTION FUND

commissioned for use in a religious association concerned with issues of childbirth and human fertility. When a woman loses a number of children through miscarriage, stillbirth, or postnatal death, witchcraft is suspected. An appeal is made to a diviner for advice, and the problem may be attributed to the presence of an ancestral spirit, *tshibola*. After being initiated into the association, such a woman would often be given one or more figures depicting aspects of motherhood.

The mother-and-child figure shown here represents a highly placed woman (fig. 11-68). The large head, the elaborate coiffure, the long neck, the elaborate body marking, and abundant jewelry conform to Lulua ideals of adult female beauty. Yet scarification and the emphasis on certain parts of the body allude to more than the tradition of body adornment. Decorative motifs often embody deeper significance. Concentric designs accentuating the swelling navel, for example, are seen not only as referring to the link between mother and child but serve too as a metaphor for the close connection with the ancestors and the continuity of generations. The beautifully formed, bulging eyes refer to the ability of an individual to detect the malevolent intentions of bewitchers in time to avoid harm. Marks on the temple indicate the point where wisdom, perceptiveness, and understanding penetrate. Concentric circles and spirals in general may refer to great heavenly bodies and are symbols of hope and life. The double line across the forehead stands for life in the human body, specifically the heart beating in the breast and the child growing in the womb.

Aided by various rituals, the beauty of the figure with its intricate surface and wonderfully arranged hair is believed to attract the *tshibola*. The ancestral spirit will be reborn in the next infant in the family and will ensure the child's survival into adulthood. Rubbed daily with a mixture of oil, camwood powder, and kaolin, the figure attains a rich, glossy patina. The child who is the result of such consultation is also rubbed with the same oils and cosmetics, and its glistening reddish tone demonstrates its special status to all.

Lulua chiefs display works of art that allude to their position. The large figure shown here is of a fairly rare type, part of the regalia of a leopard chief, the highest of chiefly rankings (fig. 11-69). Seen as living continua-

11-69. WARRIOR FIGURE. LULUA. BEFORE 1885. WOOD, HEIGHT 29⅛" (74 CM). MUSEUM FÜR VÖLKERKUNDE. STAATLICHE MUSEEN, BERLIN

The red cosmetic made from powdered camwood and oil or water to anoint the body is also applied to Lulua sculptures. In this example, only the left side of the face has been covered with red camwood.

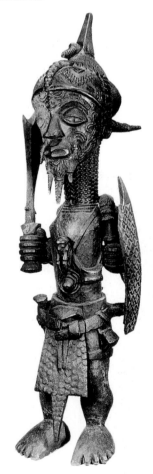

tions of their predecessors, those who attain this rank are believed to have a spiritual connection with the leopard and to draw upon its power. As in the *tshibola* figure above, abundant detail embellishes an elegantly elongated form. An elaborate hairdo of braids gathered upward to a point suggests a helmet; the beard, too, is braided and plaited. Intricate scar patterns adorn the forehead, brow, cheeks, and neck. At the waist hangs a leopard skin, the primary symbol of office. A power object in the form of a crouching figure is suspended from the neck. The motif of the crouching figure, knee on elbow, is widespread among the Lulua and other regional groups. It has been interpreted as a chief reflecting on his social commitments and obligations. At the same time, such crouching figures are

attached to the belt or the rifle of hunters and are used in rites that prepare him for the successful hunt. Other attributes bear out the depiction of the leopard chief as the ideal hunter, including the knives and other implements worn at the waist and the shield carried in the left hand. The right hands holds a ceremonial sword.

Such figures are used as mediums in rituals believed to fortify the life force of the chief, to perpetuate ties with the ancestors, and to keep the community free from adversity. Formerly, some are said to have accompanied warriors into battle to provide moral support and courage and to revitalize the power of chiefs. On these occasions supernatural ingredients from the personal reserves of chiefs and counselors would have been added to the sculpture.

CONTEMPORARY URBAN AND INTERNATIONAL ART

Often self-taught or trained as sign-painters, contemporary urban artists paint for a local, popular audience. Viewing themselves as entrepreneurs or businessmen, they create images in quantity designed to please, selling them in markets or shopfronts or on the street. Their great subject is life as it is known in modern African cities. Yet while urban artists may record the filth, corruption, and vice they see or have experienced themselves, their

11-70. *MITTERRAND AND MOBUTU*. MOKE. 1989. OIL ON CANVAS, 44 X 72″ (112 X 185 CM). THE PIGOZZI COLLECTION

11-71. *Mobali Ya Monyato* (Domestic Fight). Chéri Samba. 1989. Acrylic on canvas. Peter Herrman Galerie, Stuttgart

paintings are presented without bitterness or deep comment. In fact, there is often a somewhat optimistic point of view, one in which unpretentious ordinary people enjoy life and perhaps make a little trouble for those who think themselves too important.

In an enthusiastic composition painted on a flour sack, the self-taught Kinshasa artist Moke (born 1950) records a visit paid by François Mitterrand, President of France, to Mobutu Seke Seko, President of Zaire, as the Democratic Republic of Congo was then known (fig. 11-70). Escorted by soldiers and motorcycle police and watched over by a helicopter, they ride in a limousine along a street lined with French and Zairian flags. Mitterrand waves as Mobutu lifts his signature cane. Members of the enthusiastic crowd wave miniature flags, and two women in the foreground wear commemorative cloths featuring the Zairian flag and a portrait of Mobutu, providing further splashes of the greens and reds that pulsate through the composition.

Moke was born in the capital city of Kinshasa. Orphaned at an early age, he had very little schooling. Like most urban artists, he paints with an

audience of ordinary working people in mind. With the eye of a journalist, he often depicts events drawn from the daily news, and he is more concerned with presenting a story than in addressing matters of style or painterly skill or playing with aesthetic issues. Like many urban artists, too, his work is often rather conventionalized. He repeats his best images, themes, and compositions upon request, not as faithful reproductions, but as variations.

Chéri Samba (born 1956), another urban artist, presents a caustic, sometimes amusing view of a struggle all too familiar to his African audience. Unlike Moke the observer, Chéri Samba makes pronouncements. His views of the Democratic Republic of Congo (as well as of Europe) are unique in the art of urban painters. The message is paramount, and he tells it from a specific point of view. He is a moralist, a teacher who tries to instruct those in need of a lesson not only in his own society, but also those who may see his work in galleries and museums in Europe. In *Domestic Fight*, which was exhibited in 1989 in the "Magiciens de la Terre" exhibition at the Pompidou Center in Paris, Samba uses a device common to many of his paintings (fig. 11-71). Text is written in two languages to spell out his message more effectively to diverse audiences. Samba sees his extensive use of text as a way of making his viewers slow down and look more carefully at his paintings.

Here, he uses French and Lingala, the language spoken in Kinshasa in colonial days, and in the regime of Mobutu, by the army. Lingala is a pidgin specifically created by the colonizers for use by the Force Publique,

11-72. *Materna*. Trigo Piula

so that they would have a language different from any particular one spoken by individual soldiers. It is also the language known by the largest number of inhabitants in the nation. (Samba sometimes uses Kikongo rather than Lingala.) The walls are used for three separate speech blurbs, each in alternating French and Lingala. The blurb on the left is associated with the man, a tiny hook at floor level points to his head. He implores the neighbors to intercede on his behalf while he still has the restraint not to kill his wife and begs her, "Ahh! Madame, not down there!" The blurb in the center belongs to the woman, bemoaning men's treatment of women through the ages and demanding that everything change as her hand approaches his intimate parts, "A woman is more than a plaything! She has the same abilities as a man!" The third blurb, on the wall on the right. is the voice of a witness peeking in from the foyer who laments the ineffectiveness of dealing with marital discord and the lack of familial harmony, "Oh well, there are several ways to punish one's wife."

In the 1980s Chéri Samba's work became known outside of Africa. After being selected to participate in the acclaimed *Magiciens de la Terre* exhibition, he was offered gallery shows and museum exhibitions in Europe and New York. Change in style and subject is not typical of urban painters, but since exhibiting in Europe, Samba has rarely repeated himself. He is currently represented by a gallery in Paris and sells largely to foreigners, but he remains rooted in the urban tradition. He still lives in Kinshasa, and he continues to exhibit his paintings in the front of his shop before they travel to Europe. Samba's images still remark on his experiences in the modern African city, but he presents them in a way that is accessible to outsiders.

Other artists work with a developed awareness of outside, especially Western, art traditions, and of the international art world, a world of museums and galleries and exhibitions, critics and curators and patrons, theorized viewpoints and shifting preoccupations. These artists have generally had formal training, and they often purposefully incorporate into their work what might be called westernisms, that is motifs, styles, or techniques self-consciously quoted from the West.

In *Materna*, the artist Trigo Piula, from the Congo Republic, intermingles Kongo and Western images to comment on traditional African societies and the impact of the West upon them (fig. 11-72). The theme of the mother and child is widespread in African art south of the Sahara, and the cross-legged figure with armlets and anklets here is lifted directly from Kongo prototypes carved of wood or stone (see fig. 11-8). But the head of the figure, in marked contrast, is that of a blond European woman blandly looking at the viewer. A square behind her suggests wax-printed fabrics so readily associated with present-day Africa. The mother does not nurse her child; in fact, the pose of the child may even suggest that it is dead. Arrayed in front of the mother and child are candles and cans of imported evaporated milk, a deadly substitute for breastmilk. Projecting from two cans are images that suggest *nkisi* figures. An African slogan expresses a view that might be implied by the artist: "We can see where her head is: it has become the head of a white woman."

Trigo Piula uses westernisms to comment on the cultural predicament that contemporary Africans find themselves in, caught between the world as experienced by their ancestors and the world as it exists today. Here he addresses the evils of consumerism. Western goods (not just evaporated milk to replace mother's milk, but also other canned goods, beer, cars, televisions, and so on) are dazzling the minds of Africans, he seems to say. Here the painter serves as moral exhorter, preaching to the public to examine their values. In this way his painting is functional, just as precolonial arts were.

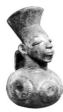

12
THE EASTERN
CONGO BASIN

A VARIETY OF CULTURES DEVELOPED in the eastern reaches of the Congo basin. In the southern savannahs Luba kingdoms, related to the Lunda to the west (see chapter 11), along with other groups, established centralized governments that employed art to undergird notions of sacred leadership invested in kings, chiefs, and other titleholders.

In the forests to the north of the savannahs, centralized systems of government are noticeably absent. Communal organizations attended to the smooth running of the community. Here, art played a role in the initiation and instruction of members of the organizations and served to instill philosophical precepts.

On the northern fringes of the forests, at least two groups, the Azande and the Mangbetu, seem to have migrated from the northern savannahs to develop chiefdoms and kingdoms in the forest belt. As in the southern kingdoms, art established the importance of leadership, but the objects here did not connote the sacred as they did in the south.

EARLY ART FROM THE UPEMBA DEPRESSION

Iron technology was used in the eastern part of what is now Congo by the middle of the fourth century AD, and by the sixth century it was used in the Upemba depression, a vast, swampy rift valley covered with lakes. An abundance of pottery, charcoal, and stone tools, and some iron implements (barbed arrowheads, spearheads, curved knives, and hoes) have been found from the Kamilambian period (between the sixth and the eighth centuries). Graves from the following early

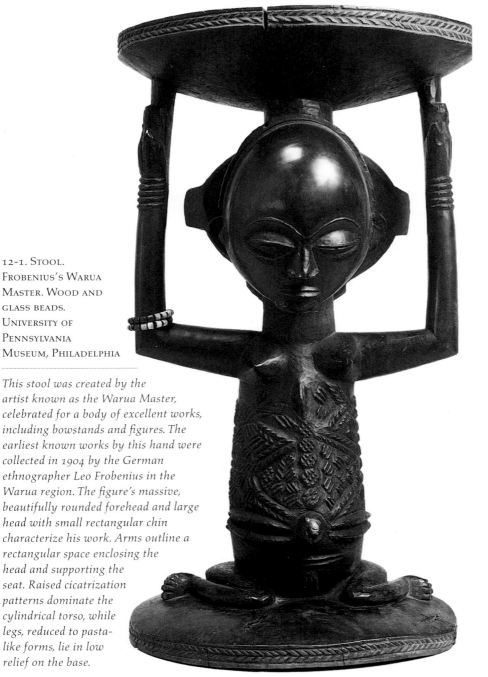

12-1. STOOL.
FROBENIUS'S WARUA
MASTER. WOOD AND
GLASS BEADS.
UNIVERSITY OF
PENNSYLVANIA
MUSEUM, PHILADELPHIA

This stool was created by the artist known as the Warua Master, celebrated for a body of excellent works, including bowstands and figures. The earliest known works by this hand were collected in 1904 by the German ethnographer Leo Frobenius in the Warua region. The figure's massive, beautifully rounded forehead and large head with small rectangular chin characterize his work. Arms outline a rectangular space enclosing the head and supporting the seat. Raised cicatrization patterns dominate the cylindrical torso, while legs, reduced to pasta-like forms, lie in low relief on the base.

12-2. Ax from a burial in the Upemba depression. Kisalian period, 8th–10th century. Iron head, wooden handle set with iron nails. Drawing by Y. Bale

Kisalian period (from the eighth to the tenth century) contain iron hoes, knives, spearheads, and ax heads (fig. 12-2). Axes with carefully shaped blades and handles decorated with iron nails are not unlike axes of authority used throughout the region today, which suggests that social hierarchies had developed already. The smith who created the ceremonial ax illustrated here strove to give aesthetic form in the forging process, working a complex symmetrical silhouette, reinforcing it with a central spine, and decorating its surface with incised patterns. Ancient axes provide evidence for the antiquity of political orders based on metal technologies.

The Classic Kisalian period begins with the tenth century. Numerous graves with many objects, an abundance of copper in the form of utilitarian objects as well as ornamental luxury goods and ivory objects such as armlets and necklaces, suggest further development of a hierarchical society. Copper necklaces, copper and iron armlets, shell beads, iron pendants, and ivory objects on the body indicate status and power. The grave illustrated here was filled with well-made vessels in a variety of shapes, some with footed bases, others with spouts and handles (fig. 12-3). Rounded bottoms, marked necks and shoulders, and in-turned lips are characteristic of vessels in Classic Kisalian graves, decorated with channels, incisions, comb stamps, and impressions.

Most excavations along the lakes consist of burials. Although everyday utilitarian objects were buried with the dead, much of the pottery seems to have been symbolic or ritual in function. The size of burial vessels seems to be proportional to the age of the deceased, the larger vessels placed with older persons, suggesting a symbolic role. Graves with more pots contain the most uncommon materials, such as cowrie shells and ivory, pointing to an even more stratified society by the beginning of the second millennium.

Throughout Central Africa, copper has long been a medium indicating status and associated with the formation of central authority systems. The amount of copper increases in Classic Kisalian graves, and luxury objects, such as bells and bracelets, suggest continued and greater trade with the copperbelt to the south.

IN THE SPHERE OF THE LUBA EMPIRE

The Luba live along lakes and rivers in the savannah region of southeastern Congo, their heartland lying in the area of the Upemba depression. They took advantage of the many natural resources, using rivers for fishing and as avenues for long-distance trade. All helped in the creation of hierarchical societies not unlike those to the west (see chapter 11), and eventually led to the establishment of an influential kingdom.

12-3. Grave no. 172, the Upemba depression

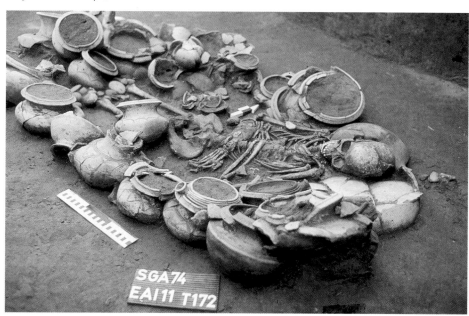

In oral histories, the tyrant Nkongolo Mwamba ruled over the region. A handsome young hunter, Mbidi Kiluwe, arrived and married Nkongolo Mwamba's sister, fathering a son, Kalala Ilunga. Kalala, a heroic warrior, defeated his despotic uncle and ascended to the seat of authority. Kalala became the embodiment of the new political structure of sacred kingship introduced from the east by his father. Among the patchwork of chiefdoms in the region today, each claims descent from the founders of Luba sacred kingship, Mbidi Kiluwe and Kalala Ilunga. (Chibunda Ilunga of Lunda and Chokwe Fame was the son of Kalala: see chapter 11.)

Leaders in neighboring areas affirmed political and economic alliances with Luba chiefs and kings through gifts recognizing seniority. This network of gift giving as well as cultural similarities led scholars to assume that there was once a Luba empire. Over time, Luba cultural identity was emulated by neighboring peoples, lending credence to the idea of a Luba empire. Today, such assumptions are being reevaluated. Although it is evident that there were many similarities among many rulers in the region and the objects used to support royal authority, it is perhaps a fiction that there was ever a single authority dominating the entire region. Luba culture and influence peaked in the seventeenth century and collapsed in the late nineteenth century, a result of the Arab slave trade. Today significant elements of the precolonial political infrastructure still exist, but Luba chiefs work within the structure of a modern national state.

The Luba Heartland

Magnificent regalia once called attention to Luba chiefs and kings. Stools, staffs of office, bowstands, cups, headrests, and ceremonial weaponry were distributed at the installations of chiefs to extend royal power to outlying areas. Human images, usually female, decorate such objects, perhaps representing the daughters and sisters of kings given as wives to provincial leaders to solidify political relationships. Such figures display elaborate coiffures and beautifully scarified bodies, signs of rank and position.

Luba power was not entirely vested in a single monarch. The king reigned over subordinate chiefs, and power was shared by numerous people in several professions, including titleholders, diviners, healers, and members of secret associations. All were initiated into a body of sacred knowledge taught through Mbudye, an association guarding political and historical precepts and disseminating knowledge selectively and discretely through ritual. Insignia for those initiated into Mbudye were often shared—stools, staffs, spears, and other weapons, symbols of power, authority, and wealth.

While such symbolic objects denoting high office are often highly visible, this was not always the case. For example, the superbly formed bowstand shown here, with three projecting, slightly curving branches sprouting from the head of a female figure, was rarely seen (fig. 12-4). Textured designs of lozenges and triangles incised into the surface of the prongs refer to scarification patterns that relate to royal prohibitions. The elegant female form exhibits the characteristic Luba style with its

12-4. BOWSTAND. LUBA. ETNOGRAFISCH MUSEUM, ANTWERP

Bowstands refer to the origins of kingship with Mbidi Kiluwe and the role of hunting in relation to leadership. Although no longer used as symbols of royal authority, they were once potent objects and were never displayed in public. Kept in secret places containing sacred relics of past rulers, they were treated with ritual and prohibitions and approached with prayer and sacrifice. When the king appeared in public, the object itself was never seen. Instead the female guardian of the bowstand followed him, clasping a simple bow between her breasts, becoming a living bowstand.

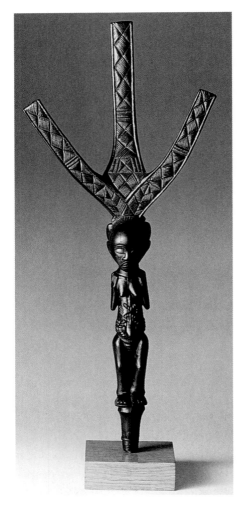

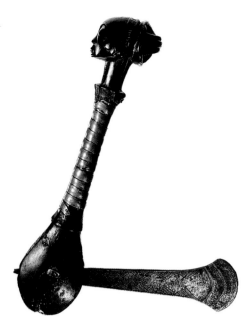

12-5. CEREMONIAL AX. LUBA. 19TH
CENTURY. IRON, COPPER, WOOD; HEIGHT
14¼" (36.5 CM). MUSEUM RIETBERG ,
ZÜRICH

Beautifully wrought ritual axes, kibiki
and kasolwa, *belong not only to kings
and chiefs but also to high-ranking
titleholders, female mediums, secret
association members, and diviners.
Like the bowstand, axes are symbolic
rather than utilitarian. Blunt blades,
incised with geometric designs, copper-
wrapped handles, and the sometimes
complex carvings on the ends do not
allow their use as tools or weapons.
They serve as a visual enhancement
and metaphorical extension of
leadership.*

highly polished surface, broad,
rounded forehead, and elaborate hair-
style and scarification. The image of
the female with her hands to her
breast refers to certain women who
guard the secrets of royalty within
their breasts. While such figures may
represent a wife or sister of a ruler, in
some areas they are said to represent
specific women of Luba history such as
those who led migrations of people.

Another explanation of the female fig-
ure states that the spirit of a Luba king
is incarnated in the body of a woman
after death and that the depiction thus
commemorates the incarnation of the
dead king. Originally such bowstands
were utilitarian objects used by
hunters for hanging bows and arrows.
They eventually became royal author-
ity symbols, ultimately referring to
Mbidi Kiluwe, the renowned hunter
whose bow was his most cherished
possession. According to the origin sto-
ries, Mbidi was also a blacksmith and
introduced advanced technologies in
both hunting and smithing from the
east.

The ceremonial ax is one of the
most important objects produced by
Luba blacksmiths. Axes are still often
worn over the shoulder of Luba kings,
chiefs, and counselors as signs of status
and wealth. Incised crosshatched pat-
terns cover the curving wrought-iron
blade of the example shown here (fig.
12-5). The bulbous handle, its shank
wrapped with copper, ends in the skill-
fully rendered head of a woman. Her
delicate features and high forehead are
typical of Luba style. The complex
hairdo, *kaposhi,* in which the hair is
gathered into four tresses and formed
like a cross, is a classic Luba style
found on most Luba carvings.

Axes were used as indicators of
authority probably as early as the
eleventh century, when they were
buried in graves of high-ranking indi-
viduals during the Kisalian period. In
addition to being prestige objects, axes
are often wielded in dance and in
important court ceremonies, carrying
profound messages and playing a cen-
tral role in the initiation rites of
Mbudye. Symbolically, the ax is used
to clear the path that leads to civiliza-

tion. The notion of cutting paths and
making traces upon the land is
metaphorically expressed in the deli-
cately engraved patterns on the
blade. These marks, *ntapo,* represent
scarification worn by women, refer-
ring both to beauty and to erotic
pleasure. *Ntapo* is seen as a form of
symbolic writing communicating
identity and social status, and con-
veying ideas of order, cosmos, and
physical and moral perfection.

As in many parts of Africa, the
right to sit during ceremonial and
religious events is limited to high-
ranking individuals. Elaborately
carved Luba stools allude to the com-
plex hierarchy of seating privileges
distinguishing members of the court
(fig. 12-1). They figure prominently
in investiture rites, marking the
moment when the new ruler declares
his oath of office and speaks for the
first time as king, setting him apart
from society. State stools are so
potent a symbol that they are kept in
different villages from the posses-
sor's home to diminish the
possibility of theft or desecration. A
stool is perceived not so much as a
functional seat as a receptacle for a
king's spirit. Wrapped in white cloth
and fastidiously preserved by an
appointed official, it appears only on
rare occasions. It is not intended for
human eyes but for the eyes of the
spirit world. When a Luba king was
inaugurated his stool was placed on a
leopard skin, prohibiting his feet
from contacting the ground and
symbolically suggesting his
supremacy over even the majestic
leopard. Other attributes of leader-
ship positioned nearby included a
staff and a spear, each emblazoned
with the female figure.

The royal residence of a Luba king is called "the seat of power," and a throne is believed literally to enshrine the soul of each king. When a king dies, his residence becomes a metaphorical seat of power, preserved as a spirit capital in which his memory is perpetuated through a female spirit medium, *mwadi*, who incarnates his spirit. The stool, a concrete symbol of this "seat," expresses the most fundamental concepts of power and dynamic succession.

In the best-known type of Luba stools a single female figure supports the seat. Elaborate hairdos and scarification are marks of Luba identity and physical perfection. Personal adornment suggests the figures represent highly positioned women. The figure refers simultaneously to the supporting role of women, the notion of ancestral continuity through women, specific royal women influential in the expansion of the kingdom, and the sacred roles played by women in religion.

Luba headrests are similar to stools in the use of supporting figures (fig. 12-6). This small utilitarian object was used by high-ranking dignitaries for sleeping comfort and for keeping its owner's head cool by raising it above the mat. More importantly, it protected elaborate hairdos for up to two or three months. Such coiffures were important (and still are) as indicators of profession, title, status, and personal history. Thus although the headrest is not sacred and is not as symbolic in nature as stools, axes, or bowstands, its function extends beyond utility to provide the status and prestige associated with leadership.

The dynamic pose, delicately chiseled features, and dramatic tumbling coiffure on the figure on the right are hallmarks of a series of headrests attributed to a nineteenth-century master carver from the Shankadi area. Because many of his works have the beautiful and luxurious hairstyle, *mikada* ("cascade"), he is known as the Master of the Cascade Hairdo. *Mikada* took about fifty hours to complete and involved working the hair over a frame of cane.

Scarification, like coiffure, is a reference to a person's social worth and self-esteem. It is especially noticeable on figures such as the one illustrated here carved by the Master of Mulongo, who has embellished thighs and torso with gently rounded patterns (fig. 12-7). Large almond-shaped eyes, smooth skin, outstretched legs, arms clasping the bowl, elegant *kaposhi* hairdo, and the shape of the high rounded forehead are typical of the Master of Mulongo's work and that of the Mulongo region. The form of the bowl suggests a type of pottery

12-6. HEADREST. MASTER OF THE CASCADE HAIRDO. BEFORE 1936. WOOD, HEIGHT 7½" (19 CM). NATIONAL MUSEUM OF DENMARK, COPENHAGEN

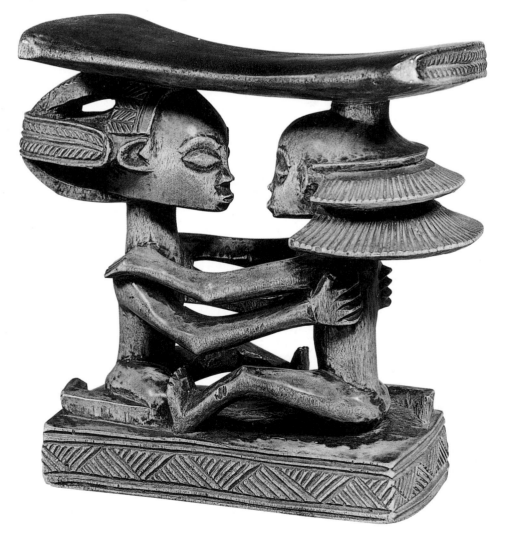

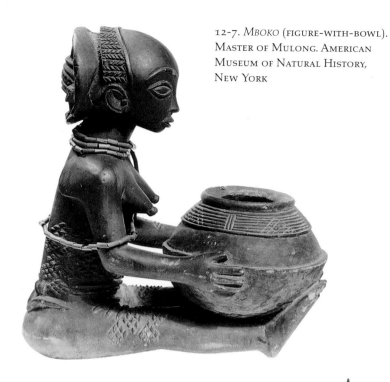

12-7. *MBOKO* (FIGURE-WITH-BOWL).
MASTER OF MULONG. AMERICAN
MUSEUM OF NATURAL HISTORY,
NEW YORK

ruler loses his *mboko*, he is required to furnish another quickly, for it is the only tangible proof of his authority.

Lukasa is the highest stage of royal initiation, attained by only a few members of three principal branches of royal culture: kings, diviners, and members of Mbudye. Such men, looked upon as "men of memory," are genealogists, court historians, and the "traditionalists" of society. *Lukasa* is also the term used for a physical emblem for those initiated, a memory aid assisting in initiation ceremonies to recall a complex body of knowledge, which is also used in performances honoring the king and his retinue (fig. 12-8). The near-rectangular wooden

that goes back to the Kisalian period or earlier (see fig. 13-2).

The figure-with-bowl, *mboko*, is a ritual object owned by chiefs and diviners to honor and remember the critical role played by the first mythical diviner in the founding of kingship. The female figure is identified as the wife of the diviner's possessing spirit. Diviners' wives are commonly accepted as having oracular powers, serving as mouthpieces for spirits, and the portrayal of the spirit wife underscores the role of the diviner's own wife as an intermediary in spirit invocation and consultation. The *mboko*, placed next to the diviner, as his own wife sits beside him, reinforces the notion of women as spirit containers in both life and art. Rulers keep *mboki* at their doors, filled with a sacred chalk associated with purity, renewal, and the spirit world. Visitors take the substance to rub on chests and arms in gestures of respect before kneeling before the king. If a

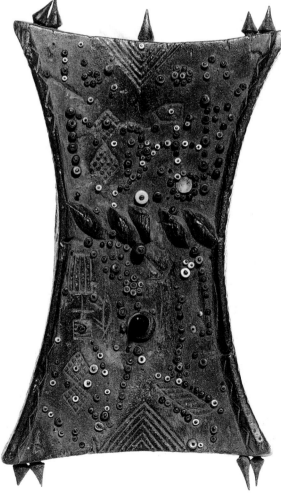

12-8. *LUKASA* (INITIATION EMBLEM). LUBA. LATE 19TH–EARLY 20TH CENTURY. WOOD AND BEADS, HEIGHT 10" (25.4 CM). BROOKLYN MUSEUM, NEW YORK. GIFT OF MR AND MRS JOHN A. FRIEDE

12-9. LUBA *KASHEKESHEKE* DIVINATION, SHABA AREA. C. 1936

Of the several mask types used by the Luba, one of the better known is *kifwebe*, a bowl-shaped mask elaborated with whitened parallel grooves on a dark ground. The large example shown here, with typical Luba eyes and rectangular mouth, was worn with a raffia costume (fig. 12-10). Danced in male/female couples and representing spirits, *kijwebe* connect this world and the spirit world. They are used to mark important periods of social transition and transformation, appearing at the death of a chief or any other eminent person, or when a person assumes an important political title. Worn on the night of the new moon, they are also performed in honor of ancestors.

board fits comfortably in the hand to be easily manipulated. It is sometimes seen as embodying an emblematic royal tortoise that recalls and honors *lukasa*'s founding female patron. A configuration of beads, shells, and pins coded by size and color on one side refers to kings' lists. Beads may stand for individuals, a large bead encircled by smaller ones perhaps representing a chief and his entourage. Bead arrangements also refer to proverbs and praise phrases. The configuration is a diagram representing the landscape, both actual and symbolic, referring to ghost capitals of former kings, a map of the residences, seating arrangements, shrines, and other significant points in the court. Lines of beads may also indicate roads or migrations. The *lukasa* provides a means for evoking events, places, and names. In Mbudye induction, it stimulates thought and instructs in sacred lore, culture heroes, migrations, and sacred rule.

A non-royal form of divination, *kashekesheke*, involves manipulating a small, sculpted instrument in the form of a human figure (fig. 12-9). The body is a hollowed rectangle topped by an anthropomorphic head. The diviners' consulting spirit dictates its form in a dream, and the figure is called by the name of that spirit. Although the spirit may be male or female, the sculpted figure is always referred to as female, even when the body is an abstract rectangular frame like the example shown here. The diviner and client each holds a side of the implement with two fingers as the diviner addresses the ancestral spirit and asks questions. The motion of the *kashekesheke* is interrupted when the spirit replies through coded movements. One of the oldest forms of Luba divination, perhaps existing long before the introduction of sacred kingship, *kashekesheke* is still used to solve problems.

12-10. LUBA *KIFWEBE* MASKER, CONGO. 1913

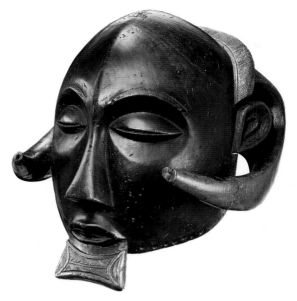

12-12. MALE ANCESTOR FIGURE. HEMBA. ETNOGRAFISCH MUSEUM, ANTWERP

In some regions, rather than appearing in male/female pairs the striped mask is paired with a zoomorphic mask representing a range of birds, mammals, and even reptiles and amphibians. A remarkable helmet mask with ram's horns from the eastern Luba may have worked in this context (fig. 12-11). The broad forehead and the forms of the eyes and other features resonate Luba style.

The Hemba

The Hemba, to the north of the Luba, were once incorporated into the so-called Luba empire. Several groups claim to be Hemba, although there are differences among them. Veneration of ancestors in large family groups is a trait shared by many claiming to be Hemba, and beautiful male ancestral carvings called attention to great lineages (fig. 12-12). The rounded face and high, broad forehead reflect the impact of Luba style. The Hemba see the serenely closed eyes and the rounded face as reflecting the ancestor's interior calm. A four-lobed hairdo,

invisible in this photograph, evokes the four directions of the universe and the crossroads where spirits assemble. Splendidly formed shoulders and arms frame a contoured torso that narrows at the waist and then swells to a protruding belly, emphasizing the navel, a sign of family and continuity. The Hemba vernacular term for "stomach" also indicates a segment of the lineage. Hands on each side of the

swelling belly thus indicate the ancestor embracing and watching over descendants.

Some ancestor portraits date to the nineteenth century, some conceivably to the seventeenth or eighteenth centuries. Not based on individual visual traits of a specific person, their purpose is not to celebrate an individual but to reflect on familial continuity and the perpetuation of lineage. Ancestors are counted, named, and arranged according to seniority in a line of descendants. Names are kept in a genealogy reflecting the social structure of clans and family groups. Any one figure may refer to a specific generation or to an entire genealogy. A chief often had three to four figures, calling attention to his being a part of a great family.

The *mwisi wa so'o* mask is used in So'o, a semi-secret society (fig. 12-13). It represents a strange

12-13. *MWISI WA SO'O* OR MUTU MASK. LENGTH (EXCLUDING FIBERS) 7″ (18 CM). LINDEN-MUSEUM, STUTTGART

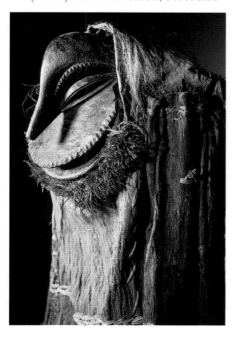

were-chimpanzee, partaking of characteristics of both the animal and the human order, but really being of neither. The wide, grimacing mouth with notched upper lip is regarded as horribly strange. High raised brows, notched and forming a countercurve to that of the mouth, are associated with wildness and craziness. The entire configuration of the mask, worn with a wig and beard of white and black monkey hair, suggests an untamed, uncontrolled presence. Pelts from both domestic and wild animals, along with materials of both village and forest, comprise the costume for the intimidating *so'o*. The use of bark cloth for a large cape and leggings associate *so'o* with the distant past.

Neither human nor animal, *so'o* is outside anticipated categories. Neither of the village nor of the forest, it has characteristics of both. In its liminality, *so'o* is like the spirit of the deceased, not yet installed in the world of the dead, no longer part of the world of the living. In funerals *so'o* enters the village, the domain of humans. In its first appearance at funerals this strange creature with no arms runs wild in the village, making no utterances or sounds. Small iron bells, associated with liminal creatures such as ghosts, provide its only warning. It chases all young people and women, who run terrified from it. *So'o* has no respect for the ordinary constraints of village space, following people into houses to capture them. During a second appearance, *so'o* performs within an oval space formed by people. In this phase, the spatial order of the village has been restored, and people can watch *so'o*, no longer running from it or scattering in its presence.

The Tabwa

The Tabwa, who live in regions adjacent to the Luba, have no unified history, and the relationships of the many people who claim to be Tabwa are complex. One shared characteristic is that none developed central states. Local chiefs merely led the community but had no ultimate authority over any individual. Being less well organized politically, they were easy prey to raids, eventually suffering at the hands of African enemies as well as Arab slave traders.

Tabwa art developed over a fairly short period during the mid-nineteenth and early twentieth centuries. Sculpture reflected more on great families than on leaders. Tabwa lineage elders kept small wooden images to represent and honor ancestor spirits, great healers, and occasionally earth spirits. The female figure shown here (fig. 12-14), part of a male/female pair, is differentiated from her male counterpart by a cap-like hairdo close to the head, while the male figure wears long braids looped behind. Oval face, straight chin, small almond-shaped eyes, thick lips, elongated torso, and stiff limbs are typical of this Tabwa style. The figure displays elaborate scars in double rows of raised patterns. Such adornment was aesthetically pleasing and served an erotic role, but also served as visual metaphors that implied positive social values and the harmony of natural forces. For example, the vertical axis down the midsection embellishes and emphasizes body symmetry, but it also ends at the navel, referring to one's beginning. The vertical axis cuts through open isosceles triangles on chest and abdomen and a diamond shape on the torso, a reference to the

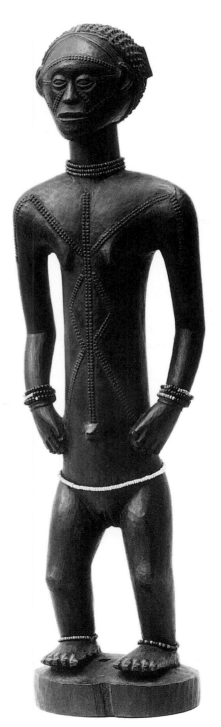

12-14. FEMALE FIGURE. TABWA. 19TH–20TH CENTURY. WOOD, HEIGHT 18¼″ (46.4 CM). THE METROPOLITAN MUSEUM OF ART, NEW YORK. THE MICHAEL C. ROCKEFELLER MEMORIAL COLLECTION. GIFT OF NELSON A. ROCKEFELLER, 1969

rising of the new moon; this is an important pattern used not only on the human body and on carved figures, but also on masks, headrests, instruments, stools, baskets, and mats.

Such figures, *mikisi*, were given specific names and kept in special buildings. Lineage elders occasionally slept near them to receive ancestral inspiration. *Mikisi*, some charged with power substances, were placed near sick people to heal, or at the entrance to a community to guard and protect. Catholic missions, arriving in the late 1870s, forbade the use of *mikisi*, resulting in the Tabwa destroying great numbers. Today, most Tabwa sculptures are in Western collections.

An exception is *mpundu* or *pasa* (fig. 12-15). Consisting of a head with extended neck on an elongated, cylindrical body terminating just below the navel, these simplified figures commemorate and venerate dead twins. Three protuberances on the cylindrical torso represent breasts and navel, and scarification, again, is organized along a vertical axis. Commissioned on the death of a twin, *mpundu* was cared for with food and offerings, and treated as an equal to the living twin. Twins are rare and special beings, believed to

mediate between nature and humans. When born, they are secluded until the umbilicus falls off. Special rituals assure their well-being, and they are given special names revealing birth order. When a twin dies, it is not mourned, for it has not died but "returned home." The wooden figure, carried by the mother until the surviving twin can walk, is kept in the house or a shrine. The practice is still observed in Tabwa country today.

The Tabwa use both anthropomorphic masks and those that mimic the features of a buffalo (fig. 12-16).

Both types are fairly rare. In the buffalo mask, graceful horns sweep to the sides, and the mouth is open as if the animal is panting or bellowing. Eyes are inset with cowrie shells. Scarification on the muzzle refers to the cosmology suggested by human scarification. The heavy mask is held in place in front of the dancer's face by his hands. The costume is a moving "haystack" of loose raffia with a variety of animal pelts attached.

Little is known of the function of buffalo masks. Sometimes performed with an anthropomorphic female

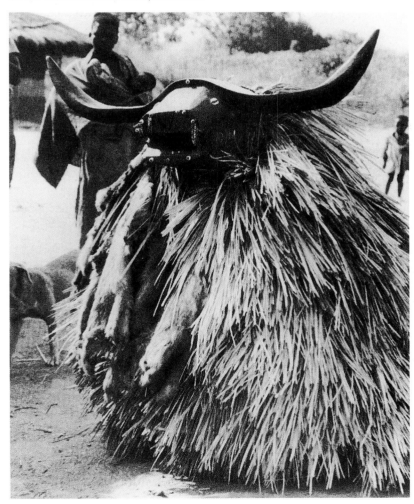

12-16. Tabwa buffalo mask, Tanzania

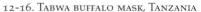

12-15. *Mpundu* (twin figure). Tabwa. 19th century. Wood, height 9" (23 cm). Museum für Völkerkunde, Staatliche Museen, Berlin

mask, the buffalo may represent the masculine aspect, associated with violence, aggression, and vengeful actions of the wild animal. Formerly, buffalo lived in herds in the grassy plains, but by the 1970s they were encountered only in remote areas. Females are red, and old males are black, and red/black opposition is an important Tabwa concept referring to violent change and secret knowledge. The nocturnal buffalo seem to be invisible during the day. When hunted in the wild, they have the ability to disappear, only to reappear behind the hunter.

The Songye

The Songye live to the north of the Luba to whom they are linguistically and culturally related. A number of sub-groups have political systems based on chiefs and titleholders like those of the Luba. The Songye system was once distinguished by the formation of large town-states, the most extensive being Kalebwe Songye, a vast area of large villages. This centralized system began to deteriorate in the 1870s with the Arab slave trade, the arrival of Belgian colonialists, and internal conflict over succession. The most powerful regional chief, Lumpungu Kaumbu, was inducted as supreme chief by the colonialists. By the beginning of the twentieth century, however, the hierarchical system fell as a result of prolonged upheaval.

While the Songye produce leadership arts, such as stools with supporting figures, most art is associated with manipulating spiritual powers. Powerful associations developed throughout the region as the result of political factions, many of them in response to succession

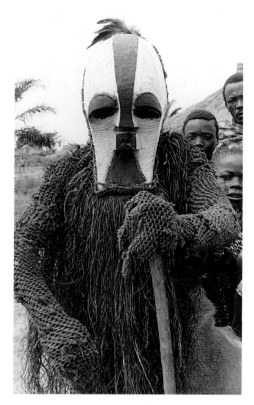

12-17. SONGYE FEMALE *KIFWEBE* MASKER

disputes and rivalry between potential successors to chieftanships. Known as Bukishi, these organizations wielded both political and mystical power associated with sorcery. Their ultimate aim was to check the power of the chiefs.

Some Bukishi are masking societies, used as agents of social and political control through the practice of sorcery. Masks, called *bifwebe* (sing. *kifwebe*), were used by one such organization, Bwadi bwa kifwebe, a powerful social instrument associated with healing and mystical control. Maskers are visual emissaries of the society, which relies on witchcraft and sorcery to sustain its rule.

Not human, animal, or spirit *per se*, *bifwebe* defy categorization. Energetic movements and strange sounds energize the arena in which they

appear. Male and female masks, all worn by men, are differentiated by form and coloration. Female masks are primarily white, with black accentuating the eyes, mouth, and a low crest over the head. White is associated with ritual, an auspicious and positive color suggesting inner and outer being, goodness, health, purity, reproductive capacity, peace, wisdom, and beauty. Although they perform in regular, staged dance events to activate benevolent spirits and detect malevolent powers, female masks are passive in their use of witchcraft powers. Their role is linked to the lunar cycle and the death and investiture of chiefs. The female mask shown here is typical (fig. 12-17). There is only one female mask in an organization.

The male mask in figure 12-18 is aggressively formed, its bulging eyes jutting well past the facial plane, its exaggerated mouth projecting to the level of the flattened nose. A crest form merging with the nose runs over the top of the head. Rather than the simple color scheme of white accentuated with black, male masks have a busier color program of red, black, and white, and sometime browns, pinks, and oranges.

Male masks, which appear in numbers, are differentiated into two groups by size. The elder mask is normally much larger than the youth, for the larger the crest the greater the magical potential and mystical strength of the character. Male *bifwebe* exercise witchcraft and sorcery overtly and involve themselves in political action and social activities. In these spheres they supervise the maintenance of roads and fields, guard circumcision camps,

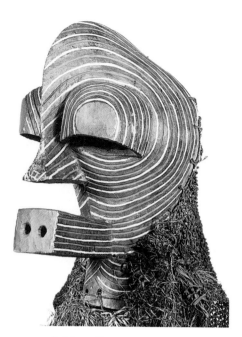

12-18. MALE *KIFWEBE* MASK. SONGYE. WOOD, HEIGHT 21¼" (5.6 CM). ROYAL MUSEUM OF CENTRAL AFRICA, TERVUREN

and, in the past, involved themselves with preparation for warfare.

Bwadi bwa kifwebe initiates learn the secret names and meanings for every part of the costume and the mask. Nostrils may be called "the openings of a furnace," the chin "the snout of a crocodile," and the eyes "the swellings of sorcerers." These secret phrases serve as vehicles for a constellation of meanings understood only in part by any given member of the society at any time.

In some Songye regions, exposure to Western culture through Christianity, education, or trade made a negative impact on masking organizations. Although some masks are used for entertainment, they are no longer used in ritual, and production is primarily for sale on the Western art market. In areas less affected by Western culture, masks and figures continue to be made for local use.

In opposition to the magical function of *bifwebe*, figure sculptures, *mankishi* (sing. *nkishi*), are associated with fighting witchcraft and sorcery: they are socially benign, bringing good, protecting, healing, and counteracting evil. While a carver produces the wooden figure, a ritual specialist, *nganga*, adds a multitude of substances and objects that give *nkishi* its power, change its patina, and enhance its visual impact (fig. 12-19). Ritual specialists create two kinds of *mankishi*—small ones for individuals and families for household use, and large ones embodying ideas of power and aggression used publicly for the entire community. Each *nkishi* is imbued with an identity, given a name, often that of a well-known chief, and treated as an individual.

SOCIETIES OF THE LEGA, THE BEMBE, THE MBOLE, AND THE AZANDE

In contrast to kingdoms in the savannahs, the peoples of the forests of Central Africa did not by and large develop centralized political

12-19. *MANKISHI* FIGURE SCULPTURES AT THE CONFLUENCE OF THE LUBANGULA AND LOMANI RIVERS, CONGO. PHOTOGRAPH C. 1936

Sculptural form and aesthetic considerations are secondary to the nkishi's ingredients. It is a ritual container with powerful substances embedded in openings made into the swollen abdomen or head. These substances derive from body parts, such as the teeth, hair, feathers, or sexual organs of powerful animals including leopards, lions, birds of prey, crocodiles, and elephants. They may also be contained in horns and calabashes. The horns normally project from the top of the head; other horns and calabashes may be attached to the figure to increase its power charge.

entities. Instead, these small groups are governed through communal voluntary associations. Initiation societies are important in running village affairs, governing relationships among people, and guiding the moral development of individuals. Among the Lega, the Bwami society constitutes the most important instrument for organizing the community. The nearby Mbole have Lilwa, and the Bembe have a number of organizations, such as Elanda and 'Alunga. The Azande are an exception in that they organized themselves into several centralized kingdoms. Here, a secret society called Mani served not to govern but to provide ordinary people with supernatural protection against the abuses of rulers.

Bwami

All Lega art is used within the context of the Bwami society, an organization that permeates every area of life. A philosophical society, Bwami teaches principles of moral perfection through proverbs, dances, and the presentation of objects in special contexts. While it is a voluntary association, it maintains and reinforces bonds of kinship within the community, lineage, and clan. Initiations into various grades and levels of Bwami are cohesive events that bind individuals, kinship groups, and generations.

Bwami produces, displays, and explains thousands of pieces of sculpture, including anthropomorphic and zoomorphic carvings, masks, caps, spoons, miniature implements, as well as abstract objects. Most anthropomorphic figures are called *iginga* ("objects that sustain the teachings and precepts of Bwami"). Each is a symbolic representation of a named personage with

Aspects of African Culture

Rites of Passage

"Rites of passage" has been an important phrase in anthropological literature since Arnold van Gennep's classic 1907 study of that title. The phrase refers to the rituals that accompany changes of status among all the peoples of the earth. Many specific passages of this sort exist, marking such transitions as child to adult, ignorance to knowledge, asexuality to sexuality, low to high status, profane to sacred space, life on earth to existence in the afterworld of ancestors. The "passage" metaphor is at once psychological, developmental, and spatial. Doors, thresholds, and even processional avenues are sites of passage from one kind of place to another, qualitatively different kind of place.

A three-segment structure, first elaborated by van Gennep, characterizes all rites of passage: separation, transition, and incorporation. Initially, the process involves the separation of the novice from his or her current, soon to be previous, state. Separation is typically marked by the symbolic death of the novice, who thus enters the limbo of transition, the second segment of the structure. This is an in-between or liminal state, which may last only minutes or extend for months, occasionally even a few years, as when a family postpones the second burial rites for an important deceased person long enough to amass the resources needed to provide an appropriate sendoff. Often, the transition is a time of mystery, fear, ordeal, and stress. Typically, and even upon elevation to kingship, the novice is at least symbolically reduced to a raw and unformed state during the liminal phase, which is left behind as rituals and instruction impart the secrets and other prerogatives of the higher status. Incorporation, the third segment, names the acceptance of the initiate into the new position. He or she is now "reborn" and stable, as the passage is now complete.

In most cases art forms are invoked, worn, manipulated, or displayed as essential components of the transitional process, with another set for celebrating the new position. Why is it, we may ask, that art is inextricably bound into rites of passage? Because in Africa, as elsewhere, the symbolic system that embodies values, ideals, sacred history, and the gods is insistently present at just such times

DISPLAY OF STATE SWORDS (SEE FIG. 7-5)

to sanction and inform the process. Symbols, being expressive, are often visually elaborated. The passages too must be rendered visible and memorable, focusing attention upon the occasion and its participants, marking them off as distinct.

Art is perfectly suited for such roles. Art forms are useful in evoking both tradition and mystery, inherited ancestral symbols and the powers of gods and ancestors whose presence is crucial to the success of the ritual. In some cases the mere presence of symbolic forms and processes is enough to create the appropriate atmosphere, while in others art objects as well as conventionalized gestures and acts are instrumental in moving the rite forward. Akan state swords with cast gold sculptures, for example, are used in swearing oaths of allegiance and fealty between chiefs. These ornamental swords are viewed as powerful in their own right, as are masked dancers in cultures where masquerade embodies the ancestral or spirit power and presence often so essential to effecting change in a community. In all, a great many visual art forms partake, whether passively or actively, in rites of passage. Their presence proves the cultural importance of these rituals while helping to create them.

specific moral qualities, either good or bad, further expressed through proverbs and songs as they are manipulated during initiations. Displayed and danced in various contexts, objects change meanings according to the context in which they are used or according to other objects displayed with them.

Although a great number of manufactured and natural objects are used in the progression through all Bwami grades, only individuals in the two highest grades own art and manipulate it, and only members of the highest grade own ivory. The ivory mask shown here manifests the typical, concave, heart-shaped face of Lega carving (fig. 12-20). Aesthetically it is smooth, well-patinated, glossy, controlled, and stylized. Of the *idumu* class, the high-

12-20. BWAMI SOCIETY MASK. LEGA. 19TH–20TH CENTURY. IVORY, HEIGHT 8½" (21.6 CM). THE METROPOLITAN MUSEUM OF ART, NEW YORK. THE MICHAEL C. ROCKEFELLER MEMORIAL COLLECTION. GIFT OF NELSON A. ROCKEFELLER, 1979

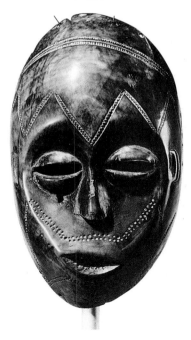

12-21. BWAMI SOCIETY MASK. LEGA. EARLY 20TH CENTURY. WOOD AND KAOLIN; HEIGHT 7⅛" (19.3 CM). THE STANLEY COLLECTION. THE UNIVERSITY OF IOWA MUSEUM OF ART, IOWA CITY

Lukwakongo is used in dramatic performances and may represent various characters or refer to numerous social, jural, moral, or philosophical principles. It may be carried in the hand, fixed to the side of the face, attached to the side or back of a hat, placed in a linear grouping with like masks, heaped in a pile with other masks, dragged by its beard or attached to a fence with other objects. Such groupings symbolize specific relationships between living and dead members or special ties between living initiates who inherit masks from one another.

est category of Bwami objects, it is used in a variety of contexts in the highest rites. Each object is associated with a body of proverbs and placed in configurations of displays, or danced and held as proverbs are revealed.

In performances, *idumu* may be attached to a framework surrounded by other masks. In these configurations, *idumu* may be placed in association with other masks such as the small mask known as *lukwakongo*, typically

12-22. BWAMI SOCIETY FIGURE. LEGA. WOOD. ROYAL MUSEUM OF CENTRAL AFRICA, TERVUREN

heart-shaped and carved of wood (fig. 12-21). Kaolin smeared on the concave portion whitens the characteristic features of slit eyes, open mouth, long nose, and fiber beard. *Lukwakongo* are symbolic emblems of membership owned individually by men initiated into the highest levels of Bwami society.

The whitened, heart-shaped face characteristic of masks is also apparent in Bwami figural sculpture. The highly stylized object shown in figure 12-22 has such a face on either side of its flat, board-like body. It raises stumpy arms and rests on bent legs. The body is perforated with many holes. The object is from one of two baskets owned collectively by members of the highest Bwami grade. Ritually transferred at each initiation, the baskets are held in trust by two of the newest members of the grade. Each contains a number of anthropomorphic and zoomorphic wooden carved objects that serve as symbols of solidarity and social cohesion within the group. The baskets must be present at any initiation: objects are removed one by one and commented upon or placed in groupings to be explained and interpreted.

Elanda and 'Alunga

The Bembe live on Lake Tanganyika to the east of the Lega, a traditionally restless area characterized by the migration of peoples. The Bembe are culturally eclectic, accepting influences from many directions in an area with complex historical relationships. This is reflected in their art, for various elements are traceable to different sources, making classification difficult. While some cultural elements can be traced to contact with the Lega, others seem to be

pre-Lega. Some art forms are unique and associated only with the Bembe, others are distinctly like those of the Lega, and others seem related to the art of the Luba to the south.

Apart from Bwami, with its Lega roots, there are a number of initiation associations. Elanda, a male association of young men already circumcised but not yet married nor initiated into Bwami, focuses on ancestors who make their will mystically known through dreams, sickness, the last words of a dying father, or transgressions of Elanda taboos. Elanda initiation centers on a mask made of bark and lambskin, covered with beads and cowries, and finished with feathers (see fig. x). The mask is considered to be a terrifying and mysterious force, *ebu'a*, which cannot be seen by those not initiated into Elanda, although they hear its mysterious voice.

The initiation system called 'Alunga seems to have derived from a hunters' organization; its mask is *ibulu lya alunga* ("the protector of honey") (fig. 12-23). The 'Alunga masquerade is also *ebu'a*; another name is *m'ma*, an ancient spirit of the wild, for it is considered to be an awe-inspiring and powerful "something" from remote times. The double-faced helmet mask is a striking vision of abstract forms. Conical eyes on black crosses project from huge, whitened, concave eye orbits. A feather- and porcupine-quill bouquet tops it. In performance, the wearer's body is covered with a banana leaf and fiber costume. The frightening character it represents calls with a harsh, hoarse voice, and the men who wear it are chosen partly for their ability to make appropriate sounds.

As *ibulu lya alunga* dances, a trumpeter calls members of 'Alunga together in neighboring villages, announcing its arrival. The role of the mask and its treatment vary during the course of its appearances. In secret places in forests or in caves, its use is a guarded secret involving ancestors and nature spirits. In a shrine outside the village, where it dresses for community appearances, its activities are still secret. In the men's house, it is transformed from a frightful bush spirit into a friendlier, more acceptable persona, and finally, in the village, the performer takes on a different gait and voice. The perceptual confusion is intentional and a desired aspect of the mask's appearance.

Lilwa

The Mbole people along the Lomami River to the northwest of the Lega produce easily recognized figures known as *ofika* for the Lilwa society

12-23. BEMBE *IBULU LYA ALUNGA* ("PROTECTOR OF HONEY") MASK. FOWLER MUSEUM OF CULTURAL HISTORY, UNIVERSITY OF CALIFORNIA, LOS ANGELES

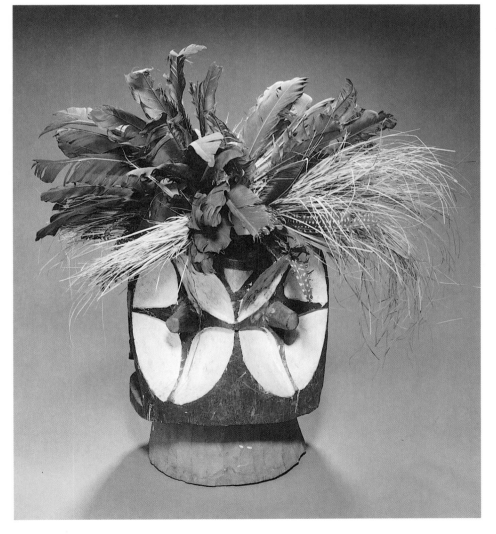

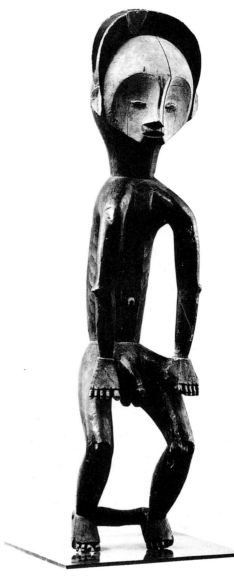

12-24. LILWA SOCIETY *OFIKA* FIGURE. MBOLE. 19TH–20TH CENTURY. PAINTED WOOD, HEIGHT 32½" (82.4 CM). THE METROPOLITAN MUSEUM OF ART, NEW YORK. THE MICHAEL C. ROCKEFELLER MEMORIAL COLLECTION. GIFT OF NELSON A. ROCKEFELLER, 1968

(fig. 12-24). The example shown here is typical, with broad forehead and crest-like hairdo running across the head. Eyes and mouth are narrow slits in the concave, heart-shaped face. The whitened face and yellow ocher chest contrast with the dark of the hair and body. The elongated body hunches shoulders forward, while loosely hanging arms touch the thighs. Feet do not rest flatly on the floor, for the figure was intended to hang suspended by cords laced through holes in the shoulders and in the buttocks.

Lilwa, a graded men's organization, dominates Mbole life. Lilwa is not unlike Bwami, for it fulfills ritual, educational, judicial, social, political, and economic functions. As in Bwami, a sophisticated moral philosophy underlies its teachings and rituals. Boys of seven to twelve years old are isolated in the forest for circumcision and initiation, undergoing ritual purification and proving themselves through ordeals and fasting. They are instructed in appropriate moral, ritual, and social behavior and receive a practical education. Objects, such as *ofika*, are purportedly used to impress on the boys the importance of secrecy within Lilwa. Execution by hanging was the punishment for a number of crimes among the Mbole, especially for revealing secret information. Each *ofika*, hidden from the uninitiated, bears the name of a hanged individual. In the first phases of initiation boys are beaten and shown the images strapped to a decorated litter. The young men learn the circumstances of the condemnation, trial, and execution of these individuals who infringed Lilwa's moral and legal code. It is a powerful warning of the need for social rules and the teachings of Lilwa.

Mani

Numerous secret societies spread through the northern reaches of the forest zone, including Mani, which appeared among various small ethnic groups in the northern Congo basin toward the end of the nineteenth century. By the early twentieth century it had reached the banks of the Uele River, where it was firmly established among the Azande peoples. Mani, composed of local lodges with male and female membership, provided success and general well-being, ensuring effective hunting and fishing, guaranteeing

12-25. MANI SOCIETY *YANDA* FIGURE. AZANDE. MUSÉE BARBIER MUELLER, GENEVA

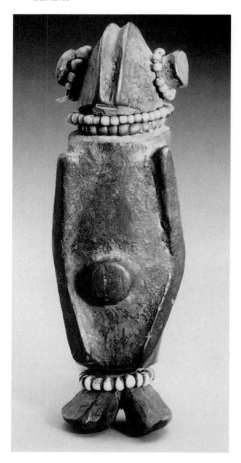

fertility, protection against evil and sorcery, and harmony within family and community. Among the Azande, Mani also served to protect members from oppression by the upper classes through supernatural means. Azande chiefs saw it as subversive, an outlaw cult. Its activities were eventually curtailed in the early twentieth century by the colonial administration.

Numerous small wooden and terracotta figures used within Mani were classified according to several types and generically known as *yanda* (fig. 12-25). The term designates mystical power and refers as well to the spirit or force to which Mani was dedicated. Most *yanda* are standing, abstracted anthropomorphic figures reduced to the essentials. While the figure illlustrated here has rudimentary arms, most *yanda* lack arms. Legs, if included, are minimal, often reduced to a cone-shaped base with the umbilicus dominating the torso. Although *yanda* figures are referred to as female, their sex is most often not recognizable.

Yanda figures, which were hidden in pots arranged on a platform below the roof of a forest structure, assisted members in achieving goals and protected them from adversity. Their power derived from several sources. The wood came from sacred trees, providing mystical potential in its very being. The figure was activated through ritual, as a substance prepared of ingredients selected for medicinal properties was applied to its surface. In subsequent rituals its keeper smeared activating substances over it and provided it gifts of food, building up a crust of magic substance. When prayers were offered, gifts of beads, metal rings, or coins were attached to the torso, neck, waist, and ears. Thus the *yanda* changed over time as it gained a patina of crusty offerings and decorative attachments.

COURT ART OF THE AZANDE AND THE MANGBETU

Whereas most peoples in the forests of eastern Congo were widely dispersed and politically decentralized, the Azande and their Mangbetu neighbors formed centralized kingdoms along the Ubangi and Uele rivers. The Azande developed from an assortment of peoples organized by Avongara chiefs from the north. They never established a single entity, but several Azande kingdoms were active. Unlike kingdoms far to the south, the Azande did not pass royal heirlooms down through generations. Regalia and ritual art were scarce. Most sacred art for Azande aristocratics tended to be minimal adaptations of practical objects such as pottery, stools, headgear, harps, slit gongs, shields, and weapons, all of superb craftsmanship but not limited to royalty.

Court items included a variety of musical instruments. A photograph from the 1930s shows a group of musicians carrying flat, bell-shaped wooden gongs (fig. 12-26). These portable

12-26. Mangbetu musicians playing wooden gongs, Uele region, Congo. c. 1935–8

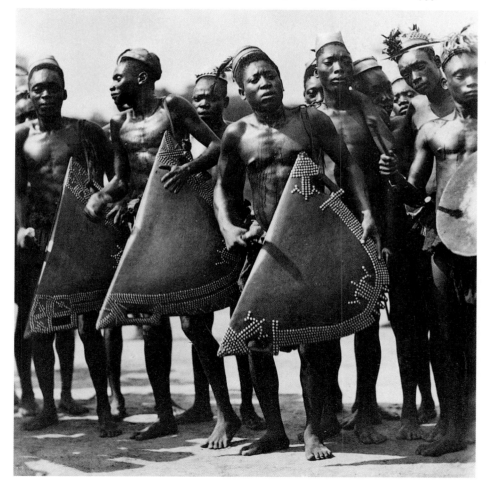

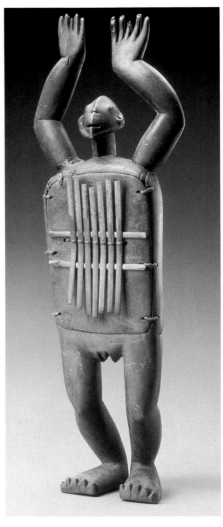

12-27. SANZA. AZANDE. 19TH CENTURY. WOOD, HEIGHT 24″ (61 CM). ROYAL MUSEUM OF CENTRAL AFRICA, TERVUREN

carefully designed, beautiful objects, their surfaces blackened with mud and embellished with designs of copper alloy studs.

Smaller instruments such as sanzas, or thumb pianos, and harps accompanied songs for less formal occasions and for personal pleasure. The sanza consists of a number of vibrating keys positioned over a sound box. Keys cut at various lengths produce a range of tones when struck with the fingers. In many regions of Central Africa parts of the sanza are compared to those of a woman's body. In the example shown in figure 12-27 the comparison is explicit, as the instrument represents a woman lifting her arms in dance.

Figured harps seem to have originated with the Azande, but many were produced among the Mangbetu to the

south of the Uele River (fig. 12-28). Made of wood and lizard skin, such harps were not important in court orchestras, but kings commissioned them as prestige gifts.

The Mangbetu established a major kingdom in the eighteenth century and influenced many neighboring peoples. By the mid-nineteenth century several European visitors had written enthusiastic accounts of their courts. While each Mangbetu ruler had a number of traditional symbols—leopard pelts, red tail feathers of the gray parrot, and iron gongs—no specific art forms were associated with his reign other than ornate knives. Upon his succession to the throne, each ruler built a new capital and commissioned objects associated with wealth. His treasury included knives with wood or ivory handles, headrests, stools, and items of personal adornment, none limited in use to the king, for any person of wealth could own them. Not symbolic of kingship, they carried no ritual meaning. Upon his death, the treasury was destroyed and buried with him.

Early visitors to Mangbetu were impressed by the opulence of the courts but recorded little in the way of figurative art. Schweinfurth's description of King Mbunza in the 1870s provides details of the court and its visual forms. A drawing shows Mbunza on a distinctive bench pieced together from carved pieces of wood and raffia palm fiber (fig. 12-29). The seat is backed with a tripod backrest made from a tree trunk with projecting limbs as supports. Chiefs' backrests were elaborately decorated with metal wrappings and studs, as

12-28. HARP. MANGBETU. MUSÉE BARBIER MUELLER, GENEVA

instruments were played in royal orchestras which also included drums, iron bells, and horns. They performed for formal, ceremonial occasions; gongs were also used to communicate during military expeditions. Distinct tones of different gongs allowed tonal languages to be mimicked, and those whose tones carried long distances were much esteemed. They were

12-29. KING MBUNZA. DRAWING BY
E. BAYARD, 1874

Mbunza holds a spectacular sickle knife of a type known as emamble, *a symbol of power which is carried like a scepter. Such knives, often with two or three holes worked into the blade, were works of exceptional merit and highly prized for fine craftsmanship. They often required artistic collaboration, a smith creating the blade and a worker in wood or ivory carving the hilt and wrapping it with copper or iron wire. An assortment of objects surrounds Mbunza and speaks of his position and wealth. Two small carved stools serve as tables, positioned on either side of the king. On one a curved, superbly formed knife rests, on the other, a small terracotta water bottle.*

12-30. CHIEF OKONDO, KASAI DISTRICT,
CONGO. 1913

in this example. Metal, especially copper, was associated with wealth, since both the highly valued copper and copper alloys had to be imported from the south.

A 1910 photograph of Chief Okondo shows the ruler seated on a bench not unlike that used by Mbunza, surrounded by royal objects displayed on a mat to prevent their touching the ground (fig. 12-30). An ornate, two-chambered terracotta vessel stands atop a small stool and a man behind plays a harp.

All Mangbetu spent a great deal of time embellishing themselves. The arts of personal adornment are evident in Bayard's drawing (see fig. 12-29). A variety of copper objects adorn Mbunza, reinforcing ideas of power and wealth—copper bars

project from his pierced ears, and there are copper rings on his arms, legs, neck, and chest, and a copper crescent on his wrapped forehead. Around his waist the distinctive barkcloth wrapper, *nogi*, made from the inner bark of two species of fig tree, passes between his legs and is belted at the waist, allowing large folds to project stiffly above.

In Mangbetu personal aesthetics, the head was the focus of attention. An infant's head was lengthened by rubbing and binding, later extended by exaggerated hairdos or headdresses such as Mbunza's narrow basketry cylinder, a foot and a half high and decorated with rows of red parrot feathers. A pompom and cascading plumage emphasize the head length even more.

12-31. MANGBETU WOMAN,
OKONDO'S VILLAGE, CONGO. 1910

Mangbetu called attention to the body by rubbing it with fragrant colored oils. Body ornament helped to express individuality and personal aesthetics, and special events called for striking body painting. Here, each wife used the juice of the gardenia to adorn her entire body. Everyone, according to Schweinfurth, tried to outshine her peers with an inexhaustible number of elaborate patterns applied freehand or with stamps, including stripes, stars, Maltese crosses, flowers, and other designs. These lasted about two days before having to be replaced.

In both Mbunza's and Okondo's towns the court consisted of a complex of architectural structures—audience halls, royal residence, wives' houses, and houses for officials, soldiers, advisors, craftsmen, relatives, servants, and slaves. The spacious audience hall shown in figure 12-32 was 140 feet long, 40 feet high, and 50 feet wide. The bold arched vault, supported by rows of perfectly straight tree trunks, was roofed and walled with midribs of

raffia palm. Woodwork was polished to a sheen, and the red clay floor was burnished. Schweinfurth's description suggested that there was a still larger reception hall, 150 feet long and 50 feet high. These imposing structures were used for feasts and royal audiences. The interior of the structure illustrated here was decorated with a display of the wealth and magnificence of the kingdom. Hundreds of metal lances and spears arranged on temporary scaffolding were admired, while trumpeters blew ivory horns and musicians clanked iron bells.

Herbert Lang read Schweinfurth's description of the luxurious halls in preparation for his extended stay among the Mangbetu and neighboring peoples as part of an expedition for the American Museum of Natural History (1909–15). When he arrived at Chief Okondo's court he was disappointed not to see one. Okondo immediately ordered one to be constructed, and when Lang returned the following year it was complete, a massive

Both women and men wore hairdos that sloped back at an angle (fig. 12-31). The hair was worked so that the emphasis was from the forehead to the rear. Extra hair, sold in the market, was worked over a funnel-shaped form of reeds for dramatic effect. String made of human hair and plant fiber bound the forehead. Both men and women wore prestige hairpins of wood, iron, copper, brass, silver, or ivory. Ivory hairpins especially indicated wealth.

A second Schweinfurth illustration shows Mbunza dancing before an audience (fig. 12-32). Royal wives sit atop carved stools to admire Mbunza while nobles line the walls of the imposing structure. The formation of their heads is conspicuous. The

12-32. KING MBUNZA'S AUDIENCE HALL, MANGBETU. 1874

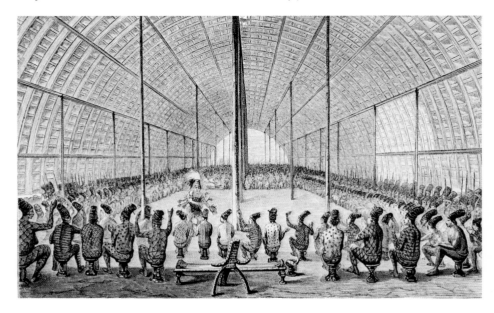

structure 30 feet high, 180 feet long, and almost 89 feet wide (fig. 12-33). Its huge sloping roof was supported by innumerable posts, some carved with geometric designs, others left plain. Both exterior and interior were covered with woven raffia.

Nineteenth-century houses were normally constructed of reeds. Visitors compared beautifully worked reed patterns to brocade and mosaic designs. By the late nineteenth century reed walls were gradually replaced by plastered mud and stick walls. Although reed walls were still fashionable when the photograph in figure 12-34 was taken, a new cylindrical style with mud-plastered walls had gained favor. Spacious communal areas lined by neat cylindrical houses with conical thatched roofs provide beautiful views. Bold geometric patterns symmetrically arranged on either side of the entrance perhaps derived from abstract patterns previously woven in reeds. Such designs are also known from body

12-33. CHIEF OKONDO'S AUDIENCE HALL. PHOTOGRAPH 1913

12-34. EKIBONDO VILLAGE, UELE, CONGO. PHOTOGRAPH 19TH CENTURY

12-35. HOUSE, OKONDO'S VILLAGE, CONGO. 1910

painting and barkcloth skirts. Attention was lavished on the aesthetic enhancement of the interior of the house as well. A 1910 Lang photograph shows support posts, each carved with a different set of geometric patterns and then burnished and blackened with dark mud (fig. 12-35).

The European presence during the colonial period expanded the market for art and encouraged the anthropomorphizing of previously nonfigurative objects. Whereas figurative

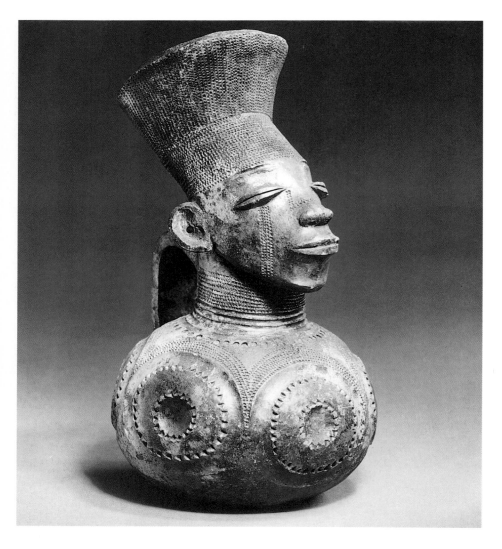

heads and bodies were added to previously non-figurative types. The pot illustrated here, like a number of objects, depicts a Mangbetu woman (fig. 12-36). A woman often made the pot, embellishing its surface with traditional patterns, while a man added the head. By Lang's arrival, pots and other figurative objects were given as prestige gifts to foreign visitors and were being used by dignitaries themselves, but anthropomorphic objects never really became part of daily living even for aristocrats. They were made for only a short time during the early colonial period, and their production soon died out.

THE MBUTI

The Mbuti are nomadic pygmy foragers of the Ituri forest near the Mangbetu. Living in small groups, they are famous for their polyphonic

12-37. MBUTI WOMEN HOLDING BARKCLOTH DESIGNS

12-36. FIGURAL POT. MANGBETU. BEFORE 1913. CERAMIC, HEIGHT 10⅖″ (26.5 CM). AMERICAN MUSEUM OF NATURAL HISTORY, NEW YORK

ornament on objects such as harp necks, knife handles, and box lids was rare in precolonial times, it became almost standard in the early colonial period. Art forms were produced in greater numbers, and production of types preferred by Europeans spread to neighboring groups. The ideal of feminine beauty with elongated bound head was mimicked in figurative art.

Both the Azande and Mangbetu had traditions of making elaborate pots with a broad range of types, styles, and surface design. Now, inspired by European preferences,

music and dancing, mentioned in ancient Egyptian documents. In yodeling they interlock discrete units of sound. In storytelling they easily switch back and forth from one language to another in the same narrative, placing seemingly unrelated elements next to each other in a provocative and effective way.

The aesthetics of verbal and musical arts are reflected in their barkcloth paintings, the visual art for which they are best known. Prior to the colonial period, barkcloth was the primary fabric used by all people of Central Africa. Men normally felt a soft, flexible fabric from the inner bark of a specific tree. Among the Mbuti, women decorate it with spontaneous expressive patterns painted with gardenia juice and carbon black. They carry freely painted abstract, linear designs in a wide variety of patterns that seem to shift radically even within the same piece. Here two Mbuti women hold up cloths painted with seemingly random patterns across the uneven barkcloth (fig. 12-37). On the left, broad spaces between the linear elements above are reduced below as lines bump into and cross the meandering parallel path. To the right, tendril-like patterns twist and curve across the upper two-thirds of the cloth, but below, a radical change occurs as two vertical bands of parallel lines with curling forms projecting to the right dominate. These sudden pattern shifts are related to the interaction of seemingly unrelated elements heard in Mbuti yodeling and storytelling. In figure 12-38, an overall pattern of short, vertical hatch marks occupies several zones, not logically but intuitively organized.

The meaning of Mbuti iconography is not known. Possibly linear designs stem from or are at least related to patterns on the faces and bodies of both men and women. Such designs are considered sacred, an indication that the wearer is a child of the forest, protected by a forest animal totem. They are signs of respect for the rituals and the tools of the forest and its people.

CONTEMPORARY ARTS

Soon after World War II, the Belgian colonial Pierre Romain-Desfosses founded an atelier, "le Hangar," in the provincial capital Elizabethville (now Lubumbashi). Typical of European-led workshops in colonial Africa, le Hangar artists used Western techniques and materials and produced for a non-African audience. Romain-Desfosses was a romantic in search of pure, fresh sources. He did not give instructions or impose criteria or principles on his followers but recommended they use their eyes to observe the world carefully. Their stylized paintings were purchased in European countries and regarded as "typically African" products, quickly bringing international recognition.

Delicate line and refined drawing set Pilipili Mulongoye (born 1914) apart from other le Hangar painters. His paintings are characterized by a highly personal style and fine brushstrokes that create a flat screen of bright colors behind subjects. Largely profit-oriented, Pilipili reproduced his paintings endlessly, rarely painting a picture that was not commissioned.

Decorative and beautifully colored, *Snake Invading Bird Nest* is typical of Pilipili's style (fig. 12-39). The linear surface treatment shows no interest in volume or space. The linearity is expressed in repeated parallels of

12-38. TEXTILE. MBUTI. BARKCLOTH. FIELD MUSEUM OF NATURAL HISTORY, CHICAGO

wing and tail feathers which contrast with the scale-like patterns of body feathers. Parallel dabs of red, blue, and yellow create a patchy ground against which the action takes place. While the painting is lovely to look at, the subject matter of birds defending their nest against a predator suggests the strife

and anguish characteristic of the lives of Africans during the colonial period, when African resources were taken away and African labor was exploited.

Discord, suffering, and anxiety were addressed by another group of Lubumbashi artists in the 1960s. Often referred to as Urban Artists, their paintings not only recorded and reflected the urban experience but also helped to form it. Unlike the artists of le Hangar, they produced not for a foreign audience nor even for the African elite. Their works were intended for the walls of the urban masses and were

very much a part of the urban discourse of the time. Content and imagery were important links to a shared narrative of the urban experience of these modern Africans, reflecting social and political issues, both past and present.

Most of the painters were self-taught and saw themselves as businessmen. Producing variations on somewhat conventionalized narrative subjects, they communicated a social message that took precedence over style or aesthetics. While some stories are general in nature, evoking

12-39. *Snake Invading Bird Nest*. Pilipili Mulongoye. 1973. Oil on canvas, 21⅔ x 22½" (55 x 57 cm). Collection of Ilona Szombati

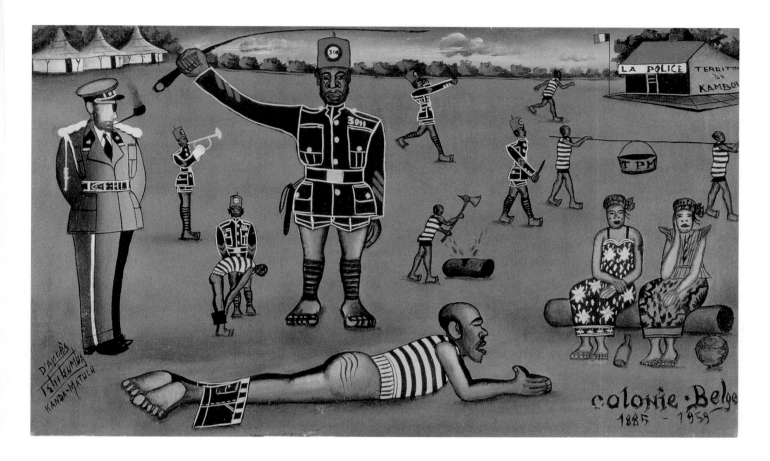

12-40. *COLONIE BELGE, 1885–1959: TERRITOIRE DE KAMBOLE.* TSHIBUMBA KANDA MATULU. 1973

ancestral images and ancient lore, others are historical, depicting known individuals in specific acts. The specificity of events is often enhanced by verbal explanations inscribed within the painting or on the margins.

Tshibumba Kanda Matulu painted in Lubumbashi in the 1970s and saw himself as a painter-historian. In a dream he conceived of painting the history of Zaire and attempted to proclaim the entire story of Congo-Zaire from precolonial times to the present in hundreds of paintings. Unlike the artists of le Hangar, Tshibumba Kanda Matulu made no attempt to be decorative. Harsh themes call attention to government excesses during the colonial period. A favorite genre, called Colonie Belge, presented a panoramic view of a colonial prison yard. In the example shown in figure 12-40 a barefoot, uniformed African policeman beats a prisoner whose bare buttocks bleed. A white colonial administrator nonchalantly looks on, puffing on his pipe. Other characters observe or participate in sub-plots: a prisoner lowers his shorts in preparation for the beating; a guard, stick in hand, oversees prisoners carrying a large tub; in the background, a policeman pursues a fleeing prisoner. The captions are often as significant as the visual details of the painting; such inscriptions are in French, the colonial language of bureaucracy, rather than in an African language of everyday discourse.

IV. Eastern and Southern Africa

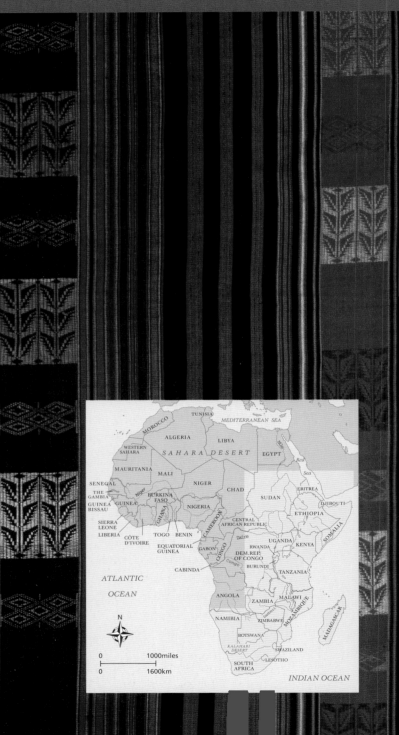

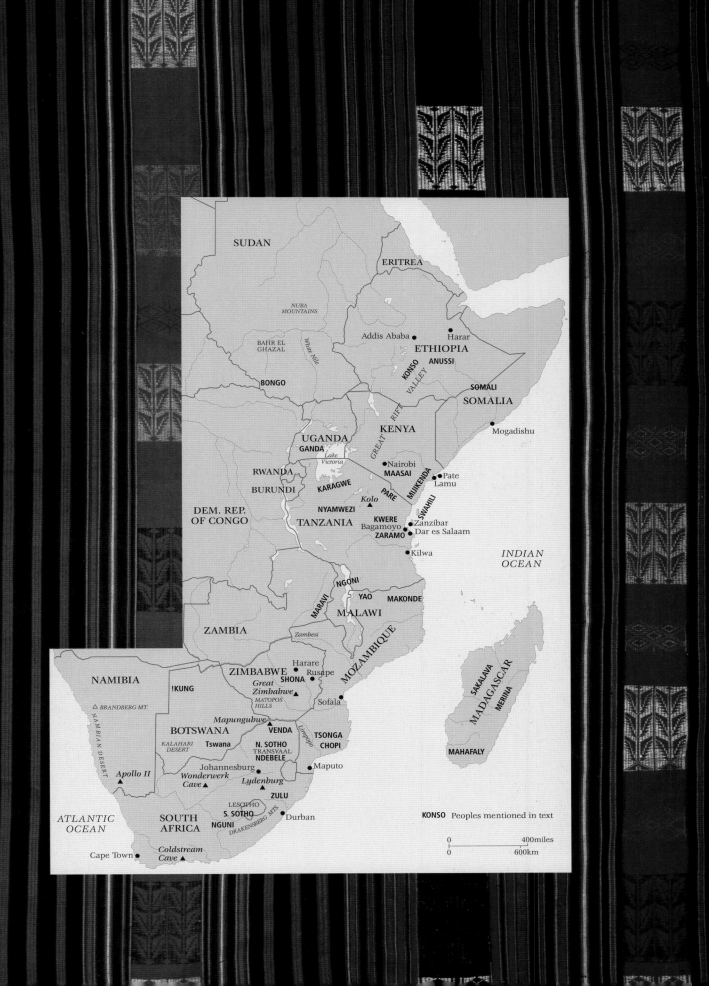

13
EASTERN
AFRICA

OF ALL THE REGIONS OF THE continent, eastern Africa is perhaps the most culturally and ethnically diverse. In part, the region's complexity has been fostered by geography. From the headwaters of the Nile in the north to the floodplains of the Zambesi River in the south, the Great Rift Valley fragments the land-scape into a series of lakes, mountains, and escarpments—each elevation forming an ecological niche for inde-pendent cultural groups. Cross-cultural contacts have also played an important role, for migrations and trade have brought varied populations into eastern Africa. In coastal areas, and on Madagascar and other off-lying islands, settlers from other continents have long mingled with African peoples.

Hunting and gathering peoples who lived in the central hills of present-day Tanzania and Kenya until a few generations ago probably repre-sented the region's most ancient cultural layer. Like the San of southern Africa (see chapter 14), they may have been descended from the earliest human populations of the region. If so, their ancestors were the creators of rock paintings now thousands of years old (see fig. 14-9).

Another ancient cultural layer in eastern Africa is formed by peoples who speak divergent branches of Nilo-Saharan languages. Some linguists believe that Nilo-Saharan languages originated in the central Sahara, dur-ing the millennia when it was a hospitable region of lakes and grass-lands (see chapter 1). With the gradual emergence of the desert, these peoples migrated elsewhere. Nilo-Saharan-speaking populations such as the Kanuri and Tebu now live in the

13-1. WOMAN WEARING SILVER JEWELRY, HARAR, SOMALIA

central Sudanic region (see chapter 3). Others once formed kingdoms in Nubia (see chapter 2). In eastern Africa, some of the groups in this widespread linguistic family are primarily farmers, while others are cattle-herding pastoralists. They are known for their spectacular body arts.

A third presence are Cushite speakers of the northeastern portion of the region, whose languages belong to the Afro-Asiatic family and are related to Chadic languages such as Hausa (see chapter 3). Cushite-speaking nomads have raided and traded with settled communities in Ethiopia and the Nile valley for thousands of years. Smaller Cushite-speaking groups have settled in mountainous regions to raise crops. These farming groups build tombs and carve memorial figures similar to those of some of their Nilo-Saharan-speaking neighbors.

The fourth and most widespread population comprises Bantu-speaking groups, descendants of peoples who are thought to have migrated into the region over the course of the first millennium AD from homelands in western Africa. Today, Bantu speakers make up the majority of the agricultural population of East Africa. In the present-day nations of Malawi, Mozambique, Zambia, and southern Tanzania, Bantu-speaking groups use both regalia and masquerades which mirror those of the Congo region (see chapter 12). In Kenya and in the interlacustrine nations of Uganda, Rwanda, and Burundi, Bantu speakers live in close proximity to non-Bantu groups, and may share the cattle-raising economies and dramatic ceremonial dress of their neighbors.

Along the coast of eastern Africa, Bantu-speaking peoples were linked by an ancient maritime trade to Arabia and India. The Arabs, whose ships came to dominate this trade, called these coastal peoples and their language Swahili, a term derived form the Arabic word for "shore." The Swahili were early converts to Islam, and their art and architecture have been greatly influenced by the art of other Islamic peoples. Additional influences have also been absorbed through Swahili trade with China, India, Madagascar, Europe, and the interior of eastern Africa.

The culture of Madagascar also presents an intriguing blend of influences. Malagasy, the name for the language as well as the people of this enormous island, is not an African language at all, but rather belongs to the Malayo-Polynesian family, a group of languages spoken on the islands of Indonesia and the South Pacific. Malagasy vocabulary includes Bantu and Arabic words, however, reflecting long interaction with mainland East Africa. Malagasy art reflects this same blend, a fascinating mixture of styles originating in both Africa and Asia.

The diversity of East African peoples thus makes it difficult to place their art into any readily definable categories. As might be expected in such a multicultural region, many art forms which are worn or carried serve to identify the owner's ethnicity as well as his or her age and status. Lineage affiliation, leadership roles, and adherence to Islam are also proclaimed by some forms of art and architecture. However, no artistic traditions are shared by all, or even by most, East African cultures. Even contemporary East African artists work in a range of styles that defies any attempt at generalization.

THE SWAHILI COAST

By the time the great Muslim traveler Ibn Battuta visited the eastern coast of Africa during the fourteenth century AD (seventh century AH), Swahili culture was well established. Through trade and migrations, the Swahili established a long chain of Islamic towns that stretched along the coast from Mogadishu, in present-day Somalia, to Sofala, in present-day Mozambique. Although he noted both the piety and riches of the merchants of Mogadishu, Ibn Battuta was most impressed by the city of Kilwa, now in southern Tanzania, which he described as "the most beautiful of cities."

Islamic Arts

In Kilwa, Ibn Battuta would certainly have seen the Great Mosque, one of the most celebrated of all Swahili buildings. Unlike the mosques of northern Africa and the Western Sudan, the Great Mosque at Kilwa has no minaret or central courtyard (fig. 13-2). The plans of Swahili mosques resemble instead the early prayerhalls of Arabia and Yemen. The original structure, a simple rectangular prayerhall, had been built soon after the city was founded, possibly in the eighth or ninth century AD (second or third century AH). Before the thirteenth century this was surrounded by a much larger stone prayerhall. By 1440 (800 AH), the aisles of the mosque had been roofed with stone barrel vaults alternating with rows of small domes. The most impressive dome in the mosque rose over the entrance next to the forecourt, where worshipers washed and purified themselves. Fluted in a manner reminiscent of the dome above the

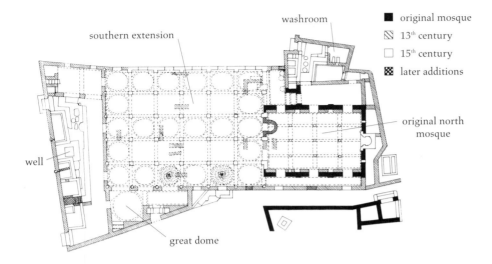

southern extension

washroom

■ original mosque
▨ 13th century
□ 15th century
▧ later additions

original north mosque

well

great dome

13-2. Plan of the Great Mosque at Kilwa, Tanzania. Drawing after Peter Garlake

mihrab in the Great Mosque of Qairouan (see chapter 1), the dome is mentioned in the Kilwa Chronicle, a history of the city written in the mid-sixteenth century.

The Great Mosque at Kilwa was constructed of rough chunks of fossilized coral (a type of limestone), imbedded in a type of cement made of crushed and weathered fragments of the same stone. The interior walls were finished in a white plaster also made from crushed coral, then burnished to a glossy sheen. Doorways and portions of arches were made of blocks of limestone, carved with bands of geometric decoration. The shimmering white interior of the mosque must have once been both elegant and austere (fig. 13-3). Interestingly, while the mosque's pointed arches formally resemble those found in northern Africa and elsewhere in the Islamic world, they are not constructed in the same way, with an arc of stone blocks (voussoirs) held in place by a central keystone. Instead, they are corbeled—successive courses of stone or brick, each one projecting slightly beyond the one beneath, eventually meet to produce an arch-shaped opening.

Worshipers who entered the Great Mosque of Kilwa knelt upon beautifully patterned mats and teachers read from precious copies of the Qur'an. The Qur'an shown in figure 13-4, which was produced in the early

13-3. Interior arcades of the Great Mosque at Kilwa.

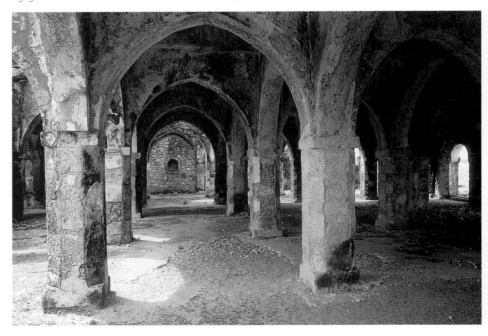

13-4. QUR'AN. SWAHILI. EARLY 19TH CENTURY. INK AND PIGMENT ON PAPER, BOUND IN LEATHER; HEIGHT 10½" (26.5 CM). FOWLER MUSEUM OF CULTURAL HISTORY, UNIVERSITY OF CALIFORNIA, LOS ANGELES

Although artisans in Siyu, where this Qur'an was probably produced, manufactured some books entirely from local materials, the paper and some of the inks used for this Qur'an were imported from Europe or Asia. An inscription records that the descendants of a daughter of Shaykh Dumayl bin Muizz bin Umar gave this Qur'an to a mosque. Unfortunately, it does not tell us where the mosque was located.

nineteenth century, is probably very similar to the sacred books that were used centuries ago in Kilwa and other Swahili cities. The book was probably made in Siyu, a town on Pate Island off the coast of northern Kenya which excelled in the production of manuscripts, embroidery, fine furniture, and other crafts. The scribe who transcribed and ornamented the pages of the

Qur'an was a religious scholar as well as a painter and calligrapher, and he or she provided the commentary that appears in boxes in the margins of the text. The headings of each verse are framed by foliate motifs heightened with red and yellow pigment.

Just outside the Great Mosque, near the exterior of the *qibla* wall, is the tomb of a saint or leader. As in many Muslim cultures, the Swahili often place tombs near a mosque. A pious man spends much of his time in the mosque, the cemetery, and the *madrasa* (the Islamic school attached to a mosque), since all three areas are suitable places for prayer and meditation. Yet to the Swahili, tombs are not merely the focus of religious devotion. They are also tangible expressions of a family's ancestral heritage, and they allow the living to celebrate their ties to the founders of the patrilineage. Tombs also honor the men and women who established a Swahili city, and who are believed by the Swahili to have brought the purity and civilization of Islam to a pagan land. Tombs

are thus evidence of a social covenant, even if they are so old that no one can remember exactly who was buried within them.

Some of the oldest tombs were erected in the Swahili heartland, the coast of southern Somalia and northern Kenya. Ornamented with square or rounded columns, these "pillar tombs" were the inspiration for later stone monuments built in several Swahili cities. The pillars on a sixteenth-century tomb from Kaolo, near Bagamoyo, Tanzania, rise to a height of some twenty feet (fig. 13-5). Pillars on some tombs are carved in relief with blind windows or doors, as though they were the houses of the deceased. Some pillars were inset with niches to hold porcelain bowls, just as niches in Swahili houses were used to display Chinese ceramics (see fig. 13-10). Other stone tombs are rectangular, often constructed of slabs of limestone carved with geometric patterns in low

13-5. PILLAR TOMB, KAOLO, NEAR BAGAMOYO, TANZANIA. SWAHILI. 16TH CENTURY. CORAL LIMESTONE AND CEMENT; HEIGHT C. 20′ (6 M)

relief (fig. 13-6). The patterns echo the ornamentation of doorways and *mihrab*s found in stone mosques of this period.

Arts of Leadership

Both the cemeteries and the mosques of many Swahili cities now lie in ruins. Kilwa and other important sites were sacked by the Portuguese in 1509, and Swahili cities went into decline as European ships disrupted trade throughout the Indian Ocean. However, some Swahili centers regained a measure of independence and prosperity over the course of the seventeenth and eighteenth centuries, before their eventual colonial domination by Omani Arabs in the nineteenth century and by Europeans in the twentieth.

Some of the regalia and symbols of office from this brief period can still be seen, including carved wooden drums and magnificent side-blown horns carved of ivory or cast in brass. The horn, *siwa,* of the city of Pate on

13-8. *KITI CHA ENZI* ("CHAIR OF POWER"). SWAHILI. WOOD, IVORY, AND STRING; HEIGHT 48½" (1.23 M). FOWLER MUSEUM OF CULTURAL HISTORY, UNIVERSITY OF CALIFORNIA, LOS ANGELES

By the fourteenth century, the patrician elders who ruled the most powerful Swahili cities lived in homes built of stone. Swahili patricians still distinguish between walled areas of a city containing stately (if crumbling) stone residences, and the surrounding areas of more modest thatched buildings. Like a monumental stone tomb, a stone house, *jumba*, is closely identified with the noble past, and with family honor, ancestry, and prosperity. It is also believed to maintain the religious purity and physical well-being of a family's living members.

While Swahili mosques are almost exclusively reserved for men—only a few mosques have areas where women may worship—a *jumba* is the domain of women, the focus of their religious and social activities. A stone house, in fact, is built as a gift from a father to his daughter upon her marriage. Even today, when a daughter is born to a patrician couple, the father may begin to gather and prepare building materials. Upon the daughter's engagement, he constructs a second or third story for her over his own (more properly, his wife's) house. If relatives live nearby, the upper stories are connected by a bridge, *wikio*. The ground floor may eventually be given to servants so that the women who own the house can live in the better-ventilated upper floors. In well-preserved Swahili communities like Lamu, in northern Kenya, a *jumba* still represents the continuity of lineages and the blessings of fertility and wealth.

The plan of a ruined stone house from Lamu shows some of the basic

Pate Island is formed of three great carved elephant tusks (fig. 13-7). Its creation is described in the chronicle of that city.

At formal gatherings, Swahili elders and the rulers who direct their councils are seated upon elaborate thrones. Like a *siwa* or drum, a "chair of power," *kiti cha enzi*, is often handed down through generations, and those in current use may thus be several centuries old. Yet others may be recent; woodcarvers such as Said Abdullrahan El-Mafazy of Lamu faithfully reproduce antique furniture owned by their relatives and neighbors. A *kiti cha enzi* is usually made of ebony, inlaid with small pieces of ivory as shown here (fig. 13-8). The use of ivory or bone inlay on furniture is very ancient in northeastern Africa (see fig. 2-13).

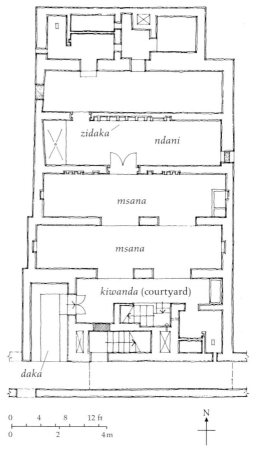

13-9. PLAN OF A SWAHILI *JUMBA*
(STONE HOUSE), LAMU, KENYA.
DRAWING AFTER LINDA DONNALY

features of a *jumba* (fig. 13-9). The walls of this *jumba*, like those of the Great Mosque at Kilwa, were constructed of rough pieces of fossilized coral limestone bound with a cement of crushed limestone and covered with smooth white plaster. This plaster is said to purify and protect the home, and it is an essential feature in any room assigned to a patrician man or woman. The flat roofs were constructed of cement laid over a wooden ceiling, probably made of mangrove saplings.

The entrance to this house was through a small porch open to the street, called a *daka*, a word also meaning "niche." Benches for casual visitors lined the porch. At one side of the porch was a double wooden door set in a majestically carved frame, the only adornment to the plain, high wall. Privileged guests were invited into the open courtyard, *kiwanda*, on the other side of the door. A guest room may have been placed on the landing of the stairway to an upper story. Servants would have slept in the area under the staircase.

Female guests and members of the family were welcomed into the house proper, with its long, shallow galleries, *misana* (sing. *msana*). The longer walls of these interior rooms ran east/west, so that doorways between them pointed the entrant northward, in the direction of Mecca. The house here had two *misana*. Beds could have been placed at the ends of each gallery, possibly screened with hanging curtains or rugs. Carved chests, matching chairs, and stools would also have furnished these rooms.

The first gallery was raised a step above the courtyard, and each subsequent gallery was raised a step further. The darkest and highest gallery was the *ndani*, the "inside" of the house. This cool, private room was occupied by the woman for whom the house was built. Behind the *ndani* of this particular *jumba* was another gallery, an extra room not usually found in this location. However, the rear bathroom (entered from the left door) and the innermost room (entered from the right door) are typical of stone houses. Usually directly behind the *ndani*, this innermost room is the site where the most sacred of all women's activities take place. Here a woman would have given birth, buried stillborn children and protective amulets, washed corpses, and secluded herself while mourning the death of her husband.

The interior walls of *misana* are inset with carved storage niches, *zidaka*. The plan of the *jumba* here shows *zidaka* set into the wall of the second *msana*, and a second, more extensive set of niches in the wall of the ensuing *ndani*, where it probably framed the woman's bedstead. *Zidaka* photographed in another ruined residence in Lamu give us an impression of the original splendor of the Swahili stone house (fig. 13-10). This particular set of niches framed the doorway of a *msana* leading to the *ndani*, whose own *zidaka* may be glimpsed through the doorway.

The patterns of the *zidaka* were sculpted using a technique known as "chip-carving." In each panel the background has been chipped away, often with just one or two strokes per segment, leaving the surface of the stone to form the lines and shapes of the design. This technique is popular in many of the lands bordering the Indian Ocean, but seems most highly developed along the coasts of East Africa and Madagascar. Here we see a variety of patterns, some formed of lozenges or triangles, others of organic, almost floral motifs that clearly share the same aesthetic as the decorative border of the Qur'an discussed earlier (see fig. 13-4).

The wooden doors at the entrance of the stone house at Lamu were once held in a rectangular wooden frame carved in the same manner as this *zidaka*. A central post might have been covered with more deeply carved floral motifs, or with stylized fish and plants. In Lamu today several different styles of doorframes can be seen. Some follow a trend established in Zanzibar

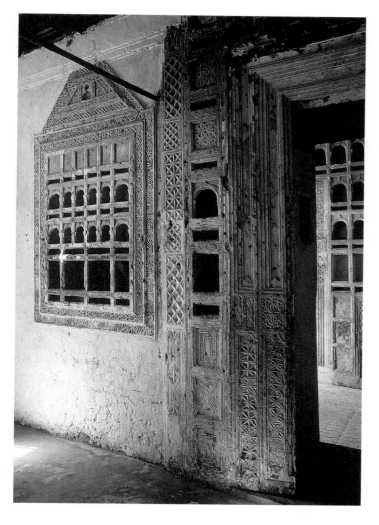

13-10. INTERIOR OF A *JUMBA* (STONE HOUSE) SHOWING *ZIDAKA* (STORAGE NICHES), LAMU, KENYA. 18TH–19TH CENTURY. CARVED CORAL LIMESTONE, LIME PLASTER

The most elaborate of a house's zidaka was filled with copies of the Qur'an, manuscripts, writing implements, and blue-and-white porcelain bowls imported from China. These were the family's treasures, cherished for their beauty and their cost. Sacred writing and shiny ceramic dishes were also believed to protect family members from supernatural harm, and the zidaka was thus a mystically charged space. As houses of the dead, Swahili tombs also came to be inset with zidaka, which were likewise filled with valuable and protective objects.

13-11. CARVED DOORWAY OF A HOUSE, ZANZIBAR, TANZANIA. SWAHILI. 19TH CENTURY. WOODEN DOORFRAMES, CORAL MASONRY

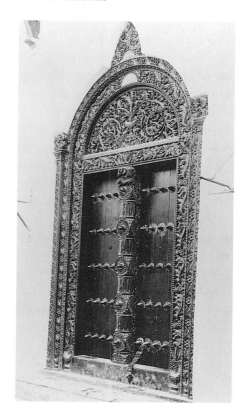

during the height of Omani Arab colonial rule in the nineteenth century, when Arab, Indian, and Swahili merchants commissioned doors with a more "international" flavor from both local and expatriate artists.

The doorway from Zanzibar shown here is an excellent example of this ornate style (fig. 13-11). The crisp abstraction of earlier frames has given way to highly detailed and naturalistic vegetal forms, which writhe across the densely packed surface. Shield-like bosses punctuate the central post, and a semi-circular area arches over the lintel. Although related to Swahili prototypes, this door is clearly tied to

foreign tastes. Doorways such as this seem to have been exported from Zanzibar to arid Muslim regions around the Red Sea and the Persian Gulf, where such large pieces of carved wood were a luxury.

As cosmopolitan trading centers, the cities of the Swahili coast developed a multicultural population and a correspondingly hybrid architecture. One particularly spectacular building in the city of Zanzibar, on the island of the same name in present-day Tanzania, was constructed by a wealthy Indian businessman and designed by an architect from Delhi. Known as the Old Dispensary, its facade presents a

Tharia Topan, the Muslim Indian businessman who commissioned this building, laid the cornerstone to mark the Golden Jubilee of the reign of Queen Victoria of Great Britain. He intended to offer the building to the populace of Zanzibar as a hospital, and he was knighted by the queen in recognition of his gesture of allegiance to the British Empire. Unfortunately, the dispensary was only finished after Topan's death in 1891. It was then sold and divided into private apartments. The building has now been restored as a cultural center.

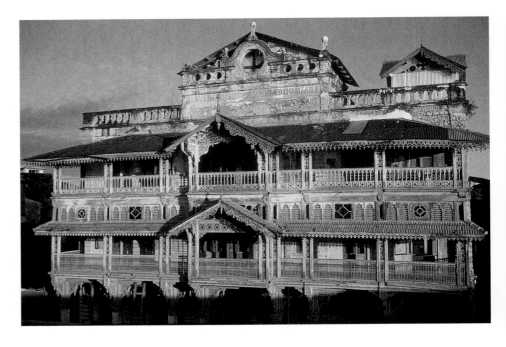

wonderful, motley mixture of Arab, Indian, African, and European elements (fig. 13-12). It was built using the materials and technology of Swahili architecture; thus the walls and decorative details are of coral limestone coated with plaster. The front balconies are loosely based upon the wooden screens covering the upper windows of Egyptian and Arabian homes. The carved columns of the lower porch, and the trefoil arches between them, are Indian inventions, while the fanciful peaked roofs and gables may derive from the exuberant folk architecture of late nineteenth-century Europe. It is interesting to compare the inventive eclecticism of this civic building with the hybrid architecture commissioned on the western coast of Africa by other cosmopolitan merchants (see chapter 6 and fig. 8-60).

OTHER COASTAL BANTU CULTURES

Along the East African coastline, inland from the cities of the Swahili, are several major clusters of Bantu-speaking peoples. Bantu-speaking Mijikenda groups, for example, live in the hills above the central and southern Kenya coast. They share many cultural features with the Swahili, though few have converted to Islam. Whereas the Swahili honor their ancestors by building stone tombs, the Mijikenda carve tall planks to venerate the dead. The most elaborate memorial planks, *vigango* (sing. *kigango*), are erected to appease the spirits of deceased members of Gohu, a benevolent association. The most thoroughly documented *vigango* are those of the Giriama people of the Mijikenda cluster.

The *vigango* of the Giriama are cut from living trees by a delegation of men. The circular head, short neck, and rectangular body of the image are carved, smoothed, and ornamented with triangles and facial features incised with chip carving. The sculpture is then painted with bright red, black, or white pigment mixed with latex. The final stages are completed during a single night, so that the statue may be consecrated at dawn. It is this dedication ceremony which is illustrated here (fig. 13-13). A white cloth has been tied around the neck of the *kigango*, and the men who participated in the night's creation are pouring libations and eulogizing the deceased.

The Zaramo and their neighbors, a homogenous cluster of Bantu-speaking peoples who live in northeastern Tanzania, also carve poles as references to the deceased. An unusually naturalistic figure with jointed limbs was evidently taken from a pole set over a Zaramo grave in the early twentieth century (fig. 13-14). The smooth head and the heart-shaped contours of the face are also found on the *vigango* of some Mijikenda groups.

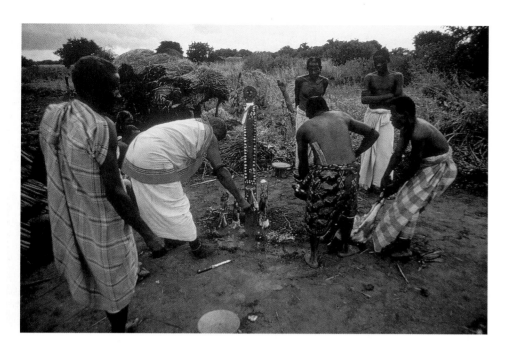

13-13. GIRIAMO DEDICATION CEREMONY FOR A *KIGANGO* (MEMORIAL FIGURE), COASTAL KENYA

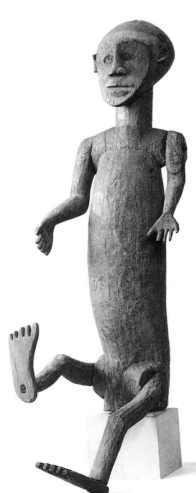

13-14. JOINTED FUNERARY FIGURE. ZARAMO. 19TH CENTURY. WOOD, HEIGHT 33½" (85 CM). MUSEUM FÜR VÖLKERKUNDE, STAATLICHE MUSEEN, BERLIN

Zaramo elders recall that such large, moveable images were made to speak during extraordinary funerary ceremonies, when the absence of a male heir demanded that the statue deliver the oration.

13-15. MEMORIAL POST. ZARAMO. 19TH CENTURY. WOOD, HEIGHT 13⅞" (35.3 CM). MUSEUM FÜR VÖLKERKUNDE, STAATLICHE MUSEEN, BERLIN

The second Zaramo grave marker shown here is more typical, with the human figure reduced to a cylindrical torso set upon two faceted bases (fig. 13-15). The head is a helmet-like form composed of a cone covered by a semi-circular arched ridge. This economical and evocative composition is a manifestation of a symbol known throughout northeastern Tanzania by variants of the term *mwana hiti.*

Mwana hiti (or *mwana nyahiti*) has been translated as "daughter of the throne" or "(female) child of the one who is enthroned." The symbol is said to be both female (because of the tiny breasts) and male (because the *mwana hiti* image as a whole is phallic in shape). *Mwana hiti* evokes the lineage-founding ancestral couple, and by extension ancestors and their

13-16. *MWANA HITI* ("DAUGHTER OF THE THRONE"). ZARAMO. 19TH CENTURY. WOOD, HUMAN HAIR, FIBER; HEIGHT 6⅝" (17 CM). MUSEUM FÜR VÖLKERKUNDE, STAATLICHE MUSEEN, BERLIN

authority in general. The symbol appears in a variety of contexts, but it is most commonly embodied in the small figures used during female initiations (fig. 13-16). The term "female child of the one who is enthroned" refers directly to the girls who are undergoing this period of training, for they are briefly seated upon the ancestral stool or throne of their mother's lineage when they are pre-

sented to the community at the end of their seclusion. The name of this symbol, as well as the image itself, thus celebrates the heritage of these young women, whose beauty, health, and fertility are viewed as gifts of the ancestors.

A girl is given a *mwana hiti* by her father's sister when it is time for her to begin her seclusion. After the girl has had her hair cut in the distinctive crested style worn by initiates, she ties tufts of it to the holes in the crest along the head of the *mwana hiti*. A very personal and highly charged substance, the hair is usually removed before the girl returns the figure to her guardian. The *mwana hiti* illustrated here may thus have been taken from a girl or her family without their permission.

All *mwana hiti* share the same basic form, yet no two are exactly alike. The peoples of northeastern Tanzania are masterful sculptors, and they exploit the subtle variations on this abstract theme to the fullest. The range of their abilities is also striking, encompassing the rigorous geometric harmonies of a *mwana hiti*, the more naturalistic grave marker described above (see fig. 13-14), and the female figure and child from the top of a staff shown here (fig. 13-17). All of these objects are attributed to Zaramo artists, but their styles are strikingly different. The diviner or leader who once owned the staff would have been able to allude to ancestral power, fertility, and blessings of all kinds by commissioning a scepter with a *mwana hiti*, as was often done. Instead, this mother with a child on her back, possibly a reference to the lineage and its progeny, the leader and his family, or to the initiator and her initiate, is a

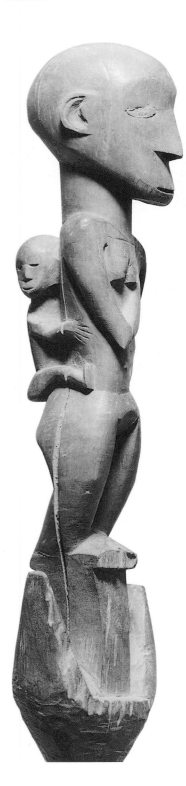

13-17. STAFF FINIAL. ZARAMO. BEFORE 1917. WOOD. STAATLICHE MUSEUM FÜR VÖLKERKUNDE, MUNICH

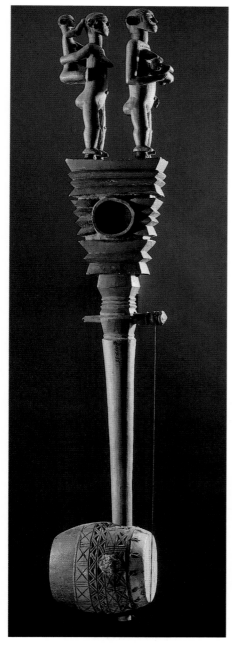

distinctive and descriptive statement. The curved contours of the woman's body and the precise placement of the child on the woman's back form a very appealing image.

Figures of women and children also appear on a musical instrument attributed to the Kwere, another group in this cultural cluster (fig. 13-18). Set atop an abstract base of great compressed energy, one carries a baby in her arms, while the other carries a child on her back. The belly of the instrument is embellished with chip-carved geometric shapes similar to those found in Mijikenda and Swahili art. While the meaning of the figures is unclear, the beauty of these carefully placed images is quite apparent.

As the term *mwana hiti* itself reminds us, thrones may be the central focus of ceremonies involving leadership and initiation. This is particularly the case with the Luguru, a large

Bantu-speaking group culturally related to the Zaramo and the Kwere. One very fine throne, taken from a Hehe community in central Tanzania but probably carved by a Luguru artist, is composed of a broad circular seat backed with a rectangular slab (fig. 13-19). Small conical breasts and the fully three-dimensional head above it identify the backrest as a female torso. It is quite fitting that such a symbol of ancestral authority should evoke a female form, for Luguru culture is matrilineal. Stylistically, the combination of a spherical head and flat torso is similar to the forms of some Mijikenda *vigango*. The crested hairstyle and small, flat face, however, are typically Luguru.

There is much contact between the Mijikenda of Kenya, the peoples of northeastern Tanzania (such as the Zaramo and the Kwere), and the Bantu-speaking groups who live further inland on both sides of the Kenya/Tanzania border. Among all of these peoples, sculpted art works have been owned by healers. In northeastern Tanzania, *mwana hiti* still serve as corks or stoppers for containers of medicine, invoking the powers of ancestors against supernatural dangers. A stopper may also be used to apply medicine to a patient. In southeastern Kenya, carved heads or partial figures once sealed antelope horns containing medicine, the points of which were driven in the ground near the healer during consultations.

13-18. MUSICAL INSTRUMENT WITH FIGURES. KWERE. 19TH–EARLY 20TH CENTURY. WOOD. REISS-MUSEUM, MANNHEIM

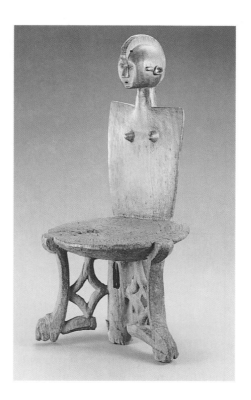

13-19. THRONE. LUGURU. 19TH–20TH CENTURY. WOOD, HEIGHT 31½" (80 CM). NATIONAL MUSEUM OF AFRICAN ART, SMITHSONIAN INSTITUTION, WASHINGTON, D.C.

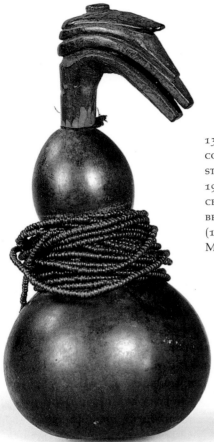

13-20. CALABASH
CONTAINER WITH CARVED
STOPPER. PARE (?).
19TH–EARLY 20TH
CENTURY. GOURD, GLASS
BEADS, WOOD; HEIGHT 6"
(15 CM). LINDEN-
MUSEUM, STUTTGART

13-21. HORN CONTAINER
WITH CARVED STOPPER.
SHAMBAA (?). 19TH CENTURY.
HORN AND FIBER; HEIGHT
21¼" (54 CM). MUSEUM FÜR
VÖLKERKUNDE, STAATLICHE
MUSEEN, BERLIN

13-22. PROTECTIVE FIGURE. PARE.
19TH–EARLY 20TH CENTURY. WOOD,
GLASS BEADS, AND TEXTILE; HEIGHT 8¼"
(21 CM). MUSEUM FÜR VÖLKERKUNDE,
STAATLICHE MUSEEN, BERLIN

*This small sculpture was commissioned
in order to enforce good behavior or
punish misdeeds, for it was said to
protect against theft. Its owners (or the
specialist who advised them) encircled
it with a cloth to bind spiritually
powerful materials to its torso.
Evidently this roughly carved but
forceful wooden figure is the eastern
African equivalent of the* nkisi *of the
Kongo peoples (see chapter 11).*

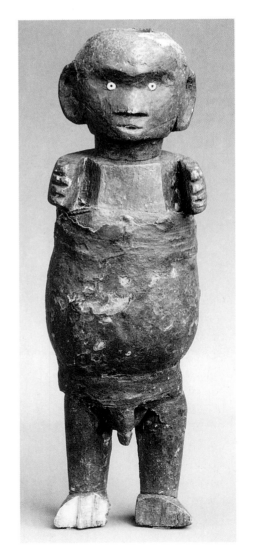

Two carved stoppers with their
medicine containers were collected
in northern Tanzania in the early
twentieth century. One stopper is a
particularly striking zoomorphic form
which fits into the opening of a beaded
gourd (fig. 13-20). Another, knotted
and tied to a container made of horn,
depicts a human head with emphatic
arches for ears and eyebrows (fig.
13-21).

Photographs taken in the 1950s
show male and female therapists in
coastal Kenya wearing beaded veils
and bags, full cloaks, ornate head-
dresses, and leather masks. In addition
to stoppered containers, they carried
carved figures, staffs, and musical
instruments. Healers in northeastern
Tanzania still display
art forms, yet little is
known about their
statuary. A wooden
figure with outstretched arms from
northern Tanzania seems to have been
prescribed for clients with particular
needs by a diviner of the Pare people
(fig. 13-22). The small beads placed in
the eyes are almost hypnotic.

Other images used or ordered by
religious specialists of coastal high-
lands Bantu-speaking peoples are
made of clay. Only the clay figures of
one of these peoples, the Chagga, have
been documented in use, however. A
typically schematic figure with a face
and open mouth may be identified as a
nungu, a protective figure used by the

13-23. *NUNGU* (PROTECTIVE FIGURE). CHAGGA. 19TH–EARLY 20TH CENTURY. CLAY. MUSEUM FÜR VÖLKERKUNDE, LEIPZIG

Chagga, because the knobbed protrusions indicate that bits of mystically charged material have been sealed into or added onto the surface of the image (fig. 13-23). More fluid clay images, both fired and unfired, are known to have served as instructional aids in the initiation of young men and women in northern Tanzania. However, since these initiations are held in secret, outsiders do not know whether (or where) the works are still in use.

PRESTIGE ARTS OF THE INTERLACUSTRINE REGION

During the eighteenth and nineteenth centuries, a vast network of trade routes linked the Swahili ports on the Indian Ocean to the peoples who lived in the interlacustrine region, the lands along the lakes and waterways of the Great Rift Valley. Merchants, warriors, and slave traders moved along these routes, as did art works and artists.

The Nyamwezi

In western Tanzania much of this trade was organized by the kingdoms and associated communities of a people known collectively as the Nyamwezi, or "people of the moon." The remarkable Nyamwezi throne shown here was carved during the late nineteenth century (fig. 13-24). Formally and conceptually it is linked to the thrones of the Luguru in the east and to the seats of authority on the western flanks of the Great Rift Valley in the Democratic Republic of Congo (see chapter 12). Seen from the front, the curved backrest of the Nyamwezi throne appears to merge with a head and a pair of hands to form a figure, as in the Luguru throne discussed above (see fig. 13-19). A rear view of the Nyamwezi work, however, reveals a slim and elongated body with bent limbs, carved in high relief, embracing the rectangular back of the throne. Only the head and hands extend past the edges of the backrest and are visible from the front. The leader or elder who sat on this throne would thus have been visually framed and conceptually embraced by ancestral authority.

The shiny finish of the Nyamwezi throne is very different from the rough, grimy surface of the Pare protective figure (see fig. 13-22), but they share the same eyes of inlaid beads. In each case the artist did not smooth away the carving marks of his adz or knife, and both figures display unusual proportions: the Pare image is compacted while the Nyamwezi figure is stretched thin. Many of the features found on the figure attached to the Nyamwezi throne—including the spherical head, uneven surface, and

13-24. THRONE. NYAMWEZI. LATE 19TH CENTURY. WOOD, HEIGHT 42" (1.07 M). MUSEUM FÜR VÖLKERKUNDE, STAATLICHE MUSEEN, BERLIN

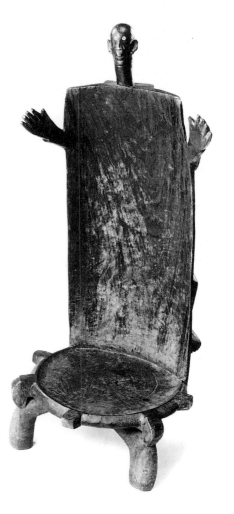

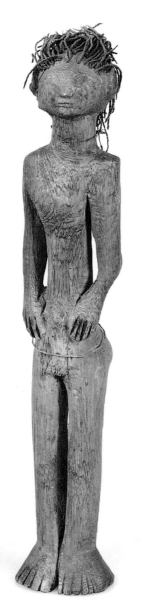

13-25. STANDING FIGURE. SUKUMA (?). 19TH–EARLY 20TH CENTURY. WOOD AND FIBER; HEIGHT 14⅕″ (36 CM). LINDEN-MUSEUM, STUTTGART

seem to have been sculpted by artists of northern Nyamwezi peoples such as the Sukuma. One of these works, possibly once part of a pair or a group of figures, comes from an island in Lake Victoria (fig. 13-25). The facial features are barely distinguishable, the hands merge into the hips, and the feet form a notched conical base. Yet although the surface is rough and the gender undefined, the hair was painstakingly constructed of attached twisted or braided fibers. The contrast between clear outlines and uneven surfaces, between crisp braids and vague face, gives this figure an aura of mystery, an aura heightened by our regrettable ignorance of its name, history, or meaning. Available information on similar works suggests only that it may have been owned by a king or community leader as part of his personal treasury.

Similar questions surround another work attributed to the northern Nyamwezi (fig. 13-26). Breathtaking in its abstraction, this attenuated figure achieves a beautiful, slow rhythm as subtle details punctuate our eyes' long vertical slide along its lustrous surface. Similar elongated statues were

13-26. DISPLAY FIGURE. NYAMWEZI. 19TH–EARLY 20TH CENTURY. WOOD. COLLECTION OF JEAN WILLY MESTACH, BRUSSELS

carried by the Sukuma as staffs in dances, but this example seems too fragile to have been manipulated by a dancer. It may have been the predecessor of large figures displayed since the 1950s by Sukuma and Nyamwezi dance troupes to enhance the visual impact of their performances.

Royal Treasuries

Wooden sculptures and thrones seem to have been acquired as prestige items by interlacustrine leaders during the nineteenth century, yet in general these sculptures were not directly connected to the institution of leadership. The royal treasuries of several centralized interlacustrine states did, however, include metal objects associated with the mystical powers of kings and their ancestors. The largest of all royal treasuries may have been located in the small kingdom of Karagwe, on the western banks of Lake Victoria. When the American adventurer William Stanley arrived in Karagwe in 1876, he saw some of the hundreds of iron and copper objects owned by Rumanika I, the king of Karagwe, including ceremonial anvils and images of cattle. A spare and elegant bovine form was one of the items of regalia taken from the Karagwe treasury by German soldiers in 1906 (fig. 13-27). The smooth curves of the horns, limbs, tail, and hump, and the delicate muzzle and ears of the creature, are very difficult to achieve in iron, and the technical skills displayed here are considerable.

The selection of cattle and horned forms as subject matter was natural in a kingdom where cattle were a source of wealth and prestige. Rumanika claimed that all of the iron objects in the treasury had been made by his

semi-circular ears—may have once been typical of art produced all along the trade routes joining the Tanzanian interior to the coast.

Freestanding figures have also been collected among Nyamwezi groups. Some of the most fascinating

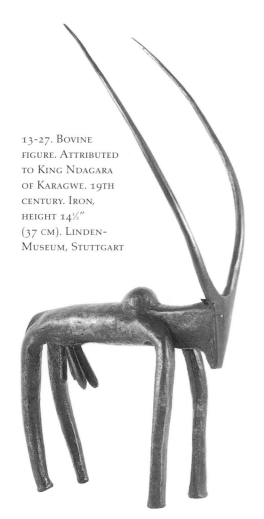

13-27. BOVINE FIGURE. ATTRIBUTED TO KING NDAGARA OF KARAGWE. 19TH CENTURY. IRON, HEIGHT 14½" (37 CM). LINDEN-MUSEUM, STUTTGART

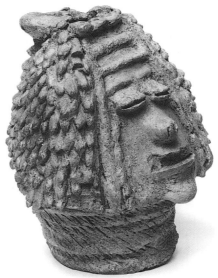

13-28. HEAD (THE LUZIRA HEAD). BUGANDA. BEFORE C. 1750. TERRACOTTA, HEIGHT 7⅞" (20 CM). THE BRITISH MUSEUM, LONDON

13-29. GOURD-SHAPED VESSELS ON BASKETRY STANDS. GANDA. 20TH CENTURY. TERRACOTTA, GRAPHITE, GLAZE, FIBER; HEIGHT OF TALLEST VESSEL 13⅜" (34 CM). THE BRITISH MUSEUM, LONDON

who served the king, *kabaka*, of the Buganda. The head was modeled at least two hundred years ago and we do not know who or what it represents. Stylistically the head resembles no other known work from eastern Africa, suggesting that art works in the past may have been quite different from those created during the nineteenth and twentieth centuries.

Ceramics and Basketry

Both ceramic vessels and finely woven baskets were owned by men and women of high status in the interlacustrine states, and some were made exclusively for royal families. Burnished black vases, *ensumbi*, were once proudly displayed by members of the Buganda court (fig. 13-29). The

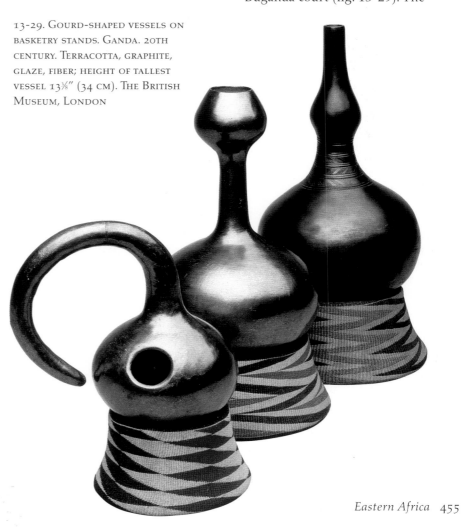

predecessor, Ndagara, who was both king and blacksmith. In Karagwe thought, Ndagara's proclaimed ability to produce this impressive object was a validation of his role as a cultural hero who practiced ancient skills. Even if Ndagara did not actually forge this particular work, the people of Karagwe believed it was created because of his skill and his ties to the ancestors.

Another object from the interlacustrine states may also have been tied to a royal court (fig. 13-28). Known as the Luzira Head, this ceramic fragment was found during the excavation of a lakeshore shrine once kept by priests

lustrous black surface was created by polishing with graphite. Made by male potters working for the king of Buganda, these shiny, long-necked containers replicate the forms of the calabashes once used by the ruling clans (who were originally pastoralists). The tightly woven fiber stands for these pots were the work of wealthy and leisured Ganda women, whose skill in creating intersecting geometric patterns is displayed in these examples. Other beautiful basketry was once made in Rwanda and Burundi.

Magdalene Odundo, a contemporary ceramic artist born in Kenya in 1950, draws upon this tradition of ceramic connoisseurship (fig. 13-30). The forms of her sculpture are even

13-30. VESSEL. MAGDALENE ODUNDO. 20TH CENTURY. , BURNISHED EARTHENWARE, HEIGHT 18" (46 CM)

freer and more fluid than those of the vases formerly used by wealthy Ganda. They are not based upon the shapes of gourds, but upon the human body. The full curves of the vase-like sculptures seem to be metaphors for fullness and fecundity. Whereas the Ganda ceramics were items of prestige traded within the interlacustrine region, Odundo's work is produced within an international context; she sculpts and lectures in the United States and Europe as well as Africa.

MASQUERADES AND OTHER ARTS OF THE MARAVI, THE MAKONDE, THE MAKUA, AND THE YAO

Western museums house a fascinating variety of masks purchased or taken as booty during the European exploration and conquest of eastern Africa in the late nineteenth and early twentieth centuries. Yet very little information accompanied these art objects, and the practice of masquerading has since died out in much of East Africa. The only peoples who continue to sponsor elaborate masquerades live in Tanzania, Mozambique, and Malawi. They include the Makonde, the Makua, the Yao, and some of the Maravi peoples.

Nyau

The Maravi once formed several distinct kingdoms which were united under the authority of a sacred emperor, *karonga*. The slave trade of the nineteenth century shattered the Maravi empire, yet in at least two Maravi groups, the Chewa and the Mang'anja, a masquerade association called Nyau can still be found. In the

Chewa kingdom of Zambia and among the Mang'anja people of southern Malawi, Nyau is responsible for funerary ceremonies held during the dry season after the corn harvest. Nyau masquerades invite animals of the forest to join temporarily with the human community in celebration, thus returning for a time to the harmony of creation. They also initiate children into adulthood. The Mang'anja see Nyau ceremonies as restoring relations between the earth and the sky so that rain may fall and life may continue (see Aspects of African Culture: Circles and Cycles, page 458).

Wooden face masks and facial coverings of fiber, feathers, and rags are worn by Nyau members to give form to the spirits of those who have died during the year. These masks are known generally as *nyau*, but they also have individual names suggested by their appearance, their behavior, or the songs sung during their performances. Some are easily identifiable as old men, Europeans, or ghosts walking on stilts. A mask of a character known as *nkhalamba*, or "old man," was collected in a Mang'anja community in the Nsanje district of southern Malawi (fig. 13-31). The projecting brows and nose of the black wooden mask are common in the *nyau* face masks of the Mang'anja. His eyes and mouth are outlined in red.

The most important *nyau* are large basketry structures made of bamboo, plant fibers, and cloth. Known as *nyau yolemba*, they make manifest the souls of forest beasts and other nonhuman presences. Among the Chewa, a northern Maravi group, the most important of these *nyau yolemba* manifests the soul of the eland, a type of antelope (fig. 13-32). Called *kasiya*

maliro, it appears at midnight to be led to the home of a deceased member of the community. After communing with the soul of the deceased, the eland brings the soul out of the house, out of the town, and into the forest. There the basketry structure is set alight, and its burning transforms the soul of the deceased into an ancestral spirit that can now be present in the lives of his

or her descendants. Boys who are being initiated into Nyau eat the ashes of *kasiya maliro* before returning home to their families.

Nyau masquerades appear when Mang'anja boys and girls are initiated into adulthood, but only boys learn

about the *nyau* of the Chewa. Chewa girls undergo completely separate initiations, which once involved animal forms modeled in the earth. While wooden figures may also have been used for girls' initiations in some Maravi groups, virtually nothing is known

13-32. Chewa *Kasiya maliro* (eland masks) in performance, Zambia. 1980s

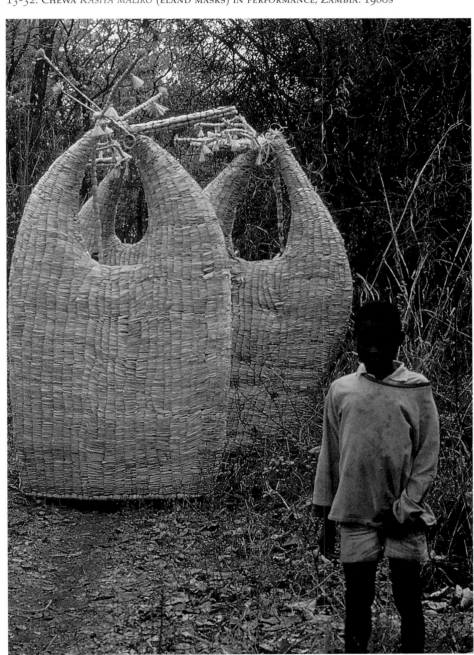

13-31. *Nkhalamba* ("old man" mask), southern Malawi. Mang'anja. 1960s

Nkhalamba, *like all* nyau *who dance at the edge of Maravi towns, is both a specific, satirical character and the bearer of the spirit of the person who has died. As a dancer and a comic actor, he entertains the men, women, and children who assemble during some stages of the ceremonies. As a spirit medium, he causes women to cry at other times in the ceremonies, for he gives a physical presence to the souls of their deceased relatives.*

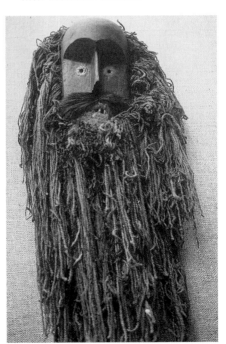

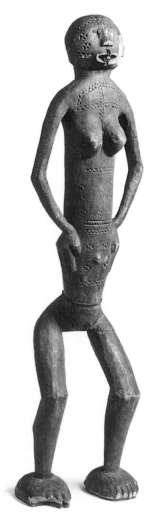

13-33. FEMALE FIGURE. MARAVI.
19TH–EARLY 20TH CENTURY. WOOD
AND GLASS; HEIGHT 22" (56 CM).
MUSEUM FÜR VÖLKERKUNDE,
STAATLICHE MUSEEN, BERLIN

of how they functioned in the course
of the girls' instruction. A few of these
wooden sculptures survive, including
the work shown here, purchased
almost a century ago (fig. 13-33). The
long, tubular torso and spherical head
tie it stylistically to figures from west-
ern Tanzania, but the heavy hands and
feet and the widely spaced legs are
quite distinctive.

Aspects of African Culture

Cycles and Circles

Most African arts have as their contexts recurrent and repeated patterns
or situations, although some sporadic or arbitrary occasions may arise. Two
models—cycles and circles—are especially useful to an understanding of
these patterns, which in turn can help us visualize the place and sway of
art in everyday and ceremonial life. The most important cycles are the
agricultural year and the course of human life from birth to death, and in
many places to reincarnation. Certain pulse points or passage rituals in
each cycle are magnets for art: planting and harvest ceremonies,
transitions to adulthood (puberty rites) and ancestorhood (second burial
celebrations). A few cultures acknowledge longer cycles; the Dogon, for
example, mark by an elaborate masquerade the turn of a sixty-year cycle
that symbolizes the replacement of one generation with another.

The ownership, orientation, and sway
of art also can be modeled conceptually by a series of concentric circles,
from the works made for and by individuals, which have the least scope
and are represented by the innermost circle, to those for and by an entire
community, which have the most scope. This model begins with an
individual, extends outward to the family, the lineage group, the village,
and the larger community such as a clan or city-state. The boundaries of a
people (either as they define themselves or as they are defined by others)
define the outermost circle which would embrace strangers who live on
the borderlands and speak different languages. Each circle tends to foster
certain types of art. Scarification and jewelry are personal and individual,
domestic compounds are family or lineage based, masquerades tend to be
larger group endeavors, while court arts are expressions of a state.

Two relatively new "circles" of
importance today are cities and the international world. Groups such as
the Yoruba and the Swahili have long built urban centers, but for much of
the continent this phenomenon has arisen with colonialism. The
international circle that is the intended audience of much contemporary
African art is largely a postcolonial, post-independence development which
embraces Africa, Europe, the Americas, and, to a lesser extent, Japan. We
can predict that these new circles will become increasingly important.

Lipiko

Nyau has its equivalent in Lipiko and Isinago, the masquerade institutions of the Makonde and their neighbors (particularly the Yao and the Makua). Lipiko performances in Tanzania feature face masks. An astounding number of beautiful wooden masks of this type, including the two illustrated here, were taken from Makonde or Makua communities in southern Tanzania by a German visitor at the beginning of the twentieth century. Unfortunately, he recorded virtually nothing about the names of the masks or the characters they represent, and did not note the names of the artists or their places of origin. Both of these masks may in fact have been sculpted specifically in response to his demand for carved objects. As is so often the case in African art, we can only admire the formal inventiveness of works whose meaning is lost to us, while praising the artistry of creators whose names we do not know.

The first mask is in the form of a lovely oval face (fig. 13-34). The forehead tattoos, the ear spools, and the labret (the cylindrical ornament filling the upper lip) were popular with women in the region, but were occasionally also worn by men, and so we cannot be sure whether the mask depicts a male or a female character. The second mask depicts the face of a rabbit, an animal described as a trickster by East African storytellers (fig. 13-35). The superb abstraction of the detachable ears and the rectangular nose and ears bear a formal resemblance to the masks of the Western Sudan, while the clear divisions between the oval

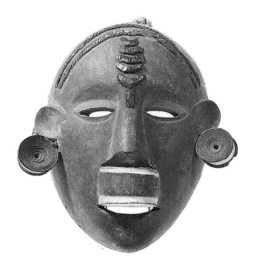

13-34. FACE MASK. MAKONDE OR MAKUA. BEFORE 1908. WOOD. MUSEUM FÜR VÖLKERKUNDE, LEIPZIG

13-35. FACE MASK. MAKONDE OR MAKUA. BEFORE 1908. WOOD, WHITE PIGMENT, FIBER; HEIGHT 18½" (47 CM). MUSEUM FÜR VÖLKERKUNDE, LEIPZIG

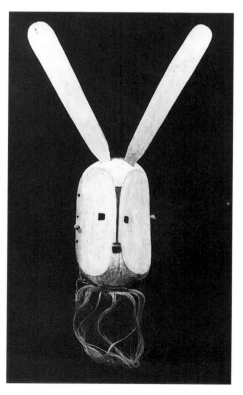

indentations on either side and the raised chin, nose, and brow recall masks from Gabon. The masterful shapes of this mask are probably not the result of outside influences, however, but derive from the artist's skill and experience.

A photograph of a Malawian dancer captures the startling naturalism of contemporary masquerades in the Lipiko tradition (fig. 13-36). This particular masquerader closely resembles the American pop star, Elvis Presley.

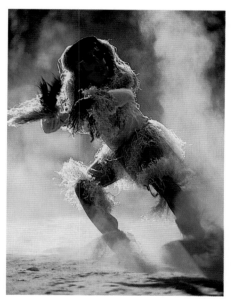

13-36. YAO OR MARAVI HELMET MASK IN PEFORMANCE, MALAWI. 1990

Lipiko announces and celebrates the initiations of both boys and girls. As in Nyau, the masquerades blend sacred and secular elements. They invoke spirit presences, but the men who are responsible for offering them to the community are named and praised. Although masked beings are highly respected, they may satirize foreigners or other foolish individuals.

Sculpture

A large variety of figures have been collected from the Makonde and their neighbors. Some of the earliest examples may have been used in female initiations, but many of the fine sculptures collected during the twentieth century were probably carved for foreigners by artists exploring new markets for their work. The geometric shapes on the face and torso of one robust figure carved by a Makonde artist of Mozambique replicate the delicate raised tattoos which

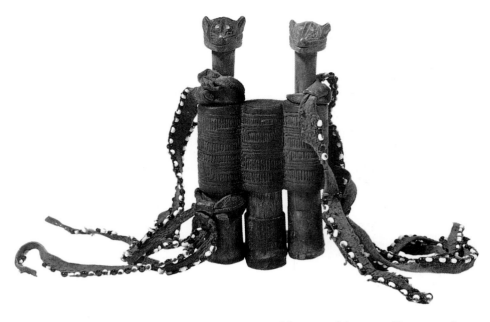

13-38. MULTI-CHAMBERED CONTAINER WITH STOPPERS. MWERE OR MAKONDE. BEFORE 1908. WOOD, BEADS, FABRIC. MUSEUM FÜR VÖLKERKUNDE, LEIPZIG

13-37. STANDING FIGURE. MAKONDE. BEFORE 1966. WOOD AND PIGMENT; HEIGHT 15¼" (39.5 CM). MUSEU NACIONAL DE ETNOLOGIA, LISBON

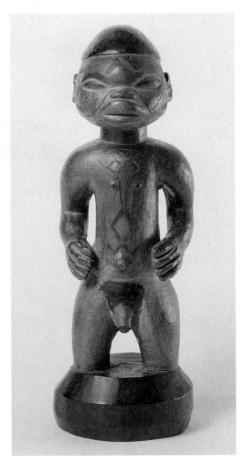

still adorn Makonde men and women (fig. 13-37).

Sculptors in southern Tanzania and northern Mozambique were not restricted to masks and the occasional figure, however. They also carved a variety of staffs and scepters, as well as smaller items used by diviners and their patients. A container filled with mystical matter and tied with strips of beaded cloth was probably used as a protective device, or as a part of a healer's tool kit (fig. 13-38). The side chambers of this delicately patterned object are closed with stoppers in the form of animal heads. They seem closely related to the carved images used to seal the gourds and horns of healers further north (see figs. 13-20, 13-21).

Export Art

Since the 1960s, many Makonde artists have been working in the Tanzanian capital city of Dar es Salaam, carving figural groups in ebony and other woods for tourists and other foreign clients. Their busy workshops are usually staffed by refugees from Mozambique and by Tanzanians of many cultural backgrounds. In Kenya, Makonde immigrants may work with woodcarvers of the Kamba people, who produce vast quantities of carved wooden animals. Although some sculptures from these workshops are deliberately grotesque, many are fluid images of human beings merging with nature and each other. Europeans have been told that these works express Makonde ideas concerning the world of the ancestors and the value of assisting others in the community. Even if these rather romantic ideas may not really be rooted in Makonde religious beliefs, they have encouraged tourists to remember Africans in a positive light. A particularly lyrical example of this type of modern Makonde

sculpture can be seen in a work by Nikwitikie Kiasi (born 1929; fig. 13-39). The shapes are polished, smooth, and fanciful, well calculated to accompany art objects on a foreign bookshelf. Although these Tanzanian works have been subjected to a good deal of critical scorn by art historians, sculptures such as this one should be admired for their inventiveness and their high degree of craftsmanship.

MADAGASCAR

Settled by seafarers from islands of Indonesia, Madagascar has produced an array of art forms based upon both Asian and African traditions. The Malagasy seem to have settled their island around AD 800, just as Swahili culture began to take shape. Numerous similarities between the sculptural traditions of peoples who live along the eastern coasts of the continent and the Malagasy suggest continuous contact between the mainland and its largest off-lying island.

The wooden object from Madagascar shown here, meant to be tied around a person's neck or chest, evokes the containers used by healers of southern Kenya and northern Tanzania (fig. 13-40; compare figs. 13-20, 13-21). This amulet, *odi*, is from the kingdom of the Merina people, in the central highlands of Madagascar. *Odi* are filled with powerful substances by a healer, *odiase*, for his clients. The partial male and female figures here did not serve as stoppers, as similar figures do on the mainland, but were instead part of the sacred materials placed within. Once joined at the shoulder, the figures may have been a reference to male and

13-40. *ODI* (AMULET). MERINA. 19TH CENTURY(?). WOOD, HORN, FIBER; HEIGHT 5⁹⁄₁₀″ (15 CM). MUSÉE DE L'HOMME, PARIS

13-39. *THE MAN WHO BECAME A MONKEY.* NIKWITIKIE KIASI. C. 1974. YACARANDA WOOD, HEIGHT 30⅜″ (77.2 CM). MUSEUM FÜR VÖLKERKUNDE, FRANKFURT

At some point in its history this odi *was damaged, and the two connected figures were split apart. Although this damage may be the result of an accident, the amulet may have been deliberately broken by someone determined to destroy its influence or its authority. During the mass conversions of Malagasy to Christianity in the late nineteenth century, many powerful* odi *belonging to individuals and to royal families were smashed and burned.*

female ancestors and an invocation of their spiritual powers. The use of small white beads for eyes and the rounded shape of the heads link these sculptures stylistically to statuary from certain areas of Tanzania (see figs. 13-22, 13-24).

While the three prongs appear to mimic cattle horns, which are occasionally used as *odi*, they are in fact wooden replicas of the more commonly used crocodile teeth. The only really dangerous predator on the island of Madagascar, the crocodile lends power and authority to protective objects. In fact, the three shapes seem to depict both crocodile teeth and the crocodile itself, with the central protrusion representing a stylized crocodile head and the other two suggesting front feet.

Memorial Arts

The Malagasy are best known for their memorial figures, which are interesting to compare to the *vigango*

and other funerary sculpture of the mainland. The Sakalava and their neighbors in eastern and southern Madagascar build fences of wooden planks or posts to form a square enclosure for the coffins of the dead. A photograph shows two of these structures in a southern Sakalava cemetery (fig. 13-41). The corner posts of each enclosure depict either a bird or a human figure. A series of carved images placed along the top of one fence is also visible in the lower left corner of the photograph. Today most Malagasy houses are built of adobe or cement, but these enclosures refer to the wooden houses of the past. The four sides of the structure are identified with the cardinal directions used in divination, as are the sides of Malagasy houses and shrines. The gender of the human figures is difficult to see in this photograph, but most carved posts of the Sakalava region are female. Male figures are usually found facing female figures, or upon enclosures where women are buried.

Human figures are shown wearing hats, though they are otherwise naked. Since the Malagasy have an ancient weaving tradition, and have always worn long cloth wrappers, unclothed figures are shockingly bare. Scholars suggest that the exposed genitals of Malagasy funerary figures give the site a sexual charge. Indeed, some memorial figures depict humans and birds copulating. Just as sexual activity is necessary to conceive a child, sexual images allow the spirits of the dead to be reborn as ancestors, and Malagasy memorial figures can be understood in the same light as the images of sexuality found in the tombs of New Kingdom Egypt (see chapter 1).

The names of a few of the sculptors active in southern Madagascar during the first half of the twentieth century have survived. Perhaps the most famous sculptor of the region was Fesira (fl. 1920–50), a member of the small Anatanosy group who worked for patrons among the

13-41. Cemetery with memorial figures, Sakalava-Vezo area, Madagascar. Photograph before 1970

Sakalava as well as the Anatanosy. The Anatanosy, like several other groups in southern Madagascar, do not place figures in the graveyard itself, but erect tall stones, wooden figures, or carved poles in the community as memorials for the dead. Fesira's images were thus not meant to give a sacred aura to a grave site, but to remind the living of the accomplishments of the dead.

Although Fesira's fundamentally naturalistic style differed little from that of other Malagasy artists, his emphasis upon the individuality of the deceased was unique. Elders remember that Fesira would interview family members at length to determine which aspects of the life of the deceased

should be commemorated in the sculpture.

Fesira's influence can be seen in contemporary funerary arts of the Mahafaly of southern Madagascar. Like the Sakalava, the Mahafaly place their dead in square enclosures. The walls are made of wood or stone, and the enclosed area is filled with rocks and boulders. Set into the rocks are the horns of the cattle killed during the course of funeral ceremonies. Like some pastoralists on the African continent, the Malagasy train the horns of their favorite cattle so that they grow into striking shapes, and these offerings may thus be seen as a form of sculpture. Also decorating the tombs

are carved wooden posts known as *alo alo*.

The contemporary Mahafaly artist Efiambolo carved the *alo alo* shown here sometime before 1970 (fig. 13-42). The stacked geometric forms of the tall planks and the chip-carving technique used to produce them are typical of these funerary monuments. The cattle and mounted figures on top of each *alo alo* are Efiambolo's contribution to the genre, and typical in their simplicity of works produced early in his career. Later, he elaborated such figures into fully orchestrated scenes similar to the commemorative images of Fesira. Today Efiambolo and his son produce

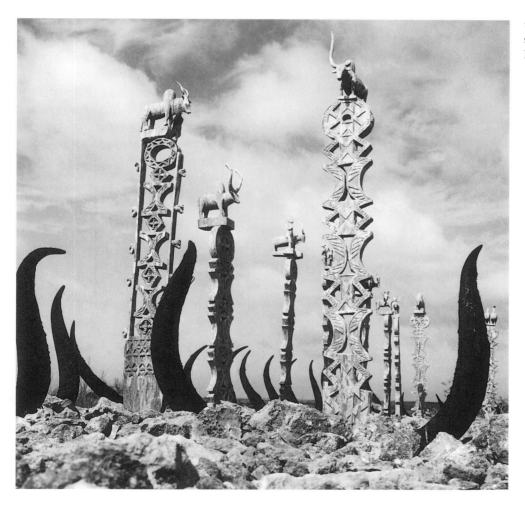

13-42. *ALO ALO* (MEMORIAL POSTS), SOUTHERN MADAGASCAR. EFIAMBOLO. PHOTOGRAPH BEFORE 1970

brightly painted *alo alo* for foreigners as well as for Malagasy patrons.

In the Merina kingdom of the central highlands, stone or cement houses of the dead may be ornamented with painted or incised geometric designs and messages, but not with figural sculpture. The most impressive art works found in Merina tombs are textiles, beautiful shrouds used to wrap and re-wrap the remains of the dead at their burial, their exhumation, and their reburial. The shroud illustrated here was woven of locally grown silk on a horizontal loom (fig. 13-44). Though it is indeed a rich red color, all shrouds, even those bleached a gleaming white, are known as *lambda mena*, or "red cloth." The color red is associated in Merina thought with both royal authority and ancestral power. During the nineteenth century, tombs throughout the kingdom were opened, and the shrouds were thus visible, when the Merina king was bathed and purified during an annual ceremony. Shrouds are still the focal point of reburial ceremonies

calculated to liberate the soul of the deceased from the pollution of death and decay.

CUSHITIC AND NILO-SAHARAN SPEAKERS OF THE INTERIOR

Just as Malagasy art is partly based upon ideas and images from Asia, the art of mainland peoples who speak Cushitic languages of the Afro-Asiatic family is grounded in the world of northeastern Africa. The art of many Nilo-Saharan speakers originated in the ancient Sahara. Yet for many centuries members of these two different language families have lived in close proximity to each other, and their shared lifestyles and similar beliefs have led them to create very similar forms of art.

Memorial Figures and Stone Tombs

The varied funerary art forms of the Malagasy and of coastal Bantu-speaking peoples in eastern Africa

have their counterparts in the tombs and memorial figures of peoples who speak Afro-Asiatic, Nilo-Saharan, and even (in southeastern Sudan) Niger-Congo languages. The most important of these art forms related to the dead are found over a broad area stretching from the Bahr el Ghazal region in southern Sudan east to the foothills of southern Ethiopia.

Tombs of the Bongo and the Bellanda peoples of southern Sudan were described by explorers during the nineteenth century. A leader was buried under a mass of rocks, which was frequently enclosed in a wooden fence similar to a Sakalava tomb. A sinuous carved figure of the deceased, together with smaller images representing his family, was placed in front of the tomb structure. A photograph of a Bongo tomb taken before 1932 shows that this practice continued into the colonial period (fig. 13-43). These elongated figures were evidently not portraits of the deceased, but rather generic evocations of men (fig. 13-45).

13-43. BONGO GRAVE WITH WOODEN ENCLOSURE AND FIGURES, BAHR EL GHAZAL REGION, SUDAN. PHOTOGRAPH BEFORE 1932

Around the time of this photograph, similar ridged columns were noted on graves further east, near the White Nile in southern Sudan. Some of the peoples in this region erected megalithic tombs or altars constructed of huge boulders leaning against each other or of rocks arranged in a circle and covered with a single broad stone. Unfortunately, the tombs and memorial sculptures of southern Sudan have not been described by foreign visitors since the 1950s, and they may have been destroyed during the warfare of the last three decades of the twentieth century.

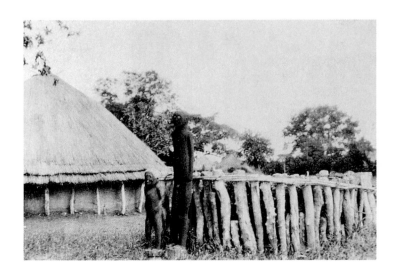

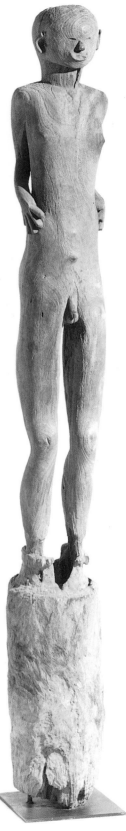

Other photographs of Bongo graves show ridged columns next to unfenced mounds of stone. They resemble stacks of calabashes or bowls and are probably wooden replicas of the rows of dishes customarily left at Bongo graves even today. Each rounded form is said to symbolize a large game animal or enemy killed by the deceased, or by a man acting in his stead.

Some settled agriculturalists in southern Sudan and southern Ethiopia also build stone tombs. The Arussi, the Derassa, the Sidamo, and other Cushitic peoples who live in the rugged hills far to the south and southeast of Addis Ababa place incised stones next to their tombs, which take the form of stone mounds or cylindrical structures. An Arussi grave

13-44. *LAMBDA MENA* ("RED CLOTH"). MERINA. 19TH CENTURY. SILK, 8′ X 5′3″ (2.44 X 1.63 M). THE BRITISH MUSEUM, LONDON

13-45. GRAVE FIGURE. BONGO. LATE 19TH–20TH CENTURY. WOOD, HEIGHT 7′10½″ (2.42 M). THE MENIL COLLECTION, HOUSTON

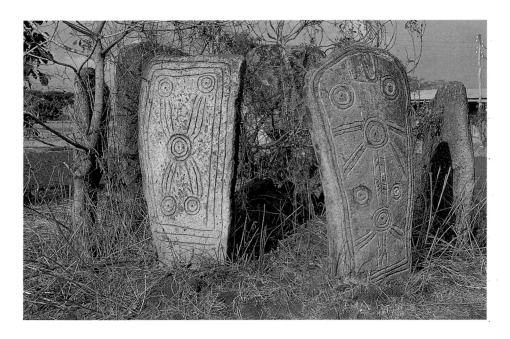

whose tradition of creating wooden memorial figures, *waga*, continues to the present day. In the photograph shown here (fig. 13-47), attention is focused on the features of the heads with their rather wedge-shaped jaws. The staring eyes beneath the deep brows, and the teeth affixed in the open mouths, give the figures an aggressive air. Like the *vigango* of the Mijikenda, Konso memorial figures may not necessarily be placed near the tomb itself. A preferred location for a *waga* is the town square set aside for men's religious activity, but a cluster of *waga* may be found in a variety of other locations.

13-46. ARUSSI GRAVE MOUND, SOUTHERN ETHIOPIA. BEFORE 1958

13-47. GROUPING OF KONSO *WAGA* (MEMORIAL FIGURES), SOUTHERN ETHIOPIA

The central figure of this grouping depicts a man wearing the forehead ornament known throughout the Ethiopian highlands as kallasha. *Made of iron or aluminum, these ornaments are worn only by men who had killed an enemy or a large game animal. The central figure is flanked by figures depicting female relatives wearing a distinctive "cockscomb" hairstyle, and by lesser male figures, which probably represent family members but which may also depict enemies. All of the male figures are equipped with spears.*

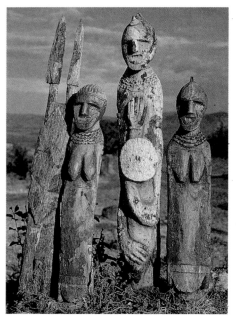

Personal Arts

Although speakers of Nilo-Saharan and Cushitic languages have other sculptural arts in addition to memorial figures, they are best known for their arts of personal adornment. Pastoralists such as the Somali, and the closely related Oromo (also known as the Galla), obtain ornate silver jewelry from a segregated class of smiths. They may also purchase amber and silver ornaments in cities such as Mogadishu (in Somalia) and Harar (in Ethiopia). A recent posed photograph shows a woman of Harar wearing a huge Somali pendant and a silver headband (fig. 13-1). The crescent-shaped silver pendant, one of the most treasured items in a woman's dowry, may contain portions of the Qur'an, which are believed to confer protective powers. Also seen in this photograph are the tightly woven, patterned baskets made by women from southern Somalia to northern Sudan.

photographed by a German expedition in 1958 is surrounded by several large slabs of stone engraved with geometric shapes (fig. 13-46). At the summit of these graves were stone half-figures.

Other peoples in this region carve memorial figures of wood. The best documented are those of the Konso,

The Somali and the Oromo are proud of their adherence to Islam, their nomadic lifestyle, their cotton robes, and their jewelry. They share these traits with the nomadic Arabs who also live in Sudan. For centuries, the values of these Muslim pastoralist peoples have led to armed conflict with non-Islamic agriculturalists. This clash of cultures has been most marked in the Nuba Mountains, the highlands west of the White Nile River and north of the Bahr el Ghazal.

Settled agriculturalists, the peoples of the Nuba Mountains speak Nilo-Saharan languages. They distinguish themselves from animals and from their bearded Islamic neighbors by shaving their bodies and carefully trimming the hair on their heads. Although they wear belts, pendants, and a few other ornaments, only the sick, the aged, or women who may be pregnant wrap themselves with cloth. Otherwise the body is covered with oil, the sweet smelling product of human labor and community life. Boys and men paint designs on their bodies, while girls wear a solid layer of red or yellow ochre. Women's bodies are further ornamented with rows of raised keloids. As among the Ga'anda of Nigeria (see chapter 3), a girl acquires a new set of scars at each important passage of her progress to full adulthood. A married woman who has weaned a child displays delicate patterns of raised skin which cover her shoulders, back, and abdomen.

Young men in the community of Kao in the Nuba Mountains learn to apply painted patterns when they join the age-grade known as *loer*. For several years they are allowed to experiment with colors, designs, and shapes which complement their

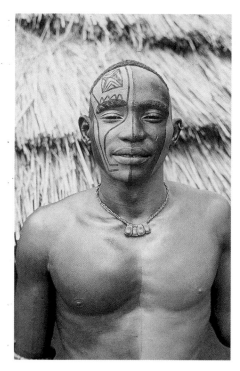

13-48. NUBA *LOER* YOUTH, KAO, SUDAN. LATE 1960s

features and express their aesthetic tastes. A *loer* youth photographed in the late 1960s has created a wonderful asymmetrical composition (fig. 13-48). Black pigment in one area of his face complements the black paint on the opposite side of his body. The white or yellow background of the other side of the face is similarly matched by the pigment of the other half of the body. The lines drawn on the face may at first suggest an ostrich whose body surrounds the eye and whose legs extend down the side of the cheek. However, the design was interpreted by the artist as a non-representational image, one subtly different from a similar pattern identified as "ostrich." Two generations earlier, a friend would have created this art work for the young man, but imported mirrors have

given each youth the opportunity to use his own face as a canvas.

The artistic skills of a *loer* are well-established by the time he becomes a *kadundor*, a mature young man who has the right to use a broad spectrum of pigments, to affix a plumed crest to his hair, to become an accomplished wrestler, and to develop an active sexual life. One *kadundor* was photographed wearing a bold design (fig. 13-49). The strict geometry of the broad lines and triangles he has painted on his face contrast with the softer organic surfaces beneath. His body is covered in a spotted pattern identified with the leopards who hunt in the Nuba hills. Such patterns only last a day or two, and must be scraped off when they are smeared so that new

13-49. NUBA *KADUNDOR* MAN, KAO, SUDAN. 1970s

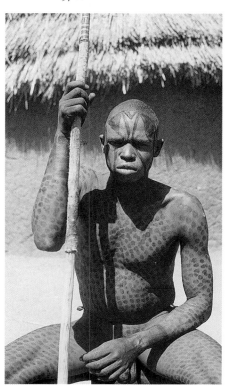

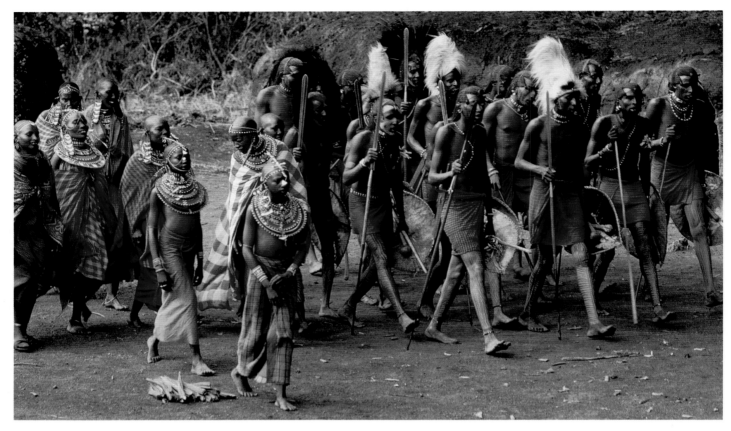

13-50. MAASAI PROCESSION IN HONOR OF *MORAN* (WARRIORS), SOUTHERN KENYA. 1980S

designs can be drawn. This art work is not only seen during festivals; it is required daily attire.

Although other Nilo-Saharan peoples living in southern Ethiopia adorn their bodies with chalk or ocher for special occasions, the men of the Nuba Mountains are unsurpassed as body painters. In other regions, men and women use paint only sparingly, relying instead upon cloth, coiffeurs, and ornaments to proclaim their beauty, strength, and maturity. Perhaps the most striking of these multicolored body arts is created by the Maasai and related peoples of Tanzania and Kenya.

A Maasai procession to celebrate a stage in the training of *moran*, or warriors, is a spectacular and unforgettable display (fig. 13-50). The warriors

themselves wear cloths tied around their waists and lengths of beads around their necks and chests. Their legs are painted with designs in white chalk for the ceremony. Two of the men here also wear distinctive fur headdresses. Each *moran* carries his shield and spear, and wears his hair in the manner of a warrior, with myriad tiny braids colored with ocher and gathered into triangular segments. Before their age-grade gained warrior status, they were not allowed to have any of these forms of adornment, and they will shave off their meticulously braided hair when they become elders and are able to marry.

The mothers and companions of the warriors walk with them. Long oval ear ornaments proclaim the

women's status as mothers of *moran*, just as their cloaks show that they are married women. The two girls, whose ornaments move rhythmically as they walk, are bedecked with beaded collars given to them by admirers. Although they are too young to marry, the community is already honoring their beauty and grace.

Many Cushitic- and Bantu-speaking peoples in this region have also developed their own dramatic forms of dress, possibly in response to the Maasai and other Nilo-Saharan peoples. Just as the Maasai define the status of both men and women through clothing, beadwork, and hairstyles, the daily dress of the Turkana, Cushitic-speaking pastoralists of northern Kenya, serves as an emblem

of their identity and rank. A photo-graph of three Turkana women shows how dress articulates each stage of life (fig. 13-51). The little girl wears only a few beads around her neck and at her hips. Her older sister, who has entered puberty and who will soon marry, wears a special leather cloak embroidered with a circle of white shell beads. Girls of this age often carry a gourd or piece of wood encir-cled with beads to represent a miniature child. This small talisman, the equivalent of a *mwana hiti* (see fig. 13-16), is intended to ensure that she will conceive and bear a healthy child. The older woman has a much simpler wrapper, but the disks on her neck beads indicate that she is a matron.

The Turkana are camel herders, and they encounter many other peo-ples in their travels through northern

Kenya and parts of southern Ethiopia. The colors of the beads the women wear identify them as Turkana, as does their distinctive hairstyle, shaved on

13-52. TURKANA MAN, NORTHERN KENYA. 1970S

13-53. *MILKING*. ELIMO NJAU. C. 1972. OIL ON CLOTH, 20″ x 15¾″ (51 x 40 CM). MUSEUM FÜR VÖLKERKUNDE, FRANKFURT-AM-MAIN

the sides and braided on top. The coif-fure of Turkana men is much less specific, for mature men of many dif-ferent groups in Kenya and southern Ethiopia wear these "mudpacks" (fig. 13-52). The hair on the forehead is shaved to create a smooth hairline, and the rest of the hair is pulled back into a rounded bun. The hair is then coated with mud, which holds feath-ered ornaments in place. Such ornaments mark this man as an elder, for warriors are only allowed simple mudpacks, and boys have none at all. Of course, this elder is also proclaim-ing his personal sense of style, for the shell ornaments, ivory lip plug, plumed cap, and knotted robe combine to give him a commanding presence.

CONTEMPORARY ARTISTS OF UGANDA, TANZANIA, AND KENYA

Personal style and expressive use of color and form are also present in the painting, sculpture, and prints of

13-51. TURKANA WOMEN AND GIRL, NORTHERN KENYA. 1970S

contemporary East African artists whose work is created for an international market. The freshness and energy of the earliest East African art made in response to European artistic and intellectual ideas of the twentieth century may be seen in works such as the linoleum block prints by the Kenyan artist, Hezbon Owiti. In the early 1960s he traveled to Nigeria to visit the Oshogbo school of Ulli Beier, where several artists were working with this type of printing process (see chapter 8).

Owiti is no longer active as an artist. A painter of his generation who continues to play an important role in the development of Kenyan art is Elimo Njau. Born in Tanzania in 1932, Njau is best known for his painterly, abstracted scenes (fig. 13-53). Both a teacher and patron of younger artists, Njau founded art galleries such as Paa Ya Paa to market contemporary art.

THE WAR VICTIM
BY PROFESSOR F. X. NNAGGENDA
DONATED BY ROCKEFELLER FOUNDATION
TO REMEMBER THE LIVES OF THOSE LOST IN WAR
AND THE RESILIENCE OF THE HUMAN SPIRIT IN UGANDA

13-54. *WAR VICTIM*. FRANCIS NNAGGENDA. 1982-6. WOOD. MAKERERE UNIVERSITY, UGANDA

According to Nnaggenda, "Destruction exists but the spirit must survive. Amputated but still full of resistance." As he states so clearly through his words and through this sculpture, war and spiritual resistance are part of the human experience in the twentieth century.

13-55. *BIRDS*. THERESA MUSOKE. ACRYLIC ON CANVAS

Until 1998, when it was destroyed in a fire, Paa Ya Paa was one of the few galleries in Nairobi (and possibly on the African continent) to be owned by an African artist.

Njau himself studied at Makerere University in Kampala, Uganda. The art program at Makerere was begun in the late 1950s by a resourceful Englishwoman named Margaret Trowell, and it served as the vibrant artistic center of East Africa for the next two decades. Another artist who was nurtured by the faculty at Makerere was Francis Nnaggenda (born 1936), who now teaches there. Nnaggenda was teaching in Nairobi in 1978 when he heard rumors of bloodshed in his homeland in Uganda. He returned home with his family and spent the next decade living through the horrifying genocidal warfare unleashed by Uganda's political struggles. His sculpture *War Victim* was a response to the violence of those times (fig. 13-54). In the words of the artist:

There is a large *mukebu* tree on the path to the school [of art at Makerere University]. Traditionally the *mukebu* is highly respected. One day, while walking home, I saw that somebody had burned grass against this magnificent tree, resulting in part of the trunk collapsing and blocking the path. I was very upset by this wanton destruction. Somehow it seemed so connected to the war and symbolic of the thoughtless killing of human beings. I rescued the burned and broken piece of wood; it became *War Victim*. By the way, this piece is not just about Uganda.

Theresa Musoke (born 1941) also teaches at Makerere University, where she has returned after years of exile in Nairobi. Her painting *Birds* is a response to the pain of her native land (fig. 13-55). Here, shadowy grey, brown, and black shapes emerging from a bluish background coalesce into images of twisted, long-legged birds. These creatures do not seem to be simply metaphors for "death" or "hope," but rather a direct evocation of fear and despair.

In addition to these academically trained artists, talented painters and sculptors with little or no formal schooling in art have managed to sell their work in commercial galleries, in tourist markets, or on the streets. Some of the most popular of these artists paint in a style developed by Edward Saidi, known as Tingatinga, who died in 1972. Tingatinga's followers produce inexpensive, bright, playful images of birds and animals. Like Makonde workshops in Dar es Salaam, "Tingatinga studios" produce an amazing volume of very similar works (fig. 13-56).

In eastern Africa today, most sculpture and painting is purchased by expatriates and other foreigners. Despite attempts by artists, cultural centers, and workshops to display art where it can be seen by the general population, patronage of eastern Africa's diverse contemporary art is still mostly limited to outsiders and to an educated elite.

13-56. MARKET SCENE WITH "TINGATINGA" PAINTINGS FOR SALE, DAR ES SALAAM, TANZANIA

14

SOUTHERN
AFRICA

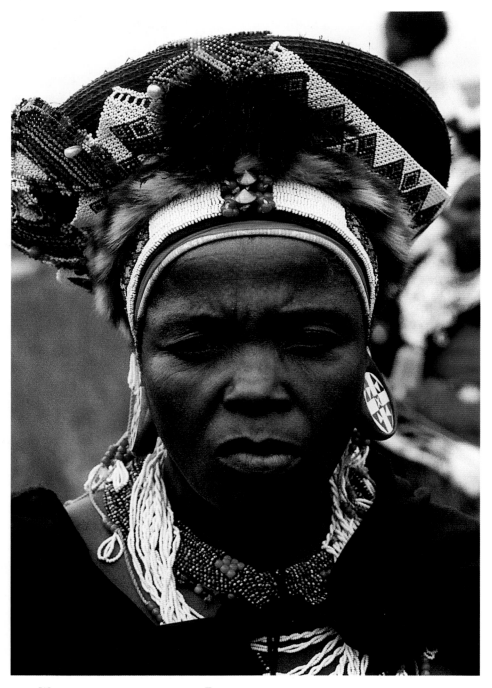

14-1. WOMAN IN BEADS AND EARRINGS. ZULU. 1975

S OUTH OF THE ZAMBEZI
River, the African landscape is a
mosaic of sandy deserts, cool
forested highlands, and broad savan-
nahs. Hunting and gathering
populations have lived in these diverse
environments since the dawn of the
human race. The images they incised
and painted on rock surfaces are the
oldest known art works on the conti-
nent, and are among the earliest art
made by human beings.

Hunting and gathering peoples
were joined in southern Africa by
Bantu-speaking agriculturalists and
pastoralists about two thousand years
ago. These immigrants, who brought
with them the technologies of iron and
pottery, were part of the great migra-
tions which brought other Bantu-
speaking peoples to central and eastern
Africa. In southern Africa, their arrival
stimulated the growth of new cultures.
Bantu-speaking communities with
stone terraces arose in the Limpopo
River valley in the eleventh century
AD; two centuries later the stone-
walled site now known as Great
Zimbabwe became an important
regional capital for the territory
between the Limpopo and Zambezi
rivers.

Great Zimbabwe was built by a
Bantu-speaking people now known as
the Shona. The Shona and their neigh-
bors no longer practice stone
architecture, though they still carve a
variety of objects in stone and wood.
Other Bantu-speaking groups of
southern Africa, including the Sotho-
Tswana and Nguni peoples, are better
known for their elaborate body arts
and for their architectural forms.

Non-African immigrants first set-
tled in southern Africa in the
seventeenth century, when Dutch

farms were established near the Cape of Good Hope. The Dutch-speaking Afrikaaners were followed by the British, who during the nineteenth century laid claim to South Africa and the territory they named Rhodesia (after the adventurer Cecil Rhodes). British victories over the Afrikaaners in the Boer War (1899–1902) resulted in new influxes of both British settlers and Asian workers to South Africa.

Namibia, a former German colony, was administered by South Africa after World War I, and Mozambique was a Portuguese possession until 1975. In South Africa, British and Afrikaaner forces removed African populations from their ancestral lands, eventually forcing many into reservations known as homelands. During the 1960s, laws drawn up under a system called apartheid classified South Africans as white, black, or colored; non-whites were not allowed to live, work, eat, travel, or be educated in areas reserved for whites without special permission. After decades of struggle, a new constitution brought majority rule to South Africa in 1994, and with it the end of apartheid.

ROCK ART OF SOUTHERN AND EASTERN AFRICA

Images painted and engraved on rock surfaces have been documented across the southern and eastern portions of the African continent. Like the rock art forms of northern Africa (see chapter 1), they elicit a host of questions: Who created them, and were their artists the ancestors of the people living in the region today? How old are they, and how can they be interpreted? If they mark sacred sites, what events or states of being did they evoke?

Earliest Images

The earliest known works of art from the African continent were found in a rock shelter named Apollo 11, in the mountains of the southern Namibian desert. Here eight fragments of painted stone were excavated by archaeologists in a layer of organic debris dated to about 25,000 BC. The stone fragments had not been chipped from the cave walls but rather had been brought into the shelter from elsewhere.

Painted in red or black on the flat surface of each stone is the image of a single animal. The most mysterious of these faded beasts covers a fragment split into two halves (fig. 14-2). The large and bulky head has been described as leonine, but the body and legs resemble those of a herbivore such as an antelope. Although the animals on some of the other stones were drawn in outline, this animal was painted in solid black.

Stones and pebbles painted more recently have been found in

14-2. PAINTED FORMS, APOLLO 11 CAVE, SOUTHERN NAMIBIA. BEFORE 21,000 BC. PIGMENT ON ROCK

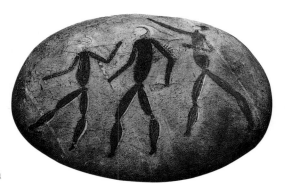

14-3. THREE FIGURES, COLDSTREAM CAVE, CAPE PROVINCE, SOUTH AFRICA. C. 2,000 BC. PIGMENT ON STONE. SOUTH AFRICAN MUSEUM, CAPE TOWN

coastal caves east of Cape Town in South Africa. The most famous of these, the so-called Coldstream stone, was unearthed in Coldstream Cave, where it rested upon the shoulder of a skeleton (fig. 14-3). Although this stone was not scientifically excavated, similar stones have been found by archaeologists in levels dating from 2000 BC to the beginning of the Christian era.

The Coldstream stone shows three human figures moving from right to left. Each is formed of a series of long, sinuous ovals surrounded by an outline. The tallest figure, with a red cockscomb-like projection on his head, raises an arm over the head of the central figure, who has a pouch over one shoulder and holds two objects in his tiny hands. Red lines streak the face of the smallest figure. Although the gestures of all three seem free and spontaneous to us, these clearly defined poses may have had a precise meaning.

A rhythmic painted scene from the wall of a cave in the Tsisab Gorge, in the Brandberg Mountains of central Namibia, may also have been painted

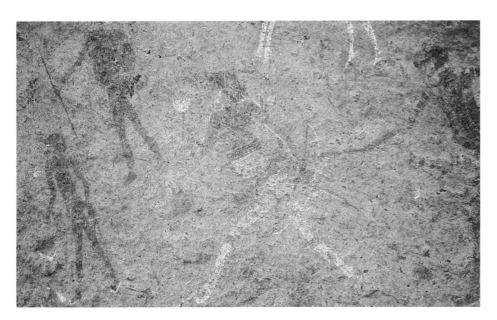

14-4. Ornamented figure from Tsisab Gorge, Brandberg Mountains, western Namibia. Later Stone Age. c. 2000–1000 BC (?). Pigment on rock face

All of the figures in this frieze stride (or dance) with legs apart. While the legs, hips, and head are shown in profile, chests twist to face the viewer. This is probably not a reference to a contorted pose, but a stylistic convention. As in Kemet, it allowed the artist to show each portion of the body as clearly as possible. Of course, the stylistic similarities of two-dimensional figures from ancient Egypt and from ancient Namibia should not suggest that the two areas of the continent were in direct contact; they are simply a reminder that talented painters may devise similar solutions to formal and conceptual problems.

as early as 2000 BC. It depicts a dozen elaborately ornamented figures marching or dancing in a long procession, one of which is shown here (fig. 14-4). Designs painted on or near the figures may either depict physical adornment and material objects, or refer to a spiritual state. For example, rows of white dots at the knees, ankles, and hair of the figure here could depict ostrich shell beads, which have a long history in the region, or they could be references to supernatural power.

Incised images are also found on exposed rock surfaces throughout southern and eastern Africa. Because such images are rarely associated with a covering of organic debris, they

14-5. Grooves in stone, Transvaal region, South Africa. Undated. McGregor Museum, Kimberley

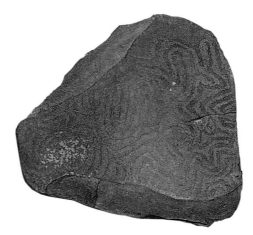

cannot be dated. A notable exception is a fragment found at a site called Wonderwerk Cave, in the central mountainous region of South Africa, which was deposited in a layer of datable debris dating back over 10,000 years. The undated example of carved rock art illustrated here is a South African boulder covered with rough cut parallel grooves (fig. 14-5). The geometric patterns formed by these concentric lines may be entopic images, replicas of hallucinations experienced in trances or other altered mental states.

Although most incised or carved rock art from southern Africa consists of such abstract patterns, some highly naturalistic engravings depicting animals have been found. Some, defined by continuous outlines, resemble Large Wild Fauna images from the Sahara (see fig. 1-2). Others consist of solid shapes scraped into the rock surface. One of the most beautiful of these is a depiction of an eland, a large antelope. It also comes from the Transvaal region of South Africa (fig. 14-6). The artist has carved away the surface in subtle negative relief, leaving low ridges to define the animal's haunches and nostrils and the markings around its eye. The pose

14-6. Eland. Bothaville Free State, South Africa. Undated. Low relief on rock

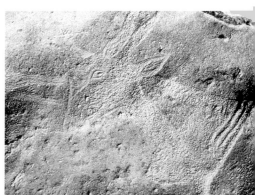

14-7. Giraffes, zebra, and abstract shapes, Nanke, Matoba Hills, Zimbabwe. Before AD 1000. Pigment on rock face

series of large joined oval shapes, seen frequently in the Matobo Hills. Some of the ovals are bright, hard-edged and distinct, while others merge with surrounding forms.

Images in a painted shelter near Rusape in northeastern Zimbabwe show several fascinating variations upon the human form (fig. 14-8). The

14-8. Figures from rock shelter, near Rusape, Makoni district, eastern Zimbabwe. Later Stone Age. Before AD 1000. Pigment on rock

The first Europeans to study southern African rock art interpreted the images in idiosyncratic ways. A French expert claimed that the art of Tsisab Gorge was too sophisticated for Africa, and identified the figure in figure 14-4 as a "white lady." A German scholar described this scene as a royal funeral orchestrated by a lost, heroic culture. Perhaps in reaction to such imaginative responses, many researchers in the mid-twentieth century regarded rock art as a record of the daily life of the hunters who created it. By the 1970s the work of David Lewis-Williams encouraged scholars to study rock art as manifestations of the artists' religious beliefs.

has been sensitively observed, especially in the legs and the position of the head.

Zimbabwe

North of South Africa, in the highland regions of Zimbabwe and central Mozambique, painted images adorn the overhanging stone surfaces which sheltered early hunters and gatherers. Since they rarely depict domesticated animals they are assumed to have been created prior to the arrival of herders and farmers about two thousand years ago. Future archaeological work may be able to date some paintings more scientifically; a recent excavation of a rock shelter in Zimbabwe uncovered flakes of painted surfaces which had fallen into layers of debris dating between 13,000 and 8000 BC.

A group of images on a concave rock surface from the Matobo (Matopos) Hills of southwestern Zimbabwe is typical of the style and the content of rock art from this region (fig. 14-7). The prominent giraffe at the top of the composition and the smaller giraffes below are joined by a zebra on the right and a spindly anthropomorphic being on the left. The smaller giraffes move through a

focus of the scene is a recumbent figure with a wedge-shaped chest, elongated torso, serpentine arms, and an extraordinary head shaped and marked like the muzzle of the sable, a swift antelope. A long curved line extends from the figure's penis, ending in a tassel-like shape below him. Although the figure is lying down, his head is lifted and the arms and legs are raised in active gestures. Its dark surface is covered with white dots, and some of this dappled area sags downward under the edges of the body. Some of the smaller surrounding figures also appear to have antelope-like markings on their faces.

Tanzania and Eastern Africa

North and northeast of the Zambezi River, rock art is even more varied than it is in southern Africa. Some eastern African rock art is quite recent, and farmers may still gather in painted caves and rock shelters for initiations, rainmaking, and the ceremonial distribution of meat. Other farmers and pastoralists scrape bits of paint from ancient rock art for use in rainmaking ceremonies. Yet here, as in southern Africa, the oldest rock art seems to have been created by hunting and gathering peoples.

On the walls of rock shelters at the site of Kolo, in the hills of central Tanzania, elongated figures were painted in what has been called the Kolo style (fig. 14-9). Stone arrowheads in debris layers on the shelter floors date from 8000 BC to the beginning of the Christian era, and the Kolo style paintings were evidently also produced during this long interval. The striking linear figures are composed of long streaks of paint, and their strange

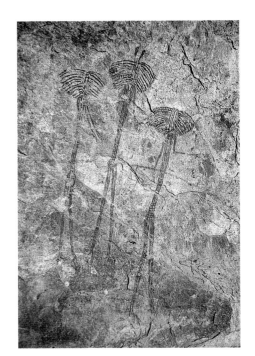

14-9. ABSTRACTED FIGURES FROM KOLO 1 SITE, NEAR KONDOA, TANZANIA. UNDATED. PIGMENT ON ROCK

heads resemble the striped wings of a moth or butterfly. While the figures shown were painted vertically on the rock face, others are stacked horizontally.

The Kolo paintings are located near the homelands of the Sandawe and Hadza peoples, who were semi-nomadic hunters until the twentieth century. Sandawe and Hadza men may still paint images of animals as they prepare for a hunt or celebrate a kill, though their work is much more rudimentary than the Kolo paintings. While these modern peoples cannot be easily linked to painters who lived over two thousand years ago, they do seem to be keeping alive an ancient tradition.

The Drakensberg Mountains

Establishing relationships between living peoples and the ancient rock art of southern Africa is also problematic, especially when we consider the painted images of the Drakensberg Mountains, which separate the southeastern coast of South Africa from the high plains of the interior. Even though evidence suggests that at least some of the evocative scenes must be thousands of years of old, scholars now generally link them with the San peoples.

San is a generic term used to describe a variety of hunting and gathering populations that were living throughout southern Africa when Europeans first arrived. San groups could be found in the Drakensberg until they suffered genocide at the hands of Afrikaaner pioneers in the late nineteenth century, and nineteenth-century accounts of these Drakensberg San yield some information about their rock art. Men and women from another extinct San group, living south of the Drakensberg, also shared important information with two early ethnographers in the late nineteenth century. Most of our knowledge of the San, however, comes from groups such as the !Kung, who still live in the inhospitable Kalahari Desert. Even though the !Kung and other Kalahari San do not paint or engrave rocks (and may never have done so), their beliefs appear to be similar to those of the extinct San who once painted the rock shelters of the Drakensberg.

A painting from Fetcani Glen, one of the sites in the southernmost mountains of the Drakensberg (fig. 14-10), shows how this rock art may be

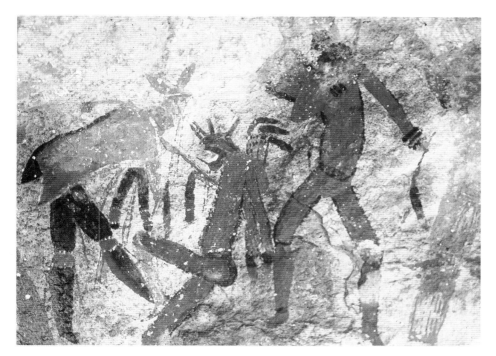

14-10. Dancing figures, Fetcani Glen, Drakensberg Mountains, South Africa. San. Undated. Pigment on rock

enter a trance state, and the animal-like heads depicted here could acknowledge the link between the human dancer and the source of his or her abilities to enter a trance. They may also more literally depict humans wearing headdresses with feathers, horns, or animal ears attached. In some San groups, dancers once wore such caps to strengthen ties with their animal helpers, heightening their ability to harness *n/um*.

Perhaps the most beautiful paintings from the Drakensberg are the magnificent polychrome depictions of eland (fig. 14-11). We can respond to the soft, full volumes and delicately shaded color. We can appreciate the attention the artist has lavished on the animals' varied poses and individual characteristics. However, our aesthetic enjoyment cannot match the wealth of

linked to accounts of San spirituality. The figures appear to be circling the walls in a healing dance, just as !Kung men and women dance today to cure an ailing person, or to cleanse and rejuvenate a community. During these dances, spiritually gifted !Kung feel a supernatural power called *n/um* boiling up within them. They may tremble, sweat, salivate, and collapse, and they need to be supported by the other dancers. In other San groups, the same type of altered state would trigger nosebleeds. *N/um* is in the sweat of the affected !Kung, and can anoint a sick patient or the families who have gathered for the dance. The dancer at the left of the scene from Fetcani Glen may be either a patient or a man in a trance, while the figure bending over him could be shedding *n/um* in his nasal blood in order to heal or soothe the fallen figure.

The heads of the figures are enigmatic, and seem to combine human and animal features. Spiritual assistance from a species of animal gives a gifted !Kung person the possibility to

14-11. Scene with eland, Drakensberg Mountains, South Africa. San. Undated. Pigment and eland blood on rock

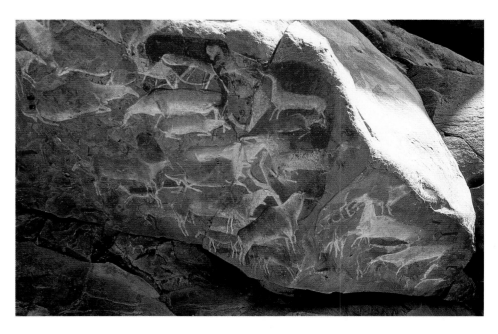

ideas and emotions the San originally brought to this painting. For these highland hunters, the eland was associated with a sacred past, with sexuality and fertility, with spiritual transformation and power, and with joy and beauty.

The painting shown here may have honored the god-like trickster and creator, /Kaggen. Qing, one of the last of the Drakensberg San, told an interviewer that the eland was the animal beloved by /Kaggen. When asked where /Kaggen is, he replied, "We don't know, but the elands do. Have you not hunted and heard his cry, when the elands suddenly start and run to his call? Where he is, elands are in droves like cattle."

In the past, a San hunter presented an eland to his father-in-law when he married, and the !Kung still say the proper killing of an eland makes a boy into a man. !Kung girls who are announcing their first menstruation anoint their families with fragrant fat from an eland. The girls are then the central figures in an eland dance performed by women, which celebrates the sexual receptivity of female eland, and of the girl herself. Eland thus remind San men and women of important stages in their sexual lives.

The lines flowing from the nostrils of the eland, and the tiny, flying human figures scampering above and around them, can be linked to San experiences of trance states. When an eland is mortally wounded by a poisoned arrow, the hair on its neck will rise, and it will stumble, as may be seen clearly in the painting. Some of the dying eland in this scene are bleeding from the nose, trembling, and gasping for breath. Similar physical symptoms are experienced by dancers filled with *n/um*. !Kung dancers say that this trance state is like floating or swimming underwater, or like the death of the eland itself. The painting may thus refer to a type of spiritual ecstasy joining dancers to sacrificial elands.

No one asked San painters why they placed these images in rock shelters. We do know that the process of making these art forms was complex and that it apparently involved the manipulation of supernatural power. For example, one account states that women heated the red ocher used as a pigment over a fire by moonlight, and that the artist mixed it with eland blood. Perhaps the images were intended to strengthen the visions and the curative abilities of the "owners of power" or the rain masters who painted them. Perhaps they allowed an artist or a group of dancers to pour out or contain supernatural power in a particular place so that it could be drawn upon in the future. At the very least, these masterpieces of rock art must have allowed ancient peoples to celebrate and relive events of intense spiritual experience.

Yet some paintings from the Drakensberg may be narrative references to past events, rather than images connected to trance states. A few show large figures with spears, probably Bantu-speaking neighbors of the San. In others, Afrikaaner pioneers appear, including men in floppy hats, and women in sunbonnets and long skirts. In paintings of the nineteenth century, British soldiers fire their guns and kill eland, while Afrikaaners fire their guns and kill the San. They represent the last rock art of the Drakensberg San.

EARLY ART OF BANTU SPEAKERS

The arrival of Bantu-speaking peoples in the region around the beginning of the Christian era led to the formation of new cultures which forged metals and fired clay. The earliest works of art known from these new cultures are the seven Lydenburg heads, named for the South African site where they were found. The heads had been buried together in a pit around the sixth century AD. The largest of these hollow terracotta sculptures could have covered a human head and neck (fig. 14-12). The white pigment which appears to have covered it once has

14-12. LYDENBURG HEAD. IRON AGE. C. AD 500. TERRACOTTA, HEIGHT 15" (38 CM). SOUTH AFRICAN MUSEUM, CAPE TOWN

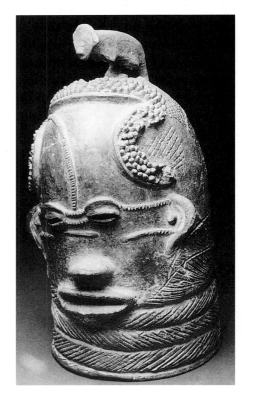

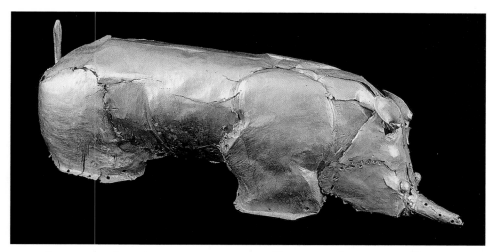

14-13. Rhinoceros. Iron Age. 11th–12th century. Gold plate. Archaeology Department, University of Pretoria

now disappeared, while a small animal-like form on the top of the head is damaged and difficult to identify.

A few centuries after the Lydenburg heads were sculpted, a series of towns arose along the stretch of the Limpopo valley dividing the present-day nations of South Africa and Zimbabwe. Cattle were important in the economy of this region, and archaeologists have found hundreds of small clay models of vaguely bovine and anthropomorphic creatures at these sites.

The richest of the Limpopo valley sites was a hilltop site called Mapungubwe, which flourished during the eleventh and twelfth centuries AD. A small rhinoceros made of sheets of gold comes from one of the burials excavated at Mapungubwe (fig. 14-13). Originally attached to a wooden core, the metal plates evoke the armored look of a rhinoceros, and the head seems to be lowered in that animal's dangerous charge. Although the function of this art work is unknown, a charging rhinoceros would have been an appropriate emblem or metaphor for a powerful leader.

The Shona and Great Zimbabwe

The gold for the Mapungubwe rhinoceros undoubtedly originated in the granite hills of the highlands north of

the Limpopo, in southern Zimbabwe, the homeland of a people now known as the Shona. From the thirteenth to the fifteenth centuries AD, one early Shona group living along the southeastern edge of the highlands constructed a capital which has become the most famous of all southern African ruins. Today we know this site as Great Zimbabwe.

The Shona word *zimbahwe* or *zimbabwe* originally seems to have referred to either a judicial center or a royal palace; it was the equivalent of the English word "court." Shona now use the word to describe any of the 150 to 200 stone ruins found in their homeland, of which Great Zimbabwe is the largest.

Great Zimbabwe can be divided into three distinct sections (fig. 14-14). Each section was constructed of granite walls joined to clay walls, which

14-14. Plan of ruins, Great Zimbabwe, southern Zimbabwe. Drawing after Peter Garlake

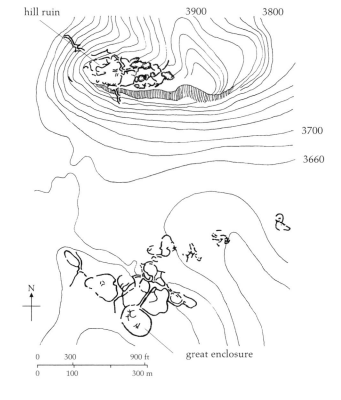

enclosed floors, platforms, and buildings of mud. The oldest, called the Hill Ruin, is built on a rocky hilltop overlooking the valley below. The Hill Ruin incorporates an extraordinary natural feature, a cave whose walls act as a huge megaphone projecting any sound toward the valley below. The second section, the imposing monument known as the Great Enclosure, is a group of structures encircled by a single stone wall 292 feet in diameter. The third section, the Valley Ruins, includes the remnants of stone walls scattered across the valley floor between the Great Enclosure and the Hill Ruin.

The Hill Ruin was constructed around AD 1250. Smooth stone blocks were laid in irregular courses to form walls between (and sometimes over) the huge boulders of the hilltop. The walls create irregular compartments and narrow winding passages, some leading to a lookout area above or to the cave below (which is still a sacred site). Two walled enclosures in the Hill Ruin once had floors of polished clay. The largest of these is surrounded by 30-foot-high walls surmounted by small cylindrical towers, or turrets, and monoliths. In both enclosures stone platforms once supported monoliths carved with geometric patterns. Seven of these stone pillars culminated in the image of a large bird.

Probably begun over a century after the Hill Ruin, the Great Enclosure was completed prior to AD 1450 (figs. 14-15, 14-16). Its tapered surrounding wall, about 20 feet high along the northern and western sides, rises to some 32 feet along the south and east. Turrets and monoliths rise above it in places, mirroring those

14-15. Plan of Great Enclosure, Great Zimbabwe. After Peter Garlake

north entrance

north-east entrance

west entrance

parallel passage

conical tower

chevron pattern

N

| 0 | 50 | | 150 ft |

| 0 | 5 | 10 | | 50 m |

14-16. Exterior of Great Enclosure, Great Zimbabwe. 1350–1450. Stone

Stonemasons fitted and shaped the granite blocks on site to form the regular courses of the smooth wall encircling the Great Enclosure. No mortar was used to bind the stone together. The wall has been amazingly stable; generally it has collapsed only where the wooden lintels above the gateways have disintegrated.

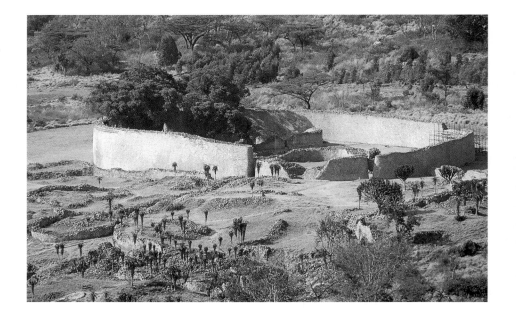

crowning the Hill Ruin. Along the top of the wall, a layer of granite blocks laid against one another in opposing diagonals forms a double row of chevrons.

Within the Great Enclosure are smaller walled areas and a narrow, canyon-like passageway formed by the gap between the enclosing wall and an inner enclosing wall. At the end of the passage are two solid stone towers built of regularly coursed granite blocks and resembling Shona granaries in form. The large tower is now about 30 feet tall (fig. 14-17).

Near the large tower was a doorway in the inner wall, leading to a space dominated by a stepped, clay-covered stone platform 25 feet in width. This platform seems to have once displayed small soapstone phalliform carvings or simple carved cones with female breasts. The wall near the platform is marked by several bands of dark stone which perhaps were meant to evoke zebra stripes, for zebras

appear on soapstone bowls taken from Great Zimbabwe and seem to have had symbolic importance there.

The Valley Ruins, the third section of Great Zimbabwe, contain a variety of different structures. In one building a cache of porcelain from China and thousands of beads from southeastern Asia were found, indicating that Great Zimbabwe was trading with Swahili merchants on the East African coast. Copper ingots and double gongs of iron tie the city to important centers on the Zambezi River as well as to kingdoms located a thousand miles to the north. In one walled ruin, a stepped platform was found next to a small conical structure of solid stone. Into this base was fixed a soapstone monolith about five feet tall. On the top of the monolith was carved the most forceful and striking of all the soapstone birds found at Great Zimbabwe (fig. 14-18).

This is obviously a bird of prey, whose rounded volumes suggest tense

muscles. The sculptor has shortened the raptor's wings and extended its legs to create a tightly interlocking triangular composition. The image combines human and avian features; the legs are muscled from thigh to toe, and the feet end in fingers or toes rather than talons. The top of the monolith was damaged, and we do not know whether the bird's curved beak once had the human lips found on

14-18. MONOLITH WITH BIRD. SHONA. C. AD 1200–1450. SOAPSTONE, HEIGHT 5′4½″ (1.64 M). CENTRAL VALLEY, GREAT ZIMBABWE NATIONAL MONUMENTS

On the bird's breast is a vertical line of raised dots, as if the artist was depicting a row of pins joining a layer of metal to a wooden core. Shona royal art works probably included gold-plated wooden objects like the rhinoceros from Mapungubwe (see fig. 14-13), for fragments of gold foil have been found in the ruins of Great Zimbabwe. This stone bird may thus be referring to art in gold which has not survived.

14-17. TOWER AND INNER WALL, GREAT ENCLOSURE, GREAT ZIMBABWE. SHONA. C. AD 1350–1450. STONE

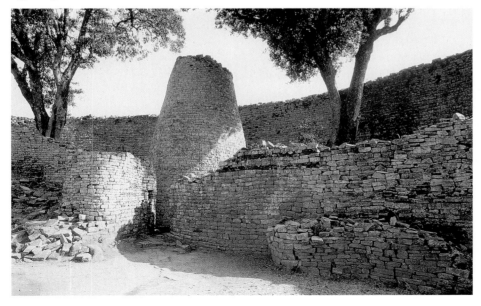

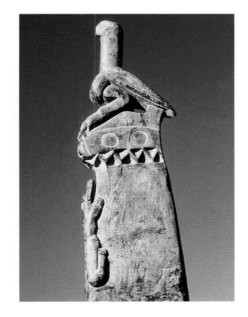

some of the other soapstone birds from Great Zimbabwe.

The anthropomorphic aspects of the soapstone birds suggest that they are symbolic images of the Shona kings who ruled at Great Zimbabwe. For the past few centuries, eagles and other raptors have been associated with Shona rulers. Fish eagles live on the rocks above sacred pools and holy caves, just as Shona kings once lived on hilltops and made sacrifices to their royal ancestors in the depths of the earth and in deep pools. High-flying eagles touch both heaven and earth, just as royal ancestors intercede with God in the sky above for the living on the earth below. Like lightning, the flight of an eagle is believed to stitch together heaven and earth in a zigzag pattern and to announce the arrival of rain. Rain-bringing birds recall the priestly roles of Shona kings, who like many other southern African and eastern African rulers, are expected to intercede with their ancestors to bring rain to their people.

Up the front of the monolith climbs a slim crocodile with notched teeth. Crocodiles are associated with kings in several southern African cultures, for they are deadly and mysterious, and they live in the deep pools sacred to royal ancestors. Below the bird are several incised circles, with two circular "eyes" on each side; these may be references to the eyes of the crocodile. The round shapes are placed above a band of chevrons. This pattern, which also appears on the walls of Great Zimbabwe (fig. 14-19), seems to symbolize the eagle's flight, the linking of sky and earth, the power of lightning and the gift of rain.

While interpretations of the function of the Valley Ruins are somewhat speculative, studies of the Great Enclosure are particularly controversial. Archaeologists note that the Great Enclosure and the Hill Ruin share so many physical features that the large site on the valley floor may be a later version of the hilltop site, possibly built to accommodate an expanded population during important civic and religious activities. An alternative interpretation suggests that the Great Enclosure may have been an initiation camp. Among the Venda and other neighbors of the Shona, modern rulers sponsor puberty ceremonies, initiations preparing young women and some young men for marriage. Ordeals and celebrations connected with these periods of seclusion and instruction take place in circular courtyards which are similar in form to the Great Enclosure, but made of wooden posts rather than stone. The small soapstone images from the Great Enclosure are similar to clay and wooden objects used today as part of the instruction that young women recieve. The conical towers and other features of the Great Enclosure may have been sexual symbols connected with initiation.

The last walls erected at Great Zimbabwe were low and roughly built. By 1500, the city was no longer a political and economic center, and successor states had arisen to the northeast and southwest. One important Shona kingdom, Torwa, was based in Khami, almost two hundred miles west of Great Zimbabwe.

Another site, Naletale, was occupied during the seventeenth century by Shona rulers of the Changamire dynasty. The stone-faced earthen terraces of this hill site were ornamented with a variety of patterns. These include rows of chevrons, dark stripes, zipper-like herringbone motifs, and checkerboards. Chevrons may refer again to lightning, the flight of eagles, and the ties between the king and his ancestors. Checkerboard patterns perhaps evoke the scales of the king-like crocodile, while the zebra stripes recall those near the conical tower of the Great Enclosure at Zimbabwe.

Although stone and metal objects have been found at sites such as Mapungubwe, Great Zimbabwe, and Khami, most three-dimensional works made in southern Africa today are sculpted from clay or wood. Thus two stone heads unearthed near the South African town of Kimberly, some two hundred miles south of the Limpopo River, appear to be linked to older stone-carving traditions. The head shown here was uncovered when

14-19. DETAIL OF WALL, GREAT ZIMBABWE, SOUTHERN ZIMBABWE. SHONA. C. 15TH CENTURY. STONE

the Afrikaaner defenders of the town were digging fortifications during the Boer War (fig. 14-20). The other was found recently by archaeologists in a burial dated to the mid-seventeenth century. Since it had not been placed upon the grave as a marker, but rather was buried with the deceased, it was probably the deceased's personal possession. Both heads are almost life-size and hauntingly naturalistic. Like the ceramic heads from Lydenburg, they are complete works in themselves, and not fragments of a larger figure.

RECENT ART OF THE SHONA AND THEIR NEIGHBORS

The stone heads and eagles described above undoubtedly had important religious associations for southern African

14-20. KENILWORTH HEAD. C. 17TH CENTURY. STONE, 6¼ x 3¾ x 4¼" (15.8 x 9.6 x 10.8 CM). MCGREGOR MUSEUM, KIMBERLEY

peoples and had no functions other than to be displayed. During the twentieth century, however, most sacred art forms from southern Africa combined both practical and religious uses. While invoking spiritual forces, they may be used as containers, clothing, furniture, or weapons.

Art and Ancestors

The shallow wooden bowl shown here, from the royal court of the Venda people of South Africa, was used by the king's advisors to determine the guilt or innocence of someone accused of a particularly serious offense. The images carved on the bowl's rim and inner surface (not visible in figure 14-21) refer variously to clan, gender, and social rank. A diviner filled the bowl with water and floated grains of corn on the surface until they either touched symbols on the rim or sank to rest upon the images below. The combination of references touched by the corn identified the person responsible for the crime.

A central mound in the middle of the bowl is said to represent the sacred hilltop where the king lives, and the crocodile barely visible on the bottom of the bowl is, as in Shona thought, a metaphor for the king himself. The abstract designs on the reverse side of the bowl are linked to the crocodile and to the python, an animal identified with female fertility. The entire bowl can be seen as a reconstruction of a sacred lake inhabited by the soul of a legendary royal ancestor. As a royal heirloom, this object allowed the Venda ruler to draw upon the vision and wisdom of the ancestors in dispensing justice to his living subjects.

The ceremonial axes of the Shona, the Venda, and the Thonga, although rarely used in combat, are further examples of functional objects with great religious content. Made both north and south of the Limpopo River, the two examples shown here display imagery seen on many daggers and ritual weapons

14-21. DIVINATION BOWL. VENDA. 19TH–20TH CENTURY. WOOD, HEIGHT 4" (10 CM), DIAMETER 13" (33 CM). THE BRITISH MUSEUM, LONDON

from the region (fig. 14-22). The example on the right is adorned with a carved stack of calabashes or bowls, containers used for sacrifices made to the ancestors. To reinforce these references to the importance of women in ancestral ceremonies (for women prepare and store sacred libations), two conical breasts appear on the handle. The example on the left acknowledges both the past and the present by setting the ancient form of the ax blade on a handle in the shape of a rifle.

Although both the divination bowl and the battle-axes were primarily ceremonial, other objects with sacred powers were used in daily life. An example of this duality is seen in

14-22. CEREMONIAL AXES. THONGA AND VENDA. EARLY 20TH CENTURY. WOOD AND COPPER; HEIGHTS, LEFT 28" (71 CM), RIGHT 27¼" (70 CM). THE BRITISH MUSEUM, LONDON

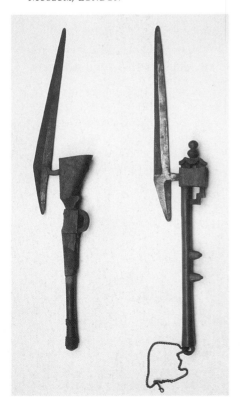

14-23. HEADREST. SHONA. LATE 19TH–EARLY 20TH CENTURY. WOOD, HEIGHT 5½" (14 CM). THE BRITISH MUSEUM, LONDON

Headrests are important objects throughout eastern and southern Africa, and had ritual roles in burials in Kemet. The sleeper's head is joined to the body represented by this Shona headrest, just as the head of Tutankhamun conceptually completed the symbol of the horizon referred to in his ivory headrest (see fig. 2-13).

headrests, the small wooden platforms which until recently served as pillows, supporting the head of a person lying on his or her side. Headrests were believed to absorb some part of their owners, since they were rubbed with oils from the sleepers' heads, and to bring men dreams that communicated messages from the ancestors. At a man's death, his headrests were often buried with him. However, they were sometimes kept by his heirs as a sacred link to the ancestral world.

A headrest sculpted in Zimbabwe displays features typical of Shona work

(fig. 14-23). It features a sloping base, a curved support for the head, and a flat central portion covered with grooved patterns known as *nyora* (the word also used to describe the raised ridges of scarification once worn by women). The triangular or chevron patterns, recalling the architectural ornaments of Great Zimbabwe, are common on Shona headrests.

The explicit female imagery of this work is extraordinary. Central conical forms replace the flat concentric circles of other Shona headrests. Circular motifs are usually described as ripples in pools, or shell ornaments, or as the eyes of a crocodile, but the shapes here are obviously female breasts. The shapes at the base of the headrest are clear depictions of the pubic triangle and the upper thighs. A sleeping man would thus provide the "head" for the abstracted torso, combining male and female in a single symbolic image.

The Tsonga and Chopi, neighbors of the Shona and Venda who live in Mozambique and South Africa, are renowned for the stylistic variety of their headrests. Although some headrests sculpted by their artists are given ears, breasts, or feet, most Tsonga and Chopi works seem to be simply celebrations of formal beauty. The example shown here, with its multiple supports and contrasts of organic and geometric shapes, uses positive and negative forms to create a sophisticated abstract composition (fig. 14-24).

Initiations and Related Art

References to ancestral powers, royal authority, and gender also occur in the initiations held by the Venda, the Tsonga, the Chopi, and the northern

14-24. HEADREST. TSONGA. WOOD. FOWLER MUSEUM OF CULTURAL HISTORY, UNIVERSITY OF CALIFORNIA, LOS ANGELES

Among the groups mentioned above, initiations preparing young women or men for marriage use figures and objects modeled of clay or carved of wood. Clay objects are often made by women and are normally destroyed after the initiation is completed. Wooden pieces, however, are purchased or rented from a male sculptor, and may be used repeatedly.

A bearded male figure wearing a beaded necklace may originally have been carved for one of these

14-25. INITIATION CEREMONY, SIBUSA, NORTHERN TRANSVAAL, SOUTH AFRICA. VENDA

Sotho. Training periods for boys and girls and ceremonies inducting members into select groups of citizens have incorporated many visual displays. Old photographs show how spectacular some of these transformations could be. The example shown here is said to record a pair of Venda initiates (fig. 14-25), while other photographs document similar masquerades among northern Sotho peoples such as the Lobedu and the Pedi. Evidently these constructions of reeds and feathers disguised men who had joined an elite association sponsored by their queen or king, and in some areas they evidently appeared during girl's initiations. Mysterious substances were placed in their headdresses, and one of these dancers carries a ceremonial iron ax (see fig. 14-22).

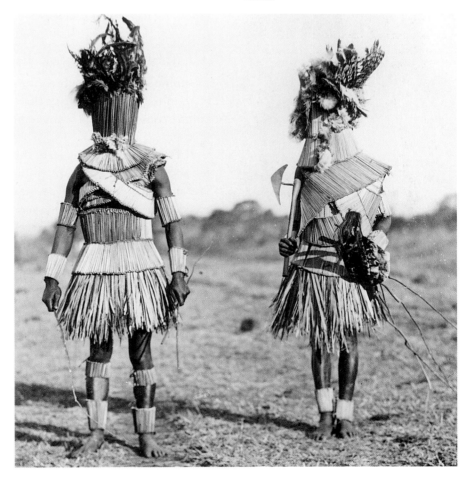

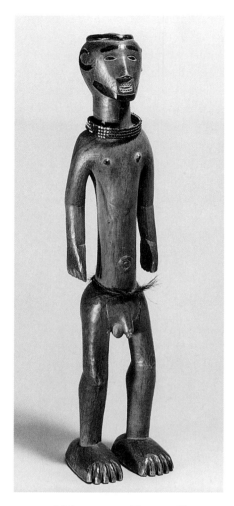

14-26. MALE FIGURE. TSONGA (?). WOOD, BEADS, PIGMENT, FIBER; HEIGHT 17⅜" (44.2 CM). INDIANA UNIVERSITY MUSEUM, BLOOMINGTON

Even though the figure has been attributed to a Tsonga artist, it shares many formal features with works from eastern African cultures much farther north (compare fig. 13-33). Many artistic styles, both figurative and non-figurative, cross ethnic boundaries in southern Africa.

initiations (fig. 14-26). The beard and the ring encircling the head imply that he is a trained warrior and a married man. This figure would have played

14-27. *MATANO* FIGURES. VENDA. UNDATED. WOOD AND PAINT; HEIGHT OF TALLEST FIGURE 26⅖" (67 CM). COLLECTION OF CHIEF KHAKHU

the role of a specific character during the numerous theatrical presentations of an initiatory school, plays that taught young men and women moral precepts.

Figures such as this were clothed for performances. Today initiation figures are often carved fully dressed. The carved and painted *matano* (a name taken from the verb "to show") shown here were created in 1973 for a *domba*, a training session primarily for girls, in a Venda community in South Africa (fig. 14-27). They include a goat-like animal, a round dwelling, a female figure dressed in beads and wrapper, and a female figure wearing a modern dress with her old-fashioned brass anklets. It is instructive to compare the bearded Venda gentleman in blue jeans and a long-sleeved shirt to his Tsonga predecessor. The stance, the proportions, and the use of shiny surfaces have changed

little, even if the type of clothing and the colors are quite different.

Several contemporary sculptors seem to have based their work upon initiatory figures. Johannes Maswanganyi (born 1948), a young Tsonga artist, learned to carve utilitarian objects from his father. His first figurative sculpture was of unpainted wood and resembled the characters featured in initiations. He then turned to carving portraits of South African celebrities and politicians, which he paints with high gloss enamel paints. His portrait of *Professor Hudson Ntswaniwisi* is more pensive than his other works, presenting a thoughtful man in jacket and tie (fig. 14-28). Despite the specificity of Professor Ntswaniwisi's portrait, its techniques and proportions have much in common with the male initiation figures discussed above. Although

Maswanganyi carves for white collectors rather than for leaders of his own community, there are strong didactic and theatrical elements in his work.

The career of Noria Mabasa (born 1938), a Venda artist, differs in many ways from that of Maswanganyi and other sculptors from South Africa. She once modeled statues into

14-29. *Carnage II*. Noria Mabasa. Wood, height 6'5½" (1.97 m). Johannesburg Art Gallery

the walls of the forecourt of her home, a practice shared by other women in the region. In response to a dream or vision she began to make freestanding figures of policemen and Afrikaaner pioneers for sale to whites. These small painted images of clay did not resemble the rough clay objects occasionally made by Venda and northern Sotho women for female initiations, but were much closer in style to the wooden figures carved by men.

After she had achieved critical and some financial success with these appealing clay figures, Mabasa had another spiritual crisis leading her to take up the tools usually reserved for male carvers. Her large, haunting sculpture *Carnage II* (fig. 14-29) was inspired by television coverage of a flood whose victims were attacked by

crocodiles. Mabasa still lives in a rural Venda community, and her future depends to some degree upon the reaction of her relatives and friends to the daring new directions of her work.

ARTS OF THE SOTHO AND THE NGUNI

In southern Africa the practice of carving freestanding wooden figures is confined largely to the Tsonga, the Chopi, and the northern Sotho. Sculptors in other Bantu-speaking areas of the region have created masterful objects which might refer to or incorporate anthropomorphic or zoomorphic forms, yet these works are overshadowed by the ceramic arts, beadwork, and architecture of the Sotho, Tswana, and Nguni peoples.

Art and Leadership among the Sotho and the Tswana

Ornamental clubs or staffs once owned by warriors, royalty, and other leaders of Nguni, Sotho, and Tswana groups were usually carved and polished into elegant abstract shapes. The extraordinary staff shown in figure 14-30, however, is embellished by an attached figure representing its owner, an important northern Sotho leader. The surfaces of the staff are particularly fluid and elongated, and the tactile pleasure the owner must have felt when grasping the staff are evident even in the photograph.

Other items associated with leadership are ornamented with references to cattle. The smooth upward curves of a southern Sotho snuff container carved from a cattle horn are repeated in its stopper, which takes the form of a bull's head (fig. 14-31). Although the

14-30. TOP OF STAFF. SOTHO. EARLY 20TH CENTURY. WOOD, HEIGHT 45" (1.14 M). THE BRITISH MUSEUM, LONDON

14-31. SNUFF CONTAINER. SOTHO. CATTLE HORN, HEIGHT 7½" (19.2 CM). SOUTH AFRICAN MUSEUM, CAPE TOWN

In some regions of South Africa, cattle and snuff are associated with male sexuality. Appreciative wives liken their husband's virility to the sexual appetite of a bull. Tobacco itself is grown and processed by men and shared by them during social events. Men once wore small ornaments containing tobacco, and snuff boxes and snuff spoons were items of male adornment.

form is quite unusual, many snuff containers are made of horn rather than wood. Others are modeled of a paste made from bits of hide and flesh from a cow sacrificed to an ancestor.

Among the Sotho, Tswana, and Nguni peoples, references to cattle in such an object evoke ideas concerning kingship. On a mystical level, a king may be incarnated in a black bull for memorial ceremonies. On a practical level, he distributes cattle from his personal herds to faithful subjects. Without gifts of cattle, offered to them by a king or other elder, young men cannot marry. Thus when kings and other leaders distribute snuff from such a container, they remind onlookers of their generosity.

Cattle are also linked to ancestors, for a man inherits the herds of his forefathers. He himself was conceived in a marriage marked by a gift of cattle to the bride's family, and his birth was a sign of ancestral approval of his parents' union. Snuff is offered by men as a sacrifice to ancestors, and may allow diviners to become possessed by the spirits of the dead. Thus both the form and the contents of this object have a spiritual dimension.

Nguni Beadwork

References to ancestral blessings and social rank also appear in the spectacular body arts of the Nguni peoples. Although in most areas of southern Africa ceremonial dress has changed dramatically over the course of the twentieth century, many Nguni-speaking peoples have tenaciously retained the forms and the meanings of earlier practice.

14-32. *Utimuni, Nephew of Shaka.*
G. F. Angas. 1849. Colored
Lithograph

An early nineteenth-century lithograph records the appearance of a warrior named Utimuni (fig. 14-32), a nephew of the famous Zulu king Shaka (ruled c. 1818–1828). Utimuni wore a short beard and an elaborate feather headdress. His circular headring proclaimed his right to marry, a privilege bestowed by Shaka himself. An ivory snuff spoon was tucked next to a clump of blue feathers on his head, and a veil of beads was suspended at the side of his face. He wore a beaded necklace, and bands of beads crossed over his chest. A kilt made of animal skins hung from his hips. Many of these items are still worn by Nguni men as a sign of ethnic pride and allegiance to the moral values of the past when they attend ceremonies at the courts of kings or participate in church festivals.

Young Zulu women photographed in the late nineteenth century wore several beaded squares or bands of beads around their necks. They had probably given similar items of beadwork to young male friends and relatives, and some of the colors and patterns of the beads may have conveyed messages. Young people still wear these beadwork panels on special occasions, now usually attached to dresses or shirts. For weddings, initiations, royal festivals, and other conservative gatherings, however, modest Zulu maidens remove imported garments. As was the case with the unmarried girls in the photograph, their aprons and beadwork leave their breasts and thighs exposed, for the beauty of their young bodies is believed to reflect the beauty of their character.

Another nineteenth-century photograph shows two Nguni women wearing the hairstyles of married women (fig. 14-33). Their leather aprons were made to protect them during pregnancy and lactation. The crescent shape in the center of the apron may refer to horns, while the many metal studs filling the square panels at the bottom of the aprons probably represented the motif inelegantly called *amasumpa*, warts; it symbolizes herds of cattle. Rural Zulu women still wear beaded versions of these garments. The leather for the apron is taken from a cow slaughtered by the expectant mother's husband as a sacrifice to his ancestors, and it serves to underscore the role of cattle in marriage and procreation.

Today married women in rural communities in South Africa cover their shoulders with a blanket or shawl. Shawls of Zulu women are adorned with beads. A dazzling shawl rich in reds and greens was photographed on a young Zulu woman living near the Lesotho border (fig. 14-34). The letters

14-33. Married Nguni women
wearing leather aprons. Zulu.
c. 1900

14-34. Married woman with shawl.
Zulu

which figure in the design seem to have been used purely as visual elements.

The ornaments worn by the Zulu woman in figure 14-1 mingle red, green, white, black, and dark blue, a color scheme called *umzansi*. What strikes us in this photograph, however, is not so much the beauty of the beaded neckrings, vinyl earplugs, and woven cap as objects, but rather the masterful arrangement of colors and shapes around the woman's face.

In the impoverished area of the former Zulu homeland known as the Valley of a Thousand Hills, women have turned their skills as beadworkers and seamstresses to commercial advantage. In the late 1970s, women from several Zulu families began to stitch small soft sculptures of fabric and beads. Their beaded helicopters were grim commentaries on the South African police state, and tiny beaded

coffins holding babies told of their hard lives. Mavis Mchunu's beaded tableau showing white women playing tennis is on one level a delightful genre scene, but it also reminds us that such wealth and leisure were once unattainable for most black women in South Africa (fig. 14-35).

Nguni Arts of Daily Life

Just as beadwork may reflect complex ideas as well as aesthetic tastes, Nguni objects carved of wood or molded from clay often carry rich conceptual associations. As is true for other southern African peoples, art works used in daily life by Nguni peoples may also be imbued with ancestral power or linked to sacred forces.

Sensuous sexual references are evident in a wooden spoon once used by a Nguni elder to distribute food (fig. 14-36). Its elegance leads us to believe

14-36. SPOON. ZULU. BEFORE 1977. WOOD, HEIGHT 22" (56 CM). MUSÉE DE L'HOMME, PARIS

that it was a prestige object, possibly given to a man by the family of the bride-to-be at a stage in the wedding transactions. With a series of subtle curves the handle of the spoon evokes an elongated female torso, to which the bowl of the spoon serves as a head.

Rectangular panels of tiny raised dots on the figural portion of the spoon have been interpreted as the *amasumpa* "herd of cattle" motif seen previously on the pregnancy apron (see fig. 14-33). This motif was first used by sculptors working at the

14-35. *WHITE WOMEN PLAYING TENNIS*. MAVIS MCHUNU. 1980s. BEADS AND CLOTH. THORPE COLLECTION, AFRICAN ART CENTER, DURBAN

Zulu royal courts in the nineteenth century and was associated with kingship. Cattle imagery also appears in the headrests sculpted for important men in Nguni cultures. A typical example of a headrest in the abstracted shape of a bull could have been created by any Nguni group in southern Africa, but comes instead from the Ngoni people of northern Malawi or southern Tanzania (fig. 14-37). The Ngoni are a Nguni group who fled from the wrath of Shaka, finally settling in eastern Africa. This headrest was given by a woman to her husband upon her marriage, and incorporates many of the references to virility and fertility mentioned in the discussions above.

Similar references to cattle appear on a thin-walled black vessel for beer with *amasumpa* panels (fig. 14-38). References to cattle on beer vessels invoke ancestors, who are believed to guide and bless the living. In most southern African families, the senior woman in a household stacks beer vessels on a special platform at the rear of her home, and her husband or son comes to this area to pour libations of beer to his forefathers.

The ceramic pot is clearly associated with the female body. In some regions, brewing beer is said to be similar to the process of pregnancy. The *amasumpa* patterns on this vessel may have been similar to the

scarification worn by the woman who once owned it. The lid for this vessel seems to have replaced an earlier cover made of woven grass. It is woven of wire wrapped with plastic, a medium well suited to these intricate diagonal designs in bright, shiny colors.

14-38. BEER VESSEL WITH LID. ZULU. 20TH CENTURY. TERRACOTTA AND TELEPHONE WIRE; HEIGHT 8¼" (21 CM). THE BRITISH MUSEUM, LONDON

Ceramic beer containers in southern Africa are involved in the social, economic, and religious life of a community. They appear at the most important ceremonies as well as at work parties, and the quality and quantity of the beer served to each participant establishes social hierarchies and reaffirms social relationships.

14-37. HEADREST. NGONI. WOOD, LENGTH 24⅘" (63 CM). LINDEN-MUSEUM, STUTTGART

Architecture

Most Nguni peoples once lived in hemispherical dwellings made of grass or reeds layered over a curved framework of cross-tied saplings or sticks and tied down by a radiating net of rope (fig. 14-39). At the summit of the house the ropes were drawn into a tightly coiled cylinder, which formed a base for a crescent-shaped wooden attachment known as the thundersticks, *abafana*, said to protect the house from thunderstorms.

For perhaps a thousand years, southern African cattle-raising peoples created communities by grouping such dwellings around a circular central enclosure for their herds (fig. 14-40). Nguni groups used the cattle enclosure as a ceremonial ground, holding assemblies within it and burying deceased men beneath its fence. Other southern African peoples put their cattle in smaller pens within

14-40. NGUNI COMMUNITY, NATAL. C. 1930S

or beside a central ceremonial enclosure, or constructed a sacred enclosure near the central corral.

The male head of the family or clan owned the "great house" farthest from the entrance to the cattle enclosure. The houses of his mother and senior wife were close by, while the homes of junior wives, brothers, and

other relatives formed a circle around the corral. Older children shared houses near the entrance to the corral, although daughters of marriageable age might be housed behind the home of a senior wife. The city of a king followed the same plan on a grander scale to house his family, soldiers, courtiers, and subjects. One of the capitals of the Zulu king Shaka was a vast circular city of 1400 dwellings.

The confiscation of land and imposition of taxes forced many Nguni families to work on white-owned farms as laborers. This was particularly the case for the Ndebele people. Defeated by the British a century ago, the Nbebele were scattered through the central part of South Africa, settling in Sotho communities. Ndebele women admired the sophisticated geometric patterns that Sotho women painted on their walls, and they developed a bold new style of house painting using bright pigments and strong contrasts of light and dark. This new style helped Ndebele refugees establish a presence in a foreign environment.

14-39. NGUNI DWELLING, NATAL, SOUTH AFRICA

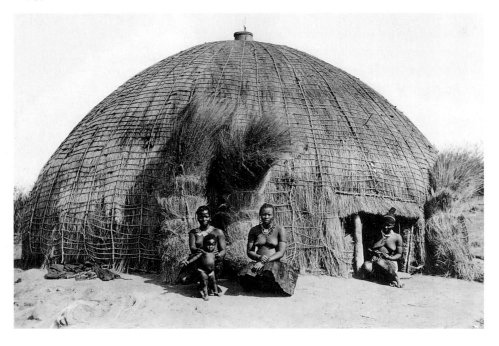

14-41. Home of Franzina and Daniel Ndimande, Kwandebele, South Africa

Franzina Ndimande is a Ndebele artist who has painted in the face of great adversity. Her home is shielded by low adobe walls, which form a series of forecourts with platforms for seats and working surfaces. These open courtyards are the setting for most domestic activities, and access to them is controlled by the women of the household. Visitors and male family members need their permission to enter the inner courtyards or the house itself. All exterior walls are covered with whitewash and ornamented with rectangular panels of brightly colored geometric designs outlined in black (fig. 14-41). Some of the designs are based upon old-fashioned razor blades, while other are architectural images, elaborate two-storey buildings.

The interior walls of the house are also painted with fanciful towers and facades (fig. 14-42). Along the wall hang beaded ornaments for festive occasions, including the large square apron, *ijogolo*, worn by married women who are mothers. The artist herself sits with her daughter and granddaughter in a corner of the room, wearing the distinctive brass rings and thick, beaded neckrings of Ndebele women. Under their blankets she and her daughter wear the beaded fringed aprons of Ndebele married women, but the granddaughter wears only the short beaded panel given to young girls and small children. Mats for seating and for bedding are stored in the rafters, while small figures of clay are placed on top of the wall. In addition to creating art for her family, Franzina Ndimande has also painted designs on canvas for European collectors.

14-42. Franzina Ndimande, her daughter Angelina, and granddaughter Maryann inside their home, Kwandebele, South Africa

ART AND CONTEMPORARY ISSUES

South African artists such as Franzina Ndimande, Mavis Mchunu, Noria Mabasa, and Johannes Maswanganyi are all aware of past artistic traditions, but they have chosen to create works which appeal to outsiders. In this they are heirs to the gifted artists who sold their work to missionaries and traders over a century ago. Since the 1970s, visionary urban artists have joined these rural sculptors, muralists, and beadmakers in South African art galleries. Their personal and idiosyncratic art has intrigued Europeans and Americans hungry for fresh images and inventive forms.

International Art

Tito Zungu may be one of the first urban South African artists to be admired for the spontaneity of his untutored visions. Born in 1946 to a dispossessed and landless family, he has spent most of his life working in the city of Durban. As a young man, he began to draw images of airplanes, ships, and enormous buildings (fig. 14-43). Zungu first drew his idealized visions on envelopes, so that other urban laborers could buy them and mail them to families they had been forced to leave behind in order to find work. His work was eventually brought to the attention of a white gallery director and subsequently became known outside Africa.

Zungu works with a ruler and colored ball-point pens, filling the surfaces with tiny lines. Sometimes he draws lines on top of or next to each other to create a greater variety of color. As in Ndebele murals, no people seem to be present. The ambiguity of these technological fantasies is revealed in Zungu's statement, "I have liked to look for fifteen or fourteen years at the white man's houses and things like aeroplanes and ships; I don't want them, but I do get jealous about these things, I don't know what to do about them."

Issues of patronage are also important in a remarkable body of work that has been produced in Zimbabwe since the early 1960s. Disenchanted with what he believed to be the stale, repetitious nature of European modernism, a British artist named Frank McEwen formed a workshop so that young artists could create new forms of art. Like European teachers elsewhere on the continent, he tried to shield his protégés from outside influences in order to safeguard what he saw as the "purity" of their African creativity. At first his students painted with oils on canvas, but the abstracted stone figures of an agricultural officer named Joram Mariga (born 1927) inspired McEwen to encourage his students to carve images from stone.

McEwen and later patrons were to publicize these stone sculptures as expressions of Shona religious belief, as the direct descendants of the soapstone birds of Great Zimbabwe. Ironically, many of the artists attracted to the McEwen workshop were not Shona; they were Tsonga, Yao, or Chewa migrant workers who had prior experience with sculpting traditions in their homelands in Mozambique or Malawi.

After McEwen left Zimbabwe and new stone-carving workshops were established in rural areas, many artists continued to sculpt in the style developed in his workshop. One of the best known is Nicholas Mukomberanwa (born 1940), who worked under McEwen but received his first artistic training under Father John Groeber, a missionary. The

14-43. UNTITLED. TITO ZUNGU. PEN AND COLORED INK ON PAPER. AFRICAN ART CENTER, DURBAN

14-44. *DESPERATE MAN*. NICHOLAS MUKOMBERANWA. 1988. BLACK SERPENTINE, 11⅞ x 9⅞ x 11⅞" (30 x 25 x 30 CM). COLLECTION OF BERND KLEINE-GUNK

geometric rigor of Mukomberanwa's sculpture may reflect his exposure to West African art, which was part of his study. His works are carved in particularly hard, smooth stone, which gives them precision and power (fig. 14-44). Younger sculptors in Zimbabwe have begun to explore a wide range of ideas and forms, but Mukomberanwa's sculpture exemplifies a conservative approach, a conformity to a particular school's unified vision.

In Mozambique in the 1960s, the sponsorship of a Portuguese architect enabled a young artist named Valente Malangatana (born 1936) to launch his career as an artist. In Malangatana's paintings, twisted, emotionally charged figures appear in acid hues of yellow, orange, blue, and blood red. Imprisoned by Portuguese colonial authorities, Malangatana has since lived through the turmoils of independence and civil war. In the

1980s, he joined with younger artists to paint public murals (fig. 14-45), and began to advise a new generation of painters, sculptors, and ceramists in Mozambique.

Art under Apartheid

In South Africa as well as Zimbabwe, mission schools encouraged art both as a form of expression and as a source of economic development. During the 1970s, one of the most influential schools was Rorke's Drift Center, where printmaking was taught. Linoleum block prints, which are inexpensive to produce, became particularly popular with impoverished artists.

Under apartheid, most South African artists not classified as white by government authorities struggled to obtain training from a variety of informal and unofficial sources. Prior to the 1960s, artists labeled black or colored often went into exile in order to create art in relative freedom. Other artists veiled their allusions to oppression and degradation. This was

14-45. MURAL. VALENTE MALANGATANA. 1985. MARRACUENE, MOZAMBIQUE

14-46. *Killed Horse.* Sydney Kumalo. 1962. Bronze on wooden base, height 13″ (33 cm). University of the Witwatersrand Art Galleries Collection

14-48. *Semekazi (Migrant Miseries)*. Willie Bester. 1993. Oil, enamel paint, and mixed media on board; 49¼ x 49¼″ (1.25 x 1.25 m). Private Collection

There is a limited market for contemporary art such as this in non-white South African communities. According to one anecdote, the internationally known artist Sam Nhlengethwa offered one of his collages to his mother. She refused the gift—none of her walls were large enough to display it.

the case for Sydney Kumalo (born 1935), whose *Killed Horse* manages to conform to an approved modernist aesthetic while expressing the artist's personal response to the injustice of South African society (fig. 14-46).

One artist who clearly depicted the despair and anger of black South

Africans in the urban slums and townships is Dumile Mslaba Feni, known simply as Dumile (1942–91). Although Dumile never received any formal training as an artist, his charcoal drawings are highly disciplined as well as intense and distorted (fig. 14-47). Responses and references to his style can still be seen in

14-47. *Agony.* Dumile Mslaba Feni. Ink on paper. 9¾ x 7″ (25 x 18 cm)

the work of artists who began to paint in the 1980s and 1990s.

Many accomplished painters and sculptors worked at the now-defunct Polly Street Center, which was established by the government during the apartheid era as a recreation and sports center for the dispossessed black population of Johannesburg. Artists such as David Koloane (born 1938) have since helped establish new urban art centers. Koloane also worked with Bill Ainslie, a white South African artist, to organize the Thupelo Workshop in 1985, the first of several events whose purpose was to allow southern African artists of all races to work together for a limited period.

Koalane experimented with various forms of abstract painting, but his critics claimed that abstraction was part of an "American cultural imperialist agenda," based upon the needs of the New York art scene rather than upon African values and African traditions. In the 1980s Koalane turned to figurative imagery. In *Made in South Africa No. 18*, a rabid dog roams the township, a symbol of self-destructive lawlessness which is the legacy of apartheid (fig. 14-49).

Descendants of European settlers in South Africa have been able to study art in universities as well as in secondary schools, and have been able to mingle socially with the collectors who buy their work. Yet many have seriously studied indigenous African traditions as well. They have incorporated southern African techniques and images into their own work, and they have publicized the work of artists in black townships under

14-49. *MADE IN SOUTH AFRICA NO. 18*. DAVID KOLOANE. 1992. GRAPHITE AND CHARCOAL ON PAPER, 25 X 36" (64 X 91.5 CM). THE PIGOZZI COLLECTION

apartheid. The experience of apartheid had a great impact upon South African artists of all races, who protested against the system in performances, sculpture, ceramics, embroidery, etchings, posters, and paintings.

With the arrival of democracy and majority rule, South African artists still address important social issues. Willie Bester (born 1956), classified as colored under apartheid, received no formal training in art until he was an adult. His collages combine actual objects with oil paint, and are dense re-tellings of contemporary history. The particular example shown here documents the life of a black worker named Semekazi, who has spent most of his life in the spiritual and physical squalor of Soweto and now finds that he has no pension (fig. 14-48). A portrait of Mr. Semekazi,

whose desperate handwritten note to the artist is reproduced on the right, peers out from under his bedsprings. In the crowded house where Mr. Semekazi lives, his bed is the only space he does not share with dozens of other people. The passbook allowing the black man to work and travel during apartheid is also incorporated into the collage.

The tragedy of apartheid challenged the values and destroyed the complacency of artists, art critics, art patrons, and art historians. Today many southern Africans find that distinctions between "art" and "craft," "fine artists" and "outsider artists," "political art" and "personal art" are no longer tenable, and in this new intellectual climate they are creating some of the world's most compelling contemporary art.

V. The Diaspora

15
ART OF THE AFRICAN DIASPORA

A FRICANS WERE TAKEN INTO slavery and shipped across the Atlantic from early in the sixteenth century until the second half of the nineteenth century, with nearly half being transported during the eighteenth century (see fig. 15-6). Approximately 14 million Africans survived the Atlantic crossing and, though they left their material culture behind, they were cultural beings who carried inside them various ways of approaching and interpreting life. Congregated in the New World, they formed communities and developed new means of meeting the same expressive and artistic needs they had felt in Africa. In some cases, Africans speaking the same language from the same cultural group were gathered together on plantations, especially in the Caribbean and in Brazil, and recognizable cultural practices from their homeland were revived and continued. Often cultural influences from several areas of Africa melded together. The Haitian religious practices known as Vodou, for example, combine Yoruba, Kongo, and Dahomean elements. In the United States, slaveowners, fearing rebellions, made an effort to group together Africans of varying cultural and linguistic backgrounds in order to suppress communication and collaboration. Still, Africans found what was most common among them and expressed themselves in ways reminiscent of their home cultural practices, though perhaps in more general ways.

One reason Africans became the primary slave labor in the New World was that they were visibly different and, unlike white indentured servants, could not melt into the free white

15-1. *THE ASCENT OF ETHIOPIA.* LOIS MAILOU JONES. 1932. OIL ON CANVAS, 23½ x 17¼" (59.7 x 43.8 cm). MILWAUKEE ART MUSEUM

population. Scarcity of labor caused whites to enter into contracts for specific periods of indenture after which they were free, but blacks remained in the labor pool and became a profitable long-term solution to the labor shortage. Scientific efforts to categorize human groups became the foundation for racism as an ideology to justify the slavery and subjugation of Africans, and to separate them from Europeans socially. The result was that most whites thought that a person of African descent was fundamentally different, inferior, and destined for physical or menial labor.

After slavery was abolished, the continued existence of racism affected the aspirations, status, and consciousness of black people. The social restrictions and obstacles they faced affected the production of art, and it is useful to consider these social and historical factors when looking at the work of African American artists. The making and appreciating of fine art in European contexts was a middle- or upper-class activity. The social and economic oppression faced by blacks made it difficult to pursue this kind of art as a career prior to the second half of the twentieth century. Folk expression, however, was less encumbered by racism, and in fact may have flourished in part because segregation left black communities more intact socially to develop as subcultures.

As we have seen throughout this book, culture is dynamic, and new circumstances and outside forces and elements have an effect upon artistic expression. Africans in the diaspora often used new materials to express themselves. European cultural forms and practices also affected them, and succeeding generations sought to become full members of the New World societies in which they were born.

ART IN SLAVE AND FOLK SETTINGS

One of the earliest art objects made by Africans in the New World still available to us is a drum acquired in Virginia in the late seventeenth century (fig. 15-2). The drum displays the bottle shape typical of *apentemma* drums made by the Akan-Asante peoples of Ghana (see chapter 9). Like those African drums, this one is carved with bands of saw-edged designs, alternating patches of vertical grooves, and plain squares. The drum head is secured by tightening pegs, just as Akan drum heads are secured. The materials of its manufacture, however, set it apart: the wood is American cedar, the skin that of a deer. It is very possible that the maker of this drum was born in Africa, but as time passed specific African designs, such as those found on the drum, gave way to more general African-influenced design in the creation of artifacts in New World slave settings, particularly in the United States.

African architectural influences can be seen in the Americas, and one such influence is the front porch. European houses did not have the kind of broad, open front porches found on American dwellings. The porch structure provides a sheltered sitting area in hot, humid climates, and it shades the interior of the house as well, helping to keep it cooler inside. In addition, the focus of social life in many settings in West and Central Africa—the areas where the majority of slaves had been taken from—tended to be outside the

15-2. SLAVE DRUM. AFRICAN AMERICAN. LATE 17TH CENTURY. CEDAR WOOD AND DEERSKIN; HEIGHT 15¼" (40 CM). THE BRITISH MUSEUM, LONDON

house, and porches reinforced this communal emphasis.

Built in the eighteenth century, the slave quarters and the big house of Mulberry Plantation in South Carolina are rare examples of another African architectural element transplanted to the New World (fig. 15-3). The steeply pitched hip-roofs on these structures resemble West African thatched roofs from the same time period. The advantage of this design, where the roof comprises over half the height of the structure, is that the heat in the interior can rise, keeping the house cooler. Also, heavy rain runs quickly off the roof rather than sitting and seeping through the thatching.

Another New World form with African roots is the Haitian *caille*, with its wattle-and-daub construction technique using natural materials

15-3. *VIEW OF MULBERRY.* THOMAS CORAM. OIL ON CANVAS. GIBBES MUSEUM OF ART

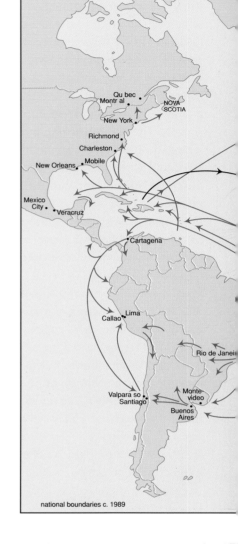

national boundaries c. 1989

from the immediate environment (fig. 15-4). The example shown here has a front porch and a hip-roof without gables similar to the roof of African House at Mulberry Plantation. Both in Africa and in the New World, such houses typically had an earthen floor. Windows, if there were any, were small. Cooking usually was done outside, so there was no kitchen.

These houses, with their long narrow formats and in-line rooms, eventually translated into the form known as a "shotgun" house (fig. 15-5). Shotgun houses can be found all over the United States, mainly in black neighborhoods, although they occur elsewhere. Built with wood or bricks, shotgun houses have a roof that is less steeply pitched than the African House. Most roofs are gabled, as in the example shown here. The narrow, gable side usually faces the road. John Michael Vlach, an expert on these structures, writes that a shotgun house "is a house without privacy," and calls it an "architecture of intimacy among black people."

15-4. RURAL *CAILLE* CHANCERELLES, HAITI. 1973

15-5. SHOTGUN HOUSE, NEW ORLEANS, USA. MID-19TH CENTURY

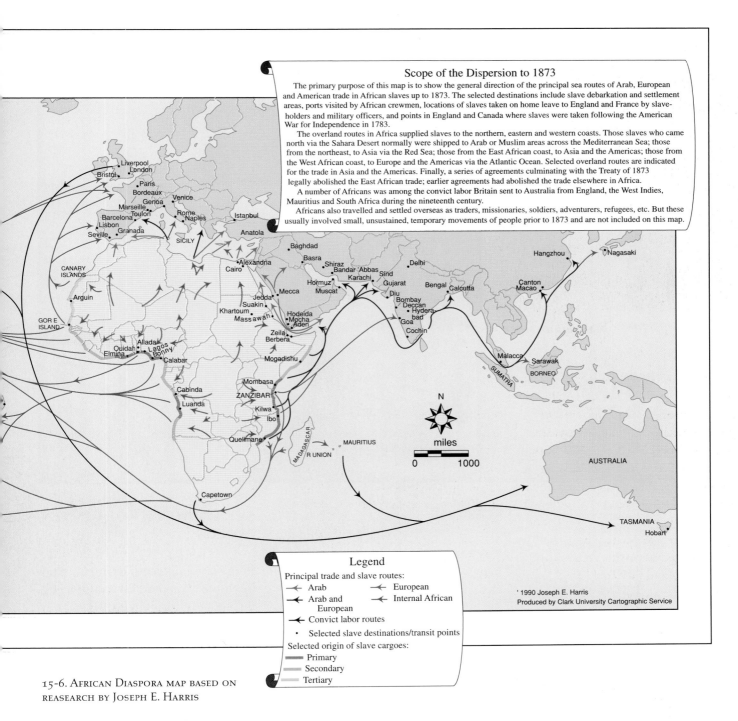

' 1990 Joseph E. Harris
Produced by Clark University Cartographic Service

Legend

Principal trade and slave routes:

Arab — European
Arab and — Internal African
European
Convict labor routes
• Selected slave destinations/transit points
Selected origin of slave cargoes:
█ Primary
█ Secondary
█ Tertiary

15-6. AFRICAN DIASPORA MAP BASED ON
REASEARCH BY JOSEPH E. HARRIS

Inside, three or more rooms are aligned consecutively, an arrangement that forces inhabitants to interact with one another and encourages them to go out into the community.

Many art and architectural forms devised in the Americas during the period of slavery adapted new materials and hybrid forms to the new social environment, but they expressed an African cultural logic. In some cases one can find direct formal links to African expression. In other cases the continuing influence of African expressive forms reveals itself in more subtle ways. Quilts, for example, are European in origin, but African Americans adopted the craft and many have applied a different aesthetic to their design. Asymmetry and strip or string designs often mark African American

15-7. BIBLE QUILT. HARRIET POWERS. 1895–8. PIECED, APPLIQUÉD, PRINTED COTTON EMBROIDERED WITH PLAIN AND METALLIC YARNS; 5'9" X 8'9" (1.75 X 2.67 M). MUSEUM OF FINE ARTS, BOSTON. BEQUEST OF MAXIM KAROLIK

Several stories from the Bible are illustrated on the quilt. The central panel in the upper register depicts Moses and a serpent. The panel next to it on the right depicts Adam and Eve in the Garden of Eden. Other panels illustrate the story of Jonah and the whale, the crucifixion of Christ, and passages from the book of Revelation.

quilts. Georgia native Harriet Powers (1837–1911) created an appliqué quilt evocative of the narrative appliqué banners of the Fon kings of Dahomey (fig. 15-7; see fig. 8-52). Powers drew her subjects from her own experiences, local folklore, and her deep Christian faith. The second panel from the left in the upper register refers to May 19, 1780, when stars could be seen in the daytime sky, an event so notable that it survived in local lore. The central panel in the second register depicts a meteor shower of November 13, 1833, that frightened people into believing the end of time had come. Financial hardship eventually forced the sale of the work, beginning the journey leading to its residence in a museum.

SPEAKING THROUGH NEW FORMS

In the late eighteenth century, a work by Scipio Morehead illustrated a volume of poetry by Phyllis Wheatly, and Joshua Johnston (c. 1765–1830) began painting portraits in the Baltimore area. These African Americans were among the first of their race on record to engage in these activities. However, during the nineteenth century several talented African American artists developed notable art careers, creating memorable work using the forms, materials, and aesthetic traditions of European Americans.

One of the first accomplished African American painters was Robert

Duncanson (1823–1872), a man of mixed race who resided for most of his adult life in the Cincinnati area. Duncanson exhibited the broad range of atmospheric and emotional elements in his work typical of the style of American landscape painting known as the Hudson River school, but few of his works included African American subjects. At the end of the 1820s, blackface minstrels emerged as a favorite form of entertainment in the United States, and it spread stereotypical ideas about plantations and blacks throughout American popular culture. These ideas combined with the dearth of black patronage and the reluctance of white patrons to purchase art with central black subjects explains why those few African American artists like Duncanson who attempted to become artists in the same sense as their white counterparts tended to avoid black genre images or references to African American vernacular culture.

Painted not long before the outbreak of the Civil War, Duncanson's critically acclaimed *Land of the Lotus Eaters* (fig. 15-8) was based upon a work by the English poet Alfred Lord Tennyson. The poem described warweary Greek warriors of Odysseus who stopped at an idyllic island on their way home and lost interest in war, going home, or anything but the magical, sensual existence of the island and its peaceful people. Duncanson may have identified directly with the poem when he went on expeditions to the western wilderness of the United States to view nature and faced returning to Cincinnati with its racial tensions and the political storm over slavery growing more violent. The

15-8. *The Land of the Lotus Eaters*. Robert S. Duncanson. 1861. Oil on canvas, 51½ x 87½" (1.31 x 2.22 m). His Majesty's Royal Collection, Stockholm

Some scholars have suggested that Duncanson's use of water in his paintings may have had metaphorical implications for blacks crossing over to a more desirable landscape, as happened in Uncle Tom's Cabin, *and the subjects in* The Land of the Lotus Eaters *are crossing a river to another type of existence, not just to another geography. However, it is just as possible that Duncanson was exploring aesthetic and humanist ideas in his work as he attempted to transcend the limits of racial definitions rather than speaking to them.*

painting presents an imaginary land-scape rather than an identifiable one. *The Land of the Lotus Eaters* separates the viewer from the scene with a watery barrier in the foreground, and with a sense of the exotic that is conveyed through the use of palm trees and tropical vegetation.

15-9. *Hagar*. Edmonia Lewis. 1875. Marble, height 52⅜″ (1.33 m). Smithsonian National Museum of American Art, Washington, D.C.. Gift of Delta Sigma Theta Sorority, Inc.

It is difficult to say how much Duncanson identified with his African heritage, but he lived during a time when there had been several riots in Cincinnati in which whites attacked blacks, and pro-slavery advocates had a strong presence there despite the fact that Ohio was not a slave state. Most indications are that he acknowledged his racial designation but chose not to address issues around that identity in his work other than in one painting, *Tom and Little Eva*, inspired by Harriet Beecher Stowe's abolitionist novel *Uncle Tom's Cabin*.

Edmonia Lewis (c. 1843–1909) was the first woman artist of African descent to gain prominence in the United States. Details about her life are sketchy, but she was born to African American and Chippewa parents. Lewis attended Oberlin College for a while before being forced to leave after a highly publicized trial in which she was accused of poisoning two of her roommates, and subsequent accusations that she had stolen art supplies.

After leaving Oberlin, Lewis began to produce portraits of well-known abolitionists of the time, and through her art and the support of patrons she was able to travel to England, France, and Italy. She settled in Rome in 1866 and developed her academic Neoclassical style there. One of her most notable works in this mode, and one of the few that survive, is *Hagar* (fig. 15-9). Lewis dealt with racial themes and subjects in her work more directly than most nineteenth-century artists of African descent, and *Hagar* illustrates how she pursued these themes with subtlety and allusion.

In the Old Testament of the Bible, Hagar is an Egyptian woman and servant (slave) to Sarah, wife of Abraham. Abraham's illicit liaison with Hagar led to the birth of his first son, Ishmael, and Sarah's jealousy caused her to cast Hagar out into the wilderness. Hagar is an African woman (despite the Neoclassical mode of presentation), a slave, and she was victimized by sexual liaisons with her master; a string of circumstances which directly related to the plight of many black women in the New World. The work was created at a time when blacks were being re-enslaved by the collapse of Reconstruction in the American South, and black women still were vulnerable to sexual exploitation due to disparities in power between whites and blacks. In Brazil, where the great majority of Africans taken in the Atlantic slave trade had been sent, the end of slavery was still over a decade away. Lewis's imagery was not black, but clearly her subject matter related to the experiences of many black women.

In 1893, at the same time as the World's Columbian Exposition in Chicago, blacks from Africa, the Caribbean, and the United States convened the Congress on Africa, possibly the first pan-African meeting. In attendance was Henry O. Tanner (1858–1937), the most accomplished and prominent African American artist of his time. That same year, Tanner completed one of the few genre paintings of his career, *The Banjo Lesson* (fig. 15-10). The painting joined a long list of nineteenth-century images depicting blacks as entertainers playing banjos or fiddles, including one by Tanner's former teacher at the Philadelphia Academy

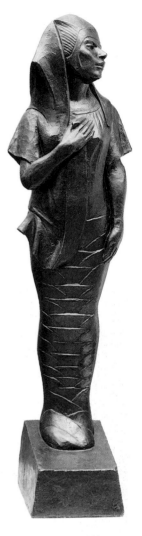

15-10. *THE BANJO LESSON*. HENRY O. TANNER. 1893. OIL ON CANVAS, 49 X 35½" (1.24 X 0.90 M). HAMPTON UNIVERSITY MUSEUM

15-11. *ETHIOPIA AWAKENING*. META WARRICK FULLER. C. 1907–14. BRONZE, HEIGHT 5'7" (1.7 M). NEW YORK PUBLIC LIBRARY, SCHOMBURG CENTER FOR RESEARCH IN BLACK CULTURE. ASTOR, LENOX, AND TILDEN FOUNDATIONS

of Art, Thomas Eakins. Tanner's work differs from most of his predecessors in its humanism and in its subtle expression of African cultural practices.

The Banjo Lesson presents a tender exchange between an elder and a youth, alluding to an educational tradition of inter-generational exchange in which lore and lessons were handed down. It also suggested that the musical skills attributed to many people of African descent as "natural" and "instinctive" were, in fact, the result of work and developed intelligence. The cultural legacies that contributed to African American vernacular cultural practice had become the subject of high

art in Tanner's painting. Tanner's sensitivity to the nuances of light, so important in his paintings of religious subjects in the coming decades, reveals itself in the distinctions he created between the yellowish light of the fireplace to the right of the image, and the bluish light falling on the subjects from the window of their cabin. Tanner developed this image from observations and photographs he made during an excursion to rural Georgia and North Carolina in 1889, a trip which sensitized him to the lives and concerns of southern rural blacks and to their cultural expressions. Soon after completing *The Banjo Lesson* and

another genre painting, *The Thankful Poor*, Tanner turned almost exclusively to religious subject matter for the next thirty years or so.

The sculpture *Ethiopia Awakening* (fig. 15-11) by Meta Warrick Fuller (1877–1968) can be seen as an extension of Tanner's painting. Fuller's work allegorically depicts a woman emerging from a deep, mummified sleep into lively animation. The lower portion of her body is still wrapped as if entombed, but the upper torso has begun turning and waking from a metaphorical sleep. The work also suggests a butterfly forcing its way out of a cocoon into a new life.

Ethiopia—from an ancient Greek word meaning the land of the "sun-burnt people"—was a term that embraced a variety of African peoples found in Egypt, Libya, Nubia, or Kush, down into the region of the present-day nation-state of Ethiopia. The term had long been applied to signify things African or black in American parlance—minstrel performances often were called Ethiopian operas—and Fuller uses it in this way here.

Fuller, who like many prominent African American artists of the era studied in Europe, worked in a narrative style. Her work, like that of Edmonia Lewis, suggested African themes and used Egypt as a synonym for Africa. With *Ethiopia Awakening*, however, the focus of Fuller's work moved beyond slave or plantation references toward a pan-African imagination. She linked the growing self-consciousness and self-confidence of African Americans with global trends, and her implication that racial identity was the equivalent of national identity as a means for unity in a common cause reflected the ideas of W. E. B. Du Bois (1868–1963), an eminent African American intellectual and one of the co-founders of the National Association for the Advancement of Colored People (NAACP).

RECLAIMING AFRICA

The last decade of the nineteenth century and the first several of the twentieth century witnessed a number of significant events and trends which radically affected African consciousness for the remainder of the twentieth century. The 1893 Chicago Congress on Africa was followed by the formation of the African Association by Trinidadian Henry Sylvester Williams in England in 1897, and a Pan-African Congress in 1900 in England. The sacking of Benin by the British Punitive Expedition in 1897 led to thousands of African art objects appearing on the market. German ethnographer Leo Frobenius stumbled upon the Ife heads during the first decade of the twentieth century, and their naturalism challenged erroneous assumptions that African art was unintentionally abstract because of an inherent African inability to produce naturalistic work. The growing interest in African art as art shown by European avant-garde artists contributed to an increased scrutiny in the West of things African and a growing appreciation of African aesthetics. In the 1920s dancer and performer Josephine Baker, a black woman from St. Louis who moved to Paris, highlighted the fascination among the French with black cultural expression. W. E. B. Du Bois helped organize several pan-African conferences beginning in 1919, and the Marcus Garvey movement energized masses of blacks in the Americas and Europe with increased interest in Africa and their links to the continent.

Image and Idea

Africa became a part of the cultural imagination of many artists in the late 1920s and 1930s. People of African descent in the diaspora had reached the second and third generations of the post-slavery period, and various migrations had moved many people from harsh, impoverished conditions in rural settings to the crowded urban settings of Chicago, New York, and smaller Midwestern and West Coast cities. Many people emigrated to the United States from Caribbean communities as well in search of economic opportunity. In the minds of most whites their African heritage linked them with African Americans as Negroes, and their shared experience of being black encouraged some pan-African ideas and sentiment. However, few of the artists of diasporan communities had actually been to Africa, and so the image and idea of Africa that inspired them, though important, was of necessity an imaginary one.

In 1925 Alain Locke published his important essay "Legacy of the Ancestral Arts" in the March issue of *Survey Graphic* magazine that he edited about Harlem, the neighborhood where most African Americans in New York lived. In this essay, reprinted later that same year in his significant book *The New Negro*, Locke implored African American artists to look to Africa for inspiration and aesthetic ideas just as European modernists such as Picasso, Braque, and Modigliani had done during the previous two decades. He also addressed the need to overcome the visual stereotypes of the nineteenth century, which had codified a distorted view of the physical features of people of African descent. Locke's challenge to African American artists was made during a period when artists and intellectuals were approaching their African cultural heritage from a perspective of self-discovery.

Many artists and poets of the astonishing flowering of literary, musical, and artistic talent known as the Harlem Renaissance created imaginary African settings or people in their work. Like the poets of the slightly later Négritude movement of francophone West Africa and the Caribbean, they explored the notion of

15-12. *CONGOLAIS*. NANCY ELIZABETH PROPHET. 1931. WOOD, HEIGHT 17⅛" (43.5 CM). WHITNEY MUSEUM OF AMERICAN ART, NEW YORK

essential African personality traits. In the United States, this translated into an idea of the Negro "soul." The poet Langston Hughes connected African Americans with the Congo, Nile, and Mississippi rivers in his famous poem "I've Known Rivers," and Countee Cullen asked, "What is Africa to me?" in his 1925 poem "Heritage."

Congolais, by Nancy Elizabeth Prophet (1890–1960), is emblematic of this trend (fig. 15-12). Prophet studied in France and taught for a while at the all-black, all-female Spelman College in Atlanta. Perhaps Congo, like the terms Egyptian and Ethiopian, here signifies things African in general, because the hairstyle of the figure is more like that of a young Maasai from East Africa than anything worn by Central African peoples. Yet the work attempts to penetrate the facade of stereotypes that limited Western understandings of African peoples at that time: although it presents an African subject, it does not emphasize her African-ness, nor does it exoticize her. Instead, it presents her as a human being with whom one might have things in common. Her downward gaze does not confront the viewer but suggests a moment of introspection and repose. One can gain some sense of the personality of this unnamed subject, and the overall effect is of a portrait.

Lois Mailou Jones (1906–1998) revisited the sense of Egypt/Ethiopia as a metaphor for an exalted African past in the black imagination with her 1932 painting *The Ascent of Ethiopia* (fig. 15-1). In this work she visually links contemporary African American creativity with the culture of ancient Egypt, represented by pyramids and the large pharaonic profile that dominates the foreground, suggesting a continuum of African achievement. Drama, music, and visual art are highlighted within concentric circles that organize and energize the composition. References to the arts emerge from behind skyscrapers just above the pharaoh's head, and each discipline is performed symbolically by black silhouettes. Art and civilization are linked graphically, mirroring the philosophical ideas of Locke, Du Bois, and other intellectuals of the period who felt that artistic and cultural achievement would help facilitate black acceptance into Western societies. The black star centered within the moon at the upper left of the image could represent Marcus Garvey's Black Star Line of ocean vessels. As a big, black-owned business, it gave hope to many blacks for economic freedom, much as the north star, almost a century earlier, served as a guiding light for slaves fleeing north from bondage via the Underground Railroad, a network of contacts that ensured safe passage.

On the West Coast, Sargent Johnson (1887–1967) explored an interest in the physiognomy of African Americans in his sculpture. "It is the pure American Negro I am concerned with," he said in a statement published in 1935, "aiming to show the natural beauty and dignity in that characteristic lip and characteristic hair, bearing and manner; and I wish to show that beauty not so much to the White man as to the Negro himself." The 1933 sculpture *Forever Free* reveals Johnson's interest in color, form, and understated social statement (fig. 15-13). The sculpture depicts a dignified mother protecting her two children at

15-13. *FOREVER FREE*. SARGENT CLAUDE JOHNSON. 1933. LACQUERED CLOTH OVER WOOD, HEIGHT 36" (91.5 CM). MUSEUM OF MODERN ART, SAN FRANCISCO

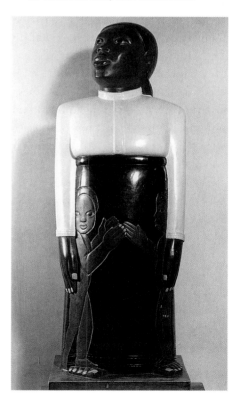

her side. The frontality of the work, its closed form, and the stylization of and emphasis upon the head link it stylistically with some freestanding African sculpture, yet its simplified form gives it abstract qualities that also invoke modernism and the work of Johnson's European contemporaries such as Brancusi or Henry Moore. The surface color was created through polychrome techniques used by ancient Egyptian and Greek artists. The surface was covered with several coats of gesso on fine linen. Each coat was sanded before the next was applied, and finally the smooth surface of the statue was polished to a high luster.

Thematically, Johnson's work improvises upon an 1867 work with the same title by Edmonia Lewis. Like Lewis's work, the subject becomes an allegorical representation of black people rather than an individual portrait. The work aggressively portrays a mother's dignity, her protective instincts, and her acceptance of the social responsibilities of motherhood. The dark skin that was so discredited by white American society, and in some ways by black Americans themselves in an intra-group conflict of light versus dark skin, here is celebrated and associated with an array of positive characteristics.

Cuban artist Wilfredo Lam (1902–1982) brought a somewhat different perspective to his career. He grew up in Cuba the son of a Chinese father and a mother of Congo descent, and his godmother was a priestess of Lucumí, also known as Santería, a religion that developed in Cuba from Yoruba belief. He moved to Europe at age twenty, living first in Spain, then in Paris, where he came under the artistic influence of Picasso and

Cubism and also of André Breton and the Surrealists. In 1941, at the beginning of the Second World War, Lam returned to Cuba. There he combined the diverse cultural and artistic influences of his life in works such as *The Jungle* (fig. 15-14).

Painted in 1943, *The Jungle* reveals Lam's use of the geometry and multiple simultaneous views of Cubism, the juxtaposition of images in sometimes surprising configurations found in Surrealism, and the iconography and meaning found in Afro-Cuban religious practices. Figures that combine human, animal, and vegetative elements suggest humankind's oneness with nature. Horse-headed females recur in Lam's work beginning in

15-14. *THE JUNGLE*. WILFREDO LAM. 1943. GOUACHE AND PAPER ON CANVAS, 7′10¼″ X 7′6½″ (2.39 X 2.30 M). MUSEUM OF MODERN ART, NEW YORK

One figure to the left of center has a mask face, which refers at once to African art and Picasso's early work, and another to the right has a face in the shape of a crescent moon. In Santería, the moon is believed to be the wife of the sun, and a crescent-shaped new moon signals a period ripe for ritual activity.

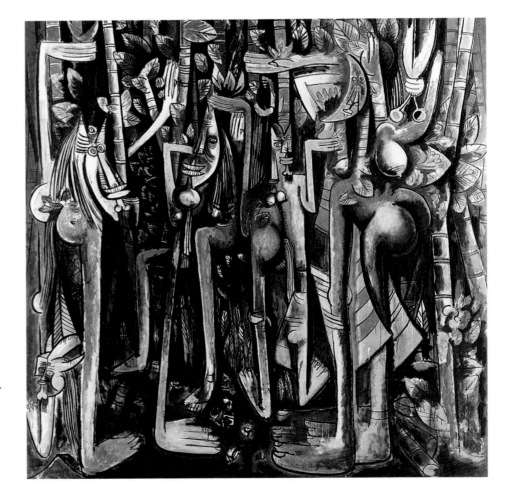

1941, and while these often allude to Picasso's work, especially the horse of Picasso's anti-war mural *Guernica*, the figure at the far left in *The Jungle* refers to the important Santería practice of possession. In possession the devotee is said to be "mounted" by the spirit, *orisha*, in an exchange of divine energy and potentiality, *ashé*. Lam's surrealistic grafting of figures onto each other created a metaphoric intersection suggestive of the joining of the *orisha* with the devotee through possession. Several of the figures in this painting lift their palms upward in a gesture of offering, heightening the sense of ritual activity in the work.

The full buttocks of the figures on either side of the work suggest an awareness of a physiognomic trait often associated with women of African descent. Such concern would link Lam coincidentally to Sargent Johnson's concern with black physiognomy a decade earlier. Two more artists whose work evinces a concern with positive portrayals of black physiognomy were African American Aaron Douglas, and Jamaican David Miller, Jr. Douglas (1899–1979) became renowned for his graphic images and murals. His 1944 work *Building More Stately Mansions* reiterates the idea of linking contemporary African Americans to ancient Egypt (fig. 15-15). One of many commissions executed by Douglas narrating African American achievement and history, this work articulates black contributions to the construction of modern and ancient civilizations as designers, engineers, and workers.

Douglas developed a visual shorthand in his silhouettes for the representation of a black body that was recognizable, but not stereotypical or

15-15. *BUILDING MORE STATELY MANSIONS*. AARON DOUGLAS. 1944. CARL VAN VECHTEN GALLERY OF FINE ARTS, FISK UNIVERSITY, NASHVILLE

derogatory. It seems most evident in this work with the image of the young boy touching the globe in the lower right of the frame. The shape of his head, the implication of close-cropped hair, and the slightly prognathous jaw make effective use of essential notions of what a black person looks like, but any sense of exaggeration is avoided.

The globe to the lower right is the center of a series of concentric circles expanding beyond the picture frame, and this geometry, along with the slight changes of value in each circle, organizes the composition in a manner superseding and complementing the verticals and diagonals of the work. A pyramid in the upper left near the pharaonic head is echoed variously by the church steeple in the center, the ancient tower to its right, and by the perspective angle of the skyscraper below the pyramid. The work prescribes education for the recruitment

of today's children as future contributors to the long history of Africans building civilizations and societies.

David Miller, Jr. (1903–1977) lived and worked in Kingston, Jamaica, with his father, also an artist. Between 1940 and 1974 he carved a number of heads which explored the physiognomy of blacks. His *Head* from 1958 combines the rich, dark color of the wood with stylized African features to create a powerful and sensitive work (fig. 15-16). The head has been elongated and narrowed, its protruding jaw emphasized, but the bags under the eyes and the wistful expression suggest a world weariness. The slight smile on the full lips both Africanizes the work and personalizes it, emphasizing the fullness of the lips while presenting an

15-16. *HEAD*. DAVID MILLER, JR. 1958. WOOD, HEIGHT 22" (55.9 CM). NATIONAL GALLERY OF JAMAICA, KINGSTON

15-17. *REVIVAL KINGDOM*. OSMOND WATSON. 1969. WOOD AND PAINT, 60 X 29" (152 X 74 CM). NATIONAL GALLERY OF JAMAICA, KINGSTON

Two drummers on either side of the central figure contribute to the sense of sound and performance in this work and provide a visible logic for the dancing, gyrating postures of many of the believers. A woman at the top apparently has fainted, overcome by the spirit whose face appears immediately below her, surrounded by an aura of radiant light or energy. The costume of the leader, the drummers, the ecstatic emotionalism of the service, and the concept of being spirit-filled all resonate with culture-specific references having African antecedents.

expression of restrained emotion that often is culturally prescribed in African art. Its naturalism and smoothness recall the terracotta heads of Ife (see fig. 8-8) or the bronze heads of Benin (see figs. 9-60, 9-61).

Miller's countryman Osmond Watson (born 1934) both carves and paints. He studied at the Jamaica School of Art and the St. Martin's School of Art in London. While in London, he spent a good deal of time at the British Museum studying African art. His 1969 carving *Revival Kingdom* shows the influence of his heritage, training, and personal explorations of African art (fig. 15-17). The subject of the work is the joy of religious awakening at a revival, and it is one of a number of Watson's works dealing with religious expression as found in Revivalism, Rastafarianism, and masquerade.

Revival Kingdom teems with figures in much the same way as a carved Yoruba door (see fig. 8-21). But where Yoruba doors often involve multiple panels or sections presenting a multi-part narrative, Watson's panel is entirely devoted to a single image. He does not attempt pictorial perspective but flattens space around the central evangelical figure facing the viewer. Folk in the foreground at the bottom of the frame are the same size as those at the top, and only their placement in the picture plane locates them in space.

The same year as he carved *Revival Kingdom*, Watson completed a self-portrait, *Peace and Love*, showing himself as a Rastafarian Christ in dreadlocks. The image owed a great deal in its style and form to Ethiopian Christian icon painting, reflecting the intense focus of the Rastafarian faith upon Ethiopia and its emperor Haile

Selassie (ruled 1930–1974). Watson's familiarity with African art allowed him to merge diasporan cultural practices with African artistic forms in creating works which mapped his full cultural heritage.

New York artist Romare Bearden (1911–1988) explored a variety of techniques and themes during his career, but he is most known for his collages portraying African American life in the South and in Harlem. Bearden became prominent as an artist during the Civil Rights era in the United States and was part of a group called Spiral. Inspired by the Civil Rights movement of Martin Luther King, Jr. and the 1963 March on Washington, Spiral organized an exhibition in 1964 called Black and White, for which each artist created a work in black and white. Despite their intention not to be overtly political, they could not help but draw attention to issues of black–white racial relations.

From Bearden's discussions with Spiral grew an interest in devising photomontage collages, including a series drawn from his experiences growing up in North Carolina. The art historian Sharon Patton writes that the series focused upon the "daily and seasonal rituals, such as planting and sowing, picking cotton, baptisms in the river, night ceremonies when one hears 'down-home' blues or jazz." A 1964 collage, *The Prevalence of Ritual: Baptism*, combines Bearden's interest in and study of modern art stylistic movements such as Cubism, Surrealism, and Abstract Expressionism with African and African American cultural references (fig. 15-18). The title of the work links baptism rituals in the black church with older African religious and social rituals, which is emphasized by

15-18. *THE PREVALENCE OF RITUAL: BAPTISM*. ROMARE BEARDEN. 1964. PHOTOMECHANICAL REPRODUCTION, SYNTHETIC POLYMER, AND PENCIL ON BOARD, 9⅛ X 12" (22.9 X 30.4 CM). HIRSHORN MUSEUM AND SCULPTURE GARDEN, SMITHSONIAN INSTITUTION, WASHINGTON, D.C.

the figure to the lower left with a mask-like face. The top of the face is drawn from African mask imagery, but the lower portion of the mouth and chin are collaged from photographs. This juxtaposition of the old with the new speaks of the effort made by many artists in the African diaspora to reconcile their heritage with their current circumstances.

A small church appears at the upper left corner of the image behind railroad tracks and a train engine. Elements in the work suggest that this baptism is taking place down by the riverside, and the total effect is to establish a sense of place, both socially and geographically, for the participants in the ritual. The church must be in a small town or rural area to be so near a river for outdoor baptism. As in blues

music, where they often serve as a symbol of longing and of the potential of renewal through relocation, trains allude to black migrations from the South. The train tracks often stood as an actual color line in southern communities dividing whites and blacks physically and socially from each other. Bearden seems to have created an image drawn from a small southern black community enacting age-old ritual to transcend time, place, and difficult conditions.

Ritual, baptism, and the train all suggest liminal points, places of transition or crossing over. The figures in the foreground dominate the picture plane in the work, suggesting human importance. Created during the height of the Civil Rights movement when racial barriers were being challenged in the

United States, this work may suggest that American society appeared to be on the threshold of a significant transition in race relations. This transformation of the social order was driven by the simple, persistent religious faith of the people following the leadership of their clergy.

Hale Woodruff (1900–1980) commemorated the centennial of the 1839 Amistad mutiny—a celebrated incident when Mende captives took over a slave ship off the coast of Cuba to free themselves—with a series of murals at Talladega College in Alabama. In their form and inspirational character the works show the influence of the Mexican muralists David Rivera, José Orozco, and David Siquierios, whom Woodruff had met during a Mexican sojourn. The subject of the murals served to connect African Americans with Africans in the historical struggle for freedom. Woodruff was living in Atlanta at the time, and the year before completing the murals he also produced several works protesting the lynchings of blacks in the South. Living in the segregated South made Woodruff terribly aware of social issues concerning African Americans, but his move to New York in 1943 for a Rosenwald Fellowship freed him from an overwhelming consciousness of these issues and gave him the freedom and resources to focus more upon aesthetic concerns.

Woodruff completed several important mural projects after moving to New York, but by the mid-1950s he had abandoned social realism in favor of abstraction. His 1969 painting *Celestial Gate* shows how he eventually turned to African design for subject matter in his later

15-19. *CELESTIAL GATE.* HALE WOODRUFF. 1969. OIL ON CANVAS, 59⅝ x 45⅝" (1.51 x 1.42 M). COLLECTION OF SPELMAN COLLEGE, ATLANTA

abstract work (fig. 15-19). Painted in the expressive, painterly style of Abstract Expressionism, the work's underlying motif is a Dogon granary door decorated with images based upon Asante gold weights (see figs. 5-15, 7-13). Woodruff said, "I have tried to study African art in order to assimilate it into my being, not to copy but to seek the essence of it, its spirit and quality as art." He combined elements from two different African societies to make what can be interpreted as a pan-Africanist statement calling for unity among various peoples of African descent.

Getting Behind the Mask: TransAtlantic Dialogues

Jacob Lawrence visited Nigeria in 1964, where he worked for months at Ulli and Georgina Beier's Mbari Mbayo workshop in Ibadan (see chapter 8). Though he produced an interesting series of works based upon his Nigerian experience, Lawrence was too far advanced in his career for the experience to have a radical impact on his imagery. However, during the 1960s, black nationalism, the Black Arts movement, the revitalization of pan-Africanism, and the optimism spawned by the increasing number of African nations throwing off the yoke of colonialism contributed to more aggressive explorations of African art and culture by younger African American artists, writers, and intellectuals. Many traveled to Africa for varying lengths of time, and the pan-African ideas of Kwame Nkrumah, Ghana's first leader after colonial independence, were inspirational to many in the diaspora. Du Bois died in Ghana in 1963, the same year he received Ghanaian citizenship, and Malcolm X stopped in Ghana after his 1964 pilgrimage to Mecca. This kind of direct experience allowed many in the African diaspora to gain a fuller understanding of African cultures, to develop relationships with people and artists living in Africa, and to confront their similarities to and differences from Africans. The romantic projections of Africa under the generic terms of Ethiopia, Egypt, or Congo gave way to more specific images. Artists began to penetrate the facade of form in African art. They began to get behind the mask.

One of the early artists to explore the ideas behind African forms was Ademola Olugebefola (born 1941). Born in the Virgin Islands, Olugebefola was a member of a group of artists in New York called Weusi, a Swahili word meaning "blackness," which promoted the study of African culture. Olugebefola's painting *Shango* evokes the Yoruba deity associated with thunder

15-20. *SHANGO.* ADEMOLA OLUGEBEFOLA. 1969. ACRYLIC AND MIXED MEDIA ON PANEL, 33 x 24" (83.8 x 61.0 CM). BANKS ENTERPRISE

(fig. 15-20). Among the Yoruba the god is represented iconographically by a double-headed ax. Olugebefola took this symbol as the primary design of his painting, but rather than reinterpreting the form of the Shango dance wand commonly seen in art collections (see fig. 8-38), he opened it up to depict the energy inside, the *ashé* that animates the deity.

Shango is a deified ancestor, a Yoruba king who was known for his fire and passion. He is represented by the exciting colors red and white, and his devotees wear beads in those colors. Olugebefola has included cowrie shells, a traditional element of monetary exchange in West Africa, in various sections of the painting, alluding to sacrificial offerings made to deities. Cowrie shells, because their shape can suggest either a woman's vulva, or, seen in profile, a pregnant woman,

were associated ritually with childbirth in some African cultures. Offerings often were made to appeal to the deity to intercede on the devotee's behalf for childbirth or some other request. The ax form is surrounded by a rich blue field, suggesting that Shango is a deity associated with sky forces, but the lower portion of the figure shows roots reaching toward some deep subterranean fire. As with most African art, the deity is not imagined naturalistically. Instead, a series of visual signs and signifiers elucidate the concept of Shango.

After returning from Africa in the early 1970s, Charles Searles (born 1937) painted a series of works called *Nigerian Impressions*, translating the experience of being in Nigeria into rhythmic, patterned compositions. One of the most notable paintings in this series is *Fìlàs for Sale* (fig. 15-22). *Fìlàs* are caps usually sold by Hausa traders all over Nigeria, and a pyramidal pile of them can be seen at the bottom of the image. Abstracted human figures fill the picture field, creating a sense of rhythmic movement and activity, much as they do in Watson's *Revival Kingdom*. Patterns and mask-like images pack the space with vibrant colors and curvilinear shapes.

Fìlàs for Sale captures the sometimes overwhelming experience of an African marketplace, with vendors piling their wares in open view, people in colorful dress moving about, and the air filled with the sound of voices. The many patterns suggest the visual impact of a marketplace, but they also operate as a sort of visual equivalent for the layered polyrhythms characteristic of much African music, where drums may weave varied timbres and rhythms together in a complex

tapestry of sounds. The painting's interlocking and overlapping patterns and rhythms fill the image area, leaving no sense of negative space, an idea that may be related conceptually to the approach of the adventurous jazz saxophonist John Coltrane in the early 1960s.

Yvonne Edwards Tucker (born 1941) found a sense of her spiritual self through the earth. She says that clay talks to her about "the spiritual nature of earth and our journey on it." Along with her artist husband, Curtis Tucker (1939–1992), she developed a love for ceramics while she studied at the Otis Art Institute in the mid-1960s. There she joined the movement started by Peter Voulkos that approached ceramics as an art form rather than as a craft. She began to include philosophical and narrative elements in her works and to emphasize sculptural concerns over the kind of utilitarian concerns normally associated with ceramics.

In the early 1970s the Tuckers saw a demonstration by Michael Cardew and Nigerian potter Ladi Kwali that inspired them to change their focus from ideas and techniques derived from Chinese and Japanese ceramics to those of Africa. Yvonne Edwards Tucker traveled to West Africa in 1975, hoping to gain a fuller understanding of her African heritage and to learn more about African ceramic techniques.

Tucker's vessel *Amadlozi for Jean, Raku Spirit Vessel* (fig. 15-21) capitalizes upon certain technical innovations in raku firing techniques devised by her husband in conjunction with Nigerian potter Abbas Abahuwan at a summer workshop in Maine in 1974. Japanese in origin, raku is a

spontaneous technique where hot pots are pulled from an open kiln with tongs and plunged into a container filled with combustible materials. Putting a lid on the container creates a reduction atmosphere, resulting in a black surface on unglazed sections of the pots and unpredictable changes and variations on glazed surfaces. Afro-raku is a variation on this technique in which the clay is first bisque-fired in an electric kiln and then raku-fired in a gas kiln.

Tucker says that she has long had an interest in functional African sculpture and prefers handbuilt clay sculptural forms to functional pots thrown on a wheel. In this work, which Tucker calls a "raku spirit vessel," she improvises upon ideas of spiritual containment found in Kongo *minkisi* (see fig. 11-18) and in the

15-21. *AMADLOZI FOR JEAN, RAKU SPIRIT VESSEL.* YVONNE EDWARDS TUCKER. 1986

15-22. *FÌLÀS FOR SALE*. CHARLES SEARLES. 1972. ACRYLIC ON CANVAS, 72 X 52" (1.83 X 1.32 M). MUSEUM OF THE NATIONAL CENTER OF AFRO-AMERICAN ARTISTS, BOSTON, MA

African American practice of placing pieces of broken vessels and plates on the graves of loved ones. The wing-like forms of the lid suggest flight, yet they also have an abstract quality and texture that is purely sculptural. The work's aesthetic qualities are more important than any utilitarian role it might have, but most important is its metaphorical work suggesting spiritual and ancestral ideas.

Martin Puryear (born 1941) has taken a different, less direct approach to creating art with African references or influences. After undergraduate art studies at the Catholic University in Washington, Puryear went to Sierra Leone with the Peace Corps, where he taught English, French, and biology. He subsequently spent two years studying furniture making at the Royal Academy in Sweden, then returned to the States, earning an M.F.A. from Yale University in 1971. This wealth of diverse experience allows him to combine nuances and techniques from utilitarian craft traditions with a sophisticated and informed aesthetic sensibility.

Unlike some artists in the African diaspora, Puryear has chosen to make art that draws on various cultural traditions but does not contain obvious symbols, cultural patterns, or recognizable narratives. He creates his sculptures with organic materials, most often wood. His works can suggest the craftsmanship of basketry or furniture making, and some objects imply both forms found in nature and human craftsmanship simultaneously. Meaning in Puryear's work is not immediately apparent. One work, for example, refers obliquely to the story of a child of an African American woman and a white man who

eventually became a chief among the Crow people of Native America. Another is a form modeled after a Mongolian nomad dwelling.

In more recent years Puryear has begun to use tar in his work, as can be seen in the large sculpture *Maroon* (fig. 15-23). A large organic form covered with textured tar has a circular "lid" area made of wood, pierced by a rectangular opening that allows viewers to peer inside. The title is culturally provocative because so many Africans in the New World sought refuge from slavery by escaping to maroon communities in the hills of Jamaica or Brazil, in the forests of Surinam, or even in North Carolina's Great Dismal Swamp. *Maroon* appears to be heavy and ponderous from the outside but a glimpse inside the opening reveals that it is, in fact, hollow. The feeling of containment and secrecy created by the work is entirely appropriate for the concept, though this may or may not be what the artist intended. Puryear is most concerned with the tension between nature and culture, and like many of his predecessors of African descent in the Americas he has chosen not to acknowledge his cultural heritage directly in his art, though we can discover traces of it there.

Autobiography: Water/Ancestros/Middle Passage/Family Ghosts by Howardina Pindell (born 1943) presents another approach (fig. 15-24). Rooted in the ideas and techniques of contemporary mainstream art, it nevertheless actively acknowledges the artist's African ancestry. In this work, and in the whole *Autobiography* series, Pindell uses her personal multicultural heritage as a means of making larger statements. She addresses the horrific Middle Passage of the Atlantic

15-23. *MAROON*. MARTIN PURYEAR. 1987–8. STEEL WIRE MESH, WOOD, TAR; 6′4″ X 10′0″ X 6′6″ (1.93 X 3.05 X 1.98 M)

15-24. *AUTOBIOGRAPHY: WATER/ANCESTROS/ MIDDLE PASSAGE/FAMILY GHOSTS*. HOWARDENA PINDELL. 1988. MIXED MEDIA ON CANVAS, 9′10″ X 5′11″ (3.00 X 1.8 M). WADSWORTH ATHENEUM, HARTFORD

Numerous images and symbols can be found throughout the painting, such as the diagram of a slave ship packed with human cargo at the lower left. Pindell says that the head of the woman in the upper center represents the African woman that genetic theory points to as the ancestor of all modern humans. Violent abuse, both physical and sexual, at the hands of slavemasters, and the social and familial upheaval and fragmentation that occurred during the slave trade is suggested by the body fragments floating throughout the painting.

15-25. *SNAKE DOCTOR BLUE*. MARTHA JACKSON-JARVIS. 1989

African practices, and they have had an impact upon her art. In *Snake Doctor Blue* ceramic fragments radiate outward from a central conglomerate form of clay and copper (fig. 15-25). Since circle and spiral forms are often associated with holistic ideas, this work seems to speak about the power of traditional medicines and spiritual healing, approaches to health common during the times before the development of modern medicine and surgical techniques.

When Jackson-Jarvis creates installations of this type, the placement of various parts allows a certain degree of improvisation, so each appearance of the work is somewhat different, attuned to the specific site in which it appears. Like many of her contemporaries, Jackson-Jarvis addresses contemporary aesthetic concerns, reflects the development of ideas from her African American cultural experience, and incorporates elements from other cultures such as Far Eastern thought or Native American practices. Her art works reveal the artist's interest in nature, cultural pluralism, issues of gender, and autobiography.

Brazilian artist Eneida Assunçao Sanches (born c. 1963) approaches ritual and African cultural survivals from a slightly different perspective than do her counterparts in the United States. She believes in the *orixa* (African deities; pronounced "orisha") that are the focus of Candomblé, the African-derived religion of her native state of Bahia. Yet the racial distinctions that have become so rigid in the United States are not maintained overtly in Brazil, so Sanches, while experiencing African cultural practices most of her life, only as an adult came

to identify herself as being black. Her art work increasingly began to explore themes and imagery derived from the black culture that pervades most of Brazil and which she took for granted.

The sculpture *Jornada impressa no metal (altar de Oxossi)* expresses Sanches's deep interest in earth materials such as metal and stone, as well as her experience in Candomblé (fig. 15-26). The work is a tribute to the *orixa* Oxossi who is a hunter deity associated with the forest. A rhythmic pattern of leaf forms dominates the upper portion of the work, evoking the practice of placing fresh leaves on the ground during the performance of Candomblé ceremonies where the *orixa* are honored and asked to visit believers through possession.

Many African art works were designed to be used in rituals, but Sanches, like many of her contemporaries elsewhere in the western

15-26. *JORNADA IMPRESSA NO METAL (ALTAR DE OXOSSI)*. ENEIDA ASSUNÇAO SANCHES. 1997

slave trade and suggests that she is a product of that experience. The work is dominated by varied tones and textures of blue that imply the ocean and perhaps suggest blues music and the process of transforming pain and pathos into art. Pindell's work expresses a political consciousness rooted in very personal interpretations and a communal identification with her African American identity. Her work does not use formal or easily recognizable African references or modes of expression, but rather relies upon ideas and topics to express her identity.

Martha Jackson-Jarvis remembers observing her grandmother taking broken bits of pottery and plates to the gravesites of relatives in North Carolina when she was a child. Such customs were continuations of Central

hemisphere, has created a work that looks at rituals through art. The work suggests that the viewer is a participant in a ceremony. Historical and autobiographical narrative of the kind found in Howardina Pindell's work is passed over in favor of a memory and evocation of cultural practices, as in the work of Martha Jackson-Jarvis.

AFRICAN HERITAGE IN POPULAR AND RITUAL ARTS

African cultural practices have often continued most clearly in popular or ritual arts of the diaspora. Popular, or folk, expression emerges from the everyday lives of people who are not deeply a part of the middle class and its cultural practices. Here African ways of doing things or interpreting the world have combined with European or Native American ideas and practices. One of the more important preservatives of culture is ritual, because its insistence on fidelity to what was done before makes it resistant to change. It is possible to hear songs in African-derived religions like Santería or Candomblé still performed in African languages using their original African drum rhythms. Also, as we have seen, practices such as placing broken pottery on gravesites exhibit African customs adapted to new settings.

Many Nigerian Benin deities can be found in renovated form in the New World in religious and ritual settings. The Yoruba *egungun* spirit and masquerade continues as the *egun* in Brazil (fig. 15-27). Most commonly these masks are thought to honor ancestor spirits. The art historian Robert Farris Thompson writes that the name "also refers to an *orixa*,

Egun, the ancestor inquisitor, personification of the probing moral demands of the gods." Like some Yoruba *egungun* (see fig. 8-42), Brazilian *egun* costumes are made of layered cloth. *Egun* are further adorned with mirrors and beads whose colors link it with a particular deity. The red and white beads of the masquerade shown here link it to Shango.

Among the Yoruba, the cloth of the *egungun* costume contains and conceals the spirit within. In the same

15-27. *Egun* masquerader, Lauro de Freitas, Brazil. 1982

The beads and mirrors of this egun *costume suggest parallels with Cuban* bandeles, *richly beaded garments used to embellish* bata *drums. Cuban master drummer García Villamil claims that the mirror "reflects what will be attracted by the drum, the coming of the* orisha *in spirit possession, and what [the drum] has within, the powers of [the deities] Anyàn and Changó." Mirrors, in Kongo belief, represent the intersection between the physical and the spiritual worlds, a sort of spiritual incandescence. The costume is meant to be seen in performance, and when one considers that many shrines and altars are adorned with draped cloth in symbolic colors,* egun *also calls to mind a shrine or a ritual object in motion.*

sense, the cloth of the *egun* mask contains the spiritual force it represents. The concept is similar to the BaKongo practice of tying to contain spiritual powers, as seen, for example, in the *nkisi nkondi* nail figures from Kongo (see fig. 11-1). In Brazil, strips of colored cloth are tied around items on altars, while in Salvador, Catholic worshipers tie strips around a cross to request a blessing. Since West and Central African cultural practices overlapped and creolized in Brazil, it is very likely that the qualities and meanings of cloth from different cultural practices collaged in ritual circumstances.

L'Merchie Frazier (born 1951) spent time in Brazil in 1995 and 1996 observing and researching Candomblé rituals. Her 1996 work, *Egun/Gelede: The Vibratory Holler* (fig. 15-28) paid tribute to the *egun*

15-28. *Egun/Gelede: The Vibratory Holler.* L'Merchie Frazier. 1996. Fiber and mixed media; height 14' (4.26 m). Installation 1996, Boston, MA

masquerade ceremonies she observed on the island of Itaperica in Bahia. The ceremonies lasted for nine hours and involved drumming, dancing, offerings of food, and the performance of *egun* masquerades. The initial installation of *Vibratory Holler* was accompanied by performance activities which took place in and around it, making it a sculpture, a stage, and a ritual site all at once.

Formally the work is an abstraction of the *egun* masks. Frazier has written that the "underlying voice of the mask is the sound of the holler—that vibratory holler evoked by the pain of the Middle Passage and the rendering of love, of survival, and healing of the institutions that evolved from our wombs." Like the *egun* costumes, this work is mainly made of colored fabric. But here the cloth is translucent, revealing more than it conceals. The sheer fabric also gives the work something of the transitory, ephemeral character of a masquerade performance.

In Haiti, sequined flags called *drapo* have been employed in the service of Vodou religious worship to announce religious affiliation and spiritual militancy in devotion to deities, *lwa*. *Drapo* may have been influenced by the appliqué banners of the Fon kings of Dahomey (see fig. 8-52). They also borrowed from the ways in which European colonial masters used flags and banners. Few examples prior to 1900 exist but Monsignor Jan, a church historian, recorded that during the benediction of the Cap Haitian parish church in 1840, members of Vodou societies came with drums and banners to join the celebration. The significance of *drapo* to the societies was illustrated

between 1865 and 1867 when Hannibal Price, witness to a government campaign against Vodou, noted that flags belonging to the societies were prominent among the ritual objects destroyed.

Many contemporary flags are made of satin, velvet, or rayon and are often adorned with sequins, beads, or appliqué. As embodiments of spirit they incorporate the colors and symbols of the deity. The flag shown in figure 15-29 is organized around a graphic emblem called a *vèvè*, a ritual drawing created on the ground to evoke the *lwa*. The central point of the crossing lines of the *vèvè* here indicates a crossroads where the spiritual and physical worlds intersect, and where the spirit arrives when invoked through ritual. Patricia Polk has written that the "scrolls, curls, and

15-29. FLAG FOR MULTIPLE *LWA*. SEQUINS ON CLOTH, 43⅓" X 35" (110 X 89 CM). FOWLER MUSEUM OF CULTURAL HISTORY, UNIVERSITY OF CALIFORNIA AT LOS ANGELES

lace-work patterns of the *vèvè* constitute a fundamental means of consecrating ritual space and a basic geometry for much of Voudou's sacred art." The linear star-like forms throughout the work are derived from *nsibidi* signs from Nigeria (see fig. 10-5).

The snakes depicted on this *drapo* refer to Danbala, a deity associated with water, coolness, and wisdom. The heart forms refer to Ezili Freda, a female deity associated with love and affairs of the heart. The circular form refers to another *lwa*, Simbi, a water deity associated with healing. During the eighteenth and nineteenth centuries, campaigns to suppress the practice of Vodou led to strategies to maintain it behind the facade of Catholicism, so while *drapo* imagery can be related directly to creolized African deities, these deities may also be masked by or syncretized with a Catholic saint. Christian saints incorporated into Vodou were selected because their histories and qualities closely approximated those of a particular African deity.

In recent years the line between art and religious ritual has become less distinct. Artists have begun making works that approximate and improvise upon altars and ritual spaces, and functional altars and ritual settings have been incorporated into art publications and exhibitions. When looking at a ritual conglomeration as art, one must read its components and colors—its symbolic elements—as visual statements before examining its formal aesthetic qualities. Often such complexes are constructed by specialists or experts. The *Throne-Altar for St. Lazarus/Babalú Ayé (Obaluaiye)* by Ramón Esquivél (died c. 1993) is an excellent example (fig. 15-30).

A *trono* is an altar of enthronement and initiation, and this one with its purple satin background and central mirror has a royal formality and symmetry. Here we find evidence of African-derived religious practice that has moved from the Caribbean to the northeastern United States. Christian and African religious beliefs have been blended together through a number of symbolic elements. The sense of visual and textural splendor is created by the use of rich textiles, including the white lace forming a canopy above the altar and the gold cloth accenting the white satin covering the altar table.

The Yoruba deify pestilence under the name of Obaluaiye (Babalú Ayé in Cuba); in the New World he became associated with the Catholic St. Lazarus (San Lázaro). Robert Farris Thompson writes that Obaluaiye's

15-30. *Throne-Altar for St. Lazarus/Babalú Ayé (Obaluaiye).* Ramón Esquivél. Union City, New Jersey, 16–7 December, 1986

moralizing purpose is to instill a sense of social conscience. "Obaluaiye, lame, was driven mad by persons making fun of his infirmity, whereupon he took out a broom and some sesame seeds (*iyamoti*) and swept the seeds into the air, charging the atmosphere with fever and epidemic. Thus he warns you not to make fun of the afflicted or of the poor, for 'little people' can exact vengeance." Obaluaiye is more than just a deity of fever and disease. He also is a god who punishes evil-doers and the insolent. According to Thompson, he is an incarnation of "moral retribution." The bowls of popcorn in the shrine refer to the seed imagery of the Obaluaiye story.

Lazarus was raised from the dead by Christ, and Catholic chromolithographs show him on crutches, his body marked with signs of leprosy, the disease that killed him. He eventually became the Bishop of Marseilles and therefore has been associated with a bishop's purple robes. However, the scars on his body allowed him to be linked with small-pox and Obaluaiye's connection to epidemics.

Houston Conwill (born 1947) was one of the earliest African American artists to produce work based upon African ritual. While doing graduate study at the University of Southern California, Conwill became interested in tracing ideographic marks on the ground—joining a larger artistic trend of studying sites and nature—and preserving them in latex castings. To his fascination with the earth he added an interest in linking African histories and practices with contemporary America. His 1978 *Juju Installation*, which

included a ritual performance by the artist, shows the blending of these interests (fig. 15-31).

Conwill spent time in the Air Force, and *Juju Installation*, as it has been photographed here, shows the sense of mapped or aerially photographed territory that he developed through flying. From above one can see the large circle that defines the space and encloses several smaller circles and one large rectangular form. Sand and stones form the ground (or background) of the work which is organized visually by the rectangular piece of cloth laid across the sand. Lacking tall structures and not dependent upon walls, the work has a sense of existing in an open space that easily could be seen from above.

The two major elements in *Juju Installation* are the stool structure pictured to the left and the circular container opposite on the cloth to the right. The stool is a reference to the stools of authority and kingship of the Asante/Akan peoples of Ghana (see fig. 7-3). Metaphorically these stools embody the interests and sanctioned authority given by a community to their ruler, and they are adorned with designs and patterns full of meaning that is not readily decipherable by outsiders. Conwill has adorned his stool with ideographic marks of the kind he had been inscribing in the earth.

The item across from the stool is a gut bucket. In the African American South gut buckets were used to contain the entrails of slaughtered animals. The term became a vernacular reference to something very basic or fundamental in black life and even came to describe a certain mode of blues music. To this one Conwill has added Kongo *nkisi* bags, textures, and ideographic marks both inside and outside. By including this particular item in the installation he has linked an African royal icon with the most basic and vernacular African American symbol; the new and old worlds have been connected. The bloody, gut-wrenching experience of slavery's Middle Passage has been incorporated into the lore of African peoples and made iconic in a sacred ritual space.

James Hampton (1909–64) did not consider himself to be an artist, but his signature work is an object of creative imagination and expression. After a stint in the United States Army during the Second World War, Hampton returned to Washington, D.C. and worked as a janitor in the General Services Administration from 1946 until his death. He lived alone and was driven by a private religious vision that was revealed after he died when his work, *The Throne of the Third Heaven of the Nations Millennium General Assembly*, was discovered in a garage he rented (fig. 15-32).

Consisting of 180 individual objects, the work reaches up to ten and a half feet in height and covers a width of twenty-seven feet. Hampton worked on it for over fourteen years, incorporating various found objects, old furniture, wooden planks, cardboard cutouts, insulation board, old light bulbs, jelly glasses, mirror fragments, and a variety of other materials. All of the surfaces are covered with gold- or silver-colored tinfoil. No plans for the work were ever found; Hampton said that God told him what to do on a nightly basis. The ensemble suggests a chancel with an altar, a throne, offertory tables, pulpits, chairs, various crowns, and objects of Hampton's own invention. Wings sprout everywhere, and combined with the flashing metal foil they create a sense of Hampton's private heavenly vision.

15-31. *Juju Installation*. Houston Conwill. 1978. Mixed media performance/installation

15-32. *Throne of the Third Heaven of the Nations Millennium General Assembly.* James Hampton. c. 1950–64. 180 pieces of mixed media, 10½ x 27 x 14½' (3.20 x 8.23 x 4.42 m). National Museum of American Art, Smithsonian Institute, Washington, D.C.

The work seems to have been inspired by the New Testament book of Revelation. To many of the objects Hampton attached labels that refer to the millennium and to the twentieth and twenty-first chapters of Revelation, which describe the first resurrection, the judgment of the dead before God, and the new heaven and earth. The metal foil here functions similarly to the sequins of a Haitian *drapo*, creating a sacred space shining with spiritual presence, and the ensemble as a whole, considered as a welcoming space for the divine, unknowingly echoes the *trono* altars. Any rituals that may have taken place there were private and we have no information to indicate what Hampton's plans for this work might have been.

Some artists in the diaspora have focused their creative expression to create objects that are both utilitarian

15-33. *Bristle Sprout.* Sonya Clark. 1996. Cotton, linen, copper nails, glass beads

and artistic. Sonya Clark is one such artist. In many West African cultures, the head is regarded as the most important part of the human body because it is the seat of thought, moral strength, spiritual presence, and personality. This outlook is the foundation for what is known as African proportion in sculpture where the head is larger than would be normal for the body below. Often the head and face are also more developed than the limbs and extremities of the body.

Clark has made headwear that improvises upon African hats and caps, and African and African-American hairstyles. Many of her creations have sculptural qualities that draw attention to the head of the wearer. *Bristle Sprout* (fig. 15-33) suggests that the head is a germinating seed, and it makes references to the Yoruba *orisha* Eshu, a deity who also appears in New World religions such as Vodou, Santería, and Candomblé. Eshu is a trickster deity, and a messenger who travels between earthly and spiritual realms. The conical form emerging from the cap's center is based on iconography associated with representations of Eshu, and the spikes bristling from the surface, true to Clark's Trinidadian heritage, are a bawdy reference to phallic imagery (compare figs. 8-32, 8-33). For those unfamiliar with the Yoruba/Caribbean significance of Eshu, Clark has provided a playful title that is a pun on brussel sprout, a vegetable with a cabbage-like head. Her use of inventive forms and bright colors make this work, like all her creations, a strong statement of cultural identity.

15-34. *SHOTGUNS*. JOHN BIGGERS. 1987. OIL AND ACRYLIC ON CANVAS, 48 X 72" (1.57 X 1.82 M). PRIVATE COLLECTION

The flock of birds soaring upward in the upper right of the painting, according to Alvia Wardlaw, "suggests a spirituality in the community which sustains the necessary resolve for a people's continuity." Perhaps in an interesting coincidence, among the Yoruba birds often appear in art to refer to the spiritual imperatives of women. Their appearance atop the beaded crowns of Yoruba kings, for example, shows that spiritually empowered women must sanction male authority for it to be legitimate (see figs. 8-18, 8-20).

15-35. *FETISH NO. 2.* RENÉE STOUT. 1988. MIXED MEDIA, HEIGHT 5'3" (1.60 M). DALLAS MUSEUM OF ART. METROPOLITAN LIFE FOUNDATION PURCHASE GRANT

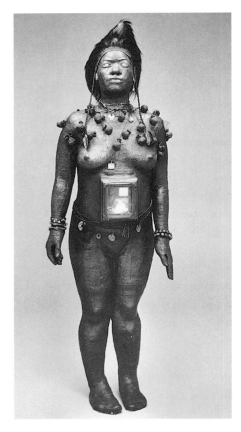

FIVE CONTEMPORARY ARTISTS

John Biggers (born 1924) was one of the first African American artists to visit West Africa, traveling to Ghana in 1957. He combined African patterns and a symbolic approach to imagery with rounded figures and spatial depth. He came to terms with his own African heritage and discovered that his experiences growing up in America had certain resonances with African life. In the later stages of his career, Biggers was able to blend his sense of both worlds in his paintings and murals.

Biggers grew up in Gastonia, North Carolina, and many of his art works draw upon his early years there. *Shotguns* is one of a series of works that pay tribute to these iconic architectural structures that are so familiar to him (fig. 15-34). He uses this architectural reference as a foundation for a further tribute to the mothers and grandmothers who sustained him and so many families of the community during harsh times.

The houses have been clustered to form a pattern that seems to be derived from Kuba cloth, but might also suggest the geometry of a quilt (see fig. 11-58). Five stylized women stand on the front porches of the work in frontal formal poses that seem similar to the stalwart mother in Johnson's *Forever Free*. Their poses and mask-like faces link the women to African sculpture, which often is meant to be seen from the front and in which the face is often stylized or abstracted.

Railroad tracks run in front of the houses and, like Bearden's collage *The Prevalence of Ritual*, speak to racial segregation and the rail line that often divided black and white communities.

*A mojo is an art of casting
spells or "working roots,"
or a charm or other object
used for that purpose. This
work addresses
transformative potentials
and histories rooted in
African spiritual belief.
Most of the symbols in the
work have spiritual and
cosmological meaning, or
are evidence of a belief in
material forms that can
influence immaterial
forces. The visual effect of
the colors and complex
patterns in the work is one
of high-energy music.
Perhaps Phillips was not
trying to approximate the
drumming used in ritual
but was creating a jazz riff
on the blues lyric "I got
my mojo workin'."*

object, and a fascinating sculpture. A
nkisi is created by a ritual expert,
nganga, for a client and activated
through rituals to become a vessel for
the spirit that is called to do the
client's bidding. Stout has cast herself
as an artist and ritual expert creating
the object, the client who has commis-
sioned it, and the object itself. Not
only has she engaged what is African
in her deeper sensibilities, but she has
placed herself within a concept that is
African.

James Phillips (born 1945) was
born in Brooklyn, grew up in Philadel-
phia and Virginia, but has lived and
worked in New York, Washington, the
bay area of California, and Japan. His
art blends African elements with New
World expressions such as jazz and
occasional Asian visual elements, an
approach that reflects an awareness of
his African heritage even as it insists
on his status as a citizen of the modern
world aware of many cultural
traditions.

Phillips's works use patterns,
often improvised from Kuba cloth,
symbols and imagery from various
parts of Africa, and high-affect colors.
His 1987 painting *Mojo* shows the
complexity Phillips has developed in
his work (fig. 15-36). The central fig-
ure is a double-faced image suggesting
the ability to see into two worlds. A
Ghanaian *adinkra* symbol known as
gye nyame ("fear only God") is at the
summit of the central row of images
and reappears several times below (for
adinkra, see fig. 7-16). The four gun
images, symbols of protection, are also
of Ghanaian origin.

Egyptian symbols are sprinkled
throughout the painting, including
Nut, the sky goddess, who appears
inside the large double-faced figure at

Tracks also suggest the mobility
offered by railroads as blacks in the
United States left the South, migrating
northward and westward in several
waves during the twentieth century.

Renée Stout (born 1958) grew up
in Pittsburgh, and two elements from
her childhood there have rippled for-
ward into her mature art. One was the
presence in her neighborhood of a spir-
itualist and seer who called herself
Madam Ching. Stout developed a
curiosity about the woman, and
subsequently about spiritualists, mys-
tic powers, and transformative objects.
The other element was a Kongo *nkisi*

nkondi nail figure she saw in her local
museum when taking Saturday art
classes there (see fig. 11-18). After art
studies at Carnegie Mellon University,
where she became a photo-realist
painter, these memories resurfaced
insistently, leading her to create sculp-
tures such as *Fetish No. 2* (fig. 15-35).

Fetish No. 2 was created as a pro-
tective charm for the artist. She drew
upon her knowledge of African *nkisi*
complexes, some folk mysticism that
occasionally surfaced in her family
experience, and her interest in spiritual
realms outside the Christian church.
The work is a self-portrait, a ritual

the center. Egyptian benue birds, symbols of renewal or resurrection, appear on either side of the central panel at the bottom. Their presence creates a sense of transparency in the vertical zigzag lines running through them, and thereby a sense of spatial depth.

Though this work has a geometric logic in its design, a close look shows that the small rectangular areas on either side are not symmetrical. Many are slightly offset, creating an asymmetrical rhythm. These structural variations along with color and tonal changes are part of the artist's effort to make the work musical in the same sense that jazz artists John Coltrane and Charlie Parker created horn solos whose organization was fundamentally rhythmical despite the play and innovation with modes or chords.

Cuban-born artist José Bedia (born 1959) has no known African ancestry, but he grew up with an Afro-Cuban cultural and religious background, and was influenced and inspired by Wilfredo Lam. In 1976, when Bedia was a teenager, his mother took him with her during her visits to a priest of the Afro-Cuban religion known as Palo Monte. The name of the faith refers to "trees of the sacred forest," and it has Kongo roots. In Haitian Vodou the two primary African sources are Dahomean Rada (which includes Yoruba ideas) and Kongo Petwo. In Cuba these two sources form two separate religions, the Dahomey/Yoruba-based Santería and Kongo-based Palo Monte.

In 1983 Bedia applied for initiation in Palo Monte. During the night of initiation Kongo cosmograms were drawn on his back in white for protection. Seven signs including crosses and parallel lines were finely cut into his chest. Bedia says, "Before my initiation, my art was essentially photographic anthropology. But after entrance into Palo I began to make drawings, lots of drawings, with a deliberately down-to-earth line."

Another influence was a series of conversations and visits he had with Wilfredo Lam in 1980 while Lam was in a Cuban hospital recovering from a serious illness. Lam told Bedia to ponder the lean, spare forms of Bamana headdresses and this seems to have contributed to the elongated stylized figures that developed in Bedia's subsequent drawings and paintings.

A great deal of Bedia's work is built around linear graphic images. Often his canvases are shaped, as can be seen in the 1993 work *Lembo brazo fuerte* (fig. 15-37). The canvas is shaped like the lower portion of a circle or the silhouette of a pot or calabash. The background of the work is a reddish brown and the linear forms are either light yellow or white. It reads like a banner with symbols and printed text.

The art historian Judith Bettleheim indicates that in Cuban culture most things are cross-referenced and may have layered or fluid meanings, so Bedia's title and imagery for this work must be read cryptically. *Lembo*, as understood in Cuba, is a KiKongo word for "arm." *Brazo fuerte* means "strong arm" in Spanish, but also refers to a Palo spirit. The plant associated with this spirit is the *marabú*, represented in the center of the painting. The dominant image in the work is a bent arm which doubles as a switchblade knife that is cutting a piece of the *marabú* for placement in a ritual pot. The head depicted in profile within the knife is the artist's, a signature device that appears in all his work. The metal of the knife also suggests the Rada deity of Ogou, a spirit associated with justice, or any spirit associated with metal.

15-37. *LEMBO BRAZO FUERTE*. JOSÉ BEDIA. 1993. ACRYLIC AND OIL STICK ON CANVAS; 6'11" X 14'2" (2.1 X 4.32 M). GEORGE ADAMS GALLERY, NEW YORK

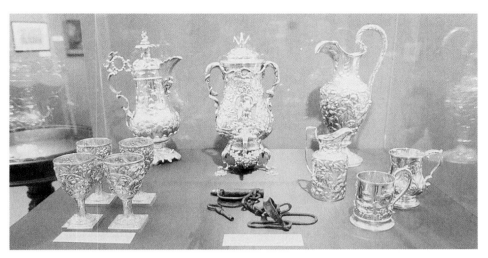

15-38. *Mining the Museum*. Fred Wilson. 1992. Slave manacles introduced into a display of 18th-century metalwork. Installation at the Maryland Historical Society, Baltimore

The linear imagery on a flat background alludes to a system of cosmograms used in Palo Monte known as *firmas*, which are similar to the *vèvè* of Haitian Vodou. Like a Dogon *dama* masquerade performance (see chapter 5), the meanings within Bedia's work become increasingly apparent the deeper one is initiated into the system behind it.

Though Bedia is not of African ancestry, the African qualities of his work point up the significance of culture in making distinctions between people and the ways they see the world. Racial definitions function very differently in the United States than in places like Cuba or Brazil where whites have practiced African religions since the nineteenth century. The creolization of various European, African, and Native American cultures have led to complex expressive forms in the Caribbean and South America and a general acceptance of fluid, layered definitions and practices. Bedia's work, like that of Wilfredo Lam and Eneida Sanches, reflects these complex mixtures. His racial heritage does not prevent him from making art of the African diaspora.

African American artist Fred Wilson (born 1954) has created several fascinating installations calling attention to issues surrounding art and museums. *Mining the Museum* was created at the Maryland Historical Society in Baltimore in 1992 (fig. 15-38). Wilson went through the displays of objects and paintings from colonial Maryland in the Society's collection and inserted artifacts relating to slavery, such as the manacles pictured among the silver here, or repositioned paintings with black servants in them so that the works containing black subjects were more prominent. Every item used in Wilson's re-installation of the Historical Society's displays was from the permanent collection of the institution.

Wilson was making visible the slavery behind the colonial culture that has been so well represented in American museums and historical collections. In doing this he was creating a tension by juxtaposing the brutal artifacts of human bondage with the delicately crafted artifacts of the upper class. The wealth and status that made the ownership of such artifacts possible was itself made possible by the system of slavery which generated the wealth. Wilson also was questioning the collection policies of public institutions which seemed to ignore the large black populations that also were a part of the history of the United States. Often the African presence in the early United States has been marginalized in paintings in which blacks inhabit the edges and backgrounds of the work as servants, or the artifacts of slavery have been segregated from other colonial objects.

Wilson helps point up the interdependence of Europeans and Africans in the western hemisphere as they formed the hybrid and creolized cultures we take for granted today. Many of the art practices used by the artists discussed in this chapter differ significantly from the types of art created in the African societies of their historical origins. Yet many artists in the Americas have drawn upon the residue of various African cultural practices still active in whole or in part in the communities in which they grew up.

Objects from early in the period of slavery, such as the drum from the seventeenth century that opened this chapter, were not much different from their counterparts in Africa. However, as time went on in the New World, the collision of European and African cultural practices in a completely new setting led to the development of new artistic forms that suited the new context. The art of the African diaspora is a rich, diverse range of expression. The work discussed here is a sampling, not a survey, of what has been done.

Glossary

academic Term applied to artists who have received formal training in art institutes or other schools based upon European models.

adobe (derived from Arabic) The technique of building with sundried bricks, usually made of earth and other materials.

Afro-Asiatic languages A family of languages found in Africa and western Asia, including Arabic, Hebrew, Berber languages, and Cushitic languages such as Hausa and Somali.

afterlife The realm inhabited by the dead, often seen as a parallel world to that of the living.

age-grade associations Groups of men (and sometimes women) with the same social (assigned) age, who share experiences such as initiations or military service.

ancestor In much of Africa the term is reserved for particularly powerful individuals whose memory is kept alive through several generations. Ancestors reside in a spirit world and are thought to influence the world of the living: they can ensure the well-being and fertility of the living and punish them for breaching different ritual prohibitions.

androgyny Either the condition of being without gender, or combining male and female features (bisexuality). Androgynous beings often appear in African creation myths.

anthropomorphic Of human form or personality; used here to describe masquerades and other art forms depicting human-like characters.

appliqué Stitching shapes cut from textile onto another fabric.

Bantu A group of languages in the Niger-Congo family, spoken from Cameroon to Kenya and South Africa.

baraka (Arabic) Spiritual power or blessing that may be gained from people, art objects, substances, colors, or motifs. Many Islamic practices are based upon the desire for *baraka*.

bards Musicians and poets who act as praise singers and story tellers. In some regions they form an endogamous group with a status similar to that of blacksmiths.

barkcloth Textile made from the inner bark of certain trees. Lengths of bark are beaten to the desired thickness, and may then be bleached, dyed, embroidered, or sewn.

batik Textiles and art forms made with the wax resist technique; wax covers the areas to be left uncolored during the dying process.

blacksmiths Iron workers (usually male) whose female relatives are often potters. They are often members of an endogamous group, and may be the sculptors and ritual specialists of their communities.

calabash Gourd which can be specially prepared for use as a durable, lightweight container, and may be beautifully decorated.

camwood Red wood known also as barwood. In powdered form, camwood is used both as a dye and a cosmetic. Camwood is rubbed on sculptural forms in many areas, providing a reddish coloration.

Chadic languages Large and varied language groups within the Afro-Asiatic family: Somali is an Eastern Chadic language and Hausa a Western Chadic language.

chip carving A technique that involves chipping small pieces out of the surface of a piece of wood to form patterns in shallow relief.

circumcision An operation whereby the foreskin is cut away from the penis. The operation is mandatory for Muslim and Jewish boys. It is practiced in many other contexts at puberty.

cliterodectomy See excision.

copal A resin drawn from certain tropical trees and used in varnishes.

cosmology System of belief concerning the creation and nature of the universe.

cowry (cowrie) shell A glossy white oval seashell with a slit-like opening, once used both as a currency and an adornment in much of Africa.

crest mask A headress with a vertical superstructure worn during a masquerade.

cut-pile embroidery Cut loops of fiber which have been tightly sewn into a textile in order to create a type of velvet.

divination A process by which the unknown is determined through the invocation of spiritual entities and the manipulation of potent objects and formulae.

excision/cliterodectomy An operation removing part of a girl's genitals. Some African cultures regard it as the female equivalent of circumcision.

figurative Representational, depicting a recognizable animate or inanimate subject. Non-figurative or non-representational images are completely abstract.

finial Ornamental attachment placed on top of a staff, umbrella, etc.

headrest A supprt for the neck and head of a sleeper; once used by many African peoples instead of a pillow.

helmet mask Headdress covering the entire head of the masquerader; a horizontal helmet mask has jaws extending forward in space, and (usually) horns projecting behind the mask.

hieratic Priestly. In art, a style bound by religious conventions.

iconography The study of the meaning of images.

ifa A divination process believed to have been instituted by Orunmila, the Yoruba *orisha* of destiny. Through *ifa*, diviners interrogate the spirit world on behalf of their clients so that they may know their destiny. The procedure involves throwing 16 palm nuts upon a divination board. Diviners pair these nuts and read the resulting 8 signs. There are 256 configurations in all and each is associated with a body of oral literature. After these texts and poems have been elicited through *ifa*, clients interpret them in the light of their own circumstances and concerns.

initiation The ceremonial process allowing men and women to assume a new status, such as adulthood, membership in an association, or assumption of a high political office. (See Aspects of African Culture: Rites of Passage, pages 424–5)

kaolin A fine-grained, white clay used in many religious contexts.

liminal/ity The state of being "in between" in ritual contexts. (See Aspects of African Culture: Rites of Passage, pages 424–5)

linoleum block print Relief print made by carving an image out of a linoleum surface, inking the linoleum and pressing it onto paper. The finished print resembles a woodcut.

lost wax A casting technique widespread in Africa. (See Aspects of African Culture: Lost-Wax Casting, page 234)

low relief (*bas-relief*) A surface with images that project only slightly into three-dimensional space; much more common in Africa than high relief (where projecting images are almost three dimensional).

magic square A geometric shape, usually divided into equal sections, based upon the correspondence between letters and numbers in Islamic philosophies. Images containing these squares are seen as offering mystical protection to Islamic and non-Islamic owners.

Mande languages A closely related group of Niger-Congo languages; Mande is often used to refer to the peoples (such as the Bamana and Jula) who speak them.

mihrab Niche in the *qibla*, the wall of a *mosque* (Muslim place of worship) which orients the worshipper toward the direction of the holy city of Mecca in Arabia.

negative relief An image cut into a flat surface so that it is lower than the surrounding background.

Niger-Congo languages An important family of languages which includes the Bantu languages and most language groups spoken in West Africa.

Nilo-Saharan languages A diverse language family which includes languages spoken by the Kanuri, the Maasai, and the people of ancient Nubia.

nkisi (pl. *minkisi*, Congo Basin) Often glossed as "sacred medicine," the term designates any number of objects thought to contain spiritual power. This power is tapped for purposes of divination, healing, and protection from evil and is used to ensure success in hunting, trade, sex, warfare, etc.

nsibidi An ideographic form of writing developed along the Cross River region of modern Nigeria.

open-work A sculpture that achieves its effect by obstructing the passage of light. The term is generally applied to such ornamental items as window frames, railings, and balustrades.

orisha In Yoruba, a deity. The Yoruba "pantheon" counts several hundred *orisha*. Not all have the same importance in all Yoruba communities, and new *orishas*

continue to manifest themselves to the human community.

patina The surface texture an object acquired from years of use.

polychrome Multi-colored; an object of a single color is monochrome.

positive form The shapes and images perceived as primary by the eye; the background or surrounding space is negative form.

qibla See *mihrab*.

raffia cloth Fabric made from the fronds of the raffia palm.

rock art Generic term for images painted or engraved on rock faces.

sacred kingship The practice of associating a ruler with a deity, or regarding him or her as a spiritually potent being. In many cases, the welfare of the state is linked to the health and prosperity of the ruler.

second burial A celebration held months, sometimes years, after a prominent person's internment. The ceremony is an occasion for vast expenditure and affirms the status of

the deceased in both this and the other world.

soapstone An opaque rock which is soft when first exposed to air and therefore relatively easy to carve.

tempera paint Paint made by mixing pigments with water and gum, glue, or egg.

terracotta Baked or fired clay.

tourist art Art objects made for sale to outsiders rather than for local use.

vodun (Fon) Supernatural powers that can be honored and petitioned as specific deities. Similar words refer to religious practices in the Americas which are based in part upon the worship of vodun in Africa.

wilderness In much of Africa, people operate a clear distinction between the civilized world of the village, town or camp, and the wilderness, which is associated with a variety of powerful and dangerous spirits.

zoomorphic Of animal form or character; used here to describe masquerades and other art forms depicting animal-like characteristics.

Annotated Bibliography

Abbreviations

AA African Art

ArtJ Art Journal

GENERAL

The art of the entire African continent is surveyed in *Africa: The Art of a Continent* (Munich, 1996), but without examples of contemporary art, and in J. Perani and F. Smith, *The Visual Arts of Africa: Gender, Power and Life-Cycle Rituals* (1997). S. L. Kasfir, *Contemporary African Art* (London, 2000) surveys the last 50 years. Almost all other books exclude the Maghreb and the Nile Valley. Of these, F. Willett's *African Art* (London, 1971) has stood the test of time as an introduction to the study of African art; the 1993 edition contains an updated bibliography. *Art of Africa*, by J. Kerchache, J.-L. Paudrat, and L. Stephan, is lavishly illustrated, but portions of the text are problematic. J.-B. Bacquart, *The Tribal Arts of Africa* (London, 1998), divides sub-Saharan Africa into 49 cultural areas. Many excellent exhibition catalogs feature scholarly essays on specific West African and Central African art objects in European and American collections. One of the best is *For Spirits and Kings* (New York, 1981), ed. S. Vogel.

PREFACE

R. Sieber's comment on understanding African art is from his "The Aesthetics of Traditional African Art," in *Art and Aesthetics in Primitive Societies*, ed. C. F. Jopling (New York, 1971): 127. For the translation of Yoruba names see N. Akinnaso, "Yoruba Traditional Names and the Transmission of Cultural Knowledge," *Names: Journal of American Name Society* 31:3 (1983): 148. The collector's comment on the anonymity of African art is quoted from S. Price, *Primitive Art in Civilized Places* (Chicago, 1989): 103. For Olowe's *oriki* see R. Walker, "Anonymous has a Name: Olowe of Ise," in *The Yoruba Artist: New Theoretical Perspectives on African Art*, ed. R. Abiodun, H. J. Drewal, and J. Pemberton III (Washington, 1994): 100–102; copyright @ 1994 by the Smithsonian Institution. Used by permission of the publisher. The Yoruba saying is from O. Owomoyela, *The Wit and Humor of the Ages: A Treasury of Yoruba Proverbs* (forthcoming). G. Blocker's quotation is taken from his "The Role of Creativity in Traditional African Art," *Second Order: An African Journal of Philosophy* 2:1–2 (1982): 12. See also R. Abiodun, "A Reconstruction of the Function of *Ako*. Second Burial Effigy in

Owo," *Africa: Journal of the International African Institute* 46:1 (1976): 4–20; "Verbal and Visual Metaphors: Mythical Allusions in the Yoruba Ritualistic Art of *Ori*," *Word and Image: A Journal of Verbal/Visual Enquiry* 3:3 (1987): 252–70; and "*What follows Six is more than Seven*": *Understanding African* Art (London, 1995).

INTRODUCTION

For further discussion of the European reception of African art, see S. P. Blier, "Enduring Myths of African Art," in *Africa: The Art of a Continent: 100 Works of Beauty and Power*: 26–32; "Imaging Otherness in Ivory: African Images of the Portuguese circa 1492," *The Art Bulletin* 75:3 (1993): 383–6; and "Art Systems and Semiotics: The Question of Art, Craft, and Colonial Taxonomies in Africa," *American Journal of Semiotics* 6:1 (1988–9): 7–18. Anthropomorphism in architecture is explored in Blier, "The Anatomy of Architecture: Ontology and Metaphor," in *Batammaliba Architectural Expression* (New York, 1987). Innovation in royal art forms is discussed in Blier, *The Royal Arts of Africa: The Majesty of Form* (UK title: *Royal Arts of Africa*) (New York/London, 1998). The art of the Fon is the

subject of Blier, *African Vodun: Art, Psychology, and Power* (Chicago, 1995).

CHAPTER 1

Archaeological evidence for dating art of the central Sahara may be found in F. Mori, *Tadrart Acacus. Arte rupestre e culture del Sahara preistorico* (Turin, 1965), and in B. Barich, *Archaeology and Environment in the Libyan Sahara: The Excavations in the Tadrart Acacus 1978–1983*, Cambridge Monographs in African Archaeology 23/BAR International Series 388 (1987). For a different chronology, see A. Muzzolini's entry in *UNESCO General History of Africa*, ed. G. Mokhtar, vol. 1 (Berkeley, 1990). For the ancient Berbers see G. Camps, *Berberes. Aux marges de l'histoire* (Paris, 1980), and *Die Numider. Reiter und Koenige noerdlich der Sahara*, ed. H. G. Horn and C. B. Rueger (Bonn, 1979). The photograph of the woman from Sous was taken by J. Besancenot, whose *Costumes of Morocco* (London, 1990) was a useful source. Quotations from Ibn Battuta are taken from the translation by S. Hamdun and N. King, *Ibn Battuta in Black Africa* (London, 1975). Diagrams of Moroccan *tigermatin* were taken from J. A. Adam, *Wohn- und Siedlungsformen im Sueden Marokkos* (Munich, 1981). For interpretations of the murals at Walata see J. Gabus, *Au Sahara. Vol II: Arts et symboles* (Neuchatel, 1958). J. Schacht, "Sur la diffusion des formes d'architecture religieuse musulmane à travers le Sahara," in *Travaux de l'Institut de recherches sahariennes* XI (Algiers, 1954): 11–27, discusses links between the Saharan oases and the inland Niger delta.

There are no reliable and up-to-date surveys of Saharan rock art in English as of this writing. The best general source of images and information is in German: K. H. Streidter, *Felsbilder der Sahara* (Munich, 1984). Beautiful photographs of art from Tassili are available in J.-D. Lajoux, *The Rock Paintings of Tassili* (London, 1963). P. MacKendrick, *The North African Stones Speak* (Chapel Hill, 1980), surveys the history of the region from the 9th century BC to the 6th century AD, and includes some illustrations. M. Brett and E. Fentress, *The Berbers* (London, 1996), illustrate and describe Berber art from this period. A recent catalogue *From Hannibal to Augustine* (Richmond, 1995) features the art of ancient Carthage. There are many excellent surveys of Islamic architecture which cover a wide variety of African and non-African religious and domestic buildings. One of the most inclusive is *Architecture of the Islamic World. Its History and Social Meaning*, ed. G. Michell (London, 1978), while *Maghreb Medieval. L'Apopée de la civilization islamique dans l'occident arabe*, ed. F. Gabrieli (Aix-en-Provence, 1991), illustrates buildings from the Maghreb and the northern Sahara. Fine photographs may also be found in J.-L. Bourgeois and C. Pelos, *Spectacular Vernacular. The Adobe Tradition* (New York, 1989), and in N.

Carver Jr., *North African Villages. Morocco, Algeria, Tunisia* (Kalamazoo, n.d.). Surveys of daily arts of the Maghreb are rare. J. d'Ucel, *Berber Art: An Introduction*, is useful for its illustrations. E. Westermarck, *Ritual and Belief in Morocco* (London, 1926), is the best account of the context of northern Berber art. *African Nomadic Architecture*, ed. L. Prussin (Washington, 1995), is an excellent source on Saharan tents, while C. Spring, *North African Textiles* (Washington, 1995), surveys weaving from Morocco to Ethiopia. Dozens of artists from the Maghreb are covered in "Afrique mediterranéenne. Afrique noire," *Revue noire* 12 (March-April-May, 1994), and Chaibia Tallal is featured in B. LaDuke, *Africa through the Eyes of Women Artists* (Trenton, 1991).

The author is grateful to Labelle Prussin for her comments, and to Jean Polet for advice on archaeological material presented throughout this chapter. Barbara Blackmun patiently read several drafts of many chapters, including this one.

CHAPTER 2

The line from "The Negro Speaks of Rivers" is from *Collected Poems* by Langston Hughes. @ 1994 by the Estate of Langston Hughes. Reprinted by permission of Alfred A. Knopf, a Division of Random House Inc. For information on pre-Islamic Nubian art see *Africa in Antiquity*, vol. 2, ed. S. Wenig (New York, 1978). The first effort to discuss the art of Kemet as African art is in *Egypt in Africa*, ed. T. Celenko (Indianapolis, 1996). Many recent sources on the art of Kemet approach this rich material in new ways. A challenging set of questions concerning the Narmer Palette is raised by W. Davis, *Masking the Blow* (Berkeley, 1992). Contemporary scholarship informs E. Hornung, *Idea into Image. Essays on Ancient Egyptian Thought* (trans. E. Bredeck; New Jersey, 1992), while a summary of current art historical research is given by R. S. Bianchi, "Ancient Egyptian Reliefs, Statuary and Monumental Paintings," in *Civilizations of the Ancient Near East*, IV, ed. J. Sasson (New York): 1533–54. The possibility that Akhenaten and other kings wished to be depicted as bisexual is raised by A. Kozloff and B. Bryan, *Egypt's Dazzling Sun: Amenhotep III and his World* (Cleveland, 1992), but the sexual implications of funerary paintings from Waset are more fully explained in G. Robins, *Women in Ancient Egypt* (London, 1993). For the cosmology of temple architecture see S. Quirke, *Ancient Egyptian Religion* (London, 1992). Ancient names for the cities of Kemet and dates of dynasties were taken from J. Baines and J. Malek, *Atlas of Ancient Egypt* (Oxford, 1980). Plans of the palaces at Axum are from *Axum*, ed. Y. M. Kobishchanov and J. W. Michels (trans. L. T. Kapitanoff; University Park, 1979). Most information on the art history of the Ethiopian highlands comes from M. Heldman, *African Zion. The Sacred Art of Ethiopia* (New Haven, 1993). The art and life of the Egyptian Nubians displaced by the Aswan Dam are

discussed in *Nubians in Egypt. Peaceful People* (Austin, 1973), and the former homes of the Sudanese Nubians are illustrated in M. Wenzel, *House Decoration in Nubia* (London, 1972). Healing scrolls which inspired the work of Gera are described in J. Mercier and H. Marchaudi, *Le roi Salomon et les maîtres du regard: Art et medecine en Ethiopie* (Paris, 1992). For information on contemporary artists from Sudan and Ethiopia see *Seven Stories about Modern Art in Africa* (London/Paris, 1996). Quotations from Amir Nour are from S. H. Williams, *Mohammad Omer Khalil, Etchings; Amir I.M. Nour, Sculpture* (Washington D.C., 1994).

An excellent introduction to the art of Kemet is G. Robins, *The Art of Ancient Egypt* (London, 1997). Also highly recommended are R. H. Wilkinson, *Reading Egyptian Art. A Hieroglyphic Guide to Ancient Egyptian Painting and Sculpture* (New York/London, 1992), and his *Symbol and Magic in Egyptian Art* (New York/London, 1994). A. Badawy, *The Art of the Christian Egyptians from the Late Antique to the Middle Ages* (Boston, 1978), is a basic reference for Coptic art. The important role played by Egypt in the development of Islamic art in North Africa and Asia is discussed in R. Ettinghausen and O. Grabar, *The Art and Architecture of Islam 650-1250* (London, 1989), and in J. Bloom and S. S. Blair, *The Art and Architecture of Islam 1250-1850* (London, 1994). See also R. Hillenbrand, *Islamic Art and Architecture* (London, 1999). D. O'Connor, *Art of Nubia* (Philadelphia, 1993) is an excellent concise survey of ancient art from this region. J. Kennedy, *New Currents, Ancient Rivers* (Washington, D.C., 1992), discusses several generations of artists from Sudan and Ethiopia.

The author wishes to thank Gay Robins for her generous and detailed critique of the sections on ancient Egypt.

CHAPTER 3

Y. I. Bityong, "Culture Nok, Nigeria," in *Vallées du Niger* (Paris, 1993): 393–415, provided recent data on Nok terracottas; several examples of terracottas clandestinely removed from northern Nigeria are illustrated in R. A. Bravmann, "Sahel and Savanna," *Africa, Art of a Continent*, chapter 6. B. Gado reports on his excavation of the Asinda-Sikka site and the Bura terracottas in " 'Un village des morts' à Bura en Republique du Niger. Un site methodiquement fouillé fournit d'irremplacables informations," *Vallées du Niger* (Paris, 1993): 365–74. Information on terracottas from the region south of Lake Chad was taken from G. Connah, *Three Thousand Years in Africa: Man and his Environment in the Lake Chad Region of Nigeria* (Cambridge, 1981), from J.-P. and A. Lebeuf, *La civilization du Tchad* (Paris, 1950), which is quite explicit about the excavators' initial unfamiliarity with archaeological methods, and from J.-P. and A. Lebeuf, *Les arts des Sao*.

Cameroun, Tchad, Nigeria (Paris, 1977), which summarizes the authors' discoveries. Drawings of Ga'anda scarification are found in M. Berns, "Ga'anda Scarification: A Model for Art and Identity," in *Marks of Civilization* (Los Angeles, 1988): 57–76. The drawings of Musgum houses come from O. MacLeod, *Chiefs and Cities of Central Africa* (Edinburgh, 1912), and information on the Jukun is based upon the dissertation of A. Rubin, *The Arts of the Jukun-Speaking Peoples of Northern Nigeria* (Bloomington, 1969). The description of Mumuye memorial ceremonies is based upon A. Rubin, "A Mumuye Mask," in *I am not myself: The Art of African Masquerade* (Los Angeles, 1985): 98–9. Photographs of Mambila art are reproduced in P. Gebauer, *Art of Cameroon* (Portland, 1979). *Suaga* is described by D. Zeitlyn, "Mambila Figurines and Masquerades: Problems of Interpretation," *AA* 3 (autumn 1994): 38–47, 94. Little information exists for the art of the Kanuri; the source consulted here was G. Nachtigal, *Sahara und Sudan*, 3 vols. (1879–89; trans. A. and H. Fisher, 1971). Malam Salif Nohu was quoted by S. Hassan in *Art and Islamic Literacy among the Hausa of Northern Nigeria* (Lewiston, 1992), the source of information on Hausa writing boards. Drawings of Fulani calabashes are from T. J. H. Chappel, *Decorated Gourds in North-Eastern Nigeria* (London, 1977), and analysis of a Fulani *khasa* is taken from P. S. Gilfoy, *Patterns of Life. West African Strip-Weaving Traditions* (Washington, D.C, 1967); the cultural background of the *arkilla* was described in an unpublished seminar paper by Rachel Hoffmann.

Some information on the sculpture and masquerades of the central Sudan can be found in two brief catalogues: R. Sieber, *Sculpture of Northern Nigeria* (New York, 1961); R. Sieber and T. Vevers, *Interaction: The Art Styles of the Benue River Valley and East Nigeria* (Lafayette, 1974). R. Fardon, *Between God, the Dead and the Wild. Chamba Interpretations of Religion and Ritual* (Washington, 1990), is an insightful study of one cultural area. Other excellent studies that focused upon a single region or specific art forms are M. Berns and B. R. Hudson, *The Essential Gourd. Art and History in Northern Nigeria* (Los Angeles, 1986), and M. Berns, "Ceramic Clues: Art History in the Gongola Valley," *AA* 22:2 (1989): 48–59, 102–103. A. Bassing, "Grave Monuments of the Dakakari," *AA* 6:4 (1977): 36–9, is the best source of information on Dakakari memorial figures. D. Heathcote, *The Arts of the Hausa. An Aspect of Islamic Culture in Northern Nigeria* (Chicago, 1977), and J. C. Moughtin, *Hausa Architecture* (London, 1985), are good introductions to the art of the Hausa. P. Imperato, "Blankets and Covers from the Niger Bend," *AA* 12:4 (1979): 38–43, surveys the work of Fulani weavers. Fulani and Hausa arts are also featured in L. Prussin, *Hatumere* (Berkeley, 1986). Beautiful photographs of the arts of the Wodaabe in Niger can be found in C. Beckwith and M. Van Offelen, *Nomads of*

Niger (2nd ed., New York, 1983), even though some portions of the text are problematic.

Marla Berns' thorough review of this chapter improved it greatly, and the author thanks her for her many contributions.

CHAPTER 4
Photographs and data on archaeological work at the sites of Kumbi Saleh, Tondidaru and Inland Niger Delta sites were taken from *Vallées du Niger* (Paris, 1993), especially from contributions by J. Devisse and B. Diallo, "Le Seuil du Wagadu," 103–115, and by M. Dembele and A. Person, "Tondidarou, un foyer original du megalithisme africain dans la vallée du fleuve Niger au Mali," 441–5. Terms for the houses of Jenne are based upon those of P. Maas and G. Mommersteeg, "L'architecture dite soudanaise: 'le modele de Djenne,'" *Vallées du Niger*, 478–92, and upon L. Prussin, *Hatumere: Islamic Design in West Africa* (Berkeley, 1986). Rao and Payoma are described in *L'Age d'or du Senegal* (Solutre, 1993). Information on the sacred uses for *bogolanfini* was provided by S. Brett-Smith, "Symbolic Blood: Cloths for Excised Women," *RES* 3 (spring 1982): 15–31. Paintings on glass from Dakar were surveyed in *Souweres: Peintures populaires du Senegal* (Paris, 1987). Contemporary artists in Dakar, and their role in Set Setal, are described by Iba Mbeng in *Africa Explores. 20th Century African Art*, ed. S. Vogel (Munich, 1991), and in *Revue noire* 7 (1992–3) devoted to Senegal. Photographs, descriptions, and video copies of films from Mali, Burkina Faso, and Senegal were provided by California Newsreel, San Francisco.

A brief survey in English of early sites in this region is provided by G. Connah, *African Civilizations. Precolonial Cities and States in Tropical Africa: An Archaeological Perspective* (Cambridge, 1987). More detailed descriptions may be found in R. McIntosh, *The Peoples of the Middle Niger. The Island of Gold* (London, 1988). *AA* 28:4 (autumn 1995) is devoted to archeological artifacts from Mali and includes both important articles and illustrations of major styles. There are excellent art historical studies of the Mande peoples available, including P. McNaughton, *The Mande Blacksmiths. Knowledge, Power and Art in West Africa* (Bloomington, 1988); B. Frank, *More than Objects: An Art History of Mande Potter and Leatherworkers* (Washington D.C., 1998); K. Ezra, *A Human Ideal in African Art. Bamana Figurative Sculpture* (Washington, 1986); M. J. Arnoldi, *Playing with Time* (Bloomington, 1995). These sources supplant R. Goldwater, *Bambara Sculpture* (New York, 1960) which is an excellent summary of French research of the 1940s and 1950s. Recent French studies that challenge the earlier research are exemplified by D. Zahan, *The Bambara* (Keiden, 1974). Beautiful photographs of homes and mosques from Senegal and Mali are found in M. C. Clark, *African Canvas. The Art of*

West African Women (New York, 1990), and J.-L. Bourgeois and C. Pelos, *Spectacular Vernacular. The Adobe Tradition* (New York, 1989). The work of Senegalese and Malian photographers is included in *In/sight: African Photographers, 1940 to the Present* (New York, 1996).

The author is immensely grateful to Barbara Frank for providing excellent feedback on this entire chapter within a very short period of time.

CHAPTER 5
The pioneer scholars of the Dogon are M. Griaule and G. Dieterlin and their students. Griaule's *Masques Dogon* (Paris, 1938) is still one of the finest, most detailed books on an African masquerade. His *Conversations with Ogotemmeli* (Oxford 1948, reprint 1965) on the extensive creation mythology, provides the basis for a great deal of later interpretations of Dogon art and architecture, which have been called to question by many more recent scholars of the Dogon. Among them are K. Ezra, whose exhibition catalogue, *Art of the Dogon: Selections from the Lester Wunderman Collection* (New York, 1988), is a cautious, sensible reading of Dogon art based on verified information. Analogous are W. van Beek's several studies, among them: "Dogon Restudied: A Field Evaluation of the Work of Marcel Griaule," *Current Anthropology* 32:2 (1991): 139–67. B. DeMott *Dogon Masks* (Ann Arbor, 1982) reinterprets Griaule's classic mask monograph. Other useful Dogon studies include R. M. A. Bedaux, "Tellem and Dogon Material Culture," *AA* 21:4 (1988): 38–45, 91; W. E. A. Van Beek, "Functions of Sculpture in Dogon Religion," *AA* 21:4 (1988): 58–65, 91; J.-C. Huet, "The Togu Na of Tenyu Ireli," *AA* 21:4 (1988): 34–7; T. Spini and S. Spini, *Togu Na: The African Dogon "House of Men, House of Words"* (New York, 1976).

In modern times the Senufo have been studied most extensively by G. Bochet, T. Forster, and A. Glaze. Glaze's works are the most accessible: *Art and Death in a Senufo Village* (Bloomington, 1981) is supplemented by several articles in *AA* on: gender 19:3 (1986): 30–39, 82; women's power 8:3 (1975): 25–9, 64; metalwork and decorative arts 12:1 (1978): 63–71, 107. Glaze and Bochet contributed to the Senufo sections in *Art of Côte d'Ivoire*, ed. J. P. Barbier (Geneva, 1993). Thanks also to Professor Glaze for personal communications and help with illustrations in this chapter. D. Richter's book, *Art, Economics and Change: the Kulebele of Northern Ivory Coast* (LaJolla, 1980) is the source of my data on the Kulebele and recent tourist art production. R. Goldwater, *Senufo Sculpture from West Africa* (New York, 1964) provides a useful overview.

The Lobi have been studied recently in depth by P. Meyer, whose exhibition catalogue *Kunst und Religion der Lobi* (Zurich, 1981) was very useful

in writing this chapter. Thanks to Lorenz Homberger of the Rietberg Museum, Zurich, for supplying Lobi and Mossi photographs.

The Burkinabe peoples (Bwa, Mossi, and others) have been studied by C. Roy, whose book, *Art of the Upper Volta Rivers* (Paris, 1987), as well as his personal help with both data and illustrations, was critical to the sections on Bwa and Mossi arts. Nankani architecture, which I have studied in the field, is explicated in an important book by J.-P. Bourdier and T. T. Minh-ha, *African Spaces: Designs for Living in Upper Volta* (New York, 1985).

CHAPTER 6
Information on stone sculpture from Guinea, Sierra Leone, and Liberia was taken primarily from F. Lamp, *La Guinée et ses heritages culturels: Articles sur l'histoire de l'art de la région* (Conakry, 1992), and from conversations with Dr. Lamp. The analyses of Sapi-Portuguese ivories and the quotations from Fernandes are from *Africa and the Renaissance: Art in Ivory* (Munich, 1988). Photographs of masquerades in Senegal, Guinea-Bissau, and Guinea (including the Balanta, Papel, and Bidjogo) were found in H. A. Bernatzik, *Der Dunkel Erdteil*. Information on the Bassari was taken from M. de Lestrange, *Les Coniaugui et les Bassari (Guinée française)* (Paris, 1955), which contained no illustrations. Photographs of masquerades in Guinea and Côte d'Ivoire appear in M. Huet, J. Laude, and J.-L. Paudrat, *The Dance, Art and Ritual of Africa* (New York, 1978). D. G. Duquette, "Woman Power and Initiation in the Bissagos Islands," *AA* 12:3 (May 1979). Photographs of masquerades for carnival in Guinea-Bissau were published by D. Ross, *AA* 25:3 (July, 1993). The history of the Mano judgement mask was recounted by G. Harley, "Masks as Agents of Social Control in Northeast Liberia," *Papers of the Peabody Museum of American Archaeology and Ethnology* 32:2 (1950). The *je (dye)* masks of the Guro are described by A. Deluz, "The Guro," *Art of Côte d'Ivoire*, vol. 1 (Geneva, 1993). A. Gnonsoa's quotation of the importance of masquerades for the Weon comes from her book, *Masques de l'ouest Ivoirien* (Abidjan, 1983). The career of Bruly Bouabre is summarized in A. Magnin and J. Soulillou, *Contemporary Art of Africa* (New York, 1966). An interview with Christine Ozoua Ayivi provided information on Vohu-Vohu.

The most comprehensive survey of the arts of this region is W. Siegmann and C. Schmidt, *Rock of the Ancestors: Ngamoa Koni* (Suakoko, 1977), and it only covers peoples living in Liberia. Good studies of the arts of specific peoples or of related art complexes include: P. Mark, *The Wild Bull in the Sacred Forest: Form, Meaning, and Change in Senegambian Initiation Masks* (Cambridge), on the Jola and their neighbors; J. Nunley, *Moving with the Face of the Devil: Art and Politics in*

Urban West Africa (Urbana, 1987), on masquerades in Freetown; F. Lamp, *Art of the Baga. A Drama of Cultural Reinvention* (Munich, 1996); E. Fischer and H. Hinmmelheber, *The Arts of the Dan in West Africa* (trans. A. Biddle; Zurich, 1984); E. Fisher and L. Homberger, *Masks in Guro Culture, Ivory Coast* (New York, 1986). Among several useful articles by M. Adams on the We is "Women and Masks Among the Western We of Ivory Coast," *AA,* 19:2 (1986): 46–55, 90. The most thoroughly researched art complex of the region are the masquerades of Sande and Bondo. Books on this subject include a comprehensive study of Sande by R. B. Phillips, *Representing Women: Sande Masquerades of the Mende of Sierra Leone* (Los Angeles, 1995), and an evocative personal response to Mende culture by S. A. Boone, *Radiance from the Water. Ideals of Feminine Beauty in Mende Art* (New Haven, 1986).

Frederick Lamp generously assisted the author during several stages in the preparation of this chapter, including providing a detailed final review. William C. Siegman's advice was also very helpful.

CHAPTER 7
Two books dealing with the relationship between art and leadership are *African Art & Leadership*, ed. D. F. Fraser and H. M. Coleand (Madison, 1971), and Blier, *The Royal Arts of Africa*. Both books contain essays or chapters on the Akan/Asante of Ghana; the former has an article by H. Himmelheber on the gold-covered objects of Baule notables. Many books deal with the arts of Ghana more specifically: R. Rattray, *Religion and Art in Ashanti* (London, 1927); A. A. Y. Kyerematen, *Panoply of Ghana* (London/New York, 1964); H. M. Cole and D. H. Ross, *The Arts of Ghana* (Los Angeles, 1977); M. D. McLeod, *The Asante* (London); *Akan Transformations*, ed. D. H. Ross and T. F. Garrard (Los Angeles, 1983); D. H. Ross, *Wrapped in Pride: Ghanaian Kente and African American Identity* (Los Angeles, 1998). Asante architecture and the Akan interface with Islam are dealt with in L. Prussin, *Hatumere: Islamic Design in West Africa* (Berkeley, 1986). Fante asafo military arts are well covered by D. H. Ross, *Fighting with Art: Flags of the Fate Asafo* (Los Angeles, 1979), and "Cement Lions and Cloth Elephants: Popular Arts of the Fante Asafo," in *Five Thousand Years of Popular Culture: Popular Culture Before Painting*, ed. F. E. H. Schroeder (Bowling Green, 1979). See also: P. Adler and N. Barnard, *Asafo! African Flags of the Fante* (London, 1992) and the same authors' *African Majesty: The Textile Art of the Ashanti and Ewe* (London, 1992). Ross deals with varied aspects of Asante royal and popular arts in: "The Verbal Art of Akan Linguist Staffs," *AA* 26:1 (1982): 56–67; "The Art of Osei Bonsu," *AA* 17:2 (1984): 28–40, 90; "Queen Victoria for Twenty-five Pounds: The Iconography of a Breasted Drum from Southern Ghana," *ArtJ* 47:2 (1988): 114–20; "More than Meets the Eye: Elephant Memories among the

Akan," in *Elephant: the Animal and its Ivory*, ed. D. H. Ross (Los Angeles, 1992): 137–59. Akan goldweights, gold, and other metalworks are explored in two books by T. F. Garrard, *Akan Weights and the Gold Trade* (London, 1980), and *Gold of Africa: Jewelry and Ornaments from Ghana, Côte d'Ivoire, Mali and Senegal in the Collection of the Barbier-Mueller Museum* (Munich, 1989). Doran Ross has also been extremely helpful in supplying illustrations for this volume, both from his extensive personal files and from the Fowler Museum of Cultural History, of which he is director.

Much of the scholarship on Baule arts is summarized and reinterpreted in S. M. Vogel, *Baule: African Art Western Eyes* (New Haven/London, 1998). The same author's "People of Wood: Baule Figure Sculpture," *ArtJ* 33 (1973): 23–6, is useful, as is her *Beauty in the Eyes of the Baule: Aesthetics and Cultural Values* (Philadelphia, 1980). P. Ravenhill wrote on *Baule Statuary Art: Meaning and Modernization* and on Wan masquerades that were adopted by the Baule: "An African Triptich: On the Interpretation of Three Parts and the Whole," *ArtJ*, 47:2: 88–94, while his book *Dreams and Reveries: Images of Otherworld Mates among the Baule, Côte d'Ivoire* (Washington, 1996) is a reinterpretation of Baule spirit figures. The author's thanks are hereby extended to both Dr. Vogel and the late Dr. Ravenhill for help with information and photographs over the years. In *Art of Côte d'Ivoire*, ed. J.-P. Barbier (Geneva, 1993), sections on the Baule were by T. Garrard, vol. 1: 290–301; A.-M. Boyer, vol. 1: 302–67; S. M. Vogel, vol. 2: 117–48.

Lagoon arts are explicated by M. Blackmun Visonà in: *Art of Côte d'Ivoire*, vol. 1: 368–83; "Divinely Inspired Artists from the Lagoon Cultures of the Ivory Coast," in *The Artist and the Workshop in Traditional Africa*, ed. Christopher Roy, *Iowa Studies in African Art*, vol. 3 (Iowa City, 1987); "Portraiture among the Lagoon Peoples of Côte d'Ivoire," *AA* 23:4 (1990): 54–61.
The recent funerary arts of southern Ghana are discussed in T. Secretan, *Going into Darkness: Fantastic Coffins from Africa* (London, 1995).

CHAPTER 8
For further reading on the Yoruba, see H. J. Drewal and J. Pemberton III, et al., *Yoruba: Nine Centuries of African Art and Thought* (New York, 1989); W. B. Fagg and J. Pemberton III, *Yoruba Sculpture of West Africa* (New York, 1982); and R. F. Black, *Gods and Kings* (Los Angeles, 1971). Information on the art of ancient Ife may be found in F. Willett, *Ife in the History of West African Sculpture* (New York/London, 1967), and in E. Eyo and F. Willett, *Treasures of Ancient Nigeria* (New York, 1980). D. Fraser investigated the Tsoede bronzes and drew

connections with the arts of Owo in "The Tsoede Bronzes and Owo Yoruba Art," *AA* 8:3 (spring 1975): 30–5. For the art of Owo see several articles by R. Poynor, among them "Edo Influence on the Arts of Owo," *AA* 9:4 (July 1976): 40–5, 90. The *udamolore* sword is discussed by Poynor in Vogel, *For Spirits and Kings*; for other ivories from Owo see E. Bassani and W. Fagg, *Africa and the Renaissance: Art Ivory* (New York/Munich, 1988). P. Stevens, who was helpful in locating images for Esie, wrote the definitive book on Esie images, *The Stone Images of Esie, Nigeria* (Ibadan, 1978). A landmark study of the arts of leadership is *African Art and Leadership*. Among numerous works addressing the royal arts of the Yoruba are: Blier, *The Royal Arts of Africa*; R. F. Thompson, "The Sign of the Divine King," *AA* 3:3 (1970), 8–17, 74–80; W. Fagg and John Pemberton III, *Yoruba Beadwork* (New York, 1980); H. J. Drewal and J. Mason, *Beads, Body, and Soul: Art and Light in the Yoruba Universe* (Los Angeles, 1998). R. S. Walker investigates the work of Olowe of Ise in *Olowe of Ise: A Yoruba Sculptor to Kings* (Washington, D.C., 1998) and in "Anonymous has a Name: Olowe of Ise," in *The Yoruba Artist*. Yoruba places are examined by G. J. Afolabi Ojo in *Afins of Yorubaland* (London, 1966). The *ogboni* society is the focus of a study by P. Morton-Williams, "The Yoruba Ogboni Cult on Oyo," *Africa* 30:4 (1960): 362–74. H. Witte looks at *ogboni* art in his catalog *Earth and the Ancestors: Ogboni Inconography* (Amsterdam, 1988). J. R. O. Ojo deals with *ogboni agba* in "Ogboni Drums," *AA* 6:3: 50–2. An early source on Yoruba religion is E. B. Idowu, *Oludumare, God in Yoruba Belief* (New York, 1963). W. Bascom investigates Yoruba divination process in *Ifa Divination: Communication Between the Gods and Men in West Africa* (Bloomington, 1969). A comparison between the gods Eshu and Orunmila is drawn by R. Poynor in *African Art at the Harn Museum: Spirit Eyes, Human Hands* (Gainesville, 1995). H. Witte surveys *ifa* trays in "Ifa Trays from the Oshogbo and Ijebu Regions," in *The Yoruba Artist*. The nature of the god Eshu is addressed by J. Wescotts, "The Sculpture and Myths of Eshu-Elegba," *Africa* 32:4 (1962): 336–53, and J. Pemberton III, "Eshu-Elegba: The Yoruba Trickster God," *AA* 9:4 (1975): 20–7, 66–70. For Yoruba stone sculpture see P. Allison in *African Stone Sculpture* (New York, 1968). The nature of the god Ogun is studied by several scholars in *Africa's Ogun: Old World and New*, ed. S. T. Barnes (Bloomington, 1989). R. Thompson explores the distribution of Osanyin paraphernalia and its meaning in "Icons of the Mind: Yoruba Herbalism Arts in Atlantic Perspective," *AA* 8:3 (1975): 52–9. Thompson focuses on Eyinle ceramic arts in "Abatan: A Master Potter of the Egbado Yoruba," in *Tradition and Creativity in Tribal Art*, ed. D. Biebuyck (Berkeley, 1969): 120–82. Numerous scholars have looked at the thunder god Shango, among them R. Plant Armstrong in "Oshe Shango and the Dynamic of Doubling," *AA* 16:2 (February

1983): 28–32, and B. Lawal, *Yoruba Sango Sculpture in Historical Retrospect* (Ann Arbor, 1970). The relationship between the Shango and twins is explored by Thompson, "Sons of Thunder: Twin Images among the Oyo and Other Yoruba Groups," *AA* 4:3 (spring 1971): 813, 77–80, and by M. Houlberg, "Ibeji Images of the Yoruba," *AA* 7:1 (1973): 20–7, 91–2. The entire issue of *AA* 11:3 (April 1978), ed. H. Drewal, is devoted to the arts of *egungun* among the Yoruba peoples with contributions from J. Adedeji, H. Drewal, M. Thompson Drewal, M. Houlberg, J. Pemberton III, R. Poynor, and M. Schiltz. Two important books have been written on the spectacle of gelede: H. J. Drewal and M. T. Drewal, *Gelede, a Study of Art and Feminine Power among the Yoruba* (Bloomington, 1983), and B. Lawal, *The Gelede Spectacle: Art, Gender, and Social Harmony in an African Culture* (Seattle, 1996). Father Kevin Carroll surveyed Epa masks in northeastern Yoruba country in *Yoruba Religious Carving* (London, 1956). William Rea shared images and information from his dissertation fieldwork with the author of this chapter .

See Blier, *The Royal Arts of Africa*, chapter 2, for the royal arts of the Fon, and *African Vodun*, for royal *bocio* and those of commoners. See also: F. Picqué and Leslie H. Rainer, *Wall Sculptures of Abomey* (London, 1999). M. Adams focuses on Fon textile arts in "Fon Appliquéd Cloths," *AA* 13:2 (February 1980): 28–41, 87. E. Bay surveys Fon iron altars in *Asen: Iron Altars of the Fon People of Benin* (Atlanta, 1985), while D. Crowley addresses brass casting in "Fon Brass Tableaux as Historical Documents," *AA* 20:1 (November 1986): 54–9, 98. For the Allada divination board discussed in the Fon section see E. Bassani, "The Ulm Opon Ifa (ca. 1650): A Model for Later Iconography," and O. Yai, "In Praise of Metonymy: the Concepts of 'Tradition' and 'Creativity' in the Transmission of Yoruba Artistry over Time and Space," in *The Yoruba Artist*.

For a discussion of Brazilian architecture along the Guinea Coast see A. B. Laotan, "Brazilian Influence on Lagos," *Nigeria Magazine* 69 (1960): 156–65. The same author investigated colonial architecture in *Rives Coloniales: Architecture, de Saint-Louis à Douala* (Marseille, 1993). Luc Gnacadja, who contributed to *Rives Coloniales*, also provided photographs for this chapter. Several sources explore art in the town of Oshogbo. U. Beier scrutinizes S. Wenger's revival of the shrines at Oshogbo in *The Return of the Gods: The Sacred Art of Suzanne Wenger* (Cambridge, 1975), and covers other aspects of Oshogbo phenomena in *Thirty Years of Oshogbo Art* (Bayreuth, 1991). The author of this chapter thanks Uli Bauer of Bayreuth University for help with ideas on Oshogbo art and Nike Davies-Okundaye for discussing and providing photographs of her work. M. D. Harris explores the work of the Ona group in "Beyond Aesthetics: Visual Activism in Ile-Ife,"

in *The Yoruba Artist*. Moyosore Okediji was kind enough to discuss his painting with the author and provide a photograph.

CHAPTER 9

Ancient cultures of the lower Niger basin are well summarized in T. Shaw, *Nigeria: Its Archaeology and Early History* (London, 1978), while Igbo Ukwu is discussed in great detail in the same author's *Igbo-Ukwu: An Account of Archaeological Discoveries in Eastern Nigeria*, 2 vols. (London/Evanston, 1970). M. A. Onwuejeogwu, *An Igbo Civilization: Nri Kingdom and Hegemony* (Londona, 1981) bridges ancient Igbo Ukwu with the modern Igbo. An earlier work on the high points of the Lower Niger region is W. Fagg, *Nigerian Images* (London, 1963).

The Arts of the Igbo and their neighbors (excluding Benin) are surveyed in G. I. Jones, *The Art of Eastern Nigeria* (Cambridge, 1984). Jones also wrote articles about two institutions explored further here: "Okorosia" [masking], *Nigerian Field* 3:4 (1934): 175–7, and "Mbari Houses," *Nigerian Field* 6:2 (1937): 77–9. The fullest, most recent survey of Igbo arts is H. M. Cole and C. C. Aniakor, *Igbo Arts: Community and Cosmos* (Los Angeles, 1984). *Mbari* houses are analyzed in some depth in H. M. Cole, *Mbari: Art and Life among the Owerri Igbo* (Bloomington, 1982), while the same author looks at *mbari* history in two articles: "The History of Ibo Mbari Houses: Facts and Theories," in *African Images: Essays in African Iconology*, ed. D. F. McCall and E. Bay (New York, 1975): 104–32, and "The Survival and Impact of Igbo Mbari," *AA* 21:2 (1988): 54–65, 96. For Igbo masking see J. S. Boston, "Some Northern Igbo Masquerades," *Journal of the Royal Anthropological Institute* 90 (1960): 54–65; C. C. Aniakor in "The Omabe Festival," *Nigeria Magazine* 126-127 (1978): 3–12, and "The Igbo Ijele Mask," *AA* 11:4 (1978): 42–7, 95; S. Ottenberg, *Masked Rituals of the Afikpo* (Seattle, 1975); R. N. Henderson, *The King in Every Man* (New Haven, 1972); R. N. Henderson and I. Umunna, "Leadership Symbolism in Onitsha Igbo Crowns and Ijele," *AA* 21:2 (1988): 28–37, 94–6; J. Picton, "Ekpeye Masks and Masking," *AA* 21:2 (1988): 46–53, 94.

For cross-cultural treatments of personal shrines in this region see J. S. Boston, *Ikenga Figures among the North-West Igbo and the Igala* (London, 1977), and S. M. Vogel, *Gods of Fortune: the Cult of the Hand in Nigeria* (New York, 1974). For Urhobo person shrines see W. P. Foss, "Images of Agression: Ivwri Sculpture of the Urhobo," in *African Images: Essays in African Iconology*, ed. D. F. McCall and E. Bay (New York, 1975); C. A. Lorenz, "The Ishan Cult of the Hand," *AA* 20:4 (1987): 70–5, 90; P. M. Peek, "The Isoko Ethos of Ivri," *AA* 20:1 (1986): 42–7, 98.

Cross-cultural treatments of contrasting light and dark masks are more difficult to find. See J. Borgatti, *From the Hands of Lawrence Ajanaku* (Los Angeles, 1979) and "Dead Mothers of Okpella," *AA* 12:4 (1979): 48–57, 91: P. Ben Amos, "Keeping the Town Healthy: Ekpo Ritual in Avbiana Village," *AA* 2:4 (1969): 8–13, 79; Cole and Aniakor, *Igbo Arts*; J. C. Messenger, "Annang Art, Drama, and Social Control," *African Studies Bulletin* 5:2 (1962): 29–35 Ibibio memorial arts are covered in J. Salmons, "Funerary Shrine Cloths of the Annang Ibibio, Southeast Nigeria," in *Textiles of Africa*, ed. D. Idiens and K. G. Ponting (Bath, 1980): 119–41.

Kalabari Ijaw arts, including festivals, are dealt with in many fine publications of R. Horton, especially *Kalabari Sculpture* (Lagos, 1965), and *The Gods as Guests: An Aspect of Kalabari Religious Life* (Lagos, 1965). For funerals and ancestral memorials, respectively, see J. B. Eicher and T. V. Erekosima, "Kalabari Funerals: Celebration and Display," *AA* 21:1 (1987): 38–45, 87–8, and N. Barley, *Foreheads of the Dead: An Anthropological View of Kalabari Ancestral Screens* (Washington, 1988). For *iria bo* dress see M. C. Daly, J. B. Eicher, and T. V. Erekosima, "Male and Female Artistry in Kalabari Dress," *AA* 19:3 (1986): 48–53, 83. Thanks to Joanne Eicher for supplying photographs.

Among the extensive bibliography on Benin is a survey of its arts by K. Ezra, *The Royal Art of Benin: The Perls Collection in the Metropolitan Museum of Art* (New York, 1992). The scholarship on Benin based on fieldwork, on the other hand, is in the many works of R. E. Bradbury, P. G. Ben Amos, B. Blackmun, and J. Nevadomsky. Paula Girshick Ben Amos and Joseph Nevadomsky were helpful in supplying photographs and expertise on earlier versions of this chapter. A fine treatment of most aspects of this art, with an emphasis on history, is by Ben Amos, *The Art of Benin* (London, 1980; rev. 1995). See too the articles by the same author: "Symbolism in Olokun Mud Art," *AA*, 6:4 (1973): 28–31, 95; "Men and Animals in Benin Art," *Man* N.S.II:2 (1976): 243–52. Varied aspects of Benin art are also explored in *The Art of Power/the Power of Art: Essays in Benin Iconography*, ed. P. G. Ben Amos and A. Rubin (Los Angeles, 1983). Benin ivory is covered in many essays by B. Blackmun; see especially "Obas' Portraits in Benin," *AA* 23:3 (1990): 61–9, 102–4, and "The Elephant and its Ivory in Benin," in *The Elephant and its Ivory in African Culture*, ed. D. H. Ross (Los Angeles, 1992): 163–83. J. Nevadomsky has written many informative essays on Benin, three of which were especially useful in writing this chapter: "Religious Symbolism in the Benin Kingdom," in *Divine Inspiration: From Benin to Bahia*, ed. P. Galembo (Santa Fe, 1993); "Kemwin-Kemwin: The Apothecary Shop in Benin," *AA* 22:1 (1988): 72–83, 100; J. Nevadomsky, "Signifying Animals: The Leopard

and Elephant in Benin Art and Culture," in *Kulte, Kunstler, Konige in Africa—Tradition und Moderne in Sud Nigeria*, ed. S. Eisenhofer (Linz, 1997): 97–107. Ivory, especially Afro-Bini ivories, is covered in Bassani and Fagg, *Africa and the Renaissance: Art in Ivory*.

The Mamy Wata phenomenon is analyzed in several papers by H. J. Drewal, who also kindly supplied the photograph. See especially his "Mermaids, Mirrors, and Snake Charmers: Igbo Mamy Wata Shrines," *AA* 21:2 (1988): 38–45, 98; "Performing the Other: Mami Wata Worship in Africa," *TDR: A Journal of Performance Studies* 32:2 (1988): 160-85. See also C. Gore and J. Nevadomsky, "Practice and Agency in Mammy Wata Worship in Southern Nigeria," *AA* 30:2 (1997): 60–9, 95.

CHAPTER 10

For further information on the Cross River, see S. P. Blier, *Africa's Cross River: Art of the Nigerian-Cameroon Border Redefined* (New York, 1980); on the Cameroon, see T. Northern, *The Art of Cameroon* (Washington, 1984); on the Gabon, see L. Perrois, *Ancestral Art of Gabon: From the Collections of the Barbier-Mueller Museum* (Geneva, 1985).

For Cross River carved stones see P. Allison, *African Stone Sculpture* (New York, 1968), and *Cross River Monoliths* (Lagos, 1968). Keith Nicklin provided the *in situ* photograph of carved monoliths for this chapter. For Cross River terracottas see V. I. Eyo, "Qua Terracotta Sculptures," *AA* 18:1 (November 1984): 58–60, 96. Nicklin provided the photograph for this chapter. For information on Ngbe society emblems see Nicklin "An Ejagham Emblem of the Ekpe Society," *Art Tribal* (1991): 3–18. Numerous sources delve into the masking societies of the Cross River, among them two articles by Nicklin: "Nigerian Skin-Covered Masks," *AA* 7:3 (spring 1974): 8–15, 67–68; "Skin-Covered Masks of Cameroon," *AA* 12:2 (February 1979): 54–9, 91. Nicklin and J. Salmons discuss regional style in "Cross River Art Style: Towards a New Definition," *AA* 18:1 (1984): 28–43.

Cameroon Grasslands architecture is surveyed in several sources, among them P. Gebauer, *Art of Cameroon* (Portland, 1979) and Northern, *The Art of Cameroon*. C. Geary, *Images from Bamum: German Colonial Photography at the Court of King Njoya, Cameroon, West Africa, 1902-1905* (Washington D.C., 1988) examines the court of Njoya. Bamum is investigated by C. Tardits, "The Kingdom of Bamum," in *Kings of Africa*, ed. E. Beumers and H.-J. Koloss (Maasstricht, 1992). Geary discusses royal stools in "Bamum Thrones and Stools," *AA* 14:4 (1981): 32–43. Both Northern and Geary address figural sculpture, a topic also explored by P. Harter, "Royal Commemorative Figures in the Cameroon Grasslands," *AA* 23:4

(October 1990): 70–7, 96, and by S. Rudy, "Royal Sculpture in the Cameroon Grasslands," in *African Art and Leadership*: 123–35. For Kom stool figures see T. Northern, *Royal Art of Cameroon* (Dartmouth, 1973). The Afo-a-Kom spurred great interest and numerous articles with its disappearance and return to Kom in 1973. Northern discusses several regulatory societies in *The Art of Cameroon*. H.-J. Koloss focuses on Kwifon in "Kwifon and Fon in Oku: On Kingship in the Cameroon Grasslands, " in *Kings of Africa*. For the Msop association see J.-P. Notué, *Batcham, sculptures du Cameroun: nouvelles perspectives anthropologiques* (Marseille, 1993). The author of this chapter thanks Rosalinde Wilcox for sharing information on the arts of Duala and portions of her dissertation, "The Maritime Arts of the Duala of Cameroon: Images of Power and Identity," University of California, Los Angeles, 1994.

Among L. Perrois' extensive writings on Gabonese art is *Ancestral Art of Gabon: From the Collections of the Barbier-Mueller Museum* (Geneva, 1985). J. W. Fernandez discusses the Fang culture and the tradition of reliquaries in "Principles of Opposition and Vitality in Fang Aesthetic," in *Art and Aesthetic in Primitive Societies*, ed. C. Jopling (New York, 1971): 356–73. For Hongwe variations on Kota reliquary figures see L. Siroto, "The Face of the Bwiiti," *AA* 1:2 (winter 1968): 22–7, 86–9, 96; Perrois offers a response in *AA* 2:4 (summer 1969): 67ff. I. Child and Siroto address Kwele in "BaKwele and American Aesthetic Evaluations Compared," in *Art and Aesthetics*: 271–89. Siroto focuses on the Kwele gon mask in "Gon, a Mask Used in Competition for Leadership among the Bakwele," in *African Art and Leadership*: 55–7. A. LaGamma shared information from her dissertation, "The Art of the Punu Mukudj Masquerade: Portrait of an Equatorial Society," Columbia University, 1995, and provided the field photograph. Leandro Mbomio kindly provided photographs of his sculpture and discussed his work.

CHAPTER 11

For further reading see: A. P. Bourgeois, *Arts of the Yaka and Suku* (Meudon, 1984); M. Felix, *100 Peoples of Zaire and their Sculpture* (Brussels, 1987); H.-J. Koloss, *Art of Central Africa: Masterpieces form the Berlin Museum fur Volkerkunde* (New York, 1990); R. F. Thompson and J. Cornet, *The Four Moments of the Sun: Kongo Art in Two Worlds* (Washington, 1981); G. Verswijver, et al., *Treasures from the Africa Museum Tervuren* (Tervuren, 1995).

M. Felix, C. Meur, and N. Batulukisi explored issues of Kongo region style and history in *Art and Kongos* (Brussels, 1995). For leadership art of the Kongo kingdom see Blier, *The Royal Arts of Africa*, chapter 5, and J. Thornton, "The Regalia of the Kingdom of Kongo, 1491-1895," in *Kings of Africa*. For the maternity figures of the Yombe see R. Lehuard, *Les Phemba du Mayombe* (Anouville,

1976). For funerary arts and associated practices see R. F. Thompson and J. Cornet, *The Four Moments of the Sun: Kongo Art in Two Worlds* (Washington, 1981). *Minkisi* or power figures are thoroughly investigated by W. MacGaffey, *Astonishment and Power* (Washington, 1993). For Teke variations of power figures see "Teke Fetishes," *Journal of the Royal Anthropological Institute* 86:1 (Jan.–June 1956): 25–36.

M.-L. Bastin has published numerous works on the Chokwe and related peoples: *La sculpture Tchokwe* (Meudon, 1982); "The Mwanangana Chokwe Chief and Art," in *Kings of Africa;* "Arts of the Angolan Peoples: Chokwe," *AA* 2:1 (Autumn 1968): 40–7, were especially helpful in sorting through issues of both figures and masks. For leadership arts of the Chokwe see D. Crowley, "Chokwe, Political Art in a Plebian Society," in *African Art and Leadership*: 21–40. A recent source is by M. Jordan, *Chokwe!: Art and Initiation among Chokwe and Related Peoples* (Munich/New York, 1998).

Among A. P. Bourgeois' extensive writings on the art of the Yaka and Suku are: *Arts of the Yaka and Suku* (Meudon, 1984); "Mbwoolo Sculpture of the Yaka," *AA* 12:3 (May 1979): 58–61, 96; "Kakungu Among the Yaka and Suku," *AA* 14:1 (November 1980): 42–8, 88; "Yaka Masks and Sexual Imagery," *AA* 15:2 (February1982): 47–50. Bourgeois provided field photographs of an adze in context, a *luumbu* and its *m-mbwoolo* figures, and an *mweelu* mask.

Information on Pende society and art came from L. De Sousberghe, *L'Art Pende* (Brussels, 1959) and Z. Strother, "Eastern Pende Constructions of Secrecy," in *Secrecy: African Art that Conceals and Reveals*, ed. M. Nooter (New York, 1993). Information on the Salampasu came from E. L. Cameron , "Sala Mpasu Masks," *AA* 22:1 (November 1988): 34–42, 98, and R. Ceyssens in *Treasures from the Africa Museum Tervuren.*

For leadership arts of the Kuba see J. Cornet, *Art Royal Kuba* (Milan, 1982); D. Coates Rogers, *Royal Art of the Kuba* (Austin, 1979); Blier, *The Royal Arts of Africa*, chapter 5. For Ndop portraits see J. Vansina, "Ndop: Royal Sculptures among the Kuba," in *African Art and Leadership*: 41–55; J. B. Rosenwald, "Kuba King Figures," *AA* 7:3 (1974): 26–31; M. Adams, "Eighteenth-century Kuba Figures," *AA* 21:3 (May 1988): 32–8, 88. Kuba royal dress and textiles are discussed by Cornet in *Art Royal Kuba.* For leadership headdresses see P. Darish and D. Binkley, "Headdresses and Titleholding Among the Kuba," in *Crowning Achievements: African Arts of Dressing the Head* (Los Angeles, 1995). For cloth and dress in leadership context see M. Adams"Kuba Embroidered Cloth," *AA* 12:1 (November 1978): 24–39. Darish investigates textile production in light of funerary ritual in "Dressing for the Next

Life: Raffia Textile Fabrication and Display among the Kuba of south central Zaire," in *Cloth and Human Experience*, ed. A. B. Weiner and J. Schneider (Washington, 1989). For masquerading in the context of the court see Cornet "Avatar of Power: Kuba Masquerades in Funerary Context," *Africa* 1: 75–97. Binkley explores the non-royal use of masks in initiation and funeral contexts in "Masks, Space and Gender in Southern Kuba Initiation Ritual," *Iowa Studies in Art*, 3: *Art and Initiation in Zaire* (Iowa City, 1990).

For Lulua figures see C. Petridis' entry in *Treasures from the Africa Museum Tervuren.* Ndengese king figures are examined by C. M. Faik-Nzuji in the same source.
For the concept of the urban artist see J. Fabian and I. Szombati-Fabian, "Art, History and Society: Popular Painting in Shaba, Zaire," *Studies in the Anthropology of Visual Communication* 3 (1976): 1–21.

CHAPTER 12
For further reading see: D. Biebuyck, *Lega Culture: Art, Initiation, and Moral Philosophy among a Central African People* (Berkeley, 1973*)*; M. Felix, *100 Peoples of Zaire and their Sculpture* (Brussels, 1987*)*; D. Hersak, *Songye Masks and Figure Sculpture* (London, 1986); H.-J. Koloss, *Art of Central Africa: Masterpieces from the Berlin Museum fur Volkerkunde* (New York, 1990); E. Schildkrout and K. Keim, *African Reflections: Art from Northeastern Zaire (*New York*/*Seattle, 1990); *Treasures from the Africa Museum Tervuren.*

F. L. van Noten discusses the archaeology of *the* Upemba Depression in *The Archaeology of Central Africa* (Graz, 1982). Many aspects of Luba culture are addressed in M. Nooter Roberts and A. F. Roberts, *Memory: Luba Art and the Making of History* (New York/Munich, 1996) and in entries they wrote for *Treasures from the Africa Museum Tervuren.* J. Flam examines symbolic leadership stools in "The Symbolic Structure of the Baluba Caryatid Stool," *AA* 4:2 *(winter 1971):* 54–9. The lukasa is examined in T. Reefe, "Lukasa: A Luba Memory Device," *AA* 20:4 (1977): 49–50, 88. For the striped masks of the Luba see M. Felix, *Luba Zoo: Kifwebe and Other Striped Masks of Southeast Zaire* (Brussels, 1992).

F. Neyt focuses on Hemba figures in *La grande statuaire Hemba du Zaire* (Louvain-la-Neuve, 1995). T. Blakely and P. Blakely have researched so'o masks and reported their findings in "So'o Masks and Hemba Funerary Festival," *AA* 21:1 (November 1987): 30–7, 84.
For Tabwa culture and art see A. F. Roberts and E. Mauer, *Tabwa: The Rising of a New Moon: A Century of Tabwa Art* (Ann Arbor, 1985). Marc Felix provided photographs of Tabwa buffalo masks in context.
The most thorough coverage of Songye art is by Hersak, *Songye Masks and Figure Sculpture*, who

also supplied the field photograph of the Songye *kifwebe* mask.

Daniel Biebuyck has provided numerous resources for studying the Lega and other groups in the eastern regions of the Democratic Republic of Congo. His *The Arts of Zaire*, 2 vols. (Berkeley, 1986) includes essential details of many groups. A landmark work on the Lega is his *Lega Culture.* His "The Kindi Aristocrats and their Art among the Lega," in *African Art and Leadership*: 7–20, and "Function of a Lega Mask," *International Archives of Ethnography* 47:1 (1954): 108–20, address specific types of objects used in the bwami society. S. Klopper uses Biebuyck's resources as a basis for her "Speculations on Lega Figurines," *AA* 19:1 (November 1985): 64–9, 88. Biebuyck addresses the art of Bembe associations in "Bembe Art," *AA* 5:3 (spring 1972): 12–9, 75–84, and that of the Mbole lilwa in "Sculpture from the Eastern Zaire Forest Regions: Mbole, Yela, and Pere," *AA* 10:1 (October 1976): 54–61, 99.

Early reports on the court of the Azande and Mangbetu are in G. Schweinfurth, *The Heart of Africa: Three Years' Travels and Adventures in the Unexplored Regions of Central Africa from 1868 to 1871*, 2 vols. (trans. E. Frewer; New York, 1874). E. Schildkrout and C. Keim investigate the Mangbetu and their neighbors in *African Reflections: Art from Northeastern Zaire* (New York/Seattle, 1990). For changes in Mangbetu pottery traditions see G. Schildkrout, et al., "Mangbetu Pottery: Tradition and Innovation in Northeast Zaire," *AA* 22:2 (Feb 1989): 38–47, 102. Schildkrout also provided personal communication and advice on photographs in the American museum of Natural History.

The barkcloth paintings of the Ituri Forest are discussed in R. F. Thompson, *Painting from a Single Heart: Preliminary Remarks on Bark-cloth Designs of the Mbute Women of Haut-Zaire* (Munich,1983), and G. Meurant and R. Farris, *Mbuti design: Paintings by Pygmy Women of the Ituri Forest* (New York, 1996). Marc Felix provided the field photograph of Mbuti women.

The concept of the urban artist is introduced in J. Fabian and I. Szombati-Fabian, "Art, History and Society: Popular Painting in Shaba, Zaire," *Studies in the Anthropology of Visual Communication* 3 (1976): 1–21. The author thanks Ilona Szombati for providing information and sharing her photographs.

CHAPTER 13
The plan of the Swahili house is from L. D. Reed, "Life in the Swahili Town House," *African Archaeological Review* 5 (1987). P. Garlake, *The Early Islamic Architecture of the East African Coast* (Nairobi, 1966), provided plans for the Great Mosque at Kilwa. Information on doors comes from J. Aldrich, "The Nineteenth-century Carved

Wooden Doors of the East African Coast," *Azania* 25 (1990): 1–18, while S. Battle, "The Old Dispensary. An Apogee of Zanzibari Architecture," in *The History and Conservation of Zanzibar Stone Town* (Athens, 1995), described this important building in Zanzibar. The work of contemporary Swahili woodworkers was described by Said Abdullraham El-Mafazy during an interview. The sculpture of eastern Africa is most fully illustrated by K. Krieger, *Ostafrikanische Plastik* (Berlin, 1990) and M. Felix, et al., *Tanzania: Meisterwerke Afrikanischer Skulptur* (Munich, 1994). For the art of the Zaramo and their neighbors see M. Felix, *Mwana Hiti: Life and Art of the Matrilineal Bantu of Tanzania* (Munich, 1990). An entry by M. Poznansky for the Luzira head may be found in *Africa: The Art of a Continent*: 140. For *Nyau* among the Mang'anja see B. Blackmun and M. Schoffeleers, "Masks of Malawi," *AA* 5:4 (summer, 1972): 36–41, 69, 88, while Chewa masquerades are documented in L. B. Faulkner, "Basketry Masks of the Chewa," *AA* 21:3 (May 1988): 28–31, 86, and K. Yoshida, "Masks and Secrecy among the Chewa," *AA* 26:2 (April 1993): 34–45, 92. K. Weule's methods of collecting Makonde and Makua art are described in his *Native Life in East Africa* (New York, 1909). Contemporary Makonde workshops are the subject of S. Kasfir, "Patronage and Maconde Carvers," *AA* 13:3: 67–70, 91–2. M. Urbain-Faublée, *L'Art Malagache* (Paris, 1963) illustrates a rich variety of Malagasy art. Grave mounds and memorial figures from southern Sudan and southern Ethiopia are illustrated in: G. Schweinfurth, *The Heart of Africa* (New York, 1874); C. G. Seligman and B. Seligman, *Pagan Tribes of the Nilotic Sudan* (London, 1932); W. Kronenberg, "Wood Carvings in the South Western Sudan," *Kush* 8 (1960): 274–8; C. R. Hallpike, *The Konso of Ethiopia: A Study of the Values of a Cushitic People* (Oxford, 1972); E. von Haberland, *Voelker Sud-Athiopiens* (Stuttgart, 1959).

For the best introduction to the arts of eastern Africa see J. Coote and J. Mack, "Africa, VII: Regions: 7. East Africa," in *The Dictionary of Art* (London, 1996). For an excellent introductory survey of early art from eastern Africa see J. Sutton, *A Thousand Years of East Africa* (Nairobi, 1990). U. Ghaidan, *Lamu* (Nairobi, 1992) provides a useful study of the art and architecture of one Swahili city. E. Wolfe, *Vigango* (Williamstown, 1986) is a readable introduction to the memorial arts of the Mijikenda. Photographs and paintings of both carved art forms and elaborate body arts are reproduced in J. Adamson, *The Peoples of Kenya* (New York, 1967). An overview of Makonde masking is given by J. Wembah-Rashid, "Isinyago and Midimu: Masked Dancers of Tanzania and Mozambique," *AA* 4:2 (1971): 38–44. The best overview of the Malagasy arts is in J. Mack, *Madagascar. Island of the Ancestors* (London, 1986). Body arts and adornment of eastern Africans were first discussed by H. M. Cole, "Vital Arts of Northern Kenya," *AA* 7:2 (winter, 1974). J. C. Faris,

Nuba Personal Art (London: 1972) and C. Beckwith and T. Ole Saitoti, *Maasai* (London, 1980) are also excellent sources. *Somalia in Word and Image*, ed. K. S. Loughran (Bloomington, 1986), surveys Somali art and literature.

Eslbeth Court provided valuable suggestions for resources on the art of East Africa, and the US Department of Education Fulbright Group Projects Abroad funded a study tour which allowed the author to refine this chapter. She wishes to thank her fellow participants for their friendship and support. Several scholars attending the University of Iowa conference on "Cross Currents: Art and Power in East Africa" read and commented upon portions of the manuscript.

CHAPTER 14
Illustrations of ancient rock art from eastern Africa can be found in M. Leakey, *Africa's Vanishing Art. The Rock Paintings of Tanzania* (London, 1983). Some specific dates and references to sites of southern African rock art were taken from A. R. Willcox, *The Rock Art of Africa* (New York, 1984). For images carved in relief see T. Dowson, *Rock Engravings of Southern Africa* (Johannesburg, 1992). The gold rhinocerous from Mapungubwe is illustrated in M. L. Hall, *Farmers, Kings, and Traders: The Peoples of Southern Africa, 200–1860* (Chicago, 1987). Iconographical analysis of the birds from Zimbabwe comes from T. N. Huffman, "The Soapstone Birds from Great Zimbabwe," *AA* 18:3 (1985): 68–73; Huffman's controversial interpretation of the site itself is set forth in "Snakes and Birds: Expressive Space at Great Zimbabwe," *African Studies* 40 (1981): 131–50. Architectural symbolism is the subject of "Indlu: The Domed Dwelling of the Zulu," in *Shelter in Africa*, ed. Paul Oliver (London, 1971): 96-105, and A. Kuper, "Symbolic Dimensions of the Southern Bantu Homestead," *Africa* 50 (1980): 8–23. Other aspects of southern African arts were taken from *AA* 21:3 (summer 1988). Information on contemporary artists comes from J. Kennedy, *New Currents, Ancient Rivers. Contemporary African Artists in a Generation of Change* (Washington D.C., 1992), and *Seven Stories about Modern Art in Africa* (London/Paris, 1996). The work of W. Bester is described in A. Magnin and J. Soulillou, *Contemporary Art of Africa* (New York, 1966).

For an excellent brief introduction to the arts of southern Africa see P. Davison, "Southern Africa," in *Africa. Art of a Continent* chapter 3. *African Art in Southern Africa. From Tradition to Township*, ed. A. Nettleton and D. Hammond-Tooke (Johannesburg, 1984), is another good summary. Ancient rock art is the subject of J. D. Lewis-Williams, *Believing and Seeing. Symbolic Meanings in Southern San Rock Paintings* (London, 1981), and P. Garlake, *The Hunter's Vision. The Prehistoric Art of Zimbabwe* (Seattle, 1995). *Art and Ambiguity. Perspectives on the*

Brenthurst Collection of Southern African Art (Johannesburg, 1991) surveys art works of the last two centuries. An excellent source for the art of the Shona and their neighbors is *Zimbabwe*, ed. W. Dewey (London, 1997); earlier research is summarized in P. Garlake, *Great Zimbabwe* (London, 1973). Good regional studies include *Ndebele. A People and their Art*, ed. I. Powell (New York, 1995), G. van Wyck, *African Painted Houses: Basotho Dwellings of Southern Africa* (New York, 1998), and J. Morris and E. Preston-Whyte, *Speaking with Beads. Zulu Arts from Southern Africa* (London, 1994). Among the excellent books and catalogs on contemporary artists of the region are: S. Williamson, *Resistance Art in South Africa* (London, 1989); G. Younge, *Art from the South African Townships* (London, 1988); O. Levinson, *The African Dream* (on John Muafangejo) (London, 1992); *Art from South Africa*, Museum of Modern Art, Oxford (London, 1990).

William Dewey provided the author with valuable assistance on many different occasions, and the author is particularly grateful for his generous, prompt, and thorough review of the final version of this chapter.

CHAPTER 15
Art made in African American communities is discussed in J. M. Vlach, *The Afro-American Tradition in Decorative Arts* (Cleveland, 1978). For art of the Caribbean islands see V. Poupeye, *Caribbean Art* (London, 1998), and *The Sacred Arts of Haitian Vodou*, ed. D. Cosentino (Los Angeles, 1995). The impact of African images and ideas in New World communities was explored by Vlack; recent scholarship on the legacy of the Kongo is found in W. McGaffey and M. D. Harris, *Astonishment and Power* (Washington D.C., 1993), and in R. F. Thompson, *Face of the Gods* (New York, 1993). Information on African Cuban art was taken from *Wilfredo Lam and His Contemporaries* (New York, 1992). Several fine exhibition catalogs provided information on specific artists: *Howardina Pindell: Paintings and Drawings* (Potsdam College of the State University of New York, 1992); P. Perry, *Free Within Ourselves: African-American Artists in the Collection of the National Museum of American Art* (Washington D.C., 1992); *Black Art, Ancestral Legacy: The African Impulse in African-American Art* (Dallas, 1990).

Excellent surveys are available on the art of African American artists. R. J. Powell, *Black Art and Culture in the 20th Century* (London, 1997), and S. Patton, *African-American Art* (New York, 1998), follow in the footsteps of R. Bearden and H. Henderson, *A History of African American Artists, From 1972 to the Present* (New York, 1993).

The author of this chapter is particularly grateful to Richard Powell for his careful reading and useful comments.

Picture Credits

Calmann & King, the authors and the picture researchers wish to thank the institutions and individuals who have kindly provided photographic material. Collections are given in the captions alongside the illustrations. Sources for illustrations not supplied by museums or collections, additional information, and copyright credits are given below. Numbers are figure numbers unless otherwise indicated.

While every effort has been made to trace the present copyright holders we apologize in advance for any unintentional omission or error and will be pleased to insert the appropriate acknowledgement in any subsequent edition.

The following abbreviations have been used:

A.M.N.H.: American Museum of Natural History, New York
Barbier-Mueller: Musée Barbier-Mueller, Geneva
B.M.: British Museum, London
C.A.A.C.: The Contemporary African Art Collection, Paris
Dapper: Archives Musée Dapper, Paris
Disney-Tishman: The Walt Disney-Tishman African Art Collection, Glendale, C.A.
Elisofon: Eliot Elisofon Photographic Archives
Estall: Robert Estall Photo Library, Sudbury, Suffolk
Fowler: The Fowler Museum of Cultural History, University of California at Los Angeles
Held: André and Ursula Held, Lausanne
Hutchison: Hutchison Library, London
Indiana: Indiana University Art Museum, Bloomington I.N.
M.A.A.O.: Musée des Arts d'Afrique et d'Océanie, Paris
Metropolitan: The Metropolitan Museum of Art, New York
M.H.: Musée de l'Homme, Paris
M.V.: Staatliche Museen zu Berlin - Preußischer Kulturbesitz, Museum für Völkerkunde
Network: Network Photographers, London
N.M.A.A.: National Museum of African Art, Smithsonian Institution, Washington D.C.
R.A.I.: Royal Anthropological Institute of Great Britain & Ireland, London
R.A.R.C.: Rock Art Research Centre, University of the Witwatersrand, Johannesburg
Rietberg: Museum Rietberg, Zürich
R.M.C.A.: Royal Museum of Central Africa, Tervuren
R.M.N.: Réunion des Musées Nationaux, Paris
W.F.A.: Werner Forman Archive, London

pages 1, 2, 8 B.M. # 1901,11-13.50; #51, 1971 AF38.2; # 1990 AF15-1
page 5 W.F.A./M.V.
page 6 Courtesy of the artist, Nike Center for Art & Culture, Oshogbo
page 7 C. Pavard/Hoa Qui, Paris
page 9 H. P. Moore. © New York Historical Society # neg 37628
i Courtesy of Rowland Abiodun
ii Henry J. Drewal. Elisofon/N.M.A.A. # A1992-028-05613
iii Courtesy of Mrs Mareidi Singer. Photo Heini Schneebeli
iv Brooklyn Museum, New York. Robert B. Woodward Memorial Fund & Gift of Arturo and Paul Peralta-Ramos. # 69.39.2
v, ix M.H. # MH.38.53.23; # MH.39.73.1
vi Eliot Elisofon, 1970. Elisofon/N.M.A.A. # Nile 1947. C-10,21
vii Lorenz Homberger
viii Herbert Cole
x Indiana. Photo Michael Cavanagh and Kevin Montague
xi British Library, London # OR516, f.100v
xii Lars Oddvar Løvdahl/Keystone Collection/Hulton Getty, London
xiii Kasmin Collection/W.F.A.
xiv Carollee Pelos, courtesy of Jean-Louis Bourgeois
xv Jean Dominique Lajoux/Rapho/Network
xvi Monni Adams
xvii B.M. # Benin 191
xviii Brooklyn Museum of Art, New York. # 37.635E
xix Fabby Nielsen/Estall

PART ONE
pages 24-25 W.F.A./M.V.
page 26 see fig. 1-10
1-1 Jean Besancenot. Courtesy of Mme M-D. Girard Besancenot and l'Institut du Monde Arabe, Paris
1-2, 1-3 Frobenius-Institut, Frankfurt-am-Main # ∂ X/181; # ∂ X/168
1-4, 1-5, 1-7, 1-9 Jean-Dominique Lajoux/Rapho, Paris/Network
1-6 Jean-Dominique Lajoux/Artephot, Paris/Estall
1-10 M. d'Heilly/Artephot, Paris
1-11, 1-28 W.F.A.
1-13 Fototeca Unione of the American Academy in Rome
1-14 Roger Wood/Corbis, London
1-15 K. A. C. Cresswell
1-18 Peter Sanders Photography, Chesham, Bucks
1-19 Abbas/Magnum Photos, London
1-20 B.M. # 1994 AF12.2
1-21 John Hatt/Hutchison
1-22 Henry Guttmann/Hulton Getty Picture Collection, London
1-24 Tim Beddow/Hutchison Library
1-25 T. Monod. M.H. #64.12558.239(1)
1-26 John Wright/Hutchison
1-29 B.M.
page 45 see fig. 3-34
1-30 G. Gasquet/Hoa Qui, Paris
1-31 Betty LaDuke
1-32 © Jellel Gasteli, Paris 1997
1-33 Courtesy of the artist. Photo Philippe Maillard, Paris

page 48 see fig. 2-21
2-1, 2-14 B.M.
2-2, 2-3 Brooklyn Museum, New York # 07.447.505; # 1996.146.1
2-4 Jürgen Liepe, Berlin
2-5, 2-11 Hirmer Verlag GmbH, Munich
2-7 Paul M. R. Maeyaert, Mont de l'Enclus (Orroir), Belgium
2-8 Museum of Fine Arts, Boston # 11.1738
2-9 Jürgen Liepe, Berlin/Egyptian Museum, Cairo # JE 56274
2-10 B.M. # EA 37977
2-12 Egyptian Expedition of the Metropolitan # TAA 512B
2-13 Harry Burton. Metropolitan # TAA 475
2-15 From Kazimierz Michalowski, *Art of Ancient Egypt* (New York: H. N. Abrams, 1969). Drawings by Pierre Hamon. Reproduced with the permission of Editions Citadelles et Mazenod, Paris
2-16 W. Vivian Davies
2-17 Staatliche Sammlung Ägyptischer Kunst, Munich # ANT 24466
2-18 Derek Welsby
2-19 Sudan National Museum, Khartoum # SBN 13.365
2-20 Brooklyn Museum, New York # 49.48
2-21 Musée du Louvre, Paris. Photo R.M.N. # AF 5511
2-22 From Graham Connah, *African Civilizations: Precolonial Cities and States in Tropical Africa: An Archaeological Perspective* (Cambridge [Cambridgeshire]; New York: Cambridge University Press, 1987). Reproduced with the permission of Cambridge University Press
2-23 Julia Bayne/Robert Harding Picture Library, London
2-24 Derek Welsby # JE 71191
2-25 Museum Narodwe, Warsaw. Photo Elzbieta Gawryszewaka # 234036 MNW
2-26, 2-27, 2-32, 2-35, 2-36 Georg Gerster/Network
2-28 © Malcolm Varon, New York. Courtesy of the Hill Monastic Manuscript Library, St John's Abbey & University, Collegeville Minnesota # EMML 7602 ff 109v-110r
2-29 © Malcolm Varon, New York. Courtesy of the Institute of Ethiopian stutdies, Addis Ababa # IES 3980
2-30 Victoria & Albert Museum, London # M.36-1915
2-31, 2-33 David Beatty/Robert Harding Picture Library, London
2-34 Courtesy of Jacques Mercier, Paris. Photo Guy Mercier
2-37 Courtesy of Mrs Markisa Marker. Photo Salah Hassan
2-38 Courtesy of the artist
2-39 Achameyeleh Debela
page 78 see fig. 3-5
3-1 National Commission for Museums and Monuments, Lagos
3-2 Dirk Bakker, Detroit # 60.J.2
3-5 M.H. # MH 49.3.842
3-6 Fowler # X88-300
3-7, 3-10 Marla Berns
3-8, 3-11 Fowler. Photo Richard Todd

3-9 Reproduced with the permission of Marla Berns
3-14 B.M. # 1911.12-14.72, 1932.10-21.117, 1954+23.962, 1954+23.966
3-15 Fowler. Arnold Rubin Collection
3-16 Arnold Rubin 1965. Fowler
3-17 Robert H. Nooter
3-18 Metropolitan. Photo Jerry L. Thompson, Amenia, N.Y.
3-19 Arnold Rubin 1969. Fowler
3-20 Arnold Rubin 1965. Fowler
3-21 Gilbert Schneider
3-22 Paul Gebauer. Robert Goldwater Library, Metropolitan # R-77
3-23 Metropolitan # 1972.4.19
3-24 W.F.A./M.V.
3-25 Eliot Elisofon, 1970. Elisofon, N.M.A.A. # G-1-HSA-91
3-26 a, b, c From J. C. Moughtin, *Hausa Architecture* (London: Ethnographica, 1985). Reproduced with the permission of the author
3-27 Abbas/Magnum Photos, London
3-28 James Morris/Axiom, London
3-29 Frank Willett
3-30 Museum for Textiles, Toronto. Photo Rachel Ashe # T94.3008
3-31 Salah Hassan
3-32 Carollee Pelos courtesy of Jean-Louis Bourgeois
3-33 Ristorcelli. M.H. # C55.1580.494
3-34 M. Renaudea/Hoa Qui, Paris
3-35 Bernard Gardi
3-36 Department of Anthropology, Smithsonian Institution, Washington, D.C. # 341658-Fulani neg 86-6852
3-37, 3-38, 3-39 Carol Beckwith/Estall
3-40 From T. J. H. Chappel, *Decorated Gourds in North-eastern Nigeria* (London: Ethnographica, 1977). Reproduced with the permission of the author
page 106 see fig. 4-18
4-1 N.M.A.A. Photo Franko Khoury # 86-12-2
4-2 Serge Robert
4-3 Dennis Rouvre/R.M.N. Courtesy Musée National, Nouakchott & Robert Vernet/Centre Regional Inter-Africain d'Archaeologie # KS.72.K1.94
4-5 Art Institute of Chicago. Photo Alan Newman # 1987.314.1-5
4-6 Jonathan Hope/Hutchison
4-7 a, b From Pierre Maas and Geert Mommersteeg, *Djenné: chef-d'oeuvre architectural* (Amsterdam: K.I.T. Press/Royal Tropical Institute, 1992). Reproduced with the permission of the authors
4-8 John Hatt/Hutchison
4-9, 4-15 Carollee Pelos, courtesy of Jean-Louis Bourgeois
4-10 Georg Gerster/Network
4-11, 4-12 Metropolitan # 1979.206.153; # 1979.206.121 & 1983.600 a, b
4-13 New Orleans Museum of Art # 77.254
4-14, 4-18 M.A.A.O. Photo R.M.N. # MNAN 1963.157; # MNAM 67.4.10
4-16 Edward Fortier. Fortier Postcard Collection. Elisofon, N.M.A.A.
4-17 Pascal James Imperato
4-19 B.M. # 1956 AF27.10

4-20 National Museum of Natural History, Smithsonian Institution, Washington, D.C. Photo Diane Nordeck # E428417
4-21 Indiana. Photo Michael Cavanagh & Kevin Montague # 71.111
4-22 Musée de l'Homme, Paris # MH.31.74.1091
4-23 Hans Himmelheber (from Robert Goldwater: *Bambara Sculpture*). Courtesy of Eberhard Fischer
4-24 M. Griaule. M.H. # C.72.1509.41
4-25 Philip Ravenhill. Elisofon, N.M.A.A.
4-26 Mary Jo Arnoldi
4-27 Margaret Courtney-Clarke/Tom Keller Associates, New York
4-28 Seydou Keita. Courtesy of C.A.A.C./The Pigozzi Collection, Geneva
4-29 M. Renaudeau/Hoa Qui, Paris
4-30 Courtesy of the artist. Photo courtesy of Clementine Deliss
4-31 Courtesy of the artist. Photo Jean-Louis Losi, Paris
4-32 Jerry L. Thompson, Amenia, N.Y. for "Africa Explores" at the Museum for African Art, New York
4-33 Courtesy of the artist. Photo Joanna Grabski, Washington, D.C.
4-34 Courtesy of Bara Diokhane and Spike Lee. Photo Jerry L. Thompson, Amenia, N.Y.
4-35 Kino International
page 130 see fig. 5-38
5-1 University of Iowa Museum of Art, Iowa City # CMS 553
5-2, 5-13, 5-25, 5-33, 5-34, 5-44, 5-47, 5-48 Herbert C. Cole
5-3 Koninklijk Instituut voor de Tropen, Amsterdam # 4133-2
5-4, 5-9, 5-20 Metropolitan. Michael C. Rockefeller Memorial Collection. Bequest of Nelson A. Rockefeller # 1978.412.322; # 1979.206.173 a-c; # 1978.412.421
5-5, 5-6, 5-8, 5-11 Dapper. Photo Hughes Dubois
5-7, 5-22 Metropolitan # 1977.384.15; # 1979.206.194 & 1979.206.193
5-12, 5-17 Walter van Beek
5-14, 5-16, 5-18 Philip Ravenhill
5-15, 5-30 Barbier-Mueller. Photo Roger Asselberghs # 1004-48; # 1006-37
5-19 Eliot Elisofon. Elisofon, N.M.A.A. # XII-R7,12
5-21, 5-35 Barbier-Mueller. Photo Pierre-Alain Ferrazzini # 1006-27; # 1006-31B
5-23 Courtesy of Frieda Rosenthal, New York. Photo © Malcolm Varon, New York
5-24 Disney-Tishman. Photo Jerry L. Thompson, Amenia, N.Y. # 1984.AF.051.021
5-26, 5-27, 5-29, 5-31, 5-32 Anita J. Glaze
5-28 Collection of Helmut Zimmer, Museum Rietburg, Zürich. Photo Piet Meyer
5-36, 5-37 Piet Meyer. Museum Rietburg, Zürich
5-38 Museum Rietburg, Zürich. Photo Wettstein & Kauf
5-39, 5-40, 5-41 Christopher D. Roy
5-42 Private Collection

5-43 Rietberg. Photo Rainer Wolfsberger

5-45 After Jean-Paul Bourdier and Trinh T. Minh-ha, *African Spaces: Designs for Living in Upper Volta* (New York: Holmes & Meier, 1985). Copyright © by John-Paul Bourdier. Reproduced and adapted with the permission of the publisher

PART TWO

pages 166-167 Courtesy of the artist, Nike Center for Art & Culture, Oshogbo

page 168 see fig. 7-18

6-1, 6-16 Fred Lamp

6-2 B.M. # VI/40

6-3, 6-30 Metropolitan. Michael C. Rockefeller Memorial Collection. Gift of Nelson A. Rockefeller # 1978.412.375; # 1979.206.264

6-4, 6-8 Barbier-Mueller. Photo Pierre-Alain Ferrazzini # 1002-3; # 1000-2

6-5 W.F.A./B.M.

6-6 Disney-Tishman. Photo Jerry L. Thompson, Amenia, N.Y. # 1984.AF.051.030

6-7 Courtesy of Frank Willett

6-9 M. Renaudeau/Hoa Qui, Paris

6-10 Danielle Gallois Duquette

6-11 Doran Ross

6-12 Fowler

6-13 University of Iowa Museum of Art, Iowa City # 1986.541

6-14 M.H. # D.94.51

6-15, 6-21, 6-27, 6-29 Michel Huet/ Hoa Qui, Paris

6-17 M.H. Photo J. Oster # MH.33.40.11

6-18 University of Pennsylvania Museum, Philadelphia # 37-22 279 neg S5-23348-50

6-19, 6-20, 6-36 William C. Siegmann

6-22 Peabody Museum, Harvard University, Cambridge, M.A. Photo Hillel Burger # B19500

6-23 © The Fine Arts Museums of San Francisco/De Young Memorial Museum # 73.9

6-24, 6-32, 6-34, 6-35 Eberhard Fischer

6-25 Fowler. Photo Denis J. Nervig

6-26 Heini Schneebeli/Bridgeman Art Library, London/New York/M.A.A.O.

6-28 Hans Himmelheber. Courtesy of Eberhard Fischer

6-31 M.A.A.O. Photo R.M.N. # MNAN 1963.163

6-33 Lorenz Homberger

6-37 Hutchison

6-38 David Gamble

6-39 Courtesy of the artist. Photo Monica Blackmun Visonà

6-40 Courtesy of the artist and C.A.A.C./The Pigozzi Collection, Geneva. Photo Claude Postel

page 194 see fig. 7-9

7-1, 7-4, 7-5, 7-7, 7-18, 7-31, 7-36, 7-38, 7-45 Doran Ross

7-2, page 197, 7-6, 7-22, 7-23, 7-32, 7-39, 7-42, 7-43, 7-44 Herbert C. Cole

7-3 © René David, Galerie Walu, Zürich

7-8, 7-9 Barbier-Mueller

7-10, 7-28, 7-35 Barbier-Mueller. Photo Pierre-Alain Ferrazzini # 1008-2, 1008-3 & 1008-1; # 1007-12; # 1007-51

7-11, 7-13, 7-14, 7-17, 7-19, 7-29, 7-40 Fowler. Photo Don Cole

7-12, 7-30 Fowler

7-15 Herbert C. Cole/B.M.

7-20, 7-21 a, b Adapted from Michael Swithenbank, *Ashanti Fetish Houses* (Accra: Ghana Universities Press, 1969)

7-24 Courtesy of Mr & Mrs Arnold J. Alderman

7-25 Metropolitan. Michael C. Rockefeller Memorial Collection. Gift of Nelson A. Rockefeller # 1978.412.390 & 391

7-26 Lap Nguyen Tien

7-27 Fowler. Photo Denis J. Nervig

7-33 Susan Vogel

7-34 Philip Ravenhill

7-37 Monica Blackmun Visonà

7-41 From Herbert M. Cole and Doran H. Ross, *Arts of Ghana* (Los Angeles: Museum of Cultural History, University of California, 1977). Reproduced with the permission of the museum.

7-46 Museum voor Volkenkunde, Rotterdam

7-47 Carol Beckwith & Angela Fisher/Estall

7-48 Courtesy of the artist and the October Gallery, London. By permission of the N.M.A.A. Photo C. O. Amuzie

7-49 Courtesy of the artist. Photo Jerry L. Thompson, Amenia, N.Y.

page 228 see fig. 8-21

8-1 Held/Museum of Ife Antiquities # IFF.17

8-2 Photo by William Fagg. R.A.I. # WBFP 58/75/6RAI

8-3 Frank Willett/Museum of Ife Antiquities

8-5 From Peter Garlake, "Excavation at the Woyeasiri Family Land" in *West African Journal of Archaeology*, vol. 7. Reproduced and adapted with the permission of the author

8-6 Ekpo Eyo/National Museum, Lagos

8-7 Jerry L .Thompson, Amenia, N.Y.

8-8 Museum of Ife Antiquities

8-9, 8-10 Held, Lausanne/Museum of Ife Antiquities

8-11 Held, Lausanne/Museum of Ife Antiquities # 79.R.12

8-12 Held, Lausanne/National Museum, Lagos # 79.R.18

8-13 Held/National Museum, Lagos

8-14 Frank Willett

8-15, 8-19 B.M.

8-16 Weickmann Collection, Ulmer Museum, Ulm. Photo Bernd Kegler

8-17 H. V. Meyerowitz by permission of the Burlington Magazine, London

8-18, 8-33 John Pemberton III, Amherst, MA

8-20, 8-24 William Fagg. R.A.I. # Fagg 1959/81/5 RAI ; # WBFP 49-50/23/10

8-21, 8-23 8-64 B.M. # 18.31; # 1949 AF46.146; # 1971 AF35.17

8-22, 8-26 Disney-Tishman. Photo Jerry L. Thompson, Amenia, N.Y. # 1984.AF.051.054; # 1984.AF.051.047

8-25, 8-29 M.V. # III C 2792; # III C 27201

8-27 Margaret Thompson Drewal

8-28 Field Museum, Chicago # A109448

8-30 N.M.A.A. Photo Franko Khoury # 95-10-1 a, b

8-31 Philip Allison, courtesy of Mrs Lesley Allison

8-32 Indiana University Art Musem, Bloomington. Photo Michael Cavanagh & Kevin Montague # 87.24.2

8-34 Harn Museum of Art, University of Florida # 1993.12.5

8-35 Seattle Museum of Art. Photo Paul Macapia

8-36, 8-40 Robert Farris Thompson

8-37 Leo Frobenius. Frobenius Institut, Frankfurt-am-Main # ∂ IV /5010

8-38, 8-44, 8-45 Henry J. Drewal. Henry J. & Margaret Thompson Drewal Collection. Elisofon, N.M.A.A. # A1992-028-01592; # 1992-028-00411; # 1992-028-00639

8-39, 8-41, 8-42 Marilyn Houlberg

8-43, 8-46 William Rea

8-47 Toledo Museum of Art, Ohio # 1977.22

8-48; 8-50, 8-58 M.H. # E64.1421.493; # E4.16; # C64.7837.173

8-51 M.H. Photo D. Ponsard # MH.94.32.1

8-52, 8-54 Suzanne Preston Blier/Musée Historique, Abomey

8-53 Dapper. Photo Hughes Dubois

8-55 Edna Bay

8-56 Brooklyn Museum of Art, New York # 49.45

8-57 Weickmann Collection, Ulmer Museum, Ulm. Photo Helga Schmidt-Glassner

8-59 Juliet Highet/Hutchison

8-60 Luc Gnacadja

8-61 Afolabi Ojo

8-62 Juliet Highet, London

8-63 Center of African Migration Studies, University of Bremen # 198-frame5

8-65 Courtesy of the artist, Nike Center for Art & Culture, Oshogbo

8-66 John Picton

8-67 Courtesy of the artist

page 274 see fig. 9-33

9-1, 9-31, 9-46, 9-47, 9-51, 9-63 B.M. # 1897.10.11.2; # 1954.Af23.428; # 1996.Af8.3; # 1950. af45.334; # 98,1-15.46; # 1910,5-13.1

9-2, 9-4 Courtesy of Thurstan Shaw

9-3 Dirk Bakker, Detroit/National Museum, Lagos

9-5 National Museum, Lagos

9-6 Dirk Bakker, Detroit/National Museum, Lagos # 79.R.5

9-7 W.F.A./National Museum, Lagos

9-8, 9-10, 9-12, 9-14, 9-15, 9-16, 9-17, 9-20, 9-21, 9-23, 9-43, 9-57 Herbert C. Cole

9-9 Eli Bentor

9-13 Courtesy of the artist and the N.M.A.A. Photo Franko Khoury

page 283 see fig. 8-55

9-18 A. W. Banfield. Royal Ontario Museum # 950.257.56

9-22 Seattle Art Museum # 81.17.625

9-24, 9-34 Fowler. Photo by Don Cole

9-25, 9-26 G. I. Jones

9-27 Simon Ottenberg

9-28 Elizabeth Evanoff

9-29 Metropolitan # 1978.412.628

9-30 N.M.A.A. Photo Franko Khoury # 87-6-1

9-32 Disney-Tishman. Photo Jerry L. Thompson, Amenia, N.Y. # 1954.AF.051.079

9-33 Field Museum, Chicago Neg 177109312

9-35, 9-36 Jean M. Borgatti

9-37, 9-52 Paula Gershick Ben-Amos

9-39, 9-40, 9-41 Keith Nicklin & Jill Salmons

9-42, 9-44 Joanne Eicher

9-45 Indiana. Photo Michael Cavanagh & Kevin Montague # 96.49

9-50, 9-64 R. E. Bradbury, courtesy of Mrs Ros Bradbury

9-53 M.V.

9-55 B.M.

9-56, 9-62 W.F.A./M.V.

9-58 From Kate Ezra, *Royal Art of Benin: The Perls Collection in the Metropolitan Museum of Art* (New York: Metropolitan Museum of Art; distr. by H. N. Abrams, 1992).

9-59 From Jan Vansina, *Art History in Africa: An Introduction to Method* (London; New York: Longman, 1984). Redrawn and adapted with the permission of the author

9-60 University of Pennsylvania Museum, Philadelphia # AF 2064B

9-61 Bridgeman Art Library, London/New York/Detroit Institute of Arts

9-65 Henry J. Drewal

PART THREE

328-9 C. Pavard/Hoa Qui, Paris

page 330 see fig. 10-16

10-1, 10-37 M.H. # MH.X.43.433; # MS.86.772

10-2, 10-4 Keith Nickin

10-3 Barbier-Mueller. Photo Roger Asselberghs #1015-23

10-6 New Orleans Museum of Art #86.83

10-7 Cambridge University Museum of Archaeology and Anthropology # 1917-51

10-8 Fowler. Photo Denis J. Nervig

page 337 see fig. 6-9

10-9 Wilhelm Schneider. Wilhelm Schneider Collection. Elisofon, N.M.A.A. # A1991-011-151

10-10 Seattle Art Museum. Photo Paul Macapia # 81.17.507

10-11 Rudolf Oldenburg. Museum für Völkerkunde, Vienna # 17470

10-12 R.M.C.A. # EPH 4556

10-13 Ankermann. M.V. # VIIIA 10654

10-14, 10-18 Frank Christol, Fontaine-Lavganne. M.H. # D66-4391-730; # C.66.4407.730

10-15 Gilbert Schneider

10-16 M.V. Photo Dietrich Graf # III C 33341a,b

10-17 Marie Pauline Thorbecke. Historisches Fotoarchiv, Rautenstrauch-Joest Museum für Völkerkunde, Cologne # 19336

10-19, 10-27 Paul Gebauer. Robert Goldwater Library, Metropolitan # 60.33; # 198-frame5

10-20, 10-21, 10-25 Ankermann. M.V. # VIII A 10646; # VIII A 5405; # VIII A 5331+2

10-22 M.V. # III C 25494

10-23 Disney-Tishman # 1984.AF.051.110 a, b

10-24 © Hans-Joachim Koloss, Berlin

10-26 Field Museum, Chicago # 175596 neg A 95753

10-28 C. Pavard/Hoa Qui, Paris

10-29 Rietberg. Photo Wettstein & Kauf

10-30 National Museum of Natural History, Department of Anthropology, Smithsonian Institution, Washington, D.C. # 166178

10-31 National Museum of Ethnology, Stockholm. Photo Bo Gabrielsson

10-32 Metropolitan # 1979.206.229

10-33, 10-36 Barbier-Mueller. Photo Pierre-Alain Ferrazzini # 1019-5; # 1019-4

10-35 Völkerkunde Museum der Universität, Zürich

10-38 © Denver Art Museum, Gift of Fred Riebling # 1942.443

10-39 University of Iowa Museum of Art # 1986.338

10-40 Musée d'Histoire Naturelle, La Rochelle

10-41 M.A.A.O. Photo R.M.N. # 69 CN 665

10-42 W.F.A./Entwistle Gallery, London

10-43 Alisa LaGamma

10-44 Courtesy of the artist and the Fundación Escultor leandro Mbomio Nsue, Malabo, Equatorial Guinea

page 366 see fig. 11-20

11-1, 11-2, 11-17, 11-21, 11-26, 11-30, 11-40, 11-65 R.M.C.A.. Photo Roger Asselberghs # RG 43800; # 14796; # RG 7943; # RG 33107; # RG 43161; # RG 43146; # RG 26520; # RG 3693

11-3 Pitt Rivers Museum, Oxford # 1886.1.254.1

11-5 Virginia Museum of Fine Arts, Richmond, V.A. The Adolph D & Wilkins C. Williams Fund. Photo Katherine Wetzel, © 1994 # 85.591

11-6, 11-24, 11-25, 11-36, 11-69 M.V. # III C 44815; # III C 2969; # III C 778; # III C 32159; # III C 3246

11-7, 11-8 M.V. Photo W Scheider-Schütz # III C 44072; # III C 6286

11-9 Peabody Essex Museum, Salem, M.A. Photo by Mark Sexton # E 67754

11-12, 11-16 H. Deval. R.M.C.A. # EPH 13535; # EPH 5833

11-13 M.H. # MH 30.29.353

11-14 Rietberg. Photo by Wettstein & Kauf # RGW 7361

11-15, 11-68 Brooklyn Museum, New York # 22.1203; # 50.124

11-18 F. L. Michel. Emil Torday and M. W. Hilton-Simpson Collection. R.A.I. # RAI 8013

11-19 Staatliches Museum für Völkerkunde, Munich # 93.630

11-20 National Museums & Galleries on Merseyside # 8.12.97.13

11-22 N.M.A.A. Photo Franko Khoury # 83-3.5a,b

11-23 W.F.A./Christies

11-27 Metropolitan # 1978.412.619

11-28 Museu do Dundu, Angola. Photo courtesy of R.M.C.A. # I 177

11-29 E. Steppé. R.M.C.A. # EPH 9420

11-31, 11-48, 11-61, 11-62, 11-63 R.M.C.A. # RG 32510; # RG 36522; # EPH 9427; # EPH 9435; # RG 24968

11-32, 11-34, 11-53, 11-60, 11-67 B.M. # 1907, 5-28.138; # 1907, 5-28.141; # 1909, 12-21.8; # 1979 AF1.2674; # 1910 4-20.201

11-33, 11-37 Arthur P. Bourgeois

11-35 Fowler # X94.15.1

11-38 F. L. Michel. R.M.C.A. # EPH 11402

11-39 Institut des Musées Nationaux, Kinshasa. Photo Arthur P. Bourgeois # 73.146.3

11-41 Rietberg. Photo Ernst Hahn

11-42 P. J. van Doorslaer, S.J. Courtesy of Arthur P. Bourgeois

11-43 Léon de Sousberghe. N.M.A.A.

11-44 Disney-Tishman. Photo Jess Allen # 1984.AF.051.364

11-45 C. Souris. R.M.C.A. # EPH 12247

11-46, 11-47 A. Scohy. R.M.C.A. # EPH 11531; # EPH 7030

11-49, 11-51 C. Lamote. R.M.C.A. #

EPH 3039; # EPH 3044
11-50 Fowler
11-52, 11-56 Eliot Elisofon. Elisofon, N.M.A.A. # C KBA 6 (2412); # 22923, P-4,11
11-55 C. Zagourski. R.M.C.A. # EPH 820
11-57 Indiana. Photo Michael Cavanagh & Kevin Montague
11-58 Indiana. Photo Michael Cavanagh & Kevin Montague # 63.327
11-59 Virginia Museum of Fine Arts, Richmond, V.A. Photo Katherine Wetzel © 1994 # 85.592
11-60 B.M.
11-64 Peabody Museum, Harvard University, Cambridge, M.A. # 17-41-50/B1908
11-66 M.V. Photo Bast # III C 26361
11-70 Courtesy of the artist and C.A.A.C./The Pigozzi Collection, Geneva. Photo Claude Postel
11-71 Peter Herrmann Galerie, Stuttgart
11-72 Jerry L. Thompson, Amenia, N.Y. for "Africa Explores" at the Museum for African Art, New York
page 412 see fig. 12-36
12-1 University of Pennsylvania Museum, Philadelphia # AF 5121
12-2 After a drawing by Mrs. Y. Bale in Francis van Noten, *The Archaeology of Central Africa* (Graz, Austria: Akademische Druck- u. Verlagsanstalt, 1982)
12-3 Pierre de Maret
12-4 Etnografisch Museum, Antwerp. Photo Paul de Backer # AE. 772
12-5 Rietberg. Photo Ernst Hahn
12-6 National Museum of Denmark, Copenhagen. Photo Lennart Larsen # G.8376
12-7 A.M.N.H. # 2423b Neg 329929
12-8 Brooklyn Museum, New York # 76.20.4
12-9 W. F. P. Burton. R.M.C.A. # EPH 3463; # EPH 3412
12-10 R.M.C.A. # EPH 8808
12-11, 12-18, 12-22, 12-27 R.M.C.A. Photo Roger Asselberghs # RG 23470; # RG 30621; # RG 55.3.40; # RG 7602
12-12 Etnografisch Museum, Antwerp # AE. 864
12-13 Linden-Museum, Stuttgart # F 52.595L
12-14, 12-20, 12-24 Metropolitan # 1978.412.591; # 1979.206.277; # 1978.412.571
12-15 M.V. # III E8626
12-16, 12-37 Marc Felix
12-17 Dunja Hersak
page 425 see fig. 7-5
12-21 University of Iowa Museum of Art, Iowa City # X 1986.571
12-23 Fowler

12-25, 12-28 Barbier-Mueller. Photo Roger Asselberghs # 1026-112; # 1026-115
12-26, 12-34 C. Zagourski. R.M.C.A. # EPH 8905; # EPH 8903
12-30, 12-31, 12-32, 12-35 Herbert Lang. A.M.N.H. # 111791; # 224507; # 111873; # 111925
12-36 A.M.N.H. Photo Lynton Gardiner Neg 338161
12-38 Field Museum, Chicago # A106712
12-39, 12-40 Courtesy of Ilona Szombati

PART FOUR
pages 438-9 B.M. # 1990 AF15-1
page 440 see fig. 13-46
13-1 Angela Fisher/Estall
13-2 From Peter S. Garlake, *The Early Islamic Architecture of the East African Coast* (Nairobi: Oxford University Press, 1966). Redrawn and adapted with the permission of the author
13-3 M. Csaky/Hutchison
13-4 Fowler. Photo Denis J. Nervig
13-5 Robert H. Nooter
13-6, 13-11 Cambridge University Museum of Archaeology & Anthropology # P6928.ACH.1; # P 6922.ACH.1
13-7, 13-10, 13-47 Carol Beckwith and Angela Fisher/Estall
13-8 Fowler. Photo Denis J. Nervig # X89.367
13-9 From Linda Donnaly, "Life in the Swahili Town House" in *The African Archaeological Review*, issue 5, 1987
13-12 David Coulson/Estall
13-13 Ernie Wolfe III
13-14 M.V. Photo Dietrich Graf # III E 7260
13-15, 13-21, 13-33 M.V. Photo W. Scheider-Schütz # III E 3593 a-c; # III E 3403 a, b; # III E 11012
13-16, 13-22, 13-24 M.V. # III E 3519; # III E 12657; # III E 6720
13-17 Staatliche Museum für Völkerkunde, Munich. Photo S. Antrum-Mulzer # 17-14-98
13-18 Völkerkundliche Sammlungen, Reiss-Museum, Mannheim. Photo Jean Christen # IV Af.9095
13-19 N.M.A.A. Photo Franko Khoury # 89-10-1
13-20, 13-25, 13-27 Linden-Museum, Stuttgart. Photo V. Didoni # 59316; # 45993; # 40486
13-23, 13-34 Museum für Völkerkunde, Leipzig. Photo Karin Wieckhorst # MAF 13023; # MAF 15663
13-26 Courtesy of Jean Willy Mestach
13-28, 13-29, 13-44 B.M. # 1931,1-5.14; # 1901,11-13.50 & 51, 1971 AF38.2; # 1990 AF15-1
13-30 Courtesy of the artist

13-31 Barbara Blackmun
13-32 Laurel Birch Aguilar
13-35 Museum für Völkerkunde, Leipzig. Photo Ingrid Hänse # MAF 16593
13-36 Chris Johns/N.G.S. Image Collection, Washington, D.C.
13-37 Museu Nacional de Etnologia, Lisbon/Instituto Português de Museus, Lisbon. Photo Carlos Monteiro # AH 961-M
13-38 Museum für Völkerkunde, Leipzig. Photo Karin Wieckhorst
13-39 Courtesy of the artist and the Museum für Völkerkunde, Frankfurt. Photo Gisela Simrock # N.S. 51074
13-40 M.H. # D.76.285.494
13-41, 13-42 N. Boulfroy. M.H. # BF.72.1085.780; # E.78.1255-780
13-43 A. N. Tucker
13-45 Menil Collection, Houston. Photo Hickey-Robertson # 83-029 DJ
13-46 Sybil Sassoon/Robert Harding Picture Library
13-48, 13-49 James Faris
13-50 Carol Beckwith/Estall
13-51, 13-52 Herbert C. Cole
13-53 Courtesy of the artist. Photo Clementine Deliss/Museum für Völkerkunde, Frankfurt-am-Main
13-54, 13-55 Courtesy of the artist. Photo Clementine Deliss
13-56 Philip Ravenhill. Elisofon, N.M.A.A.
page 472 see fig. 14-13
14-1 Mischa Scorer/Hutchison
14-2 R.A.R.C. Photo W. E. Wendt
14-3, 14-12, 14-31 South African Museum, Cape Town. Photo Herschel Mair # AA 6008; # UCT 701/1; # AE 449
14-4 R.A.R.C. Photo T. A. Dowson
14-5 McGregor Museum, Kimberley # C6431-15a
14-6, 14-8 R.A.R.C.
14-7, 14-9, 14-11, 14-16, 14-17, 14-19 David Coulson/Estall
14-10 R.A.R.C. Photo David Lewis-Williams
14-13 Department of Archaeology & Anthropology, University of Pretoria
14-14, 14-15 From Peter S. Garlake, *Great Zimbabwe* (London: Thames and Hudson, 1974). Redrawn and adapted with the permission of the author
14-18 D. Allen, courtesy of the National Museums and Monuments of Zimbabwe
14-20 McGregor Museum, Kimberley
14-21, 14-22, 14-23, 14-30, 14-38 B.M. # 1946 AF4.1; # 1954 AF23.2813 & 2815; # 1949 AF46.810; # 1937, 12-1.1; # 1934,12-1.5 & 1991 AF9.8
14-24 Fowler # X93.37.2
14-25 Cambridge University

Museum of Archaeology and Anthropology # P7434.ACH.1
14-26 Indiana # 77.36
14-27 Anitra Nettleton
14-28 The Standard Bank Collection. University of the Witwatersrand Art Galleries, Johannesburg
14-29 Courtesy of the artist. Johannesburg Art Gallery
14-33 Postcard Collection. Elisofon, N.M.A.A.
14-34 Jean Morris. Courtesy of her estate
14-35 Courtesy of the artist and the Thorpe Collection, African Art Centre, Durban
14-36 M.H. Photo C. Lemzaoude # MH 977.52.14
14-37 Linden-Museum, Stuttgart. Photo V. Didoni # 49050
14-39 V. C. Scott O'Connor. Royal Geographical Society, London # D3016
14-40 E.N.A./Popperfoto, Northampton
14-41, 14-42 Margaret Courtney-Clarke/Tom Keller Associates, New York
14-43 Courtesy of the artist and the African Art Centre, Durban
14-44 Courtesy of Bernd Kleine-Gunk, Galerie Zak, Zürich
14-45 Elizabeth Schneider
14-46 Courtesy of Mrs Esther Kumalo and the University of the Witwatersrand Art Galleries, Johannesburg
14-47 Courtesy of Marriam Morris and the National Heritage & Cultural Studies Centre, University of Fort Hare, Alice
14-48 Courtesy of the artist and C.A.A.C./The Pigozzi Collection, Geneva. Photo Claude Postel # AS/DK-5
14-49 Courtesy of the artist and C.A.A.C. # AS/WB-03

PART FIVE
pages 498-499 H. P. Moore. © New York Historical Society # neg 37628
page 500 see fig. 15-7
15-1 Milwaukee Art Museum, W.I. Purchase African-American Art Acquisition Fund, matching funds from Suzanne & Richard Pieper with additional support from Arthur & Dorothy Nelle Sanders
15-2 B.M. # SL.1368
15-3 Gibbes Museum of Art, Charleston # 68.18.01
15-4, 15-5 John Michael Vlach
15-6 Clark University Cartography and Information Graphics Service © Joseph Harris
15-7 Museum of Fine Arts, Boston # 64.619
15-8 Royal Collection, Stockholm.

Photo Alexis Daflos # CXVIG Taylor 107
15-9 Art Resource, New York/National Museum of American Art, Smithsonian Institution, Washington, D.C. # 1983.95.178
15-10 Hampton University Museum, Virginia
15-11 Schomburg Center for Research in Black Culture, New York Public Library
15-12 Whitney Museum of American Art, New York. Photo by Geoffrey Clements # 32.83
15-13 San Francisco Museum of Modern Art. Gift of Mrs E. D. Lederman # 52-4695
15-14 Museum of Modern Art, New York. Inter-American Fund © 2000. © D.A.C.S. 2000 # S-6078-374
15-15 Collection of Fisk University, Nashville, Tennessee
15-16 Courtesy of Allon B. Miller. Photo Denis Valentine, Kingston, Jamaica
15-17 Courtesy of the artist. Photo Denis Valentine, Kingston, Jamaica
15-18 Hirshhorn Museum and Sculpture Garden, Smithsonian Institution, Washington, D.C. Photo Lee Stalsworth. © D.A.C.S. 2000. # 66.410
15-19 Spelman College Museum of Art, Atlanta
15-20, 15-21 Courtesy of the artist
15-22 Museum of the National Center of Afro-American Artists, Boston
15-23 © Martin Puryear
15-24 Wadsworth Atheneum, Hartford, C.T. The Ella Gallup Sumner & Mary Catlin Summer Collection Fund # 1989.17
15-25, 15-26 Courtesy of the artist
15-27 Robert Farris Thompson
15-28 Courtesy of the artist
15-29 Fowler # X94.151
15-30 David Brown
15-31 Courtesy of the artist
15-32 Art Resource, New York/National Museum of American Art, Smithsonian Institution, Washington, D.C. # 1970.353.1
15-33 Courtesy of the artist. Photo Jim Nedresky
15-34 Courtesy of the artist
15-35, 15-36 Courtesy of the artist and Dallas Museum of Art
15-37 Courtesy of the artist and the George Adams Gallery, New York
15-38 Courtesy of the artist and Metro Pictures, New York